Abbot Suger and Saint-Denis

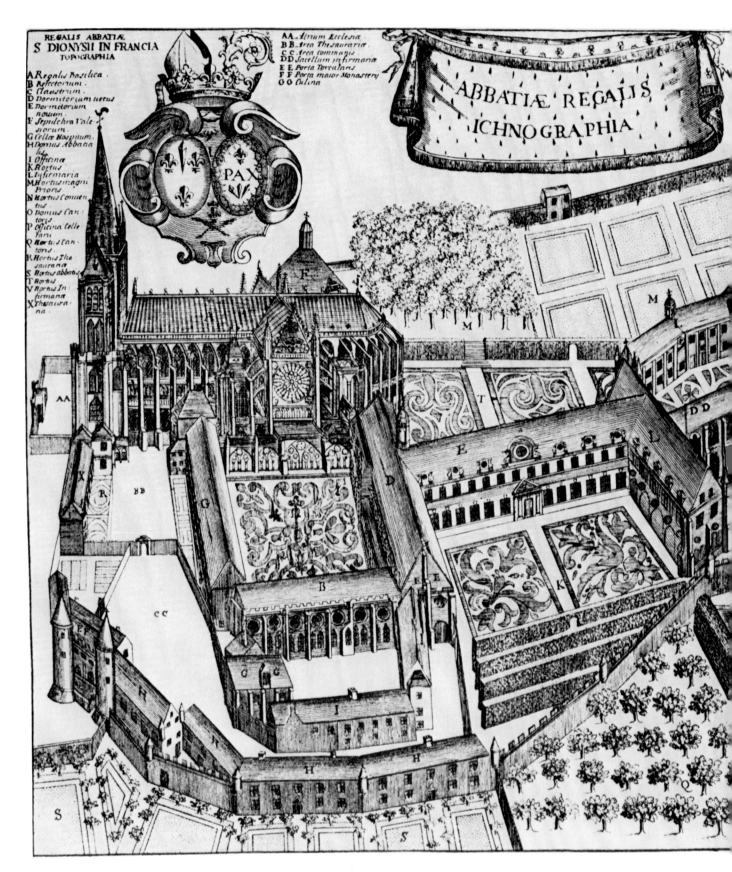

Abbey of Saint-Denis. Seventeenth-century engraving after Michel Germain (from Monasticon Gallicanum, *pl. 66)*

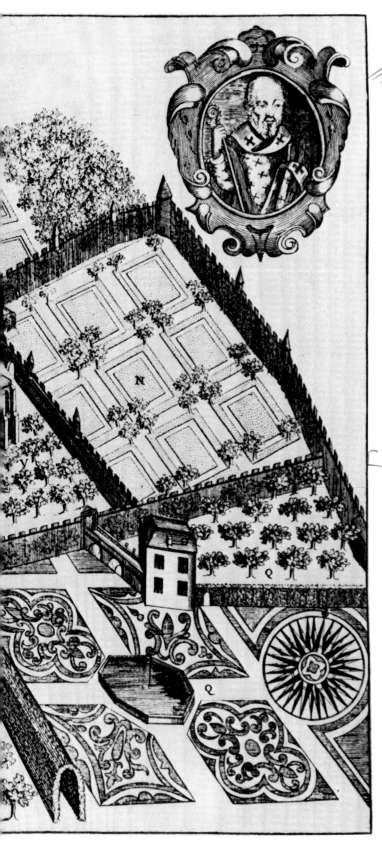

Abbot Suger and Saint-Denis

A Symposium

Edited by Paula Lieber Gerson

The Metropolitan Museum
of Art
New York

In addition to its sponsorship of a symposium on Abbot Suger and Saint-Denis, held in conjunction with an exhibition at The Cloisters entitled *The Royal Abbey of Saint-Denis in the Time of Abbot Suger (1122–1151),* the National Endowment for the Humanities has generously provided support for the publication of the symposium's papers.

Published by The Metropolitan Museum of Art, New York
Bradford D. Kelleher, *Publisher*
John P. O'Neill, *Editor in Chief*
Barbara Burn, *Project Coordinator*
Lorraine Veach and Kathleen C. Antrim, *Editors*
Joseph B. Del Valle, *Designer*
Paula Lieber Gerson, Danielle Johnson, Gabrielle M. Spiegel, Patricia Danz Stirnemann, and Françoise Vachon, *Translators*

Library of Congress Cataloging-in-Publication Data
Main entry under title:

Abbot Suger and Saint-Denis.

Based on papers presented at a symposium held in 1981 at the Cloisters and at Columbia University, sponsored by the International Center for Medieval Art and the Medieval and Renaissance Interdisciplinary Studies Committee of Columbia University.
1. Suger, Abbot of Saint-Denis, 1081–1151—Contributions in church architecture—Addresses, essays, lectures. 2. Eglise abbatiale de Saint-Denis—Addresses, essays, lectures. 3. Architecture, Gothic—France—Saint-Denis—Addresses, essays, lectures. 4. Saint-Denis (France)—Buildings, structures, etc.—Addresses, essays, lectures. I. Gerson, Paula. II. International Center of Medieval Art. III. Columbia University. Medieval and Renaissance Interdisciplinary Studies Committee.
NA5551.S214A23 1986 726'.7'0924 85-29722
ISBN 0-87099-408-5

Typeset by Partners Composition
Printed and bound in the United States of America by Arcata Graphics Company

This book is dedicated to the memories of Sumner McKnight Crosby and Louis Grodecki.

Contents

Foreword

ABBOT SUGER'S patronage of the arts during his reconstruction and refurbishing of the abbey church of Saint-Denis (1137–48) directly brought about the birth of Gothic art. In a few short years the course of Western art was changed: a new style of architecture and sculpture emerged, new forms such as the statue column were invented, and stained glass found its first large-scale monumental use. As the Gothic style matured it came to dominate European art for the next three centuries, and its impact can be seen in the styles of the nineteenth and twentieth centuries.

It thus seemed fitting in 1981 to commemorate Suger's achievements on the nine-hundredth anniversary of his birth. The celebration was a coordinated effort on the part of a group of institutions. A major symposium was held at The Cloisters and at Columbia University, sponsored by the International Center for Medieval Art and the Medieval and Renaissance Interdisciplinary Studies Committee of Columbia University. Simultaneously an exhibition at The Cloisters brought together objects from Saint-Denis now scattered in different collections, some of which had not been together since before the French Revolution. This volume of essays represents the results of this very fruitful collaboration.

Suger's achievements as a patron of the arts were so extraordinary that they have overshadowed other aspects of this remarkable man's involvement in twelfth-century life and affairs. However, Suger's influence went far beyond his contributions to the world of art. As counselor to both Louis VI and Louis VII, Suger was instrumental in developing the theory of kingship, which led to the evolution of the nation-states of Europe. His success as administrator, diplomat, and elder statesman led to his appointment as regent of France when Louis VII left for the Second Crusade. Suger chronicled events in which he played a vital part, as in the rebuilding of his abbey, and he also produced the first works of regnal history in his *Vita Ludovici grossi regis* and the fragmentary *Historia gloriosi regis Ludovici*. It is to his abbacy that we trace the beginnings of the chronicle tradition, a hallmark of the abbey of Saint-Denis in succeeding centuries.

The symposium and this volume of essays constitute the first assessment of all facets of Suger's career at Saint-Denis, and, indeed, a common mode of thinking can be seen in Suger's undertakings. His approach to architecture as a vehicle for expressing the neo-Platonic philosophy of pseudo-Dionysius the Areopagite is paralleled in the structure of his historical writings; similarly, the organization of the iconographic programs in the sculpture and stained glass of Saint-Denis is mirrored in his reorganization of the abbey's properties and income. The spiritual values he placed on liturgical objects and stained glass clearly reflect the Dionysian theology found in the texts of pseudo-Dionysius preserved in the monastic library. His ideas on economic reform and consolidation echo the political consolidations he counseled the monarchy to achieve. As Suger's political activities and historical writings demonstrate, he was an important architect of the French state as well as a brilliantly innovative patron of architecture.

The Metropolitan Museum of Art is proud to have had the opportunity to make this volume available to scholars and the general public and to help put into perspective the works and legacy of Abbot Suger of Saint-Denis. We wish to thank the editor of the volume, Dr. Paula Gerson, and the editorial committee, Drs. Pamela Blum, Elizabeth A. R. Brown, William W. Clark, and Gabrielle Spiegel, for their endeavors, and we are grateful to the eminent scholars who have contributed essays. Finally, we must thank the National Endowment for the Humanities for its assistance in providing funding for both the symposium and this book.

Philippe de Montebello
Director, The Metropolitan Museum of Art

Preface

THE ABBEY OF SAINT-DENIS has been, from Merovingian times, inextricably linked with the royal dynasties of France. Known as the burial place of the martyr Denis, patron saint of France, the abbey became the royal necropolis under the Capetians, although Dagobert was the first French king to be buried near the saint. Special tenurial ties bound the kings of France to Saint-Denis, and from the reign of Louis VI the French kings carried the abbey's banner (later called the Oriflamme) with them into battle. Thus, over the centuries the monastery became the true royal abbey of France.

Of modest birth, Suger was given as a child to the abbey. He eventually became abbot of the monastery, counselor to two kings of France, and regent of the kingdom. A man of extraordinary gifts, Suger devoted all his energies to advancing the monarchy and glorifying Saint-Denis and its patron saint during his abbacy (1122–51).

Suger was an important figure not only because of his position as abbot of Saint-Denis, but also because of the variety of his interests and the force with which he accomplished his aims. His impact was felt in such diverse areas as political history, aesthetics, art, literature, and theology. Yet Suger has not received the scholarly attention that has been accorded such twelfth-century figures as Peter Abelard, Peter the Venerable, and Bernard of Clairvaux—men whose impact was undoubtedly great but whose breadth of interests and influence were far more restricted. In 1981, as the nine-hundredth centennial of Suger's birth approached, it seemed fitting to rectify this neglect.

The idea of holding a conference for this purpose had crystallized a few years earlier when I heard Gabrielle M. Spiegel's paper "Suger, the Cult of Saint Denis and the Capetians." Having worked for many years on the west facade of Saint-Denis, I was intrigued to discover that Dr. Spiegel had isolated some of the same forces at work in Suger's approach to political problems that I had found in his approach to iconography. It therefore seemed appropriate to plan an interdisciplinary conference to consider and assess Suger's many contributions to the life and thought of the age in which he lived and worked. The essays in this volume represent the fruits of that symposium, held in April of 1981.

Sumner McKnight Crosby, honorary chair of the symposium, provided invaluable guidance and assistance during the planning period. He generously shared the results of his lifelong research on the abbey with the other participants. During the preparation of this volume of essays after his death, Sarah T. Crosby continued in the same spirit, and we owe her a great debt of gratitude.

The organizational committee for the symposium, Pamela Z. Blum, Elizabeth A. R. Brown, William W. Clark, Stephen Gardner, Jane Hayward, Harvey Stahl, Gabrielle M. Spiegel, William D. Wixom, and I as chair, tackled the problems of planning. In areas where considerable research existed, state-of-the-question papers were planned. At the same time we singled out the many areas where little or no research had been done, and leading scholars were asked to prepare presentations that we hoped would lay the groundwork for future investigations. In addition, an exhibition was planned at The Cloisters including many of the objects from Suger's reconstruction of the abbey church of Saint-Denis, objects that would be discussed in the papers presented at the symposium. Special gratitude is owed Philippe de Montebello, director of The Metropolitan Museum of Art, William D. Wixom, chairman of the Department of Medieval Art and The Cloisters, Jane Hayward, curator of The Cloisters, and Charles T. Little, associate curator of medieval art at the Metropolitan Museum. Thanks to them and their staffs the exhibition brought together for the first time in centuries many objects now scattered throughout the world.

Support for the Suger and Saint-Denis symposium was given by the International Center of Medieval Art, the Medieval Acad-

emy of America, and Columbia University's Graduate School of the Arts and Sciences Interdepartmental Committee on Medieval and Renaissance Studies; Joan M. Ferrante, Robert W. Hanning, and Robert Somerville were especially helpful. Funding from the National Endowment for the Humanities made the conference, as well as this volume, possible. Research at the abbey church itself, crucial for many of the papers, was facilitated by A. J. Brankovic of the Bâtiments de France de la Seine-Saint-Denis as well as by Mme Laurence, the former *gardienne*, and her staff at the basilica, who granted many of us access to various parts of the building and allowed temporary scaffolding to be erected in front of the west facade. A conference run on the proverbial shoestring needs many friends and many hands to function smoothly, and I thank the numerous volunteers who collected tickets, stamped envelopes, supplied translations, answered telephone calls, took care of frantic last-minute typing needs, and who, in essence, did what needed to be done. The scholars who chaired sessions but did not present papers themselves—Elizabeth A. R. Brown, Walter Cahn, Ilene H. Forsyth, and Jane Hayward—contributed greatly to the success of the symposium, as did Joseph R. Strayer, whose concluding remarks added just the right final note.

Many of the papers presented at the symposium have been revised in light of the discussion and interchange before, during, and after the conference. All the papers presented at the symposium appear here with the exception of Stephen Gardner's "Two Campaigns in Suger's Western Block." Professor Gardner withdrew his paper for earlier publication in the *Art Bulletin* 66 (1984), 574–87. Two papers not presented at the symposium have been added to this collection because the editorial committee felt they contained important discussions and complemented other essays in the volume: Xavier Barral i Altet's "The Mosaic Pavement of the Saint Firmin Chapel at Saint-Denis: Alberic and Suger," and Brigitte Bedos Rezak's "The Seal of Louis VII: Suger and the Symbol of Royal Power."

A book of this complexity requires the cooperation of many people. I was most fortunate in having the help of a superb editorial committee composed of Pamela Z. Blum, Elizabeth A. R. Brown, William W. Clark, and Gabrielle M. Spiegel, all of whom assisted in reading the essays and making suggestions for improvements. Help came from other sources as well. Bella Meyer and Carole Lazio transcribed the tape of Louis Grodecki's talk at the symposium, and Catherine Grodecki helped immeasurably with the translation of the paper after her husband's death. Suse Childs at The Cloisters answered many queries and provided essential information, and Barbara Drake Boehm of The Metropolitan Museum of Art's Department of Medieval Art was invaluable in providing accurate terminology for metalwork. Leslie Bussis and Lisa Metcalf both helped with miscellaneous research, and W. Hunt Clark, Noni Geiger, and Stephen Sechrist prepared drawings and diagrams. Barbara Burn, who supervised the project for the Editorial Department of The Metropolitan Museum of Art, the staff of the department, copy editors Kathleen C. Antrim and Lorraine Alexander Veach, and designer Joseph Del Valle all deserve praise for their patience and for their contributions to the production of this volume.

Finally, of all the people who have worked on the symposium and this book, my special thanks go to Elizabeth A. R. Brown. Her initial enthusiasm for the project was infectious. She offered good counsel and hard work without stint throughout the entire process, contributed suggestions for grant applications, and provided help with difficult translation problems and knotty editorial questions. Indeed, there is no aspect of the project in which she did not participate. Time and again she gave generously of her time and energy and buoyed my flagging spirits when tasks seemed overwhelming.

This volume of essays should stand at the beginning of the process of comprehensive evaluation of Abbot Suger and the abbey of Saint-Denis. We can look forward, in the near future, to a number of new publications, among them Sumner McKnight Crosby's posthumous volume on the architecture of the twelfth-century abbey church, Pamela Z. Blum's work on Sugerian sculpture, new translations of Suger's writings by Thomas G. Waldman and Jeremy du Q. Adams, studies of Saint-Denis liturgical texts and music by Edward Foley and Ann Walters, Michael W. Cothren's studies of Dionysian stained glass, and the latest in the ongoing explorations conducted by the urban archaeological team of Saint-Denis headed by Olivier Meyer, Michaël Wyss, David John Coxall, and Nicole Meyer. We consider that this present volume will have done its job if it serves to stimulate further interest in Suger, not only among contemporary students and scholars, but among future generations of investigators as well.

Paula Lieber Gerson
International Center of Medieval Art

Contributors to this Volume:

Xavier Barral i Altet
Université de Haute Bretagne-Rennes II

John F. Benton
California Institute of Technology

Pamela Z. Blum
Yale University

Jean Bony
University of California, Berkeley (Emeritus)

Eric Bournazel
Université de Paris X, Nanterre

Michel Bur
Université de Nancy II

Madeline H. Caviness
Tufts University

William W. Clark
Queens College, City University of New York

Giles Constable
Institute for Advanced Study, Princeton University

Danielle Gaborit-Chopin
Musée National du Louvre

Paula Lieber Gerson
International Center of Medieval Art

Louis Grodecki (1910–82)
Institut d'Art et d'Archeologie, Université de Paris IV

Robert W. Hanning
Columbia University

Andrew W. Lewis
Southwest Missouri State University

Clark Maines
Wesleyan University

Léon Pressouyre
Institut d'Art et d'Archeologie, Université de Paris I

Neils Krogh Rasmussen, O.P.
University of Notre Dame

Brigitte Bedos Rezak
The Metropolitan Museum of Art

Gabrielle M. Spiegel
University of Maryland

Harvey Stahl
University of California, Berkeley

Philippe Verdier
Université de Montréal (Emeritus)

William D. Wixom
The Metropolitan Museum of Art and The Cloisters

Grover A. Zinn, Jr.
Oberlin College

Note to the Reader

THE TEXTS WRITTEN by Suger and cited in this volume are the *Vita Ludovici grossi regis* (hereafter *Vita Lud.*), *Liber de rebus in administratione sua gestis* (hereafter *Adm.*), *Libellus alter de consecratione ecclesiae sancti dionysii* (hereafter *Cons.*), a group of charters (hereafter *Ch.*), including the *Ordinatio* (hereafter *Ord.*) and *Testamentum* (hereafter *Test.*), and a group of letters (hereafter *Let.*). In addition there is a fragment of a life of Louis VII, sometimes referred to by the title *Historia gloriosi regis Ludovici* (hereafter *Frag. Lud.*), which has been attributed to Suger.

The authors of essays in this volume have used five of the various editions of Suger's texts. These will be distinguished in the footnotes by the letters D, L, M, P, and W after the text cited. The editions are as follows:

D: André and François Duchesne, *Historiae Francorum scriptores*, 5 vols., (Paris, 1636–49). The texts of *Adm.*, *Cons.*, *Vita Lud.*, *Ch.*, and *Let.* are found in volume 4 (1641), pp. 281 ff.

L: Albert Lecoy de la Marche, *Oeuvres complètes de Suger*, Société de l'Histoire de France, vol. 139 (Paris, 1867). To prepare this work Lecoy de la Marche compared all earlier manuscript copies and printed editions. His volume contains the *Vita Lud.*, *Adm.*, *Cons.*, *Ch.*, *Let.*, as well as William of Saint-Denis's *Encyclical letter* (hereafter *Enc. Let.*) and his *Sugerii Vita* (hereafter *Vita Sug.*). Added to these texts is the fragmentary life of Louis VII contributed by Jules Lair, which can also be found in Jules Lair, "Fragment inédit de la vie de Louis VII préparée par Suger," *Bibliothèque de l'École des Chartes* 34 (1873): 583–96.

M: Auguste Molinier, *Vie de Louis le Gros par Suger suivie de l'Histoire du roi Louis VII*, Collection de textes pour servir à l'étude et à l'enseignement de l'histoire (Paris, 1887). The Latin texts are introduced by a discussion of the manuscript tradition and summaries of the *Vita Lud.* and *Frag. Lud.* in French.

P: Erwin Panofsky, *Abbot Suger on the Abbey Church of Saint-Denis and Its Art Treasures* (Princeton, 1946, 2nd edition 1979). Panofsky edited and translated into English only those parts of *Adm.* which concern Suger's rebuilding and refurnishing the abbey church. His volume does contain the full edited text and translation of *Cons.* and *Ord.* The introductory essay considers Suger's personality and his interests as a patron of the arts, and the extensive notes on the texts have been updated in the second edition and a complete bibliography added.

W: Henri Waquet, Suger. *Vie de Louis le Gros*, Les Classiques de l'histoire de France au moyen âge, 11 (Paris, 1929). Waquet's volume contains the Latin text and French translation of the *Vita Lud.* The introduction discusses the manuscripts and earlier printed editions used.

When referring to the comments of the authors of the above editions rather than the texts of Suger that they publish, the citations will be Duchesne, *Histoire;* Lecoy, *Oeuvres;* Molinier, *Louis le Gros;* Panofsky, *Suger;* and Waquet, *Vie.*

For manuscripts on which the printed editions are based see Lecoy, *Oeuvres*, pp. iii–xx; Panofsky, *Suger*, pp. 143–49; and Waquet, *Vie*, pp. xxiv–xxvii. In this volume see the essays by Gabrielle M. Spiegel (especially note 7), Harvey Stahl (especially notes 11 and 40), and Philippe Verdier.

Other abbreviated titles are:

Cartellieri, *Suger* Otto Cartellieri, *Abt Suger von Saint-Denis*, Historische Studien 11 (Berlin, 1898, reprint Millbrook, N.Y., 1965)

Du Cange Charles Du Cange, *Glossarium Mediae et Infimae Latinitatis* (new edition, Niort, 1883–87)

PG Jacques-Paul Migne, *Patrologiae cursus completus, Series Graeca* (Paris, 1857–87)

PL Jacques-Paul Migne, *Patrologiae cursus completus, Series Latina* (Paris, 1844–80)

Royal Abbey Sumner McKnight Crosby, Jane Hayward, Charles T. Little, and William D. Wixom, *The Royal Abbey of Saint-Denis in the Time of Suger (1122–1151),* exhib. cat. (Metropolitan Museum of Art, New York, 1981)

Abbot Suger and Saint-Denis

BRIEF CHRONOLOGY OF SUGER'S LIFE

1081 (or 1080)	Born
ca. 1091	Became oblate at Saint-Denis
ca. 1107	Became provost of Berneval
ca. 1109–1111	Was provost of Toury
February 19, 1122	Death of Abbot Adam
March 12, 1122	Ordained abbot of Saint-Denis
August 1124	Louis VI takes banner of Vexin from Saint-Denis, repulses Henry V
June 17, 1137	Date of Suger's testament
June–August 1137	Suger accompanies Louis VII to Aquitaine for marriage to Eleanor; Louis's coronation in Poitiers, August 8
August 1, 1137	Death of Louis VI
June 9, 1140	Consecration of chapels of facade and western bays of Saint-Denis
July 14, 1140	Foundation of Saint-Denis's chevet laid
June 11, 1144	Chevet consecrated
February 18, 1147	Named regent
March 8, 1149	Assembles council at Soissons; counters insubordination of Robert of Dreux
January 13, 1151	Death

Introduction:
Suger's Life and Personality

John F. Benton

W HEN SUGER died in 1151, his abbey circulated an encyclical letter that contained the following chronological statement:

> He died between the recitation of the Lord's Prayer and the Creed, the ides of the month of January, in his seventieth year, about sixty years after he assumed the monastic habit, in the twenty-ninth year of his prelacy.[1]

From this statement we may calculate the major dates of Suger's life: born in 1081 (or possibly 1080), he became an oblate of Saint-Denis about ten years later, was consecrated abbot in 1122, and died January 13, 1151.[2] These dates are the most essential points of Suger's monastic chronology. Let us try to go beyond them to the man himself.

Though there has been much uncertainty and controversy about Suger's origins, there is evidence that he was related to a family of minor *milites* who held property at Chennevières-lès-Louvres, a village eighteen kilometers from the abbey of Saint-Denis in the plain northeast of Paris, close to the present airport at Roissy. This was territory of relatively recent settlement—Chennevières may well have been established in the eleventh century[3]—where the abbeys of Saint-Denis and Argenteuil were major landholders, and the Montmorency family dominated a dense implantation of minor vassals and vavasors. The knights of Chennevières can be traced back to a Suger *Magnus,* who was born in the late eleventh century and may have been a nephew of Suger's father. Though the evidence is inconclusive, Suger *Magnus* may have been related, by blood or marriage, to the Orphelins of Annet-sur-Marne, who were in turn connected with the Garlandes. For such families of obscure knights in the region close to Paris, the key to success was royal patronage and church

office. To place a child in the great royal abbey of Saint-Denis was a career decision that could benefit the entire family.[4]

We know the name of Suger's father, Helinand, and those of a brother and sister-in-law, Ralph and Emeline, from obituary rolls.[5] Nowhere, however, do we learn the name of his mother, nor does he ever mention her in his writings. Or perhaps I should say he never refers to his natural mother, for repeatedly he writes in the most physical terms of his institutional, or spiritual, mother, the *mater ecclesia,* by which he always means the abbey of Saint-Denis.[6]

When Suger traveled to Germany in 1125, he was accompanied by another brother, a cleric named Peter, along with two sons of Suger *Magnus,* Ralph and Suger.[7] Reaching prominence, Abbot Suger did what was expected of a man in his position and advanced the careers of his nephews. One of them, Simon, became the royal chancellor and probably a canon of Notre-Dame, and another, William, was established as a canon of the same cathedral. A third, John, died on a mission to Eugene III on behalf of the abbey of Saint-Denis. Of a nephew named Girard we know only that in the 1140s he owed the abbey five *sous* annually from his house and five *sous* from the money collected for the transport of madder.[8] If, as I think likely, the chancellor Simon is the same man as Simon of Saint-Denis, canon of Paris, we can extend the list of Suger's favored relatives even further, for a witness list shows that Master Hilduin, who died as chancellor of Notre-Dame about 1190, was a brother of Simon of Saint-Denis, and Hugh Foucault, who was prior of Saint-Denis and Argenteuil in the 1160s and died as abbot of Saint-Denis in 1197, was an uncle of one of Simon's nephews. To have provided his nephews with the education and connections that produced a chancellor of France, an abbot of Saint-Denis, a chancellor of Notre-Dame,

Notes for this essay begin on page 8.

and at least one other canon of Notre-Dame was an achievement in which any twelfth-century man would have taken pride.[9]

At about the age of ten Suger was oblated at the Main Altar of Saint-Denis, an altar he later enriched with gold panels.[10] He then spent approximately a decade at Saint-Denis-de-l'Estrée, a dependency close to the great abbey church.[11] For a period before 1106 he went to school at some distance from Saint-Denis; he tells us that it was near Fontevrault, and Marmoutier is a possible location.[12] His classical training was solid though not unusually deep and stayed with him throughout the rest of his life, so that in his later years he could impress his monks by reciting from memory twenty or even thirty verses of Horace.[13]

By the time he was twenty-five years old he began to go on missions for his abbey, to a synod at Poitiers in 1106 and to attend Paschal II at La Charité-sur-Loire and at Châlons-sur-Marne in 1107, when the pope met Emperor Henry V. In 1112 he was present at the second Lateran council. Finding favor with Abbot Adam, he also held settled administrative responsibilities, first as provost of Berneval on the Norman coast near Dieppe, then between 1109 and 1111 as provost of the more important priory of Toury. Toury sits strategically on the road from Paris to Orléans just eight kilometers from Le Puiset. In 1112 the priory was attacked first by Hugh of Le Puiset and then by Theobald of Blois, Milo of Montlhéry, Hugh of Crécy, and Guy of Rochefort.[14] Since Suger wrote in *The Life of Louis VI* with considerable detail about the continuing conflict between the king and all these men, one does well to remember that they were important to Suger not only for their opposition to the crown but for their attacks on a domain of Saint-Denis for which he was responsible.

During these years as a monk of Saint-Denis, Suger served his king, Louis VI, as well as Abbot Adam; notably, in 1118, Louis sent him as an emissary to meet Gelasius II in southern France, and in 1121–22 he went to Italy to see Calixtus II on behalf of Louis. It was on his return from Italy in March of 1122 that the forty-one-year-old monk learned that Adam had died and that his brothers at Saint-Denis had elected him abbot. Suger took pride in the fact that he had been absent and had not even known of the election. His fellow monks may have thought that Suger's election would please the king—the two men were approximately the same age and may have known each other at the abbey school, though Louis probably left Saint-Denis a year or two after Suger became an oblate, and there is no evidence to show that they were ever friends in their youth. Before 1122 Louis had already chosen Suger for responsible positions. If the monks reasoned that Suger's royal connection would benefit the abbey, they still made the crucial mistake of failing to consult the king about the election and had to face his anger and even imprisonment when they sought his assent after the fact. Only after negotiation did the king grant Suger his peace and confirmation. On March 11, 1122, Suger was ordained a priest, and the next day consecrated as abbot.

Within a few years Suger advanced to the position of a favorite royal counselor. As abbot of Saint-Denis he enjoyed a triumph of influence and prestige when in 1124 the king came to the abbey to take the banner of the Vexin from the altar and to grant privileges to the church of Saint-Denis and then achieved a bloodless victory over the invading Henry V of Germany. In a charter granted to the abbey at that time, Louis referred to Suger (who in fact probably drafted the charter) as "the venerable abbot . . . whom we had in our councils as a loyal dependent and intimate adviser."[15]

Because Suger had worked effectively and harmoniously with Abbot Adam, whom he called his "spiritual father and foster parent,"[16] the monks of Saint-Denis presumably expected their new abbot to continue the policies of his predecessor. As abbot, however, Suger was faced with the problem of bringing the discipline of his flock into line with current ideas of reform. If he moved too far or too fast, he would lose the support of his monks, but if he did nothing he faced attack from Bernard of Clairvaux and other partisans of reform.

It is difficult for us to judge the state of the abbey under Adam and in the first years of Suger's rule. Bernard wrote that "the very cloister of the monastery, they say, was thronged with knights, beset by business affairs, resounded with disputes, and now and then was open to women." In a bitter memoir Abelard called the abbey "absolutely worldly and shameful" and said that Abbot Adam surpassed his monks in evil living and notoriety.[17] But Bernard wrote only of "what I have heard, not what I have seen," and Abelard was quite unspecific about what he found worldly and shameful. Given his strong views on the impropriety of monks eating meat, Abelard may well have been shocked by no more than Adam's establishment of an annual feast in memory of King Dagobert at which roast meat and claret were served.[18] But, however exaggerated the charges which have come down to us, Suger was faced with a challenge and took steps to reform his abbey.

It seems likely that he was guided more by practicality than zeal and found ways to make what moderate reform he introduced acceptable to his monks. When giving God credit for his achievements, he cites first the recovery of old domains, new acquisitions, enlargement of the church, and the restoration or construction of buildings, and then records with pride that the abbey was fully reformed "peacefully, without scandal and disorder among the brothers, although they were not accustomed to it."[19] He personally set an example of moderation though not of austerity for his monks, eating meat only when ill, drinking wine diluted with water, and eating food that was "neither too coarse nor too refined."[20]

Suger's reform program satisfied, or at least encouraged, Bernard, who wrote a letter of congratulation around 1127, praising

him because now "the vaults of the church echo with spiritual canticles instead of court cases."[21] According to Bernard, Suger reduced the splendor of his own life and promoted continence, discipline, and spiritual reading. But the purpose of this letter was not simply to praise Suger for amending "the arrogance of his former way of life" but to enlist the curial abbot's help in Bernard's campaign against the king's powerful chancellor and seneschal, Stephen of Garlande. Bernard noted that Suger was said to have been bound to Stephen in friendship, and he urged him to make the chancellor also a friend of truth. As we have seen, the friendship Bernard mentioned may have been based on a long-standing family connection.

Suger may well have complied with Bernard's request, though if he did his activity went unrecorded, and one must use caution in deducing intention from events. Stephen of Garlande fell, or rather was pushed, from power by early 1128, and it is reasonable to see Suger's hidden hand behind this coup d'etat and to assume that at this point Bernard and Suger had forged a firm political alliance.[22]

The monastic victors in this power struggle, wrapped in the banner of reform, aggrandized their own authority and property: in 1128 and 1129 monks replaced the nuns of Notre-Dame and Saint-Jean of Laon, Marmoutier took over Saint-Martin-au-Val near Chartres, and Morigny (with Suger's help) established its monks in the church of Saint-Martin of Étampes-les-Vielles. It is in this context that Suger's acquisition of Argenteuil should be placed.[23]

"In my studious adolescence, I used to read through the old charters of our possessions in the archives," Suger reminisced as he related how he had found Carolingian records that he claimed proved the abbey of Argenteuil properly belonged to Saint-Denis, although, because of the disorder of the kingdom under the sons of Louis the Pious, the monks had not been able to gain possession.[24] Of the charter attributed to Louis the Pious that Suger produced to support his claims, one must say, "Se non è vero, è molto ben trovato," for the historical account given there appears quite unlikely and the charter is probably a skillful fabrication.[25] And in case his historical and documentary argument seemed insufficient, Suger bolstered his claim with charges about the immoral life of the nuns. The dispute was tried before the papal legate, a former prior of Saint-Martin-des-Champs, and the court was persuaded "both by the justice of our side and the great stench of theirs."[26] And so Argenteuil was "restored" to Saint-Denis, and the monks found that reform was good business.

Serious scholars have stated that Suger withdrew somewhat from political affairs after 1127 and deferred to Bernard of Clairvaux, but one may doubt this was the case.[27] The abbey bought, for a thousand sous, a house near the northern gate of Paris to be used as a lodging for men and horses, as Suger put it, "because

of our frequent participation in the affairs of the kingdom."[28] Bernard wrote letters, but Suger could advise privately and in person—and we all know which is more effective. For the remainder of the reign of Louis VI, Suger appears to have been his most trusted minister, and in the summer of 1137 he was one of the leaders of the expedition accompanying the king's seventeen-year-old son to Bordeaux for the marriage with Eleanor of Aquitaine.[29]

Louis VI died a few days later, before the wedding party could return to Paris. In the first years of the reign of the young Louis VII, Suger stood out as the most powerful man at court. In a conflict with the queen mother, Adelaide, and the seneschal, Ralph of Vermandois, both of whom proposed to leave court and retire to their estates, Suger reproached his rivals with the taunt that, though France might be repudiated by them, it would never be bereft. "Both retired in abject fear," recounted Suger in the history he began to write about the reign of Louis VII.[30]

Shortly thereafter the young monarch asserted his independence from his father's adviser, and Suger's power was diminished. As the abbot of Saint-Denis held no official position in the royal household that would lend special significance to the absence of his name in royal charters, we must follow the shifts of his influence through the fortunes of a surrogate office, the chancellorship. At the beginning of the reign of Louis VII, the old king's vice-chancellor, Algrin, became chancellor. Algrin fell from power in 1140 and entered into open and effective conflict with the king. Suger and Bernard of Clairvaux were among those who mediated an accord, which was eventually reached at the castle of Ralph of Vermandois. One or perhaps two chancellors succeeded Algrin briefly in 1140, but before the end of the year the office was acquired by a powerful rival to Suger, Cadurc, who held the position until the king left on crusade in 1147 and again briefly after the king's return. Cadurc's second term of office was then followed by that of Suger's nephew, Simon. In 1140, too, Suger's rival, Ralph of Vermandois, returned to the office of seneschal, which had been vacant in 1138 and 1139, and held it until his death in 1151.[31]

As he entered his early sixties, Suger was pushed into the unwanted position of elder statesman in retirement. While Suger was in eclipse, the youthful king further established his independence and involved himself in an attempt to force the election of Cadurc as archbishop of Bourges (an attempt that led Innocent II to place the king under personal interdict), supported Ralph of Vermandois in his contested divorce and attempted marriage to the sister of Queen Eleanor, and led a bloody invasion of the lands of Theobald IV of Champagne.[32]

Posterity benefited from the redirection of Suger's energies. Between July 1140, when the foundation of the chevet was laid at Saint-Denis, and June 1144, when it was consecrated, the aging abbot engaged in that intense supervision of construction he re-

cords so vividly in his writings on his administration and on the consecration of the abbey. Though Suger may well have been influenced by a desire for penance as he worked on the church,[33] during this period he presumably also regretted his loss of influence and threw himself into work that would commemorate his power and might impress the king. The *Ordinatio,* which he enacted in 1140 or 1141, has the appearance of an administrative reexamination of his work at Saint-Denis.[34] And it was probably in the first half of the 1140s that he found time to compose his *Life of Louis VI,* a work that attested to the closeness of his relationship with the king's father.[35] Indeed, all his completed books appear to have been written between 1140 and 1147.

In 1144, and even more clearly in 1145, we find Suger involved again in a minor way in royal affairs, as Louis planned his crusading expedition and attempted to draw conflicting factions together before his departure. In 1147, when the king was about to leave France on the Second Crusade, Bernard of Clairvaux proposed Suger and the count of Nevers to an assembly of barons at Étampes as the men to be regents during the king's absence. But Suger, it appears, would accept the position only as representative of the pope, the protector of all crusaders. Bernard then recommended Suger fulsomely to the pope, and the matter was settled when Eugene III named the abbot of Saint-Denis to serve as regent, while the king, acting on his own authority and in a delicate balancing act, also named as regents the archbishop of Reims, Samson Mauvoisin, and Ralph of Vermandois, thus forming a nominal triumvirate of regents. For two years Suger was, for all practical purposes, the chief of state: almost all his surviving letters date from this regency. When in 1149 Louis's brother, Robert of Dreux, broke with the king, returned early from the Crusade, and plotted with Ralph of Vermandois and others against him, it was Suger who called an assembly of prelates and barons, threatened the plotters with papal excommunication, forced Robert of Dreux into submission, and earned the title his biographer records as "father of his fatherland."[36]

Although, when the occasion demanded it, Suger did not hesitate to appear at the head of armed troops, his greatest victories were bloodless. In 1124 some counseled a strategy of attack, proposing to cut off the German imperial army in order "to slaughter them without mercy like Saracens," but Suger's preference was to let Henry V retreat, and when this strategy was followed it gave the French a greater victory, as Suger put it, than one gained in battle.[37] Suger's thwarting of the plot of Robert of Dreux was equally bloodless. Looking back, near the end of his life, Suger claimed that for twenty years no peace was concluded between Henry I of England and Louis VI in which he had not played a leading role, "as one who held the confidence of both lords."[38] Indeed, of all the political leaders of the twelfth century, Suger appears preeminently as a man of peace.[39] Nevertheless, his idea of peace was no sentimental pacifism; it provided a justi-

fication for royal repression of disorder and "tyranny." Identifying the king with the God of Vengeance, he wrote approvingly of Louis VI's revenging himself "joyfully," and the word "vengeance" appears over one hundred times in his works.[40] This desire for peace through royal force justified by necessity was combined with a shrewd sense of the realities of power, and though he expressed violent condemnation of petty "tyrants" like Thomas of Marle and Hugh of Le Puiset (who were, indeed, personal enemies), he maintained a respectful attitude toward such powerful rivals of the French kings as Henry I and Henry's nephew, Theobald of Blois-Champagne.

Looking back, when he was about sixty, on his early career, Suger noted his regret that he had resorted to military force in protecting the abbey's domains in the Vexin and stated that this weighed on his conscience.[41] When he first began reconstruction at the abbey church, he prayed in the chapter that he—a man of blood, like David—might not be barred from the building of the Temple.[42] His histories show that images of blood struck Suger's mind with special force.[43] His policy of peace was stated aphoristically in the salutation in a letter of 1150 to the rebellious bishop, church, and populace of Beauvais wishing them "peace above and below from the King of kings and the king of the Franks."[44]

Both Suger and his biographers commented on his humble origins; others, moreover, remarked on his small size, since he was slender as well as short, and not robust, being easily tired by vigorous exertion. As Simon Chèvre d'Or wrote in an epitaph:

> Small of body and family, constrained by twofold smallness,
> He refused in his smallness to be a small man.[45]

Physically as well as socially Suger had to look up to others. In order to reach the level of power and achievement he attained, he must have been, like Abelard, a scrambler; but he was not a man who appears to have been rendered brittle by ambition. It is remarkable that, unlike Abelard (to name only one), Suger seems to have been quite free of jealousy. To the best of my knowledge, no contemporary accuses him of *invidia.* Moreover, unless I have read too hurriedly, the very word *invidia* appears nowhere in his writing. People commonly explain the actions of others by emotions with which they are themselves familiar. Suger frequently writes of *superbia,* but not of *invidia.*[46] Of what other medieval authors could this statement be made? Not indeed of Guibert of Nogent, Abelard, or Bernard.

Suger's ideal was probably to possess the qualities of Gelasius II, whom he describes as acting "with glory and humility, but with vigor."[47] Pride was surely the sin with which Suger had to wrestle most vigorously. Bernard had criticized Suger for the "manner and equipment with which you used to travel, which seemed somewhat arrogant."[48] Suger's writing sings out with

self-satisfaction. He gloried in his artistic and administrative achievements, and yet according to his biographer he lived modestly. As Erwin Panofsky puts it, his vanity was more than personal—it was institutional.[49]

In personal relations with those about him, Suger could be vigorous, witty, and charming; his biographer writes of his sitting up till the middle of the night telling stories, "as he was a man of great good cheer."[50] And yet there is a hidden side to his character. Much of Suger's activity and even more of his motivation remain obscure, and this is so not only because of a lack of documentary material from the early twelfth century. Suger's surviving letters are dry and unrevealing, nothing like the letters of monastic friendship left by Bernard, Peter the Venerable, and Nicholas of Clairvaux. In his histories he tells his readers what he wants them to know and attenuates or simply omits that which he found troublesome.[51]

We can understand this aspect of his character if we remember that Suger made his career as an administrator and as an intimate adviser, a *familiaris*. He had the talents of a first-rate counselor: an excellent memory, a strong sense of history and precedent, a shrewd if somewhat cynical grasp of human behavior and motivation, great oratorical skill in both French and Latin, and the ability to write almost as quickly as he could speak.[52] Moreover, he knew what not to say and what not to commit to parchment, and as a minister rather than a sovereign he knew how to efface himself behind his king. His *Life of Louis VI* establishes his own importance, but it tells us almost nothing of what he advised the king, and only in the uncompleted *Life of Louis VII*, which he probably composed after his service as regent, do we have long passages on what Suger himself said to the king.

The intimate counselor may give advice that is not taken or be the instigator of policies for which he receives neither credit nor responsibility. We cannot tell how much political or administrative ruthlessness was mixed with Suger's bonhomie. His biographer tells us that rivals and the ignorant who did not know him well "considered him too hard and unyielding and mistook his determination for brutality."[53] The case of Argenteuil shows that he could act with self-righteous severity, and probably with duplicity and deception as well.

In the introduction to the *Life of Louis VI*, which he addressed to his close personal friend Bishop Josselin of Soissons, Suger declared his intention to raise a monument more lasting than bronze.[54] His extant writings fill a little more than one thick volume: the *Life of Louis VI*, to which should be added portions of a continuation on the reign of Louis VII; the books on his own administration and the consecration of the church of Saint-Denis; under thirty letters; a will and other miscellaneous documents; and, of course, charters. His learning and the influence of both the classics and Scripture are apparent in his writing, but his style is far from classical—though I would not like to join Henri

Waquet in the opinion that he lacked taste.[55] The praise that he resembled Cicero verbally—*Erat Caesar animo, sermone Cicero*—surely applies to his oratory rather than his writing.[56]

Suger left three major monuments: his writings, his administrative and financial reforms, and his artistic achievements. He was a man of massive accomplishments—and a correspondingly massive sense of self. Collectively, Suger's writings constitute a sort of autobiography.[57] They do not, of course, tell us many of the things we would like to know, about his family and childhood, for instance, but they are highly personal works. The history of Louis VI is not a biography in the Suetonian sense but a political memoir, an account of deeds, *Gesta Francorum*, deeds of Suger as well as of Louis.[58]

Suger left his mark on his administrative reforms in a most personal way. His testament, which bears the date of June 17, 1137, should be read side by side with *De administratione*. In addition to the anniversary service he established for himself at Saint-Denis, Suger wanted Masses for the dead to be celebrated for himself in all the dependencies of his abbey, and he wanted them to be spread throughout the week: on Mondays and Tuesdays at Argenteuil, the wealthiest of the acquisitions he claimed for Saint-Denis; on Wednesdays at Saint-Denis-de-l'Estrée, where he lived for ten years as a youth; on Thursdays at Notre-Dame-des-Champs near Corbeil, where Suger established a priory; on Fridays at Zell, which Suger had acquired in the diocese of Metz; and on Saturdays at Saint-Alexander of Lièpvre in Alsace.[59] Moreover, we learn from another source, at Saint-Denis Suger was paired with Charles the Bald for a commemoration service on the day before the nones eleven months out of the year.[60]

Finally, Suger placed his mark on his church. Four of his images and seven inscriptions containing his name appeared in his church, from the entry portal to the Infancy window in the chevet. It is hard to find a clearer identification between building and patron in ecclesiastical architecture.[61] Suger treated God as author of both Solomon's Temple and his own construction at Saint-Denis when he wrote, "The identity of the author and the work provides everything needed for the worker."[62] Though Suger claimed to be satisfied by an identification between his construction and the divine author, it is Suger's own role as "author" of his works that most impresses modern commentators and is the unifying force of this volume.

If Suger's early childhood was like that of such contemporaries as Ordericus Vitalis, then he was raised with the expectation that he would enter a monastery at an early age. As we know, he became an oblate of Saint-Denis when he was about ten. In many ways Suger's adult personality can be related to the Benedictine formation he underwent. His self-discipline and his ability to keep his thoughts and feelings to himself and to act as a loyal subordinate of an established superior were surely fostered by his early experience of the Benedictine Rule. For contrast, one need

only think of Abelard, who was raised to be a knight and did not learn to hold his competitive drives in check. Suger's toughness and determination may also be associated with his monastic training, though these qualities were in ample supply among men and women of other backgrounds as well.

Early clerical and monastic training may well have encouraged a sense of fastidiousness. Both Guibert of Nogent and Suger were repelled by excrement.[63] They also both expressed in their writings a horror of bloodshed. But Guibert differs from Suger in his peculiar fascination with sexuality and mutilation, topics of minimal interest for the abbot of Saint-Denis.[64] The two men were similar, however, in their support of monarchy and fatherland. Both found surrogate parents in institutional form and placed the king in something of the role of a natural father.[65] Suger, moreover, treated Saint-Denis as an ever-nourishing, never-failing mother.

The most obvious contrast between Guibert and Suger is in their effectiveness. Both were abbots and prolific authors, but with respect to the affairs of the world Guibert appears as a timid and ineffective neurotic, Suger as a first minister of self-confidence, power, and achievement. One would be unjustified in saying simply that a secure institutional mother is better than a crippling real one, but we may conclude that either during that childhood of which we know nothing or as an oblate and young monk Suger acquired a healthy dose of self-esteem.[66]

The contrast between Suger and Bernard of Clairvaux is one of attitude and belief rather than of psychological strength. Unlike Bernard, Suger's monastic formation began before he entered puberty and adolescence. To the best of our knowledge he experienced no crisis of sudden conversion from the world. Indeed, he grew up in an environment that taught the importance of penance and instilled an awed respect for the beauty and grandeur of the great abbey church of Saint-Denis. Bernard was troubled by the problems of poverty and misery in the secular world and the expenditure of Church funds on monastic glory and good living; Suger accepted the world in which he had been raised as one that should be embellished and continued. Bernard's mysticism was one of conversion from this world, Suger's one of appreciation of it; in his famous passage on his transport "from this world below to that above," Suger tells us that his contemplation began "from love of the beauty of the house of God."[67]

Suger's complex personality and interests are better revealed by this volume as a whole than they can be by any single part of it. As it shows, Suger advanced and glorified himself through developing and preserving the power of the monarchy, through his writings, and through enriching, rebuilding, and decorating his church at Saint-Denis. In so doing, he left monuments far more lasting than bronze.

NOTES

1. William, *Enc. Let.* (L), p. 408. On William of Saint-Denis, who wrote both this letter and the *Vita Sugerii,* see Hubert Glaser, "Wilhelm von Saint-Denis," *Historisches Jahrbuch* 85 (1965): 257–322; André Wilmart, "Le Dialogue apologétique du moine Guillaume, biographe de Suger," *Revue Mabillon* 32 (1942): 80–118; and Edmond-René Labande, "Quelques mots à propos d'une lettre de Guillaume de Saint-Denis," *Mélanges offerts à Rita Lejeune* (Gembloux, 1969), vol. 1, pp. 23–25, and "Vaux en Châtelleraudis vu par un moine du XIIᵉ siècle: Guillaume de Saint-Denis," *Cahiers de civilisation médiévale* 12 (1969): 15–24. By specifying that Suger died during the performance of his final prayers, the encyclical letter establishes a comparison with the founder of Benedictine monasticism, who also died while praying, as Fr. Chrysogonus Waddell has pointed out to me. See *Gregorii Magni Dialogi,* Bk. 2, chap. 37, ed. Umberto Moricca (Rome, 1924), p. 132, line 16: *Spiritum inter verba orationis efflavit;* and also Damien Sicard, *La Liturgie de la mort dans l'Église latine des origines à la réforme carolingienne* (Munster, 1978), p. 50.

2. On the date of Suger's death see Achille Luchaire, "Sur la chronologie des documents et des faits relatifs à l'histoire de Louis VII pendant l'année 1150," *Annales de la Faculté des Lettres de Bordeaux,* 4 (1882): 284–312; and Cartellieri, *Suger,* pp. 170–74, and for the date of his consecration, pp. 129–30, no. 24.

3. Charles Higounet, *La Grange de Vaulerent,* Les Hommes et la terre, 10 (Paris, 1956), p. 11.

4. On Suger's family, see the Appendix.

5. Auguste Molinier, ed., *Obituaires de la province de Sens, Tome I (Diocèses de Sens et de Paris),* 2 vols. (Paris, 1902), pp. 332 (Nov. 28) and 349 (Sept. 4); for Helinand see also p. 325 (Sept. 4). The name of Suger's mother may appear in the necrology of Saint-Denis without any further identification, as does that of Helinand, but if it does, we have no way to know.

6. Suger, *Vita Lud.* (W), pp. 208–10: *"matrem ecclesiam, que a mamilla gratissimo liberalitatis sue gremio dulcissime fovere non destiterat";* p. 210: *"ad matrem ecclesiam, Deo opitulante, pervenissemus, tam dulciter, tam filialiter, tam nobiliter filium prodigum suscepit";* Suger, *Adm.* (L), p. 156 or Suger, *Adm.* (P), p. 40: *"a*

corpore ecclesiae beatissimorum martyrum Dionysii, Rustici et Eleu-therii, quae nos quam dulcissime a mamilla usque in senectam fovit"; Suger, *Adm.* (L), p. 190 or Suger, *Adm.* (P), p. 50: *"matris ec-clesiae honorem, quae puerum materno affectu lactaverat."*

7. Jules Tardif, *Monuments historiques* (Paris, 1866), pp. 221–22, no. 397. For a discussion of this text and my argument that the sons of Suger *Magnus* were cousins of Abbot Suger, see the Appendix.

8. On Simon see notes 22 and 31 here and the Appendix. William established Suger's anniversary service at Notre-Dame with an endowment of sixty *livres,* a solid indication of his gratitude to his uncle; Molinier, *Obituaires,* p. 99 (Jan. 16). The chancellor Simon was probably that Simon of Saint-Denis, deacon and canon of Notre-Dame, who had nephews named Suger, William, and Herlouin; ibid., pp. 177–78. For Eugene's letter of consolation to Suger, see Martin Bouquet, ed., *Recueil des historiens des Gaules et de la France,* 24 vols. (Paris, 1738–1904), vol. 15 (1878), p. 456. Girard is mentioned in Suger, *Adm.* (L), p. 157.

9. An act of 1175, in Joseph Depoin, *Recueil de chartes et documents de Saint-Martin-des-Champs,* 5 vols. (Ligugé and Paris, 1913–21), vol. 2, p. 342, no. 426 bis, includes among its witnesses: *"S. Simonis de Sancto Dionisio. S. magistri Hilduini, fratris eius . . . S. Guillelmi de Sancto Dionisio . . . S. Herluini, nepotis prefate Simonis."* Molinier, *Obituaires,* pp. xxvi–xxvii, notes the probable relationship between Simon of Saint-Denis and Abbot Hugh. As his patronymic shows, Hugh was the son of someone named Foucaldus. Possibly Simon and Hilduin were the sons of Suger's brother Girard, who held a house from Saint-Denis. Panofsky misunderstands both the historical facts and the obligations a man of influence owed his relatives when he says, "Suger kept them at a friendly distance and, later on, made them participate, in a small way, in the life of the Abbey" (Panofsky, *Suger,* p. 30).

10. Suger, *Adm.* (L), p. 196 or Suger, *Adm.* (P), p. 60.

11. Suger, *Ch.* (L), p. 339. On the location of Saint-Denis de l'Estrée, see *Oeuvres de Julien Havet,* 2 vols. (Paris, 1896), vol. 1, p. 215.

12. Letter of Suger to Eugene III in Suger, *Let.* (L), p. 264. Waquet, *Vie,* p. vi, suggests Marmoutier, or possibly Saint-Benoît-sur-Loire.

13. *"Gentilium vero poetarum ob tenacem memoriam oblivisci usque-quaque non poterat, ut versus Horatianos utile aliquid continentes us-que ad vicenos, saepe etiam ad tricenos, memoriter nobis recitaret"* (William, *Vita Sug.* [L], p. 381). This passage shows us what a monk of the first half of the twelfth century found impressive. While the ability to recite twenty or thirty lines of any poet is rarely found today, by classical or nineteenth-century standards Suger's achievement was not so great. Marcel Aubert was so little impressed by what he read that in recall he inflated the figures. *"Il était capable de réciter de mémoire des passages entiers—200 à 300 vers, dit son biographe Guillaume—d'Horace, qui était un de ses auteurs préférés";* see his *Suger,* Figures monastiques (Abbaye S. Wandrille, 1950), p. 51.

14. Suger writes of his service at Berneval and Toury in *Adm.* (L), pp. 170, 184–85; for the other events, consult the index of Suger, *Vita Lud.* (W).

15. *"Presente itaque venerabili abbate prefate ecclesie Sugerio, quem fidelem et familiarem in consiliis nostris habebamus . . . "* (Tardif, *Monuments,* p. 217, no. 391). On the terms *fidelis* and *familiaris* see Eric Bournazel, *Le Gouvernement capétien au XIIᵉ siècle, 1108–1180,* pp. 147–51; and his essay in this volume, p. 58. For the events discussed in this paragraph, consult the index of Suger, *Vita Lud.* (W).

16. *" . . . patri spirituali et nutritori meo"* (Suger, *Vita Lud.* [W], p. 208).

17. Bernard, Ep. 78. 4 in Jean Leclercq and Henri Rochais, eds., *S. Bernardi opera,* 8 vols. (Rome, 1957–77), vol. 7, p. 203; the full letter is on pp. 201–10; Abelard, *Historia calamitatum,* ed. Jacques Monfrin (Paris, 1978), p. 81, ll. 654–57.

18. The money for the anniversary of Dagobert came from Berneval, and Suger probably played a part in the creation of this festivity. See Robert Barroux, "L'Anniversaire de la mort de Dagobert à Saint-Denis au XIIᵉ siècle: Charte inédite de l'abbé Adam," *Bulletin philologique et historique,* 1942–43 (1945): 131–51. See Abelard's Ep. 7 to Heloise, ed. Joseph T. Muckle in *Medieval Studies* 17 (1955): 269: "O brothers and fellow monks, you who each day, contrary to the teaching of the Rule and your [or our] profession, shamefully slaver for meat. . . ."

19. Suger, *Vita Lud.* (W), p. 212. On Suger's reform, see Giles Constable's essay in this volume, pp. 17–32. Constable describes the features of Suger's Saint-Denis as "an orderly but not uncomfortable life," "a long liturgy," and "a concern for conspicuous display"; see p. 20.

20. William, *Vita Sug.* (L), p. 389.

21. Bernard, Ep. 78.6 in *Opera,* vol. 7, p. 205.

22. Robert-Henri Bautier considers Suger the responsible party in this event and places it in the context of other political struggles of the time in "Paris au temps d'Abélard," *Abélard en son temps,* Actes du colloque international, 14–19 mai 1979 (Paris, 1983), pp. 68–69. Though in general I find Bautier's innovative reconstruction of the politics of the time compelling, on this point his case is reasonable but not proven. As evidence that Suger benefited directly from Garlande's expulsion from the chancellorship, Bautier states without supporting documentation that the chancellor named Simon who replaced him between 1128 and 1132 was Suger's nephew Simon. Except for the name, I can find nothing to identify this Simon with Suger's nephew, who was chancellor at the end of Suger's life. See Achille Luchaire, *Études sur les actes de Louis VII* (1885; reprint, Brussels, 1964), p. 56 on Simon as chancellor in 1150–51, and Françoise Gasparri, *L'Écriture des actes de Louis VI, Louis VII, et Philippe Auguste* (Geneva, 1973), p. 14 n. 3, who says: *"Après 1127, la Chancellerie fut dirigée par un certain 'Simon.'"* If I am correct that Suger's nephew was Simon of Saint-Denis, who died between 1178 and 1180, then he would have had to become chancellor as a very young man to take office in 1128.

23. The point is developed by Bautier, "Paris," p. 71. On Suger's involvement in the affair of Morigny and Saint-Martin of Étampes-lès-Vielles, see Léon Mirot, ed., *La Chronique de Morigny,* Collection de textes pour servir à l'étude et à l'enseignement de l'histoire, 2d ed. (Paris, 1912), pp. 46–47.

24. Suger, *Adm.* (L), pp. 160–61; and Suger, *Vita Lud.* (W), pp. 216–18.

25. The charter and the related documents of 1129 are in the thir-teenth-century *Cartulaire blanc de Saint-Denis*, Paris, Archives nationales, LL 1158, fols. 278–79. It is printed in *Gallia Christiana*, vol. 7, inst. 8–9; see Johann Friedrich Böhmer and Engelbert Mühlbacher, *Die Regesten des Kaiserreichs unter den Karolingern, 751–918*, 2d ed. (Innsbruck, 1908), p. 332, no. 848 (822). Diplomatically the text is appropriate for an act of about 828, though the date is omitted. André Lesort, "Argenteuil," *Dictionnaire d'histoire et de géographie ecclésiastique* 4 (1930): 22–24, shows that no other document from before 1129 gives an indication that Argenteuil ever belonged or should belong to Saint-Denis, though he does not conclude that the text is a forgery, a matter which seems self-evident to Bautier, "Paris," p. 71. One should compare the charter with the story Suger tells in Suger, *Adm.* (L), p. 160, where the information Suger gives must come either from some other record than the document in the cartulary or from Suger's imagination. Thomas Waldman has made a strong argument that the charter is a forgery in "Abbot Suger and the Nuns of Argenteuil," to appear in *Traditio* 41 (1985). If he is, as I think, correct, one must wonder how often Suger resorted to such dishonesty. See Robert Barroux, "L'Abbé Suger et la vassalité du Vexin en 1124. La levée de l'oriflamme, la Chronique du Pseudo-Turpin et la fausse donation de Charlemagne à Saint-Denis de 813," *Le Moyen Age* 64 (1958): 1–26; and the essay by Eric Bournazel in this volume, pp. 61–66.

26. Suger, *Vita Lud.* (W), p. 218.

27. Molinier, *Louis le Gros*, p. vii; Panofsky, *Suger*, p. 11; and Waquet, *Vie*, p. viii–ix. Aubert, *Suger*, p. 83, states more soundly, "*De 1127 à la mort du roi en 1137, Suger ne quitte guère le palais.*"

28. Suger, *Adm.* (L), p. 158.

29. Suger, *Vita Lud.* (W), pp. 280–82.

30. "*Quibus tam pene desperantibus cum ego ipse, velud exprobando, numquam Franciam repudiatam vacasse respondissem, pusillanimitate nimia uterque dicessit*" (Suger, *Frag. Lud.* [M], p. 150).

31. On the offices of chancellor and seneschal, see Luchaire, *Études*, pp. 44–46, 52. John of Salisbury tells us that after Suger's death the king and Odo of Deuil, the new abbot of Saint-Denis, both took steps to humble Suger's relatives, and that his nephew Simon lost his position as chancellor because of his "hateful name" ("*ex suspicione nominis odiosi cancellariam regis amiserat*"). Playing on the name of Simon, one may suspect a charge of simony. See John of Salisbury, *Historia pontificalis*, ed. and trans., Marjorie Chibnall, Medieval Texts (London, 1956), p. 87. On the crisis of Abbot Odo's first years of rule, see Glaser, "Wilhelm," pp. 300–321.

32. On the king's activities see Marcel Pacaut, *Louis VII et son royaume* (Paris, 1964), pp. 42–46. Cartellieri's register shows how limited the demonstrable contacts were between Suger and the king from late 1140 to 1143 or early 1144. Pacaut admirably clarifies the twists of royal policy by a narrative which shows Suger's loss of power, though he may go too far in saying that "Suger fût disgracié" (p. 41). Aubert, *Suger*, p. 96, also refers to "une funeste disgrace." Disgrace is a public matter, and it is striking that no contemporary author refers to the fall from favor and influence discussed here. I do not, however, go as far as Bournazel (p. 59 in his essay in this volume), who asserts that Suger suffered no diminution of power at all.

33. See Clark Maines's essay in this volume, pp. 77–94.

34. Suger, *Ord.* (P), pp. 122–37. The engrossment of the present copy of Suger's will may date from the same period; see note 58 here.

35. *The Life of Louis VI* was written before *De administratione*, which was begun in 1144 but not completed before the end of 1148. See Waquet, *Vie*, p. xi; and Panofsky, *Suger*, p. 142.

36. "*. . . tam a populo quam principe pater appellatus est patriae*" (William, *Vita Sug.* [L], p. 398). On Suger's regency and his conflicts with Ralph of Vermandois, Cadurc, and Robert of Dreux, see Pacaut, *Louis VII*, pp. 57–58. Suger's special role as papal representative in overseeing the kingdom during Louis's absence is highlighted by Aryeh Grabois, "Le Privilège de croisade et la régence de Suger," *Revue historique de droit français et étranger*, 4th ser., 42 (1964): 458–65.

37. Suger, *Vita Lud.* (W), pp. 222–26.

38. In a letter to Geoffrey of Anjou and Empress Matilda: "*Quod si nobis credi dignaretur, non recordamur pacem aliquam viginti annis cum domino rege Francorum eum fecisse, cui fideliter et praecipue inter omnes operam jugem et fidelem non adhibuerimus, sicut ille qui ab utroque domino credebatur*" (Suger, *Let.* [L], p. 265).

39. Note his own account of urging Louis VII to show clemency to the people of Poitiers in Suger, *Frag. Lud.* (M), pp. 152–54.

40. "*. . . votivam in hostes parabat ultionem, tanto hylaris, tanto letabundus, quanto eos subita strage, inopinata ultione, inopinatam injuriam strenue ulcisci contingeret*" (Suger, *Vita Lud.* [W], p. 158). For the calculation of the number of appearances of the word *ultio* and an analysis of Suger's thought on the subject, see Claude Aboucaya, "Politique et répression criminelle dans l'oeuvre de Suger," *Mélanges Roger Aubenas* (Montpellier, 1974), pp. 9–24 (number cited on p. 18).

41. Suger, *Ord.* (P), p. 122. See also the essay by Clark Maines in this volume, pp. 77–94.

42. Suger, *Adm.* (L), p. 186 or Suger, *Adm.* (P), p. 44.

43. Suger, *Vita Lud.* (W), p. 58: *laici manibus gladio sanguinolentis*; p. 60: *sanguine fuso . . . vias* (quotation from Lucan); p. 62: *corpus et sanguinem Jesu Christi*; p. 92: *humani sanguinis sitibundus*; p. 116: *se totam sanguineam contrectans*; p. 118: *uno sanguine involutos, saturatus humano sanguine*; and so forth.

44. Ep. 23, "*. . . pacem superiorem et inferiorem a Rege regum et rege Francorum*" (Suger, *Let.* [L], p. 277).

45. *Corpore, gente brevis, gemina brevitate coactus,*
* In brevitate sua nolit esse brevis.*
See Lecoy, *Oeuvres*, p. 422, or *PL*, vol. 185, cols. 1253–54. I have here used Panofsky's translation in *Suger*, p. 33. The poem was commissioned, not by the king, but almost certainly by Count Henry the Liberal, a final mark of Suger's special relationship with the house of Blois-Champagne. See my "The Court of Champagne as a Literary Center," *Speculum* 36 (1961): 570. According to William, "*Erat quidem corpus breve sortitus et gracile, sed et labor assiduus plurimum detraxerat viribus*" (*Vita Sug.* [L], p. 388).

46. *Emulus* and *emuli* appear often, however. On *superbia* and *effrenis elatio* see Suger, *Vita Lud.* (W), pp. 182–84.

47. "... *gloriose, humiliter, sed strenue ecclesie jura disponens*" (ibid., pp. 202–4).

48. "... *tuus ille scilicet habitus et apparatus cum procederes, quod paulo insolentior appareret*" (Bernard, Ep. 78, *Opera*, vol. 7, p. 203). It is often suggested that Bernard had Suger in mind when about 1125 he wrote in the *Apologia ad Guillelmum abbatem*, XI, 27, of an abbot traveling with a retinue of sixty or more horses; *Opera*, vol. 3, p. 103.

49. Panofsky, *Suger*, p. 35. I have been strongly influenced by Panofsky's brilliant introduction, which nevertheless now seems to me too uncomplicated and positive.

50. "... *ut erat jocundissimus*" (William, *Vita Sug.* [L], p. 389).

51. Historians frequently contrast Suger's description of the defeat at Brémule in Suger, *Vita Lud.* (W), pp. 196–98 with that given by Ordericus Vitalis, *Ecclesiastical History*, ed. Marjorie Chibnall, 6 vols. (Oxford, 1969–80), vol. 6, pp. 234–42 (in Le Prévost's edition, vol. 4, pp. 354–56).

52. William, *Vita Sug.* (L), pp. 381–83, 405. William tells us that Suger explained his reluctance to discharge his agents, except in major cases and for manifest dereliction, by reasoning that "those who are removed carry off what they can, and their replacements, fearing the same thing, speed up their looting": "*dum et hi qui amoventur quae possunt auferant et substituti, quia idem metuunt, ad rapinas festinent*" (p. 383).

53. "... *durum nimis aestimabant et rigidum, et quod erat constantiae, feritati deputabant*" (William, *Vita Sug.* [L], p. 383).

54. Suger, *Vita Lud.* (W), p. 4.

55. "*Suger manque totalement de goût*" (Waquet, *Vie*, p. xvi).

56. William, *Vita Sug.* (L), p. 388.

57. Georg Misch recognized this; see his *Geschichte der Autobiographie*, 4 vols. in 8 (Frankfurt-am-Main, 1949–69), vol. 3, pt. 1, pp. 316–87.

58. Suger, *Vita Lud.* (W), p. 68. Time and again we find *et nos ipsi interfuimus* (p. 52); *et nos fuimus* (p. 56); *nos autem* (p. 145); *per nos* (p. 260); *apud nos* (p. 262); and so forth. Gabrielle Spiegel concludes in *The Chronicle Tradition of Saint-Denis* (Brookline, Mass., 1978), p. 45, that "from the time of Suger's abbacy royal historiography becomes the central intellectual activity of Saint-Denis in service to the French crown."

59. The testament is published in Suger, *Ch.* (L), pp. 333–41. The original is in the Musée des Archives nationales (A.N. K 22, no 9⁷—AE II 145), and there is an excellent photograph in *Mémorial de l'histoire de France* (Paris: Archives nationales, 1980), no. 10. Though it is dated 17 June 1137, when Suger was on the point of leaving for Bordeaux, the document cannot have been written in this form before 1139, or more likely 1140, since Samson of Reims is named as a witness with the title of archbishop. See Achille Luchaire, *Annales de la vie de Louis VI* (1890; reprint, Brussels, 1964), pp. 264–65. Probably Suger wrote a draft of his will before he left on a major expedition and had it engrossed after his return.

60. Molinier, *Obituaires,* pp. 306, 309, 311, 313, 316, 318, 321, 323, 325, 330, 332. On October 6 Charles the Bald had his anniversary service to himself: "*Ob Karolus imperator tertius et cultor beati pretiosique martyris Dionysii studiosissimus monasterii*" (p. 328). Suger does not mention his own name in his ordinance concerning the reestablishment of the commemoration of Charles the Bald; see Suger, *Ord.* (P), pp. 128–32.

61. See Misch, *Autobiographie*, vol. 3, pt. 1, pp. 365–76; and Panofsky, *Suger*, p. 29. For these inscriptions and their placement, see the essay by Clark Maines in this volume, pp. 85–86.

62. "*Identitas auctoris et operis sufficientiam facit operantis*" (Suger, *Cons.* [P], p. 90).

63. Suger, *Vita Lud.* (W), p. 248.

64. In a matter-of-fact reference to castration and blinding, Suger treats the punishment as "merciful," since the subject merited death; see ibid., p. 190.

65. On Guibert's patriotism and personality see my introduction to *Self and Society in Medieval France: The Memoirs of Abbot Guibert of Nogent* (1970; reprint, Toronto, 1984), pp. 9–31.

66. For one current view of the development of healthy self-esteem, see Heinz Kohut, *The Analysis of the Self* (New York, 1971), pp. 107–9. But it is hard for historians to make practical use of Kohut's insights, since he treats "a gifted person's ego" as an exception to his rule, and in Suger's case it is precisely the ego of a gifted person we are trying to explain. Moreover, analysts are far from agreement on the explanation of conflicts about self-worth and esteem; see, for example, the pertinent questions raised by Leo Rangell in "The Self in Psychoanalytic Theory," *Journal of the American Psychoanalytic Association* 30 (1982): 871–72.

67. Suger, *Adm.* (L), p. 198 or Suger, *Adm.* (P), pp. 62–64. On Suger "as an architect who *built* theology," see Otto von Simson, *The Gothic Cathedral*, 2d ed. (New York, 1962), p. 124–33.

APPENDIX: SUGER'S RELATIONS AND FAMILY BACKGROUND

Charles Higounet was the first to come upon the evidence of a Suger family at Chennevières-lès-Louvres and to suggest that it provided an indication "of the background and family ties of the abbot of Saint-Denis." While preparing his thorough study of *La Grange de Vaulerent*, Higounet explored the rich archives of the abbey of Chaalis, now in the Archives départementales de l'Oise, and the unedited cartulary of Chaalis at the Bibliothèque Nationale, Paris. He found that a certain *Sigerius* appeared as a witness to a donation recorded in an act of 1145 (which also recorded another donation witnessed by *Sigerius, abbas Sancti Dyonisii*), that he had a brother Ralph and a son, John Suger (who appeared in an act of 1169), and that other men used the family name Suger in the thirteenth century. To the suggestive character of this name he added a thirteenth-century reference to a *Campus Sugeri* and a document of 1183 citing rights "*in quodam frustro terre que Sugerius magnus excolebat.*"[1]

Since Higounet was studying the grange of Vaulerent and not the abbot of Saint-Denis and his family, he did no more than raise the question of a possible connection between these texts and Abbot Suger. It has not been difficult to find reasons for dismissing Higounet's discovery and his suggestion of a connection with the family of the abbot. The *Sigerius* of the charter of 1145 could have been a godson of the abbot, or the identity of names could be a simple coincidence; and the *Sugerius magnus* of the charter of 1183 could be the *Sigerius* of 1145 or any local, otherwise unknown Suger. Historians concerned with Abbot Suger have either ignored Higounet or treated his material as inconclusive.[2]

When examined more closely and placed in a larger context, however, these documents from Chaalis can be seen as more significant than Higounet suggested. I have consulted and cited here those original charters I could find in the Archives de l'Oise at Beauvais, but for the convenience of the reader I have also given references to the late-fourteenth-century cartulary of Chaalis, Paris, Bibliothèque Nationale, ms. lat. 11003, and the eighteenth-century copies of the charters of Chaalis in the Collection Moreau in the same library. From these texts and the charter naming Suger's companions on his trip to Germany in 1125, the genealogy on pp. 12–13 can be constructed. I will now present these documents in a systematic fashion.

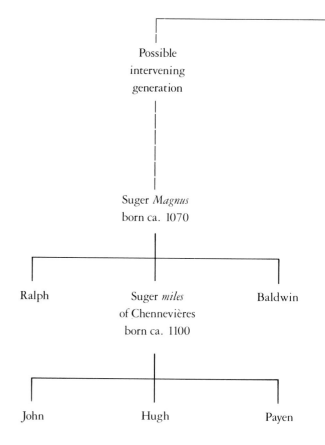

1. Witnesses on behalf of Suger in a charter of Mainard, count of Mosbach, at Mainz in 1125: "*Ex parte abbatis testes sunt: Bartholomeus capellanus suus, Petrus clericus frater suus, Stephanus miles suus de Balbiniaco, Hugo de Sancto Dionysio, Radulfus filius Sugerii, Petrus de Dommartino, Sugerius miles*" The charter is published by Tardif, *Monuments,* pp. 221–22, no. 397.

2. Undated *pancarte* of Theobald, bishop of Paris, to which a modern archivist has assigned the date of 1145 on the back of the charter. This general confirmation includes notices of a number of donations to Chaalis, with witnesses to those actions. Among the donations are:

 (a) Donation by *Rogerius Escotins de Sancto Dyonisio* and his wife, *Lupa,* of a piece of land in the territory of Vaulerent and Villeron. Witnesses: *Sigerius, abbas Sancti Dyonisii; Stephanus de Balbiniaco.* After Roger's death *Lupa* confirmed this donation. Witnesses: *Sigerius, abbas Sancti Dyonisii; Willelmus, subprior Sancti Dyonisii; Galterius de Pompona; Lethardus de Sancto Dyonisio.*

 (b) *Sigerius, miles de Canaveris (sic),* gave land in the territory of Chennevières, *laudantibus et concedentibus Johanne, Hugone et Pagano, filiis suis; Radulfo et Balduino, fratribus suis.* There is also a reference to a daughter of *Sigerius* as a nun at Jouarre. *Sigerius* held the land in fief from *Albertus, miles de Canaveris (sic),* who had a wife named Agnes and sons named Girard, Hugh, and Theobald.

APPENDIX: HYPOTHETICAL RECONSTRUCTION OF SUGER'S FAMILY

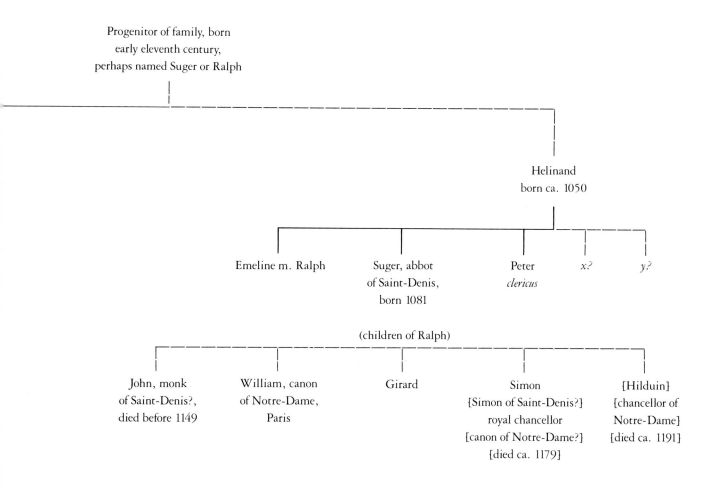

Progenitor of family, born
early eleventh century,
perhaps named Suger or Ralph

Helinand
born ca. 1050

Emeline m. Ralph

Suger, abbot
of Saint-Denis,
born 1081

Peter
clericus

x?

y?

(children of Ralph)

John, monk
of Saint-Denis?,
died before 1149

William, canon
of Notre-Dame,
Paris

Girard

Simon
[Simon of Saint-Denis?]
royal chancellor
[canon of Notre-Dame?]
[died ca. 1179]

[Hilduin]
[chancellor of
Notre-Dame]
[died ca. 1191]

(c) *Antelmus de Pissicoc, miles,* and his wife, *Comitissa,* and mother, *Adcelina,* made a donation in the territory of Epiais. Among the witnesses were: *Radulfus, miles de Vilers; Sigerius et Johannes filius eius de Canaveris (sic).* The sealed original of this act is in the Archives de l'Oise, H 5514. It is summarized in the cartulary, no. 635, fols. 188r–88v, and there is an eighteenth-century copy in Paris, Bibliothèque Nationale, Collection Moreau, vol. 60, fols. 256r–67r.

3. An undated *pancarte* of Manasses, bishop of Meaux, makes known the same donation as that recorded in 2a and names the same witnesses, including the two appearances of *Sigerius, abbas Sancti Dionysii.* The original of this charter is in the Archives de l'Oise, H 5515. There is an eighteenth-century copy in the Collection Moreau, vol. 66, fols. 143r–44r.

4. *Pancarte* of Maurice, bishop of Paris, dated 1163.

(a) *Adam de Claceu (sic)* and *Bartholomeus de Curbarun* made a donation of land in the territory of *Tarentenfossa.* Among the witnesses: *Sigerius de Chanaveriis.*

(b) *Girardus, miles de Chanaveriis,* on his deathbed, made a donation with the approval of his wife, Mathilda, of land at *Hemerias* in the territory of Chennevières. Among the witnesses: *Gautherius Becherel, avunculus suus.* The sealed original is in the Archives de l'Oise, H 5255; it is excerpted in the cartulary no. 621, fols. 185r–85v, and there is an eighteenth-century copy in the Collection Moreau, vol. 72, fols. 116r–17r.

5. Maurice, bishop of Paris, makes known in an act of 1169 that *Johannes, filius Sugerii de Canaveriis* made a donation to Chaalis of 23 *denarii parisienses.* The act is in the cartulary, no. 644, fol. 194v. I have not been able to find the original or a later copy of this act.

6. In a *pancarte* of 1171, Maurice, bishop of Paris, makes known a donation by *Antelmus Scotus.* Witnesses: *Petrus, sacerdos de Villerun; Guido de Vilerun; Raimbertus cementarius; Sigerius de Chanaveriis; Willelmus de Chanaveriis.* Among the witnesses to another donation is *Johannes, filius Sigerii de Chanaveris (sic).* The original charter is in the Archives de l'Oise, H 5517, and there is an eighteenth-century copy in the Collection Moreau, vol. 77, fol. 108r.

7. In an act of 1172, Maurice, bishop of Paris, settles a conflict between the abbey of Chaalis and two knights of Chennevières, John and his brother Hugh, over land given by *Sigerius de Canaberiis (sic) et Radulfus frater eius.* The sealed original is in the Archives de l'Oise, H 5257; it is excerpted in the cartulary, no. 623, fol. 186v, and there is an eighteenth-century copy in the Collection Moreau, vol. 78, fol. 43r.

8. In an act of 1183, Maurice, bishop of Paris, makes known a donation by *Hugo de Bosco, miles,* in the territory of Vieux-Chennevières, of a *"campipartem et domum in quodam frustro terre quam Sigerius magnus excolebat."* The act is in the Collection Moreau, vol. 87, fols. 17r–18r [citing Archives de Chaalis, Vaulerent, liasse 2, no. 27 (or 21) al. 3 L] and is excerpted in the cartulary, no. 687, fol. 200v. I was not able to find the original in the Archives de l'Oise or in the Collection de Picardie in the Bibliothèque Nationale.

From these documents we can establish that Suger, *miles* of Chennevières, had already produced three sons by 1145, John, Hugh, and Payen, and that he had a daughter who was a nun at Jouarre. Of the three brothers, Ralph, Suger, and Baldwin, only Suger appears to have had children. It seems likely that Baldwin was the youngest brother, but the birth order of Suger and Ralph is not made clear from these charters from Chaalis. Ralph was not named as a witness in any of the documents which can be dated after 1145. He may have died not long after that date, and his name may appear with that of Suger in the later charters only because they had once held land in common. Suger *miles* was alive in 1172 and probably entered Chaalis or died soon thereafter.

It should be noted that these documents provide no evidence to support Higounet's suggestion that Girard and William of Chennevières were members of the same family as the brothers Ralph and Suger.

The information that Higounet needed to clinch the case for a family relationship (but did not note) was that in 1125 Abbot Suger traveled to Germany with his brother and with Ralph, son of Suger, and a knight named Suger. I do not consider it unwarranted to conclude that Ralph and the knight Suger were the two brothers who appear in the charters of Chaalis, since the name Suger is most extremely rare. If this is the case, then we can extend the genealogy back a further generation to a progenitor named Suger. Ralph was probably the elder son, and his brother Suger would have been quite a young man in 1125, since he lived into the 1170s. The *Sugerius magnus* of the charter of 1183 was probably this first known Suger. If the knight Suger was born about 1100 and was a younger son, his father may have been born about 1070.

This late-eleventh-century Suger, whom we may tentatively call *Magnus,* may be the same man who appeared along with his brother Payen as a witness to a charter of Saint-Martin-des-Champs of about 1105, where both men are identified as nephews of Peter Orphelin.[3] The identification again rests on the extreme rarity of the name Suger, and it is strengthened by the fact that the name Payen appears again in the family among the sons of

Suger of Chennevières. If this is the case, then the family that interests us was connected, perhaps by marriage, with the Orphelins of Annet-sur-Marne, who in turn had connections with the Garlandes. Indeed, William of Garlande was one of the witnesses to the charter of about 1105, which was issued by Peter Sanglier.[4]

There are two reasons for considering that Suger of Chennevières was a cousin of Abbot Suger. We know that the abbot had a brother named Ralph (probably an older brother, since he married) and, given the logic of naming practices, it is likely that he had an ancestor or uncle named Suger after whom he was named. The pairing of the brothers Ralph and Suger (and probably in that order) in the two families strongly suggests that they were related. Secondly, the fact that Abbot Suger traveled to Germany with a Ralph and a Suger, whom we may now associate with Chennevières, adds strongly to the conviction that they were related. Suger had only been abbot for three years, and for his German expedition he needed to take with him men he could count on. One was his brother, Peter, and another was Stephen of Bobigny, *miles suus*, who appeared again with him as a witness to the donation of Roger Scot recorded in 1145 (in 2a and 3 above). That Ralph, son of Suger, and *Sugerius miles* were relatives of Abbot Suger is by far the most likely explanation of their presence.

The same rough calculation that places the birth of Suger *Magnus*, the father of Ralph and Suger *miles*, at about 1070 would place the birth of Abbot Suger's father, Helinand, at about 1050. These two men were presumably related in the male line. Helinand and the elder Suger may have been brothers (possibly with a father named Ralph or Suger), or another generation may have intervened, making Helinand the uncle of the elder Suger. Since Helinand is a name that does not appear again in either family, it seems likely that he was a younger son.

If we may consider this relationship between two branches of one family as securely established, we learn two things about the immediate family of Abbot Suger. One is that he came from the lower ranks of the knightly class, since it is unlikely that Helinand was significantly higher in the social scale than his cousins. Ralph and Suger of Chennevières were wealthy enough for both to hold the title of *miles*, but the knights of Chennevières were clearly minor landholders who shared property in a village of no great importance, and the younger Suger was himself a vassal of a minor knight, Albert of Chennevières. It is tantalizing not to be sure what land was held by Ralph, son of Suger. The family may well have held scattered estates in the region immediately to the north of Paris. Though we do not know where Helinand held property and where the future abbot was born and raised, the second conclusion we can draw is that Suger's family was most likely established not far from the cousins of Chennevières, somewhere within ten or fifteen miles of the abbey of Saint-Denis.

NOTES

1. Higounet, *La Grange,* p. 12, and see document no. 8 here. I have gratefully made use of the citations given by Higounet and repeat some of them here, but the reader who compares our references will see that I have been able to expand his documentation.

2. Spiegel, *Chronicle Tradition,* p. 34, no. 80, cites Higounet's evidence and first drew it to my attention, but concludes, "The most probable hypothesis is that he was born at Saint-Denis or Argenteuil."

3. Depoin, *Recueil,* vol. 1, p. 166, no. 104. Depoin's edition contains helpful prosopographical notes.

4. The possible connection between the Suger of this charter and the family of Abbot Suger was first pointed out by Bournazel, *Gouvernement capétien,* p. 72. On the connection with the Garlandes, see also pp. 35–36.

I.
MONASTIC LIFE

Suger's Monastic Administration

Giles Constable

Suger's activity as abbot of Saint-Denis is easily overshadowed by his achievements as statesman, builder, and author. Over a century ago a historian of Saint-Denis said that the basilica was generally better known than the monastery,[1] and the same may be said today of its most famous abbot. Yet Suger's abbacy, which lasted from 1122 until 1151, can be compared in importance to those of his contemporaries Bernard of Clairvaux and Peter the Venerable, who died in 1153 and 1156 respectively. It covered one of the most active periods in the history of monasticism in the West, which saw not only the emergence of new religious orders and the foundation of countless new houses but also the transformation of many old monasteries. Even a great independent abbey like Saint-Denis, though to some extent insulated from the winds of change by its prestige and wealth, was influenced by these developments, and Suger's abbacy not only provided the background for his other activities but also marked a stage in the history of Saint-Denis itself.

In this paper I shall look at Suger's monastic administration under the three headings of discipline, economy, and organization. "His special purpose and desire," wrote his biographer, William of Saint-Denis, in the encyclical letter written after his death, "was constantly to raise the noble monastery of Saint-Denis to every glory and honor, to arrange things in a religious manner [*religiose*], and to make the church rich in revenues, better endowed with buildings, [and] adorned with ornaments."[2] These specific aspects of his administration, however, should be seen in the light of his general background and policy.

Most important is the fact that he brought to all his work a wide and varied knowledge of monastic and secular affairs. Although he entered Saint-Denis as a boy, at about age ten, he seems not to have suffered from the narrow type of education often given to oblates and *nutriti*, who were raised entirely in monasteries and were not uncommonly regarded as unsuited for positions of responsibility.[3] He attended at least two schools, where he may have met the future King Louis VI of France, and as a young man he was present at several important meetings, including one at La Charité-sur-Loire, where, aged twenty-six, he defended Saint-Denis against the claims of the bishop of Paris before Pope Paschal II,[4] and also at the Lateran synod of 1112.[5] Meanwhile he served as provost both at Berneval-le-Grand, near Dieppe, and then at Toury, near Chartres, and thus gained experience in two regions that were subject at that time to different rulers. As provost of Toury he witnessed the charter that made provision for feeding the poor at Saint-Denis during the famine of 1111,[6] and he participated in the measures taken by Louis VI to subjugate Hugh of Le Puiset in 1111–12.[7] He represented the king before Pope Gelasius II in 1118 and before Calixtus II in 1121–22. By the time he was chosen abbot of Saint-Denis, in March 1122, he was an experienced man of affairs.

Contemporaries were unanimous in praising his ability as an administrator. William of Saint-Denis singled out his *sapientia, strenuitas, industria, magnanimitas,* and *prudentia* in his encyclical letter, where he said of Suger, "In him flourished not only a natural felicity of memory but also the highest art for understanding what needed to be done and cared for."[8] In his *Vita,* written a few years later, William praised his *liberalitas, misericordia* and *compassio, animositas, constantia* and *iustitia, prudentia, probitas,* and *moderatio* and wrote that "when he ruled in the monastery, he also ruled in the palace, and he administered both in such a way that neither did the court keep him from the care of the cloister nor did the monastery excuse him from the counsels of princes."[9] He also emphasized Suger's good sense and moderation, comment-

Notes for this essay begin on page 26.

ing, "He did not lightly remove his subordinates from their positions without sure and great reasons and [assurance of their] clear guilt," and that he punished sinners "not so much because they had sinned but in order that they should sin no more."[10]

William had been Suger's secretary and was naturally biased in the abbot's favor, but the confidence put in Suger by successive popes and kings shows that this praise was not undeserved.[11] He was described in the chronicle of Morigny as "a man second to none in the management of secular affairs" at the time the king gave him "the provision of the kingdom" during the Second Crusade,[12] and Bernard of Clairvaux recommended Suger to Pope Eugene III as "faithful and prudent in temporal affairs and fervent in spiritual affairs and humble in both."[13]

In his youth Suger learned two basic administrative lessons that seem to have served him throughout his life. The first was to go to the highest authorities when in need of support. Whenever possible he brought in the king or pope, or at least an archbishop or bishop, on the side of his abbey when it was involved in a dispute. He repeatedly stressed in his writings the special relationship between Saint-Denis and the kings of France,[14] whose anniversaries were celebrated there with special solemnity. Even before he became abbot, Suger may have been instrumental in establishing at Saint-Denis the commemoration of the anniversary of Dagobert, the first king to be buried there; and in his *Vita* of Louis VI he turned the decision made by Louis's father, Philip I, to be buried at Saint-Benoît-sur-Loire into a compliment to Saint-Denis, where his burial, Suger said, "would not have been anything great among so many noble kings."[15] Elsewhere in this work he referred both to the king's special friendship for Saint-Denis and to the role of Saint Denis as the patron and protector, after God, of France.[16] In a charter of 1124 Louis himself acknowledged his special relation with the monks of Saint-Denis, from whom he held "in fief" the county of the Vexin, of which the banner, taken from the altar of Saint-Denis, became the famous Oriflamme.[17] On two charters, one in 1130 and the other in 1131, "the lord king of the Franks and the venerable brother Suger, abbot of Saint-Denis," acted together in a dispute between Saint-Denis and the monks of Saint-Désiré, and Suger often got the king to impose settlements and to confirm and enforce grants in favor of the abbey.[18] He himself, in return, carefully protected the interests of the king in ecclesiastical as well as secular affairs, especially during the Second Crusade, when he confirmed several abbatial elections only on condition that the king could rehear the cases, if he wished, after his return.[19]

Suger also appealed to the rulers of England. In 1150 he asked the count of Anjou and Empress Mathilda to protect Berneval, his old provostship in Normandy, and Le Bocage, which King Henry I, he said, had preserved intact "even in times of war,"[20] and in 1144/51 Stephen wrote to Suger promising to protect "your lands that are in my part" and to return the land "that is still in the power of my enemies."[21] Suger also turned to the popes, stressing in his *Vita* of Louis VI the special affection of Innocent II for Saint-Denis,[22] and when necessary he also called on bishops and nobles, but above all he made use of the king of France and thus linked the interests of his abbey to the rising power of the French monarchy, to which he himself so greatly contributed.

The second lesson learned by Suger in his youth and applied throughout his lifetime was not only to seek new rights and property but also to make the most of what he had. He lived at a time when the extensive grants of land that had once been given to monasteries, especially in well-established regions like the Ile-de-France, were increasingly a thing of the past.[23] This may account for the relatively small number of known charters issued by Suger (only thirteen in the edition of Lecoy de La Marche), who devoted less attention than some of his contemporaries to acquiring new possessions. His *Liber de rebus in administratione sua gestis,* written in 1145, shows how much of his effort was devoted to reestablishing old rights and making utmost use of the existing properties of Saint-Denis. According to his biographer, William, Suger had an excellent memory and a keen interest in history,[24] and in the *Liber* he attributed Saint-Denis's loss of many properties to the breakup of the Frankish realm and thus, by implication, associated their recovery with the reestablishment of royal power.[25] The very fact that he wrote such a work shows his desire to record the abbey's rights as well as his own achievements. His activity as a builder and decorator and his revival of the liturgical commemoration for kings and emperors[26] were likewise inspired by his desire to renew the ancient glory of Saint-Denis.[27] He turned his rummaging in the abbey's archives to good account in cases such as those of Argenteuil, which will be discussed later, and Notre-Dame-des-Champs, which the bishop of Paris had given to the Cluniacs but which Suger recovered for Saint-Denis.[28] He sought to restore the old ways even when they were not of advantage to Saint-Denis, as when the inhabitants of Saint-Denis (and some of Saint-Marcel) recovered, admittedly at a price, their freedom from the mortmain they owed, according to Suger's charter, "not by the due right of ancient custom but by the ambitious introduction of a new exaction."[29] Suger showed himself to be a child of the renaissance of the twelfth century in this concern for authenticity and renewal, in institutional as well as spiritual matters and no less than in his buildings and liturgical vessels, which also combined old and new elements.

I

The most serious problem facing Suger when he became abbot was the monastic discipline in his abbey, of which a highly unfavorable account is given by two distinguished, if not unbiased,

contemporaries. The first was Abelard, who in the *Historia calamitatum* described Saint-Denis at the time of his entry in about 1118 as "of very secular and evil life" and its Abbot Adam as a low character of notorious infamy. "I made myself exceedingly burdensome and unpopular to everyone," he wrote, "by frequently and vehemently criticizing their intolerable practices, now in private, now in public."[30] Later he described his efforts to obtain permission to leave the abbey first from Adam, who refused, and then from Suger, who consented, partly owing to the intervention of the king and his council. The chamberlain, Stephen of Garlande, in particular asked Suger and his *familiares* why they wanted to keep Abelard against his will, "by which they could easily cause scandal and serve no useful purpose," Abelard wrote, "since my [way of] life and theirs could in no way conform. I knew that the view of the king's council in this matter, however, was that the less regular an abbey was the more it would be subject to the king and of use . . . for temporal gain."[31]

The second witness was Bernard of Clairvaux, in his Letter 78, which was written some time before May 1128, when Stephen of Garlande, whose simultaneous holding of military and clerical positions Bernard attacked, fell from favor. In the first part of this letter Bernard expressed joy at the sudden change in Suger's way of life—"what you have become from what you were," as he put it[32]—and said that, while he was thinking primarily of Suger's style of dress and travel, the conversion had gone beyond that of a single sinner to the entire congregation. For, whereas the abbey had formerly served Caesar more than God, and the cloister had been filled with soldiers, it was now free for God and devoted to continence, discipline, and holy readings. "Shame for the previous state of affairs," Bernard wrote, "has ordained the austerity of the new way of life. . . . The variety of holy observances drives out boredom and acedia."[33] And he gave a feeling, if somewhat unlikely, account of the breast-beatings, penitential kneelings, tears, groans, sighs, and spiritual songs with which the abbey was now filled, stressing the satisfaction these, and the change from "the arrogance of [Suger's] former way of life," had given both in heaven and on earth.[34]

The accounts given by these two writers must be taken with a grain of salt. Even leaving aside the question of the date and authenticity of the *Historia calamitatum,* Abelard by his own account entered Saint-Denis unwillingly—compelled more by the confusion of shame, he said, than by the devotion of conversion[35]—and his criticism was clearly inspired by his desire to leave. He was always critical of large and wealthy monasteries,[36] and his resentment in this case may have been sharpened by Suger's recovery of Argenteuil, where Heloise had taken refuge at the same time Abelard himself had entered Saint-Denis. Bernard was above considerations of this type, but he may have wanted to ingratiate himself with Suger in order to win his support against Stephen of Garlande.[37] So far as is known, he had no personal knowledge of conditions at Saint-Denis, and his picture of the cloister filled with soldiers before Suger's reform and with spiritual exercises afterward seems overdrawn.

The main lines of Abelard's and Bernard's descriptions are nevertheless confirmed by other evidence. An impression of disorderly lack of control under Abbot Adam is given, for instance, by the charter giving the almoner not only the almshouse and adjacent chambers and oven, "free from all exaction of the ministerials of Saint-Denis and all evil custom," such as tolls, dues on wine, and sales taxes, "or other custom or bread [made] by the bakers living in the chambers of the same," but also jurisdiction over any thieves who took refuge there.[38] One of the additions to the extracts from Suger's *Vita* of Louis VI in Paris, Bibliothèque Mazarine, ms. 554 and Paris, Bibliothèque Nationale, ms. lat. 5949A mentions Suger's visits to several southern Italian monasteries "for the sake of prayer" after the Lateran Council of 1123 and his reform after his return of "the order of holy religion" at Saint-Denis, where, "Previously, owing to the negligence of former abbots and various monks . . . the institution of regular life had been so reduced . . . that the monks kept scarcely a pretense of religious life."[39] Though the date of this addition is uncertain,[40] it shows the existence of a tradition that Suger initiated reform at Saint-Denis during the early years of his abbacy.[41] More concrete evidence comes from the Cardinal-Legate, Matthew of Albano, formerly prior of Saint-Martin-des-Champs, who referred to Saint-Denis in a charter of 1129 as "illumined with all religion,"[42] and from Pope Innocent II, who in his privilege for Saint-Denis of May 1131 described Suger's reform of religious life in the monastery as "welcome to God."[43]

The precise nature of this reform is unclear. Suger himself was a monk of the old school who had entered Saint-Denis as an oblate and was ordained a priest only just before becoming abbot,[44] and Bernard's criticism of his dress and style of travel in the early years of his abbacy may have been justified. His change could well have been motivated by conviction or by policy or by both, since he doubtless not only saw but also felt the pressure for reform. William of Saint-Denis devoted the entire second book of his *Vita* to Suger's monastic life, stressing his assiduity in the liturgy and the moderation of his food and housing, which he described respectively as "neither too vile nor too choice" and "neither too rugged nor too luxurious," adding that he built nothing for his own use except a small cell in which he was free to read, weep, and contemplate "at the hours allowed him."[45] Bishop Robert of Hereford described Suger's personal life as a mirror reflecting both "what shines outside and what is profitable inside,"[46] and while neither this nor William's account is above suspicion of flattery, they confirm what Bernard said of Suger's personal reform.

Very little, too, is known about institutional reform at Saint-Denis. It may have been motivated, like Suger's personal reform,

by a serious desire for good order or by prudential considerations, for no one would have been more aware than Suger of the truth of Abelard's comment that the king was more likely to make demands of a lax than of a strict abbey. In two charters that will be cited later he specifically associated monastic freedom with austerity and prosperity. Suger's writings show, however, that the reform (in spite of Bernard's feeling account of the devotional exercises at Saint-Denis) was along the lines more of strict black Benedictine monasticism than of some of the new religious orders. "Love is the essence [*summa*] of the monastic religion," according to one of Suger's charters,[47] which echoed the sentiments of Peter the Venerable in his famous Letter 28, in which he said, "The straightness [*rectitudo*] of the rule is love."[48] Suger showed this love in his provisions for improving conditions in the infirmary, his concern for the quality and quantity of food and drink served to the monks, and his changes to the choir, "in which those who were assiduous in the service of the church suffered greatly from the coldness of the marble and copper."[49] This more comfortable life was balanced, however, as at Cluny, by the length of the liturgy, to which Suger added a daily Mass of the Holy Spirit and weekly offices of the Virgin and of Saint Denis[50] as well as the ancient royal anniversaries and the commemoration of new anniversaries, for himself and others, marked by prayers and charitable distributions.[51] Suger stressed the need to maintain "a fullness of office, according to the observation of its order to the last iota and last detail" in his letter to Pope Eugene III concerning the reform of Sainte-Geneviève in 1148,[52] and he apparently applied the same principle at Saint-Denis.

With these two features—an orderly but not uncomfortable life and a long liturgy—Suger combined a third feature of old, black Benedictine monasticism: a concern for conspicuous display, both in charity and in building and decoration. No fewer than three thousand loaves were to be distributed on his own anniversary.[53] In *De administratione* he acknowledged that "it is most pleasing to me that whatever is more precious, whatever is most precious should above all serve in the administration of the most sacred Eucharist," and he went on to stress, after recognizing the central importance of "a holy mind, pure spirit, [and] faithful intention," that "we must also serve through the outward ornaments of sacred vessels."[54] So many gems and pearls were offered for this purpose, he wrote in *De consecratione,* that they could not be refused "without great shame and offense to the saints," and in *De administratione* he unintentionally pointed to the difference in this respect between Saint-Denis and the new orders by describing the miraculous gem-buying bargain he struck with some monks from Cîteaux and Fontevrault.[55] The style of Suger's building, and its ornamentation, and of the liturgical vessels made for him, likewise shows that his sympathies in this regard lay less with the new religious orders, which rejected such visual display, than with the older forms of monasticism.

That Suger achieved his objective of raising the level of monastic life at Saint-Denis is shown by John of Salisbury's remark, in the *Historia pontificalis,* that Suger died "leaving his church in the best state."[56] A slight shadow is thrown across this picture, however, by the troubles during the early years of Suger's successor, Odo of Deuil, who will appear again both as prior of Chapelle-Aude and as abbot of Saint-Corneille at Compiègne and who is best known as the historian of the Second Crusade. Almost nothing was known about his election at Saint-Denis before the publication in 1942 of the *Dialogus apologeticus* of William of Saint-Denis,[57] from which it appears that the monks met on the day Suger died and chose twelve *seniores,* who in turn nominated Odo as abbot, apparently without opposition. Accusations of improper influence and behavior were soon brought against him, however, and he responded by exiling some of Suger's relations and supporters, including William, who was sent to the priory of Saint-Denis-en-Vaux in Aquitaine.[58] Louis VII, Bernard of Clairvaux, and the papal curia all became involved in the affair, which was eventually settled in Odo's favor by Pope Anastasius IV. It seems to have been a perhaps inevitable reaction to the long rule of Suger, who had established policy and appointed officers for almost thirty years. Suger relied heavily on his subordinates (and perhaps also his relations) during his long absences,[59] especially when he was serving as regent during Louis VII's absence during the Second Crusade. This may have led to some discontent, as did his readiness to finance another crusade out of the abbey's resources, to judge from William's slightly defensive justification in the *Vita.*[60] Stirrings of discontent may also be reflected in Suger's appeal to his monks on his deathbed: to keep unity; avoid scandal and schism; and preserve the order, divine worship, and veneration of the saints.[61] In the long run his appeal was successful, and there is no evidence of further trouble under Abbot Odo.

Some light is thrown on Suger's monastic policy by his involvement in the affairs of several other houses, especially Argenteuil in 1129, Chaumont in 1146, Sainte-Geneviève at Paris in 1149, Fontevrault in 1149, and Saint-Corneille at Compiègne in 1150. Although his interest in Argenteuil was inspired by his desire to recover a former possession of Saint-Denis,[62] all the documents concerned with the case also make special mention of the low level of life of the nuns there, whose prioress was Heloise. Suger himself said in his testament of 1137 that the house "was almost ruined by the extraordinary frivolity of the nuns,"[63] but there are other, and less prejudiced, witnesses, such as the legate Matthew of Albano, who issued a charter saying that the matter came up at a council held at Saint-Germain-des-Prés in 1129:

When we were considering the reform of the sacred order in various monasteries of Gaul in which it had grown cool, sud-

denly a charge was made in the general meeting against the enormity and infamy of a certain monastery of nuns known as Argenteuil. . . . When everyone there demanded their expulsion, the venerable Abbot Suger of Saint-Denis . . . showed sufficiently clearly that the said monastery belonged to his church . . .

and it was duly returned to him.[64] This action was confirmed both by Louis VI and his son, who restored Argenteuil to Saint-Denis without keeping "any of the things pertaining to the royal dignity,"[65] and by Popes Honorius II and Innocent II in two bulls referring to "the women of bad life" living at Argenteuil and to the reform of religious life there.[66]

The case of Saint-Pierre at Chaumont-en-Vexin resembled that of Argenteuil in that it involved the recovery by Saint-Denis of a former possession as well as the reform of the house. In 1145 Louis VII granted the abbey to Saint-Denis and instructed the abbot and his dependents not to obey the archbishop of Rouen.[67] Suger himself said in *De administratione:*

We were at pains [*elaboravimus*] to obtain the church of Saint-Pierre at Chaumont, both the church and the canonries when the canons died, from Archbishop Hugh of Rouen and from the lord King Louis of the Franks. We also reverently installed twelve monks with a thirteenth as prior for the exaltation of that church and the propagation of the divine cult.[68]

This method of gradually replacing secular canons, as they died, with monks or regular canons was also used elsewhere.

Pope Eugene III instructed Suger in April 1148 to install eight monks from Saint-Martin-des-Champs, with the prior of Abbeville as abbot, in Sainte-Geneviève of Paris to serve as an example to the canons there, who were warned to receive the newcomers "honestly."[69] This was apparently easier said than done, for the pope changed his instructions a few weeks later, "for the good of peace, if the canons of this church, saving their prebends, will receive regular canons."[70] Even this was not easy,[71] but in due time Suger informed the pope that he had installed a prior and twelve canons from the abbey of Saint-Victor and asked him, in the passage cited above, to help maintain the full liturgical office.[72] In another letter, he wrote, "Irregular [canons] will clearly never consent to [be] regular canons except by force."[73] The task was finally completed, however, and Bernard congratulated Suger on the restoration of order and discipline at Sainte-Geneviève.[74]

The situation was different at Fontevrault, where Suger intervened with the pope in 1149 to protect the nuns from Bishop Gilbert of Poitiers (between whom and Suger, according to John of Salisbury, no love was lost[75]), who was trying to subjugate them and refused to bless their abbess.[76] "You know . . . that the bishop," Suger wrote, "is accustomed to disturbing his subjects," and he then described Fontevrault with admiration as "a place of such religious life, which we saw newly founded when we were at school in that region and which we rejoice to have heard has already grown, by the will of God, to almost four or five thousand nuns." He therefore urged the pope to allow them to run their own affairs.[77]

Finally, at Saint-Corneille in Compiègne, as at Sainte-Geneviève, the pope in June 1150 instructed Suger and Bishop Baldwin of Noyon, on behalf of the king and himself, "to propagate the religious life" by installing monks in place of the secular canons,[78] through whose malice and negligence, according to a letter from Louis VII, the house had fallen on evil days. The king had therefore been advised by the pope "to uproot those clerics like unfruitful trees, reforming that place for the better, and [to] install the monastic order there."[79] Odo of Deuil, soon to be Suger's successor at Saint-Denis, was duly chosen abbot and blessed by the bishop,[80] but the canons—with the support of their treasurer, the king's brother Philip—put up a lively resistance, seizing the relics, barricading the doors, and cutting the bell-ropes in order to prevent the monks from sounding the alarm.[81] Peace was finally established, and Odo went to Rome, where the pope gave him a privilege confirming his rule over "this monastery . . . in which hitherto secular clerics have lived irregularly and improperly, so as to reform in it a state of honesty and religion" and ordering that "the monastic order . . . should be for all time inviolably preserved there."[82] Suger informed the pope that the church had been changed "from the old into the new state of religion" and that "a camp of piety and of holy religion had been built there" in place of "a camp of iniquity."[83] But he also said that the tasks of reforming this house and Sainte-Geneviève were the hardest tasks he had undertaken at the order of the pope or the king.[84]

These cases illustrate not only the difficulty of reforming established religious houses[85]—and the measures and compromises that were sometimes necessary to carry out the reform—but also the determination and energy with which Suger tackled the job. His motives in doing so may not have been entirely religious, since the reform of these houses involved an assertion of central authority and the destruction of two important centers of local power. But there is no reason to doubt the sincerity of Suger's desire to introduce here, as in his own abbey, a more withdrawn and liturgically oriented type of religious life. He believed that it was the duty of prelates, as he said in the introductory arenga to his ordinance of 1140/41,

to provide for those who are dedicated to the service of Almighty God . . . and to care for and protect from all molestation the contemplatives who are truly the arc of divine atonement. . . . Embracing their religion with my entire soul,

I implore beseechingly the prayers of religious men, both in order that they may provide more devoutly and effectively for us in spiritual matters and [that] we, by providing for them in temporal matters, may most devoutly take care to sustain [and] foster them with provisions.[86]

II

This passage brings out clearly the link, as seen by monks of the old, black Benedictine tradition, between their liturgical intercession for the welfare of outsiders and the economic support owed them by society. "It is sure, O servants of God," Suger wrote in the arenga to a charter for the monks of Longpont in 1150, "that you live only from [your] labors and nourishment or that you are supported by alms. The stricter your life and support, the freer it should be."[87] For his own monks Suger was determined not only to recover old and acquire new property but also to prevent any improper alienation of property in the future. The arenga to a charter of 1133 for the dependent priory of Chapelle-Aude declared:

> Since those things that have been given to monasteries by the faithful for the remission of their sins ought to remain tranquil and stable in the due alms of the monks and others serving God in the church, it is improper for them to be removed or diminished by the rash levity of any person in any way.

Suger went on to prohibit in the strictest terms any gift, sale, or mortgage of the churches belonging to the priory.[88]

Suger stands out among his contemporaries in both ecclesiastical and secular positions for his farsighted and aggressive economic policy, of which he left a unique account in *De administratione*.[89] In this work he not only expressed his pride in acquiring and recovering possessions for Saint-Denis but also described the methods by which he increased the abbey's revenues: carefully cultivating the soil and vines, controlling the rapacity of mayors and sergeants, and repelling the claims of grasping advocates.[90] Likewise, in the *Vita* of Louis VI, Suger congratulated himself on the recovery of lost estates and the acquisition of new ones, the augmentation of the church, and the restoration or institution of buildings, which produced, he said, "an affluence of such liberty, good reputation, and worldly opulence."[91] Here, as in the charter for Longpont, he associated monastic liberty with austerity and wealth.

He pursued the economic advantage of Saint-Denis with energy, imagination, and occasionally a touch of opportunism, as when he (along with many other abbots) took advantage of the Second Crusade to acquire property that was sold or mortgaged by crusaders in order to pay for their expeditions.[92] He regularly exploited his powerful position in the interests of his abbey and

repeatedly sought the aid of popes and kings to secure its rights and property. Pope Calixtus II instructed the archbishops and bishops of France in a general letter to do "full justice" in cases involving any of their parishioners against whom the abbot or monks of Saint-Denis brought a reasonable complaint.[93] Louis VI, in the charter of 1124 recognizing his special relation to Saint-Denis, confirmed its *vicaria,* rights of justice, and full liberty and gave it control over the royal fair of the Indiction (known as Lendit) held outside the walls of the abbey,[94] which from then on owned both the internal and external fairs. Twenty years later Suger wrote in *De administratione* that he had raised three hundred shillings in additional annual income from this fair.[95]

Innocent II issued in 1131 a general privilege confirming these and other rights and possessions, including six estates in Lorraine acquired in 1124/25 from Count Albert of Marimont (Morsberg), who was freed from excommunication, and his successor, Mainard; the monastery of Argenteuil; six estates in the diocese of Orléans; and "the county of the Vexin . . . which our dearest son Louis, king of the Franks, is known to hold through you from Saint-Denis in benefice and fief."[96] Seventeen years later, in 1148, Pope Eugene III issued another general privilege, omitting the reference to the fairs of Lendit but naming twenty-two further properties, including nine churches [*altare*] and a chapel in the diocese of Laon (three of which were given to Saint-Denis by Bishop Bartholomew in 1125 and 1126[97]), two churches in the diocese of Cambrai,[98] one church in the diocese of Rouen given by Archbishop Hugh with the consent of King Louis, the priory of Notre-Dame-des-Champs in the diocese of Paris, the royal rights in three *villas* in the Ile-de-France,[99] two churches in the diocese of Chartres given by Bishop Geoffrey, one church in the diocese of Arras given by Bishop Alvisus in 1147,[100] and the priory of Deerhurst and its two possessions of Taynton and Northmoor in Oxfordshire, which had been given by Kings Edward and William of England.[101]

These properties in England were the subject of a dispute that illustrates the economic policies of Saint-Denis. The monks of Reading claimed that they had been unjustly deprived by Deerhurst of their church at Stanton in the parish of Northmoor. The prior and monks of Deerhurst replied that this parish "was of the right of Saint-Denis" and belonged to their church at Taynton, which they had held since its founding. The case was heard by Abbot Gilbert Foliot of Gloucester, the future bishop of London, and other judges in 1145/48, but the prior of Reading appealed to the pope,[102] and it was finally settled (without, apparently, resorting to Rome) by Archbishop Theobald of Canterbury, who told Bishop Alexander of Lincoln that Saint-Denis might build a chapel with a cemetery at Northmoor and hold it, with its parishioners and tithes, from Reading in return for an annual payment of a silver mark "in recognition of subjection to their mother church at Stanton."[103] Deerhurst's basic economic rights

were thus established and were promptly confirmed by the pope in the privilege of 1148.

Meanwhile, in 1143, Suger obtained from Louis VII a charter granting and confirming various privileges of Saint-Denis, including the right to free its serfs, jurisdiction over usurers and coiners, and control over all building within certain defined limits.[104] These rights were doubtless important, as were the new properties listed in the papal charters, but in the long run they were probably less valuable to Saint-Denis than Suger's efforts to make the most of its existing estates, many of which were suffering from neglect and oppression at the time he became abbot. Monnerville, for instance, was described in De administratione as "the most miserable villa of all" and as reduced "almost to a solitude" by the oppression of the lords of Méréville.[105] The archbishop of Reims and bishop of Soissons used almost the same words in a charter of 1145, which said that Count Hugh of Roucy had reduced Concevreux "almost to a solitude" by his excessive demands.[106]

Suger tackled this situation with his usual resourcefulness. By negotiating with bishops, religious houses, and secular lords he managed to free many estates from oppressive obligations.[107] He made use of persuasion, various types of inducements—both material and spiritual—and more drastic means if necessary, ranging from force to excommunication and including, in one case, the marriage of the heiress to an advocacy to a man he called "one of our domestics."[108] Bishop Geoffrey of Chartres, after many requests from Suger and his monks, freed the churches of Monnerville and Rouvrai "from those persons who are vulgarly called vicars,"[109] and in 1130 Louis VI gave a chapel free from all service to the bishop, archdeacon, or parish.[110] At about the same time Suger redeemed some revenues and property held in gage by a Jew from Montmorency named Ursellus.[111] Suger took strong measures to curb the authority of lay advocates over the abbey's officials, both provosts and mayors (maiores), and also to control these officials, one of whom he sent to Saint-Denis in chains.[112]

Having established the freedom of the estates, Suger saw to building and repairing the agricultural buildings, fortifying them if necessary,[113] and to resettling the land with productive workers. Of Beaune-la-Roland, for instance, he said, "We had the villas that had been entirely deserted by the hospites [exhospitatas] resettled with hospites [rehospitari]."[114] At Vaucresson he decreed that anyone wishing to settle there could have one and a half arpents of land for a census of twelve pennies free from all tallage and exactions and subject to the orders only of the abbot.[115] He encouraged the clearing of new land,[116] the establishment of fisheries,[117] and especially, since he knew the problems of a parish without a source of wine, the planting of vineyards.[118] He developed the revenues from fairs;[119] from mills, ovens, and other rights later known as banalities;[120] and from hunting rights and rights of jurisdiction, including rights over Jews, to whom

his attitude was more favorable, perhaps for economic reasons, than that of other religious leaders in the twelfth century.[121] Suger turned to advantage, as has been seen, even the unjust mortmain imposed by his predecessor on the inhabitants of Saint-Denis and Saint-Marcel, who had redeemed their freedom for two hundred shillings, by using the sum to renovate and decorate the entrance to the abbey.[122]

He sought whenever possible to clarify and define the rights of Saint-Denis and to renegotiate disadvantageous arrangements. The two charters of 1133 and 1136 settling the division of the revenues of the church of Grand-Axhe in the diocese of Liège, "out of which," as the bishop said in the former, "damage [and] controversy have often arisen," reflected the current trend toward a distinction between the rights of the patron and the priest and clearly established, as had the settlement with Reading, the economic rights of Saint-Denis. The charter of 1136 admitted frankly that the priest's portion needed to be defined because even definite and peaceful agreements often led to controversies "both out of remoteness of place and for many other reasons."[123] Tithes were a particular object of concern and figured in many charters. An interesting agreement of about 1151 dividing some tithes between Clairefontaine and Saint-Denis specified:

> You should not be surprised that only cultivated lands are included in the quarter [of the tithes] belonging to Saint-Denis, since the view [mens] of the arbitrators was that Saint-Denis seemed to be at fault [gravare] in this cause and [they] therefore wished to assist to the extent that only cultivated lands were computed in its quarter. Common usage, furthermore, to which one should resort in doubtful cases, has it that only cultivated land is included in the term lands, especially when "old" is added, for those are called old which have been cultivated for a long time and [those are called] new [which have been cultivated] recently.[124]

Suger's renegotiation of the terms for the tithes of Barville, which had been held for over a hundred years for an annual rent of two shillings, showed that he fully realized the value of revenues in kind in a period of rising prices.[125]

He protected the interests not only of Saint-Denis but also of its dependencies, such as Chapelle-Aude, to whose aid he summoned the pope and king as well as the archbishop of Bourges.[126] The campaign—which lasted over twenty years and may have led even to forgery by the prior of Chapelle-Aude, Odo of Deuil—seems to have started with a charter of Archbishop Wulgrin of Bourges in 1123 saying that, in view of the frequent complaints of Suger and the then prior of Chapelle-Aude that the monks of Ahun had taken the church of Estevareilles from Saint-Denis, he had invested the monks of Saint-Denis with the church because the prior and monks of Ahun had failed to appear on the

day they were summoned.[127] In 1144/51, however, Suger was still writing to Wulgrin's successor by one, Archbishop Peter, asking him to protect the possessions of Saint-Denis, especially Estevareilles, "which in this storm of the church of Bourges," he wrote, "the monks of Ahun have seized by lay hands from our monks of Chapelle-Aude."[128] Meanwhile, probably in 1130, Suger and the king jointly complained to Archbishop Wulgrin that the prior of Saint-Désiré, a dependency of the great abbey of La Chiusa, had unjustly taken two churches from Chapelle-Aude, in response to which the abbot of La Chiusa expressed surprise that Wulgrin would listen to "frivolous complaints," since Saint-Désiré had held the property for over thirty years without complaint, and threatened to appeal the case to Rome.[129] Innocent II wrote to both Wulgrin and the abbot of La Chiusa trying to find an occasion for settling the dispute,[130] which dragged on for some time longer, due in part to Suger's prodding of the unfortunate archbishop,[131] and which illustrates not only his determination to recover long-lost property but also his persistence in enlisting outside authorities on the side of Saint-Denis.[132]

He also worked to acquire new property for Chapelle-Aude. When four hermits approached him asking to be received into fraternity, he persuaded them to give their church and property to Saint-Denis and to submit to Chapelle-Aude in return for permission to remain as they were (*in habitu suo*) for as long as they wished and to be received as monks there "if they wanted to enter into the monastic religion."[133] Here he laid the basis for a dependent priory or *cella.*

We have already seen the arrangements made by Suger to establish priories at Argenteuil and Chaumont. He also introduced communities at Notre-Dame-des-Champs at Essones, "which he himself [according to a charter of the archbishop of Sens in 1142/51] built new to perform the service of God and founded, as it were, with his own hands";[134] at Saint-Denis at L'Estrée;[135] La Celle (Zell) in the diocese of Metz, which he acquired from the count of Morsperg in 1125;[136] and at Lebraha (Liepvre) in the diocese of Strasbourg.[137] Other sources from the abbacy of Suger refer to Sainte-Gauburge (Walpurgis) in the diocese of Seez, Salonne in the diocese of Metz, Reuilly and Chapelle-Aude in the diocese of Bourges, Saint-Denis-en-Vaux in the diocese of Poitiers, where Suger's biographer, William, was sent to rusticate by Abbot Odo, and Deerhurst in England.[138] But this list is certainly incomplete and more work needs to be done on the priories belonging to Saint-Denis.[139] Their function and relation to the mother abbey is unclear. Suger wrote in his testament: "Since all limbs should cooperate with their head, we ask that our anniversary should be celebrated in all the cells wherever they are according to the size and resources of the places." He regarded their purpose here as primarily liturgical and referred to his foundation at L'Estrée as "for the service of God and the holy martyrs,"[140] but their economic role was certainly also important,

and the priors acted as Suger's principal assistants in the control and exploitation of the properties belonging to Saint-Denis.

After the priors came the provosts, who were normally members of the community, and the *maiores,* who were lay dependents but occasionally people of some power and substance.[141] Archbishop Hugh of Sens wrote to Suger about a *maior* of the monks of Sainte-Colombe at Sens who, though a serf, behaved "as if he were the lord of their lands";[142] Louis VI referred in a charter of 1122/37 to the *maior* of Saint-Denis at Laversine "together with his wife, sons and daughters, *famuli* and nurses, one servant, [and] two men-at-arms";[143] and Suger in *De administratione* spoke of retaining the champart of the whole land of Vaucresson "except for the carrucate from the fief of the *maior.*"[144] A charter of Bishop Bartholomew of Laon in 1134 shows that at Pierres the *maior* was appointed by the provost,[145] and the office was probably closer to that of a supervisor or foreman than of a modern mayor. Below the *maiores* were found, at least in some areas, the *servientes,* or sergeants. Suger referred to repressing the rapacity of the mayors and sergeants in the Vexin, for instance, and to making a grant at Monnerville "by the hand of a monk or of our sergeant."[146] There is a reference in a charter of 1145 to a *decanus* as well as a mayor at Concevreux, and both a *villicus* and a *decanus* appear among the witnesses to Suger's grant to Longpont in 1150,[147] but the precise character of these positions is unclear.[148]

Even less is known about the nonagricultural than about the agricultural officials of Saint-Denis under Suger. There is the interesting allusion in the charter of 1111 to freeing the almshouse "from all exaction of the ministerials of Saint-Denis,"[149] which suggests that they were a power unto themselves, and in *De administratione* Suger mentioned a *ministerialem magistrum,* apparently in the sense of a master craftsman, in his description of the making of the stained-glass windows at Saint-Denis.[150] Bishop Goslenus of Soissons referred to the ministerials of Saint-Denis in a charter of 1149 settling a dispute between Saint-Denis and the Premonstratensian abbey at Valseri,[151] but the term here seems to be a general one for those in charge of the estate, and this is confirmed by the reference to the mayor and dean in the charter of 1145 as ministerials of Saint-Denis.[152] It probably parallels the terms *ministri* and *procuratores* used by Suger in *De administratione*[153] and may not always have been used to denote the same type of worker.

The most important evidence concerning the military dependents of Saint-Denis at this time is found in an unpublished charter of Matthew *Bellushomo* in 1125, in which he acknowledged himself to be "the liege man of Saint-Denis and its abbot" and listed his fiefs. Matthew, who was also known as *Bellus* and *Pulcher* (which raises some question as to whether he was really a handsome man or simply a member of the family Le Bel) was the second son of Ralph (II), lord of Villiers-le-Bel, and appeared with his brother Ralph (III) among the witnesses to a charter of

Matthew of Montmorency in 1140.[154] In the charter for Saint-Denis he listed, at the request of Suger and the entire community, "all my fiefs that I possess as my own [*in proprium*] from Saint-Denis" and those that were held from him by his liege *milites*, of whom he lists forty-one holding a total of fifty-five military fiefs ranging from churches (with and without the altars) and tithes to mills and various types of dues.[155] There are in Suger's works, in addition, a few references to *milites* and *castellani* holding fiefs from Saint-Denis, including Milo of Montlhéry (Bray), whom he called "our man, who holds half the forest [of Iveline] from us with another fief."[156] Together with Matthew's charter these give an idea of the military force at the disposition of the abbot of Saint-Denis and help explain the willingness of the king (who in a charter of 1134 referred to one of the abbey's fiefs as "under our power"[157]) to help Suger establish control over his lands.

III

This brings me to the third and final topic of the internal administration and organization of Saint-Denis, which will also be the shortest because so little is known. As an independent abbey, Saint-Denis followed its own customs and never, so far as is known, wrote them down. Even the size of the community, which is known from memorial books to have numbered about a hundred and fifty monks in the mid-ninth century,[158] is uncertain for the twelfth century. The largest number of witnesses to a charter during Suger's abbacy was to his testament in 1137, for which there were eight officials, ten priests (including two former abbots of other houses), ten deacons, ten subdeacons, and ten boys,[159] but the fact that two other charters have respectively five and three witnesses in each of these categories, as opposed to the eight and ten here, suggests that they were representative rather than complete and that the community was larger than the total of forty-eight witnessing Suger's testament. These lists show, however, that it was composed, unlike many monasteries belonging to the new orders of the twelfth century, not only of priests but also of many monks not in holy orders and also of oblates.[160]

The officers included the abbot, prior, subprior, precentor, infirmarian, treasurer, capicerius, chanter, chancellor (who was probably the same as the cartographer), cellarer, and almoner, and they appeared approximately in this order when they subscribed to charters,[161] which they never did all together, even on Suger's testament, which lacks the chanter and almoner. There was also a chamberlain, who never appeared as a witness during Suger's abbacy but figured in several other documents,[162] and a *coenator*, whose duties at Saint-Denis, according to later sources, consisted of preparing the evening refection during the summer season.[163] William of Saint-Denis served as Suger's secretary and addressed his letter written from exile in 1152/53 to the notary

and doctor as well as the precentor and cellarer, all named William.[164] It is uncertain whether all of these were regular positions in the abbey, but there was clearly a group of officials numbering about a dozen.

There was in addition a more shadowy category of *seniores* among the monks. They appeared, for instance, after Suger's death, when twelve were chosen by the monks to elect a new abbot.[165] The provosts were also members of the community, and the fact that four of them, including Suger, subscribed to the charter of 1111 concerning the almshouse shows that they participated in community affairs. The role of the priors of dependent cells is unclear, but the abbot of the independent house of Saint-Maur-des-Fossés witnessed the 1111 charter, and two *quondam* abbots—presumably resigned abbots who had joined or rejoined the community—appeared among the priests who witnessed Suger's testament. The monks, therefore, drew on a wide range of experience in their deliberations. Suger's own career before he became abbot suggests that there was a deliberate policy of choosing as officials monks who had some knowledge of the outside world. Odo of Deuil had even wider exposure, having served successively in Chapelle-Aude, England, the monastery of Arras (perhaps at Saint-Vaast), and Ferrières before going with Louis VII on the Second Crusade, after which he had the dubious honor of being chosen the first abbot of Saint-Corneille at Compiègne.[166]

Concerning Suger's choice of subordinates, William of Saint-Denis said in his *Vita* that

> [s]ince he was frequently forced to be absent from the monastery for the public uses either of the kingdom or of the church, he had established from among the monks men [who were] well tried and inspired by holy zeal [and] who in example and in doctrine fulfilled his place, when he was absent, in the flock assigned to him. In promoting these men, he had regard neither for family nor for fatherland, but he promoted him who proved himself by his life.

His principal assistant was the prior Herveus, who appears in several charters and whom William described as unlearned but of great sanctity and simplicity.[167] He clearly also relied on the chamberlain Peter, who seems to have acted as a sort of roving plenipotentiary.

The results of this process of delegation can be seen in two important and parallel developments, one toward departmentalization and the other toward consultation. While Suger did not initiate the tendency for the various monastic offices at Saint-Denis to become increasingly independent, it is no accident that so many of the sections in the *Cartulaire blanc* begin with documents dating either from his abbacy or just before or after.[168] The charter of 1111 concerning the jurisdiction of the almoner, for in-

stance, is the first in the section *De elemosina*. Both in *De administratione* and in his charters Suger set aside special revenues for the refectory, principally for extra or enlarged meals on feast days and anniversaries, the almonry, and the treasury, especially for building, decorating, and lighting the new church.[169] It is clear from these sources, and from *De consecratione*, that he felt entitled to assign as he thought best the revenues gained for Saint-Denis by his own efforts.

This increasing departmentalization was balanced by an emphasis on consultation, which both legitimized decisions and prevented excessive decentralization. Suger may in fact have ruled with an iron hand but in the written records it appears well concealed by the velvet glove of consultation. In nine of the thirteen extant charters issued in his own name, consultation with his monks is indicated by a phrase like *"communicato ex more cum fratribus nostris consilio,"* or *"communi favore capituli nostri,"* or *"per consensum meum et totius capituli nostri,"* and several of them were transacted in the chapter presided over by Suger.[170] Similar references in other charters show that he normally acted in consultation with the chapter not only in making grants but also in presenting requests, at which times Suger often appeared with his monks as petitioners.[171] Some grants to the abbey were specifically made to or for the sake of Suger and his monks rather than to Saint-Denis or to the abbot alone. Suger naturally did not

initiate this practice. His predecessor, Adam, was said in the *Historia calamitatum* to have discussed Abelard's proposed departure from Saint-Denis with "those who were with him in council," and Suger discussed the same question with his *familiares*,[172] which conveys a sense of the cronyism that doubtless marked much of this consultation. But what had often been a technicality in earlier medieval monasticism now increasingly became a reality both at Saint-Denis and in other twelfth-century monasteries.

Many abbots at this time, indeed, though surrounded by the trappings of wealth and power, increasingly lost real control over their houses and were forced to respect the wishes of their monks.[173] Even a great administrator like Suger was apparently prepared to sacrifice much of his power over Saint-Denis in return for the freedom to participate in outside affairs. The two tendencies of delegation and consultation were not unconnected either with each other or with Suger's outside activities. His ability to reform the abbey, stabilize its economy, and supervise its affairs even from a distance was the result of his knowledge of men and of his experience in the world. At the same time, it is impossible to understand Suger's position in the broader history of the twelfth century without taking into account his work in the smaller world of the abbey of Saint-Denis.

APPENDIX

Since writing this article, I have come across two small pieces of evidence showing the high esteem in which Suger's judgment was held by communities of secular and regular canons. The first was his role in making peace between the bishop and chapter of Paris in 1127, when Suger had been abbot of Saint-Denis for only five years. (See Benjamin Guérard, ed., *Cartulaire de l'église Notre-Dame de Paris* [Paris, 1850], vol. 1, p. 338, no. 32.) The second was his role in helping to find the relics of Saint Evurtius at Orléans in the late 1140s. When the newly installed regular canons of the church of Saint-Euverte heard that Suger, "a man of lofty counsel and excellent prudence," was in their city, they enlisted his help in their search for the body of their patron, and,

going into a hidden place (*secretariam*) behind the altar of Saint Evurtius, they showed him a wooden covering to a tombstone. Suger at once said, "It is here, look here, for you will find [it] here," adding, "Do not delay; exalt God, and the Exalted will exalt you." The canons took courage "from the oracle of such a father" as well as from various visions and miracles having occurred on that spot, and, digging there, found two decorated sarcophaguses, one above the other, in the lower of which they found the body of Evurtius. (See the letter from Abbot Roger of Saint-Euverte to the abbot and community of Saint-Ouen at Rouen in *PL*, vol. 199, col. 1127A-28B.) Suger's experience as a builder at Saint-Denis doubtless gave him some knowledge of archaeology, which he here turned to a practical use.

NOTES

1. Félicie d'Ayzac, *Histoire de l'abbaye de Saint-Denis en France*, 2 vols. (Paris, 1860–61), vol. 1, p. 1. There are two modern biographies of Suger: Cartellieri, *Suger;* and Marcel Aubert, *Suger*, Figures monastiques (Abbaye S. Wandrille, 1950). Cartellieri has three sections, respectively, on Suger's service to the crown (pp. 1–70), as abbot of Saint-Denis (pp. 71–107), and his literary activity (pp. 108–23); Aubert also has three sections, on the monk and abbot (pp. 1–68), the politician and historian (pp. 69–122), and the builder and artist (pp. 123–66). Cartellieri has a useful register of documents (pp. 127–66), which includes references to earlier works (especially Luchaire's catalogs of the acts of Louis VI and Louis VII) and which will be cited here simply as Cart. with a number, and a list of places mentioned in the documents (pp. 178–84). A number of unpublished documents are found in the *Cartulaire blanc* of Saint-Denis, in two volumes (Paris, Archives na-

tionales, LL 1157–1158), which was compiled in the mid-thirteenth century and of which there is a later manuscript inventory, in chronological order (Paris, Archives nationales, LL 1189), of which Professor John Baldwin of Johns Hopkins University kindly lent me a microfilm. Professor John Benton of the California Institute of Technology also supplied me with an analysis of some of this material, which will be referred to here as *Cart. blanc* (with volume, page numbers, and section references) and *Inv.* (with page and inventory number and the date or proposed date given there in parentheses). On these and other manuscript sources for the history of the abbey of Saint-Denis, see the introductions to the two books by Germaine Lebel, *Histoire administrative, économique et financière de l'abbaye de Saint-Denis* (Paris, 1935) and *Catalogue des actes de l'abbaye de Saint-Denis relatifs à la province ecclésiastique de Sens de 1151 à 1346* (Paris, 1935). Papal documents cited from the *Patrologia latina* will be indicated just by *PL*, followed by volume and column numbers, with references to the numbers in Philipp Jaffé, *Regesta pontificum Romanorum ad annum 1198*, 2d ed. (Leipzig, 1885–88) (JL).

2. William, *Vita Sug.* (L), p. 405.

3. See the documents cited in Cartellieri, *Suger*, pp. 127–29; and, on the status of oblates, Statute 66 of Peter the Venerable, Giles Constable, ed., *Consuetudines benedictinae variae*, Corpus consuetudinum monasticarum 6 (Siegburg, 1975), p. 97 (and the note there).

4. Suger, *Vita Lud.* (W), pp. 52–54; Cart. 7. Paschal later visited Saint-Denis.

5. Suger, *Vita Lud.* (W), p. 66; Cart. 14.

6. *Cart. blanc*, vol. 1, p. 51 (*De villa beati Dyonisii* 43) and, in a better copy, vol. 2, p. 557 (*De elemosina* 1); *Inv.*, pp. 219–20, no. 208 (1111); Cart. 12. Suger appears seventh among twenty-two witnesses (twenty-one in the version in *Cart. blanc*, vol. 1, p. 51), between the infirmarian and the almoner.

7. Suger, *Vita Lud.* (W), pp. 136–42; Cart. 11, 13, 15, 16.

8. William, *Enc. Let.* (L), pp. 405–6. See Hubert Glaser, "Wilhelm von Saint-Denis. Ein Humanist aus der Umgebung des Abtes Suger und die Krise seiner Abtei von 1151 bis 1153," *Historisches Jahrbuch* 85 (1965): 259–60, who dated the letter January 1151, immediately after Suger's death, and said that it presented "the moral portrait of an exemplary abbot."

9. William, *Vita Sug.* (L), p. 379. See Glaser, "Wilhelm," pp. 281–82.

10. William, *Vita Sug.* (L), p. 383.

11. Suger served the papacy in various capacities, including that of a judge-delegate, though he was without legal training: *PL* vol. 180, cols. 1401–2 (JL 9356; Cart. 245), col. 1406 (JL 9364; Cart. 277), col. 1407 (JL 9366; Cart. 273), cols. 1418–19 (JL 9391; Cart. 292).

12. Léon Mirot, ed., *La Chronique de Morigny (1095–1152)*, Collection de textes pour servir à l'étude et à l'enseignement de l'histoire, 41, 2d ed. (Paris, 1912), p. 86 (3.7); see also p. 47 (2.12).

13. Bernard of Clairvaux, Ep. 309 in Jean Leclercq and Henri Rochais, eds., *S. Bernardi opera*, 9 vols. (Rome, 1957ff.), vol. 8, p. 229. For other contemporary references to Suger, see Lecoy, *Oeuvres*, pp. 413–26.

14. See the works of Gabrielle Spiegel, "The Cult of Saint-Denis and Capetian Kingship," *Journal of Medieval History* 1 (1975): 43–69, esp. p. 46, where she said, "Throughout its history, the monastery of Saint-Denis sought to establish a tie to the ruling house . . . " and *The Chronicle Tradition of Saint-Denis*, Medieval Classics: Texts and Studies, 10 (Brookline, Mass., 1978).

15. Robert Barroux in "L'Anniversaire de la mort de Dagobert à Saint-Denis au XII⁼ siècle," *Bulletin philologique et historique (jusqu'à 1715) du Comité des travaux historiques et scientifiques*, 1942–43, pp. 131–51, remarked on the stylistic resemblances between Suger's writings and the charter of Abbot Adam establishing this anniversary, which was paid for, furthermore, from the revenues of Suger's two provostships at Berneval and Toury. Both he (p. 145) and Spiegel, *Chronicle Tradition*, p. 28, suggested that this act may have been designed to assert the association between Saint-Denis and the monarchy in view of the burial of Philip I at Saint-Benoît-sur-Loire (Fleury), on which see Suger, *Vita Lud.* (W), p. 84. See Suger, *Vita Lud.* (W), p. 266, on the burial at Saint-Denis of Louis VI's son Philip, and p. 286, on the burial of Louis himself, for whose body space in the church miraculously appeared.

16. Suger, *Vita Lud.* (W), pp. 6 and 220. Charles J. Liebman, Jr., *Étude sur la vie en prose de Saint Denis* (Geneva, N.Y., 1942), p. ii, said that *"la double préoccupation des moines de Saint-Denis, à savoir d'accréditer leur saint patron comme le protecteur de la maison royale de France, et de composer en même temps en son honneur un ouvrage historique, n'est que l'aboutissement d'un mouvement qui remonte un siècle plus haut, à l'abbatiat de Suger, et dont nous trouvons des échos dans l'épopée du XII⁼ siècle."* The charge that Suger forged the so-called Donation of Charlemagne, in which Charlemagne recognized the primacy of the abbey of Saint-Denis and deposited the royal insignia there, though denied by C. Van de Kieft, "Deux diplômes faux de Charlemagne pour Saint-Denis, du XII⁼ siècle," *Le Moyen Age* 64 (1958): 421–24, and *Étude sur le chartrier et la seigneurie du prieuré de La Chapelle-Aude (XI⁼–XIII⁼ siècle)* (Assen, 1960), pp. 60–61, who attributed it to Suger's successor, Odo of Deuil, has been revived by Eric Bournazel in his essay in this volume, pp. 61–66. Spiegel, "Cult," pp. 59–60, also commented on the resemblance between Suger's account of the events of 1124 and the language of the forgery.

17. Jules Tardif, *Monuments historiques* (Paris, 1866), no. 391; Cart. 38. See Robert Barroux, "L'Abbé Suger et la vassalité du Vexin en 1124," *Le Moyen Age* 64 (1958): 1–26, esp. pp. 10–11; Spiegel, "Cult," pp. 58–59; and Spiegel, *Chronicle Tradition*, p. 30.

18. Martial Chazaud, *Fragments du cartulaire de La Chapelle-Aude* (Moulins, 1860), pp. 120–21, nos. 79–80 (Cart. 64, 68; Émile Chénon, *Histoire et coutumes du prieuré de La Chapelle-Aude* [Paris, 1915], nos. 55–56); Tardif, *Monuments*, nos. 427, 466, 469 (Cart. 28, 113, 118); *Cart. blanc*, vol. 2, p. 23 (*De Tauriaco* 11; and *Inv.*, pp. 247–48, no. 232 [ca. 1124]; Cart. 30).

19. Suger, *Let.* (D), nos. 5 and 82, pp. 494, 520; Cart. 156, 193. See Marcel Pacaut, *Louis VII et les élections épiscopales dans le royaume de France* (Paris, 1957), p. 108, commenting that Suger did not intervene in episcopal elections under Louis VII.

20. Suger, *Let.* (L), pp. 264–66; Cart. 298.

21. H. W. C. Davis a.o., ed., *Regesta regum Anglo-Normannorum,* 4 vols. (Oxford, 1913–69), vol. 3, p. 278, no. 751.

22. Suger, *Vita Lud.* (W), p. 262.

23. Léopold Genicot, "L'Évolution des dons aux abbayes dans le comté de Namur du Xᵉ au XIVᵉ siècle," *XXXᵉ Congrès de la Fédération archéologique et historique de Belgique. Annales* (Brussels, 1936), pp. 133–48.

24. William, *Vita Sug.* (L), pp. 381–82.

25. Suger, *Adm.* (L), p. 183.

26. Suger, *Ord.* (P), pp. 129–33.

27. See the references to *renovare, reaurare,* and *reficere* in Suger, *Adm.* (P), pp. 66, 72.

28. Suger, *Adm.* (L), pp. 180–82; see pp. 12–13 and 18 below. A charter in the *Cartulaire de la Chambrerie* (Paris, Archives nationales, LL 1172), p. 142 = fol. 87v (*Inv.,* p. 249, no. 233 [ca. 1124]; Cart. 50 [1126]) refers to the recovery of a church that belonged to Saint-Denis *ab antiquitate.*

29. Suger, *Ch.* (L), p. 320; Cart. 44 (1125).

30. Joseph T. Muckle, "Abelard's Letter of Consolation to a Friend (*Historia Calamitatum*)," *Mediaeval Studies* 12 (1950): 190–91; see p. 197 for further criticism of Saint-Denis. On Abelard's career at Saint-Denis, see the articles by David Luscombe, "Pierre Abélard et le monachisme," and Louis Grodecki, "Abélard et Suger," in *Pierre Abélard. Pierre le Vénérable,* Colloques internationaux du Centre national de la Recherche scientifique, 546 (Paris, 1975), pp. 271–76, 279–84, dating his entry in 1117 (Luscombe) and 1118/9 (Grodecki).

31. Muckle, "Abelard's Letter," pp. 198–99. Permission was given for Abelard to go to a solitary (that is, uninhabited) place on condition that he subjected himself to no other abbey.

32. Bernard, Ep. 78.1 in Leclercq, *Opera,* vol. 7, p. 201.

33. Bernard, Ep. 78.4 ibid., pp. 203–4.

34. Bernard, Ep. 78.9 ibid., p. 207.

35. Muckle, "Abelard's Letter," p. 190. Fulk of Deuil wrote to Abelard that *"monachus es et sanctae religionis habitum, non invitus, sed sponte sumpsisti"* (*PL,* vol. 178, cols. 375B–76A), but Roscellinus took a less favorable view in his letter to Abelard, where he said, *"In monasterio siquidem beati Dionysii, ubi non tam ex regulae severitate, quam ex sapientissimi abbatis misericordia dispensatione pro facultate singulorum omnia temperantur, morari non sustinens ecclesiam a fratribus sub nomine obedientiae, ubi voluntati voluptatique tuae deservires, accepisti, quam cum tuis superfluitatibus tuisque desideriis sufficere non posse conspiceres, aliam ad omnem voluntatem tuam idoneam eligens a donno abbate ex generali fratrum consensu accepisti . . . "* in Joseph Reiners, ed., *Der Nominalismus in der Frühscholastik,* Beiträge zur Geschichte der Philosophie des Mittelalters, 8.5 (Münster, 1910), p. 79; see also pp. 65, 78.

36. Luscombe, "Pierre Abélard," p. 273.

37. Bernard's repeated denials that he was flattering Suger seem to protest a bit too much; see Ep. 78.7–9 in Leclercq, *Opera,* vol. 7, pp. 206–7.

38. See note 6 here. On the types of exactions and dues mentioned in this charter, the nature of some of which is obscure, see Achille Luchaire, *Manuel des institutions françaises. Période des Capétiens directs* (Paris, 1892), pp. 335–45; and Jan Frederik Niermeyer, *Mediae Latinitatis lexicon minus* (Leiden, 1976), s.v.

39. Molinier, *Louis le Gros,* p. 142. I have not seen Antonio Castellano, "L'Incontro bitontino tra papa Callisto II e Suger de Saint-Denis con alcune considerazioni sul romanico pugliese," *La Zagaglia* 15 (1973): 3–21.

40. Molinier, *Louis le Gros,* pp. xxi–xxviii, argued for a twelfth-century origin; Waquet, *Vie,* pp. xxii–xxiv, believed them to be later.

41. The date of the reform is uncertain, except that it was prior to Bernard's Ep. 78, which was written before May 1128: see Michel Félibien, *Histoire de l'abbaye royale de Saint-Denys en France* (Paris, 1706), pp. 157–62; and Achille Luchaire, *Louis VI le Gros. Annales de sa vie et de son règne (1081–1137)* (Paris, 1890), p. 185, no. 398, who commented that *"les historiens ne sont pas d'accord sur la date de la réforme de Saint-Denis. On ne trouve d'indication précise à cet égard, ni dans les oeuvres de Suger ni dans sa biographie par Guillaume, ni dans les petites chroniques de Saint-Denis."*

42. Jacques Doublet, *Histoire de l'abbaye de S. Denys en France* (Paris, 1625), p. 482; Cart. 59. In a charter issued at the same time, Bishop Stephen of Paris referred to *"nobile monasterium beati Dyonisii inter alia gallorum monasteria per dei misericordiam precipue in omni religioni elucet"*: Cart. blanc, vol. 2, p. 278 (De Argentolio 2); *Inv.,* pp. 264–65, no. 240 (ca. 1129); and Cart. 60.

43. *PL,* vol. 179, col. 93; JL 7472; Cart. 70; repeated in 1148 by Eugene III in *PL,* vol. 180, col. 1339; JL 9247; Cart. 186.

44. Suger, *Vita Lud.* (W), p. 212.

45. William, *Vita Sug.* (L), pp. 381, 389–93. See Glaser, "Wilhelm," pp. 279–80.

46. Suger, *Let.* (D), p. 500; Cart. 187.

47. Suger, *Ord.* (P), p. 126; see Cart. 79–80.

48. Giles Constable, ed., *The Letters of Peter the Venerable,* 2 vols., Harvard Historical Studies, 78 (Cambridge, Mass., 1967), vol. 1, p. 90, and s.v. "Love" in index.

49. Suger, *Ch.* (L), pp. 326–31, 336 (Cart. 41, 88); and Suger, *Adm.* (P), p. 72, also *Ord.,* pp. 124–28, 132–34.

50. Suger, *Ch.* (L), pp. 326–27, 335; Cart. 41, 88.

51. Doublet, *Histoire,* p. 480 (*"orationis . . . subsidiis"*), p. 492 (anniversary celebrated *"a domno abbate et fratribus"*), p. 494 (triennial *"convivium et generalem receptum"* at Notre-Dame-des-Champs); Cart. 51 (1126), 116 (1144), 110 (1142/51); and Tardif, *Monuments,* no. 397 (*"fraternitatem et beneficium"*); Cart. 46 (1125).

52. Suger, *Let.* (L), pp. 250–51; Cart. 29.

53. See Lebel, *Histoire,* pp. 35, 238.

54. Suger, *Adm.* (P), pp. 64–66.

55. Suger, *Cons.* (P), p. 106; and Suger, *Adm.* (P), p. 58.

56. John of Salisbury, *Historia pontificalis,* ed. and trans., Marjorie Chibnall, Medieval Texts (London, 1956), p. 87.

57. André Wilmart, "Le Dialogue apologétique du moine Guillaume, biographe de Suger," *Revue Mabillon* 32 (1942): 109–

11. See Glaser, "Wilhelm," pp. 285–99, who dated this work 1154. For earlier accounts of this affair, see Félibien, *Histoire*, pp. 192–95; Achille Luchaire, *Études sur quelques manuscrits de Rome et de Paris*, Université de Paris. Bibliothèque de la Faculté des Lettres, 8 (Paris, 1899), pp. 59–60; and Van de Kieft, *Chapelle-Aude*, esp. pp. 58–63, 172–73, who compared Odo unfavorably to Suger (p. 59) and accused him of forgery (see note 16 here).

58. From where William wrote, probably in 1152/53, a well-known letter praising his place of exile, see *PL*, vol. 186, cols. 1471–74; Wilmart, "Dialogue," p. 115; and Glaser, "Wilhelm," pp. 282–85.

59. William, *Vita Sug.* (L), p. 386. A passage in Wilmart, "Dialogue," pp. 109–10, suggests that there was some fear of improper influence from Suger's relations.

60. William, *Vita Sug.* (L), p. 400; see Glaser, "Wilhelm," p. 305.

61. William, *Vita Sug.* (L), p. 408; and Wilmart, "Dialogue," p. 110.

62. Suger, *Adm.* (L), pp. 160–61 (and pp. 441–42); and Suger, *Vita Lud.* (W), pp. 216–18; see also Suger, *Vita Lud.* (M), p. 145: "*Moniales quedam infames, que ecclesiam Beate Marie de Argentolio diu potentia cujusdam filie Caroli Magni, regis Francorum, occupaverant, industria Sugerii, abbatis Sancti Dionysii in Francia, inde expelluntur, et monachis ejusdem loci quorum prius fuerat restituitur.*" On this episode see Cartellieri, *Suger*, pp. 84–85 (and Cart. 58–61, 63, 67); Lebel, *Histoire*, pp. 16–17; Aubert, *Suger*, pp. 26–27; Luscombe, "Pierre Abélard," p. 275; and Grodecki, "Abélard," pp. 282–83.

63. Suger, *Ch.* (L), p. 338; Cart. 88.

64. Doublet, *Histoire*, p. 482; Cart. 59. See Luchaire, *Louis VI*, pp. 199–200, no. 431; Ursmer Berlière, "Le Cardinal Matthieu d'Albano" in Ursmer Berlière, *Mélanges d'histoire bénédictine* (Mardesous, 1897–1902), vol. 4, p. 19. Bishop Stephen of Paris said in the charter cited in note 42 here: "*Cumque qui aderant de enormitate et miseria monacharium* [for *monacharum*] *illarum eliminenda, omnes conclamarent, prelibato cum illis quos supra nominauimus consilio, tum propter eius quam comperimus iusticiam, tum etiam potissimum propter monasterii illius in sancta religione inmutationem . . . prefatum monasterium Argentoilense, gratuitis sanctorum martyrum beneficiis restituimus.*"

65. Félibien, *Histoire*, preuves p. xcv, no. 126; Cart. 61.

66. *PL*, vol. 166, col. 1297AB (JL 7372; Cart. 63); *PL*, vol. 179, col. 65B (JL 7426; Cart. 67).

67. Doublet, *Histoire*, pp. 869–70, granting Chaumont "*cum omnibus appendicitiis suis, quam nos et antecessores nostri longo tempore in dominacutura habueramus, libere et quiete in perpetuum possidendam sicut libere habebamus,*" and instructing the abbot "*ut contra antiquam ecclesiae vestrae dignitatem archiepiscopo Rothomagensi vel ministris eius nullatenus obediatis, nec per eum sine clamore abbatis iustitiam teneatis.*" See Achille Luchaire, *Études sur les actes de Louis VII* (Paris, 1885), pp. 152–53, nos. 167–68.

68. Suger, *Adm.* (L), pp. 183–84.

69. *PL*, vol. 180, cols. 1347–48 (JL 9256–57; Cart. 188).

70. *PL*, vol. 180, col. 1354 (JL 9272; Cart. 190).

71. See *PL*, vol. 180, cols. 1368–69 (JL 9297; Cart. 198), col. 1379CD (JL 9311; Cart. 209), col. 1380AB (JL 9312; Cart.

207), col. 1415AC (JL 9387; Cart. 284).

72. Suger, *Let.* (L), p. 250; Cart. 196.

73. Suger, *Let.* (L), p. 255; Cart. 206.

74. Bernard, Ep. 369 in Leclercq, *Opera*, vol. 8, p. 328; see also Ep. 370, p. 329. On this case, see Marcel Pacaut, *Louis VII et son royaume* (Paris, 1964), p. 79.

75. John of Salisbury, *Historia*, pp. 15–17.

76. Suger, *Let.* (L), pp. 263–66; Cart. 242.

77. *PL*, vol. 180, cols. 1413–14 (JL 9382). Eugene III confirmed the privileges of Fontevrault, saying that the nuns should be blessed by the diocesan bishop provided he was Catholic and in communion with the Holy See (vol. 1413CD).

78. Émile Epiphanius Morel, *Cartulaire de l'abbaye de Saint-Corneille de Compiègne* (Montdidier, 1904–1909), vol. 1, p. 115, no. 62. On this case, see Richard Hirsch, *Studien zur Geschichte König Ludwigs VII. von Frankreich (1119–1160)* (Leipzig, 1892), pp. 73–75; Aubert, *Suger*, pp. 60–61; and Pacaut, *Louis VII*, pp. 79–80.

79. Morel, *Cartulaire*, vol. 1, p. 119.

80. Ibid., pp. 116–18 (Suger to Baldwin and Baldwin to Suger), p. 125 (Baldwin to Eugene III). See also Wilmart, "Dialogue," pp. 109, 112.

81. Morel, *Cartulaire*, vol. 1, pp. 121–22 (Suger to Ralph of Vermandois), pp. 125–26 (Baldwin to Eugene III), pp. 127–28 (Suger to Eugene III).

82. Ibid., pp. 129–30; JL 9422.

83. Morel, *Cartulaire*, vol. 1, p. 128 (Suger to Eugene III); see also pp. 124–25 (Suger to Peter the Venerable and Baldwin to Eugene III).

84. Ibid., p. 127 (Suger to Eugene III); see also p. 125 (Baldwin to Eugene III).

85. Peter the Venerable wrote to Innocent II concerning the reform of Luxeuil: "*Nam sicut nouit sapientia uestra, in negotio religionis facilius possunt noua fundari quam uetera reparari,*" Ep. 23, in Constable, *Peter the Venerable*, vol. 1, p. 43.

86. Suger, *Ord.* (P), p. 122.

87. Suger, *Ch.* (L), p. 363; Cart. 313.

88. Chazaud, *Fragments*, p. 101, no. 59; Cart. 81; Chénon, *Chapelle-Aude*, p. 99 and no. 63.

89. Cartellieri, *Suger*, pp. 81–82; Panofsky, *Suger*, pp. 7–9; Aubert, *Suger*, pp. 22–38; and Pacaut, *Louis VII*, pp. 37, 139.

90. Suger, *Adm.* (L), pp. 156–58, 162; see also the description of his activities at Toury, p. 172. Cartellieri, *Suger*, gives lists both of specific increases (p. 104 n. 1) and of the revenues referred to in *De administratione* (p. 185).

91. Suger, *Vita Lud.* (W), pp. 212–14.

92. Tardif, *Monuments*, no. 506 (Cart. 291); Suger, *Adm.* (L), p. 182; *Cart. blanc*, vol. 2, p. 411 (*De sancta Gauburge 25*; *Inv.*, p. 331, no. 288 [ca. 1150]). See, more generally, Giles Constable, "The Financing of the Crusades in the Twelfth Century," *Outremer: Studies in the History of the Crusading Kingdom of Jerusalem Presented to Joshua Prawer* (Jerusalem, 1982), pp. 64–88.

93. Ulysse Robert, *Bullaire du pape Calixte II, 1119–1124*, 2 vols.

(Paris, 1891), vol. 2, p. 264, no. 451; JL 7113; Cart. 35. This letter is undated and may have been issued before Suger became abbot.

94. Tardif, *Monuments,* no. 391 (Cart. 38); Suger, *Vita Lud.* (W), p. 228. See Léon Levillain, "Essai sur les origines du Lendit," *Revue historique* 155 (1927): 241–76, esp. pp. 247, 251; Lebel, *Histoire,* pp. 206–7; and Spiegel, *Chronicle Tradition,* pp. 29–30. I have not seen V. Thonet, "Notes sur l'origine de la foire de Lendit à Saint-Denis (Seine)," *Fédération folklorique de l'Ile de France. Bulletin trimestriel* (1951–53): 424–26, cited in the *Bulletin d'histoire bénédictine* 5:473*, no. 3671, who proposed that the fair originated at Lendelinicurtis.

95. Suger, *Adm.* (L), pp. 157–58.

96. *PL,* vol. 179, cols. 93–95 (JL 7472; Cart. 70), cited passage col. 94B. On col. 94C the rights to Lendit were defined as *"Omnimodam potestatem, omnemque justitiam, et universas consuetudines nundinarum indicti, ipsius regis liberalitate vobis concessas."* For the arrangement with the counts of Morsberg, see Suger, *Ch.* (L), pp. 323–24; Tardif, *Monuments,* no. 397 (Cart. 45–46); and Michel Parisse, "Saint-Denis et ses biens en Lorraine et en Alsace," *Bulletin philologique et historique (jusqu'à 1610) du Comité des travaux historiques et scientifiques,* 1967, pp. 250–51. On the Vexin, see the article by Barroux cited in note 17 here.

97. Doublet, *Histoire,* pp. 479–80, 480 (Cart. 43, 51). See also the unpublished charter of Bartholomew in *Cart. blanc,* vol. 2, p. 212 (*De Claro Fonte* 6; *Inv.,* pp. 273–74, no. 249 [ca. 1130]; Cart. 32 [1122/51]) concerning the agreement between Suger and the canons of Clairefontaine over the tithes of Sorbais, of which Suger granted a third to the canons in return for two measures of grain for the major tithe and twelve pennies of Châlons for the minor tithe.

98. See Doublet, *Histoire,* p. 492 (Cart. 116), for the grant of a church by Bishop Nicholas in 1144.

99. Given by Louis VII in 1144/5 together with two others not mentioned in this bull: Tardif, *Monuments,* no. 469 (Cart. 118).

100. Félibien, *Histoire,* preuves p. cvii, no. 137 (Cart. 140).

101. *PL,* vol. 180, cols. 1339–41 (JL 9247; Cart. 186). At least six of these properties are referred to in *De administratione.*

102. Adrian Morey and Christopher N. L. Brooke, *The Letters and Charters of Gilbert Foliot* (Cambridge, 1967), pp. 100–101, no. 66. See also the writ of King Stephen for Reading in *Regesta* (note 21 here), vol. 3, p. 252, no. 680 (1135/48). On Deerhurst, see [John Nichols], *Some Account of the Alien Priories . . . in England and Wales,* 2 vols. (London, 1779), vol. 2, pp. 117–19; and David Knowles and R. Neville Hadcock, *Medieval Religious Houses: England and Wales,* 2d ed. (London, 1971), p. 64; and, on Prior Roderick, David Knowles, Christopher N. L. Brooke, and Vera London, *The Heads of Religious Houses: England and Wales, 940–1216* (Cambridge, 1972), p. 102.

103. Avrom Saltman, *Theobald, Archbishop of Canterbury,* University of London Historical Studies, 2 (London, 1956), pp. 433–34, no. 211 (identifying Saint-Denis as the Augustinian priory of that name in Southampton).

104. Tardif, *Monuments,* no. 466; Cart. 113.

105. Suger, *Adm.* (L), p. 168. See also the description of Toury there on p. 171.

106. Tardif, *Monuments,* no. 479; Cart. 122.

107. See, among others, the agreements with Ourscamp, in Achille Peigné-Delacourt, *Cartulaire de l'abbaye de Notre-Dame d'Ourscamp,* Mémoires de la Société des Antiquaires de Picardie. Documents inédits concernant la province, 6 (Amiens, 1865), p. 35, no. 53 (Cart. 33a), with Saint-Mihiel, referred to in the bull of Innocent II in *PL,* vol. 179, cols. 111–12 (JL 7502; Cart. 76), and with Clairefontaine, of which one is cited in note 97 here and another is in *Cart. blanc,* vol. 2, p. 219 (*De Claro Fonte* 17; *Inv.,* pp. 332–33, no. 292 [ca. 1151]).

108. Suger, *Adm.* (L), p. 173.

109. *Cart. blanc,* vol. 2, p. 271 (*De collatione ecclesiarum* 25; *Inv.,* p. 296, no. 262 [ca. 1137]; Cart. 31 [1122/49]), which specified that *"saluo tamen iure et dignitate ecclesie nostre et nostro uidelicet episcopi et archidiaconi, ut sicut prius ecclesie predicte fuere semper nobis obnoxie, in synodis reddendis, in circariis, in iusticiis tenendis, in omni obedientia, ita semper erunt."*

110. *Cart. blanc,* vol. 1, p. 903 (*De Monte Melliano* 17; *Inv.,* p. 270, no. 246 [1130]); see Luchaire, *Louis VI,* pp. 211–12, no. 453.

111. Suger, *Adm.* (L), pp. 156–57; and the charter there on p. 339. See Aryeh Grabois, "L'Abbaye de Saint-Denis et les Juifs sous l'abbatiat de Suger," *Annales* 24 (1969): 1188–91.

112. Tardif, *Monuments,* no. 479 (Cart. 122); Suger, *Adm.* (L), p. 172; and Suger, *Let.* (D), no. 99, p. 526 (Cart. 172). See Cartellieri, *Suger,* pp. 88–89, 98 n. 2.; and Lebel, *Histoire,* pp. 38ff. on the officials of Saint-Denis, esp. pp. 66–71 on the advocates.

113. Suger, *Adm.* (L), pp. 164–67, 169, 173.

114. Ibid., p. 176.

115. Suger, *Ch.* (L), pp. 360–61 (Cart. 121). See also Suger, *Adm.* (L), pp. 164–67; and Cartellieri, *Suger,* pp. 94–95.

116. Ayzac, *Histoire,* vol. 1, pp. 74–75; and Lebel, *Histoire,* p. 175, who (referring to the period after 1151) said: *"La vraie politique de l'abbaye consiste à défricher."*

117. Suger, *Adm.* (L), pp. 167, 185 (fishponds and *aquaria,* on which see Cartellieri, *Suger,* pp. 89–90, 187 n. 1, who cited differing views on whether it was a fishing-right or a *droit de travers*).

118. Suger, *Adm.* (L), p. 158. See Lebel, *Histoire,* pp. 186–89, referring to vineyards at Beaune-la-Rolande, Saint-Lucien, and Essones.

119. Suger, *Adm.* (L), p. 170. See Lebel, *Histoire,* pp. 24–25.

120. Suger, *Adm.* (L), p. 158 (mill), p. 160 (oven), p. 182 (mill and oven) (see Cartellieri, *Suger,* p. 187); *Cart. blanc,* vol. 2, pp. 173, 178 (*De Curte Superiori* 1, 8; *Inv.,* pp. 331–32, nos. 289 [ca. 1150], 291 [ca. 1150]), referring to an oven; and the charter cited in note 6 here. See Lebel, *Histoire,* p. 134.

121. On these rights, see Cartellieri, *Suger,* p. 187; Lebel, *Histoire,* p. 8 n. 14; Van de Kieft, *Chapelle-Aude,* pp. 99, 126 (on the *vicaria*); and Grabois, "Saint-Denis et les Juifs," pp. 1188–91.

122. Suger, *Ch.* (L), pp. 319–22 (Cart. 44). *Inv.,* p. 325, no. 282

(1147) (Cart. 151) cites a lost charter of Bishop Manasses of Orléans freeing a serf at the request of Suger.

123. Claude Gaier, "Documents relatifs aux domaines hesbignons de l'abbaye de Saint-Denis en France," *Académie royale de Belgique. Bulletin de la Commission royale d'histoire* 127 (1961): 180–88, see also pp. 167–73, showing that the controversy continued at least into the mid-1160s. See Giles Constable, "Monasticism, Lordship, and Society in the Twelfth-Century Hesbaye: Five Documents on the Foundation of the Cluniac Priory of Bertrée," *Traditio* 33 (1977): 215.

124. *Cart. blanc*, vol. 2, p. 219 (in note 107 here).

125. Suger, *Adm.* (L), p. 176. See Giles Constable, *Monastic Tithes from Their Origins to the Twelfth Century,* Cambridge Studies in Medieval Life and Thought, N.S. 10 (Cambridge, 1964), p. 107.

126. Chazaud, *Fragments,* pp. 101–28; and Chénon, *Chapelle-Aude,* pp. 32–49, 151–59. See Van de Kieft, "Deux diplômes," pp. 421–24; and *Chapelle-Aude,* pp. 48, 58–63, on Odo and his role in creating the alleged forgeries.

127. Chazaud, *Fragments,* pp. 108–9, no. 68; and Chénon, *Chapelle-Aude,* no. 50. See Van de Kieft, *Chapelle-Aude,* p. 14, who accepted the authenticity of this document although it is written in the hand of the scribe who was responsible for a group of forgeries.

128. Chazaud, *Fragments,* pp. 104–5, no. 63; Cart. 120; and Chénon, *Chapelle-Aude,* no. 93 (1144/5). See Hirsch, *Studien,* p. 37.

129. Chazaud, *Fragments,* p. 120, no. 79; Cart. 64; Chénon, *Chapelle-Aude,* no. 55; also Chazaud, *Fragments,* pp. 121–22, nos. 80, 82; Cart. 68; and Chénon, *Chapelle-Aude,* nos. 56–57.

130. Chazaud, *Fragments,* pp. 105–6, 121–22, nos. 64–65, 81; JL 7438–39, 7503; Cart. 72–73, 75; and Chénon, *Chapelle-Aude,* nos. 59, 61.

131. Chazaud, *Fragments,* pp. 107, 123, nos. 66, 83; Cart. 77–78; and Chénon, *Chapelle-Aude,* nos. 58, 62.

132. See the royal confirmation (1122/37) of Suger's agreement with Hugh Balver, which restricted his powers as advocate of Laversine (Tardif, *Monuments,* no. 427; Cart. 28) and the papal confirmation (1131) of the settlement by Matthew of Albano and six other judges of the dispute between Saint-Denis and Saint-Mihiel over Salonne (*PL,* vol. 179, cols. 111–12; JL 7502; Cart. 76), which was settled again in 1148 by Archbishop Adalbero of Trier (Tardif, *Monuments,* no. 501; Cart. 182).

133. Chazaud, *Fragments,* p. 104, no. 62; Cart. 27; Chénon, *Chapelle-Aude,* p. 68 and no. 84; and Van de Kieft, *Chapelle-Aude,* p. 81. The hermits also agreed to receive no other brothers without permission from the prior of Chapelle-Aude.

134. Doublet, *Histoire,* p. 494; Cart. 110 (1142/51). See Suger, *Adm.* (L), pp. 177–82; and the charter in Suger, *Ch.* (L), p. 339; Joseph Depoin, *Notre-Dame des Champs. Prieuré dyonisien d'Essonnes* (Corbeil, 1904), pp. 26–30; and Lebel, *Histoire,* p. 33.

135. Suger, *Ch.* (L), p. 339; Cart. 88. See Ayzac, *Histoire,* vol. 2, pp. 110–11; Cartellieri, *Suger,* p. 182; and Lebel, *Histoire,* pp. 8–9.

136. See the documents cited in note 96 here; Suger, *Adm.* (L), p. 183; and the charter in Suger, *Ch.* (L), p. 339 (Cart. 88). See Parisse, "Saint-Denis," pp. 250–51.

137. Suger, *Ch.* (L), p. 340 (Cart. 88). See Émile Duvernoy, "Une Enclave Lorraine en Alsace. Liepvre et L'Allemand-Rombach," *Mémoires de l'Académie de Stanislas,* 6th ser., 9 (1911–12): 98–112, esp. pp. 100 and 108 on its connection with Saint-Denis; and Parisse, "Saint-Denis," pp. 253–54. Lebraha and Liepvre are apparently identified by these two scholars, and also by Cartellieri, *Suger,* p. 180, who calls it Lebereau, and by Laurent H. Cottineau, *Répertoire topo-bibliographique des abbayes et prieurés,* 3 vols. (Mâcon, 1939–70), vol. 1, cols. 1578, 1606. Félibien, *Histoire,* preuves p. ccxxiii, and index s.n., however, who was in a position to know, distinguished them as Saint-Hippolyte at Val-du [le]-Lièvre and Saint-Alexandre at Lebraha (Lebraw).

138. *Cart. blanc,* vol. 2, pp. 401–11 (*De sancta Gauburge* 1–25); the documents cited in note 132 here and Parisse, "Saint-Denis," pp. 251–53 (on Salonne); *Inv.,* pp. 283–84, no. 257 (1135) (Cart. 86) (on Reuilly); and, on the others, notes 58, 102, and 126ff. here.

139. Félibien, *Histoire,* preuves p. ccxxiii, adds Saint-Clair-sur-Epte (Cottineau, *Répertoire,* vol. 2, col. 2634), Saint-Blaise at Grandpuits (Cottineau, *Répertoire,* vol. 1, col. 1330), Saint-Denis at Marnay (Cottineau, *Répertoire,* vol. 2, col. 1767), and *Furnellis* in Spain. Saint-Gobert in the diocese of Laon, which is listed in Cottineau, *Répertoire,* vol. 2, col. 2721, is mentioned simply as a church in JL 9247 (in note 101 here).

140. Suger, *Ch.* (L), p. 339; Cart. 88. Later, in referring to the provisions for celebrating his anniversary in five specific priories, Suger again said, *"Nec minus in omnibus Beati Dionysii cellis, tam propinquis quam remotis, anniversarium nostrum orationumque instantiam, missam pro defunctis semel in ebdomada rogantes obnixe impetravimus"* (p. 340).

141. The repeated references to *monachus vel maior* in Tardif, *Monuments,* no. 427 (Cart. 28; Luchaire, *Louis VI,* p. 273, no. 602), suggest, in this context, that *monachus* was the same as provost.

142. Suger, *Let.* (D), no. 99, p. 526; Cart. 172 (1147/9).

143. Tardif, *Monuments,* no. 427; Cart. 28.

144. Suger, *Adm.* (L), p. 167. See Cartellieri, *Suger,* p. 48.

145. *Cart. blanc,* vol. 2, p. 220 (*De Claro Fonte* 18; *Inv.,* pp. 281–82, no. 256 [1134]).

146. Suger, *Adm.* (L), pp. 162, 169. In the charter cited in notes 141 and 143 here, Louis mentioned the servant or sergeant of the *maior.*

147. Tardif, *Monuments,* no. 479; Cart. 122 (see Cartellieri, *Suger,* p. 99 n. 2, who called this the only reference to *decanus*); charter 13 in Suger, *Ch.* (L), p. 364; Cart. 313.

148. On these and other rural officials, see Cartellieri, *Suger,* pp. 98–101, who corrected Luchaire in distinguishing the provostships from the priories (p. 100 n. 3); and Lebel, *Histoire,* pp. 38–51 (on the *maior*), pp. 51–59 (on the provosts), and pp. 62–66 (on the sergeants). The bailiffs discussed on pp. 60–62 appear later, and there is no discussion of the *decanus.*

149. *Cart. blanc,* vol. 2, p. 557 (in note 6 here).

150. Suger, *Adm.* (P), p. 76. See Ayzac, *Histoire,* vol. 2, p. 209 n. 2.

151. *Cartulaire de la Chambrerie* (Paris, Archives nationales, LL 1172), p. 11 = fol. 22r; *Inv.,* pp. 329–30, no. 285 (1149); Cart. 257.

152. See note 147 here.

153. Suger, *Adm.* (L), pp. 169, 175.

154. On Matthew and his family, see Joseph Depoin, *Recueil de chartes et documents de Saint-Martin-des-Champs,* Archives de la France monastique 13, 16, 18, 20–21, 5 vols. (Ligugé and Paris, 1912–21), vol. 1, p. 193 n. 305, vol. 2, p. 196 n. 298; and Tardif, *Monuments,* nos. 448, 557 (Luchaire, *Louis VII,* p. 237, no. 428). Ayzac, *Histoire,* vol. 1, p. 372, called him count of Beaumont. In 1148 he granted to Saint-Martin-des-Champs the tithes of Saint-Brice-sous-Montmorency, of which Suger was suzerain for two thirds and Matthew of Montmorency for one third: Depoin, *Saint-Martin-des-Champs,* vol. 2, pp. 196–200, nos. 308–10.

155. *Cart. blanc,* vol. 1, pp. 240–42 (*De feodis emptis* 4; *Inv.,* pp. 253–61, no. 236 [1125]; Cart. 49). This important charter deserves further study. Cartellieri, *Suger,* pp. 93–94, counted over forty vassals, and Aubert, *Suger,* p. 25, considered it as evidence that Suger had a census of the property of Saint-Denis made in about 1125.

156. Suger, *Adm.* (L), pp. 164, 166, 173–74; Suger, *Cons.* (P), p. 94 (and 216–17 on Milo of Bray); and Suger, *Vita Lud.* (W), s. n. in index.

157. Tardif, *Monuments,* no. 410; Cart. 83. See also *Cart. blanc,* vol. 2, p. 23 (*De Tauriaco* 11; *Inv.,* pp. 247–48, no. 232 [ca. 1124]; Cart. 30 [1122/48]) concerning a military fief held from the king's benefice and restored to Saint-Denis with his permission.

158. Otto Oexle, *Forschungen zu monastischen und geistlichen Gemeinschaften westfränkischen Bereich,* Münstersche Mittelalter-Schriften, 31 (Munich, 1978), pp. 117–19. See Félibien, *Histoire,* p. 258 (200 monks in 1294); Ayzac, *Histoire,* vol. 1, p. 52 (180 monks under Philip Augustus); and Cartellieri, *Suger,* p. 101 n. 3.

159. Suger, *Ch.* (L), pp. 340–41, 343–44, 349; Cart. 88–90.

160. On the *pueri,* see Ayzac, *Histoire,* vol. 1, pp. 12–13.

161. This list is based on the evidence in the charter cited in note 6 here and those in Suger, *Ch.* (L), pp. 322, 340 (and 337), 343, 348; Cart. 44, 88–90.

162. Doublet, *Histoire,* pp. 479–80, 490, 492; Cart. 43, 51, 80, 116; Gaier, "Documents," p. 186. The chamberlain cited in these charters, which date from 1125 to 1144, was named Peter, and he was probably the same as the *frater Petrus* who was invested with the altar of Roubaix by the archdeacon of Laon in the charter of ca. 1124 cited in note 28 here.

163. Suger, *Ord.* (P), p. 126. Ducange, in his *Glossarium,* s.v., refers to the position only at Saint-Denis and, as *coenarius,* at Saint-Maur-des-Fossés.

164. *PL,* vol. 186, col. 1471A. See Glaser, "Wilhelm," pp. 282–83. The number of officials named William raises the possibility that the address was rhetorical. The chartographer, one

priest, and one subdeacon were named William among the witnesses to Suger's will (see note 159 here). The priest and subdeacon also appear on a charter in Suger, *Ch.* (L), pp. 343–44, and a chaplain named William witnessed Suger's grant to Longpont in 1150, in Suger, *Ch.* (L), p. 364 (Cart. 313).

165. Wilmart, "Dialogue," pp. 109–10. See Glaser, "Wilhelm," pp. 306–8.

166. Wilmart, "Dialogue," p. 102 (referring to the region of Poitou or Bourges, England, Arras, and Ferrières), and pp. 108–9 (referring to the Second Crusade and Compiègne). See Van de Kieft, *Chapelle-Aude,* pp. 58–59, 172–73; and Glaser, "Wilhelm," pp. 310–13.

167. William, *Vita Sug.* (L), p. 386; and Suger, *Ch.* (L), pp. 340, 343, 348, charters 7–9.

168. On the sections of this and other Saint-Denis cartularies, see Lebel, *Catalogue,* p. v.

169. On the refectory, see charters 4 and 7, in Suger, *Ch.* (L), pp. 326–31, 333–41 (Cart. 41, 88), where Suger indicated the sources of the grain, wine, and money needed to commemorate his own anniversary; on the almonry, pp. 332–33 (Cart. 29); on the treasury, pp. 320, 342–44 (Cart. 44, 89), where provision was made to pay certain revenues to the treasurer rather than the abbot; and Suger, *Cons.* (P), p. 102. For grants for lighting, see Tardif, *Monuments,* no. 469 (Cart. 118); and Félibien, *Histoire,* preuves p. cvii, no. 137 (Cart. 140).

170. Suger, *Ch.* (L), pp. 319–64 (cited passages on pp. 320, 331, 332). See also Suger, *Cons.* (P), p. 102.

171. 1125: *Cart. blanc,* vol. 1, p. 240 (in note 155 here) ("*rogatu domni Sugerii abbatis et tocius conuentus*"); 1126: Doublet, *Histoire,* p. 480 (Cart. 51) ("*pro amore karis. fratris Suggerii eiusdem loci abbatis totiusque conventus*"); *Cart. de la Chambrerie,* p. 142 (in note 28 here) ("*cum toto ipsius capitulo*"); 1129: *Cart. blanc,* vol. 2, p. 278 (in note 42 here); 1131: *PL,* vol. 179, col. 111D (JL 7502; Cart. 76) ("*tam concessione capituli vestri quam impressione sigilli*"); 1133: Chazaud, *Fragments,* p. 101, no. 59 ("*favente ac consentiente toto capitulo Sancti Dyonisii*"); 1135: *Inv.,* pp. 283–84, no. 257 (in note 138 here); 1148: Depoin, *Saint-Martin-des-Champs,* vol. 2, p. 196, no. 308 ("*cum assensu capituli sui*"); 1122/44: *Cart. blanc,* vol. 2, p. 419 (*De sancta Gauburge* 45; *Inv.,* pp. 274–75, no. 250 [ca. 1130]; Cart. 42) ("*donnus Sugerius abbas ecclesie sancti Dyonisii totusque conuentus fratrum*"); 1122/48: *Cart. blanc,* vol. 2, p. 23 (in note 157 here) ("*sollicitante abbate sancti Dyonisii Sugerio et monachis eius*"); 1122/49: *Cart. blanc,* vol. 2, p. 271 (in note 109 here); 1122/51: *Cart. blanc,* vol. 2, p. 212 (in note 97 here) ("*consilio et assensu fratrum suorum*"); and 1122/51: Peigné-Delacourt, *Ourscamp,* p. 35, no. 53 ("*totius capituli mei assensu*").

172. Muckle, "Abelard's Letter," pp. 198–99.

173. See Giles Constable, "The Authority of Superiors in Religious Communities in the Middle Ages," in George Makdisi, Dominique Sourdel, Janine Sourdel-Thomine, eds., *La Notion d'autorité au moyen âge: Islam, Byzance, Occident,* Colloques internationaux de La Napoule, 23–26 octobre 1978 (Paris, 1982), pp. 189–210.

Suger, Theology,
and the
Pseudo-Dionysian Tradition[*]

Grover A. Zinn, Jr.

To ASSESS the thought of Suger of Saint-Denis and identify the sources that nurtured and guided his thinking are difficult for a variety of reasons. Chief among them is the fact that Suger was neither a theologian nor a systematic reflective thinker like such contemporaries as Hugh of Saint-Victor, William of Conches, or Abelard. Suger left no theological writings, strictly speaking, and he does not appear as a major figure in books on the development of twelfth-century thought. Yet the abbot of Saint-Denis was influenced by a very specific and important set of theological ideas when he built and furnished the new church for his abbey. It is the church and Suger's treatises bearing on its construction and consecration that stand as witnesses to the abbot's perception and use of key theological ideas gaining new or renewed currency in early twelfth-century France.[1]

For access to Suger's thought-world we must enter through the church and seek the ideas that inform the structure, the iconography, the furnishings, and Suger's interpretation of these. Such an inquiry reveals no systematic statement from Suger but, rather, an assortment of clues that must be traced and linked with other ideas and people in the spectrum of twelfth-century thought. The clues are of two types: first, the literary clues left in Suger's treatises and his poems associated with the church; second, the visual clues left in the art of the church. Very much like the medieval exegete who found that he had to crack the shell to get the kernel, or pierce the dry honeycomb to taste the sweet honey of the deeper sense of Scripture, so we must deal with bare words and images in Suger's texts and building in order to grasp the once-living fabric of his thought, thought that shaped a major monument in the history of Western Christianity.[2]

A second task in assessing Suger's thought is the pressing need to set his ideas in a broader context. The studies that laid the foundation for our present understanding of Suger's ideas paid too little attention to the twelfth-century setting. Perhaps this was due to a focus too narrowly on Suger, viewing him as almost single-handedly appropriating the pseudo-Dionysian ideas that inspired him. Certainly Erwin Panofsky tended to see the abbot in this manner, for he pointed directly from Suger to John Scotus Eriugena and, through that ninth-century figure, to pseudo-Dionysius the Areopagite. Panofsky skillfully brought to light the Dionysian elements in Suger's thought, but there is a conspicuous need in his work for greater consideration of twelfth-century thought as well as a more careful separation of Dionysian and Eriugenian texts.[3] Otto von Simson has shown a broader conception of the non-Eriugenian sources and twelfth-century influences, but continuing studies have made it increasingly clear how much more precisely we can delineate both the context for, and the process of, interpreting Suger's church and the iconography associated with it.[4] What is needed is a wider consideration of issues and ideas related to symbolism, cosmological speculation, and the knowledge of God and spiritual realities as these were understood by Suger's contemporaries. Only by seeing Suger's prose, poetry, and actual church in relation to contemporary theological thought and literary discussions can we truly appreciate the way in which he drew upon Dionysian ideas, together with traditional iconographic and theological materials.[5]

To begin this examination, I wish to explore Suger's relation to a major twelfth-century thinker, Hugh of Saint-Victor, while keeping in mind two other points of view: the school of Chartres and the tradition of Dionysian interpretation and speculative thought stemming from John Scotus Eriugena. Hugh, the Chartrians, and Eriugena were each variously concerned with symbolic modes of discourse and speculative cosmologies, issues

Notes for this essay begin on page 37.

present in Suger's work also. As a result of the pioneering work of Marie-Dominique Chenu and Henri de Lubac, the importance of symbolic modes of thought in the twelfth century has been increasingly appreciated.[6] Recently, the writings of Bernard McGinn on Isaac of Stella, of Peter Dronke on medieval uses of fabulae, of Winthrop Wetherbee on literature and myth, and of Brian Stock on myth and science have deepened our understanding not only of medieval symbolic thinking but also of the importance of the related topic of cosmological speculation in twelfth-century literary, philosophical, and theological circles.[7]

Chartrians are particularly important in relation to Hugh and Suger. In *The Gothic Cathedral,* von Simson emphasized geometric and mathematical aspects of Chartrian cosmological speculation that he found important in relation to the emergence of Gothic form.[8] Of possibly greater significance for understanding twelfth-century ideas on symbolism is the kind of analytic reflection on the nature of symbols carried out by a Chartrian author like William of Conches or in the works of a contemporary theologian, Abelard.[9] When brought into conjunction with William's own attempts at cosmological speculation, which drew upon Macrobius, Boethius, and the *Timaeus* and introduced the symbol of the golden chain to represent the inherent unity and hierarchical ordering of the universe, this reflection on the nature of symbolic representation begins to lay the foundation for the speculative cosmological poems of Alain of Lille and Bernard Silvestris as well as other medieval uses of fabulae.[10] Suger would have heartily disagreed with William, Alain, and Bernard at key points, but the speculative cosmologies and concern for symbols shared by these men must be seen as part of a twelfth-century phenomenon of which Suger's work was but one aspect.

Away from Chartres and nearer to Saint-Denis, interest in symbols and in cosmological schemes of a different sort drew men to the writings of pseudo-Dionysius the Areopagite rather than to those of Macrobius. The place was the royal abbey of Saint-Victor in Paris, a community of regular canons founded in the early twelfth century by William of Champeaux that soon became a major center of intellectual and religious life in the region. There Hugh of Saint-Victor, founder of the abbey's distinctive traditions of exegesis, theology, and contemplation, composed his famous commentary on pseudo-Dionysius the Areopagite's *Celestial Hierarchy* in the 1120s.[11] Hugh's interpretation laid the groundwork for the incorporation of the Dionysian tradition into the theological and contemplative traditions of the medieval West. His definition of a symbol as "a gathering together of visible forms in order to 'demonstrate' invisible ones" is justly recognized as conveying the ability of symbols to transcend verbal categories.[12] Moreover, it shows the creative thought to be found in this commentary touching on matters of contemplation, beauty, the Eucharist, and other theological topics.

The writings of pseudo-Dionysius the Areopagite were available to Hugh and others of his generation in the translation by John Scotus Eriugena, accompanied by John's own commentary on the *Celestial Hierarchy,* and a translation of Greek glosses, especially those of Maximus the Confessor.[13] Eriugena's presence was felt strongly in the twelfth century through his association with the Dionysian tradition, even though on other grounds he was suspected of heresy and not always openly cited. Eriugena's own speculative ideas were known through the text of his *Periphyseon,* while the *Clavis physicae* of Honorius Augustodunensis succeeded in popularizing Eriugena's ideas, especially cosmological ones, in the twelfth century.[14]

With the Chartrians, Hugh, and Eriugena to provide something of a context, let us now turn to clues from Suger. A major indication of Suger's outlook is found in the poem for the gilt-bronze doors of the central portal of the new west facade. The poem has been celebrated as a compact summary of the whole theory of anagogical illumination as presented by pseudo-Dionysius the Areopagite and his translator-commentator, Eriugena.[15] In fact, the poem offers much more than a summary of the Dionysian notion that the things of the material world (described in the poem as *vera lumina,* true lamps) can lead minds upward to the True Light (*vera lux*) where Christ is the True Door.[16] Taken in conjunction with the door and its eight carefully crafted relief scenes, the poem presents a critique of the generalized Dionysian and Eriugenian idea that the material world, by virtue of its created existence, is truly able to point in a symbolic sense beyond itself to the invisible realities of the divine world and God.

The poem opens with an admonition to marvel not at the gold and expense but at the labor of the work in the doors. Suger's words echo a similar injunction by Hugh of Saint-Victor, who once told his fellow regular canons that he was placing before them a drawing with colors, shapes, and figures that would be pleasant to behold, but they were to understand that the pleasing figures were there for instruction, in order to teach wisdom and virtue to adorn the soul.[17] In a similar way, the eight medallions on Suger's door were not merely for display or devotion but for instruction that was to be conveyed through scenes skillfully depicted and, perhaps, also through the labor of the divine works portrayed.[18]

Following the opening admonition, the poem continues with three lines devoted to the theory of the capacity of matter to lead upward to invisible truth. Then comes the qualification, the criticism. In Panofsky's translation the line reads:[19]

> In what manner it be inherent in this world, the golden
> door defines:

Even Panofsky was somewhat uncertain about the proper rendering of this crucial line, but the thrust seems to be clear: the golden door defines or determines how it, the True Light, is present and understood through the vehicle of material reality. The defining character of the door is not, however, the general idea that the door in its brilliance and color represents in an exemplary way a multitude of material lamps meant to lead the mind to invisible truth. I would like to suggest that it is the iconography of the door that is meant to point to a very specific understanding of the way in which visible reality leads to invisible truth.

The eight medallions on Suger's door depicted scenes from Christ's Passion, Resurrection, and Ascension, including a representation of Christ and the two disciples at Emmaus, with Abbot Suger himself included in the latter scene.[20] The poem and medallions make a simple but crucial point: only through the crucified, risen, and ascended Christ does a person have access to the true meaning of the material world that leads to the True Light. Not a general symbolic cosmos, with material lights leading upward to truth, but a specifically Christocentric cosmos emphasizing the humanity of Christ and the significance of His Crucifixion, Resurrection, and Ascension for the symbolic function of the material world is proclaimed by the poem and the doors.

From this perspective the Emmaus scene may take on new importance. Although its presence may be due to liturgical connections and the popularity in twelfth-century France of the incident as a dramatic part of the Easter Monday liturgy, the fact that Suger had himself depicted in the scene makes it likely that it had a deeper programmatic significance. In the medieval commentary tradition stemming from Gregory the Great, the theme of seeing physically but not discerning truly in an inward, spiritual way is part of the interpretation of the Emmaus narrative.[21] With physical eyes the disciples behold their fellow pilgrim, who is actually their risen Lord. But they fail to perceive the truth of what they see—the true identity of their fellow pilgrim—until instructed and, indeed, illumined by the risen Christ Himself in the breaking of bread. Suger seems to be making a similar point and includes himself visually. Pilgrims in this life, distant from spiritual realities, must begin with the material world—even with the humanity of Christ—to gain access to truth through material images. But the truth of these images becomes clear only in relation to the crucified, risen, and ascended Christ. The Emmaus scene, with the others, suggests that Suger was concerned to convey the idea that only through the works of redemption associated with Christ can the works of creation, the material world, be rightly understood and interpreted as lamps that lead to the True Light.

In distinguishing the works of redemption from the works of creation, I am putting categories drawn from the theology of Hugh of Saint-Victor into Suger's mouth, as it were. Suger was, I believe, fundamentally influenced by Hugh in his conception of the function of the doors and other aspects of his iconographical program at Saint-Denis. The distinction between the two works was fundamental to Hugh's theology, his idea of history, and his interpretation of the writings of pseudo-Dionysius the Areopagite.

In the preface to his commentary on the *Celestial Hierarchy,* Hugh notes that although all theology uses visible things to understand invisible realities, there are two distinct theologies: there is mundane theology (*mundana theologia*), which is limited to using the *simulacrum* of nature, or the visible things of this world, in order to gain access to invisible spiritual reality; and there is divine theology (*divina theologia*), which makes primary use of the *simulacrum* of grace, the humanity of the Word.[22] God is manifest in both *simulacra,* but he is not understood in both. Nature can demonstrate the Creator, but humans perceive and understand this in an empty and erring way.[23] Only the *simulacrum* of grace can clarify the eye of reason, blinded in the Fall, so that the world and divine reality can again be understood in true perspective. Then the world can again have the quality of leading through the visible to the invisible things of God. The subject of divine theology is the works of restoration, which Hugh understands as the humanity of Jesus—or the Incarnation of the Word—together with His sacraments from the beginning of time. This theology finds its center in the incarnate, crucified, risen, and ascended Lord, who is both Creator and Redeemer and thus unifies the two worlds of material and spiritual realities. In the preface to his commentary, Hugh makes pseudo-Dionysius the Areopagite the champion of this theology centered on the "Crucifixion of Christ and the works of the Word in His flesh, in His humanness."[24]

As René Roques has pointed out, this emphasis upon the centrality of the suffering and humility of Christ, and the theme of his humanity, is completely absent in pseudo-Dionysius the Areopagite's thought.[25] It is absent, in addition, from Eriugena's commentary, as well as from his own theological and speculative construction, as shown by the *Periphyseon.*[26] This particular emphasis is of Hugh's own making and contributes a distinctive Victorine theme to the interpretation of the pseudo-Dionysian tradition. In point of fact, it adds a totally new element, drawn from Hugh's own theological position, to provide a principle of interpretation when approaching the symbolic quality of the material world.

A closer look at Hugh's attack on those who devote their energies to mundane theology reveals the basis for his apparent concern. These persons are described as wanting to "erect a ladder, made of the appearances of things, in order to reach to the invisible things of the Creator."[27] The mention of a ladder seems innocent enough until we realize that, in introducing the image of

the "golden chain" into his cosmological speculations, William of Conches identified that chain with the ladder of Jacob.[28] Hugh may well have had something like this in mind in his criticism. It would be in line with his position, expressed elsewhere, of opposing the speculative cosmologies of the Chartrians and also of questioning their notions, mistaken from his perspective, of the symbolic quality of the world. In following Hugh at this point, perhaps Suger also meant to counter similar cosmic speculations. In this case, perhaps the iconographic programs at Saint-Denis might be read, so to speak, as a statement against certain current cosmological speculations that sought to devalue or ignore the humanity of Christ and the role of His Crucifixion, Resurrection, and Ascension.

Hugh certainly worked out the theological details at greater length than Suger did, but the basic thrust of Hugh's preface and the meaning of Suger's door and poem correspond. Only through Christ, as the crucified, risen, and ascended Lord who is humble and humiliated in His humanity, can one come to a right understanding of the world as a symbol manifesting divine things. Only through the reality represented by the bronze doors can the mind be enlightened, as were the Emmaus pilgrims, so that, in Suger's words concluding the poem,

> The dull mind rises to truth through that which is
> material,
> And, in seeing this light, is resurrected from its
> former
> submersion.

The strong emphasis upon Christ's humanity in relation to the Crucifixion that we have noted thus far is also found in the symbolism of the back panel Suger had made for the Main Altar. Although no adequate contemporary description of the panel exists, Panofsky was able to reconstruct the probable arrangement of scenes through a careful analysis of Suger's poem for the altar.[29] He suggested three pairs of biblical scenes, each pair combining a New Testament event with an Old Testament "prototype." As Panofsky realized, his suggestion that God's promise to Abraham in Genesis 12 was the scene parallel to Christ's entry into Jerusalem was forced and puzzling. Equally puzzling and forced is Panofsky's distorted translation of the line of the poem referring to this particular scene of the panel. He translates:

> The promise which Abraham obtains for his seed is sealed
> by the flesh of Christ.

A more accurate rendering of the Latin reads:

> That which Abraham sacrificed for his offspring,
> the flesh of Christ signifies.

The reference remains unclear until we turn to the exegetical tradition. Again, a Victorine author provides an initial clue for interpreting Suger's text. In a section of *Allegories on the Old Testament* by Richard of Saint-Victor, Abraham's near-sacrifice of Isaac is interpreted in such a way that the ram sacrificed by Abraham is taken to represent the humanity of Christ that suffered in the Crucifixion. By way of contrast the divinity of Christ is represented by Isaac, who does not suffer death in Abraham's sacrifice. Richard writes, "Isaac, who did not taste of death in the sacrifice, represents the divinity, which felt neither punishments nor pain in the Passion. The ram, who suffered death, represents humanity, which endured the sharp bitternesses of the Passion."[30] The parallel between the ram and Christ's humanity in the allegory corresponds so closely to the parallel between Christ's flesh and "that which Abraham sacrificed for his offspring" that it seems only reasonable to infer that the panel must somewhere have depicted the sacrifice of the ram. Certainly the line in the poem does not refer to the promise of Genesis 12 in the way that Panofsky mistakenly suggested that it should. Nor does it refer to the kind of scene so often found in medieval iconography depicting the near-sacrifice of Isaac.[31] If the scene on the panel were the sacrifice of the ram, it would represent a striking departure from the usual iconographic presentation of the Abraham-Isaac story. Further investigation of the theme of the sacrifice of the ram is called for. In any case the association of the ram with Christ's humanity and suffering flesh is a distinctive theme to which Richard of Saint-Victor and Suger of Saint-Denis bear mutual witness. Even though Richard's work postdates Suger's altar, the text points to a somewhat unusual theme that was utilized in a new way by Suger. Again, by means of a subtle allegorical signification, Suger has stressed the humanity of Christ in His suffering. The connection of the Old Testament scene with the entry into Jerusalem must remain unexplained at present, although a liturgical link would not be unexpected.

Although we have focused on Suger's poems, there are other clues that point to possible Victorine or other twelfth-century influences. In the well-known passage describing an exalted state of mind reached by concentration on precious stones and their significance, Suger mentions an *anagogicus mos,* an anagogical way. Contrary to Panofsky's implication in his introduction to Suger's treatises, this phrase is used by neither pseudo-Dionysius the Areopagite nor Eriugena in the context of the *Celestial Hierarchy;* nor is it found elsewhere in the Dionysian corpus.[32] In describing the "way," Suger speaks of being "transported from this inferior to that higher world in an anagogical manner" and of "transferring that which is material to that which is immaterial. . . ."[33] The verb used here, *transfero,* is never used with this same meaning by Eriugena, who uses it in connection with translating or interpreting a word or phrase.[34] Suger's usage does not lie there. However, in the mid-twelfth century we find *transfero* used by Richard of Saint-Victor in much the same way Suger

used it in his treatises that were written some twenty years earlier. Richard refers to transferring "any description whatever of visible things to the signification of invisible things." In this way, says Richard, a person "rises up by means of the quality of visible things to knowledge of invisible things."[35] This conception, so similar to Suger's, provides a twelfth-century context for Suger's usage.

In another famous passage Suger speaks of a certain new stained-glass window that has the power of "urging us onward from the material to the immaterial."[36] The verb used here, *excitans,* is again not used in this way by Eriugena.[37] However, it does occur in Hugh of Saint-Victor's commentary in a very important passage. In discussing the relation of visible beauty to invisible beauty, Hugh says, "The human mind, being urged onward [*excitata*], ascends from visible beauty to invisible beauty."[38] A single verbal parallel such as this is a frail basis for any firm conclusion, but the parallel is suggestive. It is also notable that the quotation from Hugh occurs in the midst of material that expounds the notion of formal beauty, which M. F. Hearn has recently suggested must lie at the root of the new aesthetic sensibility that informed the iconographic programs of Saint-Denis and Chartres.[39]

In conclusion, allow me to mention in passing another possible Victorine influence on Suger. In the 1120s Hugh produced a complex drawing that presented in a visual symbol the sum of his cosmological, historical, theological, and contemplative teachings. The drawing no longer exists, but we have Hugh's detailed description of it in *De arca Noe mystica.*[40] It depicted Christ holding a disk that covered his body, leaving head, hands, and feet visible. The disk represented the cosmos and included intricate iconographic schemes illustrating the six days of Creation, the twelve months of the year, zodiacal signs and winds, the course of sacred history from Adam to the present, and the Last Judgment. The Last Judgment is depicted at Christ's feet, with the damned and saved shown to the right and left, accompanied by the texts from Matthew's Gospel, much like the scene on the Saint-Denis tympanum:

> Come, ye blessed of my father, inherit the
> kingdom prepared for you from the
> foundation of the world. (Matthew 25:34)

> Depart from me, ye cursed, into everlasting
> fire, prepared for the devil and
> his angels. (Matthew 25:41)

Hugh's drawing, along with his ideas on the gift of the Holy Spirit and the relationship of Christ's death and Resurrection to the earlier faith and sacraments of the Hebrew people, may contribute to a better understanding of Suger's tympanum and windows.

In relating Suger to Hugh or any other theologian or tradition, we must remember that a precise restatement of an idea may not appear in Suger's work. Suger was not a theologian, as we noted at the outset of this paper. He was, rather, an active thinker, a doer who drew upon a number of sources to inform his new, splendid church dedicated to Saint Denis. That glorious structure reflected both Suger's accomplishments and those of the French crown, as well as the more subtle glory of the True Light manifest in the lesser lamps of this world.

NOTES

* I would like to thank Arnold Klukas and Paula Gerson for helpful suggestions and comments.

1. On the treatises, the church, and Abbot Suger, see Panofsky, *Suger.* The treatises, "De rebus in administratione sua gestis" and "De consecratione ecclesiae sancti Dionysii," are in Lecoy, *Oeuvres.*

2. All considerations of Saint-Denis must begin with the fundamental research of Sumner McK. Crosby on the fabric of the church. Especially important are his efforts, through archaeological excavations and reconstructions guided by modern analytical techniques, to establish the history of the various structures on the site and to identify the actual remains of Suger's twelfth-century constructions in the face of later modifications and "restorations." See his following works: *The Abbey of Saint-Denis,* vol. 1 (New Haven, 1942); *L'Abbaye Royale de Saint-Denis* (Paris, 1953); "The West Portals of Saint-Denis and the Saint-Denis Style," *Gesta* 9, no. 2 (1970): 1–11; and *The Apostle Bas-relief at Saint-Denis* (Yale Publications in the History of Art, 21; New Haven, 1972). Also see Sumner McK. Crosby and Pamela Z. Blum, "Le Portail central de la façade occidentale de Saint-Denis," *Bulletin monumental* 131 (1973): 209–66.

3. See his Introduction in *Suger,* esp. pp. 18–25. Panofsky has a more detailed analysis of key texts in "Note on a Controversial Passage in Suger's *De consecratione ecclesiae sancti Dionysii,*" *Gazette des Beaux-Arts,* 6th ser., 24 (1944): 95–114, esp. pp. 105–14. There are valuable remarks on the significance of *claritas* and the weight this term had for Eriugena, Suger, and others of like mind as opposed to the later reinterpretation and devaluation of the term by Thomas Aquinas (p. 113 n. 40). Unfortunately, in his enthusiasm to root Suger's view in that of Eriugena, Panofsky even cites lines from pseudo-Dionysius as coming from the pen of the Scot: see Panofsky, *Suger,* p. 24, where the words ". . . impossibile est nostro . . . manuductione utatur" are said to be from Eriugena. They are the words of pseudo-Dionysius. See Eriugena, *Expositiones in ierarchiam coelestem* in Jeanne Barbet, ed., *Corpus Christianorum, continuatio mediaevalis* (Turnholt, 1975), vol. 3, p. 14, ll. 494–98.

4. Otto von Simson, *The Gothic Cathedral: Origins of Gothic Architecture and the Medieval Concept of Order,* 2d rev. ed. (New York, 1964), pp. 61–141; see also von Simson's general essay, "The Birth of the Gothic," *Measure* 1 (1950): 275–96. Von Simson's sense of the influence of pseudo-Dionysius in the twelfth century points in the right direction, but his broad parallels between Suger and Hugh lack the necessary precision. His appreciation of the role of the School of Chartres is likewise limited in terms of the current understanding of that school and its literary influence.

5. Studies by Sumner McK. Crosby and Pamela Z. Blum continue to clarify the actual twelfth-century church. For the broader setting in the history of art and architecture, see Whitney R. Stoddard, *Art and Architecture in Medieval France* (New York, 1972), pp. 101–11; and more recently, Millard Fillmore Hearn, Jr., *Romanesque Sculpture. The Revival of Monumental Stone Sculpture in the Eleventh and Twelfth Centuries* (Ithaca, 1981), pp. 119–223, with its good current bibliography. Louis Grodecki's study of the stained glass opens up many new avenues of understanding; see his "Les Vitraux allégoriques de Saint-Denis," *Art de France* 1 (1961): 19–46, now being supplanted by his new study, *Les Vitraux de Saint-Denis, étude sur le vitrail au XIIᵉ siècle* (Corpus Vitrearum Medii Aevi) France, "Études" (Paris, 1976), vol. 1. See also Konrad Hoffmann, "Sugers 'Anagogisches Fenster' in Saint-Denis," *Wallraf-Richartz Jahrbuch* 30 (1968): 57–88. The studies by Philippe Verdier are important; see his "La Grande croix de l'abbé Suger à Saint-Denis," *Cahiers de civilisation médiévale* 13 (1970): 1–31, and "Suger a-t-il été en France le créateur du thème iconographique du couronnement de la Vierge?" *Gesta* 15, nos. 1–2 (1976): 227–36. Valuable insights will be found in Paula Lieber Gerson, "The West Facade of Saint-Denis: An Iconographic Study" (Ph.D. diss., Columbia University, 1970), and in two of her unpublished papers, "The Trinity at Saint-Denis" and "Abbot Suger's Bronze Doors." I am indebted to Paula Gerson for allowing me to use these papers.

6. Marie-Dominique Chenu, *La Théologie au XIIᵉ siècle* (Paris, 1957), esp. chs. 5, 7, and 8. Henri de Lubac, *Exégèse médiévale,* 4 vols. (Paris, 1959–64), esp. vol. 2, part 2, pp. 125–262 and vol. 1, part 2, pp. 489–681.

7. Bernard McGinn, *The Golden Chain: A Study in the Theological Anthropology of Isaac of Stella,* Cistercian Studies Series, 15 (Washington, D.C., 1972). Peter Dronke, *Fabula: Explorations into the Uses of Myth in Medieval Platonism* (Leiden, 1974); Winthrop Wetherbee, *Platonism and Poetry in the Twelfth Century: The Literary Influence of the School of Chartres* (Princeton, 1972); and Brian Stock, *Myth and Science in the Twelfth Century: A Study of Bernard Silvester* (Princeton, 1972).

8. Von Simson, *Gothic Cathedral,* pp. 25–39.

9. Dronke, *Fabula,* pp. 11–67. McGinn, *Golden Chain,* pp. 86–102.

10. In addition to the references in note 9 here, see Wetherbee, *Platonism,* chs. 1, 4, and 5; and Stock, *Myth and Science.*

11. The work of Roger Baron, *Science et Sagesse chez Hugues de Saint-Victor* (Paris, 1957), is still fundamental. On Hugh's relation to pseudo-Dionysian thought, see René Roques, "Connaissance de Dieu et théologie symbolique d'après l'"In hierarchiam coelestem sancti Dionysii' de Hugues de Saint-Victor,"

in *Structures théologiques de la gnose à Richard de Saint-Victor,* Bibliothèque de l'École des Hautes-Études, Section des sciences religieuses 72 (Paris, 1962), pp. 294–364; Heinrich Weisweiler, "Die ps.-Dionysiuskommentare 'In coelestem Hierarchiam' des Skotus Eriugena und Hugos von St. Viktor," *Recherches de théologie ancienne et médiévale* 19 (1952): 26–47; Weisweiler, "Sakrament als Symbol und Teilhabe. Der Einfluss des ps.-Dionysius auf die allgemeine Sakramentenlehre Hugos von St. Viktor," *Scholastik* 27 (1952): 321ff.; Weisweiler, "Sacramentum fidei: Augustinische und ps.-dionysiche Gedanken in der Glaubenauffassung Hugos von St. Viktor," in Johann Auer and Hermann Volk, eds., *Theologie in Geschichte und Gegenwart* (Munich, 1957), pp. 433–56; Roger Baron, "Le Commentaire de la Hiérarchie Céleste par Hugues de Saint-Victor," in *Études sur Hugues de Saint-Victor* (Bruges, 1963), pp. 133–213; and Grover A. Zinn, Jr., "*De gradibus ascensionum:* The Stages of Contemplative Ascent in Two Treatises on Noah's Ark by Hugh of Saint Victor," *Studies in Medieval Culture* 5 (1975): pp. 61–79. For the dating of Hugh's works, see Damien van den Eynde, *Essai sur la succession et la date des écrits de Hugues de Saint-Victor,* Spicilegium Pontificii Athenaei Antoniani, 13 (Rome, 1960), esp. pp. 58–65 on the commentary *In hierarchiam coelestem.* For the founding of the abbey of Saint-Victor and the development of thought there, see Jean Chatillon, "De Guillaume de Champeaux à Thomas Gallus: Chronique d'histoire littéraire et doctrinale de l'école de Saint-Victor," *Revue du moyen âge latin* 8 (1952): 139–62, 247–72; Jean Chatillon, *Théologie, spiritualité, et métaphysique dans l'oeuvre oratoire d'Achard de Saint-Victor* (Paris, 1969), pp. 53–85; and Joachim Ehlers, *Hugo von St. Viktor* (Munster, 1972), pp. 5–27.

12. The judgment is Peter Dronke's in *Fabula,* pp. 44–45, where he mistakenly attributes the definition to Richard of Saint-Victor, apparently unaware that Richard borrowed it from Hugh of Saint-Victor. See Richard, *In apocalypsim,* prol. bk. 1, *PL,* vol. 196, col. 687A, and Hugh, *In hierarchiam coelestem,* bk. 2, *PL,* vol. 175, col. 941B.

13. On the tradition of translation and commentary, see Hyacinthe F. Dondaine, *Le Corpus dionysien de l'Université de Paris au XIIIᵉ siècle,* Storia e Letteratura 44 (Rome, 1953). On Eriugena, see Maieul Cappuyns, *Jean Scot Erigène: sa vie, son oeuvre, sa pensée* (Louvain/Paris, 1933), pp. 150–72, 216–22. More recent contributions include, Jeanne Barbet, "La Tradition du texte latin de la Hiérarchie Céleste dans les manuscrits des *Expositiones in Hierarchiam Caelestem,*" in John J. O'Meara and Ludwig Bieler, eds., *The Mind of Eriugena* (Dublin, 1973), pp. 89–97; and René Roques, "Traduction ou interprétation? Brèves remarques sur Jean Scot, traducteur de Denys," in John J. O'Meara and Ludwig Bieler, eds., *The Mind of Eriugena* (Dublin, 1973), pp. 59–77. Numerous aspects of Eriugena's thought are addressed by papers published in *Jean Scot Érigène et l'histoire de la philosophie, Laon 7–12 juillet 1975,* Colloques internationaux du Centre National de la Recherche Scientifique, no. 561 (Paris, 1977).

14. On the *Periphyseon,* see Brian Stock, "The Philosophical Anthropology of Johannes Scottus Eriugena," *Studi Medievali,* 3d ser., 8 (1967): 1–57; and Cappuyns's still useful study, *Jean Scot Érigène,* pp. 183–216. A new edition and translation by Inglis P. Sheldon-Williams has appeared, *Johannis Scotti Eri-*

ugenae Periphyseon (De divisione naturae), Scriptores Latini Hiberniae, vol. 7 (Dublin, 1968). On the *Clavis Physicae,* see Marie-Thérèse d'Alverny, "Le Cosmos symbolique du XIIᵉ siècle," *Archives d'histoire doctrinale et littéraire du moyen âge* 20 (1953): 31–81; and Paolo Lucentini, "La *Clavis physicae* di Honorius Augustodunensis e la traduzione eriugeniana nel secolo XIIᵒ," in *Jean Scot Érigène,* pp. 405–14.

15. Panofsky, *Suger,* p. 23. On the doors, see Gerson, "West Facade," pp. 22–26, 100–112; and Gerson, "Bronze Doors."

16. For *lumina* and *vera lux,* see Suger, *Adm.* (P), pp. 46–48:

> *Nobile claret opus, sed opus quod nobile claret*
> *Clarificet mentes, ut eant per lumina vera*
> *Ad verum lumen, ubi Christus janua vera.* (ll. 3–5)

See also Panofsky's comments, pp. 164–65, and the more detailed analysis in Panofsky, "Controversial Passage," pp. 108–14.

17. Hugh, *De arca Noe morali,* bk. 1.2, *PL,* vol. 176, col. 622BC. English translation is by a Religious of C.S.M.V., *Hugh of Saint-Victor: Selected Spiritual Writings* (London, 1962), p. 52, (bk. 1, ch. 7 in the trans.). On this drawing, see Zinn, *"De gradibus ascensionum,"* and "Mandala Symbolism and Use in the Mysticism of Hugh of Saint Victor," *History of Religions* 12 (1972–73): 317–41; also see Joachim Ehlers, *"Arca significat ecclesiam.* Ein theologisches Weltmodell aus der ersten Hälfte des 12. Jahrhunderts," *Frühmittelalterlichen Studien* (1972): 171–87.

18. See the suggestion by Gerson in "Bronze Doors," p. 7. As she correctly notes in this paper, there is a clear need to modify Panofsky's translation of the poem in many particulars.

19. See Panofsky's comments on the difficulty of translating this line, "Controversial Passage," p. 108 n. 25.

20. Gerson, "West Facade," pp. 100–103, 105–6, with p. 106 n. 1 pointing out the importance of Suger's presence in the Emmaus scene. On the iconographic problem of the scene, Gerson cites the useful comments in Otto Pächt, Charles Dodwell, and Francis Wormald, *The Saint Albans Psalter* (London, 1960), pp. 73–79.

21. The commentary tradition connected with the Emmaus narrative is presented by Frank C. Gardiner, *The Pilgrimage of Desire: A Study of Theme and Genre in Medieval Literature* (Leiden, 1971), pp. 1–52.

22. Hugh, *In hierarchiam coelestem,* bk. 1.1, *PL,* vol. 175, col. 925–26.

23. Hugh, *In hierarchiam coelestem,* bk. 1.1, *PL,* vol. 175, col. 926AB. On the two *simulacra,* now related by Hugh to the works of Creation and Redemption, see *De sacramentis christianae fidei,* bk. 1, prol. chaps. 1–3 and bk. 1, part 6, chap. 5, *PL,* vol. 176, cols. 183A–84C and 266B–67B, trans. Roy J. Deferrari, *Hugh of Saint Victor on the Sacraments of the Christian Faith* (Cambridge, Mass., 1951), pp. 3–4, 97–98. *De tribus diebus, PL,* vol. 176, cols. 811–38, lacks the idea of two *simulacra* but treats with detail the movement *de visibilibus ad invisibilia.*

24. Hugh, *In hierarchiam coelestem,* bk. 1.4, *PL,* vol. 175, col. 930D.

25. Roques, "Conaissance de Dieu," pp. 301–2.

26. See Stock, "Philosophical Anthropology," pp. 47–57.

27. Hugh, *In hierarchiam coelestem,* bk. 1.1, *PL,* vol. 175, cols. 923D–24D. Hugh uses the ladder theme in his own way in *De unione corporis et spiritus, PL,* vol. 177, col. 285, cited by Wetherbee, *Platonism,* p. 61.

28. See McGinn, *Golden Chain,* pp. 88–89.

29. Suger, *Adm.* (P), p. 62. See pp. 186–88 for Panofsky's comments. The text reads:

> *Voce sonans magna Christo plebs clamat: Osanna!*
> *Quae datur in coena tulit omnes hostia vera.*
> *Ferre crucem properat qui cunctos in cruce salvat.*
> *Hoc quod Abram pro prole litat, Christi caro signat.*
> *Melchisedech libat quod Abram super hoste triumphat.*
> *Botrum vecte ferunt qui Christum cum cruce quaerunt.*

30. Richard of Saint-Victor, *Liber exceptionum,* in Jean Chatillon, ed., *Textes Philosophiques du Moyen Age,* vol. 5 (Paris, 1958), pp. 237–38. Most of the material in Richard's text can be found in Isidore of Seville on Genesis and is in the *Glossa ordinaria,* which depends on Isidore at this point. See Chatillon's notes on pp. 237–38. The parallels of ram/humanity and Isaac/divinity do not appear in Isidore or the *Glossa.* There is a hitherto unnoticed parallel to Richard's use however. In his eighth homily on Genesis, Origen presents the ram as representing Christ's human nature and Isaac as representing His divine nature, with references to suffering and not suffering much like Richard's. More research is necessary to trace the development of this theme in Greek and Latin traditions, but the presence of such material in Origen's homilies is significant. See Origen, *Homiliae in Genesim,* bk. 8.9, *PG,* vol. 12, cols. 208D–09A.

31. For a survey of the iconography, see I. Speyart van Woerden, "The Iconography of the Sacrifice of Abraham," *Vigiliae Christianae* 15 (1961): 214–55.

32. This is confirmed by reference to the exhaustive indices of words in Barbet, *Expositiones,* pp. 233–358. A further examination of the indices in Philippe Chevallier, ed., *Dionysiaca,* 2 vols. (Paris, 1937), shows that the phrase *anagogicus mos* appears in neither Hilduin's nor Eriugena's translations of the entire corpus of pseudo-Dionysius's works. The word *anagogicus* does, of course, appear a number of times, however it is surprising to discover that the word *mos* appears in translations only in the fifteenth century and later. Then it appears most often in phrases like "in a human manner" or "in the manner of a tyrant." In a few instances *mos* replaces *lex* used in earlier translations.

33. Suger, *Adm.* (P), pp. 62–65. The text reads: *"de materialibus ad immaterialia transferendo, . . . ab hac etiam inferiori ad illam superiorem anagogico more Deo donante posse transferri."* For Panofsky's comments, see pp. 20–21.

34. See the *Index verborum Scoti,* in Barbet, *Expositiones,* p. 321. A typical passage is bk. 1, p. 9: *"Nam* ΘΕΑΡΧΙΚΟC *ad purum transferri non potest, nisi perperiphrasin . . ."* (ll. 296–97). An exception is found in bk. 2, p. 2: *"Naturaliter quippe materialia omnia in spiritualia transferri appetunt, spiritualia vero ad materialium humiliem uilissimamque extremitatem inclinari nolunt, quo-*

niam impossibile est" (ll. 686–89). However, this passage speaks of an inherent, "natural" seeking on the part of material things to be "transferred" to spiritual things. This is not quite what Suger has in mind.

35. See Richard of Saint-Victor, *De duodeciem patriarchiis,* 22, *PL,* vol. 196, cols. 15B–16A, trans. Grover A. Zinn, Jr., in Richard of Saint-Victor, *The Twelve Patriarchs, The Mystical Ark, Book Three of the Trinity,* Classics of Western Spirituality (New York, 1979), pp. 74–75.

36. Suger, *Adm.* (P), p. 74. The passage reads: *"Una quarum de materialibus ad immaterialia excitans."*

37. See again the *index verborum Scoti,* Barbet, *Expositiones,* p. 264.

38. Hugh, *In hierarchiam coelestem,* bk. 2, *PL,* vol. 175, col. 949C: *"Secundum hoc ergo a pulchritudine visibile ad invisibilem pulchritudinem mens humana convenienter excitata ascendit."*

39. Hearn, *Romanesque Sculpture,* p. 212.

40. Hugh, *De arca Noe mystica, PL,* vol. 176, cols. 681–704. See my description and analysis of this drawing and its significance for Victorine ideas about history, theology, and contemplation, in both my *"De gradibus ascensionum"* and "Mandala Symbolism." A somewhat different interpretation of the drawing will be found in Ehlers, *"Arca significat ecclesiam."*

The Liturgy at Saint-Denis: A Preliminary Study[1]

Niels Krogh Rasmussen, O.P.

T HE LITURGY at Saint-Denis has never been studied seriously, nor has anyone raised the question of whether or not the liturgical tradition for the twelfth century can be recovered and described from the surviving manuscripts. In this brief paper I will evaluate those sources as carriers of the twelfth-century liturgical practices and, by the questions I ask of the material, point out directions that future research might profitably take.

For an establishment as politically important as Saint-Denis, the absence of any monograph or article devoted to its liturgical tradition seems most surprising. A letter from Dom Anselme Thévard written in 1675 to the liturgist Joseph de Voisin gives evidence of awakening interest.[2] Yet, since the beginning of systematic liturgical studies, we find only incidental information that has been integrated into studies with a focus other than Saint-Denis itself. From the studies of Leclercq and Gindele on the custom of perpetual praise, for example, we know that at some time before the ninth century the abbey had adopted the *laus perennis* according to the custom of Saint-Maurice d'Agaune.[3] Michel Huglo and others have written on aspects of the Greek Mass sung on the Octave of Saint-Denis (October 16).[4] Martène published some excerpts of ordinaries in his *De Antiquis Monachorum Ritibus*,[5] and Weale published two lists of sequences in his *Thesaurus Hymologicus*.[6] Beyond this listing, the literature contains very little else, and certainly no comprehensive approach to the abbey's liturgical tradition has been attempted.

In view of the importance and renown of Saint-Denis, the primary source material for the study of its liturgy is not abundant. There are two categories of sources to be considered, the first being "authentically liturgical" texts while the second category consists of "auxiliary" texts.

Liturgical texts, as defined by Cyrille Vogel, are documents that were actually used in the performance of a liturgical rite.[7] A small number of those manuscripts written for Saint-Denis have survived from the Middle Ages.[8]

7th century:
Incomplete Gospel list (Paris, Bibliothèque Nationale, ms. lat. 256)[9]

9th–10th centuries:
Sacramentary (Paris, Bibliothèque Nationale, ms. lat. 2290)[10]
Sacramentary from Saint-Amand, accommodated to the use of Saint-Germain-des-Prés or Saint-Denis (Paris, Bibliothèque Nationale, ms. lat. 2291)[11]
Sacramentary of Nonantola, possibly written at Saint-Denis (Paris, Bibliothèque Nationale, ms. lat. 2292)[12]
Evangeliary (Paris, Bibliothèque Nationale, ms. n.a. lat. 305)[13]
Psalter of Charles the Bald (Paris, Bibliothèque Nationale, ms. lat. 1152)[14]

10th–11th centuries:
Psalter-hymnal (Paris, Bibliothèque Sainte-Geneviève, ms. 1186)[15]

11th century:
Missal-antiphonary (Laon, Bibliothèque municipale, ms. 118)[16]
Missal (Paris, Bibliothèque Nationale, ms. lat. 9436)[17]
Gradual (Paris, Bibliothèque Mazarine, ms. 384 [748])[18]
Psalter-hymnal (Paris, Bibliothèque Nationale, ms. lat. 103)[19]

Notes for this essay begin on page 45.

12th century:

Lectionary for the Mass (Paris, Bibliothèque Nationale, ms. n.a. lat. 307)[20]

Antiphonary (Paris, Bibliothèque Nationale, ms. lat. 17.296)[21]

Breviary (Winter part) possibly from a parish church of Saint-Denis (Vendôme, Bibliothèque municipale, ms. 17C)[22]

13th century:

Missal (Paris, Bibliothèque Mazarine, ms. 414 [735])[23]

Missal (Paris, Bibliothèque Nationale, ms. lat. 846)[24]

Missal (Paris, Bibliothèque Nationale, ms. lat. 1107)[25]

Missal (Rome, Biblioteca Casanatense, ms. 603)[26]

Two evangeliaries, bound together (Paris, Bibliothèque Nationale, ms. n.a. lat. 1420)[27]

14th century:

Missal (London, Victoria and Albert Museum, MS. L. 1346–1891)[28]

Missal (Paris, Bibliothèque Nationale, ms. lat. 10.505)[29]

Pontifical from Rouen, 12th century, accommodated to the usage of Saint-Denis (Paris, Bibliothèque Nationale, ms. n.a. lat. 306)[30]

15th century:

Book of Hours (Paris, Bibliothèque Nationale, ms. lat. 1072)[31]

Miscellaneous:

Sacramentary fragments (9th, 10th, and 11th centuries; Rouen, Bibliothèque municipale, ms. 275)[32]

(We have not yet been able to identify lectionaries for the office or homiliaries of Saint-Denis.)[33]

Eventually the study of these documents will establish important aspects of the internal development of the liturgical life of the abbey. They may also provide comparisons with other institutions of similar importance, such as Cluny. Work still to be done includes the listing of antiphons and responses, the establishment and development of the calendars and the feasts inscribed therein, and the identification and editing of the proper texts of proses, sequences,[34] tropes, songs, and prayers for various occasions.

The study of these service books will unveil only partial knowledge of the abbey's liturgical life, however. To understand the services fully one must consult those auxiliary documents used by people (masters of ceremonies of our day; archcantor, archpriest, and archdeacon in an earlier era) responsible for the staging and performance of the liturgy. These documents—the second category of sources for the study of Saint-Denis's liturgy—include ordines, customaries, directories, and ordinaries.[35] No monastic customary of Saint-Denis is known, and the search for one is not likely to be fruitful. For, as Giles Constable recently pointed out, Saint-Denis was never a center from which

monastic reform radiated, and his research indicates that reform constituted the primary motivation for recording the *consuetudo.*[36] We do, however, have ordinaries. Ordinaries provide faithful accounts of the state of worship in a given church at the moment of their composition and reflect the actual celebration more closely than such "authentically liturgical" texts as sacramentaries, graduals, and missals for the Eucharist, psalters, hymnals, collectories, and breviaries for the Divine Office.

Discussed by Bishop Anton Hänggi of Basel in his edition of the Rheinau Ordinary,[37] ordinaries appear in the twelfth century for use in cathedrals, collegiate, and monastic churches. They describe in detail how to celebrate the offices and Masses, how to order the processions, and which liturgical decorations and furnishings are appropriate throughout the year. The history of the genre has yet to be written, and we are fortunate that Bishop Hänggi gives a list of the ordinaries published earlier than his own work.[38] Jean Dufrasne, in an unpublished *mémoire* now available at the Institut Supérieur de Liturgie in Paris, has studied the collection of manuscripts of ordinaries in the Bibliothèque Nationale, Paris, but has limited himself to those prepared for secular churches.[39]

A copy of the most recent Saint-Denis ordinary, written during John (the Good) II's reign (1350–64), is preserved in Paris, in the Archives nationales, L 863, no. 10.[40] Used as a practical reference book, this now-lost manuscript was kept chained in the choir of the church. A second ordinary dates from the end of the thirteenth or beginning of the fourteenth century. Previously in the possession of Colbert, it is now in Paris, Bibliothèque Nationale, ms. lat. 976.[41] Another, written in the thirteenth century, the oldest manuscript and the one of greatest interest to us, is in Paris, Bibliothèque Mazarine, ms. 526 (544).

Molinier believed the Mazarine ordinary was written sometime after 1234.[42] Refining the date, the *Catalogue des manuscrits datés* suggested a date between 1234 and 1247,[43] based on the obituary of Philippe Hurepel, count of Boulogne, whose death in 1234 is recorded by the hand of the original scribe in both the calendar and text. This provides a *terminus ante quem*. The *terminus post quem* was determined by the addition to the calendar, in a second hand, of the obituary of Abbot Odo Clément of Saint-Denis, who died as bishop of Rouen in 1247.[44]

Whether or not the earliest of the extant Saint-Denis ordinaries, written in the first half of the thirteenth century, can be taken as an expression of the liturgy used in the twelfth century is the critical issue here. In short, does Mazarine ms. 526 provide evidence of liturgical practices at Saint-Denis during the abbacies of at least some of its twelfth-century abbots, and in particular of Suger's abbacy (1122–51)?[45]

It is my contention that, to a great extent and with the exception of certain obvious additions (the anniversary of the death of Philip Augustus in 1223, for example), this thirteenth-century

ordinary is a faithful expression of twelfth-century practice. There are many reasons for this, the first having to do with the general character of the liturgy and of monastic communities. Except in times of religious and social unrest, their character tends to be conservative and changes only slightly—*vestigia patrum sequentes*—manifesting an inbred respect for *quod traditum est.*

There is clear evidence that Mazarine ms. 526 reflects at least part of the twelfth-century liturgy of the abbey. The celebration of the anniversary of Dagobert (January 19), initiated by Abbot Adam (1099–1122) and described by him in a charter discovered by Barroux, does not differ significantly from the description of the same service in the Mazarine ordinary.[46] The extent to which Mazarine ms. 526 relies on earlier sources for other services can only be ascertained, however, after detailed comparisons with the earlier liturgical manuscripts, particularly with the antiphonaries of the eleventh and twelfth centuries, and with the eleventh-century missal (all listed above).

Another factor beside unrest or reform might warrant changes in the liturgical program of an establishment recorded in an ordinary: the construction of a new church, for example, or major structural alteration of an existing building would require at the very least new routes for processions and newly specified areas for the performance of services. Because Mazarine ms. 526 incorporates, in a specific way, Suger's new chevet, integrating it into the daily, weekly, and yearly liturgical cycles, the ordinary must have been based on a prototype devised for the changed fabric of the building. These new directions for services will be discussed more fully below.

There is very little evidence suggesting creative activities in liturgical matters by Suger's successors.[47] Given such a predecessor, a potential innovator would surely have wanted his name remembered alongside that of Suger. But there is no record of this having happened, and no evidence of it in the ordinaries. This leads toward the supposition that Mazarine ms. 526 reflects the established twelfth-century liturgy of the abbey, which had incorporated the changes required by Suger's new chevet.

Adding the information gleaned from other texts to the evidence provided by the oldest of the three surviving ordinaries, what can we determine about the ceremonial of Saint-Denis in the twelfth century and, more precisely, about the liturgy in use during the Sugerian era?

The first points are general in nature and come as no surprise. Examination of the documents confirms that the liturgy is monastic. The Rule of Saint Benedict was followed for the Divine Office, with feasts having twelve lessons and twelve responses, as opposed to the nine customary in the Roman rite.[48]

Not only does the liturgy of Saint-Denis correspond to the one prescribed by Benedict's Rule, but it also reflects the development of additional prayers and offices erroneously attributed to

Cluny. Symons[49] and Hallinger[50] have shown that these prayers and offices stem from the Carolingian monastic reforms of Benedict of Aniane (about 750–821), and particularly from the Aachen reform councils of 816 and 817. Among the more important of these supplementary devotions are the Offices for the Dead, for All Saints, and Office of the Virgin;[51] the recitation of the Gradual Psalms,[52] the *psalmi prostati* in Lent,[53] and the *psalmi familiares;*[54] as well as the singing of the litany before Mass.[55] All of these devotional offices are well documented in the Mazarine ordinary.[56]

While confirmation of these general points is important, the great value of the Mazarine ordinary lies in its description of elements specific to the abbey church of Saint-Denis. Foremost here is the light it throws on the relationship between the liturgy and Suger's new chevet. The ground plan of this chevet is well known, and Suger himself listed the dedications of the altars (see Caviness fig. 1 and Maines fig. 1).[57] The Mazarine ordinary demonstrates how the new architectural space was incorporated in the cultic ordinance of the abbey.

The general description of the *cursus* of the day (given here for the week after the Octave of Pentecost) shows daily common processions to the chevet at the end of matins and at the end of vespers.[58] Further, this important note is added: "If it happens that a feast of twelve lessons is celebrated, then there will be a procession to the chevet related to that feast if the altar is dedicated in honor of that saint."[59] We can observe how this direction functions for some of the saints to whom altars (or *oratoria,* as the Mazarine ordinary calls them) were dedicated. On the Feast of Saint Osmanna, September 9, there was a single commemoration at vespers followed by a procession *ad altare ipsius.*[60] For the Feast of Saint Peregrinus, May 16, early Mass was said, not at the ordinary *altare matutinalis* but at the main altar of the saint: *Magna missa celebratur ad oratorium sancti Peregrini.*[61] For Saint Eugene, November 16, there was an understandable distinction made when the feast fell on a day when large crowds were expected. If the feast fell on a Sunday, terce was to be sung in the chapel and High Mass in the choir, once the usual Sunday procession and aspersion of the common rooms had been completed. If, however, the feast did not fall on a Sunday, the High Mass was also celebrated in the chapel.[62]

These examples suffice to indicate the manner in which the liturgy was integrated into the new topography of the abbey church. The same can be demonstrated for the greatest feasts of the year, both temporal (Christmas, Easter, Pentecost) and sanctoral (such as the Feast of the Holy Martyrs, October 9).

Some processions, however, are less clearly understood. On Saint Stephen's Day (December 26) the community did not descend to that saint's altar in the crypt[63] but instead proceeded to the chapel of Saint Cucuphas in the chevet.[64] Although the Mazarine ordinary describes this, it does not explain why this pro-

cedure was followed. One must turn to another source, the *Consecrationes altarium Beati Dionysii,* to discover that the altar of Saint Cucuphas numbered among its patrons Saint Stephen Protomartyr.[65]

Clearly the ordinaries are a rich and valuable resource for understanding the relationship between the architectural space and the physical acts necessary for the performance of the services. It is also possible that some of the less-understood elements of the iconographic programs of the stained glass may be better understood in the light of the cultic activities that took place in the chevet and the chapels.

There is another specific area in which the Mazarine ordinary expands our knowledge of the liturgical tradition at Saint-Denis. This concerns the abbey's extraordinary collection of *objets d'art,* some liturgical, others the royal regalia associated with the exercise of sovereignty. Unfortunately, the Mazarine ordinary does not tell us on which days the Chalice of Suger was used, or on which days the Cup of the Ptolemies, but it does describe the relics to be carried in procession: for example, the Arm of Saint Simon or the Nail of the Cross (the latter even has a specific feast day within the Easter Octave).[66] At the highest feasts, the cantors carried royal rods (*regiae virgae*), and the six or seven subdeacons carried *textus,* lectionaries, or Gospel books. Crystal candelabra were put on the altar, together with "the Cross of lord Charles the emperor." The Cross was placed behind the Altar of the Holy Trinity, and the "small, precious candelabrum" (*candelabrum parvum pretiosum*) was placed in the center of the altar. The offertory of the monks at Christmas was made with the "golden vessels," and the cantor on that occasion offered the water in a "precious ampulla." The responsory and the alleluia were sung from "beautiful ivory tablets" (*in speciosis tabulis eburneis*), the Epistle from Saint Paul was read *in parvo textu,* and so forth.[67]

Until now, the earliest and most complete knowledge of the Saint-Denis treasury came from Suger's own description of his church and its furnishings. As Suger chose to mention only some of the objects held by the abbey, there are many missing links between his description and the later inventories, the earliest of which was written in 1505.[68] A careful examination of the Mazarine ordinary should help considerably in determining the state of the treasury in the twelfth and thirteenth centuries, and the two later Saint-Denis ordinaries will be invaluable in helping us to pinpoint the dates at which other objects disappeared.

One further area of specific liturgical interest illuminated by the Mazarine ordinary concerns royal anniversaries. The role of Saint-Denis as a dynastic necropolis is well known, and the ordinary is lavish in its details about the celebration of these anniversaries.

The anniversary of Dagobert is described at great length, as well as other principal royal anniversaries. Alain Erlande-Brandenburg[69] discussed the celebration of these anniversaries

but used only the most recent of the three Saint-Denis ordinaries.[70] The text of the Mazarine ordinary is more explicit with regard to the anniversary of Dagobert[71] but unhappily not with respect to the anniversary of Louis VI, which is of particular interest since the last three lessons were written by Suger himself.[72] One of the extraordinary features of these two anniversaries is the reading of both kings' *vitae,* in which they are celebrated as heroes or canonized saints, a rare occurrence in liturgical history.[73]

Before concluding, there are a number of other problems worth mentioning concerning the Saint-Denis liturgy. Foremost among these problems is that of the ordinance of the new choir Suger had furnished for the monks.[74] How was this choir affected in the thirteenth century by the reconstruction of the central vessel of the basilica? Crosby's measurements have shown that the dimensions of the Carolingian nave were respected in the twelfth century, but the thirteenth-century nave construction (beginning about 1231) would have changed the area of Suger's choir.[75] The Mazarine ordinary speaks about returning from processions through "ivory doors" (*portas eburneas*)[76] and through "red doors" (*portas rubeas*).[77] Because Suger mentions the ivory doors,[78] can we assume that their use at the time Mazarine 526 was written indicates the ordinary's faithful reflection of the state of the building before the thirteenth-century reconstruction of the nave? If this is so, we might be able to date the Mazarine ordinary more precisely.

Panofsky's comments on the consecration of the church bring other questions into focus. He refers once to the office of the Roman breviary, *Commune Dedicationis Ecclesiae.*[79] This, however, is an anniversary office, not an actual rite of consecration. Is it possible to find the specific pontifical that might have been in use by following Suger's description of the consecration in 1144? One might look to Rouen,[80] Beauvais, or Senlis (whose bishops were present for the consecration of the chevet)[81] or to the places of origin of the many bishops present for the definitive consecration and translation.[82]

The Greek Mass is another matter that needs further clarification. The study of Greek at the abbey was to some degree imposed because of the patron saint,[83] and scholars have thought that the singing at the Octave of Saint-Denis (October 16) derived from the origins of the abbey. Michel Huglo has studied the tradition of this Mass, however, using the three extant Saint-Denis ordinaries, and he has shown its origin to be in the twelfth century.[84] In addition, Atkinson has given an impressive catalogue of examples of Greek chants in Latin chant manuscripts, indicating that Greek insertions were in no way limited to Saint-Denis.[85] It should be determined in what manner, if any, the Saint-Denis Mass in Greek differs from the use of Greek in other Latin manuscripts, and whether there is any relationship to the Byzantine liturgical texts for Saint Dionysius.

Another promising avenue of exploration is the study of *An-*

tiphonae ante evangelium. These seem to be characteristic of greater feasts in the larger French churches in the twelfth century. Although they have been studied in their northern Italian context, there has been little work on them by historians of French liturgy.[86]

From this brief exposition it is clear that major investigations, using the sources now available, will increase our knowledge of the liturgy at Saint-Denis as well as yield valuable insights into other areas of study. It is essential that the Saint-Denis ordinaries be edited and published in full. This will provide a base on which to build the complete picture of the liturgical tradition of Saint-Denis, an insight that will also prove important to art historians and musicologists, imparting additional information about the institution that was once, in the words of Leonardo Olschki, "the ideal center of France in the Middle Ages."[87]

NOTES

1. I would like to express my gratitude to the Zahm Research Travel Fund of the University of Notre Dame, which financed studies at the Library of Congress, and to professor Ruth Steiner in the School of Music of The Catholic University of America, who graciously opened the valuable Mocquereau collection of microfilms of musical manuscripts. A special expression of my gratitude goes to the editor of this volume, Dr. Paula Gerson, for her very careful help in making the manuscript more readable and more homogeneous.

2. Paris, Bibliothèque Nationale, ms. lat. 9502, fols. 66A–66I, mentioned in Aimé Georges Martimort, *La Documentation Liturgique de Dom Edmond Martène,* Studi e testi 279 (Vatican City, 1978), p. 543.

3. Paris, Bibliothèque Nationale, ms. lat. 2290, used by Jean Deshusses in his edition *Le Sacramentaire grégorien. Ses principales formes d'après les plus anciens manuscrits. Tome 1.,* Spicilegium Friburgense 16 (Fribourg, 1971). See also Klaus Gamber, *Codices liturgici latini antiquiores, ed. altera,* Spicilegii Friburgensis Subsidia 1 (Fribourg, 1968) no. 760; Jean Leclercq, "Une Parenthèse dans l'histoire de la prière continuelle: la *Laus perennis* du Moyen Age," *La Maison-Dieu* 64 (1964): 98–101 (reprint; *La Liturgie et les paradoxes chrétiens,* Lex Orandi 36 (Paris, 1963), pp. 229–42; and Corbinian Gindele, "Die gallikanischen Laus Perennis Klöster und ihre Ordo Officii," *Revue Bénédictine* 59 (1959): 32–48.

4. Michel Huglo, "Les Chants de la Missa Graeca de Saint-Denis," in Jack Westrup, ed., *Essays Presented to Egon Wellesz* (Oxford, 1966) pp. 74–83, with a very complete bibliography. For other aspects of the *Missa graeca* problem, see esp. notes 83 and 85 here.

5. Martimort, *Martène,* pp. 544–45, gives the list of the principal extracts published by Martène and the references to the different editions of this work.

6. Eugene Misset and William H. I. Weale, *Thesauris Hymnologicis hactenus editis Supplementum amplissimum,* Analecta Liturgica 2: Thesaurus Hymnologicus, 3 vols. (Lille-Bruges, 1888–92), vol. 1, pp. 357–68 and vol. 2, pp. 530–41.

7. Cyrille Vogel, *Introduction aux sources de l'histoire du culte chrétien au Moyen Age,* Biblioteca degli 'Studi medievali,' 1 (Spoleto, 1966), pp. 45–46.

8. This provisional listing, drawn up by Rev. Edward Foley as the result of seminar work, does not include the three ordinaries of Saint-Denis to be discussed later. A more complete listing has now been drawn up by Ann E. Walters, "Music and Liturgy at the Abbey of Saint-Denis, 567–1567: A Survey of the Primary Sources" (Ph.D. diss., Yale, 1984), soon to be made available from University Microfilms International, Ann Arbor, Michigan.

9. Theodor Klauser, *Das Römische Capitulare Evangeliorum,* Liturgiegeschichtliche Quellen und Forschungen, 28 (Münster, 1935), p. xxxiii.

10. Victor Leroquais, *Les Sacramentaires et les missels manuscrits des bibliothèques publiques de France,* 4 vols. (Paris, 1924), vol. 2, pp. 19–22.

11. Ibid., vol. 1, pp. 56–58.

12. Martimort, *Martène,* p. 92.

13. Klauser, *Capitulare Evangeliorum,* p. lxii.

14. Victor Leroquais, *Les Psautiers manuscrits latins des bibliothèques publiques de France,* 3 vols. (Paris, 1940–41), vol. 2, pp. 67–70.

15. Ibid., vol. 2, pp. 148–52; Adrien Nocent, "Contribution à l'étude du rituel du marriage," *Eulogia. Miscellanea liturgica in onore di P. Burkard Neunheuser,* Studia Anselmiana 68 (Rome, 1979), p. 250 n. 20.

16. Leroquais, *Sacramentaires,* vol. 2, pp. 64–68.

17. Ibid., pp. 142–44.

18. René-Jean Hesbert, ed., *Le Graduel de Saint-Denis,* Monumenta Musicae Sacrae 5 (Paris, 1981), a facsimile edition.

19. Leroquais, *Psautiers,* vol. 2, pp. 30–32.

20. Klauser, *Capitulare Evangeliorum,* p. cxix.

21. René-Jean Hesbert, *Corpus Antiphonalium Officii,* 6 vols. (Rome, 1963–79), vol. 2, pp. xi–xv.

22. Victor Leroquais, *Les Bréviaires manuscrits des bibliothèques publiques de France,* 4 vols. (Paris, 1934), vol. 4, pp. 291–92.

23. Leroquais, *Sacramentaires,* vol. 2, p. 73.

24. Ibid., p. 140.

25. Ibid., pp. 140–42.

26. Adalbert Ebner, *Quellen und Forschungen zur Geschichte und Kunstgeschichte des Missale Romanum im Mittelalter: Iter Italicum* (1886; reprint, Graz, 1957), p. 155.

27. Klauser, *Capitulare Evangeliorum,* p. cviii.

28. Joyce Whalley, Assistant Keeper of the Victoria and Albert Museum Library, to author, May 1, 1981, "Description of the Missal of Saint-Denis Abbey, Paris (MS.L. 1346–1891)."

29. Leroquais, *Sacramentaires,* vol. 2, p. 292.

30. Victor Leroquais, *Les Pontificaux manuscrits des bibliothèques publiques de France,* 3 vols. (Paris, 1937), vol. 2, pp. 220–29.

31. Victor Leroquais, *Les Livres d'heures manuscrits de la Bibliothèque Nationale de Paris,* 3 vols. (Paris, 1927), vol. 1, pp. 49–52.

32. Leroquais, *Sacramentaires,* vol. 1, pp. 144–45.

33. However, Harvey Stahl, in his essay in this volume, pp. 163–81 note 40, has drawn attention to the Lectionary of Saint-Corneille, Compiègne (Paris, Bibliothèque Nationale, ms. lat. 16820.) It "may well have been made at Saint-Denis for Compiègne about 1150, when Suger chose Odo of Deuil, soon to be his successor, to reestablish order at Saint-Corneille." See also Léopold Delisle, *Inventaire des manuscrits latins de Notre-Dame et d'autres fonds* (1871; reprint, Hildesheim, 1974), p. 11.

34. The sequences have been edited by Misset and Weale, *Thesauris.*

35. None of these categories—almost indistinguishable from each other—has yet been treated in the *Typologie des sources du Moyen Age Occidental* of Louvain.

36. The standard editions of the *Consuetudines* are Marquard Herrgott, *Vetus Disciplina Monastica* (Paris, 1726); Bruno Albers, *Consuetudines Monasticae,* 5 vols. (Stuttgart, 1900–12); and Kassius Hallinger, *Corpus Consuetudinarum Monasticarum,* 8 vols. to date (Siegburg, 1963 sqq.).

37. Anton Hänggi, *Der Rheinauer Liber Ordinarius,* Spicilegium Friburgense 1 (Fribourg, 1957).

38. Ibid., pp. xxix–xxxvi; and *Nachtrag,* p. 323.

39. Jean Dufrasne, *"Les Ordinaires manuscrits des églises séculières conservées à la Bibliothèque Nationale de Paris,"* (*Mémoire,* Institut Supérieur de Liturgie of the Institut Catholique de Paris, (Paris, 1959), available as four microfiches, distributed by C.I.P.O.L., 4, Avenue Vavin, F-75006 Paris.

40. Paris, Archives nationales, L. 863, no. 10; see Martimort, *Martène,* p. 544.

41. Martimort, *Martène,* pp. 544–45.

42. Auguste Molinier, *Catalogue des manuscrits de la Bibliothèque Mazarine,* 4 vols. (Paris, 1885), vol. 1, p. 211.

43. Charles Samaran and Robert Marichal, eds., *Catalogues des manuscrits en écriture latine portant des indications de date, de lieu ou de copiste, Musée Condé et bibliothèques parisiennes,* 6 vols. (Paris, 1959), vol. 1, p. 245.

44. There is some possibility that the calendar and the main text of the ordinary were not conceived as a single manuscript, though the hand appears the same. The calendar dates for the royal anniversaries often carry the annotation: *quaere in fine libri quomodo debet fieri,* but in the first ordinary these anniversaries are incorporated in the main text on the pertinent days. This needs further investigation.

45. The list of abbots is conveniently printed by Michel Félibien, *Histoire de l'Abbaye Royale de Saint-Denys en France* (1706; reprint, Paris, 1967), before p. 1. Besides Adam and Suger, they are, for the last part of the twelfth century: Odo II of Deuil (1151–63), Odo III of Taverny (1163–69), Yves II (1169–73), William II of Gap (1173–86), Hugh V of Foucault (1186–97), and Hugh VI of Milan (1197–1204).

46. Robert Barroux, "L'Anniversaire de la mort de Dagobert à Saint-Denis au XIIᵉ siècle: Charte inédite de l'abbé Adam," *Bulletin philologique et historique du Comité des travaux historiques et philosophiques* (1942–43): 133–51.

47. There is, however, an intriguing remark by Félibien, *Histoire,* p. 202, about Abbot William (1173–86) and his "nouveau règlement": nothing is known about this.

48. This is, of course, not a new finding and can also easily be read out of the antiphonary used by Hesbert, *Corpus,* vol. 2, but it is necessary to state it at this point.

49. Thomas Symons, "A Note on the *Trina Oratio,*" *Downside Review* 42 (1924): 67–83 and his "Monastic Observances in the Tenth Century," *Downside Review* 51 (1937): 137–52. See also the invaluable commentaries by John B. Tolhurst, *Introduction to the English Monastic Breviaries,* vol. 6 of *The Monastic Breviary of Hyde Abbey, Winchester,* 6 vols. (Henry Bradshaw Society, 80 London, 1942–43).

50. Kassius Hallinger, "Das Phänomen der liturgischen Steigerungen Klunys (10./11..Jh.)" in *Studia Historico-Ecclesiastica. Festgabe für Luchesius G. Spätling, O.F.M.,* Bibl. Pont. Antoniani 19 (Rome, 1977), pp. 183–236 and his similar "Überlieferung und Steigerung im Mönchtum des 8. bis 12. Jahrhunderts," in *Eulogia. Miscellanea Liturgica in onore di P. Burkard Neunheuser,* Studia Anselmiana 68 (Rome, 1979), pp. 125–87.

51. Fol. 78v.

52. Fols. 28v–29v.

53. Fols. 38v–39r.

54. Fol. 79r.

55. Fol. 79v.

56. Since these devotional offices vary only slightly, and were not sung but said, we cannot document their observance at Saint-Denis on the basis of the antiphonaries alone.

57. Panofsky, *Suger,* pp. 8–34, 249–250, and Suger, *Cons.* (P), p. 118. His second edition unhappily replaces the plan of the church with a less detailed one. See also Louis Levillain, "Les Plus Anciennes Églises abbatiales de Saint-Denis," *Mémoires de la Société de l'Histoire de Paris et de l'Ile de France* 36 (1909): 250. The *oratoria* were the following beginning from the left: Saint Innocent, Saint Osmanna, Saint Eustace, Saint Peregrinus, the Virgin (at the center), Saint Cucuphas, Saint Eugene, Saint Hilary, and saints John the Baptist and the Evangelist.

58. Fols. 78v and 80r.

59. Fol. 78v: *"si duodecim lectiones etiam contingerint, ecrit processio in capitio de festo contingente, si altare fuerit consecratum in honore sancti."* I wish to thank Dr. Walters for the correct reading of this passage.

60. Fol. 167r: *Maria virgine.*

61. Fol. 127v.

62. Fol. 193v.

63. Panofsky, *Suger,* p. 249.

64. Fol. 17v.

65. Léopold Delisle, "Notice sur un livre à peinture exécuté en 1250 dans l'abbaye de Saint-Denis," *Bibliothèque de l'École des Chartes* 38 (1877): 446–76, esp. p. 465.

66. Fol. 60r: *In inuentione sacri claui.*

67. *Cuique suum:* We abstain from the tempting identifications and leave this to the art historians.

68. Blaise de Montesquiou-Fezensac and Danielle Gaborit-Chopin, *Le Trésor de Saint-Denis,* 3 vols. (Paris, 1973–77).

69. Alain Erlande-Brandenburg, *Le Roi est mort. Étude sur les funérailles, les sépultures et les tombeaux des rois de France jusqu'à la fin du XIIIᵉ siécle,* Bibliothèque de la Société française d'archéologie 7 (Genève, 1975).

70. Erlande-Brandenburg, *Le Roi,* pp. 102–3.

71. Fol. 100r: *tres extreme [sic] lectiones de vita ipsius.*

72. These lessons are printed by Migne, *PL,* vol. 186, cols. 1341–46; they are excerpts from Suger's own *Vita Ludovici grossi* (lesson 7: cols. 1255 and 1336 esp.; lesson 8: cols. 1336–38; and lesson 9: cols. 1338–40). The monastic Office of the Dead is structured like the Roman one with only nine, and not twelve, lessons and responsories, with only a few isolated exceptions (information kindly supplied by Dr. Knud Ottosen, University of Aarhus, Denmark).

73. See the apologetic statement to this exceptional practice by Edmond Martène, *De Antiquis Ecclesiae Ritibus,* Editio secunda, 4 vols. (1736; reprint, Hildesheim, 1967), vol. 2, col. 1053.

74. Suger, *Adm.* (P), pp. 72–73.

75. Félibien, *Histoire,* p. 529; see also Sumner McK. Crosby, *The Abbey of Saint-Denis* (New Haven, 1942), vol. 1, pp. 117ff., 162. The work of Crosby on the later stages of the church is to be carried to its completion by Prof. Caroline Bruzelius at Duke University.

76. Fol. 48r.

77. Fol. 17v.

78. Suger, *Cons.* (P), p. 116; and Panofsky's comments on pp. 248–49. Suger does not mention the red doors and we are badly informed about the location of both doors.

79. Suger, *Cons.* (P), p. 102 n. 43.

80. Rev. Foley has drawn our attention to the twelfth-century pontifical of Rouen, Paris, Bibliothèque Nationale, ms. n.a. lat. 306 (see note 30 here), in which all references to the Church of Rouen have been deleted and to which has been added, at the end of the thirteenth or the beginning of the fourteenth century, an additional quire of twenty-four folios (fols. 215r–238v) containing a collectary of orations to be said during the processions at Saint-Denis. Would this pontifical have been left as a gift by the Archbishop of Rouen? Or have been a legacy of Odo IV (who left Saint-Denis in 1229 to occupy the see of Rouen?)

81. Suger, *Cons.* (P), p. 96.

82. Ibid., pp. 112–15. Panofsky's unfamiliarity with liturgical texts is also apparent in his discussion of Suger's text on the laying of the first stone, pp. 100–103. On this rite and Suger, see Karl-Josef Benz, "*Ecclesiae pura simplicitas.* Zu Geschichte und Deutung des Ritus der Grundsteinlegung im Hohen Mittelalter," *Archiv fur Mittelrheinische Kirchengeschichte* 32 (1980): 9–25. Benz gives an excellent background for the texts of Suger dealing with the presence of royalty at the dedication ceremonies in his *Untersuchungen zur politischen Bedeutung der Kirchweihe, unter Teilnahme der deutschen Herrscher im hohen Mittelalter. Ein Beitrag zum Studium des Verhältnisses zwischen weltlicher Macht und kirchlicher Wirklichkeit unter Otto III. und Heinrich II.,* Regensburger historische Forschungen 4 (Kallmünz, 1975).

83. See Roberto Weiss, "Lo Studio del greco all'Abbazia di San Dionigi durante il Medio Evo," *Rivista di storia della Chiesa in Italia* 6 (1952): 426–38; reprinted in *Medieval and Humanist Greek. Collected Essays,* Medioevo e umanesimo 8 (Padova, 1977), pp. 44–59. For a comparison with an equally important abbey, see Bernice M. Kaczynski, *"Greek Learning in the Medieval West: A Study of S. Gall, 816–1022"* (Ph.D. diss., Yale, 1975), available from University Microfilms International, Ann Arbor, Michigan: 7–14, 590.

84. See note 4 here.

85. Charles Atkinson, "*Mater Graecia* Revisited: Another Look at the Origins and Dissemination of the *Missa Graeca.*" Paper delivered at the Fifteenth International Congress on Medieval Studies, The Medieval Institute, Western Michigan University, Kalamazoo, Michigan, May 1980, and expanded in 1982; and his "On the Origins and Transmission of the *Missa Graeca,*" *Nordisk Kollokvium V for Latinsk Liturgiforskning* (Aarhus, 1982), pp. 95–140; "O AMNOS TOU THEU: The Greek Agnus Dei in the Roman Liturgy from the Eighth to the Eleventh Century," *Kirchenmusikalisches Jahrbuch* 65 (1981): 7–30, and "Zur Entstehung und Überlieferung der 'Missa graeca'," *Archiv fur Musikwissenschaft* 39 (1982): 113–145.

86. Pietro Borello, *Il rito ambrosiano* (Brescia, 1964), pp. 156–57; Alejandro Enrique Planchart, "The *Antiphonae ante evangelium* in North-Italian Sources." Communications at the American Musicological Society (New York, 1979) and at the Seventeenth International Congress on Medieval Studies, The Medieval Institute, Western Michigan University, Kalamazoo, Michigan, May 1982. The second ordinary of Saint-Denis, fol. 150v, gives the complete listing of these antiphons.

87. Leonardo Olschki, *Der ideale Mittelpunkt Frankreichs im Mittelalter in Wirklichkeit und Dichtung* (Heidelberg, 1913), as quoted in Ralph E. Giesey, *The Royal Funeral Ceremony in Renaissance France,* Travaux d'Humanisme et Renaissance 37 (Geneva, 1960), p. 30. We are happy to report that the edition and partial commentary of the first ordinary has now been undertaken as a dissertation project by Rev. Edward Foley, O.F.M. Cap., at the University of Notre Dame. Since the completion of our investigation a thorough monograph on the sandyonisian liturgy has been completed: Walters, *"Music and Liturgy."* The works by Foley and Walters will henceforth be the obligatory points of departure for the study of the topic and both works contain modifications and corrections to this preliminary study.

II.
POLITICAL
AND SOCIAL HISTORY

Suger's Views on Kingship*

Andrew W. Lewis

NO HISTORIAN of the Capetian monarchy seems ever to have published a full and independent analysis of Suger's views on kingship.[1] Instead much recent historical scholarship has tended to accept without reexamination the hypotheses on this subject—first advanced in studies on early Gothic architecture—that, in the light of previously neglected evidence, appear more controversial in regard to Suger than was long assumed.[2] The essential problem is one of sources. Earlier discussions of Suger's notion of kingship have relied primarily on passages in his *De consecratione ecclesie Sancti Dionysii,* most of them, arguably, either ambiguous or of merely inferential pertinence.[3] The present essay, by contrast, is based on Suger's *Life of Louis VI,* supplemented by certain of his letters, all of them texts directly concerned with the king's functions and the rationale for them. This reversal of sources produces significant changes in perspective. *De consecratione* has been thought to present an image of sacral or even sacerdotal monarchy. Study of the *Life,* however, reveals a very different set of ideas concerning kingship, one that, given the nature of the sources, should at the least receive priority of stress in our reconstruction of Suger's views.[4]

In outline the image of kingship that emerges from the *Life of Louis VI* is traditional. Three aspects of it may be identified: (1) the king as administrator of the kingdom; (2) the king as a figure with special religious associations or attributes; and (3) the king as protector of the churches and of the "poor."[5] These are, of course, not formal categories in Suger's thought. They are interrelated or overlapping themes that here have been isolated for ease of discussion. The conventional nature of the framework is fundamental, since it places Suger in relation to a tradition of royalist ideology; yet, because it is familiar, detailed examination of it is unnecessary. What requires particular notice is that Suger's remarks about each of these aspects of royalty are in some ways distinctive.

As administrator of the kingdom, the king was charged first of all with the defense of the realm against enemies, both foreign and domestic.[6] That is immediately clear. More complex, and therefore intriguing, is Suger's thought regarding the internal, feudal structures that in his mind defined the monarch's jurisdictional relationship to other lords in the kingdom. This topic has received much scholarly attention in recent years because of the pioneering work of the late Jean-François Lemarignier, who recognized in the *Life of Louis VI* a theory—for which Suger is the first identifiable spokesman—of royal suzerainty at the summit of a pyramid of feudal ties. Such a theory had been absent in eleventh-century France; it is found very clearly in the reign of Philip Augustus. Models for this concept have been seen in the Gregorian church, perhaps especially in monasticism, and also in the influence on Suger of the hierarchical concepts that marked the writings of pseudo-Dionysius the Areopagite.[7] Since most previous appraisals have treated Suger's ideas against the background of the earlier period, and since scholars have stressed the innovative character of his theory, the inevitable result has been a tendency to exaggerate his intellectual boldness and originality. Accordingly, certain cautionary observations seem appropriate.

Suger really says little about the suzerainty. He portrays Louis VI as very conscious that, for Normandy, Henry I of England was his feudatory.[8] He has Louis, as king-designate, restoring to the church of Orléans one castle and the lordship over another castle that Leo of Meung, vassal of the bishop of Orléans for the first castle, had tried to seize for himself.[9] Finally, on the occasion of Louis VI's second campaign to protect the bishop and church of

Notes for this essay begin on page 52.

Clermont-Ferrand against oppression by the count of Auvergne, he has the duke of Aquitaine intervene in his capacity as intermediate lord to protest the king's action. "Lord king . . . " said the duke, "let the exalted Royal Majesty not be unwilling to receive the service of the duke of Aquitaine, and to preserve to the latter his right, since, while justice requires that service, it also requires that the lordship be just. Since the count of Auvergne holds Auvergne from me, and I hold it from you, if he has committed any wrong it is for me upon your command to bring him to your court." Because the duke had never been asked to do this, even though he was ready to comply, his rights in the matter had been violated; but he now offered hostages to guarantee his delivery of the count, if the king agreed. After conferring with his barons, Louis heeded the "dictates of justice" and withdrew his army, pending settlement of the dispute between the count and the bishop at the royal court in the presence of the duke of Aquitaine.[10]

How much may be read into these passages? It appears that Suger regarded the king as the highest feudal lord *in* France—although, given the existence of allods, presumably not feudal lord of all *of* France—and that for him the king had some jurisdictional claims over his subvassals, at least when the latter attacked churches. The increasing importance of the real, that is the land-based, over the personal element attached to the homages of the time is supportive of the thesis that Suger's remarks reflect a well-developed notion of a feudal pyramid; for the inherence of ties and obligations in fiefs could prompt the formation of chains of authority in a manner that the older bonds between pairs of individuals—and generally not extending to subvassals—could not.[11] Also consistent with that pattern of thought are the various other hierarchies, theoretical or actual, with which Suger would have been familiar: the theology of pseudo-Dionysius the Areopagite, the lines of jurisdiction within the church both at large and within particular ecclesiastical provinces, the politico-feudal structures within the Anglo-Norman domains, and even the chains of jursidiction linking the abbey of Saint-Denis to its possessions.[12] Suger's apparent agreement, recorded elsewhere, with Louis VI's unwillingness to perform homage to the abbey of Saint-Denis for the county of the Vexin may not fit wholly into the same framework of jurisdictions and ties, but it is certainly indicative of a pyramidal conception regarding homages.[13]

One is struck by two other elements in Suger's remarks. The first pertains to what may be called a national kingship. It is seen only dimly in the *Life*. Louis VI stands at the peak of French political structures not only as feudal lord to his vassals but as king, that is, as monarch and lord of the whole. This is reflected in Suger's account of French preparations for resistance to the threatened attack by Henry V of Germany: the magnates assemble under their king because of the threat to French land and the affront to France and to the French—that is to say, the great nobles from regions not directly affected by the crisis owe service to the king in the defense of any part of the kingdom against outsiders.[14] Similar ideas are reflected in some of Suger's remarks about internal defense, that is, the maintenance of order.[15] Suger's letters supply complementary evidence. His language concerning fealty is instructive: *fidelitas* is owed "to the king and the kingdom" by the bishop of Chartres and "to the kingdom and the crown" or "to the king and the crown" by the archbishops, bishops, and the greater lay vassals generally.[16] The joining, or even conflation, of the obligations to Louis as king and to Louis as feudal lord is significant. The royal element is notable; yet the feudal one must not be underestimated. Suger's writings reflect notions of several, sometimes inconsistent hierarchies—in particular, in this connection, an ecclesiastical one in which an archbishop will sometimes mediate between the crown and his suffragan bishops[17]—but it is to the kingdom or the crown and to the lord from whom the properties move that each bishop owes immediate loyalty.

The second element to be noted is the limitations that, according to Suger's account of Louis VI's second expedition to Auvergne, "justice" placed on the king's authority to intervene at the level of his subvassals. In view of the power relationships in early-twelfth-century France, acknowledgment of these limits is understandable. As one searches for the source or sources for Suger's conceptual model, however, these restrictions are more difficult to explain. There is no parallel to them in the theology of pseudo-Dionysius; nor is there a likely one in the ecclesiastical hierarchy of the day, since the pope had wide powers—acknowledged, and even invoked, by Suger—to intervene directly at the lower levels of the clerical and monastic orders.[18] That these models, and others, made Suger predisposed to conceptualize in terms of hierarchies can hardly be doubted, but the immediate source—if there is one—for his own ideas remains obscure.

The image of the king as a figure with special religious associations appears only fragmentally in the *Life of Louis VI*, although the few pertinent comments there are expressed in very strong terms. Thus, Suger speaks of Louis VI at his coronation as "casting away the sword of the worldly militia" and being girded "with the ecclesiastical [sword] for the punishment of evil-doers."[19] In another passage, Suger depicts clerics urging Louis—as the "vicar" of God, "whose image, to make it animate, the king bears"[20]—to take up arms against their oppressor, Hugh of Le Puiset. Finally, Louis appears as the vassal of Saint-Denis and the latter's companion saints, specifically for the Vexin, although in this case the personal aspect of the relationship seems more important than the real.[21]

These examples, however, are isolated and do not reflect the tenor of the work as a whole. Some fifty years ago, Marc Bloch noted the absence in almost all twelfth-century writers, includ-

ing Suger, of any mention of the "royal touch," the exercise of the thaumaturgic power ascribed to the French kings and explicitly recorded for Louis VI by Guibert of Nogent. Bloch plausibly speculated that the lack of such mention might be attributable to the writers' deference to Gregorian ideas.[22] In the case of Suger, more than that seems to have been involved. In general, the *Life* does not portray Louis VI as a sacral figure. In particular—and this feature is likely to surprise—in the work Suger lays little stress on royal consecration. His account of the coronation is indicative. The heading of the chapter speaks of Louis's *sublimacio in regem*. The introductory passages in the text say that Louis "was admitted to the most exalted rank of kingship [*ad regni fastigia asciscitur*]" and speak of his *exaltacio*. The description of the ceremony itself says only that the archbishop of Sens, the celebrant, "anointed him with the liquid of most holy unction, offered Masses of thanksgiving, and, after Louis had cast away the sword of the worldly militia, girded him with the ecclesiastical [sword] for the punishment of evildoers, crowned him with the diadem of the kingdom, while rejoicing, and also, with the approval of the clergy and the people, devoutly delivered to him the scepter and the rod—and by these the defense of the churches and of the poor—and [also] all the other insignia of kingship." In the remainder of the chapter, Suger uses expressions for anointment once and for crowning twice. Neither the word *consecratio* nor a synonym is ever used.[23] Elsewhere in the work several symbols of rule are mentioned—the crown or diadem, the sword, the scepter, the throne—but never Louis's anointment or consecration.[24]

In addition, and also contrary to what one might have expected, anointment effects no discernible change in Louis's nature or in that of his actions. Quite the opposite: the chapter immediately following the account of the coronation begins with the statement that Louis, now king, was incapable of discontinuing the habits of his youth, namely the safeguard of the churches, the protection of the poor and indigent, and the striving for the peace and defense of the kingdom.[25] And so the narrative, chiefly of his military exploits, continues virtually as it did before his coronation. Louis receives divine aid in his battles—as he had before his coronation, too—but no recorded divine inspiration.[26] He loves, fears, and defends the church, not as the Lord's Anointed, but as a layman.[27]

The king's role as protector of the churches and of the "poor"—that is, chiefly the weak—is the aspect of the royalty most stressed by Suger. Repeatedly the king is said to have taken up arms in response to the complaints of the clergy, to protect churches against the depredations of local barons and to protect widows, orphans, and the poor.[28] Such actions represent by far the largest single element in the text. This emphasis, although reflecting the nature of the activities in which Louis VI was often engaged, was rooted also in Suger's conception of kingship.

There seem to have been two sources for his views in this regard. The first was the royal coronation. We have seen how Suger stressed the girding of Louis VI with the "ecclesiastical sword for the punishment of evildoers" and the delivery to him of the scepter and the rod "and by these the defense of the churches and of the poor."[29] Elsewhere Suger says that kings, "by the sworn obligation of their office [*offitii jure votivo*]" put down the tyrants who pillage, oppress the poor, and lay waste the churches.[30] This "sworn obligation" must refer to the oath given by the king at his coronation; no other oath was common to all kings *offitii jure*. The inference is confirmed, moreover, by the terms of a letter from 1149 in which Suger tells Louis VII that he must return from the East to deal with the *perturbatores* of his kingdom lest he appear to be "guilty of violating the *professio* and the *juramentum* which [he had] made before God when receiving the crown of the realm."[31]

The coronation oath did not, however, contain all the elements that Suger attributes to it. The oath, or promise, itself bound the king to preserve the rights of and to defend the bishops and the churches. It was later parts of the ceremony—the declaration upon delivery of the scepter and the statement of the *rectitudo regis*—that coupled the Christian people with the church in the protection of the king.[32] The stress on the "poor"—and especially that on merchants, whom Suger includes in the royal safeguard—came from the Peace Movement.[33] Suger does occasionally refer to the peace; in one passage he even states that in restoring the peace in a given region Louis VI was "discharging the royal office."[34] The influence of ideas of the peace on Suger's thought was, however, more important than his explicit mentions of it would suggest. Repeatedly his citations of the king's motives in suppressing baronial violence link the protection of the churches required by the coronation oath to the broader obligation of the defense of the "poor" derived from the Peace Movement.[35] In effect the two are fused.

Examination of the terminology used by Suger to express kingly traits yields complementary insights. Louis VI is presented as an exalted figure: he embodies the *regia majestas*. As such he is associated with the *excellentia* or the *celsitudo* or the *magnificentia* of the *regia majestas*.[36] He exercises the *officium regis;* but *officium* here may mean no more than role or function, since knights, whom Suger did not hold in the highest regard, also had an *officium*.[37] Louis VI is not said to occupy a *dignitas* or to exercise a *ministerium*, terms connoting possible religious functions.[38] Louis's virtues are military: he is *animosus*, strong of *manus* or of *dextera*, acting *audacter* or with *strenuitas*, a *militaris vir*, the *defensor* of the kingdom, of justice, of the churches, and of the "poor." He is the worthy soldier-king.[39]

Suger's articulation of at least an inchoate theory of suzerainty, and his joining of ideas of the peace to the duties imposed by the coronation, were aspects of his thought that had both im-

mediate and future significance. In these matters he appears as an authoritative spokesman for royalist ideas. In other regards it is not he but the anonymous redactors of royal charters who appear more accurately to reflect the views dominant in immediate Capetian circles: for example, the stress on royal consecration, which is documented from the circles of both Louis VI and Louis VII.[40] Suger's conception of kingship is *one* of the essential elements for an understanding of Capetian ideology in his time. It is not, however, to be confused with the official position of the monarchs—if indeed there was one. And its relation to the cult of sacral monarchy is problematical.

NOTES

* I am indebted to Michel Bur and John F. Benton for their helpful comments on the original version of this paper.

 1. The discussion of Suger's notion of the royal suzerainty in Jean-François Lemarignier, *Le Gouvernement royal aux premiers temps capétiens, 987–1108* (Paris, 1965), pp. 175–76, is an important but only partial exception.

 2. Otto von Simson, *The Gothic Cathedral: Origins of Gothic Architecture and the Medieval Concept of Order*, 2d ed. (New York, 1962), chs. 3–4. As von Simson's footnotes indicate, historians of architecture have long associated the early Gothic style with areas of Capetian rule or influence; see p. 62 nn. 2–4. But cf. the new findings of John James, "An Investigation into the Uneven Distribution of Early Gothic Churches in the Paris Basin, 1140–1240," *Art Bulletin* 66 (1984): 15–46.

 3. Certain texts may also have been misinterpreted. Thus one questions the analogy drawn by von Simson, *Gothic Cathedral*, pp. 137–40, between the role of Louis VII in the consecration of 1140 and that ascribed to Christ in the legend concerning the original consecration. Greater weight should be placed on the function of the king and his nobles, armed with staves, in keeping the crowd inside the church from pressing too closely around the procession of prelates at the dedication of 1140: Suger, *Cons.* (P), pp. 112–14. Here the king does not appear as the representative of Christ, but as the first of the lay helpers of the clergy. Note also (p. 114) the differentiation between the procession and the onlookers, including the king: " . . . *ut potius chorus coelestis quam terrenus . . . tam regi quam assistenti nobilitati videretur apparere.*" In addition, on von Simson, p. 139 at n. 134, cf. Marc Bloch, *Les Rois thaumaturges: étude sur le caractère surnaturel attribué à la puissance royale particulièrement en France et en Angleterre* (Strasbourg, 1924), pp. 190–92.

 4. It is not necessary that one interpretation exclude the other. Von Simson's thesis of the parallelism in Suger's mind between the heavenly and terrestrial hierarchies may well describe some of the abbot's assumptions or associations regarding kingship. In that case, however, von Simson's exegesis would pertain to a different level of analysis and should be kept separate from discussion of Suger's more clearly articulated formal views.

 5. Suger's usage of *pauperes* includes the weak or defenseless as well as the economically poor. Most often he speaks of them in such expressions as the *ecclesiarum et pauperum tuicio*: See Suger, *Vita Lud.* (W), p. 6, and also pp. 12, 86, 124, 174, 180, 182. Elsewhere he says *pauperes et orphani* (pp. 84, 176) or *pauperes, vidue et pupilli* (p. 134); but cf. *pauperes et egeni* (pp. 88, 276) and *oratores, laboratores et pauperes* (p. 14).

 6. Ibid., pp. 142, 152, 170–72, 218–30; see also pp. 232–34. For Louis as *defensor regni* before his accession, see pp. 14, 20, 22; see also pp. 34–36.

 7. Lemarignier, *Le Gouvernement,* pp. 172–76; Georges Duby, "Le Gouvernement royal aux premiers temps capétiens: À Propos d'un livre récent," *Le Moyen Age* 72 (1966): 543–44. For the influence of the pseudo-Dionysian writings on Suger, see also von Simson, *Gothic Cathedral,* pp. 103–7, 120–41.

 8. Suger, *Vita Lud.* (W), pp. 106, 184.

 9. Ibid., p. 28.

10. Ibid., pp. 238–40. For a somewhat different interpretation of these passages, see Lemarignier, *Le Gouvernement,* pp. 170, 176.

11. On the homages, see Lemarignier, *Le Gouvernement,* pp. 174–76; and Duby, "Le Gouvernement," p. 536.

12. For the hierarchical arrangement of churches subject to Saint-Denis, see Suger, *Let.* (L), pp. 239–40. See also Suger, *Vita Lud.* (W), p. 222 (*beati Dyonisii copiosus exercitus*) and p. 264 (*barones ecclesie nostre feodati*). For notions of heavenly and terrestrial hierarchies as a commonplace idea, see Hugh of Fleury, *Tractatus de regia potestate et sacerdotali dignitate,* 1. 1, ed. Ernst Sackur, *Monumenta Germaniae Historica,* Libelli de lite (Hannover, 1892), vol. 2, pp. 467–68.

13. Suger, *Adm.* (L), p. 162. See also Robert Barroux, "L'Abbé Suger et la vassalité du Vexin en 1124," *Le Moyen Age* 64 (1958): 10–12; and Waquet, *Vie,* pp. xxii–xxiv.

14. Suger, *Vita Lud.* (W), pp. 220–26. Note especially the desire of the barons to punish those who "*in terrarum dominam Franciam superbe presumpserunt*" (p. 222), the presence "*ex ajuracione Francie*" of the otherwise hostile Theobald IV of Blois (p. 224), and the willingness of more distant princes to serve "*Francorum injuriam gravissime punire*" (pp. 224–26).

15. See the references of note 6 here. Note also that the princes and barons who joined in Louis VI's first expedition into Auvergne are said to have done so as *regni debitores:* Suger, *Vita Lud.* (W), p. 232.

16. Suger, *Let.* (L), pp. 257, 267, 277. See also Suger's remarks about his own *fidelitas* to the *regnum* and that of the archbishop of Reims, and his designation of the canons of Chartres as *regni fideles* (pp. 261, 256).

17. Thus in 1149, Suger, as regent, summoned the archbishop of Reims, and asked him to summon his suffragans, to the assembly at Soissons to discuss the affairs of the kingdom: ibid., p. 261.

18. See ibid., esp. pp. 263–64.

19. Suger, *Vita Lud.* (W), p. 86; cf. 1 Peter 2:14. The same verse

is cited more fully in two charters of Louis VI from 1109 and 1110: Robert de Lasteyrie, ed., *Cartulaire général de Paris* (Paris, 1887), vol. 1, nos. 154, 155^bis (Achille Luchaire, *Louis VI: Annales de sa vie et de son règne* [*1081–1137*] [Paris, 1890], nos. 82, 95). Diplomatic study of the acts of Louis VI requires caution, since the charters often were written by scribes from the recipient establishments. In this case, however, the almost identical texts are found in originals from two different hands—the first apparently that of a scribe from the royal chancery, the second probably that of a monk from Saint-Denis: Françoise Gasparri, *L'Écriture des actes de Louis VI, Louis VII et Philippe Auguste* (Geneva, 1973), pp. 17–18. Since the second act was delivered at Paris, one may infer that its scribe was then in the king's service and working from a chancery model, and thus that the biblical allusion reflects ideas from the royal circles. Note, however, that Suger rarely uses—and does not always glorify—the image of the royal sword; thus, on investiture, he has Pope Paschal II reject as sacrilegious that prelates *"sacratas Dominico corpori et sanguini manus laïci [sc. imperatoris] manibus gladio sanguinolentis obligando supponant"* (Suger, *Vita Lud.* [W], p. 58).

20. Suger, *Vita Lud.* (W), p. 134. Cf. the similar expression but different spirit in two charters of 1112 and 1113, published in Jules-Antoine Dumesnil, "Notice historique sur l'église et la ville de Puiseaux," *Mémoires de la Société archéologique de l'Orléanais* 1 (1851): 135; and Lasteyrie, *Cartulaire,* no. 163 (Luchaire, *Louis VI,* nos. 131, 160): *"eleemosyna . . . et oratio justi assidua vitiorum incentiva extinguere, et Deum, cujus imaginem portamus, valet inoffensum reddere, in cujus manus durum et horrendum est incidere."* Cf. also Hugh of Fleury, *De regia potestate* 1.3, p. 468.

21. Suger, *Vita Lud.* (W), pp. 220, 228. The implications of the relationship appear very broad, also, in Louis VI's charters to Saint-Denis from 1120 and 1124: Jules Tardif, ed., *Monuments historiques: cartons des rois,* (Paris, 1866), nos. 379, 391 (Luchaire, *Louis VI,* nos. 289, 348). Note, however, that both of these acts were written in the *scriptorium* of Saint-Denis: Gasparri, *L'Écriture,* pp. 18, 21, 25. The context for these stresses is not fully clear, for it is unsure whether at this time Saint Denis was the special patron of France or simply of the Capetian kings, and also how firm that relationship was. During the abbacy of Suger, the saint and his abbey held very high rank; during the last third of the twelfth century, however, relations between the king and the abbey, at least, appear less warm.

22. Bloch, *Les Rois,* pp. 29–32, 120–24.

23. Suger, *Vita Lud.* (W), pp. 84–88. Lemarignier, while generally seeming to place Suger in the tradition of the proponents of sacral kingship, notes that in this account Suger *"insiste peut-être un peu moins sur l'onction que sur la remise du sceptre et de la main de justice: image du roi justicier, appelé à un bel avenir"*: *Le Gouvernement,* pp. 26–27, 169 n. 6; and Jean-François Lemarignier, "Autour de la royauté française du IX^e au XIII^e siècle," *Bibliothèque de l'École des Chartes* 113 (1956): 13–14. Marcel David finds in the text *"une image, éclairante en ce qui concerne la condition partiellement ecclésiastique du roi"*: *Le Serment du sacre du IX^e au XV^e siècle: contribution à l'étude des limites juridiques de la souveraineté* (Strasbourg, 1951), p. 186. But comparison with the *ordo* itself suggests that Suger has minimized that aspect: Paul L. Ward, "An Early Version of the Anglo-Saxon Coronation

Ceremony," *English Historical Review* 57 (1942): 345–61; and Percy Ernst Schramm, *Der König von Frankreich: Das Wesen der Monarchie vom 9. zum 16. Jahrhundert* 2d ed. (Darmstadt, 1960), vol. 1, pp. 158, 146–47.

24. Suger, *Vita Lud.* (W), pp. 54, 86, 222, 260, 268, 272, 282 (crown or diadem), p. 232 (sword), p. 4 (scepter), p. 256 (throne). Suger uses "crown" in both the abstract and concrete senses, "diadem" only in the concrete; see also Suger, *Let.* (L), pp. 259, 261, 267, 277, 279, 281. The coronation is his preferred image for the assumption of royal rule. Thus in 1108 the archbishop of Reims claimed the *"prime regis corone primitias,"* and Louis VI's enemies *"regem non coronari sperabant"* (Suger, *Vita Lud.* (W), pp. 86–88); and later Suger reminded Louis VII of the oath he had taken *"in susceptione coronae"* (Suger, *Let.* [L], p. 259). The term *consecratio* Suger reserves for churches, bishops, and his own installation as abbot of Saint-Denis: Suger, *Vita Lud.* (W), pp. 52, 58, 212.

Note also that Suger does not mention the anticipatory association of Philip, eldest son of Louis VI, and recounts that of Louis VII as an episode in the visit of Pope Innocent II to France. His account is curious. While placing equal stress on the crowning and the anointment, it makes Louis VI responsible for both: *"consuluimus ei quatinus filium Ludovicum . . . regio diademate coronatum, sacri liquoris unctione regem secum . . . constitueret. Qui [sc. pater] . . . sacri olei unctione et corone regni deportacione in regem sublimatum, felicem providit regno successorem"* (Suger, *Vita Lud.* [W], pp. 266–68). Also, while stating that Louis VII was made king in the papal council at Reims, Suger does not say that the pope performed the ceremony, although he does note that many took it as an omen of future power that Louis VII had received there the blessing of so many great French and other prelates. The contradiction in stresses may be resolved by reference to the context. Suger necessarily recorded the extraordinary circumstances of the coronation of the monarch during whose reign he was writing (in the process slighting the claims of the see of Reims); but even this account, itself near the end of the *Life of Louis VI* does not suggest that consecration was the primary source of the king's authority, and it does not negate the pattern of stresses seen in the work as a whole. Certainly Suger regarded consecration as an essential element in the creation of a king; he simply drew as little attention to it as possible. The issue is one of balance.

25. Suger, *Vita Lud.* (W), p. 88. Still, the coronation had made Louis king. In this sentence alone he is called *Dei gratia rex Francorum;* in earlier passages he was the *famosus juvenis, defensor regni paterni, dominus, novus dominus, designatus dominus, naturalis dominus, rex designatus,* or *regis filius:* ibid. pp. 14, 20, 26–28, 32–34, 46–52, and elsewhere. In this regard, note that Suger never explicitly states that the French throne was hereditary, but see his designation of Louis as *naturalis dominus* (p. 34), his remarks on Philip I's sons by Bertrada of Montfort (p. 11), and the supposed statement by Hugh of Clermont, from 1102, that he held his land from Louis (p. 20). See also his unfinished biography of Louis VII: Suger, *Frag. Lud.* (M), pp. 147, 149.

26. Suger, *Vita Lud.* (W), pp. 18, 96, 138, 176. For Louis's actions as resulting from his own virtuous character, see pp. 4–6, 88, 176, 180, 232. Against a thesis of divine inspiration, note

Louis's fallibility and mistakes, pp. 158–60, 182–84, 196–98.

27. See also Suger's letter to Archbishop Samson of Reims (Suger, *Let.* [L], pp. 260–61) and his *De consecratione* (as in note 3 here). For a similar idea, see Benjamin Guérard, ed., *Cartulaire de l'abbaye de Saint-Père de Chartres* (Paris, 1840) vol. 2, no. 149 (Luchaire, *Louis VI*, no. 118, from 1111). This act was delivered at the same place and date as, and is textually related to, Tardif, *Monuments*, no. 349 (Luchaire, *Louis VI*, no. 119), which appears to have been written by a scribe from the royal chancery: Gasparri, *L'Écriture*, p. 23. Note that in a charter of Louis VII, from 1143–44, written by a clerk at Notre-Dame at Paris, the same obligations were derived from the royal unction: Lasteyrie, *Cartulaire*, no. 302 (Achille Luchaire, *Études sur les actes de Louis VII* [Paris, 1885], no. 119); Gasparri, *L'Écriture*, pp. 43–44; and Bloch, *Les Rois*, p. 191 n. 1. With regard to kingly status, note also that, in preparation for death, Louis VI wished to renounce the royalty and to die as a monk at Saint-Denis: Suger, *Vita Lud.* (W), pp. 6, 272–74, 284.

28. Suger, *Vita Lud.* (W), pp. 124, 134, 172–76, 180, 182. For the same motives before Louis VI's accession, see pp. 14–18, 24–26, 28, 84. See also p. 274. For citations of such motives in the royal acts, see Lasteyrie, *Cartulaire*, no. 150; Guérard, *Cartulaire*, vol. 2, no. 149; Tardif, *Monuments*, no. 349; Luchaire, *Louis VI*, p. 343 (Luchaire, *Louis VI*, nos. 63, 118, 119, 631). See also the references of note 35 here.

29. See pp. 50–51 here, at notes 19 and 23. This explanation of the scepter and rod is substantially the same as that in the *ordo*: Ward, "Early Version," pp. 355–56. The *ordo* does not, however, apply 1 Peter 2:14 to the sword.

30. Suger, *Vita Lud.* (W), pp. 172–74.

31. Suger, *Let.* (L), p. 259. Cf. the argument that in the twelfth century the French kings, following episcopal models, still gave only a promise (*promissio* or *professio*), not an oath (*juramentum*), at their coronations: David, *Le Serment*, pt. 1, chs. 2–3, and pp. 181–88; and Lemarignier, "Royauté française," pp. 5–7, 13–15. That Suger was apparently unfamiliar with, or inattentive to, the distinction suggests a narrower relevance for those canonical concepts than has sometimes been recognized. In the same sense, note his statement that he had summoned prelates and barons to the assembly at Soissons *"ut secundum fidelitatis nostrae et sacramenti professionem, qua regno obligati sumus . . . provideamus"* (Suger, *Let.* [L], p. 261).

32. Ward, "Early Version," pp. 351, 355, 357. Elizabeth A. R. Brown has informed me that these texts are unchanged in Paris, Bibliothèque Nationale, ms. lat. 14192, fols. 73r–83v, the only manuscript of a coronation *ordo* as yet ascribed to a Capetian circle in the first half of the twelfth century, which she argues was used in the coronation which accompanied the marriage of Louis VII to Eleanor of Aquitaine in 1137. I am grateful to Professor Brown for communicating her findings to me and for permitting me to cite them.

33. Aryeh Graboïs, "De la trêve de Dieu à la paix du roi. Étude sur les transformations de la paix au XIIᵉ siècle," in *Mélanges offerts à René Crozet*, ed. Pierre Gallais and Yves-Jean Riou (Poitiers, 1966), vol. 1, p. 586. The provisions of the peace from the Paris region have not been preserved, but from Beauvais in 1023 see Christian Pfister, *Études sur le règne de Robert le Pieux*

(996–1031) (Paris, 1885), pp. lx–lxi. For Suger on the king's protection of *mercatores*, see Suger, *Vita Lud.* (W), pp. 70, 252–54, 272.

34. *"Pacem patrie, regis fungens officio . . . reformavit"* (Suger, *Vita Lud.* [W], p. 178). See also pp. 24, 28, 42, 88, 180, 254, and esp. 172.

35. Ibid., pp. 124, 134, 174–76, 180. For expressions of similar ideas in royal acts, see Lasteyrie, *Cartulaire*, nos. 150, 154, 155ᵇⁱˢ, 157, 185 (Luchaire, *Louis VI*, nos. 63, 82, 95, 109, 284). Note that these were not uniquely royal functions; see Suger, *Vita Lud.* (W), p. 242, on Charles the Good, count of Flanders.

36. For *regia majestas*, see Suger, *Vita Lud.* (W), pp. 90, 96, 118, 132, 140. For the other terms, pp. 88, 166, 198–200, 250–52.

37. Ibid., p. 160.

38. By contrast, charters of Louis VI and Louis VII do style the royalty a *dignitas*: Lasteyrie, *Cartulaire*, nos. 165, 193, 274, 301, 355 (Luchaire, *Louis VI*, nos. 178, 315, and *Louis VII*, nos. 19, 111, 244); Basile Fleureau, *Les Antiquitez de la ville et du duché d'Estampes, avec l'histoire de l'abbaye de Morigny* (Paris, 1683), pp. 348, 596 (Luchaire, *Louis VI*, no. 161, and *Louis VII*, no. 161). Note that Suger does speak of the papacy as a *dignitas* and that he uses the same term in recording imperial claims (with which he disagrees): Suger, *Vita Lud.* (W), pp. 202, 58. But compare his reference to the *regiae majestatis dignitas* in one of the letters from his regency: Suger, *Let.* (L), p. 246. It is not clear, however, whether this letter uses *dignitas* in the sense of "office" or, instead, of "grandeur" or "excellence."

39. For *animosus*: Suger, *Vita Lud.* (W), pp. 14, 160, 244 (see also *animositas*, pp. 18, 26, 72, 184); for Louis's *manus* or *dextera*: pp. 28, 32 (see also pp. 172, 180); for *audacter*: pp. 8, 72, 164, 218 (*audacia*, p. 34; *audactissime*, p. 196); for *strenuitas*: p. 4 (*strenue*, p. 218); for *militaris vir*: p. 256. See also p. 18 (*fortissimus palestrita et spectabilis gladiator*), p. 80 (*vir pre ceteris cordatus*), p. 142 (*vir militie aptus*), p. 158 (*armatus inter armatos*), p. 160 (*miles emeritus*). For such defense: pp. 124, 134, 174–76, 180, 232.

40. Thus through 1112 almost all of the known charters of Louis VI were dated *"anno unctionis"* or *"anno consecrationis,"* not *"anno regni"*: examples are in Lasteyrie, *Cartulaire*, nos. 154, 155ᵇⁱˢ, 157, 158, 160, 161 (but cf. nos. 150, 159); Tardif, *Monuments*, nos. 347, 349, 353 (Luchaire, *Louis VI*, nos. 82, 95, 109, 115, 142, 136, 63, 123, 140, 119, 146). For Louis VII, see Luchaire, *Louis VII*, pp. 28, 31, and note 27 here. See also, from 1156, ibid., p. 403, no. 368 (possibly written by the monks of Soissons): *"nos obligati ecclesie beatorum martyrum Christini et Crispiani in quorum solemni die, ex divino munere, regiam accepimus sacram."* In addition, Suger's stresses are totally at variance with those of the royal charters in regard to the anticipatory associations of the king's successive eldest living sons (as already noted) and the importance of Louis VI's queen, whom Suger hardly mentions; see my *Royal Succession in Capetian France: Studies on Familial Order and the State* (Cambridge, Mass., 1981), pp. 55–57. I shall treat these and certain related topics in a study of the charters of Louis VI which I am preparing.

Suger and the Capetians[*]

Eric Bournazel

Vague and difficult to define, the concept of the charismatic leader poses problems for the historian. Such a multifaceted individual appears, almost alone, to be able to mold fate and change the course of history. For a long time the study and interpretation of history has emphasized the importance of such key figures. Even today the often hasty and superficial presentation of events, particularly by the mass media, has led to a similar focus on the importance of individual action.

Thus, given the current dissatisfaction with such an approach to history, it might seem strange, even bold, to choose to discuss one man (particularly someone like Suger, whose forceful personality would seem to set him apart from his contemporaries). This undertaking is not, however, as paradoxical as it might at first seem, for my purpose is to place in their proper context—the framework of Capetian government during the first half of the twelfth century—the deeds and life of the celebrated abbot of Saint-Denis.

When they ascended the throne, Louis VI and Louis VII were surrounded by a group of young men, *juvenes*, knights not yet established in the world,[1] and clerics, who also came from chivalric families or, as was true of their lay counterparts, from much humbler origins. Some of these young men filled the positions of the Great Offices of the throne, and others held inferior posts; for many their only "title" lay in their continual proximity to the king. The whole group formed the *familia regis*, the royal household, the retinue of the Capetian king. This group offered constant assistance to the king, accompanied him on his travels, served in his meager army, and guided him in his political choices.[2]

Within this *familia*, outstanding figures sometimes emerged, such as Stephen of Garlande and his brothers or the

family of the butlers of Senlis. But even among such men Abbot Suger holds a special place. Historians have long been interested in Suger,[3] and today he still retains his fascination. He was in many respects the architect of his own fame, recording for posterity valuable accounts of his deeds and his times. But his importance reaches well beyond the story of his own life. Because he served both Louis VI and Louis VII, Suger represents an element of continuity in the palace at precisely the time when institutional changes that characterized the middle of the century were just beginning to be formulated. He was directly involved in the transformation of royal government from an undisciplined and informal system of rule—in which the king, ignored by the great princes and counts of the realm, could depend only upon the clerics and knights of his entourage—to one based on structures and well-defined principles, which already looked forward to the rise of true monarchical authority.

Is it possible to determine more exactly the role and contributions of this man who has traditionally been seen as a faithful companion and most trusted adviser of the twelfth-century kings and, I may add, a far-sighted theoretician of "royal models" that were being elaborated during his lifetime?

Suger, Member of the *Familia Regis*

According to Achille Luchaire, Suger was relatively late in becoming one of the companions of the king, appearing in the royal entourage only after 1128–30.[4] Before this he was part of the entourage of Abbot Adam of Saint-Denis, undertaking at various times missions on behalf of his abbey (in 1107) and also for the king (in 1118 and 1122).[5] Luchaire's analysis, however, has the disadvantage of drawing too sharp a distinction between Suger's

Notes for this essay begin on page 66.

monastic and political activities. Suger is indeed mentioned with greater frequency in royal acts after 1130, and his appearances at the royal court increased until his death in the middle of Louis VII's reign,[6] but, from 1124 on, the king described him as *"fidelis et familiaris."*[7] Suger had, for some time, circulated among the *familia regis;* in his abbey, itself tightly linked to the monarchy, he had (over the years) paved the way, and earned the right to enter the royal entourage, with which he would one day become so perfectly integrated.

Like so many members of the royal household,[8] Suger's origins were humble. Employing a classical style— *non sum dignus domine*—in his account of his election as abbot, Suger reported his elevation "from the lowest to the highest" and spoke of the "inadequacies of his birth."[9] His remarks are not simply rhetorical; in this case his words should be taken literally. His indulgent biographer, the monk William, wrote: "The enemies of this illustrious man reproached him for his humble origins; blind and demented, they failed to see that he deserved more praise and glory for having made himself noble than he would have for being born of noble parents."[10] William's words echo those of Aubri of Trois-Fontaines, writing of Walter the Chamberlain, Louis VII's *familiaris: "Fuit nobilior gestis quam genere"*[11] (He was nobler in deeds than in family).

Suger's humble origins do not necessarily mean that he was of servile descent.[12] But, had this been the case, the abbot would not have been the only one of such status in the palace. At the end of the tenth century the probable ancestor of the butlers of Senlis, Rothold, who possessed the title of knight— *miles*—had claimed to be the heir of one of his serfs, Renaud. Later, in 1112, Henry le Lorrain (a royal servant dedicated to the cause of Stephen of Garlande) who also boasted of his recently acquired title of knight, was accused of being of servile extraction; and correctly so, it would appear, even though the accusation was dismissed. Further, in 1129 Louis VI, attempting to profit from the servile condition of his chamberlain, Valgrin, exercised the right of escheat and seized the deceased's property.[13]

Suger perhaps shared with the king a common experience of childhood, as *nutriti* at the abbey of Saint-Denis; and, if this could be clearly established,[14] it might explain the ties that later united master and servant. But these ties between the king and monk could also have resulted from the patronage of Stephen of Garlande. The chronology of their relationship supports such an interpretation. Suger began to appear in the royal entourage just when the Garlande family was powerful—not only Stephen but also Anselm, William, and Gilbert. The Garlande family had captured all the great offices of the household, except for that of constable; they had supplanted all possible rivals, such as the Senlis, with their own men.[15] In his *Life of Louis VI,* written much later, in 1144, Suger himself emphasized the exploits of the Garlande seneschals, Anselm and William,[16] and, although

mentioning the quarrels between Louis and the Garlandes (especially those involving the seneschalsy),[17] he did not, like the chronicler of Morigny,[18] dwell on them. A further link between Suger and Stephen of Garlande is provided by Peter Abelard, who in 1122, while a monk at Saint-Denis, contested the requirement that he reside at the abbey. The case was laid before the king. Stephen of Garlande represented Suger but convinced him, in accordance with the general opinion of the royal court, to drop his initial intention of insisting that Abelard remain at Saint-Denis and let him live wherever he wished.[19] Finally, there is the testimony of Saint Bernard, who in 1128, while writing to Suger to express his surprise at the abbot's sudden *conversio* and to congratulate him on the reform the latter had recently introduced into the monastery, did not hesitate to link Suger with Stephen of Garlande, recalling their long-standing friendship.[20]

In light of this relationship it seems futile to contrast, as is often done,[21] the canon/seneschal Stephen (*canonicus/militaris*),[22] who also came from modest origins but had enriched himself through royal service, with the monk raised and elevated through service to the abbey. Because he belonged to Saint-Denis, Suger was an integral part of a relatively structured royal system that, like the court, worked for the king's benefit.[23]

At the beginning of his monastic career Suger was entrusted with the *obedientia* of the *prévôté* of Berneville.[24] He subsequently obtained the administration of another *prévôté,* that of Toury, the most important of the abbey's *villae,* a *villa caput aliarum.*[25] In 1111 the king, with Abbot Adam's consent, ordered Suger to fortify this domain against the encroachments and attacks of Hugh, lord of Le Puiset, who had seized the castle of Toury.[26] To fulfill the royal command, Suger had a three-storied tower erected and set about organizing a garrison of *milites* recruited from the men of both king and abbey.[27] This force laid seige to the castle three times in two years until it was finally won. The domain was not finally stabilized, however, until soon after Suger's election as abbot. By this time the fief of the avowery had passed by inheritance to the granddaughter of Adam of Pithiviers. Suger arranged for the young woman's marriage—with the king's authorization (*"favore domini regis de cujus feodo advocatio constabat"*)—to one of the *juvenes domestici* of the monastery.[28] At the same time, he purchased or reacquired fiefs that were obligated to provide guard service (*stationes*) for two months at the castle of Toury.[29] Thus the abbey of Saint-Denis commanded, through the intermediary of its *ministri,* both monastic and lay,[30] a certain number of small, closely linked bands of vassals, which gravitated around the royal household and which the abbey could at a moment's notice assemble and call up for royal service.[31]

This kind of activity—undertaken while the Gregorian reform was at its height—necessarily involved the abbot and his monks heavily in secular affairs. Abelard recognized clearly that the attempt to profit from participation in the *conseil du roi* meant

that a less than regular monastic life, *minus regularis,* was maintained at the abbey.[32] Bernard of Clairvaux's diatribe against Saint-Denis becomes intelligible in this light; he complained that "this place customarily serves the royal army" and that "the company of monks had to pay for the support of knights."[33] Finally, Suger himself was aware that to command men-at-arms in order to pacify, for example, the Vexin,[34] was hardly a task prescribed by the Rule of Saint Benedict, and such enterprises troubled his conscience. Yet it was by performing these secular tasks that Suger was able to gain the confidence of the king and his entourage[35] and to merit the missions entrusted to him *pro quibusdam regni negotiis,* even if he was not always sent alone.[36] Through such enterprises and with such support Suger prepared for his entry into the *familia regis,* while at the same time promoting his career at Saint-Denis.

In the twelfth century, participation in the royal entourage, and its resulting proximity to the Capetian king, was an occasion for self-enrichment. A new attitude to enterprise and profit[37] appeared among the recently ennobled servitors of the king. Stephen of Garlande, for example, built palaces, accumulated domains, and amassed treasures.[38] With all due respect to William's laudatory biography,[39] Suger behaved in precisely the same way, although he was fundamentally less corruptible than Stephen.[40] Perhaps it was because of his modest origin and the poverty of his lineage that Suger was throughout his life attracted to and fascinated by wealth. There is no doubt that Suger benefited greatly from his participation in the royal *familia* and from his position as abbot of Saint-Denis. Over the years he acquired and enormously enlarged a personal patrimony that contrasts strikingly with the meagerness of his original possessions. The legacies recorded in his will[41] give some idea of his fortune, and an examination of *De administratione* permits us to observe the grandeur of his way of life. He is known to have given stained-glass windows to Notre Dame, Paris.[42] When Louis VII left on Crusade, he "restored the royal mansions, rebuilt walls and towers," and, "so that nothing might be lacking for the honor of the realm," gave the royal knights their customary fees (*fief-rentes*) and distributed to them on appointed days (*certis diebus*) the clothes and presents that were their due. "And all that," William reported, "he paid for out of his own munificence, without resorting to the royal treasury or to public funds."[43]

To be sure, Suger's wealth was amassed more discreetly and with less scandal than was that of Stephen of Garlande, but it existed nonetheless. Suger accumulated wealth for and with the help of Saint-Denis,[44] which he considered linked to the royal cause. But he also derived from the process considerable personal satisfaction. Evidence of the enormous pleasure it afforded him is provided by the minute detail with which he described the precious gifts bequeathed by Louis VI to the abbey shortly before his death.[45] He took an almost naïve pride in the jewels he had ac-

quired,[46] and the gems he had used in the exquisitely executed works of art he commissioned for Saint-Denis (retables, crosses, reliquaries, and shrines),[47] works that adorned the church and surrounded the Holy Martyrs and Suger himself in an aura of splendor. The contemplation of these treasures and works of art, with their sparkling and multicolored gems ("sardius, topaz, jasper, chrysolite, onyx, beryl, sapphire, carbuncle, and emerald"), produced in Suger a state of mystical ecstasy and dreamlike delirium: "Thus when—out of my delight in the beauty of the house of God—the loveliness of the many-colored stones has called me away from external cares, and worthy meditation has induced me to reflect, transferring that which is material to that which is immaterial, on the diversity of the sacred virtues: then it seems to me that I see myself dwelling, as it were, in some strange region of the universe which neither exists entirely in the slime of the earth nor entirely in the purity of Heaven; and that, by the grace of God, I can be transported from this inferior to that higher world in an anagogical manner."[48]

Whether or not Suger wrote such passages to justify himself,[49] and whether or not he used Saint-Denis as a pretext to store up treasures, his attitude was extremely common at the time. Three of his nephews made careers, or attempted to do so, in churches closely associated with the monarchy or with the king himself. One of them, John, was sent to Rome to defend the interests of Saint-Denis. Another, Simon, served as chancellor for a few months in 1150–51. A third, also named Suger, later became a canon of Notre Dame, Paris.[50] The Garlande and Senlis families and, under Louis VII, the descendants of the chamberlains Adam and Walter of Nemours, all behaved similarly, monopolizing lay offices and ecclesiastical dignities for their families.[51]

Suger thus gradually made his way into the royal entourage, exhibiting many of the characteristics shared by other members of the *familia.* His background, outlook, and behavior was like theirs; he distinguished himself from them only, perhaps, by his legendary moderation. In the first half of the twelfth century the royal household was a relatively cohesive body, composed of the companions of the king, but this cohesiveness did not prevent individuals, Suger among them, from achieving personal prominence. Did such prominence, however, mean that their advice was heeded?

Suger, Counselor to Kings

Suger's biographer presents him as a universal man in the service of the king: at once a respected counselor whose advice was valued, an attentive intercessor, a zealous mediator, and an impartial judge.[52] Even if such a view contains elements of truth, it obscures the fact that Suger was not the only member of the royal entourage. As one of a group of royal servants, Suger took his place within a number of concentric circles of influence that

gravitated around the king. The vocabulary used to describe the royal entourage reflects the roles played by the different members of the royal court.

In certain royal charters Suger figures among the *testes,* the more or less passive witnesses to the adopted measure, either for the king or for the person requesting the act.[53] In other charters only his presence is mentioned.[54] On rare occasions the adjective *fidelis* is appended to his name,[55] although it should be noted that the royal chancery—following Carolingian practice—granted this title to many.[56] It is, however, interesting to note that Suger is never called *fidelis* alone. The use of the superlative *fidelissimus* to designate him, especially in the king's correspondence, signifies more than merely the old vassalic relationship.[57] *Fidelissimus* is most frequently applied to Suger in association with other terms, such as *familiaris* and *amicus,*[58] both indicative of the status he enjoyed at the royal court.

Familiaris was a title reserved for only a few members of the royal entourage—such as Stephen of Garlande, Blanchard of Lorris, Aubert of Avon (who accompanied Louis VII on Crusade and died overseas), Thierry Galeran (an enemy of Queen Eleanor), Cadurc, and Bouchard le Veautre. In his biography of Suger, the monk William reluctantly mentioned Suger's frequent absences from the abbey, due to his virtually constant service at the royal court: *"pro publicis vel regni vel Ecclesiasticae utilitatibus."*[59] The king and his companions, in their continual peregrinations throughout the realm, shared a common life, and this sharing of bread and wine, together with the joys and cares of power, made them a closely knit band. The term *familiaris*— derived from *familia* but less imbued, in the twelfth century, with connotations of dependency or servility—perfectly expressed this form of palace life, which encouraged easy access to the king and the growth of affective bonds. Certainly, the king's companions were also his vassals, deriving from him the essentials of their feudal or seigneurial power. But when they offered their counsel to the king, they did so not by virtue of the *consilium* that every vassal owed his lord, but in their special capacity as *familiares.*[60]

It was the *familiares,* the *laterales regis* (those at the king's side) who supplied the king with the counsel denied him by the great barons, or provided only reluctantly. The old solemn assemblies of all the king's vassals still convened, but the absence or gradual disappearance of the high aristocracy made this ancient form of government illusory. The reality of power now rested in the hands of the king's *familiares,* whose advice was sought before any decision, however significant, was implemented. Numerous passages in Suger's *Life of Louis VI* reveal the collective influence and role of the royal *familia,* as he described the king, beseeched from all quarters (*prece multorum*) and acting *consilio familiarum* (on the advice of the *familiares*).[61] By their counsel rebellious counts and lords were pardoned, hired assassins cheated the gal-

lows, and the consecration of the future king was decreed.[62] The king sought their advice before granting the duke of Aquitaine's request that he watch over the duke's lands and accept wardship of his heiress Eleanor. Similarly, in consultation with his *familiares* after the death of William of Aquitaine, the king decided to marry his son to Eleanor. Suger, describing Prince Louis's escort to Aquitaine in June of 1137, emphasized the presence of royal *familiares: "nos autem familiares ejus et quoscumque sanioris consilii repperire potuit ei concopulavit."*[63] The *familiares* were no longer merely youthful companions of a king; they had a political role to play.

Sometimes the term *amicus* reinforced or even replaced *familiaris.*[64] The king numbered a few friends among his *familiares,* such as the seneschal Ralph of Vermandois and Abbot Suger. Certain formulas demonstrate that *degrees* of friendship also existed: for example, *rarissimus amicus Sugerius, carissimus amicus.*[65] These amplifications carry with them the idea of intimacy and even of affection or emotion. In such affective ties lay the special quality of the privileged bond uniting the king with a small number of those close to him; and here, equally, lay the strength of individuals like Suger.

The abbot describes how Louis VI was accustomed to let himself go in the company of his intimates: *"sepe intimis ingemiscendo querebatur."*[66] They consoled him in painful times, as when, in October 1131, Louis lost his eldest son, Philip.[67] The king may have joked with his knights and governed with the help of his *familiares,* but he confided only in his most intimate friends, thus expressing the high esteem in which he held them and his profound need of their presence. William underscored the special nature of this relationship when he wrote: "In Suger's absence, the palace seemed empty." And again, a few lines earlier, in writing of Suger's talent as a historian, he emphasized the abbot's special closeness to the kings he had served: "Who could better know or more faithfully report such deeds than he who lived in intimacy with both kings; from him no secret was hidden nor was any decision undertaken without his counsel."[68] Indeed, what could have been more natural for the king than to favor the counsel of his intimates and to follow the advice of those who, like Suger, deserved his trust?[69]

We should, however, be careful not to overestimate the importance of individual influences on the king at the risk of neglecting the context in which such influence was exercised. Suger himself reveals the collective nature of counsel when he depicts himself, in the *Life of Louis VI,* acting in concert with other members of the royal entourage to shape royal actions.[70] To a certain extent the same picture emerges from the beginning of his *History of King Louis VII.* Suger was involved, together with other members of the royal entourage, in the quarrel between the young Louis on the one hand and his mother, Queen Adele, and the seneschal Ralph of Vermandois on the other.[71] In 1138, when

a commune was established in Poitiers, Suger joined with other royal counselors in preparing the king's response.[72] Throughout his writings Suger emphasized his personal activity on behalf of the king. When Queen Eleanor, in order to salvage her dowry, threatened to leave Louis VII, Suger purportedly told her: "You can repudiate France, for she has never lacked for spouses."[73] He also urged the king to seek an alliance with Count Theobald IV of Champagne.[74] In the course of the negotiations, Suger exercised his talents as a mediator, a gift displayed yet again when he sought to temper repressive measures imposed on the Poitevins.[75] Suger seems fully conscious of his place and role in the government of the young king.[76]

There is no doubt that Suger's influence as a counselor increased during the reign of Louis VII.[77] This was only to be expected in view of the years he had spent at the royal court and the quality of the services he had rendered. In the essentially new entourage that Louis VII had assembled, Suger represented the wisdom of a man older and more experienced in royal affairs. William probably had the young Louis in mind when he wrote, doubtless with a touch of exaggeration: "The prince venerated him as a father and respected him as a master because of the integrity and soundness of his counsel."[78]

As could be expected, Suger's role assumed even greater importance during the Second Crusade. At the assembly at Étampes, on February 16, 1147, three regents were designated to watch over the kingdom in the king's absence: the abbot of Saint-Denis; the archbishop of Rheims, Samson Mauvoisin; and Count Ralph of Vermandois.[79] Suger swiftly gathered all authority into his own hands, becoming in law as well as in fact the only real regent,[80] using the pope's appointment of him as regent as additional support for his authority while clearly remaining the king's man.[81]

Royal directives often came to Suger alone; and, since he acted in the king's stead, his activities covered all aspects of royal concerns. The king, prey to a multitude of financial difficulties, constantly requested funds from Suger, who responded by stabilizing royal finances, reimbursing creditors, and sending Louis the sums demanded. Suger imposed his authority on the royal agents whose accounts he received. Appeals for justice and protection were addressed to him.[82] Similarly, he involved himself in the king's ecclesiastical affairs, confirming the elections of the bishops of Autun, Bourges, and Noyon, and the prior of the abbey at Corbie.[83] Finally, he succeeded in stamping out the rebellion of Robert of Dreux against his brother, Louis VII.[84] It is not surprising, therefore, that on the king's return he invited Suger, alone of the three regents, to meet with him and report on the state of the kingdom.[85]

After 1149 Suger's decisive role in Capetian government was fully confirmed by the king's gratitude. Even more than the testimony of William, Suger's correspondence and his diplomatic activities testify to his influence. More than ever he appears as a mediator, a conciliator, a man of peace, a negotiator so skilled that even the most powerful figures of the time, such as Stephen of England and Geoffrey, count of Anjou, did not hesitate to seek his support or intervention in their dealings with the king.[86] Above all, just as he had done during the king's absence, he continued to dominate the affairs of the church by the force of his personality. With Louis's agreement, on May 7, 1150, he convoked a solemn assembly, first at Laon, then at Chartres, to consider a plan for a new Crusade.[87] In 1150–51, at the pope's request, Suger acted as mediator in replacing the canons of Saint-Corneille of Compiègne with regular monks, his role in the affair being ratified by the king.[88] A few months later Louis VII charged him with solving problems related to the elections to the sees of Laon and Arras.[89]

Summing up Suger's activities in ecclesiastical matters, William declared: "By his order ecclesiastical offices were bestowed or withdrawn; with his consent bishops-elect were consecrated and abbots were ordained."[90] Is this an exaggeration? Somewhat, perhaps, but not entirely. The tone of certain letters sent to Suger demonstrates that he was treated by prelates and abbots with great respect, even deference.[91] Further, some did not hesitate to ask him to intercede with the king on their behalf when they wished to be excused from one or another convocation.[92] In such cases the will of the master merged with that of the servant, as also shown in a letter of 1151 from Louis VII to Suger: "Voluntas enim vestra, nostra est; et nos consilium nostrum reposuimus in vobis."[93]

We should not be deceived, however, by this seemingly perfect community of thought and deed. As Achille Luchaire noted, Suger was not "the sole inspiration of the young king's policies during the first ten years of the reign," or even later. In a number of important cases his advice was not followed, as, for example during the conflict with Pope Innocent II or during the war with the count of Champagne.[94] A decision as crucial as that of undertaking the Second Crusade was made, it would seem, in the face of Suger's opposition.[95] And in the end Louis VII took little heed of Suger's prudent and moderate advice when, shortly after the abbot's death, he divorced Eleanor of Aquitaine.[96] William, although he passed over the other matters in silence, confirmed this point: "It is a fact that from the time when the abbot of Saint-Denis was admitted into the councils of the prince until the moment he ceased to live, the realm enjoyed a continuous prosperity, amply extended its territories, triumphed over its enemies, and attained a high degree of splendor. But scarcely had this man been taken from the realm of the living when France began to suffer grievously. Thus it is today, through the loss of such a worthy adviser, despoiled of the duchy of Aquitaine, one of its most important provinces."[97]

The balance struck by William as a panegyrist is interesting. On one hand, he rightly recalls the often preponderant role Suger

played in the affairs of the realm, although his portrayal is often simplistic in that he considers Suger's presence at the court as inevitably a source of good, while Suger's absences lead to a reversal of royal fortunes. But, clearly, William's principal merit lies in restoring Suger's deeds to the institutional and collective framework in which he acted. In William's treatment, there are other *familiares* besides Suger, other counselors whom the king also trusted and to whom, if necessary, he confided important missions.[98] Which is only to say that Suger's counsels, often followed but from time to time rejected, represented but one voice among many, as he was but one councillor among others.

In fact, it was during the first half of the twelfth century, when Suger entered and came to dominate the royal entourage, that structural transformations in Capetian government were first instituted. With Suger and his peers, the idea slowly developed that the *familiares* should form around their master a sort of small council, permanently available to assist him and guide his political choices. Although the existence of such a council was not reflected in royal charters until after 1150,[99] contemporaries were aware of it. Thus Abelard, in appealing to the king and his council,[100] linked the presence of *consiliarii* to a meeting of the council. The institution of the council as it was elaborated in the second half of the century—as a special delegation from the *curia,* distinct from the services of the household, the *domus*—stems directly from the gatherings, however informal, of the *familiares* around the king, and its institutionalization brought increased stability to its functions.

Can this transformation be attributed to any single individual? It is difficult to say, although it is noteworthy that Suger governed his monastery along essentially the same lines. Before making a decision, he customarily secured the consent of the brothers: *"communicato ex more cum fratribus nostris consilio . . . unanimiter assensum praebuimus."*[101] Among them, and among others as well, he had his own *familiares,* his friends, such as William or Geoffrey, in whom he willingly confided and whose support he valued: *"auxilio Dei et hominum atque amicorum nostrorum consilio."*[102] In this context William's statement acquires its full meaning: "The abbot performed his double office in such a way that service at the royal court did not prevent him from fulfilling his ecclesiastical duties, while those of the monastery did not remove him from the royal councils."[103]

Suger appears, thus, both as a principal witness to, and often essential participant in, the politics of the royal court in the mid-twelfth century. To what extent, through his deeds and writings, did he influence the elaboration of the theoretical models the monarchy was attempting to put into practice?

Suger, Theoretician of the Monarchy

In the twelfth century, a hierarchical model of royal authority was beginning to be articulated in the royal entourage. This majestic vision revealed a new conception of royal power and service. At the same time, it reflected the aspirations of the counselors insofar as it directed toward the king an ever-widening current of popular legends and beliefs. The Capetian king was depicted as dominating forces that, until then, had opposed his actions, imposing himself everywhere and over everyone under the benevolent aegis of God and his patron saint, Saint Denis.

The twelfth century witnessed the creation of a new model of feudal hierarchy—a pyramid resting on a fixed structure with the fief at its base and the king at its summit. Little by little the idea emerged of a sovereign king who ruled over men because he ruled over the land.[104] The notion of *mouvance,* which expressed this concept of authority, is already delineated in Suger's writings, although he did not work out all its implications.

In his *Life of Louis VI,* Suger used the term *feodum* to designate principalities and justified the king's preeminence over the great barons of the realm on the basis of his overlordship. Thus, he put into the mouth of Louis VI's envoys, meeting with Henry I of England in 1109, the following words: "Through the generous liberality of the king of France, your efforts have gained you the duchy of Normandy as a fief, which you hold by the munificence of his right hand."[105] Further, he held that "the king of France, confident in the high position that gave him lordship over the king of England and duke of Normandy, always rose above him as over his feudal dependent."[106] Finally, Suger had the duke of Aquitaine address the king in the following manner: "Since the count of Auvergne holds Auvergne from me, which I in turn hold from you, if he has committed any wrongs, it is my duty, at your behest, to ensure that he appears at your court."[107] To be sure, Suger emphasized the personal tie of homage, but such homage had its roots in the tenure of land, here defined as an entity and appearing as the true basis of the vassalic relationship. The theory of *mouvance* was still evolving, and its expansion was facilitated by a clearer conception of the realm and of the crown.

In a few, and still ambiguous passages, Suger restricts the term *regnum,* in the sense of *Francia,* to the Ile-de-France.[108] But in his writings *regnum* recovers its original, wider meaning. Around 1150, both in his works and in acts of the royal chancery, the notion of the realm became bound up with that of the crown, itself now defined as an abstraction, distinct from the royal person.[109] Fidelity was no longer sworn only to the king but to the realm and the crown as well. Thus, in 1149, Suger made fidelity to the king and to the realm the customary condition for the return of the *regalia* to Bishop Goslin of Chartres.[110] In 1150 he invited the bishop of Beauvais, Henry (Louis VII's brother), to undertake nothing against the king and crown, on which everyone, prelate and baron alike, depended; the same year he referred to the fidelity such men owed the realm and crown *"qui, ex jure fidelitate quam regno et coronae debent."*[111]

The royal edifice was now in place. At the summit of the hierarchy of lands was the kingdom. At the summit of the pyramid of vassals, at the highest point in the system of *mouvance,* was the king and, on his head, the crown, which both enhanced and exceeded his authority, giving to royal action its institutional continuity. Such a theory emerged from a variety of sources. Some have pointed to the success of the idea of hierarchy developed in the Church by Gregorian reformers. Also relevant is the model furnished by the development of the monastic orders of Cluny and Cîteaux, with their orderly arrangement of mother abbeys and daughter houses. And, of course, there was the abbey's system of hierarchically arranged *villae,* to which the feudal lords and knights of the church were attached.[112] Once again we are brought back to Saint-Denis, where Christ's crown of thorns was piously preserved[113] and where, beginning with Louis VI, the royal insignia were deposited. The abbey had had in its possession since Carolingian times treatises attributed to the "thrice-blessed Dionysius," in which "the universe was conceived as a succession of degrees leading to God in a pyramid of light."[114]

If Suger's influence in implementing an idea of royal suzerainty at the highest level is clear, his theory of *mouvance* was in many respects limited by the novel interpretation he proposed in relation to the county of the Vexin, the monarchy, and Saint-Denis. In order to explain the continual royal interventions in the Vexin on the abbey's behalf,[115] Suger did not hesitate to present Louis VI as a feudal vassal of Saint-Denis by virtue of his possession of the county, which had passed into the territory of Saint-Denis under Philip I. While he recognized that the king's royal dignity exempted him from the ritual performance of vassalage,[116] his analysis required that the king occupy a second, and intermediate place in the chain of tenures.[117] Suger was still far from delineating the kind of rigorous conception of *mouvance* that would be expressed in thirteenth-century customals in the formula: "The king holds from no one."[118]

If Suger thought to justify canonical laxity in the administration of the Vexin, he did so on the basis of what he believed was a privileged relationship between the king and the Holy Martyr, a relationship he himself had helped develop and exalt.

From the end of the eleventh and throughout the twelfth centuries, there was a growing tendency to link the Capetian monarchy with Saint Denis and, through him, to recuperate the Carolingian legend. To this end a number of documents were forged, narrative accounts fabricated or rewritten, and "miracles" effected.[119] The whole enterprise, which lasted almost a century, was clearly the work of the monks of Saint-Denis and, in addition to them, of the royal *familiares,* for whom the abbey was the preferred sanctuary. Suger's abbacy, from 1122 to 1151, occurred in the midst of this activity. Is it possible to reconstruct and define the role he played in the "creation" of this legend?

An initial historical narrative, the *Descriptio qualiter Karolus*

(chart: C), fabricated by a monk from Saint-Denis around 1080–95, aimed at authenticating the relics of the Passion—the nail and crown of Christ—brought back from Constantinople by Charlemagne and subsequently donated to the abbey by Charles the Bald.[120] Following this, in the first half of the twelfth century, the monks used a *History of Charlemagne and of Roland,* purportedly the work of Archbishop Turpin, one of Charlemagne's legendary companions on the expedition to Spain. The text, now known as the *Pseudo Turpin,* was the product of successive revisions and had been profoundly modified at the end of the eleventh and the very beginning of the twelfth centuries by Cluniac monks, at that time firmly settled in Spain, who used it as a weapon to assert the primacy of Santiago de Compostela to the detriment of other Spanish churches, notably that of Toledo. In their version (chart: E) the monks of Saint-Denis used the claims to primacy over the Spanish Church found in the Compostelan manuscript as the model for similar claims to primacy over the French Church, having Charlemagne assign to the martyr Denis a position comparable to that of Saint James on the Iberian peninsula.[121]

At still another time the monks forged a false donation charter, supposedly given by Charlemagne to the abbey (chart: G; DK 286), which was based almost word for word on the *Pseudo Turpin* and which represents the final stage in the elaboration of a theory of royal power according to Saint-Denis.[122] In this charter, the abbey was presented as the royal sanctuary *par excellence,* the primatial church of France, standing at the head of all other churches, *caput omnium ecclesiarum regni.* By the same token its abbot was made primate over all other prelates, and without his assent or counsel no archbishop or bishop could be elected, confirmed, or condemned in Rome. A further clause specified that after his consecration the king should be crowned only at Saint-Denis. In the false charter, Charlemagne declared that he held his realm from God through the intermediary of Saint Denis. In recognition of the saint's lordship, the emperor placed his crown on the altar and entrusted the abbey with the safekeeping of the royal insignia. In a final act of submission—also copied from the Compostelan legend—Charlemagne granted to Saint-Denis a *chevage* (head tax) of four gold bezants and requested the great barons and nobles of the realm to do likewise. Each household was required to make this contribution, through which "all men reduced to servitude were emancipated and made free forever." The king of France thus became, as he was so often called in the *chansons de geste,* the "king of Saint Denis," strengthened and liberated through service to the saint.

This forged donation charter contains more than the claims of the monks of Saint-Denis to primatial power in the French Church; equally apparent are the aspirations of the royal *familiares,* who also were elevated and liberated through service to the king, now identified with service to Saint Denis. Furthermore,

under the powerful patronage of Saint Denis and Charlemagne, the monarchy laid claim to total control over the church of France despite the efforts of Gregorian reformers to limit the scope of lay authority in ecclesiastical affairs, and, to a certain extent, to the detriment of Reims's primacy.[123]

The dating of this false donation charter of Charlemagne has posed problems for historians. Robert Barroux suggests a date of 1124 and attributes the document's fabrication to Suger. C. Van de Kieft, on the other hand, places it between 1156 and 1165, during the abbacy of Odo of Deuil. He connects it with the forging, slightly earlier, of another false charter of Charlemagne (chart: F; DK 282), created to affirm the rights of Saint-Denis over certain churches in Berry. Van de Kieft's reasoning is based on internal criticism of the two acts, and also on moral considerations relating to Suger's character. Reminding the reader of Suger's stature as an *"homme probe et intègre,"* he peremptorily concludes that "such a man would never indulge in the forging of false acts."[124]

But is this absolutely certain? Suger's writings touch on a number of themes that reappear at the heart of the forgeries: the apostolicity of Saint Denis; the saint's patronage; and the deposition of the regalia at the abbey. Some of these ideas were old, but Suger developed them so as to extract their ultimate implications, never hesitating to distort historical truth or to designate as "customary" events or rights that were, in fact, without precedent, either immediate or of long standing.

Thus, for example, an ancient and continuous tradition viewed Saint Denis as the evangelist of Gaul. A charter dated 723 recalled that the mission to evangelize Gaul had been conferred on the saint by Pope Clement in the first century.[125] Again, in 1008, the preamble of a charter granted by Robert the Pious at the request of Abbot Vivien stated that Denis had been charged by God with the task of rescuing Gaul from the shadows of unbelief.[126] But nowhere in these texts was the saint presented as an Apostle. Suger, on the other hand, went further. In his *Life of Louis VI* he placed in the mouth of Pope Paschal II as he knelt before the relics of the saint while visiting the abbey in 1107 the following words: "Deign, we beg you, however small a part of the clothing of this holy man, whom we, without murmur, sent to be the Apostle of Gaul."[127] This theme of Saint Denis's apostleship Suger would reiterate in his *De administratione.*[128]

At the beginning of his history of Louis VI Suger asserted that even as a youth the king, "following ancient custom, as attested to in imperial acts of Charlemagne and other excellent princes, bound himself to the Holy Martyrs at Saint-Denis and to their servants."[129] Brought up at Saint-Denis in constant contact with the monks, Louis had been inculcated with the Martyr's power and his benevolent role on behalf of the monarchy. Here we encounter the theme of Saint Denis as patron and protector of the kings of France. It, too, was an old idea, which first appeared in

a charter of Clothar II in 625[130] and which was frequently repeated in Merovingian, Carolingian, Robertian, and Capetian acts up to the reign of Philip I.[131] In each of these charters Saint Denis extended his protection over a given king, and this induced the Capetian kings, with the exception of Philip I, to be buried at Saint-Denis.[132] In Suger's handling of this theme, the saint's protection encompassed not only the king but the realm as well. Thus he wrote of Louis VI: "Various accounts and repeated experiences taught him that Saint Denis was the special patron and, after God, unequaled protector of the realm."[133]

All that remained was for Suger to recall the fact that the dead kings of France had found their final resting place beside their titular protector. Thus, he wrote, Louis VI's oldest son, Philip, was buried in 1131 in the church of Saint-Denis, *more regio,* "according to royal custom."[134] Suger was perfectly aware that Louis's father, Philip I, had chosen to be buried, in July 1108, at Saint-Benoît-sur-Loire, a disturbing breach of tradition that he felt compelled to explain—with some embarrassment. He cited the testimony of witnesses, who claimed to have heard from the old king that "Philip I had determined to be interred far away from the sepulcher of his forefathers, the kings—a burial place, he specified, that by natural right was the church of Saint-Denis—because he had treated this church with less benevolence than had his ancestors." Thus he feared being buried there, "among so many noble kings," because "no one would attach any great importance to his tomb."[135]

Happily for Suger, Louis VI did not fail to conform to the "rule": out of respect for right and custom (*fas et consuetudo*), he was interred at Saint-Denis, following royal custom (*more regio*), not far from the Carolingians Charles and Carloman, whose successor he considered himself.[136] Furthermore, shortly before his death on August 1, 1137, Louis, feeling the end near, had expressed the wish to retire to the monastery. According to his biographer, he asked "to be taken close to his protectors, the Holy Martyrs Denis and his companions, and, renouncing his kingdom and crown before their blessed relics, exchanging crown for crown, the humble habit of Saint Benedict for the insignia and trappings of royal power, to make his profession as a monk."[137] This is more than a simple image. According to Suger, in effect, the crowns of deceased French kings belonged by right to the Holy Martyrs.[138]

Louis VI, however, had proven somewhat remiss in fulfilling promptly this pious obligation. Only in 1120 had he returned to the abbey the crown of his father, Philip I. On this occasion he granted the abbey a charter in which a number of themes dear to Suger (not yet abbot) appeared. The king, "on the advice of his palatines," declares that he is restoring his father's crown "in accordance with the right and custom of the kings of France," which holds that "the insignia of dead kings" be deposited with Saint Denis, "[their] guide and protector."[139] The same scene is

related in the *Life of Louis VI*, but Suger set it four years later, in 1124: the king, in gratitude to Saint Denis, who made it possible for him to triumph over the German emperor without doing battle, now renders to Saint Denis what is owed him, namely "his [Louis's] father's crown, which he had unjustly retained."[140] The chronological error is obvious, but was it simply a mistake or a deliberate distortion?

In 1124, threatened by the invasion of the German emperor Henry V, Louis VI had gone to Saint-Denis to beseech the Martyr to defend the realm and to receive from the altar the battle standard of his lord, Denis, which, it was thought, would increase tenfold the ardor of the combatants.[141] Once again a royal charter was granted, and Suger's presence was expressly mentioned. The king acknowledged himself to be the saint's vassal and thus permitted to bear his standard in war. He acknowledged the Holy Martyrs as his guides and protectors and granted the abbey revenues to maintain their precious relics. Finally, he affirmed that their patronage was exercised at a level above all others in the realm, *in capite regni nostri*.[142]

Given the importance and impressiveness of this event, it is difficult to believe that even twenty years later Suger's memory could have confused it with Louis's earlier deposition of the royal crown at the abbey or with the charter enacted at that time. It was simply too tempting for him, even if it meant misrepresenting the truth, to merge the two events into a single and crucial moment in the history of the kingdom. By means of this chronological sleight of hand, Suger, while exalting the beneficent power of Saint Denis, was able to justify both the king's devotion to the abbey and his submission to the saint, marked respectively by the taking of the saint's standard and by the deposition of the regalia. The primacy of Saint-Denis in the kingdom was thus firmly established, and the elements derived from the *Pseudo Turpin* (chart: E) and the false donation charter of Charlemagne (chart: G) set into place.

This is not all. Around 1140, when the abbey had already been in possession of a copy of the *Pseudo Turpin* since ca. 1124–35,[143] ritual and still more forgeries were used, clearly on Suger's initiative, to establish a relation between the two "Apostles," Denis and James. In the church of Saint-Denis, beneath the Matutinal Altar, were discovered an arm of the Apostle James, together with, on its right, an arm of Stephen Protomartyr; and, on its left, one of Saint Vincent. Suger chose the Feast of the Holy Martyrs as the day for the exhumation of these precious relics. A great number of archbishops and bishops had gathered at the abbey for the occasion, "with gratitude and to pay their due respects to the Apostle of Gaul," Suger reports. Some of them, however, remained skeptical. Suger himself was quite certain of what he would find in the compartments beneath the altar, but, had he made the original discovery in secret, perhaps some doubts would have still lingered. The best solution was to let everyone witness the exhumation and, in so doing, silence any disbelievers. As predicted, the holy bones were recovered and, with them, a document sealed with the ring of the emperor Charles the Bald that explained the relics' provenance. This document "greatly pleased everyone," Suger ingenuously added (*quod valde omnibus placuit*).[144] In this way, Saint Denis's apostolicity was miraculously linked to the arm of Saint James.[145]

This miraculous intervention reproduced in its entirety passages in the *Descriptio Karolus* (chart: C), which asserted that the relics had been brought back from Constantinople by Charlemagne and bequeathed to Saint-Denis by Charles the Bald.[146] And, just as Suger's predecessor, Adam, had in 1108 reestablished the feast for the anniversary of Dagobert,[147] so Suger in 1140–42 established that of Charles the Bald, expressly alluding to the crown of thorns mentioned in the *Descriptio* and to the arm of Saint James.[148]

The parallel between Suger and Adam is worth pursuing. During Adam's abbacy, a campaign of falsification had been initiated and successfully carried out, and this resulted in 1109 in the restitution of certain territories in Poitou.[149] Similarly, at the beginning of his own abbacy, Suger and the monks of the Dionysian priory of La Chapelle-Aude had had some difficulties with their churches in Berry. The conflict was aggravated at the time of Peter of La Châtre's episcopacy (rejected by the monarchy), a period that Suger, in a letter dated 1144, punningly referred to as the *tempestas* of the Church in Berry.[150] To settle the dispute, Suger proposed to the archbishop that the opposing sides submit their differences to a court or to arbitration. In my opinion, Suger at that time possessed the first false charter of Charlemagne (chart: F; DK 282), copied from that of Charles the Bald (chart: D; Tessier no. 481), which had been forged during Adam's abbacy to aid the campaign for the churches of Poitou. To it Suger added a list of sanctuaries in Berry and inserted, from the *Descriptio* (chart: C), a reference to Pope Leo III and a list of bishops, at the head of which he inscribed the archbishop of Bourges.[151]

It appears that Suger's epistolary authority sufficed to establish his rights. There is no evidence that the case was ever submitted to a court hearing or arbitration, and it is unlikely, therefore, that the act (chart: F) was ever produced. This was probably fortunate, since the charter contained a gross error: a reference to Abbot Fulrad, who had died in 784. The charter—fabricated during the first phase of the quarrel in Berry—is nonetheless extremely interesting for our purposes, since a short time later, around 1144–45, a second false charter of Charlemagne was forged (chart: G; DK 286), the donation charter. Based on interpolated passages in the Dionysian version of the *Pseudo Turpin* (chart: E), it reproduced the list of witnesses appearing in DK 282 (chart: F) but with corrections.[152]

This second charter (chart: G), which adapted the Compostela narrative for the benefit of Saint-Denis, was composed at the

900 950 1000 1050 1100

CHRONOLOGY
(Lawsuits or conflicts)

Abbacy of Adam
(1090–1122)
(First campaign in Poitou)

1109: Restitution by
Aimer, viscount of
Chatellerault, of the
church of Saint-Denis-
en-Vaux, because of the
acts of Dagobert and
Charlemagne

ARCHIVES
(Authentic acts)

B
905: Charles the Simple
(Lauer no. 50)

ARCHIVES
(Forged acts)

D
Charles the Bald (Tessier
no. 481) borrows from
A and B

Merovingian forgeries
attributed to Dagobert

RITUAL
and
"DIONYSIAN
HISTORIOGRAPHY"

A
Ninth century:
Gesta Dagoberti

C
1080–95: *Descriptio
qualiter Karolus;*
Crown of thorns and
nail brought back by
Charlemagne and given
by Charles the Bald to
Saint-Denis

1108: Restoration of the
celebration of the
anniversary of Dagobert

1150

Abbacy of Suger
(1122–51)
(First campaign in Berry)

1123: The monks of Ahun
in Berry claim the church
of Estivareilles from the
Dionysians of Chapelle-
Aude. Vulgrin upholds
the Dionysians' rights.

1144: Letter of Suger to
Peter of La Châtre to
demand Estivareilles.
Mentions the act of
Vulgin. Proposes
judgment in court.

Abbacy of Odo of Deuil
(1151–62)
(Second campaign in
Berry)

1151: After Suger's death,
Peter of La Châtre seizes
the church of Chassenais.

1152: Lawsuit against
Peter of La Châtre

I
1156: Bull of Hadrian IV;
adds the list of the
churches in Berry
(according to H) to the
traditional confirmation of
the holdings of Saint-
Denis

F
DK 282. Draws on D and
adds a list of the churches
in Berry; includes a
modified list of the
witnesses of C

G
1144/46: DK 286. False
donation charter; draws
on E and includes an
amended list of the
witnesses of C and F

H
Richard, archbishop of
Bourges, uses the list of
the churches in Berry from
F with some corrections.

Sealed act of Charles the
Bald; same outline as C

E
1124–35: *Historia Tilpini
de Hispania;* Dionysian
version of the pseudo-
Turpin text, draws on
the false Clunisian
document for Santiago de
Compostela

ca. 1140: Invention of the
arm of Saint James

1140/42: Restoration of
the celebration of the
anniversary of Charles the
Bald; reference to the arm
of Saint James

same time the Second Crusade was being planned.[153] It was not, as Van de Kieft suggested,[154] inspired after the fact by Suger's activities during the regency but instead served to prepare and strengthen the legal basis for them by drawing on the tradition of legends. In fact, from a legal point of view the question was not simple: How could an abbot rule the Church of France? By what right? Archdeacon Stephen of Garlande, Suger's protector, had already confronted this delicate issue and had run up against the intransigent opposition of Saint Bernard.

Suger did not accept the regency until after he had been designated by the pope. He went so far as to obtain papal bulls conferring on him the religious authority of an actual papal legate.[155] But Suger could not function simply as the pope's vicar, for his position was that of viceroy. The false donation charter of Charlemagne was intended to enhance the royal side of his ecclesiastical government, since it was the emperor himself who had bestowed the privilege on Saint-Denis, *caput omnium ecclesiarum regni*.[156] Legend preceded and prepared the way for reality. To resolve a crucially important and primarily political dilemma, Suger and his associates resorted to the same methods they had used to handle their problems with the abbey's domain. And by and large they seem to have been successful. "The abbot, although pastor of a single monastery, was equally the head of all the churches of the kingdom," William could write.[157] As Aryeh Graboïs emphasized, beginning with Suger's regency, "The ec-clesiastical powers concentrated in the abbot's hands were considered a part of royal authority."[158] Carolingian tradition had eclipsed papal privileges. Once again, the theoretical constructions elaborated at Saint-Denis succeeded in enhancing the image of royalty and in strengthening its power.

In this long series of forged charters in whose creation Suger actively participated, nothing was left to chance. Texts and acts were linked together, reciprocally drawing upon and responding to one another to form a cohesive whole equal to the purposes for which they were devised: the greater glory of Saint Denis and his protected servant, the king of France. The grandeur of the cause doubtless justified the choice of means.

We should not forget, however, that this Dionysian influence, so devoutly desired by our falsifying theoretician, would undergo an eclipse at the end of the twelfth century, during the last part of the reign of Louis VII. The growing importance of the Champenois party, symbolized by Queen Adele, and the monarchy's problems relating to succession were probably instrumental in diminishing the role of Saint-Denis in royal affairs. Louis VII would be buried at Barbeaux, but, with the accession of Philip Augustus, Suger's efforts would bear fruit. As a young prince, Philip had found in Saint Denis a savior and protector.[159] Once king, he did not forget the debt he owed to the Holy Martyr, duly placing before the saint's altar the four fateful coins required by the false charter of Charlemagne.[160]

NOTES

*This essay was translated from the French by Gabrielle M. Spiegel.

1. Georges Duby, "Les 'Jeunes' dans la société aristocratique dans la France du Nord-Ouest au XII^ème siècle," *Hommes et structures du Moyen Age* (Paris, 1973), pp. 213ff.

2. Eric Bournazel, *Le Gouvernement capétien au XII^ème siècle (1108–1180). Structures sociales et mutations institutionnelles* (Limoges, 1975), pp. 102ff., 143ff.; and Jean-Pierre Poly and Eric Bournazel, *La Mutation féodale, X^e–XII^e siècles* (Paris, 1980), pp. 276ff.

3. Achille Luchaire, *Les Premiers Capétiens (987–1137)*, pp. 327ff., and *Louis VII, Philippe Auguste, Louis VIII (1137–1226)*, pp. 11ff. in Ernest Lavisse, *Histoire de France depuis l'origine jusqu'à la Révolution*, vols. 2 and 3 (1900–11; reprint, New York, 1969); see also Cartellieri, *Suger*, p. xi.

4. Achille Luchaire, *Louis VI le Gros, annales de sa vie et de son règne (1081–1137)* (Paris, 1890), intro., pp. ix ff.

5. Suger, *Vita Lud.* (W), pp. 52, 56, 206, 212.

6. On Suger's presence in the entourage of Louis VII, see Achille Luchaire, *Études sur les actes de Louis VII* (Paris, 1885), index. See also Bournazel, *Le Gouvernement*, p. 21.

7. Jules Tardif, *Monuments historiques, Cartons des rois 528–1789* (Paris, 1866), p. 217, no. 391; and Luchaire, *Annales*, no. 348.

8. On the social levels of the members of the *familia regis*, see Bournazel, *Le Gouvernement*, pp. 66ff.; and Poly and Bournazel, *La Mutation*, pp. 276ff.

9. "Quo consueto Dei omnipotencie facto, quanto ab imo ad summum . . . sublimavit, tanto humiliorem et, si fragilitas humana non impediat, in omnibus devotiorem manus tam dulcissima quam potentissima comparavit . . . novit enim insufficientia nostri tam generis quam scientie" (Suger, *Vita Lud.* [W], p. 212).

10. "Verum quia illustri viro ab aemulis humilitas objicitur generis, non considerant caeci et hebetes ad majorem illius laudem pertinere vel gloriam suos effecisse nobiles, quam nasci de nobilibus" (William, *Vita Sug.* [L], p. 380).

11. *Recueil des Historiens des Gaules et de la France*, vol. 18, p. 769, hereafter *R.H.F.*

12. See the recent work of Régine Pernoud, *Héloïse et Abélard* (Paris, 1970), p. 91, "In spite of his humble origins—he was the son of serfs—Suger attained a powerful position"; however, the author cites no source for her statement. For the most current analysis, see the essay by John Benton in this volume, pp. 3–15.

13. Bournazel, *Le Gouvernement*, pp. 108ff. Louis VI subsequently renounced Vulgrin's possessions in favor of the monastery of Morigny, but the first step he took was significant.

14. Luchaire, *Annales*, intro., p. xii and no. 3.

15. On the dominant role played by the Garlande family and the struggles for power within the *familia*, see Bournazel, *Le Gouvernement*, pp. 94ff.

16. Suger, *Vita Lud.* (W), pp. 92ff., 94, 96, 143, 156, 170.

17. Ibid., pp. 40, 254–56. In 1127 the Garlande family was temporarily dismissed from the royal entourage because they wanted to make the seneschalsy a hereditary office. As a result, Gilbert lost the office of cupbearer, and Stephen the office of seneschal and chancellor. Stephen was reinstated as chancellor in 1132. Bournazel, *Le Gouvernement*, pp. 111ff.

18. When Stephen and his nephew by marriage Amauri of Montfort attempted to claim the seneschalsy as a hereditary office, Suger avoided pronouncing on the validity of their claim. The monk of Morigny, less wise and more hostile to Stephen, denied the legitimacy of their pretensions. Léon Mirot, ed., *La Chronique de Morigny 1095–1152*, 2d ed. (Paris, 1912), p. 53; and Bournazel, *Le Gouvernement*, p. 112.

19. "*Cui rei nec ille [Suger] primo acquiesceret, postea intervenientibus amicis quibusdam nostris, Regem et consilium ejus super hoc compellavi et sic quod volebam impetravi. Stephanus [of Garlande] quippe tunc dapifer, vocato in partem abbate et familiaribus ejus, quaesivit ab eis cur me invitum retinere vellent, ex quo incurrere facile scandalum possent et nullam utilitatem habere, cum nullatenus vita mea et ipsorum convenire [congruere] possent*" (Peter Abelard, "Lettre à un ami [*Liber de calamitatibus suis*]," *R.H.F.*, vol. 14, p. 290).

20. "*Peperci homini, quippe quem tibi aiunt familiaribus iam olim amicitiis esse devinctum*" (*R.H.F.*, vol. 15, p. 548). On the possibility of a familial relationship, see the essay by John Benton in this volume, pp. 11–15.

21. Luchaire, *Premiers Capétiens*, p. 327.

22. Mirot, *La Chronique*, p. 28. Here the expression refers to the royal clerk, Algrin of Étampes, who was very close to Stephen of Garlande; it could, however, equally apply to his master, the chancellor/seneschal, of whom Saint Bernard said, "*Ergo pulchrius est vocari dapiferum quam decanum, quam archidiaconum? Est equidem, sed laico, non clerico; militi, non diacono*" (*R.H.F.*, vol. 15, p. 547).

23. At the end of the Carolingian period, Charles the Bald had already assumed the title of lay abbot (Georges Tessier, *Recueil des actes de Charles II, le Chauve, roi de France* [Paris, 1952], vol. 2, nos. 379, 875), perhaps as early as 867, on the death of Abbot Louis (Alain Erlande-Brandenburg, *Le Roi est mort: étude sur les funérailles, les sépultures et les tombeaux des rois de France jusqu'à la fin du XIIIᵉᵐᵉ siècle* [Geneva, 1975], p. 73). The abbey's domain was then divided into *ministeria*, some of which were held by monks (see, for example, Tessier, *Recueil*, no. 228, for the *villa* of Mitry, which was under the control of the monk Dieudonné); others probably were held by vassals. At the beginning of the eleventh century, this old system, which had completely deteriorated, was restored by Abbot Vivien (Jean-François Lemarignier, "Autour d'un diplôme de Robert le Pieux pour Saint-Denis, 1068," *Comptes rendus de l'Académie des Inscriptions et des Belles-Lettres* [avril–juin 1971]: 22ff.). Abbot Vivien based his reforms on the structures established by Cluny, whose possessions were divided into deanships administered by monks (Georges Duby, "Le Budget de l'abbaye de Cluny entre 1080 et 1155. Économie domaniale et économie monétaire," *Hommes et structures*, pp. 61ff.). Suger began his career in a system that evolved continuing the reforms that Vivien had instituted: a hierarchized organization of *praepositurae* given in *obedientia* to a certain number of administrators and controlled by the monarchy. The vocabulary here is Cluniac; see Georges Duby, *La Société aux XIᵉᵐᵉ et XIIᵉᵐᵉ siècles dans la région mâconnaise* (Paris, 1971), pp. 184–85.

24. "*In ea autem quae dicitur Bernevallis possessione . . . in qua etiam primam alicujus praepositurae ab antecessore meo suscepi obedientiam*" (Suger, *Adm.* [L], p. 184).

25. Suger, *Adm.* (L), p. 170; in 1111 Suger was the provost of Toury. See the text cited in Suger, *Ch.* (L), p. 365; cf. also the small abbey of Chaumont-en-Vexin, given to Saint-Denis together with its canonries by King Louis VI, which became "like a noble member attached to its head," namely, the church of Saint-Denis (Suger, *Adm.* [L], pp. 183–84).

26. Suger, *Vita Lud.* (W), p. 136.

27. "*Hominum suorum et nostrorum.*" This wording is ambiguous, ibid., p. 136; see also pp. 152ff.

28. Suger, *Adm.* (L), p. 173.

29. Ibid., pp. 173–74.

30. "*Per manus ministrorum monachorum aut laicorum*" (Suger, *Ch.* [L], p. 351).

31. Suger, *Adm.* (L), p. 172. In some cases the abbot temporarily increased his troops by recruiting supplementary forces, ibid., p. 162; and Suger, *Vita Lud.* (W), p. 156.

32. *R.H.F.*, vol. 14, p. 290.

33. Ibid., vol. 15, p. 547.

34. "*Et quod etiam conscientiam meam gravat*" (Suger, *Ch.* [L], p. 350). The reconquest of the Vexin, in which Suger actively participated, resulted in the recovery of that part of the domain of Saint-Denis that consisted of the fiscal possessions of the *comitatus*, which formed the *praepositura Vilcassini* (ibid.) and which had deteriorated under pressure of numerous ecclesiastical advocates (who were in fact secondary advocates). On the question of the Vexin, see Suger, *Adm.* (L), pp. 161ff.; and Poly and Bournazel, *La Mutation*, pp. 302ff.

35. From this period, Suger's influence in the royal palace became quite significant. When Hugh of Le Puiset attempted, in 1112, to seize the domain of Toury through trickery, he tried to remove Suger by asking him to intercede in his favor with the king. Suger, *Vita Lud.* (W), p. 154.

36. Ibid., p. 206.

37. Bournazel, *Le Gouvernement*, pp. 89ff.

38. See the famous letter of the archbishop of Tours, Hildebert of Lavardin, to the deposed seneschal; "*turres excelsas et pulchra palatia exstruxisti, vineas plantasti, servos et ancillas multamque familiam habuisti; coacervasti tibi argentum et aurum*" (*R.H.F.*, vol. 15, p. 325).

39. William, *Vita Sug.* (L), pp. 388ff., declared that, following the example of the Stoics, Suger was a moderate and temperate man.

40. On the venality of the *familia,* see Bournazel, *Le Gouvernement,* p. 86.

41. Suger, *Ch.* (L), pp. 333ff.; and Bournazel, *Le Gouvernement,* p. 86.

42. William, *Vita Sug.* (L), pp. 387ff.

43. *"Siquidem et aedes restauravit regias, et ruinas murorum erexit et turrium ... Et ne propter regis absentiam regno quicquam deeset honoris, ab hoc milites solita consequebantur stipendia, et certis diebus vestes vel dona regia. Quae omnia constat illum propria potius munificentia tribuisse, quam de regis aerario vel re publica"* (ibid., p. 395). On the *fief-rentes,* see Bournazel, *Le Gouvernement,* pp. 105ff.

44. On several occasions William extolled Suger's talents as an administrator through whose able management the revenues of the abbey increased (*Vita Sug.* [L], pp. 391, 400). Stephen of Garlande behaved in a similar manner: at Rosoy and Eponne, he succeeded in increasing the productivity of ovens, wine presses, and especially mills that belonged to the Church of Paris (Benjamin Guérard, *Cartulaire de l'Église de Notre-Dame de Paris* [Paris, 1850], vol. 1, no. 12, pp. 380ff., act of 1120; text cited by Bournazel, *Le Gouvernement,* p. 59). In return for his clever administration, Stephen received from the canons a certain portion of the increased income. Perhaps this was true of Suger as well; it would partly explain the origins of his fortune.

45. Translation of Suger, *Vita Lud.* (W), pp. 276–77: "As for [the contents of] his precious chapel—his very precious Bible adorned with gold and gems, his censer of forty ounces of gold, his candelabra of one hundred and sixty ounces of gold, his costly shining chalice adorned with most precious gems, his ten copes made of costly fabric—he charged us to carry it all to the Holy Martyrs [altar]. He removed from his hand the very precious hyacinth inherited from his grandmother, the daughter of the king of Russia, and ordered us to place it on the Crown of Thorns of our Savior." See also his description of the procession during the visit of Pope Innocent II to the abbey of Saint-Denis in April 1131, ibid., pp. 260–62. In another passage Suger regrets not being able to buy more precious stones, "whose scarcity made them very expensive" (*raritas enim eas cariores facit*) (Suger, *Adm.* [L], p. 195). Happily a miraculous donation solved his momentary deficiency.

46. Pilgrims from Jerusalem assured Suger that the marvels of Saint-Denis outshone even the treasures and ornaments of Hagia Sophia in Constantinople, despite its riches and treasures. Suger, *Adm.* (L), pp. 198–99.

47. To this end, he sent for craftsmen, jewelers, and goldsmiths from many regions, sometimes from afar, as from Lorraine (ibid., p. 196), just as the Frankish king used to do for the construction of his palaces. See Georges Duby, *Guerriers et paysans, VIII^e–XII^e siècles. Premier essor de l'économie européenne* (Paris, 1973), p. 64.

48. *"Omnis, inquam, lapis preciosus operimentum tuum, sardius, topazius, jaspis, crisolitus, onix et berillus, saphirus, carbunculus et smaragdus. De quorum numero, praeter solum carbunculum, nullum deesse, imo copiosissime abundare, gemmarum proprietatem cognoscentibus cum summa ammiratione claret. Unde, cum ex dilectione decoris domus Dei aliquando multicolor gemmarum speciositas ab exintrinsecis me curis devocaret, sanctarum etiam diversitatem vir-*

tutum, de materialibus ad immaterialia transferendo, honesta meditatio insistere persuaderet, videor videre me quasi sub aliqua extranea orbis terrarum plaga, quae nec tota sit in terrarum faece, nec tota in coeli puritate demorari, ab hac etiam inferiori ad illam superiorem anagogico more Deo donante posse transferri" (Suger, *Adm.* [L], p. 198). On this text, see Poly and Bournazel, *La Mutation,* p. 309. The English translation appears in Panofsky, *Suger,* pp. 63, 65.

49. *"In exterioribus etiam sacrorum vasorum ornamentis, nulli omnino aeque ut sancti sacrificii servitio, in omni puritate interiori, in omni nobilitate exteriori, debere famulari profitemur"* (Suger, *Adm.* [L], p. 200). Here *nobilitate* also means brilliance.

50. Bournazel, *Le Gouvernement,* p. 72. Suger, the abbot's nephew, became a canon in 1160; his nephew, William, seems to have succeeded him in his office in 1173. Françoise Pont, "Les Chapitres cathédraux de l'Ile-de-France au XII^{ème} siècle" (Mimeographed thesis for the *doctorat de 3^{ème} cycle,* University of Paris IV, 1981), p. 9. See also the essay by John Benton in this volume, pp. 11–15.

51. Bournazel, *Le Gouvernement,* pp. 36ff., 43ff., 75ff., 104.

52. William, *Vita Sug.* (L), pp. 379–80.

53. Luchaire, *Annales,* nos. 498 and 600; and Luchaire, *Études,* nos. 95, 200.

54. Luchaire, *Annales,* no. 581; and Luchaire, *Études,* pp. 56, 169.

55. Luchaire, *Annales,* no. 348.

56. Bournazel, *Le Gouvernement,* p. 149.

57. For example, Luchaire, *Études,* nos. 236, 242.

58. Luchaire, *Annales,* no. 348 (*fidelis et familiaris*); and Luchaire, *Études,* no. 139 (*vir venerabilis et familiaris*), nos. 232, 236 (*dilectus et fidelissimus amicus*), and no. 242 (*fidelissimus amicus*).

59. William, *Vita Sug.* (L), p. 386. William states that the abbot had made necessary arrangements so that his absences would not be detrimental to the abbey.

60. Bournazel, *Le Gouvernement,* pp. 147ff., 162ff.

61. Suger, *Vita Lud.* (W), p. 24.

62. Poly and Bournazel, *La Mutation,* p. 286.

63. Suger, *Vita Lud.* (W), p. 280.

64. Luchaire, *Études,* nos. 137, 1144 (*amicus et familiarus*); and note *supra.*

65. Ibid., nos. 169, 240.

66. Suger, *Vita Lud.* (W), p. 270.

67. Ibid., p. 266.

68. *"Quis enim ea melius nosset, quis fidelius scriberet, quam is qui utrique familiarissimus extitit, quem nullum secretum latuit, sine quo nullum reges inibant consilium, quo absente solitarium videbatur palatium?"* (William, *Vita Sug.* [L], p. 382).

69. A diploma of 1134 expressly links the king's counsel with that of Suger: *"consilio domini regis et domini Sugerii abbatis,"* Luchaire, *Annales,* no. 545.

70. Cf. the discussion that follows.

71. *"Tam ipsum quam nos et quoscumque palatinos"* (Suger, *Frag. Lud.* [M], p. 150).

72. *"Dominus rex, nostro et amicorum consilio"* (ibid., p. 152).

73. The queen was ashamed and decided to stay: *"Quibus tam pene*

desperantibus cum ego ipse, velud exprobrando, numquam Franciam repudiatam vacasse respondissem, pusillanimitate nimia uterque dicessit" (ibid., p. 150).

74. Ibid., p. 151.

75. *"Et ut . . . apud dominum regem pie intercederemus, amarisse deplor-antes . . . [Rex], totum tamen consilio et arbitrio nostro, quicquid unde fieri approbarem remisit"* (ibid., pp. 152–53).

76. *"Nos autem qui et regni debitores et beneficii paterni merito ipsius con-silio . . . inherebamus"* (ibid., p. 150). See also his foresight in the affair of the Castle of Talmont; *"Nos vero, et pauci nobiscum sentientes, perfidie eorum discredebamus"* (ibid., p. 155).

77. I do not believe that Suger was ever out of favor at the court, as has been suggested by Marcel Pacaut, *Louis VII et son roy-aume* (Paris, 1964), pp. 42–46. See also the essay by Benton in this volume, pp. 5–6 and n. 32. The correspondence re-ceived by Suger during the first ten years of the reign of Louis VII, the requests for recommendations as well as the appeals addressed to him, support this interpretation. See for exam-ple, *R.H.F.*, vol. 15, pp. 436, 484–87, 604, 711.

78. *"Hunc propter magnifica et recta consilia princeps venerabatur ut patrem, verebatur ut pedagogum"* (William, *Vita Sug.* [L], p. 379).

79. Eudes de Deuil, *La Croisade de Louis VII roi de France,* ed. Henri Waquet (Paris, 1949), pp. 24ff.

80. Cartellieri, *Suger,* pp. 45ff.

81. Suger accepted this commission only after the pope had also nominated him (Lecoy, *Oeuvres,* p. 414). His actions during the Regency, however, demonstrate that he functioned exclu-sively as the king's man: *"nobis qui loco ejus [domini regi] pro-videmus"* (Suger, *Let.* [L], p. 247); and *"Nos autem, quantum ex parte domini regis cujus vices agimus"* (Suger, *Let.* [L], pp. 255, 257). Aryeh Graboïs, "Le Privilège de croisade et la régence de Suger," *Revue historique de droit français et étranger* 42 (1964): 458–65, believes, on the contrary, that despite his title of re-gent, Suger was the vicar of the pope.

82. Bournazel, *Le Gouvernement,* p. 120.

83. *R.H.F.*, vol. 15, pp. 487, 492, 506.

84. Pacaut, *Louis VII,* p. 58.

85. *R.H.F.*, vol. 15, pp. 518–19.

86. Ibid., pp. 520, 521. See William, *Vita Sug.* (L), p. 384, for an earlier case of Suger acting as mediator between the king of France and Henry of England: *"Nonne hunc apud Francorum re-gem Ludovicum mediatorem sibi et pacis vinculum constituerat?"* In 1150, Louis VII entrusted the abbot with the task of bringing to an end a trial between Ralph of Mauvoisin and the poor people of Chartres, Luchaire, *Études,* no. 248: *"easque [quere-las] ad vestram discretionem terminandas vobis imposuimus";* and *R.H.F.*, vol. 15, p. 525.

87. See *R.H.F.*, vol. 15, p. 523, letter to Peter the Venerable of Cluny.

88. Luchaire, *Études,* nos. 257, 258; *"mediate venerabili Sugerio,"* in *Gallia christiana* (Paris, 1715–1865), vol. 10, Instrumenta 34, col. 120.

89. Luchaire, *Études,* no. 260, 1151.

90. *"Hujus decreto ecclesiastici vel dabantur honores, vel detrahebantur singulis: quippe cujus assensu consecrationem obtinebant electi*

pontifices, cujus nutu ordinabantur abbates" (William, *Vita Sug.* [L], pp. 395–96). In another passage William wrote that Su-ger "ruled in fact all the churches of the kingdom, though he was the pastor of only one monastery" (ibid., p. 387).

91. See, for example, *R.H.F.*, vol. 15, p. 525, a letter from Alan, bishop of Rennes to Suger: *"Ad vos vero, ut ad dominum et pa-tronum . . . veniemus."*

92. See *R.H.F.*, vol. 15, p. 705, a letter from Peter of La Châtre, archbishop of Bourges, and pp. 529–30, a letter from Nicho-las II, abbot of Corbie: *"unde vestram crebo expertam dilectionem obnisce deprecor, quatinus domino regi me excusetis."*

93. Ibid., p. 525.

94. Luchaire, *La Société française au temps de Philippe-Auguste* (Paris, 1909), p. 13.

95. This is at least what William claimed, *Vita Sug.* (L), p. 394.

96. See the letter that Suger wrote to Louis VII during the Cru-sade, urging him to refrain from any hasty decisions about his wife: "As for the queen your wife, we beg you to accept the following advice: Conceal your rancor until God grants you a safe return. You will then be able to settle this question as well as all the others" *R.H.F.*, vol. 15, pp. 509–10.

97. William, *Vita Sug.* (L), p. 382.

98. Thierry Galeran or Cadurc, for example. Bournazel, *Le Gou-vernement,* p. 161.

99. Ibid., pp. 166ff. Cf., however, the diploma issued by Louis VI at the time of the threatened German invasion: *"[Sugerius] . . . quem . . . familiarem in consiliis nostris habebamus,"* Luchaire, *Annales,* no. 348.

100. *"Regem et consilium ejus super hoc compellavi . . . Sciebam autem in hoc regii consilii sententiam esse"* (*R.H.F.*, vol. 14, p. 290).

101. Suger, *Ch.* (L), p. 320, also p. 342 or 360; and the essay by Giles Constable in this volume, pp. 25–26.

102. Suger, *Adm.* (L), p. 168. See also William, *Vita Sug.* (L), p. 376, where William dedicates his *Vita Sugerii* to Geoffrey: *"Cujus quia vitae aliquandiu tecum interfui et secreta perspexi";* p. 383: *"His vero qui proprius accessissent, quique illi familiarus jungebantur, longe aliter apparebat. Verum cum esset circa familiares humanus satis et jocundus";* and p. 386 or 389, where Suger, giving in to the entreaties of his friends, agrees to modify his diet: *"Esu carnium nunquam est usus, nisi cum illum corporis coegisset infirmitas, et amicorum auctoritas compulisset."* See finally, the text by Abelard already quoted in note 19 here.

103. *"Sicque utrumque dispensabat officium, ut nec illum a claustri cura prohiberet curia, nec a consiliis principum hunc excusaret monster-ium"* (William, *Vita Sug.* [L], p. 379).

104. See Louis Halphen, "La Place de la royauté dans le système féodal," in *À travers l'histoire du Moyen Âge* (Paris, 1950), pp. 265–74. More recently, Jean-François Lemarignier, *Le Gou-vernement royal aux premiers temps capétiens (987–1108)* (Paris, 1965), pp. 171ff.; Poly and Bournazel, *La Mutation,* pp. 298ff.; and Jean-Pierre Poly and Eric Bournazel, "Couronne et mouvance; institutions et représentations mentales," *La France de Philipe Auguste: le temps des mutations,* Actes du col-loque international organisé par le C.N.R.S., Paris, sep-tembre 29–octobre 4, 1980, ed., Robert-Henri Bautier (Paris, 1982), pp. 217–34 (discussion, pp. 235–36).

105. *"Cum generosa domini regis Francorum liberalitate ducatum Normannie tanquam proprium feodum ab ejusdem munifica dextra vestra recepisset industria"* (Suger, *Vita Lud.* [W], p. 106).

106. *"Rex Francorum Ludovicus, ea qua supereminebat regi Anglorum ducique Normannorum Henrico sublimate, in eum tanquam in feodatum suum efferebatur"* (ibid., p. 184).

107. *"Avernensis comes, quia Alverniam a me, quam ego a vobis habeo, habet, si quid commisit, curie vestre vestro habeo imperio representare"* (ibid., p. 240).

108. Charles T. Wood, *"Regnum Francie:* A Problem in Capetian Administrative Usage," *Traditio* 23 (1967): 117ff.

109. In 1148 a letter from Louis VII to Suger connected the protection of the crown and the defense of the kingdom (*R.H.F.*, vol. 15, p. 508); the same year he wrote to Theobald of Blois: *"Et quoniam ad vestram fidelitatem praecipue respicit honor coronae atque totius regni defensio"* (ibid., p. 502); and Bournazel, *Le Gouvernement*, pp. 172–73.

110. *"Hic est redditionis ordo et consuetudo, ut, sicut diximus, in palatio statutus, regi et regno fidelitatem faciat, et sic demum regalia recipiat"* (Suger, *Adm.* [L], p. 257).

111. *"Rogo . . . ne contra dominum regem et coronam, cui omnes archiepiscopi, episcopi et barones innitimur et jure fidelitatis debitores existimus . . . calcaneum elevetis";* (ibid., pp. 277–78) and *"ex jure fidelitatis quam regno et coronae debent,"* p. 267. See also p. 281. Suger, who felt his death was drawing near in 1150/51, recommended to the king the church of Saint-Denis: *"pro nobili ecclesia Beati Dionysii, quae maxima regni et coronae vestrae portio est, nobilitatem vestram attentius deprecor."*

112. Cf. below and also the passage in which Suger refers to "the feudal barons of our church" (*Barones vero ecclesie nostre feodati*). Suger, *Vita Lud.* (W), p. 264.

113. Ibid., p. 276. In fact the abbey had in its possession only one thorn of the Crown and one nail of the Cross. On the royal crown, cf. note 111 here.

114. Poly and Bournazel, *La Mutation*, pp. 305ff.

115. In 1092, Philip I invested Prince Louis with the French Vexin: *"[Philippus rex] Ludovico igitur filio suo . . . Pontisariam et Medantum totumque comitatum Vicassini donavit,"* Oderic Vital, *Historia ecclesiastica*, ed. Le Prévost (Paris, 1838–55), p. 390. In 1104, Louis, on his father's orders, turned over to his brother, Philip, the castle of Mantes. Suger, *Vita Lud.* (W), p. 36. At the end of the twelfth century, Chaumont and the viscounty attached to it were still held directly from the king. Léopold Delisle, *Le Premier Registre de Philippe Auguste, reproduction héliotype du manuscrit du Vatican exécutée par A. Martelli* (Paris, 1883), pp. 178–83.

116. *"Vilcassini . . . comitatum . . . proprium beati Dionysii feodum, quem etiam rex Francorum Ludovicus . . . professus est se ab eo habere, et jure signiferi, si rex non esset, hominium ei debere"* (Suger, *Adm.* [L], pp. 161–62).

117. On these problems, see Poly and Bournazel, "Couronne."

118. Jean-François Lemarignier, *La France médiévale, institutions et société* (Paris, 1970), p. 259.

119. On this Dionysian enterprise, see Poly and Bournazel, *La Mutation*, pp. 288ff.

120. On the *Descriptio qualiter Karolus*, see Léon Levillain, "Essai sur les origines du Lendit," *Revue historique* 157 (1927): 241–

76; and C. Van de Kieft, "Deux diplômes faux de Charlemagne pour Saint-Denis," *Le Moyen Âge: Revue d'Histoire et de Philologie* 64 (1958): 401ff. The purpose of this text was to sacralize a number of relics attributed to Charlemagne: the sword, the lance, the battle standard of the old emperor.

121. Poly and Bournazel, *La Mutation*, p. 289.

122. *Monumenta Germaniae Historica, Diplomata Karolinorum*, vol. 1, no. 286, hereafter, *M.G.H.;* and Van de Kieft, "Diplômes."

123. Poly and Bournazel, *Mutation*, pp. 292ff.

124. Robert Barroux, "L'Abbé Suger et la vassalité du Vexin en 1124," *Le Moyen Âge: Revue d'Histoire et de Philologie* 64 (1958): 1ff.; and Van de Kieft, "Diplômes," p. 421. Arguing *intuitu personae* is, a priori, hardly satisfactory. On Suger's capacity for duplicity and for forgery (in order to obtain the expulsion of the nuns of Argenteuil in 1129), see Robert-Henri Bautier, "Paris au temps d'Abélard," *Abélard en son temps*, Actes du colloque international, 14–19 mai 1979 (Paris, 1983) pp. 69, 71; the essay by Benton in this volume, p. 5 and note 25; and the forthcoming article by Thomas Waldman, "Abbot Suger and the Nuns of Argenteuil," *Traditio* 41 (1985).

125. *"Inter ceterus gloriosus triumphus martyrum beatus Dionisius cum sociis suis, Rustico et Eleotherio qui primi post apostolos sub ordinatione beati Climenti, Petri apostoli successoris, in hanc Galliarum provinciam advenerunt, ibique praedicantes baptismus paenitentiae et remissionem peccatorum, dum in hunc modo concertabant, ibique meruerunt palmam martyriae et coronas percipere gloriosas"* (*M.G.H., Diplomata regum francorum*, vol. 1 (1872), no. 93, p. 82).

126. *"Dum Deus omnipotens hanc Galliarum patriam a tenebris infidelitatis eruere disponeret, sanctissimum Dyonisium"* (Tardif, *Monuments*, no. 250, p. 158). On this text, see Lemarignier, "Autour d'un diplôme."

127. *"Ne displiceat, inquiens, si de vestimentis ejus nobis vel parum reddideritis, qui eum vobis apostolatu Gallie insignitum absque murmure destinavimus"* (Suger, *Vita Lud.* [W], p. 54). The acts of Philip I for Saint-Denis do not include any allusion to this "apostolicity."

128. *"Domnum papam Eugenium ad celebrandum sanctum Pascha, sicut mos est Romanis pontificibus in Galliis demorantibus, ob honorem sancti apostolatus beati Dionysii, quod etiam de Calixto et Innocentio illius praedecessoribus vidimus, ad nos adduxit"* (Suger, *Adm.* [L], p. 196); see also p. 201.

129. Suger, *Vita Lud.* (W), p. 6.

130. *M.G.H., Diplomata regum francorum*, vol. 1, no. 10, p. 13: *peculiares patroni nostri.* See also no. 17, p. 18, act of Dagobert I, 627/38: *peculiares patroni nostri*, and the acts of Pepin in 749, no. 21, p. 107 and no. 2, p. 108, circa 751. A number of false Merovingian charters attributed for the most part to Dagobert I, repeat these formulas: *peculiaris patroni nostri* (no. 22, p. 139), *specialis patroni et protectoris nostri* (no. 25, p. 142).

131. Cf. in 1008, an act of Robert the Pious: *specialis patroni nostri*, Tardif, *Monuments*, no. 240, p. 156; and for Philip I, Maurice Prou, *Recueil des actes de Philippe Ier, roi de France (1059–1108)* (Paris, 1908), no. 29, (1067): *domini Dyonisii speculiares patroni nostri;* and Prou, *Recueil*, no. 40, (1068): *peculiaris patroni nostri.*

132. See Erlande-Brandenburg, *Le Roi est mort,* pp. 68ff.

133. *"Et quoniam beatum Dionisium specialem patronum et singularem post Deum regni protectorem et multorum relatione et crebro cognoverat experimento"* (Suger, *Vita Lud.* [W], p. 220).

134. Ibid., p. 266.

135. Ibid., p. 84.

136. Ibid., pp. 284–86.

137. Ibid., p. 272.

138. *"Jure enim ad eos omnes pertinent"* (ibid., p. 228).

139. Tardif, *Monuments,* no. 379, p. 213.

140. Suger, *Vita Lud.* (W), pp. 226, 228.

141. Ibid., p. 220.

142. Tardif, *Monuments,* no. 391, p. 217.

143. André de Mandach, *Naissance et développement de la Chanson de Geste en Europe: La Geste de Charlemagne et de Roland* (Geneva-Paris, 1961), vol. 1, pp. 55, 94.

144. Suger, *Adm.* (P), pp. 66ff. See pp. 187ff. for Panofsky's comments.

145. In *De administratione,* Suger discusses his discovery of the arm of Saint James the Apostle (Suger, *Adm.* [P], p. 66: *brachium sancti Jacobi apostoli*) without giving any details. In the *Ordinatio,* commenting on the same episode, he adds that Saint James was "the brother of our Lord" (Suger, *Ord.* [P], p. 128: *os brachii sancti Jacobi apostoli fratris Domini*). This reference adds ambiguity to Suger's providential discovery. Two Jameses appear in the early lists of the twelve Apostles: one, James, son of Zebedee, known as James the Major, was identified with the shrine of Santiago de Compostela in Spain; the other, James, son of Alpheas, known as James the Minor, was the brother of Matthew. In addition, there were two other Jameses who were not Apostles: one, the son of Joseph, was "the brother of the Lord"; the other, even more obscure, was the son of a certain Mary (called from her husband's name "Cleophas") who was a sister of Mary, the mother of Christ. Some authors confuse James the Minor with these two Jameses, relatives of Christ, who were themselves confused: see Ulysse Chevalier, *Répertoire des sources historiques du Moyen Âge,* 2 vols. (Paris, 1905–7). In the fourth and fifth centuries the Church fathers (Eusebius of Caesarea, John Chrysostome, Theodoret of Cyr) distinguished clearly between the Jameses who were Apostles, and James, brother of the Lord, whom the Apostles ordained Bishop of Jerusalem. This distinction is found in Jerome's martyrology and in the Roman martyrology. In the East, in the ninth century, Nicetas of Paphlagonis differentiated between James, son of Zebedee; James, son of Alpheas; and James, brother of the Lord; the second was martyred in Persia, and the third was stoned to death in Jerusalem. Nonetheless, the three Jameses were confused, even in Spain. (On this see the Bollandist's *Acta Sanctorum,* Maii, vol. 1, pp. 18ff.)

The editor of this volume, Dr. Paula Gerson, has communicated to me her belief that Suger did not mean to imply that the arm of James he discovered belonged to James the Major. Based on her research on the cult of Saint James in connection with the *Pilgrim's Guide to Santiago de Compostela,* Dr. Gerson feels that the confusion of the other Jameses with James the Major was considerably lessened after Spain adopted the Roman rite in the late eleventh century. She has written the following to me: "By the 1140s James the Major was so celebrated due to the activities surrounding the pilgrimage to Santiago de Compostela, and his family relationships (the son of Zebedee and the brother of Saint John) were so well-established he could not be confused with James, the brother of the Lord. Rather, it is James the Minor, who remained a more shadowy figure, and whose family relationships were less well known, who is usually confused with James, the brother of the Lord."

Given the state of current research, I cannot agree with Dr. Gerson or Panofsky, *Suger,* p. 196, that Suger was clearly referring to James the Minor and not James the Major. I believe, rather, that Suger consciously confused the issue in order to elevate his monastery. In this period saints bearing the same names were consciously and designedly confused; note in particular the case of Mary Magdalene (Louis Duchesne, *Fastes épiscopaux de l'ancienne Gaul* [Paris, 1900–1915], vol. 1, p. 314, and more recently Victor Saxer, *Le Culte de Marie-Madeleine en Occident, des origines à la fin du Moyen Âge* [Auxerre-Paris, 1959]); and especially Saint Denis (Édouard Jeauneau, "Pierre Abélard à Saint-Denis" in *Abélard en son temps,* pp. 161ff.). Pilgrims and the devout had little interest in or knowledge of scholarly debate on these issues. It was perhaps in response to their expectations that the "synthetic" images of the new popular saints were created.

146. Ibid., p. 70. Charles the Bald had found the precious relics in the imperial treasury.

147. Erlande-Brandenburg, *Le Roi est mort,* p. 76.

148. Suger, *Ch.* (L), pp. 349ff.

149. According to Van de Kieft, who meticulously gathered the dossier I am using, a diploma of Charles the Bald (chart: D) was forged on this occasion (Tessier, *Recueil,* vol. 2, no. 481, p. 599). This document established the rights of Saint-Denis over lands located in the Limousin, in Anjou, and especially in Poitou. The forger used a passage from the ninth-century *Gesta Dagoberti* (chart: A), as well as an authentic act of Charles the Simple dated 9 February 905 (chart: B). Forged charters of Dagobert were probably fabricated at the same time: in 1109, on seeing the charters of Dagobert and Charles the Bald, Aimery, viscount of Chatellerault returned the church of Saint-Denis-en-Vaux in Poitou to Saint-Denis. See Van de Kieft, "Diplômes," pp. 407, 410.

150. It is possible to more precisely date the first difficulties that the monks of Saint-Denis encountered in Berry in the twelfth century. In 1123, Vulgrin, archbishop of Bourges, upheld the rights of Suger and the monks of Saint-Denis to the church of Estivareilles, which was a dependency of their priory of La Chapelle-Aude but was also claimed by the monks of Moûtier d'Ahun (Tardif, *Monuments,* no. 389). In 1144, or shortly thereafter, Suger asked Peter of La Châtre to restore this church which had been taken from La Chapelle-Aude by the monks of Ahun (Suger, *Ch.* [L], p. 329.)

151. *M.G.H., Diplomata Karolinorum,* vol. 1, no. 282; and Van de Kieft, "Diplômes," pp. 407, 414.

152. In sum, I agree with Van de Kieft that these two forgeries of Charlemagne are contemporaneous; that the false donation

charter, DK 286 (chart: G), was written slightly later than DK 282 (chart: F); and that the latter was fabricated in order to establish the rights of Saint-Denis over churches in Berry. But I believe they should be assigned to Suger's abbacy, during the first stage of the conflict in the Berry, which Van de Kieft ignored.

I also would like to revive Van de Kieft's argument *intuitu personae,* since the false charter of Argenteuil (note 124 here) and the discovery of the arm of Saint James prove that Suger was capable of forgery. Furthermore, while it is easy to see that DK 282 (chart: F) would be useful to Odo of Deuil, it is difficult to grasp what benefits he could have derived from DK 286 (chart: G), since he was not as close to the king as his predecessor. On the other hand, both texts were necessary, indeed essential, for Suger's purposes.

After Suger's death, the conflict in Berry was given a new impetus and entered its second stage. Peter of La Châtre took advantage of Suger's death to seize the church of Chassenais. It was at that moment that a forged document (chart: H) attributed to Richard, archbishop of Bourges at the end of the eleventh century, was fabricated during the abbacy of Odo of Deuil. This act, which included a modified list of the churches of the Berry, taken from DK 282 (chart: F), influenced a bull of Hadrian IV in 1156. See Van de Kieft, "Diplômes," *passim.*

153. At Christmas 1154, Louis VII announced his intention to aid the Christian community in Syria, but his decision had been made earlier; Luchaire, *La Société française,* pp. 21ff.; see also, Zoé Oldenbourg, *Les Croisades* (Mayenne, 1977), pp. 340ff.

154. Van de Kieft, "Diplômes," p. 424.

155. Graboïs, "Le Privilège," p. 464 and note 28.

156. This sheds light on the passage in which William summarized Suger's ecclesiastical activities; see below. Also relevant is the curious passage in *De administratione* in which Suger de-

scribed a *tabula* richly adorned with precious stones and erected in front of the reliquary containing the bones of the Holy Martyrs. (Suger, *Adm.* [P], pp. 54–55, with Panofsky's comments on pp. 168–69.) Addressing himself to the reader, the abbot wrote:

> You could see how kings, princes, and many outstanding men, following our example, took rings off the fingers of their hands and ordered, out of love for the Holy Martyrs, that the gold, stones, and precious pearls of the rings be put into that panel. Similarly archbishops and bishops deposited there the very rings of their investiture as though in a place of safety, and offered them devoutly to God and His Saints.

The noble lords gave priceless offerings, the prelates relinquished their rings, which symbolized their alliance with their church. What other gesture could better express the supremacy of Saint-Denis? Is this not the fulfillment of the goals of the false donation charter? Finally, Suger does not seem to be employing a purely rhetorical formula when, in 1149, he called the see of Reims "the precious stone that adorns the summit of the crown of the kingdom," Suger, *Let.* (L), p. 261. Let us keep in mind that this very crown was in the safekeeping of the abbey of Saint-Denis.

157. William, *Vita Sug.* (L), p. 387.

158. Graboïs, "Le Privilège," p. 465. Graboïs suggests, however, no connection with the false donation charter (chart: G); he merely states that in France the crusading privilege did not benefit the papacy.

159. Poly and Bournazel, "Couronne," *passim.*

160. Gabrielle Spiegel, "The Cult of Saint-Denis and Capetian Kingship," *Journal of Medieval History* 1 (1975): 43–69.

A Note on Suger's Understanding of Political Power[*]

Michel Bur

SUGER'S *Life of Louis VI*, the beginning of his *Life of Louis VII*, and his accounts of the administration of the abbey of Saint-Denis and of the dedication of the abbey church are not political treatises. Each observes the conventions of its own literary genre, and each reflects immediate preoccupations that are in sum those of a historian. Nonetheless, both because of their common subject—a glorious reign, the flowering of a great royal abbey—and because of their author's position, they provide important insights into the events recounted in them and furnish valuable information regarding the society of the time, the functioning of its institutions, and the ideology of power in twelfth-century France.

The author of these works, "this venerable abbot whom we admitted to our council as *fidelis* and *familiaris*," as Louis VI said of him in an act of 1124,[1] was the king's contemporary, involved during his entire life in the affairs of the kingdom. When Suger wrote the works mentioned above, between 1140 and 1145, he had already lived for some six decades; he was old enough to have no hesitation about making clear his preferences and his judgments, as the markedly different pictures he gives of Louis VI, Henry I of England, and the German emperor Henry V demonstrate.

Offered as a child to the abbey of Saint-Denis, Suger never ceased demonstrating to this "mother filled with sweetness" his filial devotion; he worked continually to exalt and elevate the abbey. When, during the Second Crusade, he governed the kingdom, he acted more as vicar of the pope (to whom the king had entrusted the guardianship of his kingdom) than as regent.[2] Thus, his attitude to political life was that of an ecclesiastic rather than that of a statesman. The relationship between these two sides of his personality and their relative significance are difficult to grasp. They are nonetheless fundamentally important.

In this short note, I cannot present an exhaustive analysis of Suger's political thought, which was linked inextricably to the events in which he participated or that he witnessed and is expressed in passages scattered throughout his works. Here I will simply attempt to provide a sketch of the chief characteristics of his conception of power and discuss the conditions under which he worked to advance the kingdom's interests.

As Andrew Lewis reminds us,[3] Suger defined the *officium regis* in traditional terms. The king must employ his power in the service of justice, guarantee order and peace, protect the poor, and defend the churches of his kingdom. Suger avoided addressing the question of the source of these obligations, royal unction, because he felt that anything that enhanced the glory of the church of Reims might detract from the growing prestige of Saint-Denis. In Suger's mind, the king's first responsibility as protector of the kingdom's churches was to be exercised on behalf of his abbey, which was the royal burial site; only secondarily, in his view, was the king responsible for the other churches of France. Finally—and this is an idea that was radically new and dramatically enlarged the king's horizons—he also had, as Charlemagne's successor, a responsibility for the pope.[4]

Suger enriched the ideology of the French monarchy, associating it with the traditions of the *chansons de geste*. He asserted that the monarchy should be subordinate to no earthly authority, even that of the German emperor. But no matter how elevated its goals, power cannot exist without the means of exercising it. After their accession the Capetians had devoted themselves to developing these means. Resolutely, they marshaled the resources of the domain and, determined to be the masters of their own house, expelled the princes from their council. Thus, it seems,

Notes for this essay begin on page 75.

should be interpreted the disappearance of episcopal and comital witnesses to royal acts, notably after 1077.[5] Further, continuing the practices of their ancestors, the dukes of France, who relied on a large body of followers to establish their power at the expense of the Carolingians, the Capetians made feudal relationships a true instrument of government.

At the beginning of the twelfth century two main networks, parallel and independent, led to the king. One involved the vassals of the kingdom, the other those of the domain. Suger shows that both networks were effective.

Within his realm the king required the aid of his great vassals—the dukes and counts of Flanders, Burgundy, Aquitaine, Anjou, Blois, Brittany, Vermandois, Nevers, Troyes—as well as support from the bishops and abbots. He often enlisted their help: against Henry I, duke of Normandy and king of England, between 1109 and 1118; against the German emperor in 1124; against the count of Auvergne in 1126. This was not a question of simple individual service. In 1109 the count of Flanders rallied to the king's cause with four thousand men.

It is nevertheless true that many of these princes, distinguishing their own interests from those of their lord, attempted to limit their assistance to causes involving the independence of the kingdom or the well-being of Christianity—in repelling the emperor in 1124, for example, and in participating in the Second Crusade. They thought that the king should not meddle in their affairs, and the boldest of them, Theobald of Blois and Champagne, dared for years to assign greater importance to his blood ties to Henry I of England than to his fidelity to Louis VI.[6] Royal policy was directed at strengthening the ties between the king and the great vassals, and, as Suger well understood, it was essential that the king not be forced by his own territorial acquisitions to render homage to anyone—even to the abbot of Saint-Denis. The sovereign must always be above his vassals.[7]

The second network was limited to the castellans of the domain—the lords of Montfort, Rochefort, Corbeil, Le Puiset, Montmorency, Garlande, Senlis—who surrounded the king and served as the officers of his court. The ambitions of these families created a serious crisis in the Ile-de-France at the end of the reign of Philip I. The Rochefort family felt strong enough to attempt to marry a daughter to the heir to the throne. The lord of Le Puiset rebelled a bit later. Theobald of Blois, their lord for the viscounties of Chartres and of Troyes, secretly supported both families. These disturbances were relatively minor, and such energetic rulers as Henry I in Normandy and Louis VI in France were able to reestablish order and bring the rebels to submission.

The nature and the size of these two networks differed sharply. The king and his great vassals exercised virtually equal power. The minor lords of the Ile-de-France, by contrast, could in no way rival the counts of Flanders and Champagne. But it was these minor lords who populated the king's court, made up his

council, and determined his policy. The great lords could not for long accept this situation. In the tenth century the duke of Burgundy and the marquis of Neustria refused to permit a Haganon to direct the royal council,[8] and in the twelfth century no prince would bow to the orders of obscure knights.

When Suger came to power, he was wise enough to understand that the service of the great vassals could no longer be demanded without asking their advice in return. This was particularly true of Count Theobald. His brother Stephen's accession to the English throne and the Angevin claims to the same throne placed him in a strategic position. Although Suger's admiration for Theobald was limited, the abbot made an effort to attract him to the king's entourage and, after 1137, to give him an official place there: "For it was our intention to bind that man to the lord king by an oath of fidelity, since he excelled all in the kingdom in his faith and oath and the legitimacy of his decrees."[9] Later, after becoming regent in 1147, Suger again attempted to mollify Theobald, although these efforts were largely frustrated by the count's suspicions of the Capetians. Nonetheless, as if to underline Theobald's place in the king's household, Suger consistently accorded to him (in all his major writings) the old and outmoded title of Count Palatine.[10]

Such a policy was not arrived at arbitrarily or by accident. It was deliberately formulated to reconcile the magnates and the king, and it carried with it great risks. The great lords were no readier than before to work hand in hand with the lesser members of the council. They were determined to maintain their status and prerogatives and to act as a group of peers. Their claims were asserted later, at the trial of Jeanne of Flanders in 1224, but by that time events had altered the balance of power within the network of vassals and had given the king increased authority over all his dependents.

Events, rather than legal theory, led to the unification of the two networks into a single, coherent system. After the battle of Bouvines, in 1214, the duke of Normandy—count of Anjou and duke of Aquitaine as well—disappeared from the scene. The king stood at center stage. By contrast, the duke of Aquitaine played a threatening though courtly role in 1126, when he stood between Louis VI and the count of Auvergne and revealed the determination of a man long conscious of his rank and rights.[11] This consolidation of the networks during the reign of Philip Augustus resulted not in the creation of a sharply pointed feudal pyramid but in the suppression of a level of the hierarchy, which brought the king closer to the base. For many, the king became their direct lord rather than their suzerain, and royal power consequently increased. The princes were reduced in number and importance.

The events of the age of Philip Augustus ushered in a new era,[12] in which Suger's thought appears somewhat old-fashioned. His importance nonetheless justifies the attention that this vol-

ume accords him. His concept of a consecrated monarchy led him to claim for the king of France a Carolingian role as protector of the pope. His respect for hierarchy led him to place the king at the feudal summit. Finally, his sense of the public welfare inspired him to bring the great princes back to the royal council.

Like all great political figures of the past, Suger adopted the point of view of both moralist and historian. Experience gave him a deep knowledge of social and institutional mechanisms. In his writings he recorded his observations without attempting to present them in a systematic or ordered fashion. Rather, he molded them to the aesthetics of his discourse, since he considered himself as much a writer and linguistic artist as a man charged with the exercise of the weightiest responsibilities. His attitude to the world of politics was subjective, revealing his intellectual preoccupations and his sensitivities. Its richness sprang from his gifts of observation and analysis as well as from the eminent position that for almost thirty years he occupied with distinction. Suger's genius grew out of his inspired understanding of his own milieu and his own time.

NOTES

*I would like to thank John F. Benton and Elizabeth A. R. Brown for their assistance in translating this essay.

1. Jules Tardif, *Monuments historiques* (Paris, 1866), p. 217, no. 391.

2. Aryeh Graboïs, "Le Privilège de croisade et la régence de Suger," *Revue historique de droit français et étranger,* 4th ser., 42 (1964): 458–65.

3. See the essay by Andrew Lewis in this volume, pp. 45–54.

4. "*Cum quibus [regibus Phylippo et Ludovico, anno 1107] de statu ecclesie, ut sapiens sapienter agens, familiariter [Paschalis] contulit eosque blande demulcens, beato Petro sibique ejus vicario supplicat opem ferre, ecclesiam manutenere, et sicut antecessorum regum Francorum Karoli Magni et aliorum mos inolevit, tyrannis et ecclesie hostibus et potissimum Henrico imperatori audacter resistere*" (Suger, *Vita Lud.* [W], p. 54).

5. Jean-François Lemarignier, *Le Gouvernement royal au temps des premiers Capétiens, (987–1108)* (Paris, 1965).

6. In his description of the forces that opposed one another in the kingdom before 1135, Suger provides a valuable guide to the geopolitics of France. To the west the duke of Normandy, to the south and east the count of Blois and Champagne threatened the royal domain. Louis VI confronted them with his allies, the count of Flanders to the north, the count of Anjou to the south: Suger, *Vita Lud.* (W), pp. 184, 186. When the count of Anjou became duke of Normandy and king of England, the king continued to rely on the count of Flanders and allied with the count of Blois and Champagne.

7. As count of the Vexin, the king held this fief from the abbey of Saint-Denis; as king he was dispensed from rendering homage: Suger, *Adm.* (L), p. 462.

8. Flodoard, *Annales,* ed. Philippe Lauer (Paris, 1905), p. 2 (anno 920).

9. "*Erat enim intentio nostra ut virum illum, quia cunctis in regno fide et sacramento et legitimis sanctionibus precellebat, domino juramento fideliter necteremus*" (Suger, *Frag. Lud.* [M], p. 151).

10. Michel Bur, *La Formation du comté de Champagne (v. 950– v. 1150)* (Nancy, 1977) p. 289.

11. Suger, *Vita Lud.* (W), p. 283.

12. See the proceedings of the conference devoted to the reign of Philip Augustus, held in Paris from 29 September to 4 October 1980, published in Robert-Henri Bautier, ed., *La France de Philippe Auguste, le temps des mutations.* Colloques internationaux du Centre National de la Recherche Scientifique, no. 602 (Paris 1982).

Saint-Denis, ambulatory chapel, Infancy of Christ window, Annunciation panel, detail of Suger at the feet of the Virgin

Good Works, Social Ties, and the Hope for Salvation: Abbot Suger and Saint-Denis

Clark Maines

I N HIS writings, Abbot Suger of Saint-Denis describes himself insistently as a contrite sinner who is genuinely concerned for the welfare of his soul. Sometimes Suger's descriptions are literal and direct, like those in the *Ordinatio* or in his Testament (*Testamentum*); sometimes they are metaphorical and indirect, like one in *De administratione*.[1] When they have been commented upon at all, these descriptions have been explained away as a show of remorse or dismissed as postures containing elements of professional hypocrisy. Rather than take these descriptions seriously, scholarship has instead focused on the magnitude of Suger's accomplishments. The abbot has been treated as a successful monastic administrator, as a wise counselor to two kings, as an important historian, and, not least, as a great patron of the arts.[2] Seldom if ever has he been treated as a penitent.

Ignoring or downplaying Suger's awareness of personal sin and his concern for the fate of his soul has resulted in a misinterpretation of at least some of what he accomplished at Saint-Denis and a misunderstanding of some of the forces that motivated him.[3] Reexamination of the images of Suger, both figural and epigraphic,[4] and reinvestigation of the abbot's writings demonstrate the need to take Suger's concern about past sins seriously. Reconsideration of Suger's monumental inscriptions and writings reveals that Suger believed his pious gifts and labors for the abbey and church of Saint-Denis established ongoing reciprocal relationships between himself and the abbey's major saint that could aid in redeeming his sinful condition.[5] Two other works of art, not from the abbey of Saint-Denis but related in time and place to Suger, demonstrate that contemporaries also saw pious donations as vehicles for establishing reciprocal relationships for the future benefit of their souls. Examination of Suger's writings and patronage in the light of twelfth-century thinking about the

fate of the soul after death and about purgatorial fire reveals why Suger believed the reciprocal relationships he established needed to exist in perpetuity. Such an examination also shows how Suger's images of himself might have served to perpetuate those relationships.

SUGER'S AWARENESS OF HAVING SINNED

The Images

Eleven images of Abbot Suger, specifically four figures and seven inscriptions that mention his name, were once arranged sequentially along the main axis of the abbey church (fig. 1 and Appendix).[6] Two figures and two inscriptions appeared on the central portal of the west facade (see Gerson fig. 5).[7] A third inscription appeared on the right side of the Main Altar at the crossing.[8] A third figure and the fourth inscription were placed on the foot of the Great Cross (see Gerson fig. 10), which Suger erected in front of the new chevet.[9] Two more inscriptions appeared on the Altar of the Martyrs in the chevet.[10] The fourth and last figure appeared in the Annunciation panel of the Infancy window in the axial chapel of the chevet (see fig. page 76).[11] The remaining, dedicatory inscription is known only through the text in *De administratione*. Although it is thought to have been located in the chevet, its placement cannot be precisely determined.[12]

All four of the so-called donor portraits,[13] of which two survive and two are known through descriptions, represent the abbot on his knees, clad in ecclesiastical garb, with his hands clasped in prayer. An abbatial crozier appeared with each of the figures except, apparently, the one in the tympanum of the west facade.[14] Of the seven inscriptions mentioning Suger's name,

Notes for this essay begin on page 86.

→transept.

1. *Figure of Suger, west facade, central portal lintel*
2. *Figure of Suger, west facade, bronze doors*
3. *Inscription, west facade, central portal, lintel (Appendix, 1)*
4. *Consecration inscription, west facade, above the portals (Appendix, 2)*
5. *Location movable, inscription on Suger's Ewer (Appendix, 8)*
6. *Location movable, inscription on the Eleanor Vase (Appendix, 9)*
7. *Inscription, Main Altar, right side (Appendix, 3)*
8a. *Figure of Suger, Great Cross*
8b. *Inscription, Great Cross (Appendix, 4)*
9. *Inscription, altar of the Martyrs, right side (Appendix, 5)*
10. *Inscription, altar of the Martyrs, back (Appendix, 6)*
11. *Inscription, chevet interior (?) (Appendix, 7)*
12. *Figure of Suger, chevet chapel, Infancy window*

Fig. 1. Saint-Denis, plan of the abbey church, ca. 1144 (modified after Crosby), showing the locations of "images" of the penitent Suger

only two are purely commemorative, and one of these is the relatively minor inscription on the back of the Martyrs Altar.[15] The five remaining major inscriptions (Appendix, 1–5), all explicitly ask for mercy or aid as does, for example, that on the now-destroyed lintel of the central west portal:

> Receive, O stern Judge, the
> prayers of Thy Suger;
> Grant that I be mercifully
> numbered among Thy own
> sheep.

One of these five, significantly that on the Main Altar (Appendix, 3), not only asks for mercy but goes even further to express Suger's sense of sinfulness in explicit terms:

> Make worthy the unworthy through thy indulgence,
> O Virgin Mary.
> May the fountain of mercy cleanse the
> sins both of the King and the Abbot.

In summary, Suger's images, both figural and epigraphic, present him as a humble suppliant.[16] Moreover, these images "resonate" upon one another.[17] The verse on the Main Altar (Appendix, 3) recalls the image of Suger kneeling before the enthroned Virgin Annunciate in the axial chapel. Similarly, the image of Suger kneeling at the "foot" of the cross on the tympanum is repeated in the figure kneeling at the foot of the cross at the top of the Great Cross which stood before the chevet.[18] Suger's prayer to Saint Denis inscribed on the west doors is echoed on the Martyrs Altar, where the inscription asks Saint Denis to open the doors of Paradise for Suger (Appendix, 2 and 5).

Donor portraits comparable to the portraits of Suger are usually different from his in form.[19] The monk Airardus, who was represented on the now-lost *valvae antiquae* that Suger transferred from a portal of the Carolingian basilica to the north door of his new west facade, was shown standing and offering an image of his gift.[20] The abbot Desiderius of Montecassino, who is represented in the eleventh-century apse fresco at S. Angelo in Formis, is also shown standing and holding an image of his gift.[21] Suger's younger contemporary, Bishop Henry of Winchester, is represented on a plaque from a shrine or altar he commissioned between 1150 and 1154. Although the bishop is shown in a kneeling pose, he nevertheless holds an image of the gift he provided.[22]

Just as these images differ from those of Suger, so also do the inscriptions accompanying them. The Airardus distich is a straightforward dedicatory inscription.[23] The inscriptions accompanying the images of Desiderius[24] and Henry[25] praise the donor. None explicitly asks for mercy or aid. None expresses a sense of sinfulness.

Thus, Suger's images stand apart from otherwise comparable ones in number and in type.[26] Taken together, as they must be, the abbot's images ensured that the resident monastic community could not (easily) perform its liturgical duties without repeatedly encountering the presence of Abbot Suger.[27] However, while these images together forcefully perpetuate the memory of the abbot, they do not commemorate him as a worthy donor; rather the Suger they commemorate is presented as a sinful suppliant, insistently asking for mercy.[28]

The Writings

Nowhere in Suger's writings is his concern for past sins and for the future welfare of his soul so elaborately expressed as in his little-studied Testament of 1137.[29] Here, Suger refers repeatedly to sins he has committed.[30] He describes himself as a spiritual invalid, long ungrateful for God's benevolence toward him.[31] He describes the day of his future burial as a day of terror, calamity, and misery.[32] In his Testament, Suger establishes prayers, a weekly Mass for the dead, and an anniversary Mass in *all* of the dependencies of Saint-Denis.[33] At the abbey itself Suger provides that a daily Mass of the Holy Spirit be said for his soul beginning immediately. This Mass is to continue throughout his lifetime and *requiem aeternam* after his death.[34] On the anniversary of his death, the Masses are to be increased in number and supplemented by the display of Suger's liturgical vessels, by special distributions for the brothers, and by the gift of alms to the poor.[35]

In the Testament, Suger does not enumerate which sins troubled him so, although he does specify Saint-Denis-de-l'Estrée as a place where he committed "many offenses . . . when young in age and manners."[36] From Suger's other writings, too, we learn that his early ecclesiastical career seems to have contributed greatly to the abbot's sense of sin and regret. His active involvement in the temporal affairs of his church is well known, if only because of the literary tongue-lashing he received for it in a letter from Bernard of Clairvaux.[37] That Suger felt genuine remorse for this secular activity, though little remarked, is readily attested to in the records he kept of his labors for the abbey. In the *Ordinatio*, Suger tells us that when, in the early days of his prelacy, he recovered domains in the Vexin from local malefactors, he did so " . . . with a strong and (a fact now aggravating [his] conscience) *militari manu*," or "armed force."[38] This and other forthright passages[39] have parallels that are rhetorically more complex and thus more easily misread. In *De administratione*, he states:

> In our chapter as well as in church I implored Divine mercy
> that He who is the One . . . might not repel from the building of the temple a *bloody man* who desired this very thing,

with his whole heart, more than to obtain the treasures of Constantinople.[40]

Suger's self-identification with David, each a *virum sanguinum* (bloody man), may be understood less as a measure of Suger's ego than as a measure of Suger's sin.[41] David was called a bloody man by Shimei, not for killing anyone by his own hand but for sending Uriah to the battlefront in the expectation that he, Uriah, would be slain.[42] Similarly, Suger, as a man of God, probably never killed anyone himself. However, as head of an "armed force" at various times in his early career, he probably did send men to battle and sometimes to die in the service of his abbey. David was "punished" for his sin by being denied the privilege of building the Temple in Jerusalem;[43] in contrast, Suger was permitted to build his "temple" at Saint-Denis. The implication of the metaphor is not that Suger was therefore somehow better than David. Punishment for sins, in this case obviously comparable sins, was held to be unavoidable.[44] David's punishment was meted out in his lifetime; Suger, when he wrote *De administratione*, had reason to believe his was to come after death.

Suger's abandonment of military activities was one of the reasons Bernard of Clairvaux praised Suger's efforts at personal reform in the 1120s.[45] Although Bernard never actually called him a *"virum sanguinum,"* Suger surely saw the irony in Bernard's praise, which was couched in an extensive metaphor presenting Suger as a spiritual soldier wielding a spiritual sword on behalf of his monks.[46] Suger no doubt felt the sting of Bernard's harsh words for the cleric who wielded the temporal sword. In the same letter to Suger, Bernard wrote:

> I ask you what sort of monster is this that being a cleric wishes to be thought a soldier as well . . . who would not be astonished, or rather disgusted, that one and the same person should, arrayed in armour, lead soldiers into battle and, clothed in the alb and stole, pronounce the Gospel in the Church . . .[47]

Bernard was actually speaking of Stephen of Garlande, archdeacon of Paris and, simultaneously, seneschal of France, but the applicability of the passage to Suger was probably not lost on either abbot.[48]

Suger's insistence on his sinful state seems too pervasive in his writings to be dismissed as merely containing elements of professional hypocrisy.[49] It is also too systematic in its expression, especially in the images and in the Testament, to be passed over by saying that the abbot protests too much. Some measure of his personal dilemma, though evidently not all of it, probably lay in the fact that many of the sins that troubled him were committed in the service of his abbey and thus for a good cause. Suger said as much himself in his Testament when he wrote that it was for his monks' peace that he exposed himself in labors of the present.[50]

RECIPROCAL RELATIONSHIPS IN SUGER'S GOOD WORKS

That good works—from prayers to pious donations such as Suger's labors for the abbey of Saint-Denis—redound to the credit of the doer at his death and judgment is, of course, found in the Bible in Matthew and in the Pauline Epistles.[51] The process by which such credit might be awarded is not, however, elaborated there. That this process was perceived, at least in eleventh- and twelfth-century northern France, as one involving quasi-contractual, reciprocal relationships[52] can be seen by analogy in the relationship established in Suger's Testament between the abbot and the present and future monks of Saint-Denis.[53] In the Testament, Suger provides for the monks' material comfort in return for their promise to pray for the welfare of his soul[54] beginning, as we have seen, from that time forward (1137) in perpetuity.[55] Suger evidently believed his gifts to the abbey and its patron saint would establish similar ties between himself and Saint Denis. The inscription placed by Suger on the west facade (Appendix, 2) identifies the gift and its anticipated counterpart which, together, reveal to us the reciprocity established:

> For the splendor of the church that
> has fostered and exalted him,
> Suger has labored for the splendor
> of the church.
> Giving thee a share of what is thine,
> O Martyr Denis,
> He prays to thee that he may obtain
> a share of Paradise.

The same reciprocal relationship between Suger and Saint Denis is spelled out again in the inscription on the saint's altar in the chevet (Appendix, 5):

> Great Denis, open the doors of
> Paradise
> And protect Suger through thy pious
> guardianship.
> Mayest thou, who hast built a new dwelling
> for thyself through us,
> Cause us to be received in the dwelling
> of Heaven,
> And to be sated at the heavenly table
> instead of at the present one.
> That which is signified pleases more
> than that which signifies.[56]

Fig. 2. Mervilliers, priory church, tympanum

In the *Ordinatio,* there is yet another, even more literal statement of the reciprocity Suger sought through his artistic patronage:

There remains one other important article which we have deemed proper to include in this record; though it is evidently predicated upon the performance of promises, we wish and hope that it may benefit us in regard to eternal retribution. In the nineteenth year of our administration, we had willingly and faithfully labored on the new structure in the front part of the church.[57]

The gifts, prayers, and anticipated reciprocal intercession may also be said to be expressed, visually, in those four works of art that show Suger as a suppliant. The gifts are, of course, the works of art themselves; the prayers are evident in the figures' poses; and the anticipated reciprocity is expressed by the existence (receipt) of the gift.[58]

Thus, three general principles concerning pious donations which have been formulated for eleventh- and twelfth-century northern France can be adduced to summarize Suger's good works:[59] (1) a pious donation or gift (under which label Suger's

works can be reasonably subsumed) usually involves a counter-gift, often in the form of spiritual benefits; (2) relationships established by the gift involve not only a donor and an immediate recipient (here Suger and the community of monks at Saint-Denis) but also the patron saint to whom the gift is actually made and even God; (3) the gifts themselves symbolize the relationships so established.

REPRESENTATIONS OF RECIPROCITY
IN OTHER WORKS OF ART

Two contemporary commissions—one a sculpture, the other a manuscript illumination—can be compared to Suger's artistic patronage at Saint-Denis. Like Suger's, these two images are accompanied by texts that render the reciprocity within the visual forms more intelligible. The fact that the donors, who are both laypeople, are shown offering gifts to their respective patron saints need not concern us;[60] what is crucial is that these images demonstrate clearly other patrons' use of works of art to establish, witness, and confirm reciprocal relationships for the benefit of their souls.

Fig. 3. Mont-Saint-Michel Cartulary (Avranches, Bibliothèque municipale, ms. 210, fol. 25v)

Mervilliers

One of these images is the badly eroded tympanum from a priory church at Mervilliers (fig. 2), in the canton of Janville near Toury-en-Beauce,[61] where Suger himself was *praepositus* early in his ecclesiastical career.[62] The tympanum, which has been dated to the first half of the twelfth century,[63] records the offering of a pious donation of some sort to a saint, in return for spiritual benefits. The patron saint, enthroned at the center of the scene and identified by the inscription as S(anctus) IEORGIVS, receives an object symbolizing a gift from the knight on the left.

To the right, a priest, who presumably represents the church in actual receipt of the gift, offers his benediction to formalize the donation. At the lower right, a cleric "records" the act on a banderole, which becomes the border of the composition. A bust-length image of Christ, flanked by censing angels, appears at the apex of the tympanum to bless the scene. The damaged inscription, which removes any doubt about the interpretation of the scene, can be reconstructed. The saint speaks:

> Herbert [gave]
> William similarly conceded. . . .

Rembald, knight, his heir, conferred on me
present treasures in order to have
[treasures] without end.[64]

The tympanum may have been commissioned by the knight, or by the prior, or by both. It not only records the donation for posterity but also gives monumental form to the benefits exchanged by both parties to the agreement. By making Saint George the speaker, the inscription attests to the belief, held by the worldly participants, in the active role of holy personages in reciprocal acts.

The Mont-Saint-Michel Cartulary

The second image (fig. 3), appears in the well-known Mont-Saint-Michel Cartulary (Avranches, Bibliothèque municipale, ms. 210, fol. 25v) compiled for Robert of Torigny shortly after 1154.[65] The folio illustrates and faces the text of a charter of Duke Robert of Normandy dated between 1027 and 1035.[66] Given the paucity of Western medieval charter illustration, there is no reason to suppose that the full-page illumination in question copies an earlier one. Indeed, it and the three other full-page illuminations in the cartulary[67] were probably created for that manuscript to emphasize the texts that describe or record the founding of Mont-Saint-Michel as well as the three major donations to the abbey. In an important sense, then, the manuscript is more than a collection of charters; it is a written and visual record of the abbey's history, of which the charters are an essential part. The compilation of the cartulary is itself probably best understood as part of the reform initiated under Robert of Torigny, following a period of poor administration in the 1120s, and of monastic chaos stemming from and paralleling the Anarchy of King Stephen (1135–53).[68]

The illumination presents three scenes arranged in two registers. At the lower left, Saint Michael appears to Duke Robert in a dream, presumably ordering the duke to make the gift.[69] At the lower right, the duke, in the presence of two of his liege men, places a glove, symbolic of the gift, on an altar above which hovers an image of Saint Michael, who appears to bless the action.[70] Above, in a single scene, a tonsured cleric receives a scepter from the saint, which symbolizes the transfer of the gift to the abbey of Mont-Saint-Michel.[71] To the left of the cleric is a striding figure in secular costume. He also wears a monastic cowl and approaches the altar with his hands clasped in a gesture of supplication. Certainly not a second figure of the cleric, this figure has been plausibly identified as Duke Robert.[72] To the far left are witnesses arranged in two rows of two figures each. The accompanying text of the charter speaks of Duke Robert's transferring of the saint's altar and the monastery to Saint Michael for the abbot and the monks who will have custody of it.[73] The duke does this for the good of his soul and for the souls of his imme-

diate family and causes the gift to be confirmed by a number of his liege men.[74]

All of the text may be said to be represented in the cartulary illumination, including Robert's supplication for the good of his soul, which is implicit in the gesture made by the figure of the duke before the saint on the altar in the upper register. The dream scene, however, appears nowhere in the charter;[75] it is probably to be explained on the basis of compositional and iconographic parallels with the frontispiece of the cartulary. This latter illustrates the history of the founding of Mont-Saint-Michel and shows Saint Michael appearing in a dream to Saint Aubert in which he tells the latter to found the abbey.[76]

In this illumination the patron, Robert of Torigny, and the original donor, Robert of Normandy, are clearly not the same person. We must remember, however, that donations such as this were really exchanges with an extended temporal dimension.[77] Abbot Robert and his monks continued to benefit from the initial donation as much as did, we may assume, Duke Robert and members of his family. The illumination and the facing, recopied text of the charter may be said to affirm the still current efficacy of the benefits to all parties in the agreement and to visually underscore the active role of Saint Michael in this process.[78]

These two "charter illustrations" present, then, in visual form, the saintly reciprocity anticipated by donors and recipients in formalized pious giving. They provide explicit parallels to our interpretation of Suger's intentions surrounding his artistic patronage at Saint-Denis.

PURGATORIAL SUFFERING
IN TWELFTH-CENTURY THOUGHT

Thus testimony that pious donors made their gifts in perpetuity can be found in monumental programs, in occasional explicit statements in cartularies, and in the sanction clauses which often accompany the gifts.[79] In principle, all parties concerned seem agreed that subsequent alteration of the gift, even after the death of the donor, deprived the original donor of at least some of his benefits.[80] To cite only one example, a mid-twelfth-century Anglo-Norman charter:

> Now I myself, Roger de Valognes, moved by love of God and the blessed and glorious Virgin Mary [here the patron saint] have granted that this gift should be made [to Saint Mary's Binham] and do now confirm it thus made . . . for the soul of my mother and for the soul's health of myself, my wife, Agnes, and my sons who are of one mind with me in this grant the same themselves, and for the common salvation of all our kin alive and dead. . . .[81]

The charter goes on to add:

. . . that if this man's heir should try to take away the alms which is interposed as a bridge between his father and Paradise, by which his father may be able to pass over, the son, so far as he may, is disinheriting his father from the kingdom of heaven. . . . [82]

This same desire for the continuance of gifts and the idea of disinheritance can be found in the writings of Suger. In *De administratione* Suger tells us that he and a group of churchmen went before Louis VI to appeal for aid against the rapine of the lords of Le Puiset. They appealed to Louis on the grounds of the " . . . depopulation of the churches, the deplorable state of the poor and the orphans, and the disinheriting of the alms offered to the churches by his ancestors and himself."[83] Here, too, the idea of disinheritance presupposes a felt need for the continuance of the gift through time.[84]

Today this seems a strange notion. However, the expressed need to make gifts in perpetuity and, by extension, to continue the attendant reciprocal relationships can be understood in the light of twelfth-century thinking about purgatorial fire.[85]

Contemporaries of Suger, like Hugh of Saint-Victor,[86] held that souls consigned to purgatorial punishment suffered for an unspecified (and unspecifiable) time,[87] during which they might receive benefit from the prayers of "friends" and relatives on earth and *in heaven*.[88] Hugh of Saint-Victor even seems to imply that one should seek out such friends.[89] Because purgatorial fire itself would endure until the Eschaton and because a soul might suffer purgatorial fire until that time, there was a clear theological reason to retain "in perpetuity" those social ties resulting in saintly intercession and communal prayers that a donor might establish for himself through his gift to an abbey and its patron saint.

Although Suger never seems to have expressed fear of purgatorial fire directly, he does give voice to his fear that the relationships established by his good works might not survive in perpetuity.[90] At the beginning of *De administratione*, he says that he writes so that the record of "the considerable increases that the great munificence of God has brought in the time of our administration not be lost by the silence of inept successors"[91] (and, one might add, so that the spiritual benefits accruing to Suger might not be lost along with them). Elsewhere in *De administratione*,

Suger explains that, in order to help perpetuate a gift of alms (which, as he said, extinguishes sin), he had it "confirmed by a charter of King Louis, conserved in the public archives."[92] Similar concern is expressed in a different way in the *Ordinatio*, where Suger speaks at length about reviving and reconstituting the memorial observances for the soul of Charles the Bald, observances that had been " . . . discontinued on account of a very great lapse of time." According to Suger they merited reconstruction because of the emperor's "great liberality and generous munificence" toward the abbey and because he, Suger, thought it worth the effort "for the salvation [of his] own soul."[93] To put the matter another way, Suger insinuated himself into an existing relationship, which he perceived as a reciprocal one, by reconstituting it, thereby earning the gratitude (prayers) of Charles the Bald and, one assumes, the saints in question.[94] This interpretation is supported by the association of Suger and Charles in the inscription on the side of the altar where the observances were held (Appendix, 3).

Thus, it is possible to suggest that Suger's images—figures and inscriptions so strategically placed along the main liturgical axis (fig. 1) of Saint-Denis—are less images of an immense ego than they are the commemorations of his pious gifts and the means of perpetuating (as constant witnesses, one might say) the attendant reciprocal relationships the gifts had brought into existence.[95] Moreover, through Hugh of Saint-Victor's suggestion that souls might suffer purgatorial fire at those places where the sins were actually committed,[96] we can understand Suger's concern for establishing anniversary Masses at the abbey's dependencies, such as Saint-Denis-de-l'Estrée, Toury-en-Beauce, and Berneval in the Vexin—all places where, by Suger's own witness, we know he sinned.

In conclusion, we should probably not dismiss as pure rhetorical flourish the passage in *De administratione* in which Suger tells the reader that, in return for writing his book, he, Suger, would be promised " . . . the continual fervor of all succeeding brethren in their prayers for the salvation of [his] soul. . . . "[97] If not their actual promise, it was surely Suger's pious hope. As Suger himself put it in a related context, "The recollection of the past is the promise of the future."[98]

APPENDIX

Epigraphic Images of Suger

1. West facade, central portal, lintel
 Suger, *Adm.* (P), pp. 48, 49

 > Suscipe vota tui, judex districte, Sugeri;
 > Inter oves proprias fac me clementer haberi.

 > Receive, O stern Judge, the prayers of Thy Suger;
 > Grant that I be mercifully numbered among Thy own
 > sheep.

2. West facade, central portal
 Suger, *Adm.* (P), pp. 46, 47

 > Ad decus ecclesiae, quae fovit et extulit illum,
 > Suggerius studuit ad decus ecclesiae.
 > Deque tuo tibi participans martyr Dionysi,
 > Orat ut exores fore participem Paradisi.
 > Annus millenus et centenus quadragenus
 > Annus erat Verbi, quando sacrata fuit.

 > For the splendor of the church that has fostered and
 > exalted him,
 > Suger has labored for the splendor of the church.
 > Giving thee a share of what is thine, O Martyr Denis,
 > He prays to thee to pray that he may obtain a share of
 > Paradise.
 > The year was the One Thousand, One Hundred, and
 > Fortieth
 > Year of the Word when [this structure] was
 > consecrated.

3. Interior, crossing bay, Main Altar, right side
 Suger, *Adm.* (P), pp. 60, 61

 > Has arae tabulas posuit Suggerius abbas,
 > Praeter eam quam rex Karolus ante dedit.
 > Indignos venia fac dignos, Virgo Maria.
 > Regis et abbatis mala mundet fons pietatis.

 > Abbot Suger has set up these altar panels
 > In addition to that which King Charles has given
 > before.
 > Make worthy the unworthy through thy indulgence,
 > O Virgin Mary.
 > May the fountain of mercy cleanse the sins both of the
 > King and the Abbot.

4. Interior, in front of the chevet, Great Cross

Inventaire de 1634; also see Panofsky, *Suger,* p. 183

 > Rex bone, Suggeri dignare pius misereri;
 > De cruce protege me, pro cruce dirige me.

 > Good King, deign mercifully to pity Suger;
 > From the Cross protect me; for [the sake of] the Cross
 > direct me.

5. Interior, chevet, Altar of the Martyrs, front side
 Suger, *Adm.* (P), pp. 54, 55

 > Magne Dionysi, portas aperi Paradisi,
 > Suggeriumque piis protege praesidiis.
 > Quique novam cameram per nos tibi constituisti,
 > In camera coeli nos facias recipi,
 > Et pro praesenti coeli mensa satiari.
 > Significata magis significante placent.

 > Great Denis, open the doors of Paradise
 > And protect Suger through thy pious guardianship.
 > Mayest thou, who has built a new dwelling for thyself
 > through us,
 > Cause us to be received in the dwelling of Heaven,
 > And to be sated at the heavenly table instead of at the
 > present one.
 > That which is signified pleases more than that which
 > signifies.

6. Interior, chevet, Altar of the Martyrs, back
 Doublet, *Histoire de l'abbaye,* 1625, p. 248; Panofsky, *Suger,*
 p. 173, transmits the inscription, but does not translate it.
 See also pp. 172–80 and esp. pp. 179–80 for Panofsky's
 discussion.

 > Fecit utrumque latus, frontem, tectumque Sugerus.

 > Suger made both sides, the front and the roof.

7. Interior, chevet (specific location not certain)
 Suger, *Adm.* (P), pp. 50, 51

 > Annus millenus et centenus quadragenus
 > Quartus erat Verbi, quando sacrata fuit.

 > (Quibus etiam epitaphii versibus hos adjungi
 > delegimus:)

 > Pars nova posterior dum jungitur anteriori,
 > Aula micat medio clarificata suo.
 > Claret enim claris quod clare concopulatur,
 > Et quod perfundit lux nova, claret opus

Nobile, quod constat auctum sub tempore nostro,
Qui Suggerus eram, me duce dum fieret.

The year was the One Thousand, One Hundred, Forty
and
Fourth of the Word when [this structure] was
consecrated.

(To these verses of the inscription we choose the
following ones to be added:)

Once the new rear part is joined to the part in front,
The church shines with its middle part brightened.
For bright is that which is brightly coupled with the
bright,
And bright is the noble edifice which is pervaded by
the new light;
Which stands enlarged in our time,
I, who was Suger, being the leader while it was being
accomplished.

8. Location movable, Suger's Ewer
 Suger, *Adm.* (P), pp. 78, 79

Dum libare Deo gemmis debemus et auro,
Hoc ego Suggerius offero vas Domino.

Since we must offer libations to God with gems and
gold,
I, Suger, offer this vase to the Lord.

9. Location movable, Eleanor Vase
 Suger, *Adm.* (P), pp. 78, 79

Hoc vas sponsa dedit Aanor regi Ludovico,
Mitadolus avo, mihi rex, Sanctisque Sugerus.

As a bride, Eleanor gave this vase to King Louis,
Mitadolus to her grandfather, the King to me, and
Suger to the Saints.

NOTES

1. The specific passages referred to here are discussed in detail below, pp. 79–80.

2. The best single life of Suger remains Cartellieri, *Suger.* On Suger's role as counselor, see Eric Bournazel, *Le Gouvernement capétien au XIIᵉ siècle* (Paris, 1975). On Suger's political activities, see Achille Luchaire, *Louis VI, le Gros, 1081–1137* (Paris, 1890). On Suger as a historian, see Gabrielle Spiegel, *The Chronicle Tradition of Saint-Denis: A Survey* (Brookline, Mass., and Leyden, 1978), esp. pp. 44–54. The literature on Suger's artistic enterprises is voluminous. Louis Grodecki, *Les Vitraux de Saint-Denis, étude sur le vitrail au XIIᵉ siècle* (Corpus Vitrearum Medii Aevi), "Études" France (Paris, 1976), vol. 1, pp. 138–42, provides a recent extensive bibliography not limited to the glass. Panofsky, *Suger,* pp. 1–37, remains the most penetrating assessment of Suger's personality and has become the standard interpretation of his character. Other important treatments of Suger include: Marcel Aubert, *Suger,* (Paris, 1959); Hubert Glaser, "Beati Dionysii Qualiscumque Abbas. Studien zu Selbstbewusstsein und Geschichtsbild des Abtes Suger von Saint-Denis" (Ph.D. diss., Munich, 1957); and Otto von Simson, *The Gothic Cathedral, Origins of Gothic Architecture and the Medieval Concept of Order,* 2d rev. ed. (Princeton, 1974), esp. pp. 61–141. See also the remarks of John Benton in the introduction to this volume.

3. Panofsky, *Suger,* p. 30, qualifies " . . . Suger's colossal but, in a sense, profoundly humble vanity" by claiming that "Suger asserted his personality centrifugally [in contrast to the individual during the Renaissance]: he projected his ego into the world that surrounded him until his whole self had been absorbed by his environment." This view is conditioned by Panofsky's opinion that the church acted as a surrogate mother for Suger. Deprived of his own mother, he completely fused " . . . his personal aspirations with the interests of the 'mother church' . . . [gratifying] . . . his ego by renouncing his identity . . . [expanding] . . . himself until he had become identical with the Abbey" (p. 31). Entirely apart from the clinical viability of such an interpretation, it is not necessary in order to account for Suger's concern with "self-perpetuation." Moreover, Panofsky is also struggling to account for the manifestation of Suger's ego within the limits of the old construct of "medieval anonymity" versus "modern individualism." That the construct itself was never viable has recently been shown by Heinrich Klotz, "Formen der Anonymität und des Individualismus in der Kunst des Mittelalters und der Renaissance," *Gesta* 15 (1976): 303–12.

4. I assume throughout this study that monumental inscriptions which mention Suger by name evoked the abbot's presence as effectively as did figural representations of him.

5. The methodology frankly borrowed and herein applied to Suger's artistic patronage was first formulated by Marcel Mauss, *The Gift, Forms and Functions of Exchange in Archaic Societies,* trans. Ian Cunnison (1924; reprint, New York, 1967). Recently, this approach has been applied to medieval European gift-giving by Aron Gurevič, "Représentations et attitudes à l'égard de la propriété pendant le haut moyen âge," *Annales Économies, Sociétés, Civilisations* 27 (1972): 523–47, and by Georges Duby, *The Early Growth of the European Economy. Warriors and Peasants from the Seventh to the Twelfth Centuries,* trans. Howard Clarke (1973; reprint, Ithaca, N.Y., 1974), pp. 48–57. My own thinking on the matter has benefited greatly from

conversations with my colleague, Stephen White, whose own study, "Pactum . . . Legem Vincit et Amor Judicium, the Settlement of Disputes by Compromise in Eleventh-Century Western France," *American Journal of Legal History* 22 (1978): 281–308, makes an important contribution to the discussion of social relationships in medieval France. Also important for the understanding of reciprocal relationships in medieval France are: Stephen White, "The *Laudatio Parentum* in Northern France in the Eleventh and Twelfth Centuries: Some Unanswered Questions," *American Historical Association Proceedings*, 1977, pp. 1–28 (a much expanded version of this paper is forthcoming); and two articles by Patrick Geary, "L'Humiliation des saints," *Annales Économies, Sociétés, Civilisations* 34 (1979): 27–42, and "Exchange and Interaction Between the Living and the Dead in Early Medieval Society" (forthcoming).

6. These seven "permanent" inscriptions were supplemented by at least two (see Appendix here, 8 and 9) and perhaps four essentially commemorative inscriptions on portable liturgical objects. In his Testament of 1137, Suger arranged for the brethren to display these objects on the anniversary of his death. Given their precious nature, we can reasonably assume that Suger's liturgical vessels were on display during the abbey's major feasts. During these periods, these objects added to the insistent presence of the man who provided them. On the objects and their inscriptions, see Blaise de Montesquiou-Fezensac and Danielle Gaborit-Chopin, *Le Trésor de Saint-Denis* (Paris, 1977), vol. 3, pp. 41–42 (on Suger's Ewer); pp. 63–64 (on the Eleanor Vase); pp. 42–43 (on Suger's Eagle Vase); and pp. 57–59 (on Suger's chalice). The inscription on the Ewer is a restoration but is thought by the authors to replace an original. On the Testament, see Suger, *Ch.* (L), pp. 333–41 and esp. p. 338. Panofsky, *Suger,* p. 29, speaks of thirteen *versiculi* on walls and liturgical objects that included Suger's name; I have been unable to locate the remaining two.

7. On the iconographic authenticity of the restored figure of Suger in the central portal tympanum, see Pamela Blum and Sumner McK. Crosby, "Le Portail central de la facade occidentale de Saint-Denis," *Bulletin monumental* 131 (1973): 220–21. On the destroyed figure of Suger formerly on the bronze doors of the portal, see Paula Gerson, *"The West Facade of Saint-Denis, an Iconographic Study"* (Ph.D. diss., Columbia University, 1970), pp. 100–111. On the architectural circumstances of the inscription-bearing lintel, see Paula Gerson, "The Lintels of the West Facade of Saint-Denis," *Journal of the Society of Architectural Historians* 34 (1975): 189–97.

8. Panofsky, *Suger,* p. 186, the right side was the south side.

9. Philippe Verdier, "La Grande croix de l'abbé Suger à Saint-Denis," *Cahiers de civilisation médiévale* 13 (1970): 1–31, on what is known and knowable about the Great Cross.

10. There have been a number of reconstructions of Suger's Altar of the Martyrs beginning with Eugène Emmanuel Viollet-le-Duc, "Autel," *Dictionnaire raisonné de l'architecture française* (Paris, 1859), vol. 2, esp. pp. 23–26. Recent studies on the altar include, Sumner McK. Crosby, *The Apostle Bas-Relief at Saint-Denis* (New Haven, 1972), esp. pp. 17–24; and Blaise de Montesquiou-Fezensac and Danielle Gaborit-Chopin, "Le 'Tombeau des Corps-Saints' à l'abbaye de Saint-Denis," *Cahiers*

archéologiques 23 (1974): 81–94.

11. On the authenticity of this panel see Grodecki, *Les Vitraux,* pp. 81–83. Of the figure of Suger, only the head, hands, crozier crook, and the inscription, *SVGERIVS ABA,* are original. The clasped hands confirm the reconstructed kneeling pose.

12. Panofsky, *Suger,* pp. 168–69, associated the text of this inscription with inscriptions in the churches of Old Saint Peter's and SS. Cosma e Damiano in Rome and in the abbey church at Montecassino. Since the first and third of these appeared on the triumphal arches of their churches, and since the juncture of Suger's new choir with the old Carolingian crossing tower may well have provided a suitable field, perhaps Suger's inscription followed its models in location too. See also note 15 here.

13. See Kurt Bauch, "Portraiture, the European West, the Middle Ages," *Encyclopedia of World Art* 11 (1972): cols. 483–87; Peter Bloch, "Dedikationsbild," *Lexikon für christliche Ikonographie* 1 (1968): cols. 491–94; and Harald Keller, "Portrait," *Lexikon für christliche Ikonographie* 3 (1971): cols. 446–55. As these brief essays reveal, little has been written, and even less recently, on western medieval "donor portraiture." I have also benefited from reading Kate Gilbert, "Medieval Charter Illustration" (unpub. ms., Yale University, 1980).

14. Two observations seem germane here. The abbatial crozier is the attribute of office that distinguishes the representation of an abbot from one of his monks. All four figures of Suger are identical in the essential characteristic of pose. Although only the figure of Suger on the central portal tympanum may have been naked originally, one should probably nevertheless ask whether that representation also included a crozier. The remaining original portions of the sculpture lie behind the nineteenth-century insert and thus do not preclude the presence of the attribute. See Blum and Crosby, "Portail central," pls. Va, Vb, and fig. 4.

15. See Appendix, 6. The other is, of course, the lengthy dedicatory inscription (Appendix, 7) which was located somewhere in Suger's eastern addition. Panofsky, *Suger,* pp. 29 and 169, makes much of Suger's description of himself as *dux* (leader), discussing the passage as a manifestation of Suger's quest for glory in the Burckhardtian sense (p. 29). It is true that in the two inscriptions to which Panofsky compares Suger's, namely, those on the triumphal arches of Old Saint Peter's and Montecassino, the *dux* is God or Christ. However, the passage may not be as exceptional or "modern" as Panofsky would have us believe. The dedicatory inscription from the cloister of Moissac reads:

Anno ab incarnatione eterni principis millesimo
centisimo factum est claustrum istud tempore
domine Ansquitilii abbatis amen

and is illustrated in Meyer Schapiro, *Romanesque Art, Selected Papers* (New York, 1977), fig. 3 between pp. 140 and 141. Rather than make claims for Ansquitil's "modernity" it would seem that Suger's dedicatory inscription was less than atypical as a dedicatory inscription (*dux* being no more surprising than *domine*) and that Panofsky's reading of it has more to do with his general view of Suger than with the inscription itself. What is important here is that Suger's dedicatory inscription be seen in relation to the five other, very different inscriptions.

16. Three of the figures of Suger were originally full-length, the exception being the figure in the central portal tympanum who kneels in a sarcophaghus. Unfortunately, neither the descriptions of the figures on the bronze door or on the Great Cross, nor the state of preservation of the figure in the axial chapel window allow us to determine whether Suger was barefoot or wore liturgical sandals. Professor Giles Constable has reminded me how useful such information would be for any interpretation of the penitential quality of the images.

17. This fact does not seem to have been pointed out before, but it is essential to an understanding of how Suger intended his images to be effective. See also note 18 here.

18. Verdier, "Grande croix," pp. 16–20, draws parallels between the iconography of the central portal of the west facade and the complete program of Suger's Great Cross. He does not explore the purely formal relationships in the light of the two images of Suger.

19. The images chosen for comparison are all of churchmen. Either the image itself is connected with Saint-Denis or the individuals represented are comparable to Suger as personalities. Donor portraits of artists and secular patrons have not been included here in order to maximize the comparability of the images to be discussed. The famous portrait of the scribe and monk Eadwine in the psalter which bears his name (Cambridge, Trinity College Library, MS. R. 17.I) has recently been shown on stylistic and codicological grounds to be a posthumous commemorative portrait and thus not strictly comparable to Suger's images. See George Zarnecki, "The Eadwine Portrait," in André Chasel et al., eds., *Études d'art médiéval offertes à Louis Grodecki* (Paris, 1981), pp. 93–98.

20. The figure of Airardus was described briefly and reproduced (without the gift) in Jean Mabillon, *Annales ordinis S. Benedicti* (Paris, 1739), vol. 2, pp. 236–37. Blaise de Montesquiou-Fezensac, "Les Portes de bronze de Saint-Denis," *Bulletin de la Société nationale des Antiquaires de France,* 1945–47 (1950): 128–37, discusses additional prerevolutionary descriptions that confirm that the figure of Airardus faced a figure of Saint Denis dressed as a bishop and that Airardus offered the saint a model of his doors. See the reconstruction by Panofsky, *Suger,* p. 161.

 Based on Mabillon, Panofsky associates this Airardus with the master of the works of Fulrad's Carolingian basilica. Montesquiou-Fezensac asserts that the doors date from the second half of the eleventh century on epigraphic grounds. Jean Hubert, "La Tour occidentale de Saint-Denis," *Bulletin de la Société nationale des Antiquaires de France,* 1945–47 (1950): 137–40, suggests that the doors may have been hung on the so-called Tower of William the Conqueror. While it would be useful to be able to date the doors securely, the important fact for this study is that Suger knew the Airardus image and, in preserving it, contrasted it with his own.

21. Ottavio Morisani, *Gli Affreschi di S. Angelo in Formis* (Naples, 1962), figs. 12 and 15. On the frescoes, see also Janine Wettstein, *La Fresque romane, Italie, France, Espagne, études comparatives,* Bibliothèque de la Société Française d'Archéologie (Paris and Geneva, 1971), vol. 2, pp. 61–74. On Desiderius and his images, see Herbert Bloch, "Montecassino, Byzantium and the West in the Earlier Middle Ages," *Dumbarton Oaks Papers* 3 (1946): 193–200; and Gerhart Ladner, *Die Papstbildnisse des Altertum und des Mittelalters,* Bd. 1 (Rome, 1941), pp. 219–28. Parallels between the decorative programs of S. Angelo and Montecassino (Bloch, "Montecassino," pp. 199–200) suggest that a figure of Desiderius as donor may also have been present in the latter church where Suger would have seen it in 1123 (Panofsky, *Suger,* p. 169). See also notes 12 and 15 here.

22. The semicircular plaque representing the Bishop of Winchester and its pendant, which represents a pair of censing angels, have been the objects of much scholarly debate. See recently, Neil Stratford, "The 'Henry of Blois' plaques in The British Museum," *The British Archaeological Association, Conference Transactions* 6 (1980, publ. 1983): 28–37, for the earlier literature and a reassessment of the plaques which Stratford dates from the "mid- to third quarter of the 12th century" (p. 33). See also, Neil Stratford, "The Henry of Blois Enamel Plaques," in George Zarnecki et al., *English Romanesque Art, 1066–1200* (London, 1984), pp. 261–62. On the career of Henry of Blois, see Lena Voss, *Heinrich von Blois, Bischof von Winchester (1129– 1171),* Historische Studien, 210 (1932; reprint, Vaduz, 1965); and David Knowles, *The Monastic Order in England* (Cambridge, 1949), pp. 285–93.

23. Montesquiou-Fezensac, "Portes de bronze," p. 130:

 Hoc opus Airardus caelesti munere fretus,
 Offert ecce tibi Dionysi pectore miti.

24. Wettstein, *La Fresque,* p. 64 n. 12:

 CONSCENDES CELU[M] SI TE COGNOVERIS
 IPSU[M]
 UT DESIDERIUS QUI S[AN]C[T]O FLAMINE
 PLENUS
 COMPLENDO LEGE DEITATI C[ON]DIDIT
 ED[EM]
 UT CAPITAT FRUCTU[M] QUI FINE NESCIAT
 ULLU[M]

 The inscription appears on the lintel of the western portal of the church, separated by the length of the nave from the image of the abbot, Desiderius, in the apse to which it clearly refers.

25. Stratford, "Plaques" (1980), p. 33:

 + ARS AVRO GEMMIS O🜨 PRIOR·PRIOR
 OMNIBVS AVTOR·
 DONA DAT HENRICVS VIVVS IN ERE DEO:
 ⸜ ..MENTE PAREM MVSIS·ʎ MARCO VOCE
 PRIOREM:
 FAMA VIRIS·MORES CONCILIANT SVPERIS.⸎

 The inscription on the angels plaque reads:

 + MVNERA GRATA DEO PREMISSVS VERNA
 FIGURAT:
 ANGELVS AD CELVM RAPIAT POST DONA

DATOREM?·

τNE TAMEN ACCELERET NE SVSCITET ANGLIA
LVCTVS:

CVI PXA VEL BELLVM MOTVSVE QVIESVE
PER ILLVM⁓

26. A representation of an abbot as donor/suppliant strikingly similar to the images of Suger evidently once appeared in a stained-glass window in the church of Notre-Dame in Senones. The image, known from an eighteenth-century drawing, showed Abbot Anthony of Senones (d. 1136) and one brother Gaufridus prostrate at the feet of a figure of the Virgin. See Georges Durand, *Les Églises romanes des Vosges,* Revue de l'art chrétien, suppl. 2 (Paris, 1913), fig. 272 and pp. 363–64, where the parallel to the images of Suger is mentioned. An assessment of this image forms part of the author's larger, comparative study, "The Donor as Suppliant: a mode of monastic patronage," which is in progress.

27. The images, arranged along the main axis and grouped at the west, in the center, and at the east, must also have been one of the leitmotifs around which Suger . . . *bono initio bonum finem . . . concopularet . . .* (Suger, *Adm.* [P], p. 44).

28. The mosaic pavement from the Chapel of Saint Firmin at Saint-Denis once contained an image of a donor that appears to be strictly comparable to those of Abbot Suger. The central roundel, which along with two other panels has been reset in the chapel, shows a tonsured, kneeling figure in monastic garb whose hands are clasped in prayer. Jean-Pierre Darmon and Henri Lavagne, *Recueil général des mosaïques de la Gaule, II. Province de Lyonnaise, 3. partie centrale* (X^e Supplément à *Gallia*) (Paris, 1977), pp. 177–83 and pls. cxxv–cxxxii. According to Darmon and Lavagne, the inscription within the roundel reads: *HOC PIVS ALBERICVS NOBILE FECIT OPVS,* and that enframing the roundel reads: *QVI TE DEVOTVS ORO/CVI SERVIO TOTVS/MARTYR SANCTE DEI/QVAESO MEMENTO MEI* (p. 180). Darmon and Lavagne believe that the donor figure " . . . ne peut s'agir d'un moine ordinaire, [parce que] la somptuosité de son costume et son attitude de donateur indiquent au moins un abbé . . . " (p. 183). Objection must be raised to this suggestion because the example of the Suger images indicates that an image of an abbot would be accompanied by either a crozier (as attribute of office) or the word *abba* (as title) or both. Perhaps the criteria these authors cite are indications that the person in question did hold some other, lesser office at Saint-Denis. Darmon and Lavagne date the mosaic to "vers 1200" (p. 183) on stylistic grounds. Jules Formigé, *L'Abbaye royale de Saint-Denis, recherches nouvelles* (Paris, 1960), p. 124, follows Viollet-le-Duc, *Dictionnaire,* vol. 6, p. 404, in dating the mosaic to the late twelfth century, apparently on technical grounds. See also the recent thorough study by Christopher Norton, "Les Carreaux de pavage du moyen âge de l'abbaye de Saint-Denis," *Bulletin monumental* 139 (1981): 69–100, esp. pp. 83, 94 n. 6, where the dating possibilities "du temps de Suger" and "de la fin du XII^e siècle" are reviewed, and the essay by Xavier Barral i Altet included in this volume, pp. 245–55. Norton seems to support the earlier date and Barral i Altet a post-Sugerian one. Regardless of which date is correct, the Alberic mosaic should

probably be considered as an imitation of the form, and perhaps also the spirit, of those of Suger himself.

29. Suger, *Ch.* (L), pp. 333–41. I am grateful to Professor Elizabeth A. R. Brown for advice on this document and for help with the Latin.

30. Ibid., pp. 333, 335, and 339. The sins are referred to as: *iniquitatum mearum antiquarum; nobis peccata; offensis.*

31. "Cumque de eis et in eis post Deum confidens, tanquam aegrotus fideli medico sollicitudinum mearum angores replicare[m], annos meos in amaritudine animae meae reponens, deplangere et aborrere introrsum coepi: meam circa divinorum beneficiorum largitatem longam ingratitudinem repraesentans mihi . . . " (ibid., p. 334).

32. " . . . diem terroris, calamitatis et miseriae . . . " (ibid., pp. 335–36).

33. " . . . in omnibus Beati Dionysii cellis, tam propinquis quam remotis, anniversarium nostrum orationumque instantiam, missam pro defunctis semel in ebdomada rogantes obnixe impetravimus . . . " (ibid., p. 340).

34. " . . . et praesentis chartae memoriali confirmatione sancientes, toto tempore vitae meae, omni die missam de Spiritu sancto celebrari"; and "Cum autem miserrimum hujus vitae hominem exuero, . . . pro remedio animae meae et fratrum et benefactorum ecclesiae, eo quo diximus ordine, missam sancti Spiritus, Requiem aeternam . . . " (ibid., p. 335).

35. Ibid., pp. 336–38. On anniversaries generally, see, Auguste Molinier, *Les Obituaires au moyen âge* (Paris, 1890), pp. 105–38: "C'est au XI^e siècle que les anniversaires commencent à se multiplier; les rois d'abord, et les prélats, puis les nobles; au XIII^e, on voit apparaître dans les obituaires des églises de simples bourgeois des villes . . . " (p. 133); and N. Huyghebaert, o.s.b., *Les Documents nécrologiques,* Typologie des Sources du Moyen Âge Occidental, fasc. 4 (Brepols/Turnhout, 1975), pp. 33–70.

36. " . . . quam pro multis, quas ibidem per decennium commoratus juvenis aetate et moribus commisi offensis . . . " (Suger, *Ch.* [L], p. 339).

37. *PL,* vol. 182, cols. 191–99, esp. col. 191 (letter 78). The letter dates to 1127. An English translation appears in Bruno Scott James, *The Letters of St. Bernard of Clairvaux* (London, 1953), pp. 110–18 (letter 80).

38. " . . . valida et (quod etiam conscientiam meam gravat) militari manu . . . " (Suger, *Ord.* [P], p. 122). Panofsky (p. 123) translates *militari manu* as "armed hand," but I agree with Professor Thomas Waldman, who is preparing a new translation of the entire *De administratione,* that "armed force" is a better reading. Suger also uses the words in *De administratione,* where the context supports this interpretation: *"Unde mihi aliquando contigit quod, cum Aurelianum cum militari manu post dominum regem festinarem . . . "* (Suger, *Adm.* [L], p. 172).

39. For example, at the beginning of the *Ordinatio,* Suger describes himself as a "prevaricator of God's commands" and an "irreligious man": *"Eapropter ego Sugerius, . . . mandatorum Dei praevaricator, ad cor Dei miseratione redire festinans, unde venerim, quid fecerim, et quo ire debeam, in timore et amaritudine animae meae recogitans, ad servorum Dei tutelam tremulus confugio; et qui irreligiosus existo . . . "* (Suger, *Ord.* [P], pp. 122–23).

40. " . . . tam in capitulo nostro quam in ecclesia divinae supplicans pie-

tati, ut qui initium est et finis, id est Alpha et Omega, bono initio bonum finem salvo medio concupularet, ne virum sanguinum ab aedificio templi refutaret, qui hoc ipsum toto animo magis quam Constantinopolitanas gazas obtinere praeoptaret" (Suger, *Adm.* [P], p. 44). The biblical passage referred to is 2 Samuel 16:5–8.

41. Panofsky, *Suger,* p. 149, has difficulty interpreting this passage. He says that it "... carries a twofold connotation. On the one hand, Suger accepts Shimei's unflattering characterization ... as a 'bloody man' ... because ... [he had resorted to arms] and later on looked back upon these military exploits with a feeling, *or at least a show,* of remorse [italics mine] ... On the other hand, he rejoices in the fact that he, unlike David, ... had nevertheless *not* been refused the privilege of 'building an house for the Lord to dwell in.' " The military exploits to which Panofsky refers are described in the passage on pp. 122–23 just cited. Thus Panofsky questions the earnestness with which Suger says, "... *quod etiam conscientiam meam gravat* ... " However, Panofsky's tendency to vacillate on the sincerity of Suger's regret over past sins seems to be conditioned by his view of Suger's ego. He never notices how systematic Suger's expression of his sense of sinfulness really is throughout both his artistic patronage and his writings. Even if one rejects Suger's sincerity out of hand, as I am not prepared to do, one must still address independently the structure of the abbot's patronage and his writing, which Panofsky overlooks. Likewise, Panofsky's interpretation that Suger rejoiced over what he, but not David, was allowed to build seems conditioned by his assessment of Suger's sense of self. However, Suger's rejoicing should probably not be explained, even indirectly, as ego manifestation; its meaning lies in the discussion of reciprocity which follows below, pp. 80–81.

42. 2 Samuel 11:2–27.

43. 1 Chronicles 22:6–16, esp. 7–8, in which David says to Solomon: "My son, as for me, it was in my mind to build a house unto the name of the Lord my God: But the word of the Lord came to me, saying, Thou hast shed blood abundantly, and hast made great wars: thou shalt not build a house unto my name, because thou hast shed much blood upon the earth in my sight."

44. Ultimate punishment for sin underlies the idea of judgment as it is articulated, to cite only two passages, in Matthew 25:31–46 and in Revelations 20:11–15.

45. Bernard says that what really bothered him was Suger's public arrogance: *"Solumque ac totum erat quod nos movebat, tuus ille scilicet habitus et apparatus cum procederes, quod paulo insolentior appareret"* (*PL,* vol. 182, col. 193A). Yet, just a few lines later, Bernard clearly refers to military matters: *"Locus quippe ab antique nobilis, et regiae dignitatis exstiterat; palatii causis regumque exercitibus deservire solebat. Sine cunctatione et fraude, sua Caesari reddebantur; sed non etiam Deo quae Dei sunt persolvebantur aeque fideliter"* (*PL,* vol. 182, col. 193B). For the English, see James, *Letters,* p. 112.

46. To cite only a few lines, *"Sic strenuus in bello miles, imo sic pius ac fortis militum dux, ubi suos forte conspexerit in fugam versos, jamque hostili passim gladio trucidari, etsi se vel solum videat evadere posse, libet tamen mori magis cum illis, sine quibus vivere pudet"* (*PL,* vol. 182, col. 191B). The metaphor continues in typical Bernardine fashion. For the English, see James, *Letters,* p. 111.

47. James, *Letters,* pp. 116–17. For the Latin see *PL,* vol. 182, col. 197B–198A.

48. It is understandable that Bernard of Clairvaux, who presented Suger and the count of Nevers as elected co-regents to the royal assembly at Étampes in 1147, should have announced them with the words, "Behold the two swords" (one spiritual and one temporal). It is perhaps a bit ironic that, during the regency, the two swords effectively became one in the hands of Suger. For a discussion of these events and bibliography, see von Simson, *Gothic Cathedral,* p. 76 and nn. 59–60.

49. In discussing Suger's resort to arms early in his prelacy, Panofsky, *Suger,* p. 8, says, "But it is more than professional hypocrisy—though an admixture of this element cannot be overlooked—when he professes regret on this account ... " Panofsky goes on to say that Suger would have settled accounts peacefully had he been able to do so. One can certainly agree with the latter point, but there is no necessary reason to call into question Suger's regret over past violent actions. Anyone, including Suger, is capable of sincerely regretting having had to choose between the lesser of two evils.

50. [To the brethren] *"Pro quorum certe quiete laboribus inpraesentiarum me expono* ... " (Suger, *Ch.* [L], p. 334).

51. Matthew 19:21, "If thou wilt be perfect, go sell what thou hast, and give it to the poor, and thou shall have treasure in heaven." Ephesians 6:8, "... whatsoever good thing any man shall do, the same shall he receive from the Lord, whether he be bond, or free." There are Old Testament precedents as well, for example, Wisdom 5:16. See Joseph Pohle, "Merit," *Catholic Encyclopedia* 10 (1913): 202–8. The biblical basis of good works (merit) was traditional in the Middle Ages. The doctrine came under attack in the Protestant Reformation only to be reaffirmed by the Council of Trent.

52. For the methodology involved in the following paragraphs, see the literature cited in note 5 here.

53. Cf. above pp. 77–79 and notes 34 and 35 here. Suger, *Ord.* (P), pp. 122–23, also refers to his reciprocal arrangements with the brethren at the opening of the *Ordinatio.*

54. It is important to point out that these reciprocal relationships were perceived as being somehow binding on all parties involved. At the end of his Testament, Suger reminds the brethren that there will come a time when they will be held accountable: "... *sicut responsuri in extremo districti judicii die, cum nos invicem viderimus in eo qui nos et actus nostros per omnia videt* ... " (Suger, *Ch.* [L], p. 340). See also note 58 here.

55. The role of time in reciprocal relationships such as these is absolutely essential to a full understanding of the arrangements. We will consider this matter further on pp. 83–84. Suger expressed explicitly his concern for extending the terms of his Testament into the future without limit. At the end of the will, he urges and beseeches the brethren to honor their promises to him, "... *per omnia temporum curricula, successivis fratrum succedentium temporibus* ... " (Suger, *Ch.* [L], p. 340).

56. It has usually been assumed that the last sentence of the inscription refers to the heavenly altar and the altar that bore the inscription. Suger may also have understood the words to refer to the relationship established between himself and Saint Denis and to the inscription which attests to that relationship.

57. *"Superest siquidem et aliud probabile capitulum, quod, licet exsecutione rerum pollicitarum terminabile appareat, tamen, quia ad aeternitatis nobis proficere et optamus et speramus retributionem, huic scripto interserere dignum duximus. Nono decimo administrationis nostrae anno, cum novo operi in anteriori ecclesiae parte libenter et fideliter desudassemus . . . "* (Suger, *Ord.* [P], pp. 132–33).

58. The quasi-contractual aspect of anticipated reciprocity discussed in note 54 here, has been shown to have extended to include special beings such as saints. There were, in fact, avenues of coercion when a saint did not fulfill his or her end of the bargain. See Geary's study on the humiliation of saints cited in note 5 here. That the power to coerce the intervention of the holy person sometimes resided with the living also lies at the heart of Saint Anselm's "Prayer by an Abbot (or Bishop) to the Patron Saint of his Church." After bemoaning his inadequacy to hold office, the suppliant says:

> . . . you have done this,
> either by commanding it or by permitting it.
> So it is you, who have in some way done this thing,
> who must act—you by praying, and you by
> giving—
> so that what you have done
> may hold back neither me nor others,
> but may lead forward me and many others.
> You have made an ignorant doctor, a blind leader,
> an erring ruler:
> teach the doctor you have established,
> guide the leader you have appointed,
> govern the ruler that you have approved. (ll. 38–
> 49)

And again later on in a similar context:

> Act, sir, act for me,
> for you see that I have neither the knowledge nor the
> ability
> to act in your place.
> Rather, act not for me but for yourself,
> for this pertains first and more greatly to you than me,
> and if it pertains to me, it is after and under you. (ll.
> 113–18)

This English translation is in Sister Benedicta Ward, *The Prayers and Meditations of Saint Anselm* (Harmondsworth, 1973), pp. 208, 210. For the Latin, see Franciscus Schmitt, *S. Anselmi Cantuariensis Archiepiscopi, Opera Omnia* (Edinburgh, 1946), vol. 3, pp. 69, ll.21–27 and 70, ll.57–59. For the dissemination and the illustration of the prayers, see, respectively, Richard W. Southern, *St. Anselm and His Biographer* (Cambridge, 1963), pp. 36–38; and Otto Pächt, "The Illustrations of St. Anselm's Prayers and Meditations," *Journal of the Warburg and Courtauld Institutes* 19 1956): 68–84. Guibert of Nogent expresses the same sense of the saint's obligation to the abbot. See John Benton, *Self and Society in Medieval France* (New York, 1970), p. 44.

59. White, "Pactum," p. 302.

60. Comparison of donors or donor figures to Suger or to his images is not the issue here as was the case on p. 79.

61. See the remarks on Mervillers in André Lapeyre, "Le Tympan de l'église du Heaulme (Seine-et-Oise) et la légende de Saint Georges," *Bulletin monumental* 95 (1936) (317): 324–27. Among older studies, the initial investigation of the tympanum, Jules Quicherat, "Une Donation du XII⁰ siècle figurée en bas-relief," *Revue archéologique* 1 (1854): 171–73, remains essential. De Boisvillette, "Rapport sur les travaux de la société, 1860–1861," *Société archéologique d'Eure-et-Loir, Procès-Verbaux* 2 (1861): 37–41; and Gustave Sainsot, "Le Tympan du portail de Mervillers," *Congrès archéologiques* 67 (1900): 97–119, make contributions. Adolphe Lecocq, "Un Symbole d'investiture au moyen-âge," *Société archéologique d'Eure-et-Loir, Mémoires* 3 (1863): 135–45, is totally dependent on Quicherat. Recently the tympanum has again attracted attention. See Henry Kraus, *The Living Theater of Medieval Art* (Bloomington, 1967), pp. 33–34, who discusses it in the light of feudal relationships; and Walter Cahn, "The Tympanum of the Portal of Sainte-Anne at Notre-Dame de Paris and the Iconography of the Division of the Power in the Early Middle Ages," *Journal of the Warburg and Courtauld Institutes* 32 (1969): 61–62, who discusses the sculpture in relation to the composition of the Paris tympanum. A plaster cast of the tympanum, made for the Société archéologique d'Eure-et-Loir in the nineteenth century and now in the Musée des Beaux-Arts, Chartres, probably offers the best state of preservation given the eroded quality of the surface of the original.

62. Suger describes his activities at Toury, which began in 1109, in Suger, *Adm.* (L), pp. 170–73. Related information is also given by Suger in the *Vita Lud.* (W), pp. 128–69.

63. Quicherat, "Une Donation," p. 172, on the basis of " . . . *les formalités de la donation et . . . le costume . . .* " Lapeyre, "Le Tympan," p. 326, suggests stylistic analogies with the capitals of the choir of Saint-Benoît-sur-Loire which he dates " . . . *de 1110 à 1120.*" The provincial setting of the priory and its evident lack of ecclesiastical importance raise questions about the viability of easy comparisons with major monuments like Saint-Benoît. The *formalités* can equally apply to the eleventh century so that the possibility of discovering a definite date is limited and a half century may even be too narrow a range based on our current knowledge.

64. The inscription is carved in low relief and not engraved.

> [Donavit] hERBERTVS
> [WIL] LERMVS SIMILITER CVNCESSIT . . .
> RENBAVDVS MILES MIChI 'TVLIT (contulit) E . . S (ejus)
> hERES GAZAS PSENTES (presentes) VT hAbERET X
> X SINE (sic fINE) CARENTES [GAZAS].

Quicherat, "Une Donation," pp. 171–72 and Sainsot, "Le Tympan," pp. 110–11, have commented on the inscription. Sainsot (p. 110) pointed out that the *S* forms all appear in reverse and that the *E* forms vary occasionally. Both assume that Herbertus Willermus is one person, which is rather unlikely. Separating the names requires the insertion of another word, such as *donavit*, along the lower border of the tympanum which both the space and the absence of any terminal mark permit. Sainsot (p. 111) saw a lacuna of two or three letters after *cuncessit*

but he offered no suggestions to fill it; in fact, none is necessary and a terminal mark such as a cross may have been present. Quicherat (p. 172) read the *E..S* as *et pius*, which Sainsot (p. 111) corrected to read *ejus*. Sainsot (p. 110) first recognized that the badly formed *S* in *SINE* was better understood as either a damaged or incorrectly carved *f* for *fINE*. My colleague, Stephen White, whose advice on this inscription has been invaluable, suggests that the final *GAZAS* is at least implied; the spacing at the lower right-hand corner of the tympanum is sufficient for it to have been carved there.

65. Fundamental to any study of the cartulary illuminations is Amédée Boinet, "L'Illustration du cartulaire du Mont-Saint-Michel," *Bibliothèque de l'École des Chartes* 70 (1909): 335–43. Also important are: François Avril, "La Décoration des manuscrits au Mont-Saint-Michel (XIᵉ–XIIᵉ siècles)," in J. Laporte et al., eds., *Millénaire monastique au Mont-Saint-Michel* (Paris, 1967), vol. 2, pp. 203–45; François Enaud, ed., *Millénaire au Mont-Saint-Michel, 966–1966,* exhib. cat. (Mont-Saint-Michel, Paris, 1966), pp. 75–76, no. 139; and Gilbert, "Charter Illustration," pp. 11–21. The *Millénaire monastique* was intended to include six volumes of which only the first three have appeared. Regrettably, the sixth, which was to have been an edition of the cartulary, remains among the unpublished.

 The cartulary contains 138 folios of which the oldest are those from fol. 4r to fol. 112r. Folio 5 begins the text of the vision of Saint Aubert, which tells the story of the monastery's legendary founding. This is followed by a summary history of the abbey. The collection of charters proper begins on fol. 17r and continues to fol. 112r, after which there are miscellaneous items dating from the twelfth to the fourteenth centuries including a four-year history thought to be written in the hand of Robert of Torigny (Boinet, "L'Illustration," pp. 335–36).

66. The text of the charter is published in Marie Fauroux, *Recueil des actes des ducs de Normandie de 911 à 1066* (Caen, 1961), pp. 210–14. An English version of the text appears in J. Horace Round, *Calendar of Documents Preserved in France Illustrative of the History of Great Britain and Ireland, 1, 918–1206* (London, 1899), pp. 250–51.

67. The other illuminations also face the texts that they illustrate: fol. 4v, which represents the vision of Saint Aubert (this is the only illumination with a gold ground); fol. 19v, which illustrates the text of a charter of Duke Richard II of Normandy; and fol. 23v, which illustrates the text of a charter of Duchess Gonnor of Normandy. These scenes have been illustrated most recently by Enaud, *Millénaire,* pls. 7–9.

68. For these events, see André Dufief, "La Vie monastique au Mont-Saint-Michel pendant le XIIᵉ siècle (1085–1186)," in Laporte, *Millénaire monastique,* pp. 81–126. The abbey was well administered from 1085 to 1123 under successive abbots named Roger. From 1124 to 1131 the abbey was poorly led by Abbot Richard de Méré who was characterized as a layman. The monastery began an eighteen-year period of at least partial reform under Bernard de Bec, but from 1135 on, it was caught up in the English war. In electing successors to Bernard, the monks came into conflict with Henry II. From 1151 to 1154 the abbey was in a state of anarchy and at one point had two abbots. It was onto this stage that Robert of Torigny entered to begin his reform abbacy.

69. Boinet, "L'Illustration," pp. 339–40, first identified the figures and interpreted the scene. We might add that the gesture made by the duke's hands suggests a receptiveness to the angel's request or command.

70. Ibid.

71. Ibid., p. 339; Avril, "La Décoration," pp. 231–32; and Gilbert, "Charter Illustration," pp. 12–13, agree that the scene shows a cleric handing a flowering rod or scepter to the saint. The visual evidence alone suggests that the opposite is the case. The expansive, open-handed gesture of the saint echoes the gesture with which Duke Robert offers his gift in the register below. Similarly, the clasped position of the cleric's hands, which echoes the gesture of receptivity made by the duke in the dream scene in the lower register, suggests reception rather than offering. We will see that the text of the charter supports such a reading.

72. First identified by Avril, "La Décoration," pp. 231–32.

73. *"EGO ROTBERTUS COMES FILIUS MAGNI RICHARDI, GRATIA DEI DUX et princeps Normannorum, reddo Sancto Michaeli altare suum cum toto monasterio quod predecessores mei sibi hactenus vindicaverant. Reddo autem illud tali conditione, ut quaecumque a fidelibus populis ibi Deo et Sancto Michaeli fuerint oblata, monachi ibidem Deo servientes omino habeant, teneant et possideant in loci utilitate, nec ulterius veniat in custodia clericorum aut laicorum, nisi abbatis et monachorum"* (Fauroux, *Recueil,* p. 212).

74. *"Et hoc facio, pro remedio animarum parentum meorum, patris et matris, fratrum et sororum et mea . . . fidelium auoque nostrorum testimoniis firmandum trado."* (ibid.)

75. Boinet, "L'Illustration," p. 340, drew attention to this fact.

76. That Duke Robert's charter was, in a sense, a second foundation may have suggested the visual parallel between the first and the last full-page pictures of the cartulary.

77. This temporal dimension in reciprocal relationships will be discussed in the next section.

78. It may well be that the events of the preceding decades (see note 68 here) called for "re-establishing" the original terms of the charter through the medium of the new cartulary and its illustration. In this regard it is perhaps worth recalling that the charter says that the abbey would never fall into the custody of laymen or (secular) clerics and that it may have been regarded as having done so under the abbacy of Richard de Méré (1124–31). It may also be that in reaffirming the old grant textually and visually, Abbot Robert was laying the groundwork for a new confirmation of the original grant by the new duke and king of England, Henry II Plantagenet.

79. Such as Suger's inscribed on the left side of the main altar:

 Si quis praeclaram spoliaverit impius aram,
 AEque damnatus pereat Judae sociatus.

 ("If any impious person should despoil this excellent altar,
 May he perish, deservedly damned, associated with Judas.")
 (Suger, *Adm.* [P], pp. 60–61.)

 On anathema and sanction clauses, see recently, Lester Little, "La Morphologie des malédictions monastiques," *Annales Économies, Sociétés, Civilisations* 34 (1979): 43–60.

80. See the examples discussed and the penetrating remarks by White in his *"Laudatio Parentum,"* pp. 14–16 and "Pactum," pp. 305–7.

81. The English translation is given in F. M. Stenton, *The First Century of English Feudalism, 1066–1166,* cor. ed. (Oxford, 1950), p. 37. Stenton on p. 259 gives the Latin: *"Hanc igitur donacionem ego ipse Rogerus de Valonis amore dei coactus et beate et gloriose uirginis Marie . . . requisicione et precibus et concedo factam atque confirmo . . . pro anima matris mee, et pro mea propria, uxorisque mee Agnetis, et filiorum meorum salute, qui mihi in hac eadem re consencientes sunt et hoc ipsum concedunt et pro communi omnium nostrorum salutione tam uiuorum quam mortuorum."*

82. *" . . . addens eciam quod si heres eius elemosinam que quasi pons inter ipsum patrem et paradysum interponitur per quem pater transire ualeat auferre conatur utique et a regno celorum idem heres quantum in ipso est patrem eius exheredat . . . "* (Stenton, *First Century,* pp. 37 and 260).

83. I am indebted to Professor Thomas Waldman for permitting me to quote from his forthcoming translation of the *De administratione.* For the Latin, see Suger, *Adm.* (L), p. 171: *" . . . ecclesiarum depopulationem, pauperum et orphanum deplorationem, ecclesiarum eleemosynis antecessorum suorum et suis exhaeredationem lacrimabiliter exposuimus."*

84. In this passage, Suger does not speak directly about the extension of alms into the future. However, by speaking of disinheriting Louis's ancestors in the present, he speaks indirectly of it. The conception of disinheritance is the same in both cases.

85. On purgatorial fire and purgatory in the twelfth century, see recently, Jacques le Goff, *La Naissance du Purgatoire* (Paris, 1981), pp. 177–314, esp. pp. 181–208 on *le feu purgatoire,* and pp. 284–314 on *la logique du purgatoire.* Le Goff discusses the shift, in Paris after 1170, from thinking about purgatorial fire to thinking about purgatory; that is, the shift from thinking about suffering after death but before judgment in a state of being (purgatorial fire) to thinking about suffering after death but before judgment in a particular place (purgatory). However, in *"Sacramentum* and *Purgatorium:* the Reconceptualization of Penance in the Late Eleventh Century," a recent paper delivered at the 20th International Congress on Medieval Studies, Kalamazoo, Michigan, 9–12 May 1985, Theresa Gross-Diaz took issue with Le Goff by demonstrating a manuscript tradition treating purgatory as a place dating to as early as the late eleventh century. Gross-Diaz associates the development of the idea not with the schools of Paris and the decade of 1170, but with the much earlier church reform movement. The issue is thus far from resolved and it is to be hoped that Gross-Diaz will soon publish the results of her work. See also A. Michel, "Purgatoire," *Dictionnaire de théologie catholique* (Paris, 1936), vol. 13, cols. 1163–1326, esp. cols. 1237–44 on the Latin West in the Middle Ages and his "Feu de Purgatoire," *Dictionnaire de théologie catholique* (Paris, 1913), vol. 5, cols. 2246–61, esp. cols. 2258–60 on the Latin tradition.

86. Relationships between Hugh of Saint-Victor and the abbey of Saint-Denis have long been a topic of discussion. See, for example, von Simson, *Gothic Cathedral,* p. 105 and passim, and also the important contribution by Grover Zinn in this volume.

87. Hugh, of course, never specifies how long souls might suffer

purgatorial fire, or punishment. Indeed, the Catholic Church has never defined that duration. It was and is unspecified and unspecifiable.

88. *"Et fiunt amici qui eis in aeterna tabernacula suscipiant, nec tam bonae ut ad tantam beatitudinem adipiscendam eis ipsa sufficiat, nisi eorum meritis quos amicos fecerunt misericordiam consequantur"* (Hugh of Saint-Victor, *De Sacrementis Christianae Fidei,* bk. 2.16.7, *PL,* vol. 176, col. 594B).

89. See note 88 here.

90. See esp. p. 80 and note 55 here.

91. English translation by Waldman forthcoming. *" . . . quae tempore amministrationis nostrae larga Dei munificentia contulit, silentio malis successoribus depereant incrementa . . . "* (Suger, *Adm.* [P], p. 40).

92. English translation by Waldman forthcoming. The entire passage reads: *" . . . sperantes de Dei misericordia, quod ea pauperibus attributa eleemosyna divinae retributionis beneficium nobis ab omnipotenti Deo misericorditer impetrabit. Dixit enim quod sicut aqua extinguit ignem, ita eleemosyna extinguit peccatum. Et ut in sempiternum necessitatibus pauperum firmius deserviat, praecepto regis Ludovici, quod in archivis publicis repositum continetur, firmari fecimus"* (Suger, *Adm.* [L], p. 174).

93. The complete passage reads: *"Porro, quoniam parvitatis nostrae memoriam, praesentium et futurorum fratrum dilectioni absque praecedentibus meritis obnixe commendamus, ut saluti animae nostrae proficiat, operae pretium duximus imperatorum et majorum nostrorum, qui eas multa liberalitate, larga munificentia meruerunt fieri, vel multo temporum curriculo sopitas ad salutem animarum suscitare et informare memorias, inter quas inclyti et nobilissimi imperatoris Karoli tertii solemnes memorias recreare et restituere hoc modo censuimus"* (Suger, *Ord.* [P], p. 128. See Panofsky's translation on p. 129).

94. In addition to Saint Denis, the narrative goes on to list three other saints: Saint James Minor, Saint Stephen, and Saint Vincent, who figure in the original relationship. Charles the Bald gave the abbey relics of each of them which were placed in the altar near the Emperor's grave. See Suger, *Ord.* (P), pp. 128–29.

95. That images actually functioned to perpetuate events or relationships is unequivocal in at least one example from ca. 1235, namely, the tomb of Philip Dagobert, *ex* Royaumont, now in Saint-Denis. The base beneath the effigy was decorated with an arcade within which alternated angels and monks. The tomb was inscribed (in part): *" . . . Unus spirituum paries alter Monachorum/Signant perpetuum Sic jubilare chorum."* See Georgia Wright, "A Royal Tomb Program in the Reign of St. Louis," *Art Bulletin* 56 (1974): 225–26 and n. 6. While Wright remarks that the " . . . epitaph is unusual in that it refers to the imagery" (p. 225), we may reasonably suspect that it gives written presence to a function long understood for the images alone. For another instance of the work of art as witness, see William Hinkle, "The Gift of an Anglo-Saxon Gospel Book to the Abbey of Saint-Rémi, Reims," *Journal of the British Archaeological Association,* 3d ser., 33 (1970): 21–35.

96. *" . . . cujus locus omnino determinatus non est, nisi quia multis exemplis et revelationibus animarum in ejusmodi poena positarum saepe numero monstratum est in hoc mundo illam exerceri, et fortassis probabilius erit ut in iis potissimum locis singulae poenam sustinere cre-*

dantur, in quibus culpam commiserunt, sicut multis saepe documentis probatum est. Alia vero si qua sunt harum poenarum loca non facile assignantur" Hugh of Saint-Victor, De Sacramentis, bk. 2.16.4, PL, vol. 176, col. 586C–D).

97. " . . . fratrum succedentium omnium jugem orationum pro salute animae nostrae mereri instantiam . . . " (Suger, Adm. [P], p. 40).

98. "Praeteritorum enim recordatio futurorum est exhibitio" (Suger, Adm. [P], p. 52). Suger is speaking here of his successors having to complete work on a new nave that he realizes he may not be able to finish himself. One suspects from the context that Suger is also alluding to his own reuse of as much as was possible of the old Carolingian nave walls in the hope that his successors might do the same for his building as they went about completing the new nave. In large measure, they did as he bid them.

Suger and the Symbolism of Royal Power: The Seal of Louis VII*

Brigitte Bedos Rezak

THE GREAT seal of majesty represents the tangible sign of sovereign authority. An essential element in the validation of a royal act, the seal was handed over to the care of the chancellor, the court's official charged with redacting and authenticating royal charters. In the twelfth century the great seal symbolized the king himself; anyone who falsified or destroyed it was construed to attack the very person of the sovereign and was charged with the crime of lèse-majesté. Thus, the seal functioned as a juridical and diplomatic instrument of authentification as well as a mark of identity. Because of the seal's iconographic significance, it put forth, in a fashion similar to coinage, a representative image of royal power, with its symbols evoking the particular nature of that power.

The seal of Louis VII marks an important stage in the elaboration of this sigillographic symbolism: it bore a new type of throne, a folding chair, with lions' heads adorning its posts and with legs, which ended in lions' feet, forming an angle that gave the royal seat the shape of an X; this shape was a characteristic so specific to the French throne that it enabled this chair to stand as a symbol of the Capetian monarchy as a whole.

The circumstances leading to the adoption of this image of the throne on the royal seal seem to have been connected with Suger acting in his dual role as (1) an abbot concerned with asserting the preeminence of his abbey and (2) a royal minister bound to the Capetians and determined to strengthen, for their benefit, the emerging royal myth of France. The sigillographic throne appears, in fact, to be based on the "throne of Dagobert," which Suger had had restored at the abbey of Saint-Denis. The transformation of a model furnished by Saint-Denis into one of the most important elements among the sigillographic regalia, that

is, the throne, is in keeping with Suger's various other initiatives to promote his abbey as the official and exclusive burial place of the French kings. The hypothesis that Suger actively participated in shaping the iconography of the royal seal is strengthened when we consider another aspect of Suger's influence on the development of royal symbolism: the final adoption of the fleur-de-lis as the heraldic emblem of the Capetian family.

When Louis VII ascended the throne in 1137, the great seal was already endowed with an iconography symbolizing the sovereign character of its possessor. Depicted on the seal was an enthroned, crowned king, holding scepter and fleuron.[1] The inspiration for this representation in majesty did not, however, come from the kings of France.[2] Otto I, after reviving the western part of the Empire (February 2, 962), had introduced a fundamental change to the seal's iconography: he abandoned the ancient type of effigy—a face in profile crowned with laurel or diadem—which had been used by French and German rulers since the time of the Carolingians,[3] in favor of a full-face bust with scepter and globe,[4] thus imitating the iconography of the Byzantine imperial bull.[5]

It was soon thereafter, in 966, that the king of West Francia, Lothar, similarly adopted the bust of majesty on his seal,[6] although he replaced the imperial globe with a simple baton.

The bust of majesty remained in use during the reigns of Hugh Capet[7] and Robert the Pious;[8] it was retained on the French royal seal until 1031, at which time Henry I replaced the bust with a figure of the king enthroned.[9] Here, again, he was following the example of an emperor—this time Otto III. In 997 Otto III had introduced an imperial seal on which he was represented enthroned and crowned, holding the fleur-de-lis scepter

Notes for this essay begin on page 100.

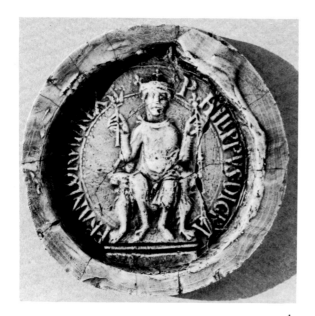

1a

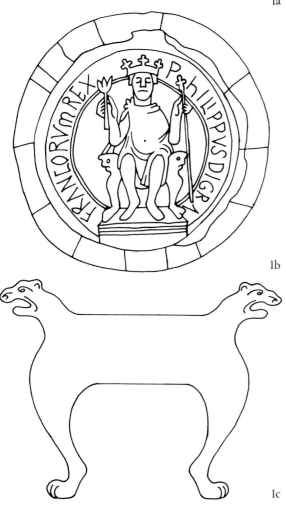

1b

1c

Fig. 1a–c. Seal of Philip I, king of France (Douët d'Arcq, Sceaux, no. 34, 1082)

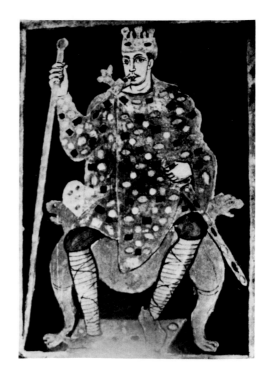

Fig. 2. Throne of Lothar, ca. 845. From a psalter in London (British Library, Ms. Add. 37768, fol. 4r)

and globe.[10] The type of throne chosen by Otto for his seal was inspired by the images of seated sovereigns on architectural thrones seen in Carolingian manuscripts, for example in the Evangelary of Lothar I (dated 849–851)[11] and in the Psalter and Bible of Charles the Bald (ca. 860).[12] Henry I, who is depicted on the same type of architectural throne chosen by Otto III, holds a fleuron and wears a fleur-de-lis crown (a crown type first seen in images of Charles the Bald in Carolingian manuscripts).[13]

Between 1076 and 1080, Philip I, successor to Henry I, changed the design of the sigillographic throne, replacing the architectural throne of his predecessor with an armchair, whose arms and legs were ornamented with the heads and feet of lions (fig. 1).[14] Although this type of throne had appeared on the seal of William the Conqueror, beginning about 1069,[15] the model used by the engraver of Philip I's seal was taken almost exactly from another Carolingian prototype, the throne of Lothar I as it appears in his psalter (dated ca. 845, fig. 2).[16] This type of throne with lion supports evoked the throne of Solomon, described in I Kings 10:18–20 as being framed by two lions.

Although some scholars have claimed that the throne depicted in the Psalter of Lothar I and on the seal of Philip I was based on the "throne of Dagobert" (fig. 3),[17] this is clearly not the case. The thrones of Lothar I and Philip I are armchairs, whereas the "throne of Dagobert" is equipped with X-shaped

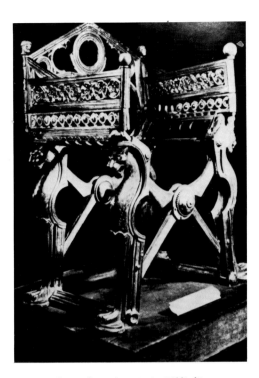

Fig. 3. *Throne of Dagobert, Paris, Bibliothèque Nationale, Cabinet des Médailles. Carolingian period*

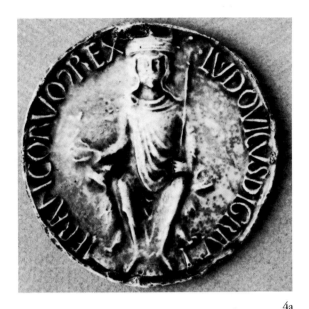

4a

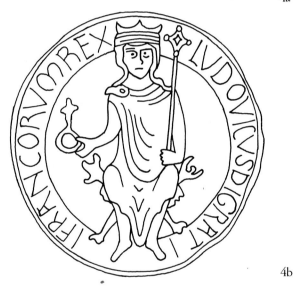

4b

4c

Fig. 4a–c. *Seal of Louis VII, king of France, obverse (Douët d'Arcq, Sceaux, no. 36, 1141)*

legs so that it could be folded.

Louis VI's seal differs very little from that of his father, Philip I: the king, crowned and holding scepter and fleuron, is seated in the armchair adopted by Philip.[18]

When Louis VII ascended the throne in 1137, the great seal of France possessed an iconographic program designed to symbolize royal authority, with an impression of the royal person on the obverse. Crown, scepter, throne—the regalia—were already in place, having been introduced into the sigillographic field in imitation of the Ottonians, but were based on biblical, Byzantine, and Carolingian models. Nothing, however, was on the reverse because at that time the seal was still affixed to documents by soft wax. The part of the parchment to receive the seal was cut to provide points that helped rivet the wax to the document.

Louis VII introduced three important modifications into the seal of majesty, and taken together, they constitute an important step in the development of royal sigillography: (1) he chose, as stated earlier, a new throne which was subsequently associated with the French crown throughout the Middle Ages; (2) he abandoned the use of the applied seal (*sceau plaqué*), replacing it with a pendant seal; (3) he introduced into the royal chancery the use of the counterseal, thus accelerating the process by which the Capetians were to adopt a heraldic emblem.

From the beginning of Louis VII's reign, the royal seal (fig. 4)[19] bore the X-shaped folding chair, whose design recalls that of

the "throne of Dagobert," restored and embellished by Suger, who had had its back remade and its arms pierced (fig. 3).[20] The simultaneous restoration of the throne by Suger and its representation on the seal leads us to ask what part Suger may have played in the elaboration of the seal's iconography.

Suger's interest in Dagobert was expressed in diverse ways, as was his constant preoccupation with strengthening the ties that bound his abbey to the ruling dynasty.[21] The connection between monastery and monarchy had been seriously jeopardized by Philip I: he had designated Saint Remi rather than Saint Denis as his personal patron;[22] had failed to return, after his consecration, the royal crown to Saint-Denis, which claimed the right to function as the normal depository of the regalia;[23] and had chosen as his place of burial not Saint-Denis but Saint-Benoît-sur-Loire.[24] In a series of decisive interventions, Suger sought to counteract this accumulating evidence of royal defection. In order to remind the king that the traditional royal necropolis was the abbey of Saint-Denis, he created (in 1109) a solemn liturgical ceremony to commemorate the memory of Dagobert, the first French king to be buried at the abbey, on the day of the anniversary of his death.[25] He obtained the return of the crown to Saint-Denis (1120).[26] And he reestablished Saint Denis in his role as "patron and protector of the realm of France" by bestowing the saint's banner on Louis VI, vassal of the abbey for the county of the Vexin, when Louis marshaled his forces against the threatened invasion of the German emperor Henry V in 1124.[27] It is in this context[28] that the restoration of the "throne of Dagobert" and the concurrent placement of Louis VII on this same throne on the great seal should be understood.

It was, Suger reports, upon this very throne that the kings of France were accustomed to sit in order to receive their first homages from the great lords of the realm.[29] In taking note of this ancient, lapsed custom, Suger was furthering his struggle against Reims over prerogatives:[30] he sought to locate at Saint-Denis an important phase in the first years of the king's reign, namely, the recognition of royal suzerainty by the high-ranking vassals. In assigning this function to the "throne of Dagobert," he also endowed his political program with an ancient and customary past, the principles of which rested on a feudal conception of kingship considered as the apex of a hierarchy of lordships.[31]

But why did Suger attribute this throne to Dagobert? It is impossible to recover the criteria on which such an identification was based, especially in light of the fact that the throne was the product of a Carolingian atelier in operation during the first half of the ninth century, possibly at Aix-la-Chapelle, and thus would suggest a Carolingian rather than Merovingian attribution.[32] Nonetheless, the significance of the attribution remains: for Suger, the throne was that of Dagobert; its restoration should be related to the earlier institution of a liturgy commemorating the

death of this ruler who, first among the kings of France, was buried at Saint-Denis and who, while he lived, had considerably enhanced the prestige and wealth of the abbey by bestowing upon it rights, privileges, and lands.[33] It was to Dagobert that the monks referred when they wished to recall the antiquity of their association with the throne. Suger reasserted the tradition of the abbey's foundation by Dagobert, as it had been established by Hincmar in the Gesta Dagoberti.[34] During his reconstruction of the abbey church, he sought to preserve the wall of the eighth-century church, which legend claimed had been consecrated by Christ.[35] To invoke Dagobert was to recall the royal foundation of Saint-Denis and to demonstrate to his royal successors the fidelity they owed the abbey. To place Louis VII on the "throne of Dagobert," preserved at Saint-Denis, was similarly to affirm, by means of the seal image, the bond uniting monarch and monastery.

Moreover, associating Louis VII with this throne served to establish iconographically the reality of the successional line connecting the Capetian heir with all his predecessors. If Suger was concerned to create the basis for a durable alliance between the king and his abbey, he also wished to use the power and authority of Saint-Denis in the service of monarchy. It was for this reason that he initiated and perhaps supervised the beginnings of royal historiography at Saint-Denis, an enterprise that would become its central intellectual activity.[36] To this project Suger contributed his own Vita Ludovici grossi, a work conceived as a political tool. In it there already appears the triple purpose that would characterize the chronicles of Saint-Denis as they were later elaborated: to narrate, while authenticating, the deeds of the kings of France; to establish an official version of the importance of the Capetian monarchy in the history of the kingdom; and to legitimize the activities of the Capetians (the Troisième Race) by inserting its history within the royal history of France as a whole.[37] It was precisely such legitimacy that Suger emphasized when, by reviving the use of the restored chair on the seal, he sought to link Louis VII directly to his Merovingian predecessors.[38] The inclusion of the "throne of Dagobert" on the great seal, where it would remain throughout the course of the Middle Ages, expressed iconographically the same political message as would appear, following the lead established by Suger, in the Grandes Chroniques de France. In this way everything could be seen as stemming from Saint-Denis: the Capetian king received the insignia of his authority from the abbey, the repository of the regalia, to which he was bound by ties of vassalage; through its writing, the abbey promoted the diffusion of the monarchical myth that affirmed the presence of the Capetians on the throne of France. The "throne of Dagobert," symbol of royal power both with respect to its prerogatives and its unbroken succession through the Trois Races (Merovingian, Carolingian, and Capetian), appeared on the seal in the same period that witnessed the

beginnings of royal historiography at the abbey.[39] The simultaneous appearance of Merovingian themes on the seal and in the chronicles denotes a desire to inform, an attitude characteristic of Suger, who, as a historian, carefully recorded the events he witnessed. To be sure, his information was tendentious, placed at the service of his overriding goal of promoting the twin grandeur of Saint-Denis and the king. Nonetheless, he gave to the great seal its model of the X-shaped throne which was so associated with the Capetians that their allies in turn adopted it for their seals. The "throne of Dagobert," in fact, reappears on the seals of the kings of Jerusalem (from 1190),[40] on that of the new Latin emperor of Constantinople, Count Baldwin of Flanders (1204–1205),[41] and on the seal of Peter II, King of Aragon (about 1203).[42]

Suger's influence in determining the iconography of the royal seal, an influence wholly compatible with what we know of his aims and political concerns, is reminiscent of the contemporary activities of Abbot Wibald of Stavelot (1097–1158). Wibald, a counselor at the imperial court, was charged with engraving the seal of Frederick Barbarossa (1152). Like Suger, Wibald expressed his political program—maintaining the unity of Rome and the empire—through his choice of iconographic themes.[43] Both abbots enjoyed comparable situations, each occupying important positions in their respective countries as counselors at court and patrons of art. It is clear, in Wibald's case, that his relations with the greatest goldsmiths of his time led to his being asked to supervise the execution of imperial seals and allowed him to directly inspire the artists responsible for carrying out the task. Could not Suger equally have performed these same functions in the making of Louis VII's seal?[44] An investigation of a different aspect of royal iconography, its heraldic imagery—to the shaping of which Suger also contributed—supports the hypothesis that he actively participated in determining important elements of royal symbolism.

The second sigillographic modification that occurred during the reign of Louis VII involved the manner of attaching seal to document; formerly applied to the parchment, it became pendant,[45] a change doubtless based on technical needs. From the time the seal began to bear the entire effigy of the king, its diameter was considerably enlarged and its relief elevated. Enormously heavy, it held poorly to the document on which, moreover, it took up considerable space. Parchment was a material sufficiently difficult to procure that one thought twice before wasting it.

But such technical considerations were not the only reasons for the change. Political circumstances, too, pushed Louis VII to adopt the pendant seal. Through his marriage to Eleanor of Aquitaine, he added to his royal title that of duke of Aquitaine and wished to include it on his seal—without, however, placing it on the same level as his title as king. By allowing the seal to

hang pendant, the obverse could be reserved exclusively for the image of the enthroned king, while the now-available reverse of the seal could bear an equestrian portrait surrounded by the legend *ET DUX AQUITANORUM*[46] much as the Anglo-Norman kings had done.

The English chancery used a pendant seal with two engraved sides, beginning some time during the reign of Edward the Confessor (1042–66).[47] When William the Conqueror became king of England, he wished to preserve and acknowledge on the royal seal his status as duke of Normandy. The utilization of the double-sided seal, bequeathed to him by his predecessor, provided the obvious solution: the obverse was used for the enthroned king, while the reverse bore the equestrian figure of the duke,[48] a system maintained by William Rufus,[49] Henry I,[50] and Stephen of Blois.[51]

Compared with his vassal, the Norman king and duke, the king of France cut a weak figure and welcomed the opportunity to strike his own royal and ducal seal. The exchange of influences between the English and French chanceries proves, once again, the extent to which the seal was considered to be an affirmation of power and authority. Long before he opened the great struggle with Henry II, at a time when he was supporting Stephen of Blois on the English throne against Matilda and Geoffrey Plantagenet, Louis VII perceived the danger his Norman vassal posed to the Capetian monarchy. His seal, in direct competition iconographically with that of the English ruler, demonstrates royal awareness of the threat posed to the French realm by the growing power of the Anglo-Normans.

Fig. 5. Counterseal of Philip Augustus (Douët d'Arcq, Sceaux, no. 38 bis, 1180)

However, Louis VII lost the struggle he had broached on the sigillographic front. His divorce from Eleanor, in March 1152, obliged him to abandon all control over the duchy of Aquitaine, and with it the use of the ducal counterseal.[52] Nevertheless the chancery retained the practice of engraving an image on the reverse of the great seal, employing both an antique abraxas, and a gemstone etched with a figure of the goddess Diana;[53] then, in the last years of Louis's reign (around 1175), the fleur-de-lis, which for the first time on royal French seals occupies, alone, the entire field.[54] It was, thus, during the reign of Louis VII that the fleur-de-lis became the heraldic emblem of the Capetian monarchy. It was sufficiently well established as such by 1180 for Philip Augustus to continue the tradition on the counterseal of his great seal (fig. 5).[55]

The utilization for ornamental or emblematic purposes of the fleur-de-lis was common throughout all times.[56] Its significance as a royal attribute had led the Carolingians and Ottonians to adopt it on certain of their regalia, and the Capetians, beginning with Robert the Pious, placed it on their scepters.[57] Louis VI had had it placed on the reverse of a denier issued by the atelier of Dreux.[58] With Louis VII, however, the use of this emblem intensified. The fleur-de-lis is found during his reign on the obverse of a denier from Compiègne;[59] used as an overall pattern on certain royal clothing;[60] and, from certain indications, on the royal banner itself.[61] Finally, it appeared (henceforth to stay) on the counterseal of the great seal (fig. 5). It remains to inquire why, and under what influences, Louis VII chose the fleur-de-lis as his heraldic emblem.

In the course of the twelfth century, the symbolic value of the fleur-de-lis was enriched by a strong current of christological and marian interpretation. The christological significance of the fleur-de-lis is found in the *Song of Songs* 2:1, *Ego flos campi et lilium convallium,* a phrase extensively commented on by Christian authors from Saint Jerome to Saint Bernard.[62] Christian iconography, inspired by this text, often depicted Christ among lilies or fleurons. Saint Bernard, based on his reading of the *Song of Songs* and numerous other passages derived from Scripture and the church fathers, associated the lily with the Virgin,[63] a symbolic attribution given enormous impetus by the explosion of the cult of Mary, which Bernard himself did so much to encourage. Bernard (d. 1153) often had occasion to provide counsel to Louis VII, and it is possible that he was responsible for suggesting to the king the use of this emblem, which evoked both sovereignty and piety.

In my opinion, however, it was not Bernard's but Suger's influence that predominated in the selection of the fleur-de-lis as the Capetian emblem. The same political and ideological considerations that had led Suger to place the "throne of Dagobert" on the royal seal also suggested an interpretation of the fleur-de-lis persuasive enough to lead Louis VII to adopt this motif for his seal. In this sense Louis VII's seal, although appearing in its final form after Suger's death (1151), embodies an iconographic program the political ideology of which was conceived by the Dionysian abbot.

An analysis of the Tree of Jesse window (ca. 1144, see Grodecki fig. 1) executed for Suger at Saint-Denis[64] allows us to understand the significance Suger attributed to the lily.[65] The window conforms to the biblical text of Isaiah 11:1 ("And there shall come forth a rod out of the stem of Jesse, and a branch shall grow out of his roots") and represents the genealogy of Christ, with the sleeping Jesse depicted at the bottom of the tree, three Old Testament kings and the Virgin above, and, at the very top, Christ. In this iconographic scheme the kings of Israel appear for the first time,[66] and, equally significant and novel, the tree is replaced by the superimposition of large fleurs-de-lis, each sheltering a genealogical figure.[67] The replacement of the tree with the fleur-de-lis, from which the christological and marian significance of the motif derives,[68] takes on a new meaning when seen in relation to the depiction of the kings of Israel. The use of the fleur-de-lis seems to be the result of a conscious design to establish a visual bond between the Capetian kings, as represented by their heraldic symbol, and the kings of the Old Testament; and to affirm, by means of the culminating figure of Christ, the divine character of the Capetian monarchy. Is not Suger asserting here the sacerdotal character of royalty, an idea not much current in the twelfth century but one that appears in the *Vita Ludovici?* On the day of the royal consecration, Suger writes, Louis VI was girded with "the ecclesiastical sword."[69] The divine character of royal power and the alliance between monarchy and clergy find perfect iconographic expression in the fleur-de-lis, which assumes this dual royal and Christian significance. In choosing the fleur-de-lis as a heraldic emblem, Louis VII adopted a floral motif admirably epitomizing the political program the abbot of Saint-Denis expected of him. The presence of the fleur-de-lis at Saint-Denis illustrates the hope, so important to Suger, of inextricably linking the destinies of the royal family, represented by its arms, to that of the abbey of Saint-Denis.

NOTES

* This essay was translated by Gabrielle M. Spiegel.

1. Louis Douët d'Arcq, *Collection de sceaux,* 3 vols. (Paris, 1863–68), vol. 1, no. 36.

2. Robert-Henri Bautier, "Échanges d'influences dans les chancelleries souveraines du Moyen Âge, d'après les types des sceaux de majesté," *Comptes rendus de l'Académie des Inscriptions et Belles-Lettres,* 1968, pp. 196–205.

3. Bautier, "Échanges," p. 196. Examples of Carolingian seals are

found in Douët d'Arcq, *Sceaux,* vol. 1, no. 12 (Pepin the Short, 751), no. 15 (Charlemagne, 774), no. 17 (Louis the Pious, 816), no. 20 (Lothair I, 843), nos. 21–26 (Charles the Bald, 843–77), and no. 27 (Louis the Stammerer, 879).

4. Otto Posse, *Die Siegel der deutschen Kaiser und Könige von 751 bis 1913,* 5 vols. in 3 (1909–13; reprint, Leipzig, 1980), vol. 1, p. 7, nos. 3 and 4 (seals of 962), no. 5 (seal of 965).

5. Compare on this subject, Gustave Schlumberger, *Sigillographie de l'Empire byzantin* (Paris, 1884); and Brigitte Bedos, "Signes et insignes du pouvoir royal et seigneurial au Moyen Âge; le témoignage des sceaux," *Actes du Cent Cinquième Congrès national des Sociétés Savantes, Caen 1980, Section de Philologie,* 1984, pp. 47–62.

6. Bautier, "Échanges," pp. 197–98.

7. Hugh's seal is known only through a description. See Marjolaine Caucheteux-Chavannes, "Les Sceaux des rois de France, d'Hugues Capet à François Ier (987–1547)," thèse d'École des Chartes (1962), Paris, Archives nationales, AB 28144, no. 1, pp. 1–3 of her "Catalogue des sceaux des rois de France"; and Bautier, "Échanges," p. 199.

8. Douët d'Arcq, *Sceaux,* no. 31.

9. Ibid., no. 32.

10. Bedos, "Signes," pp. 50–51; Bautier, "Échanges," pp. 199–200 and pl. II, no. 6; and Posse, *Die Siegel,* vol. 1, pl. 10, no. 1.

11. Paris, Bibliothèque Nationale, ms. lat. 266, fol. 1v.

12. Paris, Bibliothèque Nationale, ms. lat. 1152, fol. 3v; and ms. lat. 1, pl. 39. For an analysis of the iconography of these manuscripts, see Galienne Francastel, *Le Droit au trône, un problème de prééminence dans l'art chrétien d'occident du IVe au XIIe siècle* (Paris, 1973), p. 214.

13. Douët d'Arcq, *Sceaux,* no. 32; Bautier, "Échanges," p. 200 and pl. II, no. 7; Bedos, "Signes," p. 51. On the fleurs-de-lis crown of Charles the Bald, see Francastel, *Le Droit au trône,* p. 215. Charles the Bald is represented as wearing a crown adorned with fleurs-de-lis in several manuscripts: in the Bible of Vivian (844–51, Paris, Bibliothèque Nationale, ms. lat. 1); in the *Codex Aureus* of Saint-Émmeran, ca. 870 (Munich, Staatsbibliotek, Clm. 14000 cim 55); in the Bible of *S. Paolo fuori le mura* at Rome (870–75). Lothar I similarly wore this type of crown in his Evangelary (849–51, Paris, Bibliothèque Nationale, ms. lat. 266). Photographs of the four crowns are in Percy Ernst Schramm, *Kaiser Könige und Päpste,* 2 vols. (Stuttgart, 1968), vol. 2, pls. 12, 16, 17, 18; commentary on the crowns is found on pp. 101–2.

14. Douët d'Arcq, *Sceaux,* vol. 1, no. 34.

15. Ibid., no. 9998 (1069).

16. Psalter, London, British Library, MS. Add. 37768, fol. 4r. Bautier, "Échanges," pp. 202–4 and pl. III, no. 11. Schramm, *Kaiser,* vol. 1, p. 363, pl. 3; and Percy Ernest Schramm, *Herrenschaftszeichen und Staatssymbolik* (Stuttgart, 1954), vol. 1, pl. 28.

17. The throne appears in the collections of the Cabinet des Médailles of the Bibliothèque Nationale in Paris. A photographic reproduction is in Panofsky, *Suger,* pl. 22; Schramm, *Herrenschaftszeichen,* vol. 1, pls. 29 and 30 (details); and Schramm, *Kaiser,* vol. 1, p. 362, pl. 2. On the similarities between the "throne of Dagobert" and the armchair of Lothar, see Françoise

18. Dumas, "Le Trône des rois de France et son rayonnement," *Monnaie miroir des rois,* 1978, p. 231; Schramm, *Kaiser,* vol. 1, p. 208; and Schramm, *Herrenschaftszeichen,* vol. 1, p. 329.

18. Douët d'Arcq, *Sceaux,* vol. 1, no. 35.

19. Bautier, "Échanges," p. 204. In his description of Louis VII's seal, Douët d'Arcq, *Sceaux,* vol. 1, nos. 36 and 37, implies that there existed two different matrices for the obverse of the great seal. In fact, Louis VII used only one matrix for the royal side of his seal. On this subject, see Caucheteux-Chavannes, *Les Sceaux,* p. 19 n. 1 of the catalogue of seals of the French kings. On the other hand, Louis employed several counterseals, each issued from different matrices. See notes 52 to 54 here. Moreover, Douët d'Arcq does not expressly differentiate, in his description of Louis VII's seal, the newly etched throne from that made for Philip I and Louis VI. Several other authors have considered the throne adopted by Philip I as the model continued by his successors; on this subject see Dumas, "Le Trône," p. 233; Albert Lecoy de la Marche, *Les Sceaux* (Paris, 1889), pp. 119–20; Georges Tessier, *Diplomatique royale française* (Paris, 1962), p. 195; and Caucheteux-Chavannes, *Les Sceaux,* pp. 140–41.

20. Suger, *Adm.* (P), p. 72–73. Cf. note 29 here.

21. For the respect that Suger showed toward Dagobert, see Panofsky, *Suger,* pp. 27–28, 200, 244; Suger, *Adm.* (P), pp. 59, 73; and Suger, *Cons.* (P), p. 87. See also notes 33 to 35 here. On Suger's efforts to tighten the ties between Saint-Denis and the Capetians, see the articles in this volume by Gabrielle Spiegel, John Benton, Eric Bournazel, and Michel Bur.

22. Sumner McK. Crosby, *L'Abbaye royale de Saint-Denis* (Paris, 1953), p. 6. Gabrielle Spiegel, *The Chronicle Tradition of Saint-Denis: A Survey* (Brookline, Mass., and Leyden, 1978), p. 28.

23. Spiegel, *Chronicle Tradition,* p. 31. Georgia Sommers Wright, "A Royal Tomb Program in the Reign of Saint Louis," *The Art Bulletin* 56 (1974): 224–43, esp. 226.

24. Spiegel, *Chronicle Tradition,* p. 28. Wright, "Royal Tomb Program," p. 229.

25. On Saint-Denis's function as royal necropolis, see Alain Erlande-Brandenburg, *Le Roi est mort: étude sur les funérailles, les sépultures et les tombeaux des rois de France jusqu'à la fin du XIIIe siècle* (Paris-Geneva, 1975); and Wright, "Royal Tomb Program," passim. See also Robert Barroux, "L'Anniversaire de la mort de Dagobert au XIIe siècle," *Bulletin philologique et historique du Comité des Travaux Historiques et Scientifiques,* 1942–43, pp. 131–51, esp. 141. This liturgical ceremony was founded during the abbacy of Adam, but Suger, then provost of Berneval, provided the necessary financial resources for the institution of the anniversary and seems even to have drawn up the act of foundation, Barroux, "L'Anniversaire," p. 146. Suger, *Vita Lud.* (L), p. 47, interprets Philip I's desire to be buried at Saint-Benoît-sur-Loire as the king's admission of his unworthiness to lie among his royal ancestors, and he asserts that the burial at Saint-Benoît had been executed against *jus naturale.*

26. Spiegel, *Chronicle Tradition,* p. 31; see the passage in Suger, *Vita Lud.* (L), p. 120, in which Suger, disclosing the role that he played in the restitution of the crown to the abbey, places its return under his abbacy in 1124, and not in 1120, when it actually was returned.

27. Robert Barroux, "L'Abbé Suger et la vassalité du Vexin en 1124," *Le Moyen Âge* 64 (1958): 1ff; Spiegel, *Chronicle Tradition,* pp. 30–31 and n. 67, which contains a good review of the bibliography concerning the Oriflamme; Gabrielle Spiegel, "The Cult of Saint Denis and Capetian Kingship," *Journal of Medieval History* 1 (1975): 59 Suger, *Adm.* (L), p. 162; and Wright, "Royal Tomb Program," p. 226.

28. For Suger, the goal was to assert the royal mission of his abbey and its special meaning for French kings, a position strongly contested by Reims, site of the royal consecration, and by the abbeys of Saint-Germain-des-Prés and Sainte-Geneviève, which equally insisted on the antiquity of their relations with the French monarchy and also claimed the status of royal necropolis. On this subject, see William Clark, "Spatial Innovations in the Chevet of Saint-Germain-des-Prés," *Journal of the Society of Architectural Historians* 38, no. 4 (1979): 348–65, esp. 359–60 and n. 36.

29. *"Nec minus nobilem gloriosi regis Dagoberti cathedram, in qua, ut perhibere solet antiquitas, reges Francorum, suscepto regni imperio, ad suscipienda optimatum suorum hominia primum sedere consueverant, tum pro tanti excellentia officii, tum etiam pro operis ipsius precio, antiquatam et disruptam refci fecimus"* (Suger, *Adm.* [P], p. 72).

30. See note 28 here.

31. Marcel Pacaut, *Louis VII et son royaume* (Paris, 1964), p. 161.

32. On the questions raised by the dating of the throne, see Dumas, "Le Trône," p. 231; and Blaise de Montesquiou-Fezensac and Danielle Gaborit-Chopin, *Le Trésor de Saint-Denis. Inventaire de 1634,* 3 vols. (Paris, 1973–77), vol. 1, p. 291, no. 362; vol. 2., pp. 472–74, no. 362; and vol. 3, pls. 100–102. Panofsky, *Suger,* pp. 200–201; Percy Ernst Schramm, *Der König von Frankreich,* 2 vols. (Weimar, 1960), vol. 1, pp. 215–17; Schramm, *Herrenschaftszeichen,* vol. 1, pp. 326–31; and Schramm, *Kaiser,* vol. 1, p. 208.

33. Spiegel, *Chronicle Tradition,* pp. 17–18.

34. Ibid., pp. 16–17, 19.

35. Suger, *Adm.* (P), p. 50; and Panofsky's comments, *Suger,* pp. 27–28, 170; and Spiegel, *Chronicle Tradition,* p. 19 n. 27.

36. Spiegel, *Chronicle Tradition,* pp. 44–45.

37. Ibid., p. 45.

38. Professor Clark Maines has drawn my attention to the fact that Louis VII, in contrast to his predecessors, is depicted on the seal with long hair, in the fashion of Merovingian kings, for whom it symbolized the superior character of their princely status (compare the seal of Childeric in use between 458 and 481, Douët d'Arcq, *Sceaux,* vol. 1, no. 1). Is it possible to see in this presentation of Louis VII with long hair another aspect of the Merovingian "renaissance" which might also have influenced the appearance of the "throne of Dagobert" on Louis's seal? The question deserves to be raised, even if it cannot be definitely resolved. Louis's son and grandson, Philip Augustus and Louis VIII, also are figured on their seals with long hair (Douët d'Arcq, *Sceaux,* vol. 1, nos. 38 to 40). Only with Louis IX do the Capetians return to the style of short hair (Douët d'Arcq, *Sceaux,* vol. 1, no. 41).

39. Spiegel, *Chronicle Tradition,* p. 40.

40. Bautier, "Échanges," p. 205.

41. Ibid., p. 207.

42. Ibid.

43. On this subject, see the convincing study by Josef Deér, "Die Siegel Kaiser Friedrichs I Barbarossa und Heinrichs VI in der Kunst und Politik ihrer Zeit," *Festschrift Hans R. Hanloser,* 1961, pp. 47–101.

44. See p. 100 of this essay.

45. Lecoy de la Marche, *Les Sceaux,* p. 91. Louis VI was the first in the history of the French chancery to seal with a pendant seal. But he returned on several occasions to the use of a seal *plaqué.* It is only with Louis VII that the use of the pendant seal was definitively established.

46. Douët d'Arcq, *Sceaux,* vol. 1, no. 36 bis.

47. Ibid., no. 9997 and bis (1059). On the complex sources of Edward the Confessor's seals, cf. Brigitte Bedos Rezak, "The King Enthroned: A New Theme in Anglo-Saxon Royal Iconography. The Seal of Edward the Confessor and Its Political Implications." (Proceedings of the Acta Conference held in April 1984 at SUNY-Stonybrook, CEMERS.) Forthcoming from the SUNY Press in Joel Rosenthal, ed., *Medieval Kings and Kingship.* Like Henry I of France, Edward, imitating Ottonian iconography, adopted a representation of an enthroned king which he had engraved on the two sides of his seal. But where the Capetian monarch sought to approximate Carolingian models of sovereignty, the English king drew on elements belonging to a Byzantine symbolic system.

48. Douët d'Arcq, *Sceaux,* vol. 3, no. 9998 and bis (1069).

49. Ibid., D 9999 and bis (1087–1100).

50. Ibid., D 10000 and bis (1100) and D 10001 and bis (1135).

51. Ibid., D 10002 and bis, D 10003 and bis (1135–54).

52. In his article, "La Formule *Rex Francorum et dux Aquitanorum* dans les actes de Louis VII," *Bibliothèque de l'École des Chartes* 45 (1884): 305–13, Élie Berger has shown that Louis VII did not renounce the title of duke of Aquitaine at the time of the divorce from Eleanor. He ceased calling himself duke of Aquitaine only in 1154, the date at which peace was signed between him and Henry Plantagenet. Between 1154 and 1175, the great seal was appended without a reverse image. See Caucheteux-Chavannes, *Les Sceaux,* p. 146 and n. 3. See also notes 53 and 54 here for the appearance of new counterseals.

53. Douët d'Arcq, *Sceaux,* vol. 1, no. 37 bis and ter; these imprints were obtained by the impression of antique seal rings; we have here an example of reuse, so common throughout the Middle Ages, of the gems of antiquity. For a discussion of the date of appearance of these counterseals, see note 54 here.

53. Douët d'Arcq, *Sceaux,* vol. 1, no. 37 bis and ter; these imprints were obtained by the impression of antique seal rings; we have here an example of reuse, so common throughout the Middle Ages, of the gems of antiquity. For a discussion of the date of appearance of these counterseals, see note 54 here.

54. The current cast bearing a fleur-de-lis and maintained by the British Library as Gray Birch, *Catalogue of Seals,* vol. 5, no. 18075 (counterseal of Louis VII) is identical to the counterseal of Louis IX (Gray Birch, no. 18080 and Douët d'Arcq, *Sceaux,* vol. 1, no. 42 bis). If Louis VII and Louis IX had employed the same counterseal, Gray Birch might well have mentioned this, as he did for others. The implication that he catalogued a now-lost or mislaid counterseal is further supported by the descrip-

tions of Théodore Danjou de la Garenne, "Essai d'une description historique des sceaux," *Société de Sphragistique de Paris,* 1851–52, p. 344: *"celui* [the counterseal] *de Louis VII portait une fleur de lis épanouie comme celle de Florence;"* and by Caucheteux-Chavannes, *Les Sceaux,* p. 147–48 and p. 18, no. 7 of her catalogue, where she describes an act issued by Louis VII which was sealed with his great seal and a counterseal bearing the fleur-de-lis (25 × 18mm., and not 40 × 32mm. as for the supposedly similar counterseal of Louis IX). Louis VII's act was not dated and is currently irretrievable. As the use of the counterseal with the image of an abraxas and Diane does not occur before 1174, it seems reasonable to attribute to this same period the initial employment of the counterseal with fleur-de-lis. See Caucheteux-Chavannes, *ibid.,* and the forthcoming work by Martine Dalas Garrigues, *Corpus des sceaux royaux médiévaux.*

55. Douët d'Arcq, *Sceaux,* vol. 1, no. 38 bis.

56. Robert A. Koch, "The Origin of the Fleur-de-lis and the *lilium candidum* in Art," *Approaches to Nature in the Middle Ages,* ed. Lawrence D. Roberts (Binghamton, 1982), pp. 109–30; Michel Pastoureau, "La Fleur-de-lis, emblème royal, symbole marial ou thème graphique," *Monnaie miroir des rois,* 1978, pp. 254–55; and Michel Pastoureau, *Traité d'Héraldique* (Paris, 1979), pp. 160–62, with a good discussion of the state of the question in n. 128.

57. Seal of Robert the Pious in 997, Douët d'Arcq, *Sceaux,* vol. 1, no. 31; and seals of Henry I and Philip I, Douët d'Arcq, *Sceaux,* vol. 1, nos. 32, 33.

58. Jean Lafaurie, *Les Monnaies des rois de France* (Paris, 1951), p. 12, no. 107; pl. IV, no. 107.

59. Ibid., p. 16, no. 149; pl. V, no. 149.

60. Pastoureau, *Traité,* pp. 161–62.

61. In a manuscript of Girart de Roussillon (1136–80), the author describes the shield of Charles Martel as "semé de fleurs de lis d'or," attributing to the Carolingian the arms that he must have seen borne by his contemporary king, Louis VII. See René Louis, *Girart comte de Vienne dans les chansons de geste,* 3 vols. (Auxerre, 1947), vol. 1, p. 370; and Hervé Pinoteau, "L'Ancienne couronne francaise dite "de Charlemagne" (1180–1794)," in his *Vingt-cinq ans d'études dynastiques* (Paris, 1982), pp. 375–430, esp. p. 429. On the problem of the origins of the arms of France, over which much ink has been spilt, see the review of Hervé Pinoteau, *Héraldique capétienne* (Paris, 1954), vol. 1 passim; and Hervé Pinoteau, "La Création des armes de France au XIIᵉ siècle," *Bulletin de la Société Nationale des Antiquaires de France* (1980–81): 87–99.

62. Koch, "Origin," p. 115. Pastoureau, *Traité,* p. 160.

63. Sandra Hindman and Gabrielle Spiegel, "The Fleur-de-lis Frontispieces to Guillaume de Nangis's *Chronique Abrégée:* Political Iconography in Late Fifteenth-century France," *Viator* 12 (1981): 381–407, esp. 394.

64. On this window, see Louis Grodecki, *Les Vitraux de Saint-Denis, Histoire et restitution (Corpus Vitrearum Medii Aevi),* France "Etudes" (Paris, 1976), vol. 1, pp. 71–80. Suger, *Adm.* (P), p. 73; and Panofsky's comments, *Suger,* pp. 208–10 and pl. 12. On the profound implications of the Tree of Jesse as an iconographic theme current in the twelfth century, see the interesting remarks of Howard R. Bloch, *Etymologies and Genealogies: A Literary Anthropology of the French Middle Ages* (Chicago, 1983), pp. 87–90.

65. In discussing the significance of the lily at Saint-Denis we must also consider Suger's Great Cross, built between 1145 and 1147. It was described in the inventory of the abbey drawn up in 1634 as being covered on the sides with *"fleurs de lys d'or enlevées,"* Paula Gerson, "The Great Cross of Abbot Suger" (Master's thesis, Columbia University, 1966), p. 82. Philippe Verdier, "La Grande croix de l'abbé Suger a Saint-Denis," *Cahiers de civilisation médiévale* 13, no. 1 (1970): 1–31, esp. 9, connects the fabrication of this *"fleurdelisée"* cross with the Crusade and sees in it a double Christian symbol of a royal standard. But Danielle Gaborit-Chopin in her review of Verdier's article, "La Croix de l'abbé Suger," *Bulletin monumental* 128 (1970): 243, presents the hypothesis that Suger's cross was restored some time before the sixteenth century, and that it was in the course of the restoration that the fleur-de-lis, whose use as a decorative motif was still restricted under Louis VII, might have been added. As far as I am concerned, I accept the presence of the fleur-de-lis on the twelfth-century cross, since one finds the same symbol, with exactly the same symbolic meaning—that is, the union of Christ, the Capetian monarchy, and the abbey of Saint-Denis—on the contemporary Tree of Jesse window at Saint-Denis.

66. On the iconography of the Tree of Jesse other than at Saint-Denis, see James R. Johnson, "The Tree of Jesse Window at Chartres: *Laudes Regiae,"* *Speculum* 36, no. 1 (1961): 1–22. Arthur Watson, *The Early Iconography of the Tree of Jesse* (London, 1934). Koch, "Origin," pp. 119–21, associates, following Johnson, the window of Chartres depicting the Tree of Jesse with the Capetians, and he attributes to Louis VII the responsibility for the choice of the fleur-de-lis as a Capetian heraldic emblem and cites as evidence the fact that it was used on the counterseal by his son, Philip Augustus. But he fails to notice that it is on the counterseal of this king, and not on that of Philip Augustus, that the fleur-de-lis appears. See note 54 here. On the originality of the Dionysian window with respect to the incorporation of biblical kings, see Panofsky, *Suger,* p. 210.

67. Hindman and Spiegel, "Frontispiece," p. 398. The article has a good discussion of the state of the question and ample bibliography.

68. Suger participated in the cult of Mary then so prevalent: in 1130 he founded a weekly office dedicated to Notre-Dame and to Saint-Denis, and he devoted a part of the iconographic program of the abbey church to the representation of the Virgin, namely, the window depicting the Infancy of Christ (Grodecki, *Les Vitraux,* pp. 81–92; and Panofsky, *Suger,* pp. 204–5 and pl. 15) and the panels of gold on the main altar, which represented the Annunciation and the Visitation of the Nativity (Panofsky, *Suger,* p. 185; and Georges Duby, *Le Temps des Cathédrales* [Paris, 1976], p. 133). On Marian iconography at Saint-Denis, see also the article in this volume by Pamela Blum.

69. Marc Bloch, *Les Rois thaumaturges* (Paris, 1961), p. 190. Panofsky, *Suger,* p. 2.

III.
ARCHITECTURE

Suger's Church at Saint-Denis: The State of Research[1]

William W. Clark

PRIDE OF place for the chevet of Saint-Denis in the history of Gothic architecture was first recognized by Dallaway and Whittington, writing, in 1806 and 1809 respectively, probably not independently of each other.[2] Theirs was the first research to study the actual building—a break with the older text tradition represented by such historians of the abbey as Doublet and Millet, writing in the seventeenth century, who took into account only the documentary evidence and, for that reason, attributed the whole of the present building to Abbot Suger.[3] By the second half of the nineteenth century the scholars who were not attacking or defending the restorations began to practice the new science of "archéologie" and to correlate the physical evidence of the building itself with the literary evidence of Suger's writings.[4] As increasingly sophisticated archaeological methods have been applied to analysis of the facade, west bays, crypt, and chevet, Abbot Suger's claims have been verified.[5] It is now generally accepted that Suger's writings, which detail his abbacy and building activity, are reasonably reliable by modern standards.[6] Although the documentary evidence is well known, the on-site archaeology has not yet yielded all of its information. Thus, assessment of the current state of research must begin with the physical fabric of the building itself.

Over the years Sumner Crosby's excavations uncovered fundamental archaeological information about the abbey church during all phases of its history.[7] In addition to unearthing the remains of previous buildings often known from and confirmed by historical accounts, the excavations have brought to light unexpected, undocumented evidence. One important example concerns the work left incomplete at Suger's death. Prior to Crosby's work the argument over whether or not the abbot intended to replace the eighth-century nave had been left largely to the Latin-

ists and their interpretations of Suger's writings.[8] Crosby's discovery of the extensive twelfth-century nave foundations, however, proved not only that Suger wanted to replace the old nave but that work had actually started. Enough of this work survived for Crosby to reconstruct the plan and suggest the elevation.[9]

Crosby was also at the forefront in the use of new tools and techniques of analysis, specifically, photogrammetry, which has produced important information about the standing parts of the structure.[10] As his posthumous book will demonstrate, excavations and photogrammetry have consistently yielded important new discoveries and insights into the planning procedures and construction sequences, bringing new clarity to the analysis of the spatial organization of the church. The assessment presented here concentrates on Crosby's evidence from excavations and from photogrammetric analyses. Adding interpretations and conclusions where warranted, this essay raises some problems not discussed by Crosby and indicates some future directions for research.

The West Bays and Facade: Excavations

One of the more troublesome points resolved by the excavations concerns the floor levels in the western block.[11] After a visit in 1811, Napoleon ordered the floor level of the transept, nave, and west end raised.[12] Although Viollet-le-Duc returned the nave and transept pavements to the lower, thirteenth-century level, he left the pavements of the narthex and parvis as we find them today and did not reestablish the original, pre-Napoleonic levels. In several separate *sondages* Crosby located the sills of the west portals, established the twelfth-century interior floor level in the

Notes for this essay begin on page 118.

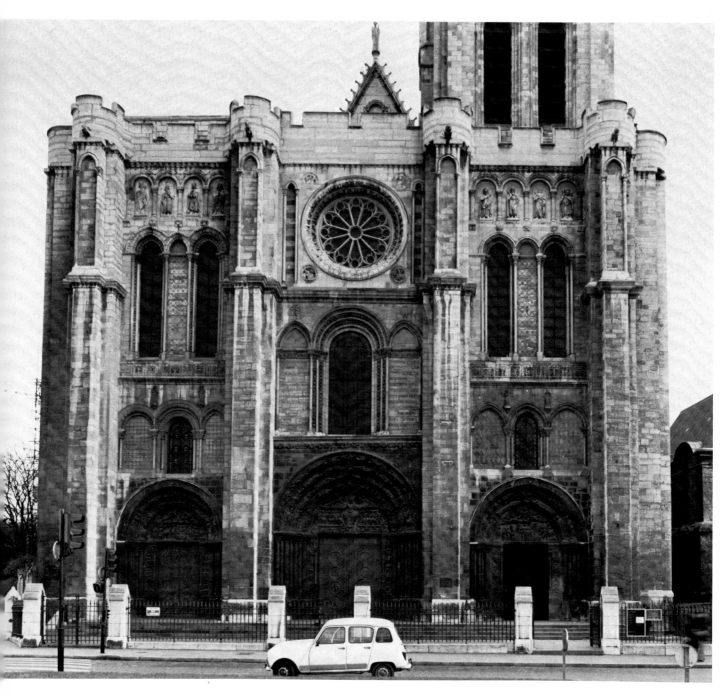

Fig. 1. Saint-Denis, west façade

west bays, and found many more of the original pier bases, still in place, than had Viollet-le-Duc. The door sills were 52cm. lower than the present ones, which provided openings that easily accommodated Suger's bronze doors, whose dimensions were estimated according to the records of Doublet.[13] Although no confirming evidence was found, it seems reasonable to suppose that from the parvis in front of the church the sill level was reached by several ascending steps.[14] The archaeological evidence confirms the interior pavement level 104cm. below the present floor. The 80-odd centimeters difference in height between the door sills and the interior pavement indicate that there must also have been interior steps descending, but no trace of them was found.[15] To the east of the west bays several more steps probably descended to the pavement of the transitional bays leading to the old nave.

The West Bays and Facade: Photogrammetric Analysis

In addition to his discoveries made by excavation, Crosby pioneered new methods of studying the building. In 1969 he commissioned the Institut Géographique National to prepare photogrammetric studies, made possible by the application of techniques borrowed from aerial cartography. The IGN surveyed the twelfth-century parts of the abbey church and produced a series of analytical drawings. After studying them Crosby summarized the results in the volume of studies dedicated to Louis Grodecki.[16] Some of the photogrammetric findings were predictable and, corroborated by archaeological discoveries, confirmed long-held hypotheses, but others had not been anticipated.

Particularly revealing are some of the details of the west facade (fig. 1). For example, the south portal is 30cm. wider than the north portal, a measurement corresponding to the difference in aisle widths of the eighth-century nave. The difference is, no doubt, the inevitable result of the extension of the dimensions of the old nave into the new west bays. Dimensional differences continue in the heights of the portals, with the result, revealed by the photogrammetric studies, that the string course above the central portal is not horizontal but 30cm. higher on the south side. The degree of architectural accomplishment was so high, however, that this is and was the only sloping line on the facade. The photogrammetric studies confirmed that all of the other lines were regularized to the horizontal during construction, despite consistent differences between the widths of the north and south sections.

If we consider (1) Crosby's assertion that the plan of the western bays was laid out independently of the design of the facade and (2) Gardner's division of the work between the two builders, we can logically conclude that the design of the facade above the portals was the creation of the second builder. Thus, it was the second builder who regularized the horizontal lines and went on to create not only the design of the upper parts of the facade but also the system of foliate ornament that articulates the design.

The New Reconstruction of the Plan of the West Bays

The application of photogrammetric analysis is most useful for producing extremely accurate plans of the curves and contours of vaults, starting from the level of the abaci. In the west bays, for example, it can now be shown that five of the six remaining twelfth-century vaults have curves based on a 400cm. or a 425cm. radius. With the addition of 20cm. (to account for the projections of the two blocks beneath the plinth), the photogrammetric plan of the vaults at abacus level permitted Crosby to reconstruct the original ground plan of the west bays. Wherever possible the new plan was checked and confirmed by excavation. Excavation of the original bases and plinths revealed the

consistent 20cm. difference in projection between their lower extensions and the abaci and also confirmed that, in those excavated portions, the positioning of individual elements at abacus level followed the positioning of the corresponding elements in the base blocks.[17]

Using what he described as the "center points" of the main piers in the west bays, Crosby demonstrated that the new plan repeats the overall proportions and dimensions of the old transept. In addition he identified a telling indication of layout and working procedure: the plans of the inside of the three western bays and of the eastern center bay in the facade block exhibit bilateral symmetry; one side is the mirror image of the other. The symmetry does not extend to the eastern lateral bays because, among other reasons, they had to reflect and provide the transition to the different widths of the eighth-century aisles, which had been continued in the new nave bays.[18]

The Role of Ornament in the Visual Articulation of the Facade and West Bays

One aspect of the western end of Saint-Denis that needs detailed investigation and analysis is the role of ornament in the visual articulation of the designs. In this context my remarks will necessarily be confined to a few observations and some suggestions for future research. In the design of the west facade the three portals, with their sculpture, play the major visual and conceptual role. Their importance in the history of twelfth-century sculpture is well established.[19] The precise analyses of Blum and Crosby identifying the original sculptures remaining in the tympana, archivolts, and jambs make it possible to speak now of a Saint-Denis style.[20] Gerson has identified important internal compositional elements in them and studied the now missing lintels.[21] Over the years considerable attention has been given to the question of the statue-columns.[22]

I think, however, that we must not lose sight of the facade design as a whole in which the portals are but one element (fig. 1). Even though much of their visual importance results from their location and lavish scale, their context within the overall facade design is equally significant. Indeed, comparable attention has not been given to the other elements of the design. Beginning with the richly varied foliate and figural capitals and imposts (fig. 2a) in all three portals, there is a wealth of elaborate architectural ornament, much of it original (fig. 2b), on the west facade of Saint-Denis, that needs study.[23] This decoration establishes the horizontal divisions and articulates the openings, relating them to the whole scheme. In fact, articulation of the overall design is accomplished by this ornament. It has not, however, been studied as thoroughly as the portals, in part because of the problems posed by the restorations and additions, especially those of Debret, and because the location makes close examination difficult.[24]

Until such a study can be undertaken, it is sufficient to indicate that when we imagine the facade without the incongruous, floating sculptural additions of Debret the organization takes on a logic and order that is without precedent.[25] The bands of acanthus foliage and the elaborate, multiple arches around the window openings play a crucial role in establishing the total design. The changes embodied in the facade of Saint-Denis—and their departure from those precedents with which it is often compared—resulted in nothing less than the creation of the first Gothic facade. This new design scheme displays an overall logic and organization and a new surface articulation achieved by the judicious application of the architectural and sculptural elements between the strongly projecting buttresses. Photogrammetric analysis of the facade revealed the differences between the two lateral sections and identified the string course above the central portal as the only non-horizontal line. Such details illustrate the careful attention paid to the whole scheme and the importance attached to the regularization of the horizontals. Given the clear differences between the lateral sections that, according to Crosby, resulted from the use of the two doorway dimensions as the generating systems for their respective parts, we realize how well these differences were minimized through minor adjustments in the handling of the individual elements. In short, we need a full analysis of the role of architectural ornament to understand how it contributes to the success of the facade design. More than merely repeating the acanthus foliage patterns in the various sections, the arrangement reveals intentional repetitions of motifs and patterns to tie the whole scheme together.

In this context we must remember that the exterior horizontal articulations do not correspond to the west bay interior divisions. For example, the windows that are visually articulated as a second level on the exterior above all three portals actually open into the ground-floor chambers. The windows at the third level and the central rose give into the upper chambers of the west bays. Thus, whereas the interior has only two stories, the exterior, which Crosby shows was laid out separately from the interior, appears to have three stories reiterating the three vertical divisions created by the buttresses.[26] The "3 × 3" division suggests a grid, but the different portal heights create an irregular grid that emphasizes the portals. The key compositional element is the handling of the architectural moldings and bands that create the visual sense of a linear surface grid and, thus, articulate the facade design.

On the interior of the west bays an analogous kind of visual logic is at work, but it is one based on the manipulation of plastic form—the great clusters of shafts that make up the piers—as opposed to the linearity of the facade. Crosby has noted a centralizing effect in the western center bay, resulting from the prominent angling of the piers and the high relief into which the supports for the ribs and transverse arches are thrown. Although

these effects are created by the projection of elements in the piers themselves, the full impact becomes clear only in the capitals. The west bay capitals constitute not only a staggering variety of foliate and figural ornament but also a series of differing visual effects.[27] For example, the most prominent capitals in the west bays, by virtue of both their decoration and the way they project from the sequence of adjacent capitals, are those of the western center bay ogives (fig. 2c).

The richness and variety of the capital foliage and figures should probably be considered a reaction to the paucity of ornament elsewhere in the west bays. I suspect we should also regard as part of this reaction the few small sculptural caprices, from the well-known corbel in the northeast bay to the usually overlooked series of masks and grotesques in the spaces between capitals and vault severies, as well as on otherwise blank strips of cornice.[28] By their juxtaposition they seem to underline the emphasis on the capitals. As part of the dionysian aesthetic, these distinctive forms add to the richness of the overall effect. Despite the presence of a second builder in the upper bays of the west end, the continuity of patterns and attitudes in the upper stories confirms that the same artists worked on both levels of these bays. In fact, the distinctive foliate ornamentation on the bases supporting the feet of the figures in the archivolts of the central portal (fig. 2a) indicates that the figures and their supports were carved by some of the same sculptors responsible for capitals in the west bays (fig. 2d) and facade. Their work is also found in the crypt and upper chevet (figs. 2f, g, and h). In addition, the capitals surviving from the cloister suggest they were still at work there when it was constructed. All of this sculpture needs to be studied as a whole if the working methods of this important group of artists are to be understood.[29]

The East End: Layout and Plan

In contrast to the richness of the finds in the west end of Saint-Denis, archaeological excavations by Crosby and others in the east end have revealed less. Although informative in the reconstruction of earlier structures and in the exploration of the remaining tombs, to date the usefulness of the excavations has been confined to checking floor levels in the crypt.[30] Photogrammetric studies of both the crypt and chevet have helped establish the relationship between them.[31] Equally valuable evidence has emerged from Crosby's close scrutiny of structural details. The result is a far more comprehensive analysis of the east end than has been previously possible.

The bilateral, mirror-image symmetry noted in the west end is also characteristic of the east end plan—with two exceptions. These exceptions lead to a new understanding of the planning, layout, and construction sequence. The symmetry in planning becomes readily apparent in the treatment and positioning of the

Fig. 2. *Saint-Denis, examples of acanthus foliage*
a. *West facade, central portal, capitals of the left jamb*
b. *West facade, foliage band above central portal, detail*
c. *Western bays, west-center bay, capitals on the southeast face of pier seven*
d. *Western bays, upper level, arcade capital in opening from center chapel into the south tower*
e. *Merovingian marble capital recut in the twelfth century, now in the Musée de Cluny (Inv. no. 12116)*
f. *Crypt, axial radiating chapel, pier to right of entrance*
g. *Chevet ambulatory capital of first column on north side*
h. *Chevet ambulatory capital of third column on north side*

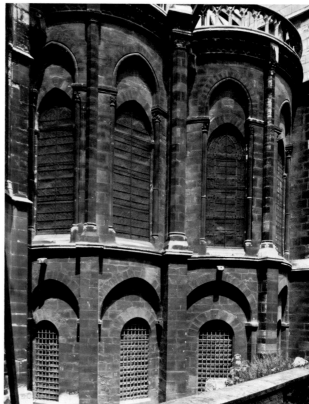

Fig. 3. Right: Saint-Denis, exterior of the chevet, north side
Fig. 4. Left: Saint-Denis, exterior of the chevet, south side

exterior pier buttresses between the new crypt chapels (figs. 10, 3, and 4). The north and south sides are mirror images of each other up to the point where the symmetry ceases, at the pier buttress between the first and second chapels from the west on the south side and also at the wall of the first chapel itself. The intermediate buttress on the north side (fig. 3), like all of the other buttresses around the east end, displays the typical projections from the perimeter and the sequence of small vertical setbacks. This northern buttress (marked X on fig. 6) is also marked by the conventional extension of the relieving arches that frame the chapel windows; that is, the buttress is flanked by pilasters. On the first south chapel both of these relieving arches are corbeled into the center pier buttress rather than articulated by pilasters (fig. 4). The same treatment occurs on the west face of the southern intermediate buttress (marked (X) on fig. 6). In addition this buttress does not project as far from the perimeter as the others and has one less vertical setback. It is also narrower than the other peripheral buttresses, and the windows in the south chapel on both levels are smaller. Because the two levels, crypt and chevet, are in perfect alignment, the irregularity in the buttress pattern extends to the upper level (figs. 10 and 13).[32]

Study of the crypt ground plan and photogrammetric analysis of the vaults, Crosby argued, reveals additional reasons for the anomalies on the south side. Superficially the difficulties appear to stem from the re-orientation of the axis of the hemicycle slightly to the south of the axis of Hilduin's chapel to achieve a better visual balance with the axis of the old nave and the new west bays. According to Crosby, the changes visible on the south side reflect the difficulties of aligning architectural elements along two irregular but nearly concentric interior arcs. The inner arc traces the center line on which the ambulatory columns are placed, while the outer indicates the front surface of the pier masonry between the chapels.

The distance from the ambulatory columns to the pier masonry varies between 287cm. and 289cm., agreeing with the abacus-to-abacus variation of 267cm. to 271cm. The spans of the transverse arches across the crypt ambulatory measure 277cm. to 279cm., except for the 284cm. span of the southernmost arch. The crowns of these semicircular transverse arches rise 105cm. above the tops of the abaci (figs. 14 and 6). The 8cm.– 12cm. difference (between the radius of the span, 139cm. to 142cm., and the height, 150cm.) probably resulted, Crosby asserted, from the wooden formwork used in the vault construction. The crypt columns are evenly spaced 207cm., center to center, along the inner arc. The chapel entrance piers, however, are not precisely aligned with these columns. Thus, on

the north side, where construction began, the layout is regular, but becomes irregular toward the south as the masons adjusted the pier positions from the idealized plan to the practical exigencies of building. As photogrammetric analysis revealed, irregular spacing of the piers resulted in irregularities in the plan and shape of the groin vaults on the south side but, interestingly, produced no deviation from the high level of precision in the vault construction.

The East End in Relation to the Eighth-Century Building

Crosby's studies have shown that the harmonizing of the new work with the old—a desire expressed by Suger several times in his writings[33]—took the form of repeating not only individual architectural elements, such as columns, but also dimensions from the old structure in the west bays, crypt, and chevet. The question of the return to the freestanding column in the east end of Saint-Denis has been discussed, most recently by Bony, in relation to the passage in which Suger speaks of bringing marble columns and capitals from Rome to be used in the new building.[34] I believe, however, that we must be more specific. We know the nave was built in the eighth century, but Suger and his contemporaries believed it to be Merovingian. Thus, the marble columns and capitals brought from Diocletian's Palace and other bath structures would probably have been intended for the new nave bays linking the west block to the eighth-century nave, which apparently contained marble capitals (fig. 2e), bases, and columns from still older, Merovingian structures.

We need not, I believe, look to Roman and Late Antique sources for the use of columns in the east end, particularly when the old columns of the nave provide the closest prototypes.[35] Crosby found a number of dimensional correspondences between the columns of the east end and those of the nave. The width of the bases and abaci for the massive crypt columns varies from 94cm. to 104cm., the latter being the measure of each side of the bases in the nave arcade. The width of the abaci and bases of the chevet ambulatory columns also varies between 94cm. and 104cm. The diameter of the eighth-century nave columns, 52cm., is repeated, as we should expect, in the diameter of the twelfth-century columns in the new bays linking the west end to the old nave, as well as in the lower diameter of the chevet ambulatory columns. This dimension was also repeated in the height of their capitals. As interesting as these dimensional consistencies are—and the list could be extended at some length—I believe they must be seen in the proper context: intentional harmonizing of the new work with the old.

We are, in fact, dealing with two approaches to achieving that harmony. The first attempts to "match," in antiquity and materials, the original nave columns with imported marbles. The second draws inspiration from, and even repeats, dimen-

sions from the nave columns in the new east end supports. Confirmation is provided by comparing the surviving Merovingian marble capitals, now preserved in the Musée de Cluny (fig. 2e), with the newly revived acanthus foliage (figs. 2c, d, g, and h). A few examples appear in the facade and west bays in positions of prominence (fig. 2c), but become the dominant type in the east end.[36] Although the foliage is undeniably twelfth-century, the east end capitals represent another attempt to harmonize the new work with the old.[37] In the search for the sources of this new "dionysian acanthus" not enough emphasis has been given to the earlier marble capitals.

The Use of Geometry in the Planning of the East End

As Crosby demonstrated in his new analysis, the dimensional consistencies and repetitions between the old work and the new do not indicate that the new east end was laid out on the basis of numerical measurement.[38] The layout was based on dimensions taken from the old building, but the building procedure at Saint-Denis followed geometric, not arithmetic, concepts. The accuracy of the photogrammetric analyses and the new east end plans (figs. 10 and 13) all bear this out without, however, making it possible to identify the specific geometric system or systems utilized by the builder. After investigating many attempts to generate the plans by geometric means, Crosby concluded that the precise sequence of systems used in the layout remains elusive. In fact, no known system or combination of systems has proved successful.[39] The *ad quadratum* scheme provides more answers than the others tested; but, as Crosby noted, it does not produce some of the most significant dimensions. For example, it gives neither the radius for the arcs along which the chevet ambulatory columns were erected (this is the same radius for the arcs that define the limits of the wall masonry separating the crypt chapels), nor the radius for the arcs of the radiating chapels. Any system or systems for laying out the east end plans must include a means of determining these fundamental measurements.

In addition, it should be noted that the systems found by Crosby to conform most closely, such as the *ad quadratum*, have all been recognized after the fact. That is, they have only been found by trial and error, working back from the completed structure to a possible generating system, not vice versa. I suspect this means that the geometric basis serving as the starting point for the layout of the east end was flexible enough to accommodate program changes due either to specific liturgical demands or to the practical expediencies of the actual building process. In short, it is no accident that we cannot identify the precise geometric formulation; the achievement, the magnificent spatial complex glowingly described by Suger, is greater than the planning geometries.

Planning Procedures in the East End

The application of geometry must account for many aspects of the Saint-Denis plan; but, just as the repetition of dimensions from the old work does not provide all the answers, nor does the geometric scheme. Building modifications made during the course of construction aside, the planning ingenuity of the builders is undeniable. A few years ago Crosby observed that the depth of the chapels at both levels increased in an eastern progression culminating in the axial chapels (figs. 10 and 13). In the crypt the axial chapel is noticeably deeper than the others. The semicircular transverse arches of the crypt ambulatory measure 277cm.–284cm., while 207cm. is the distance between the column centers. In the upper level a distance of 207cm. separates the center points of the hemicycle columns, rebuilt in the thirteenth century on top of the twelfth-century plinths still in place.[40] Whereas the spacing of the columns is the same for both levels, the arcs along which they are erected differ, the crypt curve being the shallower. Thus, the westernmost hemicycle columns overhang the crypt columns more than those positioned closer to the axial chapels. Because the chevet ambulatory columns are centered along the same arc that marks the inner limit of the masonry between the crypt chapels, the overhang between the two levels is consistently half the diameter of the upper ambulatory columns.[41] This can be seen in the photogrammetric elevation that cuts through both stories (fig. 5). The constant relationship between the upper ambulatory columns and the masonry between the crypt chapels means that the increase in chevet chapel depth exactly mirrors the increase in crypt chapel depth.

Finally, there is the correspondence of the outside wall between the two levels, down to the mirror-image placement of all of the pier buttresses, except the southernmost one. The crypt chapels reflect this bilateral symmetry, again excepting the southernmost. The chevet interior contains an interesting variation on this planning procedure. Each chapel has two low, base moldings around the peripheral wall. The lower begins as an extension of the plinth on which the various colonnette bases rest, while the upper links the bases themselves (fig. 18). This extended base molding is consistent around the wall separating the chapels and excludes the base of the transverse respond shaft between each chapel. The base molding is mirrored in the molding that links the abaci from window opening to window opening, even to the exclusion of the abacus of the transverse respond shaft (fig. 19). As a result the wall sections between the chapels seem more like compound piers than walls. The handling of the plinth molding is also uniform at the junction between chapels, which adds to the impression of piers. Careful examination, however, reveals differences in the plinth moldings in the chapels, where there are four variations of the plinth treatment, far too many to

be accidental. The four are illustrated by the successive changes in the chapels on the north side (fig. 6).

Beginning at the outer edge on the north side, construction progressed toward the axial chapel, with individual differences in each chapel. Then the sequence began over again in the chapel adjacent to the axial chapel on the south side and progressed westward to the south chapel.[42] What is unusual is that the builder deliberately chose not to repeat the mirror-image symmetry that characterizes the exterior buttresses. Thus, as in fig. 6, the interior series can be described as A-B-C-D-A-B-C, whereas the exterior buttresses read in sequence from north to south X-Y-Z-Z-Y-(X). The precise reasons for these variations, which do not occur in the crypt chapels, are unknown and will probably never be discovered. We can speculate that the arrangement might possibly have had something to do with the original altars or other chapel furnishings. But, in the final analysis, I be-

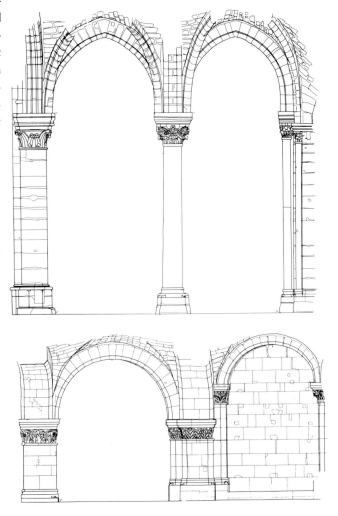

Fig. 5. Saint-Denis, photogrammetric section through the axial ambulatory bay and radiating chapel at crypt and chevet levels (above)

lieve it may be nothing more than an indication of yet another working procedure.

Contradicting this pattern of plinths in the interior of the chapels are indications of a possible sequence of decoration with respect to the display of chapel capitals in pairs, repeating the exterior buttress order and following the interior progression of increasing chapel depth. Whether or not there is a discernible pattern in the positioning of the chevet chapel capitals by ornament types is an avenue of investigation that needs to be followed, with particular attention given first to restoration problems.[43] The recent dissertation by Wulf on the Sugerian capitals goes a long way toward establishing types and groups of related works but does not touch on this problem. My preliminary research indicates, however, that the possibility should not be dismissed.[44]

The Buttresses and External Structure of the East End

The two levels of the eastern end correspond exactly in their mirror-image exterior layout, except for the obvious crowding of the south chapel and the shortening and shrinking of the adjacent strip buttress (figs. 3 and 4). Crosby observed that the direction of the buttresses is not determined by the configuration of the peripheral wall. The implication is that the buttresses were not angled simply to stabilize the wall. Lines extending inward, perpendicular to the outside faces of the buttresses, do not align with such interior elements as the crypt piers or the chevet ambulatory and hemicycle columns. As Crosby indicated, the extended lines converge along the longitudinal axis at different points, although several come close to the spot where the hemicycle and ambulatory columns are visually aligned (fig. 14).[45] That they do not align is yet another indication of the adjustment of the scheme to the exigencies of construction. The proximity of the three points of convergence suggests that the spot where the hemicycle and ambulatory columns are in alignment was the intended location of the chevet hemicycle keystone; and that the point was established when the crypt was laid out.

Crosby demonstrated time and again, and my own findings have independently confirmed, that one of the most important and consistent characteristics of the east end builder was his willingness to sacrifice geometric exactness to practical needs. His major achievement was the creation and preservation of visual harmony and unity, optical regularity if you will, undisrupted by the many minor constructional variations and adaptations.

There is one more important structural element that must be singled out for discussion. On top of the transverse arches between the chapels and across the ambulatory are the remains of low masonry walls (fig. 7).[46] Visible now on top of the ambulatory and chapel vaults as single or double courses of twelfth-century blocks, these transverse radial walls vary in height and have

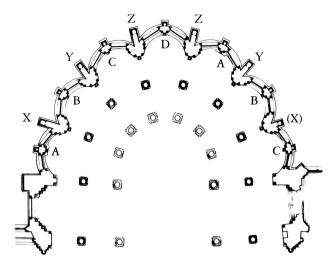

Fig. 6. *Saint-Denis, schematic plan of the chevet, with chapel plinth schemes (A–D) and buttresses (X–Z) labeled*

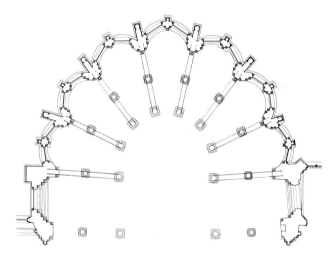

Fig. 7. *Saint-Denis, schematic plan indicating the approximate location of the radial walls above the chevet vaults*

an estimated thickness of 45cm.–50cm.[47] Although they must originally have risen at least to the height of the adjacent vault crowns, and possibly somewhat higher, the upper courses were removed and replaced with thirteenth-century masonry.[48] The nineteenth-century lateral arches in brick that carry the present roof were set into slots hacked into the thirteenth-century blocks on top of the twelfth-century walls.

Short of removing the chapel roofing, it is not possible to determine if these radial walls tie, as they seem to, into the exterior buttresses. Given that the exterior cornice was replaced and enlarged in the thirteenth century and then restored in the nineteenth century, it is difficult to know whether or not the area of the joining remains undisturbed.[49] Because these twelfth-century wall fragments appear to follow the lines of the transverse arches in the vaults below (figs. 13 and 7), I suspect that they

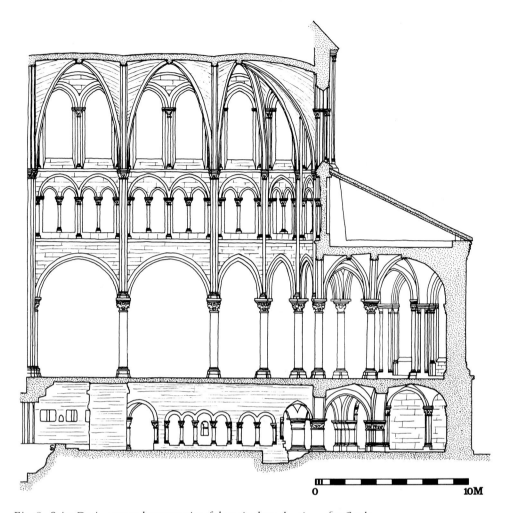

Fig. 8. Saint-Denis, suggested reconstruction of the main chevet elevation, after Crosby

were related to the original upper stories of the main space. They would thus have been conceived and constructed as part of a system of externalized support. That is, they are elements in a system for stabilizing and stiffening the structure from the outside, around and across the east end. Concealed beneath the roof and visible on the outside of the peripheral wall, the supports would have created a series of spinelike radial diaphragm walls between the chapels and across the ambulatory—walls that made for rigidity without encumbering the interior space (figs. 7 and 14).[50]

The Original Elevation Restored

In this regard, as Crosby noted, there is nothing preserved above the ambulatory and chapel vaults that could be interpreted as evidence that the upper stories of the east end of Saint-Denis included a vaulted tribune gallery, despite the claims of earlier historians.[51] The twelfth-century vaults show no signs of ever having had either masonry or timber flooring laid on top of

them.[52] The lower course of the twelfth-century radial walls is hardly disturbed and shows no wall joints along the line between the ambulatory columns. One would find traces of such a wall indicating the periphery had a gallery been constructed, or even intended but never built. Likewise, neither the radial walls nor the exterior buttresses can be used in the futile attempt to misinterpret the Sugerian texts in favor of flying buttresses built around the original east end.[53] Flying buttresses did not exist on the chevet of Saint-Denis prior to the thirteenth-century reconstruction of the central space.

Crosby favored a three-story reconstruction of the original main elevation (fig. 8), and in this I am convinced he was correct.[54] The first story consisted of arcades corresponding to the level of the ambulatory columns and chapels. The main supports were also columns: the original plinth blocks of the hemicycle piers are still in place beneath the thirteenth-century column bases. The hemicycle plinths are slightly larger than those of the ambulatory but still within the dimensional range of elements

from the eighth-century nave.[55] The second story was a series of subdivided, arched openings into the space over the ambulatory vaults and beneath the lean-to roof. The design in the turning bays probably resembled the design of the second story in the eastern center bay at the west end, but with a lower ledge for the center colonnette, in the manner of the second story in the turning bays of the chevet of the abbey church of Saint-Germain-des-Prés.[56] In the straight bays of the chevet the second story units were doubled owing to the greater width of the bays. As at Saint-Germain-des-Prés, the clerestory windows were doubled in the straight bays but contained single lancets in the narrower turning bays. Except in the proportions and in the dimensions of the individual elements, which were again borrowed from the eighth-century nave, the main elevation of Suger's chevet at Saint-Denis most closely resembled the chevets of Saint-Germain-des-Prés, the cathedral at Sens, and probably Saint-Maclou at Pontoise, although the actual design, if we take the ambulatory and chapels as a reliable indication, would have been finer and more elegant.[57]

Visual Articulation in the East End

We are still in need of a detailed analysis that ties together the designs of the crypt and chevet. Even Crosby, whose studies revealed many dimensional consistencies and planning relationships between the two levels, treated their design analysis in separate chapters, never convincingly making of the two a coherent whole. All too frequently we receive no sense of the design relationship, although even superficial examination indicates the two levels were planned at the same moment by the same builder/designer. The crypt is, after all, the platform on which the chevet sits. In many ways the contrasts between the two are easier to see than the similarities. The crypt is low and massive, as well as relatively heavy and dark, while the lightness, both figuratively and literally, of the chevet is well known.

Part of the problem lies once again in recognizing the oft-stated desire of Suger to have the new work harmonize with the old. In this case, I believe, the decision to use groin vaults in the new crypt was an intentional accommodation to the earlier work. The central chamber of Hilduin's chapel (marked on fig. 10) was preserved, its walls reinforced inside and out with blind arcades and the level of the central barrel vault changed. The two lateral hall-like spaces were also redecorated with new arcading and barrel vaulted at the same height as the center chapel. Groin sections inserted in these barrel vaults mark the entrances to the rectangular chapels of the new work. The two lateral spaces not only parallel Hilduin's chapel, but create the passages to the ambulatory and radiating chapels beyond, in which groin vaults now refine and order the spaces.

Visual emphasis on the old work is continued in the new capitals. The arcading added to Hilduin's chapel contains, along with some intentionally re-used architectural elements, new foliate capitals that deliberately imitate the simple, rather archaic foliage patterns of older styles.[58] They add an element of richness to the old walls but are at odds with the foliate capitals of the crypt ambulatory and chapels. The latter are clearly, even in their heavily restored state, related to the capitals of the facade and west bays (compare fig. 2f to figs. 2a, b, and c). The distinction between the two groups of contemporary capitals in the crypt reflects the clear intent to emphasize the antiquity of Hilduin's chapel and the lateral spaces flanking it, on the one hand, and the "newness" of the ambulatory and chapels on the other, without disturbing the harmony achieved by the architecture itself. This was as much a deliberate choice as was the placing of Merovingian capitals at both ends of the crypt lateral spaces. Merovingian capitals, probably in pairs, marked the western entrances to the lateral spaces, as well as the transition into the new ambulatory.[59]

It was in the new ambulatory and chapels (figs. 10, 11, and 12) that the builder for the first time faced the problem of how to evoke a greater sense of interior spaciousness, given that the crypt was the foundation for the chevet. Unlike the design for the west bays and facade, this new design now had to encompass a sequence of units. More important, the builder had to create a sense of regularity and continuity from one unit to the next in the ambulatory, all the while keeping each chapel separate but accessible. The groin vaults do not lend themselves to the kind of linearity seen on the facade; at the same time the sense of spatial expansion is at odds with the plasticity of the west bay piers, which mold space at angles to the mass. The key to the visual conception in the crypt ambulatory and chapels is provided by the groin vaults, with their faceted surfaces. The shifting planes and edges separated by broad, flat, champfered bands are continued in the clusters of irregularly polygonal pilasters at the chapel entrances and around their walls. These multiple flat planes, none of which meet at sharp, projecting right angles, are crucial in establishing visual continuity from ambulatory to chapels. The vault units are separated by arches that are champfered to lessen the sense of projection from the surface. The heaviest structural members are those about which the least could be done, the stout ambulatory columns. The concentration of ornament in the proportionately large foliate capitals, all of which are the same size and set at the same height throughout the ambulatory, gives a focus to the space. The chapel walls, being defined as background surfaces, do not project thickness. They become surfaces rigorously edged by beveled formeret moldings and continuous plinths.[60] Within each chapel the capitals are again uniform in their dimensions but are set higher than in the ambulatory.

The faceting of walls and vaults creates a feeling of surfaces

folded around complex spaces. Nowhere is the shifting polygonality of architectural members, walls, and vaults used to such effect as in the crypt ambulatory and chapels (figs. 11 and 12). The regularity of the repeated units lighted by the paired windows in the outer walls results in a lateral spaciousness rarely encountered in crypts, but which is a clear forerunner of the spatial configurations in the chevet.

The regularity of repeating units in the crypt chapels is continued on the exterior in the two parallel rows of continuous windows punctuated by strip buttresses (figs. 4 and 5). The foliate linearity of the facade is asserted on the east end exterior by the moldings, ranging from the simple champfered relieving arches resting on continuous, profiled imposts around the crypt windows to the more elaborately profiled upper window moldings (fig. 9). Colonnettes with foliate capitals and continuous imposts frame the upper windows and emphasize the grid. The exterior grid is composed of the vertical buttresses, between and centered on the chapels, and the three continuous horizontal moldings. The plinth creates a firm foundation, whereas the original cornice would have tied the whole, gently scalloped screen of wall together. The intermediate horizontal molding runs across the bottom of the chevet window splays and also serves as the baseline on which all of the upper architectural members rest. Below this molding are the distinct layers of wall, pilasters, and buttresses of the crypt; above is the chevet, with more elaborate decorative and visual effects (fig. 9). For example, all of the buttresses change from simple rectangular projections to engaged octagonal shafts topped by elaborately carved capitals and friezes of fantastic animals and monsters.[61]

We are, of course, more familiar with the visual articulation of the chevet, universally cited as exemplifying the new, Gothic space. It is characterized by the daring elimination of masonry between the ambulatory columns and the chapels (figs. 13, 14, 17, and 19). The segmental sections of wall that do remain function visually more like curved compound piers than mural surfaces (fig. 18). This is the result of two things, the first being the extended plinth, base, and impost moldings. The second is the carefully ordered and maintained sequence of positioning for the wall shafts. Visual distinction is precisely maintained between the responds for the transverse arches between the chapels, those for the transverse vault ribs centered in each chapel (fig. 19), and those for the diagonal vault ribs (fig. 20d). The transverse arch responds are taller, have a shaft of greater diameter, stand in front of the walls between the chapels, and carry an arch of more complex profile (figs. 18 and 20b).[62] Centered between the windows in each chapel (fig. 19), the responds of the transverse vaulting ribs still stand away from the surface of the peripheral wall, but they have the same diameter as the single torus vault ribs they appear to support. The diagonal rib responds, like the shafts of the arches framing the windows, sit in reveals cut into the wall

fabric and are topped by imposts that, like the plinths at the bottom, follow the curve of the chapel walls.[63]

Curiously, these visual distinctions, which are consistent right through the level of the imposts, all but disappear in the vaults themselves (compare figs. 20a and c with figs. 20b and d).[64] The diagonal vault ribs in the ambulatory and chapels (figs. 20c and d) all have the same single torus profile, 18cm. in diameter, and all are arcs generated by a 207cm. radius. The same radius produces the other east end arches, the profiles of which also consist of tori, usually two smaller tori separated by a flat band (figs. 20a and b) or, in the case of the hemicycle arcade arches, four grouped tori that obviously have a strong visual association with the ribs in the vaults.

Spatial Organization in the East End of Saint-Denis

The success of the chevet of Saint-Denis lies in the direct expression of a visual logic in the arrangement of the architectural elements. The ambulatory and chapel vaults together form a seemingly delicate armature of arches and arcs, built of small stones held in compression by skillful counterbalance, that rest lightly on a network of slender shafts denying mural surface.[65] Space is visually concentrated in the vaults, which are lifted on slender columns (figs. 15 and 16). So strong is the sense of space itself that it seems almost separated from the glass-and-masonry membrane around it. The thin shafts emphasize the interweaving multidirectional lines. The omnidirectional column, an idea borrowed from the eighth-century church, here becomes the means of opening up the spaces, of overriding the sense of individual units in favor of the total space. Unity of space is achieved through the visual interpenetration of the parts, each of which is intentionally subsumed within the dominant expression of the whole.

The key to this visual clarity is the concentration of optical and structural lines in the narrow columns, which opens the space to the full advantage of the large stained-glass windows. The east end of Saint-Denis, built for Abbot Suger in three years and three months, is unquestionably the most elegant platform constructed for the display of relics in the twelfth century. Indeed, it is the very embodiment of the new spatial synthesis we now call the Gothic style. Equally important to the successful presentation of the new space are the light, the glass, and a new approach to decoration. The conspicuous display of an almost staggering variety of sculptural ornament, largely but not exclusively concentrated in the capitals, is equated with richness and splendor.[66] "The church shines with its middle part brightened. For bright is that which is brightly coupled with the bright," Suger wrote. "And bright is the noble edifice which is pervaded by the new light."[67]

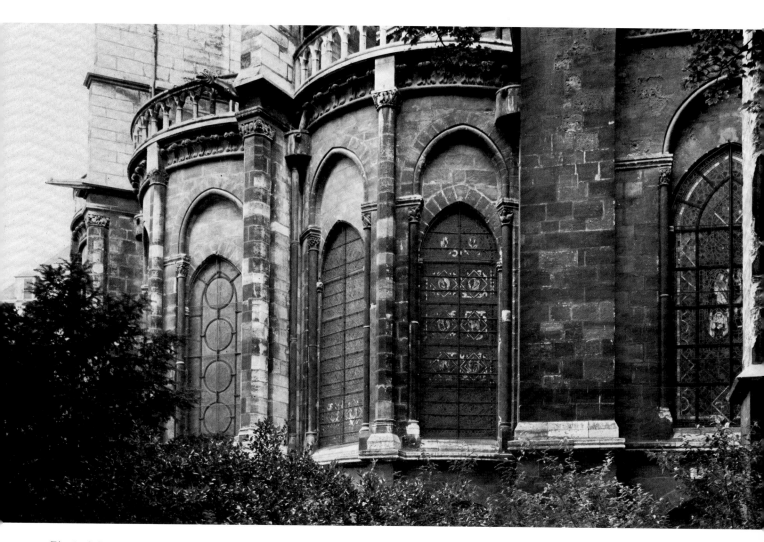

Fig. 9. Saint-Denis, upper windows of the chevet, north side

Conclusion: Directions for Future Research

Sumner Crosby's forthcoming book is a summary of many years of investigations. It will be most valuable for the presentation of the wealth of evidence he accumulated from excavation and analysis. The fact that he did not push the interpretation of this evidence too far will make it all the more useful for future generations. If anything, he can be said to have erred on the side of caution when the evidence did not warrant it. The book will be as important for the application of new tools and techniques as for the discoveries revealed by excavation. As Crosby demonstrated, photogrammetry is just one of a range of sophisticated modern tools available to the scholar for observing and recording details with a new precision and accuracy. Simultaneously, however, Crosby's work is a reaffirmation of the importance of an archaeological method that takes as its starting point the examination and analysis of the monument itself. His collection

and detailed presentation of the body of evidence led him to new and different interpretations, indicating directions for future research, but fostered others that are already under way.

One of the more important but most difficult areas for future research at Saint-Denis will be the study of the work of the many restorers, from Cellerier and Debret through Viollet-le-Duc, Formigé, and beyond. At present our knowledge of their work is limited to brief reports, attacks on the work, and the restorers' responses.[68] Thorough assessment of the restorations can begin only after all of the documentation is available. The massive accumulation of material in the archives of the Direction du Patrimoine in Paris and other public collections, as well as papers still in private hands, must first be identified and then catalogued.[69]

Concomitantly identification and documentation of the many architectural elements found in the excavations or removed during the restorations are essential. They are currently concentrated in four main collections: the Louvre, the Musée de Cluny, the

Musée Municipal de Saint-Denis, and the lapidary collection at the basilica itself.[70] Their study will permit us to identify the modern replacements in the church and to assess in another light the work of the restorers. In many cases, I suspect the accuracy of the copies will be confirmed by the originals.

A useful adjunct to these investigations is the continuing series of municipal archaeological excavations. Their findings will help to broaden our picture of other abbey buildings and might make it possible to identify the original locations of such pieces as the four impost blocks brought together for the 1981 Cloisters exhibition.[71] The excavations are currently confined to the north of the basilica, on the site of the church of the Trois Patrons.[72]

Ideally, excavations should be conducted closer to the church, particularly in the garden on the north side; but also on the south side around the Maison de la Légion d'Honneur, in order to investigate the locations of some of the abbey buildings.

Finally, the emerging picture of the work of Abbot Suger at Saint-Denis will lead to a reevaluation of the impact of Saint-Denis in the development of Gothic architecture in the twelfth century. That impact is as far-reaching as the search for sources has been complex,[73] particularly in such areas as spatial organization, structural articulation, and the study of the role of ornament in the enhancement of architectural design.

NOTES

1. This study would have been impossible without Sumner Crosby's generosity, cooperation, and willingness to share not only the manuscript of his book, now in press, and his wealth of architectural drawings, but also his enthusiasm and his deep affection and respect for Abbot Suger and Saint-Denis. To him I owe a special debt of gratitude and to his memory this study is dedicated. Other ideas were developed in lengthy discussion with Jean Bony, who generously shared his opinions and, in typescript, his now published paper, "The Genesis of Gothic: Accident or Necessity?" *Australian Journal of Art* 2 (1980): 17–31, and during the exploration and examination of the abbey church with him and with Stephen Gardner in the summers of 1979 and 1980. By the time of the symposium the exchange and borrowing of ideas had reached a point where these three colleagues should share credit. The work done since 1981 has also been influenced by discussions with Crosby, Bony, and particularly as concerns sculpture, Pamela Blum. I alone, however, bear responsibility for the way in which the material is here presented. Special thanks are also due to Joel Herschman for his advice and criticism, as well as for his efforts in making some of the new photographs specially for this publication (figs. 4, 9, 14–17, and 20b–d), to Donald Sanders for fig. 8, and to W. Hunt Clark for figs. 6, 7, and 10.

2. James Dallaway, *Observations on English Architecture, Military, Ecclesiastical and Civil* (London, 1806); and George D. Whittington, *An Historical Survey of the Ecclesiastical Antiquities of France with a View to Illustrating the Rise and Progress of Gothic Architecture in Europe* (London, 1809). Both works are discussed by David Watkin, *The Rise of Architectural History* (London, 1980), pp. 56–58. Only Whittington's work was known to Paul Frankl, *The Gothic; Literary Sources and Interpretations Through Eight Centuries* (Princeton, 1960), pp. 498–99.

3. Jacques Doublet, *Histoire de l'Abbaye de S. Denys en France* (Paris, 1625); and Germain Millet, *Le Trésor sacré ou inventaire des sainctes reliques et autres précieux joyaux qui se voyent en l'église et au trésor de l'abbaye de Sainct-Denis en France* (Paris, 1638). An anonymous writer, "Coupe-d'oeil historique sur la ville de Saint Denis près Paris," *Recueil Polytechnique des Ponts et Chaussées* 2 (1807): 145–56, attributed the chevet to Suger (p. 149) but considered the west end to date from the time of Charlemagne (p. 145). Nonetheless, there is much valuable information contained in such descriptive studies of the building. See also M. P. de S.-A., *Promenade aux sépultures royales de Saint-Denis et aux catacombes* (Paris, 1825). My thanks to Elizabeth R. Brown for this reference. The thirteenth-century church has been studied by Caroline Bruzelius; her book is forthcoming from the Yale University Press.

4. See, among others, François Debret, "Notice sur les divers constructions et restaurations de l'église Saint-Denis," *Institut Royal de France. Séance publique annuelle des cinq académies,* 1842: 11–28; Alphonse N. Didron, "Saint-Denys. Restauration de l'église royale," *Annales archéologiques* 1 (1844): 230–36; Félix de Verneilh, "Origine française de l'architecture ogivale," *Annales archéologiques* 2 (1845): 133–42; Alphonse N. Didron, "Flèche de Saint-Denis," *Annales archéologiques* 4 (1846): 175–85; Alphonse N. Didron, "Un Million pour démolir la flèche de Saint-Denis," *Annales archéologiques* 4 (1846): 259–60; Alphonse N. Didron, "Démolition de la flèche et de la tour de Saint-Denis," *Annales archéologiques* 4 (1846): 319–24; Alphonse N. Didron, "Démolition de la flèche de Saint-Denis," *Annales archéologiques* 5 (1846): 62–68; Alphonse N. Didron, "Achèvement des restaurations de Saint-Denis," *Annales archéologiques* 5 (1846): 107–13; Baron François de Guilhermy, "Restauration de l'église royale de Saint-Denis," *Annales archéologiques* 5 (1846): 200–215; Eugène Emmanuel Viollet-le-Duc, "L'Église impériale de Saint-Denis," *Revue archéologique* n.s., 3 (1861): 301–10, 345–53; Félix de Verneilh, "Le Premier des monuments gothiques," *Annales archéologiques* 23 (1863): 5–18, 115–32; Anthyme Saint-Paul, "Suger, l'église de Saint-Denis et Saint Bernard," *Bulletin archéologique* (1890): 258–75; Anthyme Saint-Paul, "La Transition," *Revue de l'art chrétien* 44 (1894): 470–82, and 45 (1895): 1–20, 97–107; and Gabriel Vauthier, "L'Église abbatiale de Saint-Denis

(1802–1817)," *Bulletin de la Société de l'histoire de Paris et de l'Ile-de-France* 52 (1925): 142–48. Additional bibliography concerning these questions is found in Sumner McK. Crosby, *The Abbey of St.-Denis 475–1122* (New Haven, 1942).

5. Little credence can be given to such misguided attempts to ignore both the documentary and archeological evidence as that of Jan van der Meulen, "Die Abteikirche von Saint-Denis und die Entwicklung der Frühgotik," *Kunstchronik* 30 (1977): 60–61; see also the work of one of his students, Thomas E. Polk, "The Early Gothic Chevets of Saint-Denis and Noyon: Methodological Considerations" (Ph.D. diss., Pennsylvania State University, 1976). Access to the materials revealed by the photogrammetric analyses would have substantially altered Polk's conclusions.

The term "chevet" is used here to describe only the raised portion of the east end of Saint-Denis, although chevet normally refers to everything east of the transept. Frequently the raised area of Saint-Denis is referred to as the "choir," but this is inaccurate. The choir at Saint-Denis was to the west of the raised east end and included the area of the crossing and the four eastern bays of the nave.

6. Panofsky, *Suger.* For the complete edition of Suger's texts see Lecoy, *Oeuvres.*

7. Crosby's posthumous book supersedes all previous studies in its conclusions. Until it is published, with the appendices covering the excavations, his separate articles provide the most complete presentation of the results. A complete bibliography of Crosby's publications is included in the necrology by Pamela Z. Blum and Jane Hayward in *Gesta* 22 (1983): 93–95.

8. Sumner McK. Crosby, "New Excavations in the Abbey Church of Saint-Denis," *Gazette des Beaux-Arts* 6th ser., 26 (1944): 115–26; and Sumner McK. Crosby, "Fouilles exécutées récemment dans la basilique de Saint-Denis," *Bulletin monumental* 105 (1947): 167–81.

9. Sumner McK. Crosby, *L'Abbaye royale de Saint-Denis* (Paris, 1953), p. 46, proposed a three-story *nave* elevation with a vaulted gallery at the second story. See also Jean Bony, *French Gothic Architecture of the 12th and 13th Centuries* (Berkeley, 1983), p. 95, figs. 86–87, who proposes a three-story elevation.

Crosby suggested that the large impost blocks, two now in the collection of the Cloisters and two in the Glencairn Museum, Bryn Athyn, Pennsylvania, might have been intended for the new nave undertaken shortly before Suger's death. See Crosby, *L'Abbaye royale*, p. 48; *Royal Abbey*, pp. 56–57, nos. 8A–8D; and The Metropolitan Museum of Art, *Notable Acquisitions 1983–1984* (New York, 1984), p. 9. I have been unable to verify the existence of additional capitals of this type at Saint-Denis in the church or its reserves, or in the local museum or its reserves. In addition, I think it more reasonable to associate these capitals with some as yet unidentified part of the abbey complex built in conjunction with the cloister.

10. The technique and its application to buildings is explained in the publication, *Photogrammétrie des monuments et des sites* (Paris, 1972), prepared by the Comité International de Photogrammétrie Architecturale, in which the drawing of the chevet ambulatory and chapel vaults at Saint-Denis was first published. See also M. Carbonnell, "Contribution de la photogrammétrie à l'étude et à la conservation des centres historiques," *Bulletin d'information de l'Institut géographique national* 24 (December 1973): 18–35. My thanks to John Cameron for the second reference.

11. The following discussion is largely based on the new manuscript, although some of the information can be found in Sumner McK. Crosby, "The Inside of St.-Denis' West Facade," in Margarete Kühn and Louis Grodecki, eds., *Gedenkschrift Ernst Gall* (Berlin, 1965), pp. 59–68; and Sumner McK. Crosby, "The Plan of the Western Bays of Suger's New Church at St.-Denis," *Journal of the Society of Architectural Historians* 27 (1968): 39–43. The question of campaigns in the west bays will not be discussed. See Stephen Gardner, "Two Campaigns in Suger's Western Block at Saint-Denis," *Art Bulletin* 66 (1984): 574–87.

12. Baron François de Guilhermy, "Notes archéologiques," Paris, Bibliothèque Nationale, ms. n.a. fr. 6121 and 6122, pp. 14–15.

13. The new dimensions of the door openings alter only in slight dimensional changes the hypotheses and conclusions concerning portal lintels advanced by Paula Gerson, "The Lintels of the West Facade of Saint-Denis," *Journal of the Society of Architectural Historians* 34 (1975): 189–97. The indications of levels given by Jules Formigé, *L'Abbaye royale de Saint-Denis* (Paris, 1960), pp. 35–37, are inaccurate.

14. The steps can be seen in some of the eighteenth- and nineteenth-century views of the facade.

15. Crosby suggested that evidence of the interior steps existed on the right side of the central portal and were revealed in his excavations. No evidence, however, was found in the excavated area of the north portal.

16. Sumner McK. Crosby, "Some Uses of Photogrammetry by the Historian of Art," *Études d'art médiéval offertes à Louis Grodecki* (Paris, 1981), pp. 119–28. Under an arrangement with the Institut Géographique National, which prepared the photogrammetric drawings and analyses, first publication is reserved to Sumner Crosby. This discussion of the drawings and the information they provide is taken from Crosby's analyses; drawings and analyses will appear in his book. I must express my gratitude once again to Sumner Crosby for suggesting the publication here, as fig. 5, of a detail of one of the photogrammetric drawings in order to clarify the discussion.

The reconstruction of the west facade lacks the topmost horizontal molding and the bratices of the crenelated parapet (see Crosby, "Some Uses of Photogrammetry"). Their omission changes the visual sense of the articulation of the upper part of the facade. As Stephen Gardner, "The Influence of Castle Building on Ecclesiastical Architecture in the Paris Region, 1130–1150," in Kathryn Reyerson and Fay Powe, eds., *The Medieval Castle, Romance and Reality,* Medieval Studies at Minnesota, vol. 1 (Minneapolis, 1984), pp. 97–123, indicates, the parapet would surely have been present in the original design.

17. There are three areas I find troubling in the reconstructed plan, none of which has been excavated: the eastern faces of the two piers on the western side of the east central bay and the eastern face of the northern pier; that is, the southwest pier of the east-

ern aisle bay on the north side. The angled abacus blocks under the vault ribs at those three points do not reflect the stepped bases and, in the center bay, are positioned higher than the other abaci. The lack of correspondence suggests that they may not reflect the intention of the first builder, who laid out the plan. These three groups of angled abaci are right at the break between the work of the two builders. In his reconstructed plan Crosby adopted the angled abaci as the basis for the pier plans in the center bay but rejected them in the northeast aisle bay. While final judgment should be reserved until the areas are excavated, I am inclined to believe that all of the bases in these eastern bays were originally stepped, as Viollet-le-Duc reconstructed them, and that none of them were angled. Gardner, "Two Campaigns," also misses the importance of this change.

18. We must keep in mind that Crosby demonstrated that the west facade was laid out on a different basis from the west bay plan. See Crosby, "The Inside"; and Crosby, "The Plan." Crosby's excavations in the south aisle revealed a change in the alignment of the foundations for the four new nave bays. The two eastern bays seem to have continued the width of the eighth-century south aisle, but the two western bays were wider and seem to have matched the north aisle bay width. See Maines fig. 1.

19. The earlier literature on the sculpture is given in Willibald Sauerländer, *Gotische Skulptur in Frankreich 1140–1270* (Munich, 1970), pp. 63–65. See also Millard Fillmore Hearn, Jr., *Romanesque Sculpture. The Revival of Monumental Sculpture in the Eleventh and Twelfth Centuries* (Ithaca, 1981), pp. 191–97; and *Royal Abbey,* pp. 25–33. Pamela Blum is preparing a major study of the sculpture at Saint-Denis that will supersede many of the articles cited here.

20. Sumner McK. Crosby, "La Sculpture des portails occidentaux à Saint-Denis et le style dionysien," *Bulletin de la Société nationale des Antiquaires de France,* 1969: 236–38; Sumner McK. Crosby, "The West Portals of Saint-Denis and the Saint-Denis Style," *Gesta* 9, no. 2 (1970): 1–11; Sumner McK. Crosby and Pamela Z. Blum, "Le Portail central de la façade occidentale de Saint-Denis," *Bulletin monumental* 131 (1973): 209–66; and the article by Pamela Blum in this volume.

21. See Gerson, "Lintels"; Paula Gerson, "The Iconography of the Trinity at Saint-Denis," *Gesta* 17, no. 1 (1978): 73; and Paula Gerson, "The West Facade of St.-Denis: An Iconographic Study" (Ph.D. diss., Columbia University, 1970). See also the article by Paula Gerson in this volume.

22. Léon Pressouyre, "Une Tête de reine du portail central de Saint-Denis," *Gesta* 15 (1976): 151–60, with bibliography. Most recently, see Konrad Hoffmann, "Zur Entstehung des Königsportals in Saint-Denis," *Zeitschrift für Kunstgeschichte* 48 (1985): 29–38.

23. The dissertation by Walter Wulf, *Die Kapitellplastik des Sugerbaus von Saint-Denis, Europäische Hochschulschriften,* ser. 28 Kunstgeschichte, 10 (Frankfurt am Main, 1979), is limited to the capitals.

24. The color-coded Debret drawings in the Bibliothèque de la Direction, Paris, are a starting point for the study of the upper ornament. The west rose was recently studied by Chantal Hardy, "La Fenêtre circulaire en l'Ile-de-France au XIIᵉ et XIIIᵉ siècles" (Ph.D. diss., University of Montreal, 1983); and Chantal Hardy, "Beauvais ou Saint-Denis?" Paper presented at the Fourth Annual Canadian Conference of Medieval Art Historians, Victoria, B.C., 19 November 1983. A major opportunity was missed when, during washing, the facade was covered with scaffolding in the early 1970s.

25. The ideas of Bony on the linearity of the Gothic influenced this approach to the west facade design.

26. See Crosby's articles: "The Inside," "The Plan," and "Photogrammetry."

27. See Wulf, *Die Kapitellplastik,* for the capitals, as well as older studies such as Emma Alp, *Die Kapitelle des XII. Jahrhunderts im Entstehungsgebiete der Gotik* (Detmold, 1927).

28. There are even a few on the bases in the upper levels of the west bays. The style, technique, and decorative motifs indicate these little sculptures were the work of the same artists carving the capitals.

29. Not all of the carvers worked on all areas of the new work at Saint-Denis. Some of the artists who worked in the west bays seem to have left to work at Château-Landon, for example. The activity of some of these sculptors will be the focus of the study John James and I are preparing. See François Deshoulières, "Château-Landon: Église Notre-Dame," *Congrès archéologique* (Orléans) 93 (1930): 242–59; and Anne Prache, *Ile-de-France romane* (La Pierre-qui-vire, 1983), p. 369–73. On the cloister, see the article by Léon Pressouyre in this volume. Additional works by some of these sculptors were recently mentioned by Stephen Gardner, "The Church of Saint-Étienne in Dreux and Its Role in the Formulation of Early Gothic Architecture," *Journal of the British Archaeological Association* 137 (1984): 86–113. Their activity is considerably broader and rather more far-reaching than he suggests, nor can I endorse his dating attempts.

30. Crosby's excavations are presented in detail in the appendices to his new book. Bibliography of the more recent archaeological excavations, primarily in the area of the cemetery beneath the crossing and nave, can be found in Robert Brichet, "Fouilles et travaux récents à la basilique de Saint-Denis," *La Construction moderne* 77 (1961): 60–65; and in the issue of *Les Dossiers de l'archéologie* 32 (January-February 1979), devoted to the analysis of the burial of Aregonde, which includes Michel Fleury, "Les Fouilles de Saint-Denis," pp. 19–26. See also Michel Fleury and Albert France-Lanord, "Les Sépultures de la basilique de Saint-Denis (premier article)," *Cahiers de la Rotonde* 7 (1984): 37–69.

31. The new discussion in Crosby's book supersedes all others because of the accuracy of the photogrammetric drawings.

32. This difference was first recognized by Crosby. The irregular handling of the buttress and window-relieving arches might also be explained by the presence of the abbey buildings to the south of the church. All traces of the twelfth-century abbey buildings in this area have disappeared, although fragments of the twelfth-century cloister have been found.

33. Suger, *Adm.* (P), pp. 52–53; and Suger, *Cons.* (P), pp. 90–91, 100–101. This is one of the themes discussed by Bony in his article in this volume.

34. Beat Brenk, "Sugers Spolien," *Arte medievale* 1 (1983): 101–7, discusses this passage and its ideological associations with Montecassino. In addition to the examples discussed by Bony,

it is possible that another, nearly contemporary precedent existed. If, indeed, the nave of the Temple Church in Paris did date, as current opinion suggests, ca. 1140, then the six free-standing columns of this rotunda, built in imitation of the Holy Sepulchre and the Dome of the Rock in Jerusalem, are likewise a conscious revival of an antique form. On the destroyed Temple Church, which had a groin-vaulted ambulatory and a rib-vaulted central space, see the visual and historical documentation discussed by Jacques Boussard, *Nouvelle histoire de Paris de la fin du siège de 885–886 à la mort de Philippe Auguste* (Paris, 1976), pp. 154, 175–77; Élie Lambert, "L'Architecture des templiers," *Bulletin monumental* 112 (1954): 7–60, 129–65; Yvan Christ, *Églises parisiennes actuelles et disparues* (Paris, 1947), no. 84; and Henri du Curzon, *La Maison du Temple de Paris* (Paris, 1888), esp. pp. 71–76, 83–86, who demonstrates the fallacies in the reconstructions proposed by Eugène Emmanuel Viollet-le-Duc, "Temple," *Dictionnaire raisonné de l'architecture française du XIᵉ au XVIᵉ siècle* (Paris, 1868), vol. 9, pp. 12–20.

35. In addition there were a number of Merovingian models available in Paris, among them, Saint-Étienne, Sainte-Geneviève, Saint-Germain-des-Prés, Saint-Marcel, Saint-Julien-le-Pauvre, and Saint-Pierre de Montmartre. See May Vieillard-Troïekouroff, *Les Monuments religieux de la Gaule d'après les oeuvres de Gregoire de Tours* (Paris, 1976), pp. 201–16; Patrick Périn, *Paris mérovingien*, exhib. cat. (Musée Carnavalet, Paris, 1981); and Patrick Périn, *Lutèce: Paris de César à Clovis,* exhib. cat., (Musée Carnavalet, Paris, 1984). Patrick Périn *et al.*, *Collections mérovingiennes*, Catalogues d'art et d'histoire du Musée Carnavalet, II (Paris, 1985), *passim*. On the influence of Merovingian capitals on the development of capital foliage at Saint-Denis, see note 36 here.

36. May Vieillard-Troïekouroff, "Les Chapiteaux de marbre du Haut Moyen-Âge à Saint-Denis," *Gesta* 15 (1976): 105–12, points out that at least two of the sixth-century marble capitals from Saint-Denis now in the Musée de Cluny (fig. 2e) have areas that were recut in the twelfth century (nos. VIII and IX in her list). Denise Fossard, May Vieillard-Troïekouroff, and Elisabeth Chatel, *Recueil général des monuments sculptés en France pendant le haut moyen âge (IVᵉ–Xᵉ siècles)*, vol. 1, *Paris et son département* (Paris, 1978), pp. 157–61; May Vieillard-Troïekouroff, "Supplément au Recueil général des monuments sculptés en France pendant le haut moyen âge (IVᵉ–Xᵉ siècles), vol. 1, Paris et son département," *Bulletin archéologique,* n.s., 15 (1979): 181–227. That they were repointed in the twelfth century is sure confirmation of the debt of early Gothic carvers to the earlier work, as well as an indication that the Merovingian marbles were still in use in the building. Preliminary study suggests that the carver who recut the Merovingian marbles was one of the major artists at work at Saint-Denis. In addition to the acanthus foliage, his hallmark is a variation on the form of classical acanthus that resembles a palm tree. Two such Merovingian marble capitals from Saint-Denis that might well have been his source still survive and are now in the Musée de Cluny. Three of his capitals with "palm trees" are prominent at Saint-Denis; the first in the western center bay of the western block, the second in the chevet, and the third is an exterior window respond capital in the first chapel to the south of the

axis. His acanthus foliage is also found in the west bays, on both levels, in the capitals of the central portal, as well as on the foliage pedestals for figures in the archivolts of this doorway, as well as in the chevet. Because of the restorations, I am less certain of his work in the crypt, although other crypt capitals can be associated with other sculptors working in the west bays and facade. Finally, it is worth noting that one of the capitals in the Musée de Cluny once associated with the Merovingian marbles (Vieillard-Troïekouroff, "Les Chapiteaux," no. 13; and Fossard, Vieillard-Troïekouroff, and Chatel, *Recueil,* p. 213, no. 402) is, in this volume, assigned by Pressouyre to the cloister and that its twin can still be found in place in the chevet. John James and I are currently studying works by the "palm tree" master and several of his associates at Saint-Denis. Preliminary research indicates that they carved not only capitals, but also some figure sculpture at Saint-Denis and in a dozen other buildings and portals. Thus far, we have been able to outline the "professional career" of this sculptor from his earliest work at Saint-Denis prior to 1140 to Laon in the early to middle 1160s. Independently, I am studying the impact of the Merovingian capitals on the development of early Gothic acanthus capitals, as part of a larger study of the revival of Merovingian forms, specifically in Paris during the reign of Louis VI. See, most recently, Jean-Pierre Caillet, *L'Antiquité classique, le haut moyen âge et Byzance au Musée de Cluny* (Paris, 1985), pp. 69–74.

37. The development of dionysian acanthus has important consequences for the future of early Gothic architectural sculpture and probably also explains the disappearance of historiated capitals in early Gothic buildings. There are exceptions, of course, and portal capitals should not be included.

38. The schemes suggested in earlier studies are now repudiated. The earlier articles include: Sumner McK. Crosby, "Abbot Suger's St.-Denis. The New Gothic," *Romanesque and Gothic Art, Studies in Western Art 1, Acts of the Twentieth International Congress of the History of Art* (Princeton, 1963), pp. 85–91; Sumner McK. Crosby, "Crypt and Choir Plans at Saint-Denis," *Gesta* 5 (1966): 4–8; and Sumner McK. Crosby, "Le Plan de la crypte et du choeur de l'église de Suger à Saint-Denis," *Bulletin de la Société nationale des Antiquaires de France,* 1967: 230.

39. Numerous students in Crosby's graduate seminars at Yale over the years failed to arrive at a conclusive answer. For further discussions of geometric systems, see Lon Shelby, "The Geometrical Knowledge of Medieval Master Masons," *Speculum* 47 (1972): 345–421; Stephen K. Victor, *Practical Geometry in the High Middle Ages,* Memoirs of the American Philosophical Society 134 (Philadelphia, 1979); Michael Evans, "The Geometry of the Mind," *Architectural Association Quarterly* 12, no. 4 (1980): 32–55; and, most recently, Otto von Simson, "The Cistercian Contribution," in Timothy G. Verdon, ed., *Monasticism and the Arts* (Syracuse, 1984), pp. 115–37. The various studies by Guy Beaujouan cited by Victor, Evans, and Bony are also important.

40. The diameter that produces the arcs for all of the ribs in the upper ambulatory and chapel vaults is 207cm.

41. The ambulatory columns, Crosby observed, are not perfectly vertical but lean outward slightly. This might be the result of the thirteenth-century rebuilding of the central chevet space,

including remaking the hemicycle columns. The tilt of these columns is the only distortion in the original scheme that has been revealed.

42. The direction of construction reflects the progressively increasing depth observed in the planning of the chapels and the fact that the sequence of construction moves from north to south.

43. "Pattern" may be too strong a term to characterize an aesthetic sensitivity evidenced in the placement of capitals in complementary positions. There is, however, no denying the obvious pairing of the griffin capitals on the transverse responds between the second and third and the fifth and sixth chapels. The transverse respond capitals on the eastern sides of the two outermost chapels may be considered a pairing of comparable motifs: heads and masks in foliage. There is a general tendency to reduce nonfoliage designs as one approaches the axial chapel. Restraint should be exercised, however, in any analysis of capital placement at Saint-Denis, because of the still unstudied problem of nineteenth-century replacements, although in general they seem to reflect the originals. Certain areas may also reflect nothing more complex than the cutting and positioning of capitals as the construction progressed. As examples, I mention the two instances of inside capitals with sirens (supporting the northeast angle of the vault rib in the north rectangular chapel and on the transverse arch respond to the left of the axial chapel) in relation to the two outside capitals with sirens (both occurring in the window-relieving arch supports closest to their interior counterparts). The use of notched abaci may be related to the interior "decoration patterns." That is, their use seems analogous to the capital sequences. Notched abaci are found on all the ambulatory column capitals, as well as on the transverse arch respond capitals between the chapels. Considering the three remaining originals, it is likely that the capitals of the transverse rib responds of the chapel vaults also had notched abaci. Notched abaci are not restricted to these locations, but the other instances seem to be dictated by the design of the individual capitals. In the end, caution is advised because any attempt to find a consistent pattern to the ornament at Saint-Denis must be tempered by the prevailing aesthetic in which deliberate variety is regarded as a conscious expression of richness and splendor.

The possibility of patterns in the placement of capitals and other architectural ornament at Saint-Denis is suggested by the examples of the east ends of Noyon and Saint-Germain-des-Prés. Further investigations into these problems, including other buildings, are planned.

44. Discussions with Walter Wulf at the time of the symposium suggest that, in his opinion, if such patterns did exist, it might now be impossible to confirm because of the nineteenth-century restorations.

45. Oblique reference to this point was first made by Sumner McK. Crosby in "Early Gothic Architecture—New Problems as a Result of the St.-Denis Excavations," *Journal of the Society of Architectural Historians* 7 (1948): 13–16. The difference between the points of convergence and alignment is about one meter.

46. In the summer of 1979, I examined several of these walls with Stephen Gardner, Jean Bony, and a group of graduate students from Columbia University. In 1981, I made a more systematic examination and rechecked the dimensions. These walls were

discussed by Gardner in a paper, "Speculations on the Upper Parts of Suger's Choir at Saint-Denis," at the 1985 College Art Association Annual Meeting in Los Angeles.

47. The twelfth-century thickness was estimated by measuring the thickness of the thirteenth-century masonry through two air holes linking the otherwise separate spaces atop the vaults and adding the increments of difference between the two levels.

48. Radial walls, which should be termed transverse walls in the straight bays, must also have existed at Notre-Dame, Paris, prior to the rebuilding of the choir gallery. They still exist above the vaults in the north side aisle of the church of Saint-Martin at Champeaux. The prerestoration drawings by Sauvageot suggest they might also have existed at Saint-Pierre de Montmartre. Alfred Lamouroux, "Rapport de l'architecte [Sauvageot] sur le projet de restauration de l'église Saint-Pierre de Montmartre," *Commission du vieux Paris* (1898, #5, Séance du 2 juin): 29–32, two unnumbered plates. The Saint-Denis reconstruction drawing, fig. 8, shows the radial walls slightly above the crown height of the vaults but their real height must remain conjectural.

49. The exterior cornice of the chapels dates from the thirteenth century; but the whole area shows evidence of extensive nineteenth-century work, in conjunction with the construction of the present roof over the ambulatory and chapels.

50. This is an idea reached independently but discussed on several occasions with Jean Bony, both of us thinking ahead to the next example of such externalized support, the chevet of Notre-Dame, Paris, as well as of the local sources for Saint-Denis. See the article by Bony in this volume; Jean Bony, "Essai sur la spiritualité de deux cathédrales," *Chercher Dieu* (Paris, 1943), pp. 150–67; Bony, *French Gothic;* and the two articles cited in note 65. See also William W. Clark and Robert Mark, "The First Flying Buttresses: A New Reconstruction of the Nave of Notre-Dame de Paris," *Art Bulletin* 66 (1984): 47–65.

51. The idea seems to have originated with Georg Dehio and Gustav von Bezold, *Die kirchliche Baukunst des Abendlandes* (Stuttgart, 1901), and was perpetuated until recently by the drawing prepared by Paul Frankl for the first edition of Panofsky, *Suger,* p. 221. Crosby supplied the reconstruction sketch used in the second edition, p. 239, which correctly shows the second story to be a series of arches fronting the space between the vaults and the lean-to roof protecting them. This sketch, however, does not agree with the evidence Crosby found for the original height of the main vessel; see note 54 here.

52. Examination of the top of the ambulatory and chapel vaults indicates that nothing was ever erected on top of the arches between the ambulatory and the chapels. Under several centimeters of dirt early mortar was found intact. Since the initial examination in 1979, work consolidating the weakened nineteenth-century brick arches carrying the roof has contributed additional dirt; but the evidence was rechecked in 1981.

53. John Fitchen, *The Construction of Gothic Cathedrals* (Oxford, 1961), pp. 289–95; and Kenneth John Conant, "Édifices marquants dans l'ambiance de Pierre le Vénérable et Pierre Abélard," *Pierre Abélard—Pierre le Vénérable, Colloques internationaux du Centre national de la recherche scientifique,* 546 (Paris, 1975), pp. 727–29, believed flying buttresses existed at

Saint-Denis.

54. The drawing published here as fig. 8 was prepared by Donald Sanders according to Crosby's data and conforms more closely to his evidence than the student sketch published in the second edition of Panofsky, *Suger,* p. 239. That sketch is too short in overall height.

55. Just as the ambulatory plinths are smaller than the hemicycle plinths, so too are the respective abaci. The ambulatory abaci are 31cm. tall and vary in length between the champfers 95cm.–100cm. The height of the hemicycle abaci ranges from 34cm.–37cm., whereas the length variation is 104cm.–9cm. This suggests that the hemicycle columns were about 10 percent larger than the ambulatory columns.

56. William W. Clark, "Spatial Innovations in the Chevet of Saint-Germain-des-Prés," *Journal of the Society of Architectural Historians* 38 (1979): 348–65, with bibliography.

57. The choir elevation of Saint-Denis was recently restored as it might have looked had it been finished in 1164 or 1174, as opposed to 1144: Ulrike Bangert, Bernhard Laule, and Heinfried Wischermann, *Saint-Denis I: Der Aufriss des Suger-Chores,* Berichte und Forschungen zur Kunstgeschichte 4 (Freiburg i. Br., 1980). For Saint-Germain-des-Prés, see Clark, "Spatial Innovations"; for Sens, note 66; for Pontoise, Eugène Lefèvre-Pontalis, "Pontoise; église Saint-Maclou," *Congrès archéologique (Paris)* 82 (1919): 76–99, with bibliography.

58. Some of the capitals have been dated eleventh century by Jules Formigé. Scholars have universally commented on the archaic feeling of this design. Pamela Z. Blum, "The Saint Benedict Cycle of the Capitals of the Crypt at Saint-Denis," *Gesta* 20, no. 1 (1981): 73–87, noted that at least one of them was a nineteenth-century copy.

59. On the more recent work in the crypt, see André-J. Donzet, "L'Aménagement de la crypte de Saint-Denis," *Monuments historiques* 104 (September 1979): 78–84.

60. Within several of the chapels there are clear indications that the line of the bases was also extended as a wall molding, a detail that will reappear in the chevet chapels.

61. Several of these friezes seem particularly Italian in character. Investigations prompted by Bony's remarks (see his note 25) suggest the presence of Italian sculptors working at Saint-Denis. In particular, the "palm-tree" master, whose earliest known and dated work so far is at Saint-Denis, may have come from Italy. The closeness of his work to capitals and friezes at the Sagra di San Michele and in Piacenza is undeniable. Christine Verzar [Bornstein], *Die romanischen Skulpturen der Abtei Sagra di San Michele, Studien zur Meister Nicholaus und zur 'Scuola di Piacenza,'* Basler Studien zur Kunstgeschichte n.s. 10 (Bern, 1968); and Christine V. Bornstein, "The Capitals of the Porch of Sant'Eufemia in Piacenza: Interacting Schools of Romanesque Sculpture in Northern Italy," *Gesta* 13, no. 1 (1974): 15–26. These Italian connections were first recognized by Paula Gerson and Pamela Blum and will form an important part of Blum's monograph on the sculpture at Saint-Denis.

62. The separation is heightened by the difference in base heights and by the extension of the bases in the chapels through a molding clearly visible behind the shaft of the transverse arch.

63. I know of no other structure in which this exact set of architectural articulations was repeated. See Clark, "Spatial Innovations."

64. As we learn more about the original floor covering in the east end of Saint-Denis, we become increasingly aware of the richness and diversity of the tile work and mosaics. The uniform floor level in the chevet is a major contributory factor to the spatial unity, although it is usually overlooked in favor of the uniformity presented by the vaults. On the floor, see Christopher Norton, "Les Carreaux de pavage du Moyen Âge de l'abbaye de Saint-Denis," *Bulletin monumental* 139 (1981): 69–100; Christopher Norton, "Les Carreaux de pavage en France au Moyen Âge," *Revue de l'art* 63 (1984): 59–72; and the article by Xavier Barral i Altet in this volume.

65. The fundamental study by Jean Bony, "Diagonality and Centrality in Early Rib-Vaulted Architectures," *Gesta* 15 (1976): 15–25, profoundly influenced my approach to the spatial analysis at Saint-Denis. Equally important are Jean Bony, "The Genesis," pp. 17–31, which was kindly made available prior to its actual publication; Jean Bony, "La Genèse de l'architecture gothique: 'accident ou nécessité'?" *Revue de l'art* 58/59 (1983): 9–20; and Sumner McK. Crosby, "Abbot Suger's Program for His New Abbey Church," in Timothy G. Verdon, ed., *Monasticism and the Arts* (Syracuse, 1984), pp. 189–206.

66. Only one original console holding a small squatting figure remains in place between the transverse rib and capital in the first radiating chapel on the north side of the chevet. There is every indication that each chapel originally was to have a console figure. Except for these consoles, sculptural ornament was restricted to the capitals in the chevet. See Wulf, *Die Kapitallplastik.* Sens Cathedral preserves a series of vault corbels that, like the capitals, is related to the east end of Saint-Denis. For Sens, see Kenneth Severens, "The Early Campaign at Sens, 1140–1145," *Journal of the Society of Architectural Historians* 29 (1970): 97–107. The corbels appear at Sens because no provision was made for ribs in the first design of the ambulatory and aisles. Jacques Henriet, "La Cathédrale Saint-Etienne de Sens: le parti du premier maître et les campagnes du XIIᵉ siècle," *Bulletin monumental* 140 (1982): 81–174, esp. 108–14, believes ribs carried on corbels were planned from the beginning, a hypothesis that is disproved by the remains of groin vaults in place in the ambulatory.

67. Suger, *Adm.* (P), p. 51.

68. See the works cited in note 4 here and Michel Fleury, "Les Fouilles de l'abbatiale de Saint-Denis depuis le XIXᵉ siècle," *Archéologie en Seine-Saint-Denis* (Saint-Denis, 1980), pp. 29–32.

69. Due to a number of people and circumstances beyond his control, ranging from World War II and Marcel Aubert to Jules Formigé, Crosby was tragically prevented from making a systematic and detailed analysis of all of the restoration dossiers, as well as from rechecking materials seen in 1939. With the material now being more accessible, these lacunae should be remedied. A checklist of the holdings in the Archives of the Monuments Historiques is being prepared by Hanna Losowska, under the direction of Françoise Bercé. My thanks to Caroline Bruzelius for this information.

70. A *maîtrise* on the lapidary collection at the basilica was recently

completed by Caroline de La Fournière, under the direction of Léon Pressouyre.

71. *Royal Abbey,* nos. 8A, B, C, and D. See note 9 here.

72. Saint-Denis, Musée municipal. *L'Église des Trois-Patrons à Saint-Denys en France: fouilles et découvertes* (Saint-Denis, 1906). The new excavations are discussed in Olivier Meyer et al., *Archéologie urbaine à Saint-Denis,* exhib. cat. (Maison des Jeunes et de la Culture de Saint-Denis, Saint-Denis, 1979), p. 9, figs. 3 and 4; Olivier Meyer et al., "Archéologie urbaine a Saint-Denis (Seine-Saint-Denis); Présentation d'une expérience en cours," *Archéologie médiévale* 10 (1980): 271–309; Olivier Meyer et al., "Les Fouilles urbaines de Saint-Denis," *Archéologie en Seine-Saint-Denis* (Saint-Denis, 1980), pp. 33–38; Olivier Meyer et al., *Rapport d'activité 1980,* excavation report, Saint-Denis-93, Fouilles urbaines (Saint-Denis, 1981), figs. 21–23, 32–34; Olivier Meyer and Caroline Relier, *1981; Bilan d'une année de recherches archéologiques à Saint-Denis,* excavation report (Saint-Denis, 1982), pp. 29–60, esp. 49–51; and Olivier Meyer and Michaël Wyss, *Recherches archéologiques urbaines, Rapport 1982,* excavation report (Saint-Denis, 1983).

73. See the study by Bony in this volume. Bony, *French Gothic,* identifies and discusses the Parisian milieu that led to the developmental "breakthrough" at Saint-Denis.

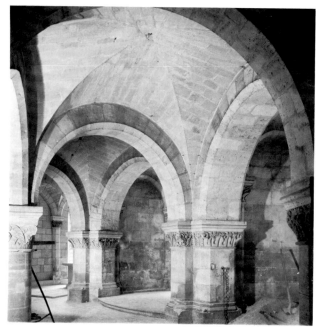

11

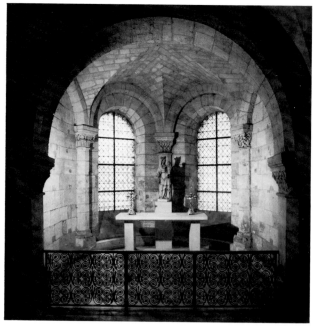

12

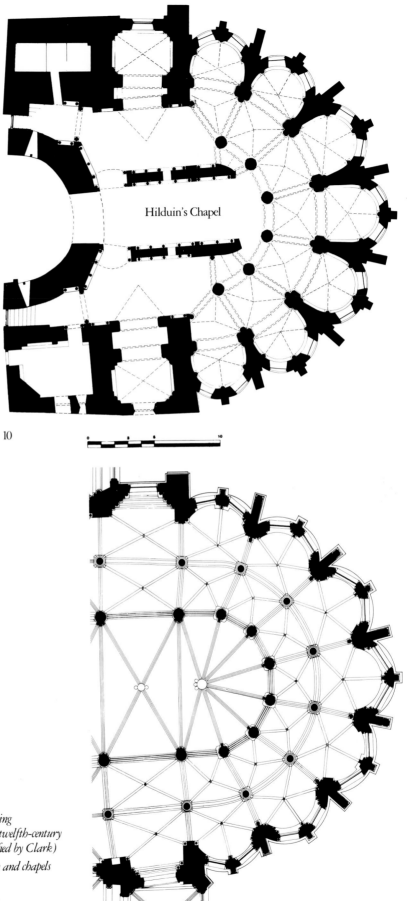

Hilduin's Chapel

10

Fig. 10. *Saint-Denis, restored plan of the crypt, showing*
eighth-century apse, Hilduin's Chapel, and twelfth-century
ambulatory and chapels, after Crosby (modified by Clark)

Fig. 11. *Saint-Denis, interior of the crypt ambulatory and chapels*

Fig. 12. *Saint-Denis, axial chapel of the crypt*

Fig. 13. *Saint-Denis, plan of the chevet, after Crosby*

13

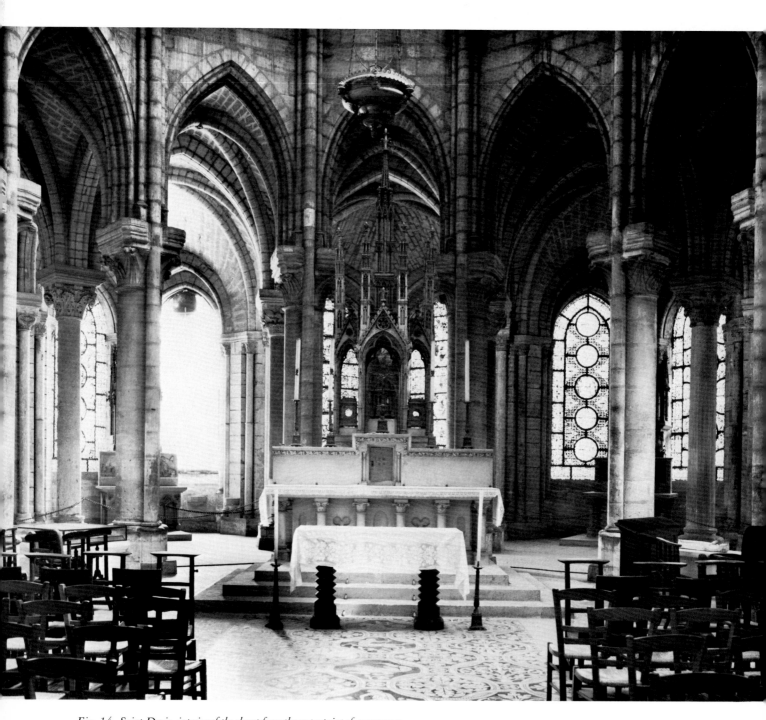

Fig. 14. Saint-Denis, interior of the chevet from the center point of convergence

Fig. 15. Saint-Denis, interior of the chevet ambulatory

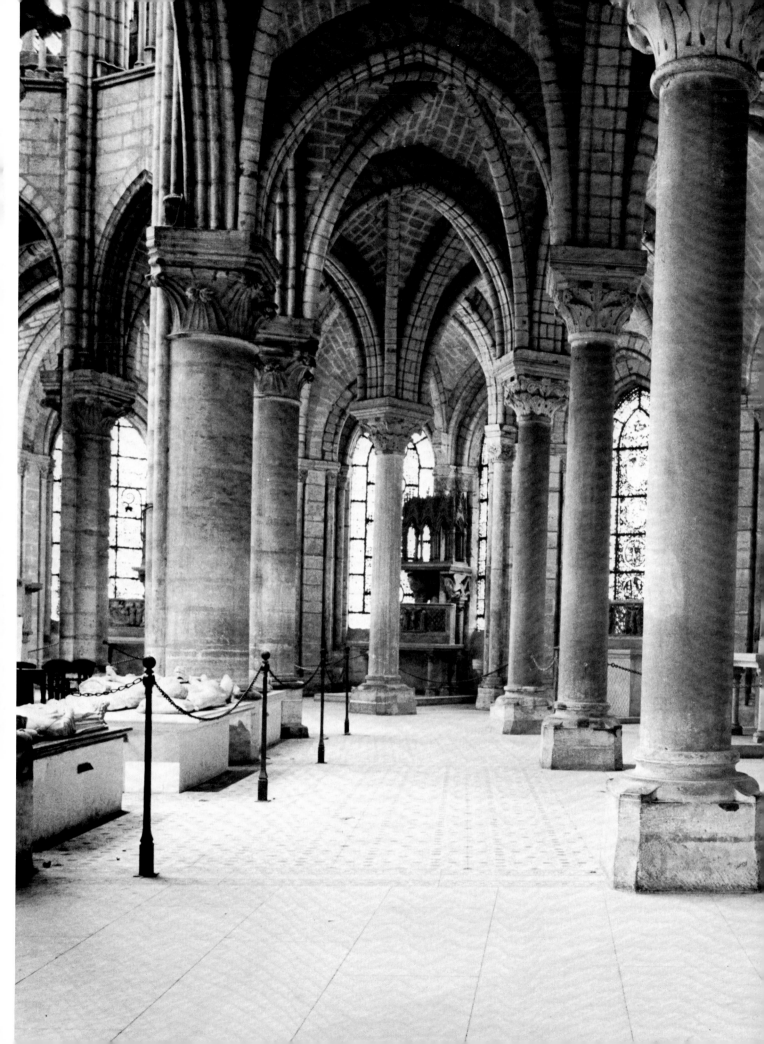

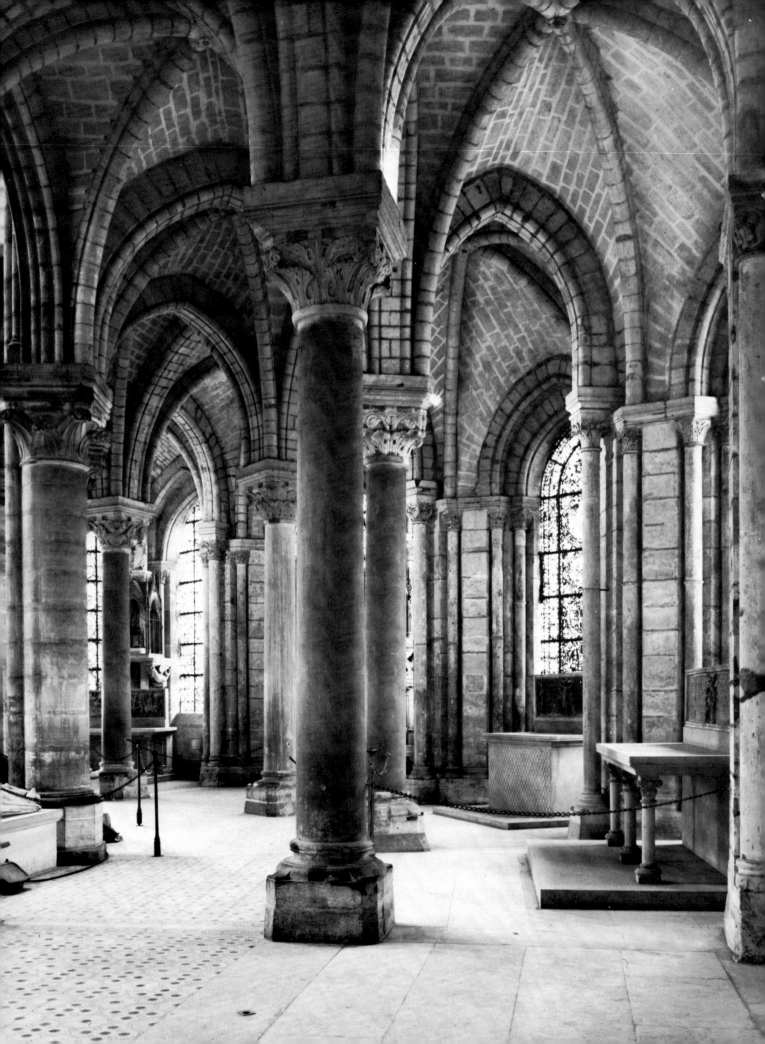

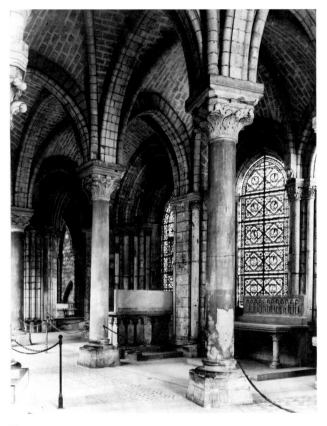

17

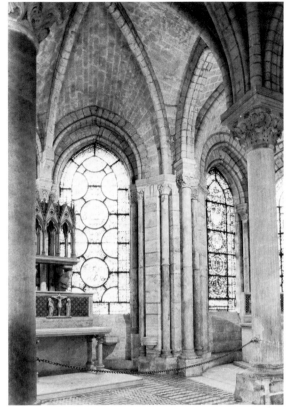

18

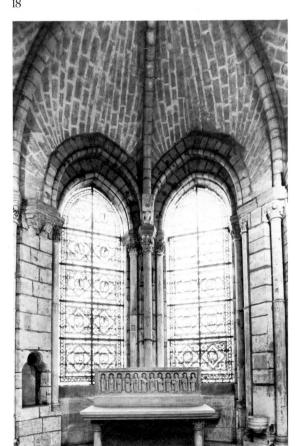

Fig. 16. Opposite: Saint-Denis, interior of the chevet chapels

Fig. 17. Saint-Denis, chevet ambulatory columns on north side

Fig. 18. Saint-Denis, pier at entrance to a radiating chapel

Fig. 19. Saint-Denis, chevet radiating chapel interior

19

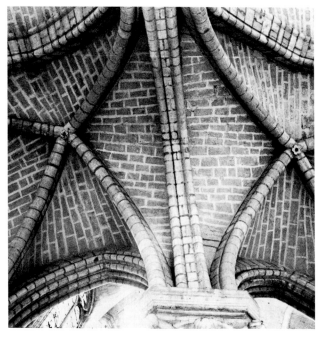

20a

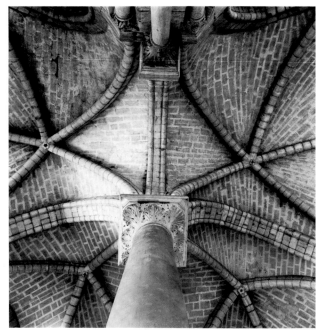

20b

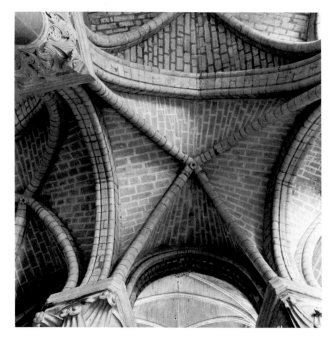

20c

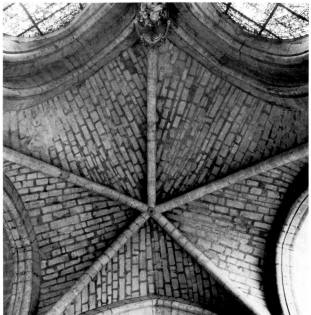

20d

Fig. 20. Saint-Denis, chevet vaults
 a. Ambulatory vaults
 b. Chapel vaults
 c. Ambulatory vault
 d. Chapel vault

What Possible Sources for the Chevet of Saint-Denis?

Jean Bony

IN VIEW of the very exceptional position it occupies in the history of medieval architecture, as a major and most unexpected leap forward, marking the break between Romanesque and Gothic, the chevet of Saint-Denis poses in unusual terms the problems of its background and origins. To look for the sources of a breakthrough, trying to evaluate what may have been determinant, is a chancy undertaking.[1]

The field to be scanned is so wide open that all kinds of potential sources have been put forward; but it is unfortunately all too easy to come up with somewhat artificial analogies and transform them into no less artificial forerunners. Let us take an example or two. The skeletal quality of the chevet of Saint-Denis has sometimes been compared with the system of perforations in the apse and transepts of Peterborough (fig. 1),[2] which also conforms to what can be described as a "logical" pattern. But can the two structures really be compared? At Peterborough the so-called articulations are so reduced in their projection that they are hardly more than painted on the surface of a massive wall structure. Only with the crosswise intersections of a thinned-out wall and sharply projecting transverse spurs, as in the east end of Saint-Denis (Clark figs. 3, 4, and 16), does that articulation become powerful enough to lead to a real skeletonization.

Another Anglo-Norman parallel could be suggested, this time in reference to the big windows of Saint-Denis. They could be compared with the aisle windows of the early twelfth-century choir of Canterbury Cathedral (fig. 2), that "glorious choir" of Conrad, dedicated in 1130, which are among the largest of the Romanesque period (and, in spite of Willis, they were not enlarged by William of Sens; their heightening took place in the course of construction, certainly no later than the 1120s). But Saint-Benoît-sur-Loire, too, has unusually large windows in its

ambulatory (fig. 3) to illuminate the east end; and Saint-Benoît was in many ways the rival Saint-Denis had to outdo.

So it would seem that the sampling of specific features is not a very safe method to follow, any more than is a search for actual prototypes. And it would be no less misleading to imagine that the Saint-Denis east end could be viewed in the same perspective as the west facade ensemble, for the Anglo-Norman and Ottonian connections, which can be claimed for the narthex, cease to apply as soon as one turns to the second stage in Suger's enlargement program, the east end and chevet.

To get started on a more realistic and down-to-earth approach, one should first take a good look at the overall arrangement of that east-end structure and at the major constructional ensembles that comprise it. Three essential characteristics emerge, for which one can then attempt to trace the most immediate sources.

In the first instance, the east end of Saint-Denis is a raised east end (fig. 4), or more exactly a split-level east end, for it is not really accurate to say simply that the chevet is raised above a crypt. Such a description could adequately apply to the great crypts of Romanesque England—St. Augustine's at Canterbury, Winchester Cathedral, Canterbury Cathedral in its twelfth-century state—in all of which the whole east arm of the church is raised, the break being at the eastern arch of the crossing.[3] But at Saint-Denis the elevated platform begins only well beyond the area of the crossing, farther east by one deep straight bay, which means that the sanctuary proper and the high altar remain on the same level as the nave and transept. The part of the building that is raised above the level of the vaults of Hilduin's old outer crypt (and of the additions that surround it) is not the choir or even the presbytery: it is the feretory alone, that is, the

Notes for this essay begin on page 140.

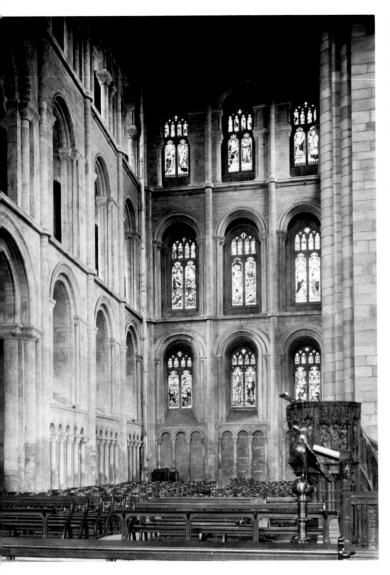

Fig. 1. *Peterborough Cathedral, interior of north transept*

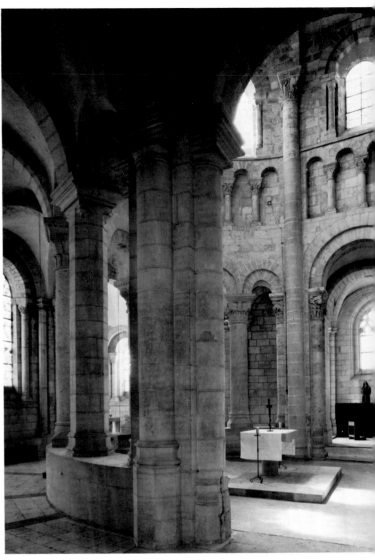

Fig. 3. *Saint-Benoît-sur-Loire, interior view of ambulatory*

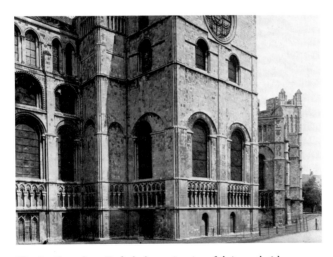

Fig. 2. *Canterbury Cathedral, exterior view of choir, south side*

area where the bodies of the patron saints and all the reliquaries were placed on show and glorified (an arrangement that was textually copied forty years later at Canterbury Cathedral [fig. 5], with the Pilgrims' Steps leading to the raised Trinity Chapel). Before Saint-Denis, only Saint-Benoît-sur-Loire—another place where a famous holy body was venerated—would seem to provide a source for this split-level arrangement of the east end (fig. 6), separating neatly sanctuary and feretory. There were, of course, many Romanesque chevet compositions with different levels for center and aisles (or ambulatory): Flavigny, for instance,[4] or, differently, S. Stefano in Verona.[5] But in these buildings the central space was all on one level; the functions of the various parts were not distributed in the same way as at Saint-Benoît or Saint-Denis.

The two other major characteristics that demand attention are

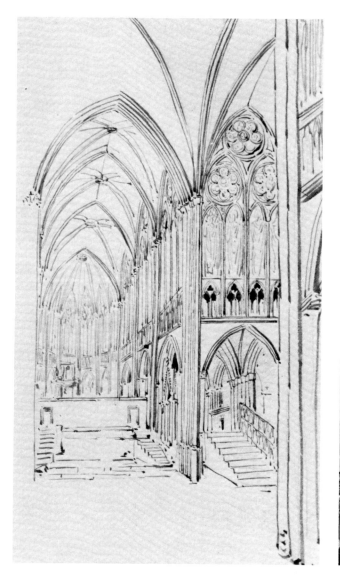

Fig. 4. Saint-Denis, drawing by Charles Percier showing change of level in the east end

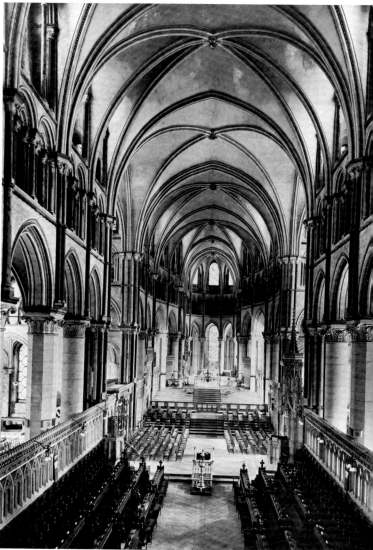

Fig. 5. Canterbury Cathedral, interior view of choir showing change of level

the very different types of structure adopted for the crypt level on the one hand and for the upper church, or ambulatory level, on the other.

The crypt is a solidly built, firmly partitioned structure (Clark fig. 11),[6] and the plan it follows, with its deep contiguous chapels, is not actually so very novel. It must be considered in the perspective of Norman innovations of the late eleventh century: the choir of Fécamp, built by William de Ros (abbot from 1082 to 1108) and dedicated in 1106; and the cathedral of Avranches, built under Bishop Turgis (1094–1133), begun in 1109 and dedicated in 1121.[7] Contrasting with the usual Romanesque ambulatory plans, which left a sufficient gap between the chapels for the piercing of a window to give direct lighting to the ambulatory, these two Norman churches initiated the trend toward a continuous sequence of chapels that was to lead not only

to Saint-Denis and its series but also to Dommartin and Thérouanne in the north and to Avénières in the west and continued in a reduced variant well into the second half of the twelfth century in the region around Paris (Senlis, Saint-Germer, Saint-Leu-d'Esserent).

The crypt of Saint-Denis (Clark fig. 10) has two notable particularities: (1) the number of its radiating chapels, seven instead of the usual five, all of them deep, especially the three axial ones; and (2) the presence of rectangular chapels along the straight bays, which enlarges considerably the surface size of the chevet. These two features, which are absolutely new, simply indicate that the layout of the crypt was commanded by the design of the floor above, the upper church level, for which it plainly acts as a substructure.

As for the upper level, the fusion of the whole chapel space

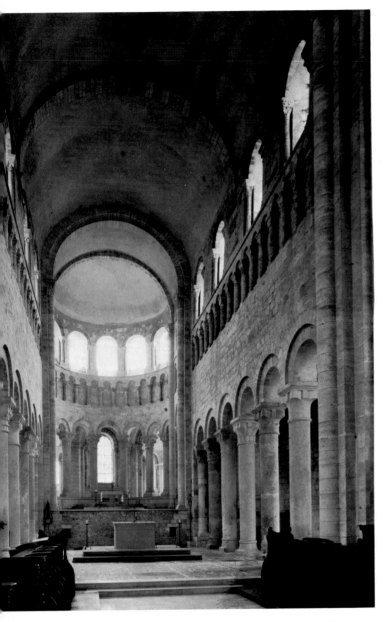

Fig. 6. *Saint-Benoît-sur-Loire, interior view showing levels of sanctuary and feretory*

(along the straight bays as well as around the hemicycle) into a second open ambulatory creates there that vast inner continuity that was the great innovation of Saint-Denis: the miraculous structure praised by Suger[8] and extolled again since the 1840s by most historians of Gothic architecture.[9] Its lightness of structure and its unencumbered spaciousness are the two striking features that have made modern historians place at this point the breakthrough to Gothic.

But it has long since been recognized that the double ambulatory plan itself had been initiated in Paris perhaps as many as ten years earlier in one of the most imaginative of Late Romanesque buildings, the choir of Saint-Martin-des-Champs (fig. 7).[10] A definite trend toward increased interior spaciousness is typical of the Late Romanesque period generally: from the 1120s and early 1130s it can be perceived in many regions, and one of the clear signs of that tendency was the widening of the interior space of east ends. At first this five-aisled enlargement took place in the straight bays only—at Fontgombault (fig. 8), for instance, or, somewhat later, at Saint-Laumer at Blois.[11] Then the decisive step was taken at Saint-Martin-des-Champs, soon after 1130, where that double aisle was extended all around the curve of the east end. The merging of the chapels into an outer ambulatory, and the scalloped shape given to the outer wall by reason of the multiplicity of the chapel spaces to be enclosed, undoubtedly provided the point of departure for the plan of Saint-Denis.

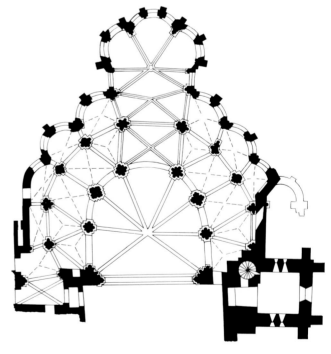

Fig. 7. *Paris, Saint-Martin-des-Champs, plan of chevet, after Deneux*

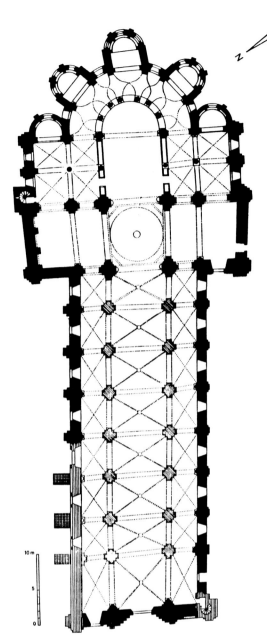

Fig. 8. Fontgombault, abbey church of Notre-Dame, plan

But it is essential to bear in mind that originally at Saint-Martin-des-Champs this enlarged peripheral area was not intended to be made use of in the same manner as at Saint-Denis.

The east end of Saint-Martin-des-Champs is notorious for the untidiness of its design: the circuit of walls along the periphery does not coincide in its divisions with the outer row of ambulatory supports, and that outer row coincides even less with the inner semicircle of piers that surrounds the central space. In addition, the big axial chapel, by pushing apart the north and south sectors of the chevet, introduces a further element of irregularity. With the present open hemicycle, the whole arrangement is very odd; but it becomes much less so as soon as one realizes that this ambulatory area had been conceived at first as a kind of desegregated outer crypt, a spacious, peripheral extension placed at a slightly lower level (one still goes down five steps) and built around the old apse of the eleventh-century church, which would have been made to communicate with it through a perforation of the old walls. A miniature (fig. 9), which seems accurate in its representation of the church as built in 1059–67,[12] shows a deep apse, with eleven bays of two superposed windows each, that would have corresponded exactly with the design of the outer zone of the chevet. Only when, a little later, in the 1140s, the old eleven-bay apse was pulled down and replaced by a seven-bay hemicycle did the odd readjustments of the vaulting compartments in the inner ambulatory have somehow to be contrived. Saint-Denis unified that spaciousness systematically by giving it a perfect regularity of divisions (Clark fig. 13).

This principle of regularity emerges as one of the major characteristics of the design of the Saint-Denis chevet; and this reminds us that the genesis of a new architectural movement is always an intellectual phenomenon—which brings us to introduce here sources of another order.

The chevet of Saint-Denis is the product of a new design technique. It manifests the rise of a new art of geometry. And, if we follow Guy Beaujouan's suggestions,[13] we must establish a close relationship between that advance in geometric sophistication and the recognition recently given by philosophers to what was then called "practical geometry" and covered, together with architecture, all the branches of engineering and of industrial technology. This enriched conceptual foundation led to the construction of new models in the mind, making possible more complex and better-integrated designs.

And this is also where the new ideologies of the time enter into play, dictating new aims to be expressed: symbolic, mystical, spiritual aims, such as the metaphysics of light, which was spreading at that moment as the direct result of the revival of Dionysian philosophy and theology.[14] Hugh of Saint-Victor, as much as Suger, appears as a key figure when we reconstruct that intellectual background. All this has to be counted—no one denies it—among the sources of Saint-Denis. Given the breadth

of this landscape, what really matters now is to discover how these diverse elements were made to interrelate and what set off the whole mechanism.

In fact, the point of contact between ideology and technology at Saint-Denis does not seem to be very difficult to identify: it was an interestingly renovated kind of "Antique Revival." The chevet of Saint-Denis marks a deliberate return to Roman-like colonnades (fig. 10), a return to the Corinthian column viewed as the only acceptable type of support; and Suger gives very much the impression that he was responsible for that critical programmatic decision. He wanted the new work to accord in every possible way with the old,[15] with that early Carolingian church he believed to have been Dagobert's church, therefore still Late Antique, and furthermore consecrated by Christ himself according to the legend—which added a new dimension to its antiquity. The measurements of the new work had to agree with those of the old basilica, and so had the forms. Suger had even thought of bringing marble columns from Rome,[16] from the Baths of Diocletian or of Caracalla; and there is no doubt that Early Christian

Rome stands in the background of the design of the 1140s.

With the double colonnades of the straight bays of the chevet (which were to have been extended later to the whole nave), the Saint-Denis of 1140 revived the type of five-aisled basilica of the Constantinian age, exemplified by Old Saint Peter's, the Lateran basilica, the basilica of the Holy Sepulchre in Jerusalem, the Church of the Nativity in Bethlehem, and the long series that followed[17] in Italy, in Greece, in Africa, even in Gaul (where there was at least one example, Saint-Étienne in Paris, built in the second quarter of the sixth century). And in the ambulatory area the two semicircles of columns, that curved double colonnade, also recalls, with significant alterations and on a much reduced scale, that largest of Early Christian rotundas, S. Stefano Rotondo,[18] dating from the second half of the fifth century (468–483). Double ambulatory rotundas are rare, but the church of S. Sofia at Benevento (fig. 11) could be adduced as an example of the revival of the type in the Lombard duchy of Benevento, under Duke Arichis, in the middle of the eighth century.[19]

Such details as the revival of the acanthus in capitals and

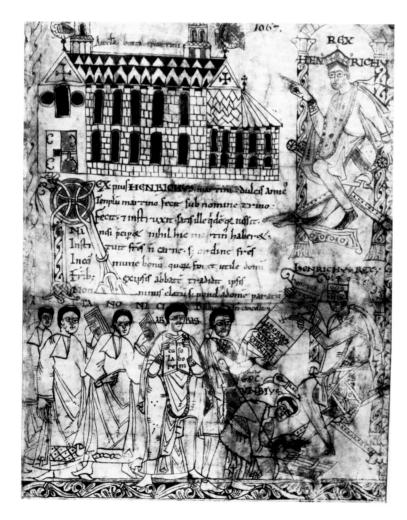

Fig. 9. *Left: Miniature depicting the Romanesque apse of Saint-Martin-des-Champs (London, British Library, MS. Add. 11662, fol. 4r)*

Fig. 10. *Saint-Denis, ambulatory columns*

Fig. 11. *Benevento, S. Sofia, plan*

Fig. 12. *Saint-Denis, acanthus capital*

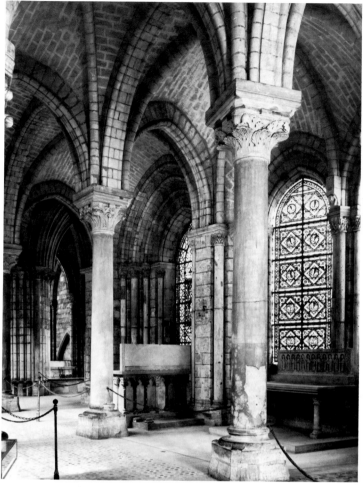

10

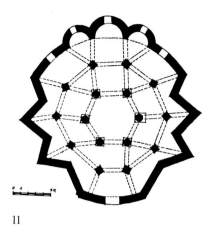

11

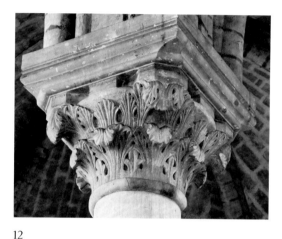

12

friezes—a distinctive revival, with a style of acanthus (fig. 12) quite different from that of Romanesque Burgundy, for instance—and the return to the *en délit* technique, for responds as well as for window jambs (another typical Roman feature, which had been preserved throughout the pre-Romanesque period as a sign of adherence to the constructional traditions of Rome) simply confirm the conscious revival of the Antique in Suger's east end. Saint-Denis is part of the renaissance of the twelfth century, and the exclusive use of the Corinthianesque column in the post-1140 work can be taken as representative of that neo-Antique trend.

But when we place these Roman-like columns in the constructional context of the time, when we see that they had to be integrated into the fabric of medieval vaulted structures at a moment when efforts were being made to enlarge the buildings and improve their stability, then we begin to realize what a paradox this revival of the column represented. And we begin to understand how the impact of that idea of return to an ideal past could disrupt (for better or worse) the accepted modes of constructional thinking.

Gothic architecture as it happened to arise and develop was an unpredictable phenomenon. But the sequence of its invention can be reconstructed. The initial step in that direction had been a first gamble: the hypothesis that the Anglo-Norman rib vault could be dissociated from the heavy Norman walling and adapted, by means of a number of technical adjustments, to the lightweight structures of the Ile-de-France. This could schematically be called the Beauvaisis stage, although Paris was as deeply involved in it as the Beauvaisis. It was then found that walls could remain thin if piers were given more depth, more power, and made to project more into the central space, in groups of three, then five, engaged columns and shafts. Saint-Pierre-de-Montmartre (fig. 13) in the 1140s is a good Parisian example of that first stage.[20]

Then came a second gamble, that of spatial enlargement, which tended to strain the system to the limit, as at Saint-Martin-des-Champs, from which the Saint-Denis chevet derived its concept of spaciousness. And now, on top of that, Saint-Denis added a third and apparently even more unreasonable gamble,

that of rejecting the just-adopted principle of well-anchored piers (in the Beauvaisis manner) and of substituting for them mere posts of stone that could in no way resist a lateral thrust. Of course, according to the hypothesis on which everyone in the most advanced circles in and around Paris was then working, this was pure absurdity. Such an idea could make sense only if a conceptual breakthrough had been achieved in structural engineering; and this is what we have to postulate.

Instead of focusing on the stability of each pier, as had been done until then, the Saint-Denis master of 1140 made the jump of visualizing the structure of the whole chevet as a single coherent unit that needed only to be firmly anchored on its periphery to be kept in a stable state, even on the thinnest of supports, the whole ensemble being held together through the tension of the mutually buttressing vaulting units of the ambulatory zone and of whatever could be added on the back of those vaults to reinforce them. The new hypothesis consisted of counting essentially on the stiffness of that zone of ambulatory vaulting to direct the buttressing out to the peripheral shell of walls and buttresses. But that mode of thinking implied, in addition, the use of some system of radial stiffening to transmit to that periphery also the thrusts of the great vaults that covered the central space. We know now that such a system existed: the lower courses of a series of radial walls (Clark fig. 7) connecting each of the hemicycle piers with the corresponding buttresses on the outside still exist above the ambulatory vaults.[21] What we do not know is what was originally there, above those lower courses. Were there full triangles of wall, spurs similar (on a smaller scale) to those used in the Baths of Diocletian or in the Basilica of Maxentius?[22] Such a system had recently been revived in northern Italy, and certainly Roman and Italian sources would not be unlikely in the Saint-Denis context—in which case the chevet of Saint-Denis would mark the beginning in France of the system of wall buttresses of the Laon-Arras type.

This radial organization, which can be read from the plan itself, has been noticed long since and its importance has been especially emphasized by Sumner Crosby in all his studies on the east end of Saint-Denis and its designing.[23] Some have claimed that Saint-Denis must therefore have had fully developed flying buttresses. But such a suggestion is difficult to take seriously: many other modes of radial linkage were possible, and we know that several were actually practiced at the time, whereas the flying buttress was not a form then in existence, its invention occurring only some thirty years later.[24]

Whatever the details of the reconstruction, it is quite obvious that the kind of Antique Revival that took place at Saint-Denis in the 1140s, namely the return to the monolithic column, was no mere matter of taste. Such a change in pier form had enormous constructional implications. It could not have been achieved without a conceptual revolution based on a new overall view of the play of forces in a complex vaulted structure and on hypotheses that altered radically the kind of engineering problems to be handled by architects. This is how a strong-minded patron, by demanding the impossible, can provoke sudden technical advances—since technical adventure leads, as a rule, to technological progress.

All these risks could be taken at Saint-Denis more easily than elsewhere because the Saint-Denis work was planned on a fairly small scale. This again was part of the concept of *cohaerentia* of the new work with the old basilica: the width of the central space remained the same as in the Carolingian nave, that is, not quite thirty-four feet—a long way from the fifty feet of Sens (fig. 14), which gave the scale for the later ambitions of Gothic builders. With its double ambulatory, the chevet of Saint-Denis covers less ground than the single-ambulatory east end of Sens: a total width of eighty-two feet versus ninety-four at Sens. On that small-scale model, experimentation was still possible. And this may be the reason the double ambulatory of Saint-Denis was not repeated for more than twenty years, for enlarging its scale was a major challenge and required time.

To come back more rigorously to the problem of sources, one last line of questioning should at least be sketched: is there no way of detecting something definite about the origins of that "Saint-Denis master?" Are there not some elements of "signature" that could give us clues? At ambulatory level, what we find most generally is the revival of Antique forms, and perhaps in that respect the kind of acanthus foliage might provide significant indications. Analogies with northern Italian forms have been suggested,[25] and this line of inquiry should certainly be pursued. But it might be more profitable to examine the crypt level, which presents very specific features: not only the formerets and the groin vaults of coursed ashlar, but also the chamfered profiles and, even more remarkable, those wonderful unarticulated semi-octagonal responds, repeated everywhere. Octagonal columns are an early architectural form, Carolingian (witness the crypt of Saint-Germain at Auxerre, fig. 15) and post-Carolingian. It would seem to be a somewhat refined variant of the square pier and of the square pilaster. There are some octagonal columns at Hildesheim, in the transept galleries; and square columns in the crypt of Huy, in Mosan Belgium. More examples occur in the north of France and Burgundy, the best being at Reims, at Saint-Remi (in this case a true octagonal respond, fig. 16). There are also octagonal piers at Baume-les-Messieurs, at the Basse-Oeuvre of Beauvais; octagonal columns at Ronse and Nivelles in Belgium, at Nesle in Picardy; and columnlike quasi-octagonal piers in the crypts at Ivrea Cathedral and at Saint-Avit of Orléans.[26] But this is a most incomplete and imprecise listing.[27] An intensive search would be required, and the article recently published on Saint-Arnoul at Crépy-en-Valois[28] shows at the same time the interest inherent in the works that remain

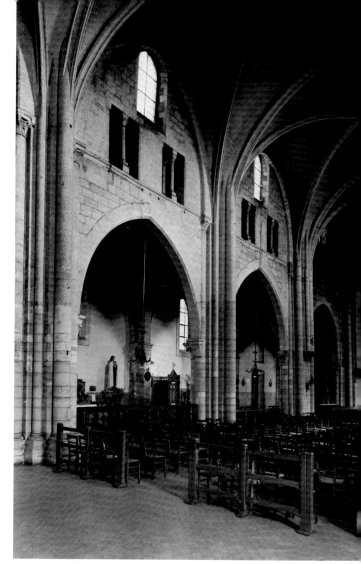

Fig. 13. Right: Paris, Saint-Pierre-de-Montmartre, nave

Fig. 14. Below: Saint-Denis and Sens, comparative plans at the same scale

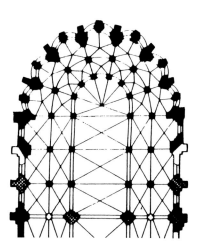

Saint-Denis, east end

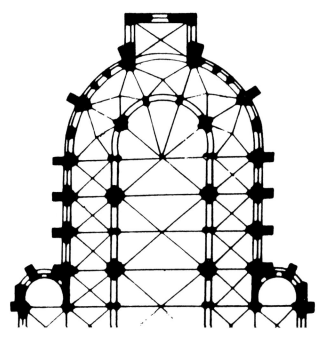

Sens, east end

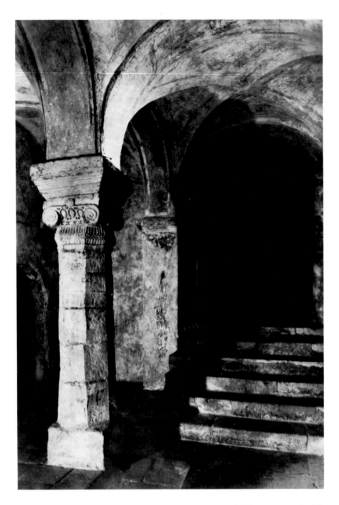

Fig. 15. Auxerre, Saint-Germain, crypt, octagonal column on south side

Fig. 16. Reims, Saint-Remi, south aisle of nave, octagonal engaged column at the west

to be discovered and the scope of the problems they are likely to raise.

In the meantime what could be said about that Saint-Denis master of the 1140s? An Ile-de-France or northern Burgundian, somewhat archaistic background; a close study of Roman models of all kinds; a taste for the reduction of supports to thin compact forms; a superior training in the most modern methods of geometric designing as well as of constructional thinking; and a subtle understanding of all the elements of meaning architecture can

convey; plus Suger's exacting demands to force him into imagining the hardly imaginable in terms of lightness and light. This is the kind of provisional model one could suggest for that remarkable and surprising artistic personality. Such a model would seem to make sense when placed in the context of a rich, multilayered historical conjuncture and at a moment of extreme technical and stylistic fluidity, in the full burst of a new start, before things began to coalesce and stabilize.

NOTES

1. On this theme, refer to Henri Focillon, "Généalogie de l'unique (Fragment)," *Actes du 2ᵉ Congrès international d'esthétique et de science de l'art,* 2 vols. (Paris, 1937), vol. 1, pp. 120–27.

2. See for instance Pierre Héliot, "Du Carolingien au gothique.

L'évolution de la plastique murale dans l'architecture religieuse du nord-ouest de l'Europe (IXᵉ–XIIIᵉ siècle)," *Mémoires présentés par divers savants à l'Académie des inscriptions et belles lettres* 15, no. 2 (1967): 69.

3. The first example was St. Augustine's at Canterbury, begun in 1072 or 1073; next came (ca. 1077) Evesham Abbey, still mysterious in many ways; Winchester Cathedral, begun in 1079;

then, in the last years of the eleventh century, the new choir of Canterbury Cathedral, begun by Prior Ernulf (soon after 1096) and completed thirty years later by Prior Conrad. In other buildings, such as Worcester Cathedral, Bury St. Edmunds, or Gloucester Abbey (now Cathedral), the crypt does not raise significantly the level of the choir. See Alfred W. Clapham, *English Romanesque Architecture After the Conquest* (Oxford, 1934), pp. 64–67; and on Bury St. Edmunds, Roy Gilyard-Beer, "The Eastern Arm of the Abbey Church at Bury St. Edmunds," *Proceedings of the Suffolk Institute of Archaeology* 31, no. 3 (1969): 256–62.

4. On Flavigny, see René Louis and Jean Marilier, "Les Cryptes carolingiennes de l'abbaye de Saint-Pierre de Flavigny-sur-Ozerain, de 1957 à 1959," *Revue archéologique de l'Est et du Centre-Est* 10 (1959): 253–62; Georges Jouven, "Fouilles des cryptes de l'abbatiale Saint-Pierre de Flavigny," *Les monuments historiques de la France* 1 (1960): 9–28; Élie Lambert, "L'Ancienne abbaye bourguignonne de Flavigny et le chevet de son église," *Les monuments historiques de la France* 1 (1960): 1–8; Jacques Reynaud, *Flavigny-sur-Ozerain* (Paris, 1960); Christian Sapin, "L'Abbaye Saint-Pierre de Flavigny à l'époque carolingienne," in Carol Heitz and François Héber-Suffrin, eds., *Du VIIIᵉ au XIᵉ siècle: Édifices monastiques et culte en Lorraine et en Bourgogne,* Université de Paris X-Nanterre, Centre de recherches sur l'antiquité tardive et le haut moyen-âge, cahier 2 (1977): 47–62; and Carol Heitz, *L'Architecture religieuse carolingienne. Les formes et leurs fonctions* (Paris, 1980), pp. 173–77.

5. On S. Stefano at Verona, see Paolo Verzone, *L'Architettura religiosa dell'alto medio evo nell'Italia settentrionale* (Milan, 1942), pp. 137–45, 167.

6. For an analysis of the design and construction of the crypt, see in this volume, William W. Clark, "Suger's Church at Saint-Denis: The State of Research," pp. 105–30 and plan (Clark fig. 10).

7. On Fécamp, see Jean Vallery-Radot, *L'Église de la Trinité de Fécamp* (Paris, 1928). On Avranches, see Paul Coutan, "La Cathédrale d'Avranches," *Académie des sciences, belles lettres et arts de Rouen, Précis analytique des travaux,* 1900–1901 (Rouen, 1902), pp. 196–210. At Fécamp, part of the chevet built under Guillaume de Ros has survived; on the other hand, the cathedral of Avranches was totally destroyed in the Revolutionary period.

8. *Suger Adm.* (P), pp. 48–51; *Cons.* (P), pp. 100–101; and Panofsky's comments on pp. 166–67.

9. The historical importance of the choir of Saint-Denis had been perceived as early as 1809 by George D. Whittington, but his remarks passed unnoticed. Franz Mertens seems to have made the same discovery on his own in 1841 and his ideas began to spread in French and German circles by the mid-1840s. See Paul Frankl, *The Gothic: Literary Sources and Interpretations Through Eight Centuries* (Princeton, 1960), esp. pp. 499, 525, 531–34, 563–65, 685, 781.

10. See Eugène Lefèvre-Pontalis, "Étude sur le choeur de l'église de Saint-Martin-des-Champs à Paris," *Bibliothèque de l'École des Chartes* 49 (1886): 345–56; Eugène Lefèvre-Pontalis, "L'Église de Saint-Martin-des-Champs à Paris," *Congrès archéologique de France (Paris)* 82 (1919): 106–26; and Jean Ache, "Le Prieuré royal de Saint-Martin-des-Champs, ses rapports avec

l'Angleterre et les débuts de l'architecture gothique," *Centre international d'études romanes, Bulletin trimestriel* 1 (1963): 5–15. The connections with England should not be overstated: the Loire countries, Northern Burgundy, Notre-Dame at Étampes, and the old Parisian milieu of the 1120s were more directly involved.

11. Begun in 1138, the east end of Saint-Laumer of Blois was built very slowly and dates mostly from ca. 1160–90, but the plan must go back to the late 1130s. The design was no doubt influenced by Fontgombault, begun before 1130, and by some Burgundian buildings such as Paray-le-Monial. See Frédéric Lesueur, "L'Église abbatiale Saint-Lomer de Blois," *Bulletin monumental* 82 (1923): 36–65.

12. This miniature, which represents the dedication of Saint-Martin-des-Champs, can be dated in the 1070s. It is found in London, British Library, MS. Add. 11662 on fol. 4r. See Jean Porcher, *Medieval French Miniatures* (New York, n.d.), pp. 12, 13 and fig. 6.

13. Guy Beaujouan, *L'Interdépendance entre la science scholastique et les techniques utilitaires (XIIᵉ, XIIIᵉ et XIVᵉ siècles),* Université de Paris, Conférences du Palais de la Découverte, ser. D, 46 (Paris, 1957).

14. See Gabriel Théry, O. P., *Études dionysiennes,* 2 vols. (Paris, 1932–37); Maurice de Gandillac, *Oeuvres complètes du Pseudo-Denys l'Aréopagite* (Paris, 1943); Panofsky, *Suger,* pp. 18–24; and Otto von Simson, *The Gothic Cathedral: The Origins of Gothic Architecture and the Medieval Concept of Order* (London, 1956), esp. pp. 103–7, 120–22.

15. The idea of *cohaerentia* with the old work is expressed three times by Suger; see *Adm.* (P), pp. 52–53, and *Cons.* (P) pp. 90–91 and 100–101.

16. Suger, *Cons.* (P), pp. 90–91, and Panofsky's comments, *Suger,* p. 213.

17. Between the late fourth and the early seventh centuries these examples can be listed: in Italy, Milan (S. Tecla), Rome (S. Paolo fuori le mura), Naples (S. Restituta), Ravenna (the cathedral), Capua Vetere (S. Maria), and Pavia (the cathedral); in Greece, Epidauros (the basilica), Saloniki (Hagios Demetrios), and Nikopolis (Basilica B); in Africa, Orléansville (of Constantinian date), Carthage (four basilicas: Damous el Karita, St. Cyprian, the Basilica Majorum at Mçidfa, and Dermesch), Feriana (two basilicas), Djemila, Tipasa, and Enchir Harrat (or Segermes).

18. See Richard Krautheimer, "Santo Stefano Rotondo a Roma e la chiesa del Santo Sepolcro a Gerusalemme," *Rivista di Archeologia Cristiana* 12 (1935): 51–102; and Richard Krautheimer, *Early Christian and Byzantine Architecture,* Pelican History of Art (Harmondsworth and Baltimore, 1965), pp. 65, 324 n. 48.

19. See Paolo Verzone, *From Theodore to Charlemagne: A History of the Dark Ages in the West,* Art of the World (London, 1968), vol. 27, pp. 193–97. S. Sofia in Benevento was currently presented as an imitation of Hagia Sophia. Suger states in his writings his intention of making his new church rival the splendor of Hagia Sophia. I am grateful to Charles McClendon for pointing out to me the analogy of intention—as well as of form—between the two structures. Since Suger passed through Benevento on at

least one of his trips to Italy, there may be more than a mere coincidence here.

20. See: François Deshoulières, "L'Église Saint-Pierre-de-Montmartre," *Bulletin monumental* 77 (1913): 5–30; Maurice Dumolin, "Notes sur l'abbaye de Montmartre," *Bulletin de la Société de l'histoire de Paris et de l'Ile-de-France* 58 (1931): 145–238, 244–325; Amédée Boinet, *Les Églises parisiennes,* 2 vols. (Paris, 1958), vol. 1, pp. 76–89; and Denise Fossard, "Montmartre. L'église Saint-Pierre," in "Les Églises suburbaines de Paris du IVᵉ au Xᵉ siècle," *Paris et Ile-de-France* 11 (1960): 217–21.

21. The existence of these remains of radial walls was recognized in the course of a collective reexamination of Saint-Denis initiated by the organizers of this symposium. I understand that Stephen Gardner is planning to write an article on that matter.

22. A good Lombard example of such triangles of wall, in the church of Ognisanti at Novara, is illustrated in Maria Laura Gavazzoli Tomea, ed., *Novara e la sua terra nei secoli XI e XII* (Novara, 1980), p. 49. The heavy transverse arches in the ambulatory vaults of Saint-Martin at Étampes suggest that the same method of abutment had originally been used in that church.

23. Sumner McK. Crosby, "Abbot Suger's Saint-Denis. The New Gothic," *Studies in Western Art, Acts of the Twentieth International Congress in the History of Art, New York, 1961* (Princeton, 1963), vol. 1, p. 89; and Sumner McK. Crosby, "Crypt and Choir Plans at Saint-Denis," *Gesta* 5 (1966): 5.

24. Quadrant arches hidden under the roofs of the aisles or tribunes (as opposed to buttressing walls or spurs) seem to have been used quite frequently in the late 1150s and early 1160s, as at Saint-Germer, possibly also in the church of Saint-Évremond at Creil before its destruction and, in all probability, in the nave of Cambrai Cathedral and in the choir of Notre-Dame in Paris.

Before the restorations, which have disfigured it, the choir of Domont near Montmorency showed an early case of emergence of these arches just above the level of the ambulatory roofs. The Paris region presents, in the 1180s, a number of flying buttresses of early types, some added after completion (chevet of Saint-Germain-des-Prés), some in the course of construction (east end of Saint-Leu-d'Esserent), and some planned from the start (east end of Gonesse, nave of Champeaux). The first structure built from the ground with a system of frankly rising exterior flying buttresses seems to have been the nave of Notre-Dame, begun ca. 1175. See William W. Clark and Robert Mark, "The First Flying Buttresses: A New Reconstruction of the Nave of Notre-Dame de Paris," *Art Bulletin* 66 (1984): 47–65.

25. See Christine Verzar Bornstein, "The Capitals of the Porch of Sant'Eufemia in Piacenza: Interacting Schools of Romanesque in Northern Italy," *Gesta* 13, no. 1 (1974): 15–26.

26. On the crypt of Saint-Avit at Orléans (now within the Lycée Jeanne d'Arc), see Jules Banchereau, "Orléans. Saint-Avit," *Congrès archéologique de France (Orléans)* 93 (1930): esp. the fig. on p. 74.

27. Strongly projecting responds of square section (as distinct from the more current shallow rectangular pilasters) were used in late antique and early medieval buildings, for instance in the "crypts" of Saint-Paul's church at Jouarre (west wall, late eighth century). To the list of octagonal piers should be added Saint-Liesne at Melun, of the late tenth century, and the chevet of Peterborough Cathedral, begun in 1118.

28. Éliane Vergnolle, "Saint-Arnoul de Crépy, prieuré clunisien du Valois," *Bulletin monumental* 141 (1983): 233–72. If the diagonal plantation of some of its responds can be trusted, that crypt could not be dated earlier than ca. 1130, which would make it a direct antecedent for the crypt of Saint-Denis.

Saint-Denis in about 1780, etching by Martinet (Paris, Bibliothèque Nationale, Cabinet des Estampes)

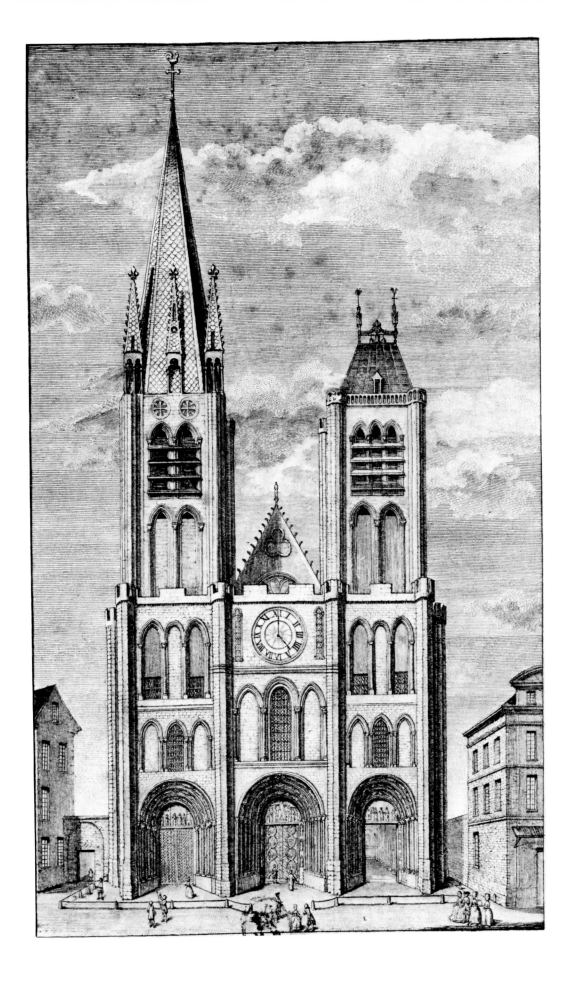

IV.
LIBRARY AND
LITERATURE

Suger's Literary Style and Vision

Robert W. Hanning

THIS ESSAY does not propose to undertake a systematic analysis of Suger's style or of the contents of his writings from a literary critical point of view. Instead, it will concentrate on a few passages chosen almost at random from the *Liber de rebus in administratione sua gestis* and on one excerpt from the *Libellus alter de consecratione ecclesiae sancti dionysii.*[1] Its aim is to try to discover what the events Suger chose to record and his method of recording them (his rhetorical strategies, syntax, juxtaposition of sentences) tell us about his sense of himself and of the goal of his activities. In the process of our examination, we will inevitably learn something about his personality, his hopes, and his fears.

Although we tend, and rightly so, to think of Suger as an innovator because of his intimate involvement in the beginnings of Gothic architecture, his prose—at least in those works dealing with his efforts to reconstruct and decorate his abbey church—seems remarkably resistant to analogous innovations in twelfth-century French intellectual, educational, and literary expression. It lacks the stylistic characteristics—division and subdivision of large topics, clear separation and articulation of all parts of a complex rhetorical unit—that distinguish the prose of contemporaries such as Peter Abelard and Hugh of Saint-Victor. Their style reflects a new way of thinking systematically about ideas and problems—indeed, a new fascination with, and faith in, rationality.[2] If, following Erwin Panofsky's lead, we see a close cultural parallel between the systematic thought of scholasticism and the clearly articulated, rational solutions to problems of construction and design that mark the emergence and progress of the Gothic style of architecture at the same time in the same area,[3] then the contrast between Suger the patron-organizer and Suger the writer becomes all the more remarkable.

Suger's new abbey church of Saint-Denis, into which he poured his organizing and executive skills, is a landmark of the emergent Gothic; by contrast, his prose in the works here under discussion conforms to very different expressive and aesthetic norms. To be specific, we shall see that what holds the narrative of the *De administratione* together is not an intellectual construct, such as Suger's adaptation of pseudo-Dionysian light metaphysics or anagogical thought,[4] but rather an impulse to gather together in one record the entire spectrum of his interests and accomplishments. This "collector's impulse"—which Suger manifests as much in his treatment of objects as in his treatment of words—reminds us, insofar as it organizes his writings, of the concept of "collective unity," defined by Saint Bernard of Clairvaux (in the fifth book of *De consideratione*) as "when, for example, many stones make one pile."[5] To Bernard, this type of unity is the most rudimentary, the furthest from the sublime unity of the Trinity. As we look more closely at our two chosen texts, however, we will discover complexities of intention and character underlying the apparently simple strategies of Suger's literary style.

We may start by noting that the narrative of the *De administratione* repeatedly reveals Suger's desire to convert time into space, or, if I may so put it, to annihilate time and its effects by reconceiving temporal relationships in terms of artifacts precisely located with respect to each other within the abbey church of Saint-Denis. This unusual program, and the attitudes upon which it is based, point to an equally unusual psyche, one Panofsky felt to be "projected into the world that surrounds him until his own self had been absorbed by his environment."[6] My own, admittedly tentative reading differs respectfully from Panofsky's; I see Suger engaged in a lifelong attempt not to diffuse or disperse himself but to objectify his perceptions and desires by

Notes for this essay begin on page 149.

consciously manipulating the uniquely significant physical environment of which he found himself the custodian as abbot of Saint-Denis.

Let us begin by looking closely at Chapter 32 of the *De administratione*, which concerns the Great Cross that Suger ordered to be made for Saint-Denis.[7] The chapter opens with a long, involved sentence of which the core and raison d'être are Suger's desire to decorate this artifact as richly as its significance deserves:

> *Adorandam vivificam crucem, aeternae victoriae Salvatoris nostri vexillum salutiferum, de quo dicit Apostolus:* Mihi autem absit gloriari nisi in cruce Domini mei Jesu Christi, *quanto gloriosum non tantum hominibus quantum etiam ipsis* angelis filii hominis signum apparens *in extremis* in caelo, *tanto gloriosius ornatum iri tota mentis devotione si possemus inniteremur, jugiter eam cum apostolo Andrea salutantes:* Salve crux, quae in corpore Christi dedicata es, *et* ex membris ejus tanquam margaritis ornata.[8]

The sentence is structured around the three quotations (from Galatians, Matthew, and the Acts of Saint Andrew, respectively) that occupy its center of gravity, thrusting the abbot and his plans for a specific, exemplary cross into a position subordinate to the testimony of the Bible and the saints concerning the original and real cross. Suger's intended decoration of his Great Cross implicitly prefigures the splendid, ultimate manifestation of the glorified cross to men and angels at the end of the world. By extension, the church in which Suger's cross would give forth its bejeweled glory prefigures the heavenly city of the Eschaton. Not only the cross but the entire church, in other words, take on both commemorative and eschatological significance; a major portion of salvation history is, as it were, detemporalized and compressed into a single artifact and its spatial setting.

The next sentence punctures both the hope and the visionary expansiveness established by the content and style, respectively, of its predecessor:

> *Verum quia sicut voluimus non potuimus, quam melius potuimus voluimus, et perficere Deo donante elaboravimus.*[9]

The crisp, condensed chiasmus (*voluimus non potuimus . . . potuimus voluimus*) contrasts sharply with the complexity and amplitude of the first sentence of Chapter 32; we are brought very much down to earth as the vision gives way to Suger's practical problems of carrying out a decorative project with limited resources. But the third sentence reverses the process, beginning with the earthbound activities of collecting gems and assembling craftsmen through whose efforts we see the cross taking shape, as if before our very eyes:

> *Hinc est quod preciosarum margaritarum gemmarumque copiam circumquaque per nos et per nuncios nostros quaeritantes, quam preciosiorem in auro et gemmis tanto ornatui materiam invenire potuimus praeparando, artifices peritiores de diversis partibus convocavimus, qui et diligenter et morose fabricando crucem venerabilem ipsarum ammiratione gemmarum retro attollerent, et ante, videlicet in conspectu sacrificantis sacerdotis, adorandam Domini Salvatoris imaginem in recordatione passionis ejus tanquam et adhuc patientem in cruce ostentarent.*[10]

We then proceed from the gem-encrusted back face of the crucifix to the pathetic image of the crucified Christ, which does not just commemorate or illustrate the Savior's past suffering but seems to make it present — *tanquam et adhuc patientem.*

The brief sentence following this one seems to change the subject, mentioning that the body of Saint Denis had rested on this spot — under the altar for which the cross was made — since the time of King Dagobert, supposed founding donor of the Church of Saint-Denis.[11] Without further transition, Suger swings with a will into the story — or *jocosum, sed nobile miraculum,* as he calls it — of how his need for more gems was unexpectedly supplied by the arrival in his *camerula* one morning of Cistercians and other reformed monks, no friends of Suger's schemes, who offered him a large supply. To crown the jest, Suger pays much less for them than they are worth, ending the interlude on a note of mercantile glee more appropriate to a fabliau than to an account that has, only a moment before, evoked Christ's passion.[12] Even within the digression (if such it be) there is a further digression, when Suger tells us the history of the gems, as they passed from King Henry of England to King Stephen, Count Theobald, the monks, whence to him and finally to the Great Cross.

Suger then describes the completed work of art and its ornamentation, with figures of the Four Evangelists and scenes from the life of Christ paired with typologically apposite Old Testament scenes. The chapter ends with an account of the pope's consecration of the Great Cross and the anathema he pronounced against any would-be thieves or vandals — an anathema Suger caused to be inscribed on the artifact itself.

Suger's Great Cross serves in this chapter as an admirable instance, to be sure, of his passion for decorating his church to the full extent of his resources, and of that mixture of shrewdness and good luck that so favored his enterprise. But the Great Cross also functions as a focus for Suger's lively and varied interests, which can all be shown to be rooted in a complex sense of history and are operating at various levels in the collection of facts and insights that makes up the chapter. There is, first of all, the history of salvation, from Passion to Last Judgment; then the history of the abbey, from Saint Denis to Dagobert to the present; and, in a broader sense, there is history as that process of change and exchange exemplified in the passage of the gems from one hand

to another down through the years:

Qui autem eas [the gems] *habebant, a comite Theobaldo sub elee-*
mosyna obtinuerant, qui a thesauris avunculi sui regis Henrici de-
functi, quas in mirabilibus cuppis toto tempore vitae suae
congesserat, per manum Stephani fratris sui regis anglici receperat.[13]

Finally, the Great Cross as part of Suger's own history—a project
to which he commits himself with all his energy and enthusi-
asm—provides a medium through which we can observe his
worries about resources and his prosecution, in the unlikely
sphere of commercial transaction, of his ongoing rivalry with
those monastic orders whose aesthetic outlook ran so counter to
his own.

The prose of this chapter seems to reproduce the complex, un-
systematic interaction of these concerns and perspectives within
Suger's mind. Lacking is any sense of a scheme or hierarchy of
categories and subjects intellectually imposed on the raw mate-
rial of experience and sensation prior to the act of writing, a
scheme that would give to Suger's prose the unity of a Gothic
facade or of the argument developed step by careful step in a trea-
tise by a twelfth-century scholastic or Cistercian. Instead, the
twists and turns, the alternating crispness and complexity of the
sentences, seem to reflect the thoughts crowding into Suger's
memory even as the monks from rival orders crowded unexpect-
edly into his *camerula* that fateful morning, bearing a bewilder-
ing array of precious stones:

. . . ecce duorum ordinum trium abbatiarum, videlicet Cistellensis et
alterius abbatiae ejusdem ordinis et Fontis Ebraldi, camerulam nos-
tram ecclesiae inhaerentem intrantes, gemmarum copiam, videlicet
jacinctorum, saphirorum, rubetorum, smaragdinum, topaziorum,
quantam per decennium invenire minime sperabamus, emendam
nobis obtulerunt.[14]

It is, of course, impossible to judge the extent to which Su-
ger's artlessness is a pose. In the chapter's first sentence there is
something suggestive about the way Suger's desire to decorate
his cross as richly as he can is buried in the middle of the scrip-
tural quotations that, in effect, decorate the True Cross. The
quotations and the sentence provide a model and a frame for Su-
ger's own proposed activity. The sentence could be said to repro-
duce in words the effect of an image of a tiny donor crouching at
the foot of a great cross.[15] The description of the two faces of the
cross, as I have suggested, brings the Crucifixion forward in time
to Suger's moment, while the immediately subsequent, appar-
ently intrusive mention of Saint Denis serves further to associate
in one place Christ and Saint Denis, as if the centrality of one in
Suger's life automatically evokes the centrality of the other. The
Latin closely juxtaposes *in cruce* at the end of one sentence (de-

scribing Christ) and *eodem loco* (describing Saint Denis's resting
place) at the beginning of the next. Within this second sentence
occurs the further juxtaposition of the *tempora* of Dagobert and
nostra (that is, Suger's own) *tempora*. The two sentences together
form a microcosm of Suger's universe, organized around the key
moments of Calvary, Saint Denis's martyrdom, Dagobert's
founding of the abbey, and Suger's own stewardship, precipitated
out of the temporal flow of history and united in the crucible of
his imagination, in the spatial frame of his church with its focal
points of altar and Great Cross, and in the collective medium of
his prose. We can discover in a passage like Chapter 32 a guiding
principle for Suger's labors: the re-creation of foci in artifacts,
language, and (as we shall see) occasions where temporal distinc-
tions can be overcome in an environment dominated, manipu-
lated, and controlled by himself.

Suger repeatedly singles out and explicates the foci of his at-
tention in his writings about Saint-Denis and its precious arti-
facts. In so doing he allows us to perceive his deep ambivalence
about time: a fascination with history that is nevertheless shot
through with a deep awareness of time's ability to ruin all it
touches in passing. In Chapter 33A, for example, after describ-
ing his refurbishing of the Matutinal Altar, he tells us of another
cross he erected between this altar and the tomb of Charles
the Bald:

Crucem etiam mirabilem quantitatis suae, quae superposita est inter
altare et tumulum ejusdem Karoli, in cujus medio fama retinuit con-
fixum nobilissimum monile Nantildis reginae, uxoris Dagoberti re-
gis ecclesiae fundatoris, aliud vero in frontem sancti Dionysii (tamen
huic minori nullum aequipollere peritissimi artifices testantur), erigi
fecimus, maxime ob reverentiam sanctissimae boiae ferreae, quae, in
carcere Glaucini sacratissimo collo beati Dionysii innexa, cultum et
venerationem tam a nobis quam ab omnibus promeruit.[16]

In a sentence so complex and tortuous that Panofsky can only
translate it by the addition (in brackets) of two clarifying verbs,
Suger tells us that fastened to this cross is a necklace reputed to
have belonged to Queen Nanthilda, wife of King Dagobert. He
has added a smaller but extremely fine necklace to the forehead of
the bust reliquary containing the head of Saint Denis, in honor
of the iron collar worn by the saint in prison. All of this material,
jammed into the sentence until it seems ready to burst, reflects
the connection in Suger's mind between (once again) the cross
and Saint Denis, Saint Denis and Dagobert—a connection ren-
dered concrete by the two necklaces, which in turn seem to rep-
resent (in suitably heightened form) the martyr's iron collar.

Here again we see a complicated set of temporal relations re-
solved into a set of focal artifacts, this time centered around the
person of yet another historical figure of importance to Suger, the
emperor Charles the Bald, the great Carolingian benefactor of

the abbey and church. Suger is the principle that makes this sentence a collective unity, and he is represented by its one central verb, *erigi fecimus,* found buried amidst the welter of historical figures and commemorative artifacts. Suger has in fact "erected" the sentence as much as a history-crammed monument to his own shaping imagination as to his more concretely shaping presence in his church. It is no accident that we repeatedly encounter in Suger's prose, as the keystone or framing verb of a sentence, the combination of a passive infinitive and *fecimus: erigi fecimus, configi fecimus, componi fecimus,* and many more.[17] Sentence after sentence leads to, or is organized around, this locution, which in turn represents through verbal symbols Suger's organization of his environment. Crosses or bust reliquaries with necklaces fastened to them serve in turn as adequate emblems for the techniques of sentence composition favored by Suger. Perhaps an even more revealing visual and artifactual parallel to the workings of Suger's mind comes in Chapter 33, where Suger tells how he fastened to the Main Altar of Saint-Denis many valuable ornaments he was afraid of losing:

> *Multa de acquisitis, plura de quibus ecclesiae ornamentis quae perdere timebamus, videlicet pede decurtatum calicem aureum et quaedam alia, ibidem configi fecimus.*[18]

This desire to conserve by heaping up comes very close, I believe, to the activating impulse behind the *De administratione,* and to the prose with which it is constructed.

One of the pieces Suger singles out for mention among those fastened to the Main Altar is *"pede decurtatum calicem aureum."* This haunting image of mutilation reminds us that Suger's activities at Saint-Denis consisted as much in refurbishing and replacing ruined or antiquated structures and objects as in making all things new. The Matutinal Altar suffers from old age; the frame for the altar stone is in sad shape, *"ipsa vetustate interpolata admodum disrupto."* Suger must order seven candlesticks to be created to replace an equivalent number donated to Saint-Denis by Charles the Bald because the originals *"vetustate dissipata apparebant."* The throne of King Dagobert, on which, according to tradition, the Frankish kings sat to receive the first homage from their nobles, now appears *"antiquatam et disruptam."*[19] Time is the enemy of the enterprise of giving glory to God through material creation. Perhaps it is Suger's vivid awareness of time's relentless devouring of wood, metal, and precious stones that underlies the superhistorical cast of his imagination, which seems to attempt to defeat time by denying its reality as a medium separating his heroes from each other. Such an antitemporal attitude would in turn be reflected in the heaping up of facts in his sentences and the heaping up of episodes in his chapters. Suger's prose denies the importance of logical sequence, and sequence is, of course, the embodiment of time in an intellectual structure.

If time—relentless, wearing time—stands as one great enemy of Suger's self-appointed role as guardian and improver of the patrimony of Saint Denis, it does not stand alone. Suger worries constantly in his writings about another enemy: theft (with its related evils of loss and vandalism). Hence the importance of Pope Eugene's anathema against anyone who would steal all or part of Suger's cross, and of Suger's inscribing the malediction on the base of that cross.[20] Hence, also, the chaining of objects to the altar. Suger's worry, well known to any librarian, curator, or collector, leads me to the last subject I will deal with in this essay: his attitude toward crowds. We all know that Suger was famous in his time for his desire to make available the ceremonies of his abbey church to the largest possible number of the faithful. This aspect of his character and career we may call his showman side, and it won him the distrust of Saint Bernard and the Cistercians, and also, I believe (though this has not been previously noted), of Peter Abelard, who must be referring to Suger in this passage from the fourth letter of his correspondence with Heloise:

> Yet there are many wearing our habit who despise this counsel, or rather, this divine precept, and we find them hard to tolerate when they celebrate the divine offices with cloister or choir wide open and conduct themselves shamelessly in full view of both men and women, especially during the Mass when they are decked out in valuable ornaments like those of the worldly men to whom they display them. In their view a feast is best celebrated if it is rich in external ornament and lavish in food and drink. . . . Anyone who cares to may entrust himself to the prayers of these men, which are offered with doors open, but you who have been led by the King of heaven himself into his chamber and rest in his embrace, and with the doors always shut are wholly given up to him, are more intimately joined to him. . . .[21]

What has, perhaps, not been sufficiently recognized is the extent to which the showman side of Suger, which prompted the immense labors of enlarging, and thus rebuilding, the abbey church to ease crowding and let more of the faithful enter on feast days, existed in tension with the curator side of him, perpetually worried about the diminution and loss of the world he was guarding, restoring, and creating in praise of Saint Denis and as a series of objective, spatially defined foci for his temporally disparate interests and heroes. Crowding meant the increased possibility of damage and theft; like time, crowds threatened his domain, the expression of his vision.

Perhaps the clearest indication of Suger's sense of the dangers posed by the world to his work, and of his efforts to counteract them, comes in the *De consecratione,* in the description of the great day of consecration of the new abbey church itself, the largest symbol of his aspirations and the container for all his smaller works of restoration and new creation. The bishops and other

clergy arrange themselves in beautiful and solemn order around the vat in which is to be blessed the holy water for the consecration of the church. Suger evokes the scene vividly, inviting us to re-create it in our minds, a spectacle of beauty and above all of order captured in the balanced clauses and elaborate parallelism of the prose:

> *Videres, et qui aderant non sine devotione magna videbant, tot tantorum choream pontificum vestibus albis decoram, mitris pontificalibus et circinatis aurifrisiis pretiosis admodum comatam, pastorales virgas manibus tenere, circumcirca dolium ambire, nomen Domini exorcizando invocare; tam gloriosos et admirabiles viros aeterni sponsi nuptias tam pie celebrare, ut potius chorus coelestis quam terrenus, opus divinum quam humanum, tam regi quam assistenti nobilitati videretur apparere.*[22]

We feel ourselves in the presence of Suger's *summum bonum:* a multitude of visitors molded by the occasion and by their responses to it into a gloriously systematized spectacle. What Panofsky correctly calls Suger's snobbery is surely at work here, in his enthusiasm for the high clergy and nobility.[23] But there is more to this moment than mere social climbing: the prose in which the moment is preserved bespeaks Suger's deep longing for order and system beyond what he can usually accomplish in deeds or in words.

The effect of this passage is heightened by what follows, as Suger proceeds to describe the scene outside the church:

> *Populus enim pro intolerabili magnitudinis suae impetu foris agebatur, et dum chorus praefatus aquam benedictam extra, hysopo ecclesiae parietes virtuose aspergendo, projiciebat, rex ipse ejusque decuriones tumultuosum impetum arcebant, et virgis et baculis regredientes ad portas protegebant.*[24]

As the clerics complete the consecration by aspersing the exterior of the building, the secular arm keeps the mob at bay. The two-fold action—protecting the church sacramentally, restraining the *populus* physically—here so strikingly portrayed can be read symbolically as an expression of Suger's two spheres of activity, each with its desired fulfillment. The juxtaposition of the orderly ceremony within the church and the tumultuous mob outside suggests powerfully the abbot's program and vision: on the one hand to call together and organize the forces that will sanctify Saint Denis, the martyr and his church; on the other to fight off the dangers that crowd in upon him, dangers not only palpable, like the potentially larcenous and destructive mob, but less tangible, like time-inspired ruin and decay. Consecrating and beating back—these are the goals of Suger's public, official career and presumably of his private imagination as well.

Given what I have called the tension in Suger's makeup between the showman and the curator,[25] the passages in his works dealing with crowds provide, I believe, a valuable, albeit indirect, clue to his personality. His mixed feelings about at least one aspect of his life's work constitute a window on his mind, as do the other passages I have examined where the collective style and complex, additive syntax reflect the writer's sense of himself as holding together the great figures of various times both in his imagination and in his arrangement of objects in space. To see in these excerpts from Suger's writings and in the objects he commissioned external, concrete versions of his inner life is not, I believe, merely to ratify Panofsky's dictum about Suger's diffusion of self but rather to suggest that Suger, like many another great twelfth-century creative spirit, was engaged throughout his career in attempting to impose his vision, with varying degrees of success, on the rich, fascinating, and intractable material of life—material that provided his age with the greatest challenge to its new sense of the marvelous power of the human faculties, best described collectively with a favorite term of the day: *ingenium.*[26] Suger's literary style and vision display his *ingenium* in ways we have yet to explore fully.

NOTES

1. Hereafter *Adm.* and *Cons.*, respectively. All references to, quotations from, and translations of these works follow the editions and translations of Panofsky, *Suger*, 2d ed.

2. See R. W. Hanning, *"Ut enim faber . . . sic creator":* Divine Creation as Context for Human Creativity in the Twelfth Century," in Clifford Davidson, ed., *Word, Picture, and Spectacle* (Kalamazoo, 1984), pp. 103–4; and R. W. Southern, *Medieval Humanism* (New York, 1970), pp. 29–41.

3. Erwin Panofsky, *Gothic Architecture and Scholasticism* (New York, 1957).

4. On these important aspects of Suger's thought, see Panofsky, *Suger*, pp. 14–26, and the essay by Gabrielle Spiegel, "History as Enlightenment: Suger and the *Mos Anagogicus*," in this volume, pp. 151–58.

5. See Bernard of Clairvaux, *Five Books on Consideration: Advice to a Pope,* trans. John D. Anderson and Elizabeth T. Kennan (Kalamazoo, 1976), pp. 162–64. The quotation is from p. 163.

6. Panofsky, *Suger,* p. 30.

7. On the dimensions, placement, and decoration of this Great Cross, see Panofsky, *Suger,* pp. 180–83 and the bibliography cited there.

8. "We should have insisted with all the devotion of our mind—had we but had the power—that the adorable, life-giving cross, the health-bringing banner of the eternal victory of our Saviour (of which the Apostle says: *But God forbid that I should glory, save in the cross of our Lord Jesus Christ*), should be adorned all the more gloriously as the *sign of the Son of Man*, which *will appear in Heaven* at the end of the world, will be glorious not only to men but also to the very *angels;* and we should have perpetually greeted it with the Apostle Andrew: *Hail Cross, which art dedicated in the body of Christ and adorned with His members even*

as with pearls" (Suger, *Adm.* [P], pp. 56–57).

9. "But since we could not do as we wished, we wished to do as best we could, and strove to bring it about by the grace of God" (ibid.).

10. Translated as two sentences by Panofsky: "Therefore we searched around everywhere by ourselves and by our agents for an abundance of precious pearls and gems, preparing as precious a supply of gold and gems for so important an embellishment as we could find, and convoked the most experienced artists from diverse parts. They would with diligent and patient labor glorify the venerable cross on its reverse side by the admirable beauty of those gems; and on its front—that is to say in the sight of the sacrificing priest—they would show the adorable image of our Lord the Saviour, suffering, as it were, even now in remembrance of His Passion" (ibid., pp. 56–59).

11. "*Eodem sane loco beatus Dionysus quingentis annis et eo amplius, videlicet a tempore Dagoberti usque ad nostra tempora, jacuerat.*" ("In fact the blessed Denis had rested on this very spot for five hundred years or more, that is to say, from the time of Dagobert up to our own day.") (Ibid., pp. 58–59.)

12. "*Nos autem onere quaerendarum gemmarum exonerati, gratias Deo referentes, quater centum libras, cum plus satis valerent, pro eis dedimus.*" ("We, however, freed from the worry of searching for gems, thanked God and gave four hundred pounds for the lot though they were worth much more.") (Ibid.)

13. "Their owners had obtained them from Count Thibaut for alms; and he in turn had received them, through the hands of his brother Stephen, King of England, from the treasures of his uncle, the late King Henry, who had amassed them throughout his life in wonderful vessels" (ibid.).

14. "... then, lo and behold, [monks] from three abbeys of two Orders—that is, from Cîteaux and another abbey of the same Order, and from Fontevrault—entered our little chamber adjacent to the church and offered us for sale an abundance of gems such as we had not hoped to find in ten years, hyacinths, sapphires, rubies, emeralds, topazes" (ibid.).

15. Panofsky reproduces the famous image of Suger in this pose at the feet of the Virgin, from the "Life of the Virgin (Infancy of Christ) Window" in the northern bay of the Chapel of the Virgin, Saint-Denis; ibid., fig. 15 and fig. facing p. 1. Recall also the image of Suger at the feet of the Lord on the central portal of the west facade.

16. "We further erected the cross, admirable for its size, which is set up between the altar and the tomb of the same Charles, and to the middle of which is fastened, according to tradition, the most noble necklace of Queen Nanthilda, wife of King Dagobert, the founder of the church (another one, however, [we fastened] to the brow of Saint Denis, and this, though smaller, is equaled by none according to the testimony of the most competent artists); [we did this] chiefly out of reverence for the most sacred Iron Collar which, having circled the most sacred neck of the blessed Denis in the "Prison de Glaucin," has deserved worship and veneration from us and all" (ibid., pp. 70–71).

17. See ibid., p. 42, ll. 16–17, *aptari et . . . depingi . . . fecimus;* p. 56, ll. 3–4, *circumcingi fecimus;* p. 60, l. 8, *intitulari fecimus;* p. 60, l. 15, *circumcingi fecimus;* p. 62, l. 4, *configi fecimus;* p. 62, l. 8, *mandari fecimus;* p. 70, l. 27, *erigi fecimus;* p. 72, l. 16, *erigi fecimus;* p. 72, l. 27, *reaurigi fecimus.*

18. "Much of what had been acquired and more of such ornaments of the church as we were afraid of losing—for instance, a golden chalice that was curtailed of its foot and several other things—we ordered to be fastened there" (ibid., pp. 62–63).

19. Ibid., p. 66, l. 28; p. 76, ll. 15–16; p. 72, l. 24.

20. "*. . . publice coram omnibus, quicumque inde aliquid raperent, quicumque ausu temerario in eum manum inferrent, mucrone beati Petri et gladio Spiritus sancti anathematizavit. Nos autem idem anathema inferius in cruce intitulari fecimus.*" (". . . and publicly, in the presence of all, he anathematized, by the sword of the blessed Peter and by the sword of the Holy Ghost, whosoever would steal anything therefrom and whosoever would raise his hand against it in reckless temerity; and we ordered this ban to be inscribed at the foot of the cross.") (Ibid., pp. 60–61.)

21. "*Cuius quidem consilii immo praecepti divini multos huius habitus nostri contempores adhuc graviter sustinemus qui, cum divina celebrant officia claustris vel choris eorum reseratis, publicis tam feminarum quam virorum aspectibus impudenter se ingerunt, et tunc praecipue cum in solemnitatibus pretiosis polluerint ornamentis, sicut et ipsi quibus se ostentant seculares homines. Quorum quidem iudicio tanto festivitas habetur celebrior, quanto in exteriori ornatu est ditior et in epulis copiosor. . . . Horum orationibus, quae aperto scilicet fiunt ostio, qui voluerit se commendet. Vos autem quae in cubiculum coelestis regis ab ipso introductae atque in eius amplexibus quiescentes, clauso semper ostio, ei totae vacatis, quanto familiarius ei adhaeretis. . . .*" (Joseph T. Muckle, ed., "The Personal Letters Between Abelard and Heloise," *Mediaeval Studies* 15 [1953]: 85–86; Betty Radice, trans., *The Letters of Abelard and Heloise* [Harmondsworth, 1974], pp. 141–42). I have made one correction in the translation. On Cistercian and other opposition to Suger and his activities, see Panofsky, *Suger,* pp. 10–15, 25–27.

22. "You might have seen—and those present did see not without great devotion—how so great a chorus of such great pontiffs, decorous in white vestments, splendidly arrayed in pontifical mitres and precious orphreys embellished by circular ornaments, held the crosiers in their hands, walked round and round the vessel and invoked the name of God by way of exorcism; how so glorious and admirable men celebrated the wedding of the Eternal Bridegroom so piously that the King and the attending nobility believed themselves to behold a chorus celestial rather than terrestrial, a ceremony divine rather than human" (Suger, *Cons.* [P], pp. 114–15).

23. Panofsky, *Suger,* pp. 33–34.

24. "The populace milled around outside with the drive of its intolerable magnitude; and when the aforesaid chorus sprinkled the holy water onto the exterior, competently aspersing the walls of the church with the aspergillum, the King himself and his officials kept back the tumultuous impact and protected those returning to the doors with canes and sticks" (Suger, *Cons.* [P], pp. 114–15).

25. Cf. "In arranging his processions, translations, foundation ceremonies and consecrations Suger foreshadowed the showmanship of the modern movie producer or promoter of world's fairs, and in acquiring pearls and precious stones, rare vases, stained glass, enamels and textiles he anticipated the unselfish rapacity of the modern museum director. . . ." (Panofsky, *Suger,* p. 14).

26. See R. W. Hanning, *The Individual in Twelfth-Century Romance* (New Haven and London, 1977), pp. 21–22, 28–31, for a discussion of this term in relation to Peter Abelard's career.

History as Enlightenment:
Suger and the *Mos Anagogicus*

Gabrielle M. Spiegel

IN ANY LIST of twelfth-century monastic writers of history Abbot Suger of Saint-Denis would surely rank among the select few whose works have achieved an enduring significance both for their intrinsic excellence and for what they teach us about the nature of life and modes of thought during this crucial and innovative period of the Middle Ages. Suger's *Life of Louis VI* and the beginnings of his work on the life of Louis VII, interrupted by death, were the first in a series of royal biographies written at Saint-Denis to record—and, in recording, to celebrate—the deeds of France's ruling monarchs. As abbot of Saint-Denis when the first collection of chronicles was compiled in the opening decades of the twelfth century, Suger probably supervised, or at least stimulated, the inception of royal historiography at the abbey.[1] From small beginnings during his abbacy would flow a veritable stream of historical works, making the chronicles of Saint-Denis, like the abbey itself, a symbol of the unity of France and the greatness of her kings.

Yet it remains a curious fact of Sugerian scholarship that, to date, no thorough study of his historiographical activity has appeared.[2] In particular, after 850 years, we still lack a comprehensive investigation of the *Vita Ludovici grossi* that explores its historiographic aims, structure, and craft, a prerequisite for any serious interpretation of the work. This is not to say that the importance of the text has gone unnoticed. It was repeatedly copied from the twelfth century on, both within the abbey of Saint-Denis, beginning with the *Gesta Gentis Francorum,* to which it was appended circa 1160,[3] and without, notably at the nearby Parisian abbey of Saint-Germain-des-Prés, where work on the *Continuation of Aimoin* was then in progress.[4] At the end of the twelfth century it was incorporated into the Dionysian handbook represented by Paris, Bibliothèque Nationale, ms. lat. 12710[5]

and was copied again in the middle of the thirteenth century as part of the major compilation of Dionysian Latin histories contained in Paris, Bibliothèque Nationale, ms. lat. 5925, from which it was translated into French by Robert Primat in 1274 as part of the initial installment of the *Grandes Chroniques de France.*[6] At present, Suger's *Life of Louis VI* is available in ten manuscripts and six printed editions—two possessing French translations—which testify to its continuing popularity throughout the Middle Ages and thereafter.[7]

The relative scholarly neglect of Suger as historiographer is all the more surprising given that he was almost alone among his contemporaries in his marked preference for historical rather than theological inquiry. Indeed, among monastic authors of his time, Suger is probably the only one who did not compose a single theological treatise. His Dionysian biographer, the monk William, copiously documented Suger's passion for history: his practice of recounting the deeds of past kings named to him at random; his long discourses on French history conducted far into the night; and, in characteristic Sugerian fashion, his frequent accounts "of his own actions, as much as those of other men."[8] But his historical interests have not encouraged our interest in his historiography.

The reasons for this neglect appear to fall into two basic categories. The first, and doubtless most significant, has been the tendency for scholars to read the *Vita Ludovici* simply as a source of information for the political history of Louis's reign. Such an approach to the text is ultimately allied to a view of Suger himself as, to borrow the title of a seventeenth-century biography written by Jean Baudouin, *Le Ministre Fidèle.*[9] A product of "the faithful minister," Suger's account of the reign of Louis VI has attained a privileged status for its own fidelity to factual accuracy, with cer-

Notes for this essay begin on page 156.

tain notable but easily recognizable lapses. To read the *Vita Ludovici* in this way legitimately calls for no more than the factual correction of the text, and in large part this is the reading it has received. That the positivistic assumptions governing the historian's utilization of the work might prove untenable in light of its literary character and goals is a question that has never been raised, although, upon reflection, such assumptions may seem naïve.

The second reason for the neglect of Suger's historiographic art stems from the complexity of the *Vita Ludovici* itself as a piece of historical writing. As almost every editor of the text has recognized, the work defies easy classification. More panegyric than history, say some; a work of edification and practical instruction, say others; marred, all agree, by a literary style that strains for rhetorical elegance but achieves only affectation at best, prolixity, confusion, and obscurity at worst.[10] Although entitled *Vita,* the work fails to conform to the normal standards of biography— even those of the Middle Ages—as it persistently loses the expected focus on its subject in favor of long digressions, disproportionate attention to events whose pertinence to Louis seems insignificant, and an apparently haphazard criterion of historical selection that makes it difficult to identify the principles guiding Suger's choice of material. Even less can the work be treated under the rubric of autobiography, a recent, if regrettable, trend among historians concerned with the "discovery of the individual" in the twelfth century.[11]

Clearly, the simplest solution is to call it a regnal history, one concerned not so much with the "life" of the king as with the deeds done during his reign, *res gestae,* whose importance is judged by their contribution to the furtherance of monarchical power and prestige.[12] Even this, however, is less than satisfactory, for the *Vita Ludovici* lacks the distinguishing features of chronicles of this kind, namely a commitment to chronological progression through the reign, clear thematic development usually governed by ethical precepts defining "good" and "bad" kingship, and at least an avowed, if perfunctory, concern for historical completeness. One need only compare the *Vita Ludovici* to Rigord's *Gesta Philippi Augusti* to perceive the gulf that separates Suger's work from other Dionysian regnal histories, a genre at which, in fact, the abbey of Saint-Denis excelled.

How, then, should the *Vita Ludovici* be characterized? How can its confused chronology and seemingly capricious handling of events be explained in terms of an encompassing historiographic intention that, one assumes, a writer of Suger's experience and purposefulness possessed? If not biography or royal *gesta,* what is the *Vita Ludovici?* In the following pages I should like to propose one possible interpretation of the *Vita Ludovici* based on an analysis of its underlying narrative structure, for it is my contention that this narrative structure provides a clue to the intended meaning of the work.

Leaving the prologue to one side, a close examination of the *Vita Ludovici* reveals that each successive chapter contains the narration of a single "event-unit" that may, but does not necessarily, delimit a comparable unit of historical time; hence the chronological imprecision all commentators on the text have found so puzzling. Study of these narrative units, moreover, discloses a virtually identical internal structure in which historical action is inaugurated by a disturbance to an existing situation, followed by the king's attempt to deal with the consequences of that disturbance and concludes with the restoration of "correct" order, viewed either as a return to the previously existing situation or as the institution of a new, and ethically more just, arrangement. Lest this narrative structure be seen only as another example of a pattern common to all clerical chroniclers,[13] as William Brandt has argued, it should be pointed out that in the *Vita Ludovici* the initial disturbance that sets the narrative action in motion is specifically treated as a disruption of the proper hierarchical ordering of society, and it is toward the restoration of this order that the remaining historical action is directed. The internal structure of Suger's narrative "event," then, is basically triadic, consisting of an initial deformation of historical order, corrective action taken by the king, and the final resolution, more often than not presented as a form of restoration.

A sampling of the opening chapters to the *Vita Ludovici* serves easily to illustrate this narrative pattern. Chapter one, which treats Louis VI's early struggles against King William Rufus of England, attributes the cause of war to William's aggressive aspiration to possess the French throne—in Suger's view a violation of the legal subordination of the English king to his French overlord.[14] But, "because it is neither proper nor natural for the French to be subject to the English (but rather for the English to be subject to the French),"[15] Louis valiantly withstood the onslaught in a series of military engagements, until William was killed in a hunting accident, an unforeseen outcome that Suger nonetheless advances as a resolution of the conflict, achieved through the administration to William of the very wrongs that he had attempted to impose on others: for "he who had unreasonably disquieted others was himself much more heavily disquieted, and he who had coveted all was himself despoiled of all."[16]

Chapter two describes Louis's attacks on Bouchard, lord of Montmorency, who had despoiled the lands of Saint-Denis. For this act of violence, Bouchard was judged in King Philip I's court. When he refused to accept the royal judgment, Louis— acting as his father's agent—humbled him "to his will and pleasure" and made Bouchard experience "just what inconvenience and misfortune are deserved by the insubordination of those subject to the royal majesty."[17] Bouchard's insubordination calls forth the corrective response of the prince, who, by humbling him, promotes the cause of order and justice. Similarly, in Chap-

ter three, Count Matthew of Beaumont unfairly seized the castle of Luzarches from Hugh of Clermont, who appealed to Louis for aid. Louis, "giving Hugh his hand in friendly fashion," ordered Matthew to "restore in full from the man he had despoiled without proper form."[18] When the count refused, Louis "avenged the refusal," took the castle by force, and "restored it to Hugh."[19]

Skipping ahead, Chapter eighteen recounts Louis's appropriation of the castles of Mantes and Montlhéry from his half brother, Philip, who, "pluming himself on his noble birth, had the impertinence to be recalcitrant,"[20] and schemed even to capture the throne for himself. The king, tired of his brother's "depredations of the poor, the wrongs done to churches, and the disorder he had brought to the whole countryside,"[21] found himself forced to raise an army, for which he "drew to himself all the better men of the land in the hope of receiving the benefit of his known generosity and proven mercy."[22] Meanwhile, Philip had conferred the honor of Montlhéry on Hugh of Crécy, from whom Louis now reclaimed it by force of arms, expelling Hugh, whose "shameful expulsion taught him to reflect on what it meant to enter into alliance against his lord with his lord's enemies."[23] Once again, the forces of insubordinate pride trigger those willful acts of wrongdoing it is the king's duty to correct and avenge in order to maintain the stability and peace of the realm.

Perhaps the most interesting example of Suger's narrative scheme is afforded by his handling of the continuing conflict between Louis VI and Henry I of England, which will serve here as a last, and highly telling, illustration of the lengths to which Suger was willing to go to preserve intact the underlying triadic structure of his narrative units. The action, recounted in Chapter twenty-six, opens characteristically with a disturbance to right order stemming from the refusal of the English king to recognize his due hierarchical subordination to royal majesty, which Suger presents in his most rhetorically insistent voice, inaugurating the chapter with the kind of aphoristic assertion he reserved for particularly compelling occasions: in this case that "arrogant ambition is worse than pride, because pride admits no superior, while ambition admits no equal."[24] Having thus set the moral tone for the ensuing discussion, he proceeds to explain:

King Louis of the French was perpetually raised in majesty above Henry, king of the English and duke of the Normans, by the fact that Henry was his feudatory. The king of the English was made impatient of his inferiority both by the nobility of his kingship and the marvelous abundance of his wealth. He labored to derogate from Louis's lordship, to upset his kingdom and disturb Louis at the request of his nephew, Count Theobald, and of many who envied the kingdom.[25]

War naturally followed. Since not even Suger could pretend that Louis was the instrument of Henry's correction (if one could call it that), it was left to the wheel of Fortune to play the role of royal avenger: "Thus it was that the king of England, after such long and marvelous successes of a most peacefully enjoyed prosperity, as if falling from the highest point of the wheel, was harassed by the changeable and unlucky ways things turn out . . . and reached the depths of misfortune."[26] To be sure, God rescued Henry and raised him once again in time for his crushing defeat of Louis's army at Brémule (1119), in which 140 French knights were taken prisoner. At Brémule, Louis personally lost his horse and battle standard, which were subsequently purchased by Henry from the soldier who had captured them. Henry returned the French king's charger, saddle, and bridle but retained the standard as a souvenir of victory (facts known to us not from Suger, who supresses them, but through the account of Ordericus Vitalis).[27] Undeterred by this turn of events, Suger boldly resolves the narrative unit with the patently false conclusion that Louis and his men returned home "not ceasing to repay their momentary misfortune with a long, continuous, and very heavy revenge."[28]

While examples such as these could be enumerated from almost any chapter of the *Vita Ludovici,* those already reviewed should suffice to demonstrate the general point that Suger's narrative units are both triadic in structure and intended to promote a larger thematic purpose, namely to show how, in Suger's words, "if anything which offended the king's majesty occurred anywhere in the kingdom, he would not put up with it in any way, nor leave it unavenged."[29] The offense to royal majesty represents a deformation of hierarchical order and unleashes Louis's vengeance against the pillaging, despoiling, overweening, ravening disturbers of the peace of the kingdom so familiar to all readers of the *Vita Ludovici.* To sustain this theme, Suger willfully violates chronological order, conflating events or deferring the conclusion of a chapter until he can properly narrate the resolution of the disturbance and the restoration of order, always carefully marked by the repetition of lexical formulas of "recovery," "return," "restoration," and the like. The chronological looseness of the *Vita Ludovici,* therefore, is not the result of confusion, but of narrative intention—for the sake of which, it might be added, Suger avoids mentioning any dates at all.

The total narrative structure of the *Vita Ludovici* consists not so much in the progressive unfolding of an overarching theme (a familiar enough pattern in monastic chronicles) as in the assembling of detached histories—what I have called "event-units." Chapters are strung out in a paratactically juxtaposed sequence whose movement is reiterative rather than strictly linear. Within each chapter appear recurrent themes of reciprocity: of friendship and enmity, vengeance and gracious aid, pollution and purification, treachery and loyalty, tyranny and justice. For the expression of these themes, Suger employs a rhetoric of reciproc-

ity that greatly contributes to the inflated literary style of the text. To cite a few examples: "Plunderers were plundered and torturers were tortured as vigorously, if not more so, than they had tortured";[30] Philip I is "ravished by lust for his ravished wife,"[31] (whom of course he had ravished in the first place); Louis's troops "repelled those who had repelled them";[32] Henry I "worked for the profit of all, so also all served him";[33] Haimo of Bourbon is reduced by Louis "to a state and depth of humility . . . equal to his previous height of pride";[34] the king's goodness and friendship "draw" the better men to him in affection, while his vengeance repels wrongdoers.

Ever in flux, Suger's world is one of perennial challenges to order that must be set right, a world in which the bonds of friendship and enmity determine the lines of force, the ebb and flow of human striving for justice and peace. It is a hierarchically ordered world constantly undergoing deformation and thus continually in need of reformation and restoration.

If one inquires into the sources of such a view of human history, it seems reasonable to conclude, as Georges Duby has suggested in another context,[35] that Suger translated into human events and actions the principles governing the celestial and ecclesiastical hierarchies of pseudo-Dionysius the Areopagite, the anonymous fifth-century theologian whom the monks of Saint-Denis mistakenly identified with their own patron saint.[36] For both Suger and pseudo-Dionysius, the concept of hierarchy is the keystone of the divine regulation of all good order, which requires, as pseudo-Dionysius had written, that every being "pursue just things justly . . . not contrary to one's rank and place."[37] Hierarchy is an *ordo sacer* that arrays all created things in a vertical chain of being reaching from the lowest to God, from the material reality of the sense-perceptible world to the invisible being of the intelligible world. Such a concept of hierarchy presupposes, as Dom Chenu demonstrated in his brilliant discussion of the Platonisms of the twelfth century, that "classic Platonic thesis of two worlds, of intellect and of sense; but it alters this thesis profoundly by taking the sense-perceptible world as a field in which symbols were in play."[38] The pseudo-Dionysian theology to which Suger was heir through the medium of John Scotus Eriugena was built on the principle, enunciated in John's *De divisione naturae,* that "there is nothing among the visible and corporeal things that fails to signify something incorporeal and intelligible."[39] The world's *visibilia,* its corporeal realities, are true ontological symbols (not merely epistemological signs)[40] of the *invisibilia,* the hierarchically ordered realms of being, toward which they point. While there is hierarchy, there is no dichotomy;[41] communication with, or more nearly participation in, the divine truths of the intelligible begins with the apprehension of material symbols, the cruder the better, since according to pseudo-Dionysian theology the crudest symbols are those most capable of signifying mystery,[42] a principle giving rise to what

Chenu has called the "object-centered culture" of pseudo-Dionysian symbolism.[43]

Within each ordered rank of being, the subordinate strive to ascend, as far as lies within their power, to be united with God, a process achieved, according to pseudo-Dionysius, by "continuous and persistent struggles toward the One, and by the entire destruction and annihilation of things contrary."[44] In this process, inferior beings pursue the path of anagogy, the "upward-leading" movement of the mind from (and through) material symbols to an understanding of the invisible being of the intelligible. To achieve this ascent, inferior beings are aided by the exemplary attraction of those above them, which acts by means of the exchange of affection with the good just as it "justly reproves anyone who rouses hatred against good men."[45] Within the duly ordered ranks of the pseudo-Dionysian cosmos, then, is found the continuous, eternal, cyclical movement produced by the strivings of beings toward higher beings, and toward the first principle of their being.[46]

In the *Vita Ludovici,* only one figure stands outside the reiterative flux and reflux of human striving, and that is the king himself. For, Suger proclaims, the king "is the vicar of God, whose image he bears."[47] At his coronation Louis "put off the sword of secular knighthood" and "was girded with the sword of the church for the punishment of evildoers," in order to perform the "office of the king, who does not bear the sword in vain" (Romans 13:4).[48] Through royal consecration and anointment, the king is elevated to an ontological level far above those over whom he has been appointed by God to rule.[49] To attack the king is to oppose God, to go against, as Suger says of Hugh of Le Puiset, the "king of the Franks and the King of Kings."[50] The human hierarchy mirrors the heavenly hierarchy, and the king, like God, surmounts an ordered pyramid and is charged with protecting the lives and tranquility of all, while ceaselessly suppressing evil and tyranny.

At the very center of the *Vita Ludovici* Suger provides a carefully articulated image of this perfectly ordered society in the famous account of the battle plans drawn up at Reims to meet the invasion threatened by the imperial forces of Henry V in 1124. Here, for once, the whole kingdom was gathered in a properly arrayed series of ranks around the king, forming "a large army of men devoted to the crown."[51] The royal summons dissolved all hostilities—Theobald of Champagne and others at war with the king nonetheless answered the king's appeal—and joined all in a common unity of purpose. While the army assembled at Reims, Suger reports, "many devout people and religious women" frequented the altar of Saint-Denis, where the relics of the holy martyrs remained in place for the duration of the crisis, and where the brethren sang a continual office, "day and night."[52] Linked together by the sympathetic bonds of a shared enterprise, secure in the justice of their ultimate victory, king,

army, church, and people compose an ordered unity. "Never," boasts Suger, "in modern times or ancient, had France accomplished a more striking exploit than when, uniting the strength of her members . . . she triumphed over the Roman emperor. After this, the pride of enemies was stifled . . . and, in every direction she could reach, her enemies, returning to her favor, stretched forth their hands in friendship."[53] Suger thus terminates the account with a characteristically Dionysian resolution of conflict and restoration of order in which enmity is reciprocally exchanged for friendship, war for peace, the whole accomplished by the process of human striving so central to the natural dynamism of pseudo-Dionysius's cosmos.

If at the center of the *Vita Ludovici* there stands an ideal image of human society, one symbolizing the order and justice of the invisible, divine hierarchy, so also is the work as a whole framed by a movement best understood in terms of the pseudo-Dionysian notion of anagogical ascent. In the *Vita Ludovici* this anagogical ascent is symbolized by the passage of Louis's life. As Suger presents it, Louis's life moves from the external, corporeal beauty of youth to the spiritual majesty of death. Louis, when first introduced to the reader at the age of twelve or thirteen, is a "handsome youth in the first flower of his age," admirable for his "development of moral character and for the growth of a well-made body."[54] Yet at the end, when sensing the approach of death, "In the sight of all, clerks and laymen, he put off his kingship, laid down his kingdom . . . and invested his son Louis with his ring. There and then, for the love of God, he distributed to the churches, the poor, and the needy his gold and silver, his valuable vases and goblets, his clothes and cloaks; nor did he neglect to give his garments or his royal robes [down] to his very shirt." Making his Communion, Louis "returned to his chamber and, having rejected all pomp of worldly pride, he lay down with only a single sheet."[55] Moreover, these acts were performed in the context of Louis's desire to make his profession as a monk of Saint-Denis, to exchange, Suger says, "his royal insignia and imperial ornaments for the humble habit of Saint Benedict."[56] Although Louis's wish to become a monk was thwarted by the increasing pains of the illness that finally overtook him, "What he could not do in fact he did with heart and soul,"[57] and the series of distributions listed in the text stand as testimony to the earnestness of his intentions.

In disrobing and unburdening himself of the royal insignia, Louis in effect becomes invisible, through a material process that parallels exactly the pseudo-Dionysian idea of death as "becoming invisible to human ken."[58] The act of disrobing has, as well, a precise spiritual significance that pseudo-Dionysius explains in his discussion of monastic ordination in the *Ecclesiastical Hierarchy* and that, given the context of Louis's act, acquires a particular relevancy. In pseudo-Dionysian symbolism, "The casting aside of a different habit [in the ceremony of monastic ordination]

is intended to show the transition from a middle religious life to the more perfect . . . just as in baptism the exchange of clothing denotes the elevation of a thoroughly purified life to a contemplative and enlightened condition."[59] To become invisible is also to ascend, to recover and be restored to that state of contemplative enlightenment for which it is the life task of every being to strive. The history of Louis's life enacts this passage from the material state of external beauty to the invisible state of enlightenment, and it remains only for Louis to be wholly hidden from human ken by burial, where, Suger asserts in closing, "he waits to partake in the future resurrection."[60]

The *Vita Ludovici*, it is now possible to suggest, is Suger's offering of yet another material symbol through which the mind of the beholder can ascend to an understanding of the intelligible, a symbol comparable in purpose, if not in scale, to the abbey church. Just as the observer who enters the church is anagogically elevated by the contemplation of its beauty to an understanding of the divine, so the reader, in contemplating the life of Louis VI, shares in the experience of enlightenment that his life reflects. In this context, the figure of Louis VI functions not as a moral *exemplum* but as a material symbol bearing the full ontological significance conferred on such symbols by pseudo-Dionysian theology. As such, the *Vita Ludovici*, I would like to propose, is intended as a work of edification in the root sense of the word, that is, as a formal construction—which is to say the construction of forms—whose purpose is to effect the spiritual reconstruction of the reader.[61] And it is precisely the narrative structure of the text that reveals this historiographic intention by repeatedly providing models (forms) of human restoration pointing the reader toward an understanding of a future spiritual restoration, in keeping with the ontological bias of pseudo-Dionysian theology that permitted access to the transcendent through the mystical absorption of the concrete, achieved by following the *mos anagogicus*, the anagogical way.

"*Praeteritorum recordatio futurorum est exhibito,*" Suger wrote in *De administratione*: "The recollection of the past is the promise of the future."[62] History, no less than gold and gems, buildings and ornaments, becomes in Suger's hands an appropriate object of anagogical contemplation, a form of theological enlightenment aiding the reader in his upward ascent and helping him to anticipate the spiritual rewards of the future. It is, as Suger says in the prologue to the *Vita Ludovici*, a "monument more durable than bronze," by which he pays back the gifts of "charity and gratitude"[63] shown him by his friend and ruler, and through which he passes down to posterity the image of a model life.

The preceding interpretation of Suger's aims in writing the *Vita Ludovici*, if granted, raises several questions. To begin with, the normal question one asks of any historical text: Does it work on its own terms? Can history, that is to say the study of past deeds—of *res gestae*—bear the weight of such pseudo-Dionysian

symbolism, particularly in light of that symbolism's underlying Platonic disinterest in contingent events?[64] This is only another way of inquiring whether *gesta* (or gold and buildings, for that matter) are really appropriate objects of anagogical contemplation. Just as generations of art history students have found in Suger's architectural writings little more than a thinly disguised aesthetic indulgence, a formalized, theological justification for what they, not so naïvely, perceive as the expression of an unabashed entrepreneurship of *objects de luxe,* so, too, Suger can perhaps be accused of an unseemly level of political enthusiasm, an enthusiasm encouraged to a certain extent by the importance of material symbols in pseudo-Dionysian thought, but more specifically discouraged by pseudo-Dionysius's tendency to relegate any reference to history to a place of secondary consideration. Inevitably, the invisible order of the divine hierarchy remains only implicit in the *Vita Ludovici,* while its narration fills page after page with busy human activity. One may reasonably ask whether Suger's own enjoyment of and commitment to the dignity and majesty of the secular world do not impede the reader's ascent from the contemplation of material forms to the comprehension of the invisible and unchanging.

A related problem stems from the necessarily linear nature of historical narration, which does violence to the architectonic structure of Suger's pseudo-Dionysian model and thus sabotages, in ways that may have been difficult for Suger to avoid, the hierarchical ordering of the material world in relation to the immaterial forces of which it is but a symbol. The clarity of vertical hierarchies, so brilliantly expressed in Suger's abbey church, was bound to be lost when laid out along the narrative grid of a chronologically ordered historical sequence. Although it can be argued that the absence of dates or a fixed chronology in the *Vita Ludovici* represents Suger's attempt to overcome this problem, the very nature of written history worked in this case against the historiographical goals of the text. To the extent that Suger failed, understandably, to solve this difficulty, the *Vita Ludovici* retains some characteristics of a genuine biography, at least insofar as it follows an apparent biographical sequence. To view the *Vita Ludovici* simply as royal biography is, in this writer's opinion, to miss its true intent, but the external form of the narration may well be cause for confusion.

However one resolves these questions, it seems clear that no discussion of the *Vita Ludovici* can afford to ignore them. Tradi-

tional positivistic approaches to the text, which seek to extract from it the data upon which to build an understanding of the growth of the feudal state or Capetian kingship in the twelfth century, must proceed with caution. For, if correct, the foregoing analysis suggests that Suger was more concerned with providing a cultural image of kingship and its role within a cosmologically defined hierarchy of being than with reporting the operations or administrative achievements of the monarchy in the political universe of twelfth-century France. This does not mean that Suger's *Vita Ludovici* has nothing to tell us about the increase of royal power, or even about the practical doings of the king, only that the communication of factual information is not the goal of the *Vita Ludovici,* and to read the text as if it were is seriously to misunderstand it and to risk misjudging the nature of the information it conveys.

For too long, the study of medieval historiography has been subjected to the demands of positivistic research, which, not surprisingly, has left scholars with a deep-rooted suspicion that what is being reported in chronicles, *gesta,* biographies, and the like, is not always, or wholly, credible. The instrumental and "scientific" aims of scholarship have required the use of such texts for the construction of historical narratives, and so, for better or worse, medieval narration has had to serve those ends. If this analysis of the *Vita Ludovici* does nothing else, it should serve as a warning against the positivistic assumptions of any research that relies upon historical writing in the Middle Ages as a source of factual information. In the case of the *Vita Ludovici,* the very abundance of such information, recorded by a man universally deemed worthy of belief, has inhibited the study of the text in terms of its own expressive purposes and modes of elaboration. Although the *Vita Ludovici* may finally be considered unsuccessful in realizing its historiographical intentions, to make this judgment is to say something very different than to declare that it has failed to live up to our standards of historical reliability. That history, in the end, proved a difficult vehicle for the encouragement of mystical contemplation does not mean that Suger did not wish it to be used in this fashion, and it behooves us to pay close attention to the ways in which his intentions shaped and gave meaning to the work. For to Suger, the recollection of the past was not only a memory; it was also, and perhaps more importantly, the promise of the future.

NOTES

1. For Suger's role in the inception of royal historiography at Saint-Denis, see Gabrielle M. Spiegel, *The Chronicle Tradition of Saint-Denis: A Survey* (Brookline and Leyden, 1978), pp. 39–40.
2. Apart from the introductions to his published works, no gen-

uine study of Suger's historical writings has ever been undertaken. Even the better biographies of Suger, such as those by Cartellieri, *Suger,* and Marcel Aubert, *Suger* (Paris, 1950), discuss his historiography only in brief.
3. See Molinier, *Louis le Gros,* pp. xvii–xviii, and Spiegel, *Chronicle Tradition,* p. 41.

4. Simon Luce, "La Continuation d'Aimoin et le manuscrit Latin 12711 de la Bibliothèque Nationale," *Notices et documents publiés pour la Société de l'Histoire de France à l'occasion du cinquantième anniversaire de sa fondation,* Société de l'Histoire de France (Paris, 1884), pp. 57–70; and Jean-François Lemarignier, "Autour de la royauté française du IXᵉ au XIᵉ siècle. Appendice: La continuation d'Aimoin et le manuscrit Latin 12711 de la Bibliothèque Nationale," *Bibliothèque de l'École des Chartes* 113 (1955): 25–36.

5. Jules Lair, "Mémoire sur deux chroniques latines composées au XIIᵉ siècle à l'abbaye de Saint-Denis," *Bibliothèque de l'École des Chartes* 33 (1874): 543–80.

6. Spiegel, *Chronicle Tradition,* p. 78.

7. For a review of the manuscript tradition and printed editions see Waquet, *Vie,* pp. xvii–xxvi. Three additional manuscripts which possess copies of the *Vita Ludovici,* unknown to Waquet, are, first, Rome, Biblioteca Apostolica Vaticana, Cod. Reg. lat. 550, a copy of the *Continuation of Aimoin,* written, according to Marc Du Pouget, around 1202–05 ("Recherches sur les chroniques latines de Saint-Denis et édition de la *Descriptio clavi et Corone,*" unpublished thesis, École des Chartes, p. 16) and housed in the library of Saint-Denis, where it later served as the basis for the initial portion of Paris, Bibliothèque Nationale, ms. lat. 5925, itself largely a copy of the *Continuation of Aimoin.* The second and third manuscripts consist of two versions of a newly discovered early vernacular prose history entitled *Chronique des Rois de France,* written in *Francien,* in all probability at the abbey of Saint-Germain-des-Prés, between 1210 and 1229–30. Both manuscripts—Rome, Biblioteca Apostolica Vaticana, Cod. Reg. lat. 624 and Chantilly ms. 869—include the first translation of Suger's *Vita Ludovici* into French, and Pierre Bottineau has established that Primat, when he came to translate the *Vita Ludovici* in the first installment of the *Grandes Chroniques,* used this vernacular text as a source. (See Pierre Bottineau, "Une Source des Grandes Chroniques de France: l'Histoire de France en prose française de Charlemagne à Philippe-Auguste," [unpublished typescript]). On the Vatican manuscript see Élie Berger, "Notices sur divers manuscrits de la Bibliothèque Vaticane," *Bibliothèque des Écoles françaises d'Athènes et de Rome* 6 (1879): 10; Ronald N. Walpole, "La Traduction du Pseudo-Turpin du Manuscrit Vatican Regina 624. À Propos d'un livre récent," *Romania* 99 (1978): 484–514; Pierre Bottineau, "L'Histoire de France en français de Charlemagne à Philippe-Auguste: La Compilation du Ms. 624 du Fonds de la Reine à la Bibliothèque Vaticane," *Romania* 90 (1969): 79–99; and on both the Vatican and Chantilly mss., Ronald N. Walpole, "Prolégomènes à une édition du Turpin Français dit le *Turpin* I," *Revue d'Histoire des Textes* 10 (1980): 210–30, and 11 (1981): 325–70. Madame Gillette Labory of the Institut de Recherche d'Histoire et des Textes in Paris and I have undertaken a joint study of the manuscript of Chantilly and its Latin sources. Her study of the first 165 folios, constituting the translation of the *Continuation of Aimoin,* will appear shortly in article form entitled, "The Historian's Métier at the Beginning of the XIIIth century: The Anonymous of Chantilly and the *Chronique des Rois de France.*"

8. For William's biography of Suger, see William, *Vita Sug.* (L), pp. 382, 389.

9. Jean Baudouin, *Le Ministre Fidèle représenté sous Louis VI en la personne de Suger, Abbé de S. Denys en France et Régent du Royaume sous Louis VII* (Paris, 1640).

10. See Waquet, *Vie,* p. xii; Lecoy, *Oeuvres,* p. iii; Aubert, *Suger,* p. 116; and Panofsky, *Suger,* p. xi.

11. As in the recent books of Colin Morris, *The Discovery of the Individual 1050–1200* (New York, 1972); and Karl Weintraub, *The Value of the Individual Self and Circumstances in Autobiography* (Chicago, 1978). Georg Misch, in his *Geschichte der Autobiographie,* 4 vols. in 8 (Frankfurt-am-Main, 1949–69) vol. 3, similarly includes Suger's personal testimonies as evidence for the growing consciousness of personality in the twelfth century.

12. The author confesses to having said as much herself; see Spiegel, *Chronicle Tradition,* pp. 46–47.

13. William Brandt, *The Shape of Medieval History: Studies in Modes of Perception* (New Haven and London, 1966), ch. 2.

14. Suger, *Vita Lud.* (W), p. 10.

15. Ibid. Suger's Latin here has been cause for some confusion. He states: *"quia nec fas nec naturale est Francos Anglis, immo Anglos Franci subici . . . "* Waquet (p. 11) translates this as: *"parce qu'il n'est ni permis ni naturel que les Français soient soumis aux Anglais, ni même les Anglais aux Français . . . "* However, the *Grandes Chroniques de France* (ed. Jules Viard [Paris, 1928], vol. 5, p. 85) understood the text in the way I have translated it and gives a reading of *"mes por ce que ce n'est pas droiz ne chose naturel que François soient en la subjectiom d'Anglois; ainz est droiz que Anglois soient sugiet à François . . . "* It seems fairly clear that *immo* is best taken to mean "but rather" or "on the contrary," instead of "nor" as Waquet translates it. For the complex relations between the Capetians and the Anglo-Norman kings over the question of homage owed the kings of France, see C. Warren Hollister, "Normandy, France and the Anglo-Norman *Regnum,*" *Speculum* 51 (1976): 202–42. Also useful are Jean-François Lemarignier, *Recherches sur l'hommage en marche et les frontières féodales* (Lille, 1945) and his *La France médiévale: Institutions et sociétés* (Paris, 1970); and John le Patourel, *The Norman Empire* (Oxford, 1976), pp. 218–21.

16. Suger, *Vita Lud.* (W), p. 12.

17. Ibid., p. 16.

18. Ibid., p. 20.

19. Ibid.

20. Ibid., p. 122.

21. Ibid., p. 124.

22. Ibid., p. 126.

23. Ibid., p. 128.

24. Ibid., p. 182.

25. Ibid., p. 184.

26. Ibid., p. 188.

27. Ordericus Vitalis, *Ecclesiastical History,* Marjorie Chibnall, ed. and trans. (Oxford, 1978), vol. 6, p. 240. Suger does, of course, acknowledge Louis's defeat but says only that he "withdrew, not without great damage to his host" (*"non tamen sine magno erratici exercitus detrimento . . . "*), Suger, *Vita Lud.* (W), p. 198.

28. Suger, *Vita Lud.* (W), p. 200.

29. Ibid., p. 271.

30. Ibid., p. 26.

31. Ibid., p. 82.

32. Ibid., p. 72.

33. Ibid., p. 102.

34. Ibid., p. 182.

35. Georges Duby, *The Three Orders: Feudal Society Imagined,* trans. Arthur Goldhammer (Chicago and London, 1980), pp. 113, 228.

36. For a summary of this development see Gabrielle M. Spiegel, "The Cult of Saint Denis and Capetian Kingship," *Journal of Medieval History* 1 (1975): 43–60. Also Sumner McK. Crosby, *The Abbey of St.-Denis 475–1122,* Yale Historical Publications (New Haven, 1942), pp. 14ff.; Gabriel Théry O. P., "Contribution à l'histoire de l'Aréopagitisme au IXᵉ siècle," *Le Moyen Âge* 25 (1923): 111–53; and Panofsky, *Suger,* p. 18.

37. Pseudo-Dionysius, *Letter 8,* in Ronald F. Hathaway, *Hierarchy and Definition of Order in the Letters of Pseudo-Dionysius* (The Hague, 1969), p. 146.

38. Marie-Dominique Chenu, "The Platonisms of the Twelfth Century," in *Nature, Man and Society in the Twelfth Century,* Jerome Taylor and Lester Little, eds. and trans. (Chicago, 1968), p. 82.

39. Marie-Dominique Chenu, "The Symbolist Mentality," in *Nature, Man and Society in the Twelfth Century* (Chicago, 1968), p. 115 n. 40. John is elaborating the principle, stated at the beginning of the "Celestial Hierarchy" by pseudo-Dionysius, that "it is not possible for our mind to be raised to that immaterial representation and contemplation of the heavenly hierarchies without using the material guidance suitable to itself, accounting the visible beauties as reflections of the invisible comeliness . . . and the ranks of the orders here, of the harmonious and regulated habit, with regard to Divine things." All English quotations from pseudo-Dionysius are taken from the English translation by John Parker, *The Works of Dionysius the Areopagite,* (reprint, London, 1976). The quoted passage is from "On the Celestial Hierarchy," p. 3. See also Grover A. Zinn's essay in this volume.

40. Chenu, "Symbolist Mentality," p. 123.

41. Panofsky, *Suger,* p. 19.

42. Chenu, "Symbolist Mentality," p. 132.

43. Ibid., p. 126.

44. Pseudo-Dionysius, *Ecclesiastical Hierarchy,* pp. 84–85.

45. Hathaway, *Hierarchy,* p. 142.

46. Ibid., p. 52.

47. Suger, *Vita Lud.* (W), p. 134.

48. Ibid., p. 86.

49. It is in this context that Suger's famous dictum that the king of France cannot do homage—or would, *si non rex esset*—should be understood. Not because it violates feudal custom (which before Louis VI's time is silent on this point), but out of an absolute ontological incapacity to break rank, to submit to a lower order of being. As with so much else in Suger's thought, the roots of his originality lie in his application of pseudo-Dionysian thought, in this case to feudo-vassalic relations. Suger's statement occurs in the context of Louis's assumption of the Oriflamme, the banner of the Vexin, which the king held in fief from Saint-Denis, at the time of Henry V's threatened invasion of France in 1124: " . . . *rex Francorum Ludovicus Philippi, accelerans contra imperatorem romanum insurgentem in regnum Francorum, in pleno capitulo beati Dionysii professus est se ab eo habere, et jure signiferi, si non rex esset, hominium ei debere . . . "* Suger, *Adm.* (L), p. 162.

50. Suger, *Vita Lud.* (W), p. 130.

51. Ibid., p. 222.

52. Ibid., p. 228.

53. Ibid., p. 230.

54. Ibid., p. 4.

55. Ibid., pp. 274–76.

56. Ibid., p. 272.

57. Ibid., p. 284.

58. Pseudo-Dionysius, *Ecclesiastical Hierarchy,* p. 86.

59. Ibid., p. 142.

60. Suger, *Vita Lud.* (W), p. 286.

61. Cf. the similar conclusion of Barbara Nolan with respect to Suger's rebuilding of the abbey church in her interesting book, *The Gothic Visionary Perspective* (Princeton, 1977), pp. xv, 46–50.

62. Suger, *Adm.* (L), p. 191.

63. Suger, *Vita Lud.* (W), p. 4.

64. Chenu, "Platonisms," p. 86.

Some New Readings of Suger's Writings*

Philippe Verdier

TWO TEXTS of Suger's writings concern the reconstruction of the abbey church of Saint-Denis and the enrichment of its art treasures. The first, which describes the consecration of the western part of the church in 1140 and the consecration of the chevet in 1144, was written shortly after the second ceremony. The second text covers the improvement of the abbey's financial welfare before giving an account, a sort of diary, of the remodeling and embellishment of the church; Suger finished writing it during the Second Crusade. These two texts are ordinarily quoted, respectively, under the references of *De consecratione* and *De administratione*. They can be found in their original form in only three manuscripts.[1]

De consecratione, titled *Suggerius abbas S. Dionisii de ecclesia a se aedificata*, was part of the library of Claude-Alexandre Petau when it was published in 1641 by François Duchesne in volume four of the *Historiae Francorum Scriptores*. Two pages were missing at the end, just after mention of the Main Altar. The pages were reconstructed in *Vetera Analecta*, by Mabillon, who used a manuscript from the Bibliothèque de Saint-Victor: *De renovatione ecclesie beati Dionysii*. The complete text of *De consecratione* was reproduced by Dom Félibien in his *Histoire de l'Abbaye Royale de Saint-Denys en France* (1706).

De administratione, *Suggerii abbatis liber de rebus in administratione sua gestis*, exists in a twelfth-century manuscript probably originating at Saint-Denis.[2] In 1641 Duchesne published a transcription of this text.

When Lecoy de la Marche edited the *Oeuvres complètes de Suger* in 1867, he inserted a few corrections, using the collation of the original *De administratione* manuscript; he was not aware, however, of the existence of two other *De consecratione* manuscripts. They were identified by Luchaire,[3] who published the variants of

the text in 1899.[4] Erwin Panofsky made a list of these variants and added his own in 1947.[5] The complete list is incorporated in the 1979 edition of Panofsky's work, *Abbot Suger on the Abbey Church of Saint-Denis and Its Art Treasures*, first published in 1946. Madame Gerda Panofsky-Sorgel is responsible for this new edition, which includes the post-1946 bibliography.[6]

The 1979 text and critical apparatus of *De consecratione* lend themselves to a few remarks and corrections. On page 88, line 10, *abhorrentes* must remain; it should not be changed to *abhorreres* nor be restituted as *adhaerentes*. On page 112, line 26, following the example of Félibien, one should read *cordis* (and not *corporis*) *intentione*. On page 106, lines 27–28, the *perlucidas et maculis distinctas smaragdines* somewhat jar because *perlucidas* and *maculis* contradict each other. These words should be amended as follows: *signaculis distinctas*, "[emeralds] detached from the royal signets" (according to the meaning of *distinctus* in classical Latin). On page 96, line 28, it is unnecessary to correct *emptioni et venditioni* to *emptione et venditione* in front of *teruntur*: Suger did not want to say that in the flea market of the Place Panetière, in front of the church, every article was worn out and spoiled by selling and buying; on the contrary, he meant that all sorts of junk were liquidated according to supply and demand. *Tero* can be translated here by "to sell off," as at a yard sale. Finally, on page 112, line 24, one should read *et* and not *ex* before *altioribus ecclesiae suae personis;* and, on line 34, *tanta* and not *intenta* before *tantarum personarum*.

On page 116, line 24, Panofsky read *septima manus* and offered a brilliant but overly subtle exegesis. Why not accept the correction *sceptrigera manus*, "the hand carrying the scepter," or the royal hand. This reading was suggested by Dom Brial in volume fourteen of the *Rerum gallicarum et francarum scriptores*, where the

Notes for this essay begin on page 161.

Benedictines of the congregation of Saint-Maur had given the abridged text of *De consecratione*. On June 11, 1140, Suger, Louis VII, and a group of bishops went down to the narrow Carolingian *confessio* to remove the relics of Saint Denis and his companions; the king was then himself urged to carry the silver reliquary containing the relics of the saint. However, the small *confessio* was so crowded that the royal hand was unable to reach the chasse. From the time of the Carolingian dynasty the king of France carried two scepters: in the right hand, or strong hand, he carried the *clavis David*, "the key of David"; in the left one, a rod topped with an ivory hand.[7] The two scepters must have hampered the king's movements in the *confessio*. From the end of chapter seven of *De consecratione* it can be deduced that the king used the short scepter, namely the rod, to help his guards drive back the crowd when, a little earlier on this same day, the procession reentered the church after having sprinkled the outside walls of the chevet with holy water: *"rex ipse ejusque decuriones tumultuosum impetum arcebant, et virgis et baculis regredientes ad portas protegebant"* (page 114, lines 25–27).

After I collated the *De administratione* text of the Bibliothèque Nationale manuscript, I felt entitled to make the following observations.

First, *tacita visus cognitione*, page 62, lines 4–5, has been kept by all previous editors. In the Bibliothèque Nationale manuscript *tacita* has been changed to *ascita*. I am referring to the retable[8] that Suger added to the altar frontal of Charles the Bald and to two gold *tabulae* that he had added to the sides of the altar. This gold retable had been so adorned with precious stones and pearls by Germanic goldsmiths invited to Saint-Denis that Suger composed *tituli* to describe the subjects represented. *"Et quoniam tacita visus cognitione materiei diversitas . . . absque descriptione facile non cognoscitur, opus . . . apicibus litterarum mandari fecimus."* Did Suger mean that the mute perception of the eye is inferior to the intellectual comprehension we today call a reading? *Ascitus* means "assumed," "borrowed." This is why I would prefer to retain the reading *ascita*, confirmed by the manuscript and therefore read as follows: "As it is difficult to grasp the meaning of a work overloaded with gold, precious stones, and pearls if one appeals only to one's eyesight without the help of a description. . . ."

Second, in folio 65r of the manuscript the following inscription, composed by Suger for the sardonyx ewer, which was set into a silver-gilt mounting and used for the Mass at the Altar of the Holy Martyrs and the Main Altar—*"Dum libare Deo gemmis debemus et auro/Hoc ego Suggerius offero vas Domino"*—has been added in three and a half lines that had earlier been left blank. Lecoy de la Marche attributed this addition to a sixteenth-century hand. Because of its technique and epigraphy, this inscription, in capital letters executed in niello on the silver-gilt base of the mounted ewer, is completely different from the inscriptions Suger had affixed to the Eleanor and Eagle vases. This inscription

was probably engraved when the base was repaired and gadroons added, around 1500.[9] Perhaps it was then copied into the manuscript. We have no way of knowing whether the goldsmith had access to a manuscript of *De administratione* different from the one that survives in the Bibliothèque Nationale or if he reproduced the inscription engraved on the damaged base.

The third text translated by Panofsky, the *Ordinatio,* a charter written after the consecration of the new western block in 1140, exists in a twelfth-century document in Paris, (Archives nationales, K. 23, no. 5). Suger stated there that in the nineteenth year of his abbacy the eighth-century nave (*antiquum opus*) was quite properly (*apte*) linked to the western block (*novum opus*) by an arcade supported by columns that harmoniously extended the elevation of the old nave (page 132, lines 29ff.). In *De consecratione* (page 94) Suger discussed the need for twelve main beams to complete the work in the nave. God gave him a sign[10] that they could be found in the deepest part of the forest of Iveline, in the Chevreuse valley. The trunks were carried in chariots to the *chantier,* and Suger ordered them *"novi operis operturae superponi"* (page 96, lines 9–10). The word *opertura* is used again in a later passage of the *De consecratione* (page 108, line 21). Here it refers to the roofing in the description of the storm that, on January 19, 1143—or 1144—shook the roof of the sanctuary above the rib vaults; the joins of the ribs and transverse arches had not yet had time to set, and no webs had been built between them. In the passage quoted above (page 96, lines 9–10), should we change *superponi* to *subterponi* and therefore understand that the beams were thrown across *under* the roof? However, *operturae* is a dative, and it is simpler to translate this section as, "I had the beams hauled over the walls to complete the roof."

I want to mention a case in which an archaeological problem can be solved through rereading Suger's texts. On June 9, 1140, three oratories were dedicated in the western block and its basilical link with the eighth-century nave: in the tribune on the reverse of the facade an altar was consecrated to the Virgin, Saint Michael and the Angels, and to Saint Romanus. Where, then, were the altars consecrated to Saint Hippolytus, on the northern side, and to Saint Nicholas, on the southern side? And why does Suger use *inferius* in describing their locations? The relevant passages are in *De consecratione* (page 96, lines 33–34; page 98, lines 1–8); in the *Ordinatio* (page 132, lines 31–35); and in *De administratione* (page 44, lines 18–27). It has always been stated that both altars were in the towers. The first floor of the twin towers is indeed at a level under that of the oratory between them.[11] There is, however, no trace of altars in the towers. The location of the two oratories *inferius* is roughly, but certainly, given in *De administratione*. They were *"in inferiori*[12] *testudine ecclesiae." Testudo,* in Suger's glossary, always meant "nave": *"mediam ecclesiae testudinem quam dicunt navim,"* from *De administratione* (page 50, lines 25–26); the eighth-century nave

is called *"antiqua testudo ecclesiae"* in *De consecratione* (page 100, lines 17–18). The link between the facade and the end of the part of the eighth-century nave kept by Suger, which was vaulted in its western part but covered with a wooden ceiling in its longer, eastern part,[13] was called *directa testudo,* the link in the axis of the old nave, in *De consecratione* (page 88, lines 30–31). That the oratories of Saint Hippolytus and Saint Nicholas were actually on the northern and southern non-vaulted parts of the link is proved by the treatise on relics owned by Saint-Denis up to 1215 found in the *Vita et Actus Sancti Dionysii.*[14] When Pope Alexander III paid a visit to Saint-Denis in 1163 an oratory was prepared for him in front of the marble altar consecrated to Saint Hippolytus. The Pope asked who was resting there. When he heard that it was Saint Hippolytus, he exclaimed, *"Non credo."*[15] At these words Saint Hippolytus's body started such a racket within the

altar that the doubts of Alexander III were dispelled and he consecrated the altar. The altar had already been dedicated in 1140, but Suger had expressed reservations about the authenticity of the relics.[16] The trick played by the monks seemingly justified a second consecration. The altar remained located *ante majorem crucifixum,* that is, leaning against the jube (which perhaps did not exist in Suger's time) in front of the monks choir.[17] We do not know exactly what sort of liturgical barrier dominated by the major crucifix existed between 1140 and Matthew of Vendôme's jube (after 1258). The relics were transferred, in 1236, to the chapel that is still today dedicated to Saint Hippolytus, the first west of the northern arm of the transept rebuilt in the Gothic rayonnant style.[18] According to the *Chronicon Sancti Dionysii ad Cyclos Paschales,* the relics had remained a long time *in media navi.*[19]

NOTES

*This essay was translated by Françoise Vachon.

1. The manuscript tradition has been summarized by Panofsky, *Suger,* pp. 141–45. See also Lecoy, *Oeuvres,* pp. ix–xx; cf. note 7 of the essay by Spiegel in this volume.

2. Paris, Bibliothèque Nationale, ms. lat. 13835.

3. They are: Rome, Biblioteca Apostolica Vaticana, cod. Reg. lat. 571 (former Petau library), folios 119r–29v; Paris, Bibliothèque Arsenal, ms. 1030, folios 137r–43v. In the first eleven lines of folio 81r of *Arsenal 1030* one can read the end of the *Sermo de Vexillo dicto L'Auriflambe,* and in folio 82r the beginning of the *Sermo de dedicatione.* On the punctuation of the end of *De consecratione* according to the manuscript of the Arsenal and the correction *Qui* (for *Quae*), p. 120, ll. 6–18, see Philippe Verdier, "La Grande Croix de l'abbé Suger à Saint-Denis," *Cahiers de Civilisation médiévale* 13 (1970): 1–31, esp. p. 8.

4. Achille Luchaire, "Les Oeuvres de Suger," *Études sur quelques manuscrits de Rome et de Paris* (Paris, 1899), vol. 8, pp. 1–5. Luchaire brought to light unpublished passages of *De consecratione* which were taken from a historical compilation of the fourteenth century (Paris, Bibliothèque Nationale, ms. lat. 5949A) in Achille Luchaire, "Une Très ancienne histoire de France," *Revue historique* 12 (1887): 271.

5. Erwin Panofsky, "Postlogium Sugerianum," *The Art Bulletin* 29 (1947): 119–21.

6. All my quotations refer to the pagination in the 1979 edition.

7. Hervé Pinoteau, "La Main de justice des rois de France; essai d'explication," *Bulletin de la société nationale des antiquaires de France,* 1978–79, pp. 363–64; and Claire Richter Sherman, "The Queen in Charles VI's Coronation Book," *Viator* 8 (1977): figs. 12, 15, 17 (which reproduces the illuminations of London, British Library, MS. Cotton Tiberius B. VIII, folios 58r, 59v, 63r, 64r.) The *virga,* or hand of justice, is described at article 115 of the *Inventaire de Saint-Denis* (1634) and reproduced in a watercolor by Gagnières: Paris, Bibliothèque Nationale, ms. fr. 20070, fol. 6. An engraving of it appears in Michel Félibien,

Histoire de l'Abbaye Royale de Saint-Denys en France (Paris, 1706), pl. IV, N (see page 294).

8. The reasons why Suger's *tabula* was actually a retable have been explained in my article, "Saint-Denis et la tradition carolingienne des *tituli*," *Mélanges René Louis* (Paris, 1982), pp. 348–51.

9. Blaise de Montesquiou-Fezensac, and Danielle Gaborit-Chopin, *Le Trésor de Saint-Denis, III, Planches et notices* (Paris, 1977), pp. 41–42. Also see the essay by Gaborit-Chopin in this volume, p. 289 and note 32.

10. The *intersignis* (*Cons.* [P], p. 96, l. 17), the signs from God, are revelations or premonitions of divine character rather than miracles. Villiers de l'Isle Adam used the word *intersigne* in this way still in the nineteenth century.

11. Sumner McK. Crosby, "The Inside of Saint-Denis' West Facade," in Margarete Kühn and Louis Grodecki, eds., *Gedenkschrift Ernst Gall* (Berlin and Munich, 1965), p. 59, fig. 34.

12. The *tabula aurea,* or antependium, of Saint-Denis's altar in the chevet is termed *superior,* Suger, *Adm.* (P), p. 54. Artists painted the stained glasses *"tam superius quam inferius,"* in the chevet as well as in the western block and the link. Suger, *Adm.* (P), p. 72, ll. 30–31.

13. Sumner McK. Crosby, *The Abbey of Saint-Denis I* (New Haven, 1942), vol. 1, pp. 94, 118, 150–54. Panofsky, *Suger,* p. 150.

14. Charles Liebman, Jr., *Étude sur la vie en prose de Saint Denis* (Geneva and New York, 1942), pp. xvi–xix, 204ff. Rigord confirmed that the Saint Hippolytus altar was in the nave, east of Pepin the Short's tomb. Soissons, Bibliothèque municipale, ms. 129, fol. 136 v.

15. The pope's skepticism was not unfounded. Hippolytus, martyred antipope of the A. D. 235 persecution, was said to have been buried in the cemetery on Via Tiburtina. But the fabrics given by Pope Leo IV (795–816) for being deposited on the tomb in the basilica at Porto would substantiate the tradition after which Charles the Great would have obtained relics of

Hippolytus from Leo IV. They would have been deposited at Orswiller, in Alsace (Cella Fulradi). See Pasquale Tartini, "San Ippolito all'Isola Sacra," *Atti della Pontificia Accademia di Archeologia,* ser. 3, vol. 43 (1971–72): 223–58. Saint-Denis possessed two reliquaries of Saint Hippolytus, one for the body, a copper chasse, and a silver-gilt reliquary containing a bone of the saint. Montesquiou-Fezensac and Gaborit-Chopin, *Le Trésor,* nos. 313, 315.

16. "*. . . inferius . . . in sinistro [latere] [oratorium] ubi sanctus requiescere perhibetur Hippolitus,*" Suger, *Cons.* (P), p. 98, ll. 6–7. The body of Saint Hippolytus would have been obtained by Fulrad from Pope Stephen III in 763 and deposited at Fulrado-Villiers, Saint-Bilt, in the diocese of Metz. See Félibien, *Histoire,* p. 53. In Fulrad's will (Félibien, *Histoire,* pièces justificatives, vol. 1, pp. xxxviii–xxxix) this cella is called Audaldo-Villare. Another cella in the Vosges region is called Fulrado-cella. On Saint-Bilt (Bliterstorf), near Sarreguemines, see Suger, *Adm.* (L), p. 183; and Suger, *Ch.* (L), pp. 323, 367.

17. A drawing by the Jesuit architect Martellange in Paris, Bibliothèque Nationale, Cabinet des Estampes (Db. 9), shows the jube built during the abbacy of Matthew of Vendôme (1258–86), topped by the wooden crucifix that Suger had erected there, if we are to believe Jacques Doublet, *Histoire de l'abbaye de Saint Denys en France* (Paris, 1625), p. 286. The oldest examples in France of a *crux triumphalis* between the mourning figures of the Virgin and Saint John, as at Saint-Denis, are the wooden statues of the Virgin and Saint John transferred from the jube at Cerisiers to Sens cathedral (ca. 1200), and an engraving showing the destroyed jube in Chartres cathedral (ca. 1230). But a *crux triumphalis* erected in the nave, at the traditional spot of the altars of the Cross in Carolingian abbey churches, is mentioned in the *Speculum de Mysteriis Ecclesiae,* attributed to Hugh of Saint-Victor. Reiner Haussherr, "Triumphkreuzgruppen der Stauferzeit," *Die Zeit der Staufer* (Stuttgart, 1979), vol. 5, pp. 131ff.; cf. pp. 136–37.

18. Sumner McK. Crosby has hypothesized that the body of Saint Hippolytus was, at the time of Suger's abbacy, buried under the ruins of the tower of William the Conqueror. He had located the tower between the transept and the northern side of the Carolingian abbey church. The body would have been found when the ground was cleared in order to begin the 1231 reconstruction of the choir, transept, and nave of the church. The body would have been carried to his new chapel (the same as that of today), close to the previous location of the tower. The texts are however categorical: the body stayed in the nave until 1236.

19. Élie Berger, ed., *Chronicon Sancti Dionysii ad Cyclos Paschales,* Bibliothèque de l'École des Chartes 40 (1879): 270ff.; cf. pp. 281, 290 in the *Petite Chronique de Saint-Denis;* and Félibien, *Histoire,* pièces justificatives, vol. 2, p. ccv, where "*a parte Sancti Hippolyti*" refers to the achievement of the reconstruction of the choir on the *northern* side of the church.

The Problem of
Manuscript Painting at Saint-Denis
During the Abbacy of Suger[*]

Harvey Stahl

THE MANUSCRIPTS owned and produced at an institution like Saint-Denis are potentially both a source and an expression of the larger religious and cultural life that flourished there. For the study of Saint-Denis during the abbacy of Suger, the evidence of manuscripts may be especially significant. Even though relatively few of the abbey's manuscripts are known today, they are of sufficient importance to show that the abbey possessed one of the major collections of manuscripts in northern Europe. It housed Late Antique and Carolingian works, manuscripts in both Greek and Latin, luxury codices, and historical and literary as well as sacred and theological texts.[1]

The abbey's books are likely to have interested Suger in several ways. On the one hand, they provided specific ideas and texts, like those of pseudo-Dionysius the Areopagite, which Suger could have found in the library both in Hilduin's Latin version and in the Greek codex from which it was translated.[2] On the other, certain books, such as those donated by Charles the Bald and perhaps by Charlemagne, must have suggested to him the abbey's privileged link to France's Carolingian past and may thus have constituted an important institutional symbol.[3] One would naturally like to know what else the abbey library made available to Suger and how, publicly or privately, he may have used it. Of no less interest is learning if the library's contents influenced the building and decorative programs he began, and if artistic activity during his tenure included the production and decoration of new manuscripts.

These questions are difficult to answer, for relatively little is known about the library and manuscript production at Saint-Denis during the twelfth century or, for that matter, during most of the Middle Ages.[4] Suger hardly mentions the library or books in his writings, and references in documents and texts are rare.[5] Medieval catalogues are not preserved, and the library itself was pillaged and its contents dispersed several times, beginning in the sixteenth century.[6] Thus only a small portion—perhaps five percent—of the books belonging to the abbey in the twelfth century has been identified, the characteristics of manuscript production there have never been described, and so far not one illumination dating from the time of Suger has been attributed to the abbey.

That Suger does not cite important manuscripts in his writings is of limited significance. The text where he would be most likely to refer to them is *De administratione*. There his concern is principally with what he himself commissioned or had restored, and the non-architectural works he refers to are primarily liturgical objects remarkable for their materials and craftsmanship.[7] In this context one would expect him to mention any fine liturgical manuscripts or precious bindings made during his administration. Several such manuscripts and bindings were inventoried in the treasury alongside works he does describe, and, although seven of the sixteen manuscripts we know existed in the treasury still survive, none clearly dates to the second quarter of the century.[8] Thus neither Suger's writings nor any preserved books provide evidence that he commissioned precious liturgical manuscripts or repaired the old ones. But in his writings he would have had little reason to mention the fine manuscripts already in the abbey's collection or those of lesser quality or of non-liturgical purpose made during his abbacy.

If it is not possible to show that Suger himself was a patron of fine manuscripts, there can be no doubt that during his abbacy, as at other times, production facilities existed at Saint-Denis and new manuscripts were made. A scriptorium would have been essential to provide the new and revised works necessary for the

Notes for this essay begin on page 174.

performance of the Mass, to replace old manuscripts and copy new ones, and to draw up documents and charters. Paleographical evidence indicates a scriptorium active there in the eighth and ninth centuries, and documents make it clear that manuscripts were produced, illuminated, and repaired at the abbey in the thirteenth.[9] There is no reason to believe, therefore, that this activity was interrupted in the twelfth. In fact, several Saint-Denis charters dating from Suger's abbacy are written in book hands similar to those found in manuscripts belonging to the abbey at the same time.[10] Furthermore, two activities frequently undertaken at Saint-Denis in the twelfth century involve books and manuscript production: the collection and study of texts related to Saint Denis and to pseudo-Dionysius the Areopagite; and the writing of chronicles and treatises, including those by Suger himself.[11]

If some in-house production of manuscripts continued without interruption at Saint-Denis, manuscripts may also have been purchased from outside and specialists are likely to have been brought in for specific tasks. This was the case there in the thirteenth century and it would not be surprising if it had been in the twelfth, when we know artists were brought in to work in other media.[12] The investigation of manuscript production at Saint-Denis should then allow for two possible types of activity: a persistent, indigenous tradition, at least of routine quality, but quite possibly significant or becoming so; and the evolution of new forms arising from outside sources but nonetheless responsive to and perhaps just as distinctive of the abbey at the time.

The study of Saint-Denis manuscripts is naturally contingent on assembling a corpus of identifiable works. But very few manuscripts have inscriptions or other similarly definite documentation of origin.[13] Normally, one might still identify Saint-Denis manuscripts on the less precise basis of physical characteristics, that is, the scribal, artistic, and production traits of the abbey. For most periods, however, the manuscripts of known Saint-Denis origin are too few to establish the broad criteria necessary for attribution on this basis alone.[14] The identification of Saint-Denis manuscripts and the development of criteria for attribution must thus proceed from a comparative analysis of the large number of manuscripts that can be associated with the abbey because of shelf marks, later inscriptions, or other evidence. Assuming that in certain periods the abbey produced at least some of the manuscripts the community possessed and used, such an analysis should lead to the identification of a group of manuscripts with a range of consistent production traits, some of which would occur also in works known to have been made at the abbey. Together with such secondary evidence as text, liturgical use, and medieval provenance, the analysis should point compellingly to a Saint-Denis origin for the entire group.

Any study of Saint-Denis manuscripts thus depends upon first identifying the large number of manuscripts owned and used at the abbey, wherever they may have originated. Effectively, this means the reconstitution of the abbey's libraries.[15] This task essentially began in 1868, when Delisle published a list of about seventy-five manuscripts identified on the basis of ownership inscriptions and, more importantly, thirteenth- and fifteenth-century class marks.[16] Since then other manuscripts with similar markings have been recognized, but only in recent years, with the help of modern catalogues and special studies, such as that of Donatella Nebbiai, approximately two hundred more have been assigned a Saint-Denis provenance.[17] Those with library class marks form the largest group—over 125 manuscripts—and include the most significant works today associated with Saint-Denis. In addition to these an important number of manuscripts without library markings may be attributed to the abbey's collections on the basis of inventories, such as those of the treasury, or of documents attesting to the manuscripts' having been donated, borrowed, seen, or copied there.[18] Still others may be tentatively assigned a Saint-Denis provenance because of liturgical or textual indications directly associated with the abbey.[19]

The recognition of physical characteristics of Saint-Denis production will make it possible to attribute additional manuscripts to the abbey and to advance the systematic study of the library and manuscript production there during various periods. Two factors may be expected to facilitate such a study. First, the chronological distribution of manuscripts of known Saint-Denis provenance provides a reasonable enough sampling of all major periods from the ninth to the fourteenth centuries that it will be possible to test for consistent production characteristics at different dates.[20] Second, many Saint-Denis manuscripts were acquired by a few well-known collectors of the late fifteenth and early sixteenth centuries. Several of their libraries remained relatively intact and eventually entered into public collections.[21] It is in these modern libraries and subcollections that most Saint-Denis manuscripts have so far been identified and where, no doubt, others remain to be discovered.[22]

Almost forty twelfth-century manuscripts or fragments of Saint-Denis provenance have been identified, with almost half falling into distinct chronological groups displaying consistent production characteristics. The approximate dates of eleven of these fall within the abbacy of Suger, and eight are likely to have been made at the abbey.[23] It is a small group but one in which noteworthy drawings or illuminations are to be found in three manuscripts: a Greek codex of the Divine Office, a copy of Origen's *Homilies,* and an antiphonal. A separate study would be required to describe all the relevant twelfth-century manuscripts and their production characteristics. What follows is a discussion of the three works of artistic interest, the features leading to their attribution to the abbey, and some of the larger questions they raise.

Fig. 1. Manuscript containing the Divine Office in Greek (Paris, Bibliothèque Nationale, ms. gr. 375, fol. 1r), Christ Enthroned in Judgment, detail (also showing text of verso)

The earliest work is a pen drawing on the first folio of Paris, Bibliothèque Nationale, ms. gr. 375, a manuscript dating from 1022 and containing the Divine Office in Greek (fig. 1).[24] It was certainly at Saint-Denis by the twelfth century: pericopes, translations, and notes were added in several twelfth-century hands, one of which mentions Abbot Odo of Taverny (1162–69). The text later served as the source for the fourteenth-century Greek additions to a ninth-century sacramentary that was in the church treasury.[25] The parchment of the first folio is worn and damaged, but the central drawing is of fine quality and merits careful study.[26]

The drawing represents the enthroned Christ seated erectly on a globe, his feet on a semicircle, his right arm and part of his chest bare. Both hands are open to show his wounds, but his right arm extends nearly straight out from his shoulder and the left is lower and extends away from his side. The words *Videte*

manus meas et pedes (Luke 24:39) are written in a twelfth-century hand in the open book near his lap. The other inscriptions, the circular forms behind and above Christ and in the corners, and the Four Symbols of the Evangelists are slightly later, perhaps of the early thirteenth century.

The text of the inscription in the book comes from the episode of Christ's last appearance to the apostles, but the scene is one of enthronement in which the display of the wounds is the key element.[27] This combination of enthronement and wounds begins to figure importantly in Western art from the late eleventh century, especially in representations of the Last Judgment and of Christ with the Instruments of the Passion, or *Arma Christi*.[28] The contrast in Christ's gestures occurs in representations of both subjects. It is derived from Matthew 25:31–46 and signifies his acceptance of the blessed and rejection of the damned at the Last Judgment.[29] These gestures in scenes of the *Arma Christi* also suggest a context of judgment, and Schiller correctly refers to Christ in such representations as the "Judge of the World."[30] Our drawing, however, shows neither the Instruments of the Passion nor the usual elements associated with the Last Judgment. It does nonetheless seem to reflect these themes and, in its twelfth-century state, may have been an incomplete sketch or study.

The book on Christ's lap is the most unexpected part of the drawing. The book occurs in a number of theophanies, especially the *Maiestas Domini* and the Second Coming, and is based in part upon Revelation 5:1 and 20:12.[31] It also occurs in some versions of the *Arma Christi* but is not essential to that subject and may reflect the influence of representations such as the *Maiestas*.[32] This may well be the case in our drawing too, for the book is peculiarly out of place in the composition. Christ displays the wounds in both hands and thus cannot hold the book, which seems to be suspended over his lap just to the right of center, about where he would have held it in one of the traditional theophanies. Our drawing may well be based on a traditional model of this type, and archaic details, such as the globe throne and arc footrest, indeed suggest that it was inspired by an earlier work.[33] We shall see that the style of the drawing points to the same conclusion.

The drawing may thus be an attempt to work judgmental themes into the context of a traditional theophany. It is interesting that this dichotomy was apparently understood by the artist who worked on the page a half century or so later. The inscription above Christ makes it clear that he has returned to judge, but the Four Symbols of the Evangelists placed in the corners effectively transform the page into a *Maiestas*.[34] The later artist thus maintained and extended, rather than resolved, the differences in subject. This interweaving of themes of Judgment and the Second Coming occurs elsewhere at this time and is one of the concerns of the designer of the sculptural program of the west central por-

2

3

4

5

6

Fig. 2. *Missal of Saint-Denis (Paris, Bibliothèque Nationale, ms. lat. 9436, fol. 15v), Christ Enthroned*

Fig. 3. Origen, *Homilies (Paris, Bibliothèque Nationale, ms. lat. 1626, fol. 160v), initial Q*

Fig. 4. *Antiphonal of Saint-Denis (Paris, Bibliothèque Nationale, ms. lat. 17296, fol. 73v), initial Q*

Fig. 5. Origen, *Homilies (Paris, Bibliothèque Nationale, ms. lat. 1626, fol. 80r), initial S*

Fig. 6. Origen, *Homilies (Paris, Bibliothèque Nationale, ms. lat. 1626, fol. 35v), initial S*

tal of Saint-Denis.[35] Although our drawing has no relation to the portal sculpture, it shows that similar problems were being thought through earlier at the abbey and that sources already available there may have played a role.

The style of our drawing suggests that one such source was a work of the eleventh century. The slim, elongated torso; the swift, elliptical arcs of the robe; the continuous curve of the silhouette, especially to the right of the shoulder and arm; and the careful drawing of folds defined by double lines, one thick and one thin, are features of eleventh-century manuscripts, especially from the north of France. A particularly relevant example is the so-called Missal of Saint-Denis, a work made at Saint-Vaast in Arras and in all likelihood at Saint-Denis in the early twelfth century (fig. 2).[36]

However, if some details of the drawing recall the eleventh century, its most advanced aspects point to the twelfth: the figure has a new erectness and bearing, the head is more independent and finely modeled, and there is a new clarity of facial structure. Similar characteristics occur in the dedicatory miniature of a manuscript of Guibert of Nogent's *Tropologia,* made not far from Paris at Nogent-sur-Coucy and recently dated 1120–24.[37] The Saint-Denis drawing may therefore slightly precede Suger's abbacy or date from its first years.

The second of our three manuscripts from Saint-Denis is a copy of Origen's *Homilies* (Paris, Bibliothèque Nationale, ms. lat. 1626), a manuscript finely decorated with eighteen large initials containing vine and floral motifs and usually including animals and human figures.[38] The manuscript has Saint-Denis class marks of the thirteenth and fifteenth centuries and may be attributed to the abbey partly on the basis of its relation to an antiphonal of Saint-Denis use (Paris, Bibliothèque Nationale, ms. lat. 17296).[39] Like other Saint-Denis office books, the antiphonal does not have library class marks, but it is assignable to the abbey because of its many chants for the feasts of Saint Denis's birth and death, including the vigils and octaves. As we shall see below, the antiphonal was copied directly from a Saint-Denis manuscript of the eleventh century, and the antiphonal's single illumination is stylistically related to contemporary stained glass at the abbey.

The antiphonal slightly postdates the *Homilies* but repeats two of its three types of initials. The first type, one found throughout the *Homilies,* is a simple penned initial with secondary decorative lining but no floral forms or background. Although relatively plain in conception, this specific type recurs identically in numerous examples in both manuscripts (figs. 3 and 4). The second and more distinctive initial is the kind with floral and other motifs already mentioned (figs. 5 and 6). Although these motifs constitute only a small part of the full-page historiated initial in the antiphonal, they develop in a similar

Fig. 7. Antiphonal of Saint-Denis (Paris, Bibliothèque Nationale, ms. lat. 17296, fol. 136v), initial A

way from the extremities of winged dragons and share particular features, such as the distinctive curl and contour of the leaf forms (figs. 5 and 7). Both manuscripts also exhibit an unusual type of vine that splits open, its scalloped sides only partly enclosing a hollow core or pod (figs. 6 and 7).[40]

The principal initials in the Origen manuscript are stylistically related to a group of miniatures and initials cut from a large Romanesque bible and now dispersed in several European and American collections. Swarzenski first published the group and attributed it to England because of similarities in decoration to such works as the Lambeth Bible.[41] Cahn has recently noted the relation of the *Homilies* to the bible cuttings and, while acknowledging the presence of English elements, has attributed them to northern Burgundy or Champagne on the basis of similarities to

a bible from Sainte-Colombe at Sens and to other works.[42] This latter localization is sound, and the connection of the Origen manuscript to work from this area points up one of the important sources for painting at Saint-Denis. But, as we shall see, the Origen manuscript differs from the bible cuttings in several respects and these differences also provide a useful perspective on painting at the abbey.

The initial from the Book of Daniel best demonstrates the relation of the group of bible cuttings to the Origen manuscript (figs. 8 and 9). In addition to the very similar floral and animal motifs, there is a common conception in the design and rhythm of forms as well as in the technique. Both manuscripts are executed with a careful pen line, delicately modeled with washes and set against lightly colored ink backgrounds. The differences are minor in these examples: the forms of the Origen initial are smaller and thinner, the rhythms milder, the balance of color tone more subtle.[43]

Some initials in the Origen manuscript are not related to the bible cuttings but nonetheless point to the same region of France. For example, several of the bible fragments have small, thin-limbed figures with finely traced folds (fig. 17), whereas the figures in the Origen manuscript are for the most part more squatly proportioned, have full chests and round limbs, and folds that are more sharply defined, sometimes in bold triangular patterns (figs. 10 and 18). These characteristics are also found in Clairvaux manuscripts (fig. 11) and, more commonly, in Mosan-

related styles, perhaps as early as the 1140s.[44] The Origen manuscript thus seems to draw upon a broader and perhaps slightly more advanced range of sources from the same region.

The Origen manuscript also differs from the bible cuttings in the kinds of English characteristics it incorporates, and this may well point to a still different source of influence. The clearest example is found in an initial that bears a striking resemblance to those in the first volume of the Winchester Bible in Oxford (figs. 12 and 13).[45] The density of entwined motifs and the specific leaf forms, with edges curled in series and with gripping lobes and nodule caps, indicate the vocabulary of the so-called Master of the Entangled Figures, an artist who worked at Winchester and elsewhere from about 1140.[46]

A different but contemporary English style may be reflected in several of the finest Origen initials (fig. 5). In these the floral forms have a particularly elegant sweep of line and either end in small, delicately turned leaf forms or open in broad petals with a fine undulating edge. This type of initial, so dependent upon mastery of line, is found in a number of English schools around 1140, such as that of St. Albans (fig. 14).[47]

The careful drawing and expert use of washes in these initials might suggest the hand of an English artist. Works of comparable technique and quality are found, however, in the nearby French provinces,[48] and one other Origen initial suggests that northern France may have played an intermediary role (fig. 15). That initial has a distinctive acanthus ornament, with striated

Fig. 8. Below left: Origen, Homilies *(Paris, Bibliothèque Nationale, ms. lat. 1626, fol. 41v), initial M*

Fig. 9. Below right: Bible (Toledo Museum of Art), initial A

8

9

10

11

12

13

Fig. 10. Origen, Homilies *(Paris, Bibliothèque Nationale, ms. lat. 1626, fol. 117r), initial M*

Fig. 11. Saint Augustine, Expositio in Psalmos *(Troyes, Bibliothèque municipale, ms. 40.4, II, fol. 2v), initial O*

Fig. 12. Origen, Homilies *(Paris, Bibliothèque Nationale, ms. lat. 1626, fol. 33r), initial V*

Fig. 13. Bible (Oxford, Bodleian Library, Ms. Auct. E. inf. 1, fol. 281r), initial V

Fig. 14. Manuscript from St. Albans (Oxford, Bodleian Library, Ms. Auct. D. 2. 6., fol. 6v), Occupation of the Month, detail of a calendar page

14

Fig. 15. Origen, Homilies (Paris, Bibliothèque
Nationale, ms. lat. 1626, fol. 151v),
initial O

Fig. 16. Bible of William of Carilef (Durham Cathedral
Library, Ms. A. II. 4, fol. 65r), Psalms, initial B

vine forms and short, curled leaves, features of Norman-influenced works on both sides of the English Channel from the late eleventh century (fig. 16).[49] It is not possible at this time to determine if these initials as well as others in the Origen manuscript were influenced by England directly or through continental, probably northern French, intermediaries. It is clear, though, that English influence appears in the Origen manuscript more selectively and in a distinctively different way than in the bible fragments. The Origen manuscript thus seems to reveal an independent and characteristic response to northern French or English sources, just as it did to those of Burgundy and Champagne. At an important center like Saint-Denis, this diversity of sources is not surprising and is paralleled by work there in other media.[50]

The question, then, is whether or not a meaningful direction emerges from the various sources and styles we have seen and, if so, what this suggests about artistic activity at the abbey. The answer may best be seen in an initial that represents Christ enthroned, the only non-decorative initial in the Origen manuscript and artistically the most revealing one (fig. 18). What is distinctive in the miniature may best be seen by first comparing it to the representation of David Enthroned with his Four Musicians from the group of bible cuttings (fig. 17).[51]

The figure of David is of the small, thin-limbed type referred to earlier. His chest and lower body are conceived as a single unit, his small torso developing without interruption into the swelling contour of his lap and legs. The lower body is described by thin lines that spread across and display its shape.[52] These slight and curving forms contrast boldly with the four corner units and their diagonal sides, which have the appearance of metal borders, and which lock the figure in and also suggest, by passing behind his feet, that his body projects out and in front of the picture plane.

The Origen Christ presents a notably different conception of the figure and of its relation to a setting. His body is the fuller type discussed earlier but, in comparison to David, the internal forms of the body are more linear, geometric, and spatially progressive. The repeating forms on the torso are strongly blocked in and enlarge upward toward the shoulders, and the hooked lines over the left leg and right arm are slightly bowed and are drawn with a pen held at an angle. These lines thus appear to be incised at intervals into a round form, so that they articulate mass and at the same time create surface tension. Proportions have changed, the body has lost its ductility, and the hands, arms, and feet are softly modeled. Not only is the treatment more sculptural but the body is beginning to be subdivided into large areas

that play against each other, especially the swelling chest in relation to the compact lower legs. These two areas are in turn related to the double structure of the mandorla, which is subsidiary to the figure but echoes its internal shapes and unifies the composition. The figure is thus more still and imposing, for its elements, all known earlier, have begun to experience a reintegration, with a resulting gain in clarity, focus, and concentration. The vocabulary of motifs may still be Romanesque, but there are new formal values at work that betoken a rationality and monumentality that are essentially proto-Gothic.

Some of these features are well known in Burgundian works, in sculpture if not in painting. The tendencies toward a more simplified monumentality and rational integration of form are familiar in large-scale Cluniac sculpture; and the use of multiple incised lines to sustain surface tension, among other purposes, is characteristic of sculpture at Vézelay, Autun, and elsewhere.[53] But no works before 1140 bring both currents together in quite the same way as the Origen Christ does, and although the west portal of Saint-Denis is approximately contemporary with the Origen Christ, its style and sources are different, even if the point of view is not entirely dissimilar.[54]

One may be hard put to find a work precisely comparable to the Origen Christ, but the evolution of which it is a part is nonetheless familiar, for it soon led to the central west portal of Chartres. To be sure, the Origen Christ, like the Christ of the west portal at Saint-Denis, lacks the logic and euphony, the syntax and humanity of Gothic; yet, as we have seen, it is no longer quite Romanesque. Instead, it represents an experiment and direction typical of advanced work about 1140. And so far it is the earliest manuscript from the Paris region to bring the evidence of painting to bear on the familiar problem of the sources and development of early Gothic art.

The principal illumination in the antiphonal cited previously is a full-page initial *A* which introduces and illustrates the Easter antiphon *Angelus domini* (fig. 7).[55] In contrast to the other drawings and illustrations we have seen, this is a large-scale composition fully painted in bright, saturated colors. In the upper part of the letter is a half-length representation of Christ blessing and holding an open book. He is approached by two angels who stand on rocky hillsides drawn into the corners of the miniature beyond the diagonal sides of the letter. Bent slightly forward, they hold closed books, the angel at the right offering his with covered hands. The lower part of the initial represents the Three Women at the Tomb.

The iconography of the lower scene is conventional but the upper one merits comment. Although the text of the antiphon accounts for the juxtaposition of Christ and the angels with the scene below, there are unusual or unprecedented features in the absence of borders, the half-length figure of Christ without man-

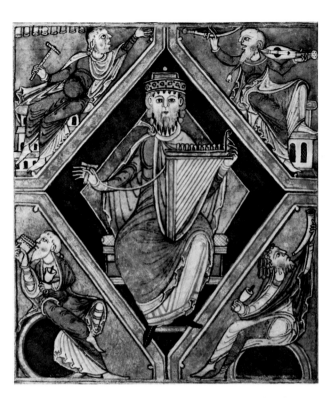

Fig. 17. Bible cutting (Paris, Bibliothèque Nationale, ms. lat. 6755, no. 2, fol. A), David and the Musicians

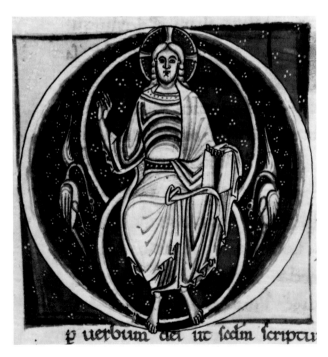

Fig. 18. Origen, Homilies *(Paris, Bibliothèque Nationale, ms. lat. 1626, fol. 60v), initial O with Christ Enthroned*

dorla, the placement of the angels outside the letter on an extraneous hillside, and the unusual way they bend forward and offer books rather than hold censers. It is likely that this part of the miniature was based on a model showing a full-length figure of the enthroned Christ and that the artist abbreviated the figure and rearranged other elements of his model, perhaps to make room for the lower scene.

The actual model for the antiphonal miniature apparently survives in a fine eleventh-century gradual of Saint-Denis use known to have been preserved at the abbey at least until the fifteenth century.[56] Anne Walters, who has studied the musical and liturgical relations of the two manuscripts, has found that the antiphonal list at the end of the eleventh-century manuscript served as a guide for the twelfth-century work and that several anomalies the manuscripts have in common also indicate the same kind of dependence.[57]

This dependence may also be seen in the gradual initials. One of them (fig. 19) contains a full-length figure of Christ enthroned

Fig. 19. Gradual of Saint-Denis (Paris, Bibliothèque Mazarine, ms. 384, fol. 95v), initial R with Christ Enthroned

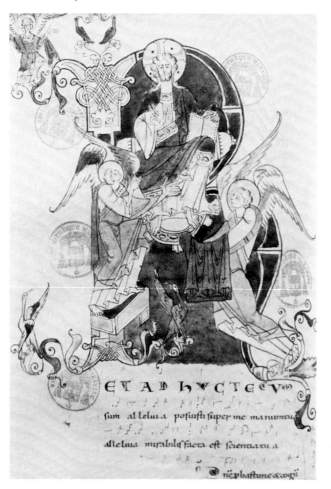

and holding a book; like the antiphonal miniature, it is unframed and there is no mandorla. Below are two angels, partially outside the initial: the one at the left exclaims with open, uncovered hands; the one at the right, who holds up Christ's footstool, partly kneels and has covered hands thrust outward to support it. It would appear that when the antiphonal artist cut off the lower half of his model, presumably to add the scene of the Three Women, he transferred the angels to the sides and gave them books but retained the gestures (the covered hands and extended arms of the angel at the right) from their former context. The details that made no sense in the antiphonal miniature are thus all explained by the drawing in the gradual. It is therefore likely that the antiphonal artist had this very gradual under his eyes, another indication of the abbey's continued reliance on earlier and especially eleventh-century models.

The antiphonal miniature is of modest quality and is a pastiche stylistically as well as iconographically. The elements are cramped, there are awkward changes in scale, and the elaboration given to the corners diffuses the focus without really balancing the composition. The garments of Christ and, to a lesser extent, of the angel on the tomb are articulated by large triangular forms and elastic ridges of fold characteristic of byzantinizing work, widespread in Europe and found at Saint-Denis itself, notably in the Tree of Jesse window (Grodecki fig. 1).[58] In contrast, the more modeled forms of the angel at the upper right are reminiscent of contemporary Mosan styles, especially in the way the full, rounded forms of the body emerge through the robes. Here too, significantly, precedents are to be found in contemporary sculpture and glass at the abbey.[59] Still other stylistic currents are reflected in the figures of the Three Women, whose tall bodies, weak and restrained gestures, and large rounded faces recall similar features in panels from the Life of Saint Benedict window at Saint-Denis (Grodecki fig. 2).[60] To the antiphonal artist these styles were apparently no more than modes of painting he could variously combine. Unlike the artists of the Origen, who attempted a synthesis of styles from various regions, the antiphonal artist seems to have depended upon the diverse stylistic and iconographic sources already available at the abbey itself. He may well have been trained at Saint-Denis during Suger's rebuilding program, and the manuscript may therefore date from the very end of Suger's abbacy, or slightly later.

Apart from its figural style, the antiphonal miniature's general presentation recalls stained glass. Its colors are saturated and uniformly warm, and they are arranged by hue in distinct and evenly lit patches. Each figure is effectively constituted of two colors corresponding to its robe and mantle, and these colors, discrete yet analogous, contrast to the warmer color of the background, which almost entirely surrounds each figure and seems to create a setting for it. The shape of the initial and the major forms of the composition delimit five such backgrounds, and

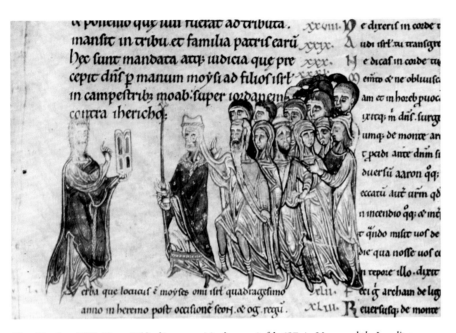

Fig. 20. Sens Bible (Sens, Bibliothèque municipale, ms. 1, fol. 157r), Moses and the Israelites

Fig. 21. Bible from Chartres (Paris, Bibliothèque Nationale, ms. lat. 55, fol. 218v), initial O with Malachias and the Angel

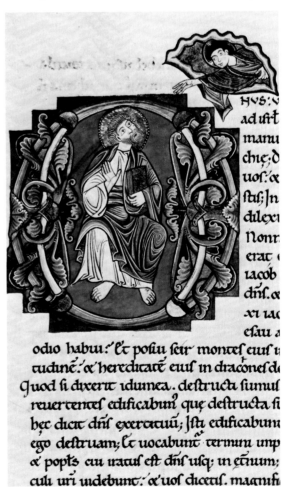

they alternate in color as if they were separate panels and link up the parts of the miniature. Color thus adds considerably to the interest and legibility of the miniature, and its distribution provides an element of balance that the composition alone does not. Its use is no more refined than are the other aspects of the miniature, such as the drawing, but it plays an unexpected role.

These relationships between the antiphonal miniature and stained glass are not sufficiently close to show that some Saint-Denis artists worked in both media or that one medium significantly inspired the other. But they do underscore what the two media have in common as painting, despite their differences in scale and technique, and they remind us that both glass and manuscript painting must be considered when exploring the larger problems of painting at the abbey.[61] In this sense, two manuscripts not made at Saint-Denis are relevant to our discussion, for their links to the stained glass at the abbey provide a somewhat larger perspective on several of the subjects we have discussed, and suggest new directions for research.

The first is the Bible from Sainte-Colombe at Sens, already mentioned as a Burgundian work related to the group of bible cuttings and thus, secondarily, to the Origen manuscript. One hand in this manuscript paints in a Cluniac style with Italo-Byzantine characteristics such as one finds in the frescoes at Berzé-la-Ville (fig. 20).[62] This style does not appear in the manuscripts we have attributed to Saint-Denis, but Caviness has compared the Cluniac frescoes to two windows at the abbey, those of the Tree of Jesse (see Grodecki fig. 1) and of Saint Vincent (see Caviness fig. 11).[63] Even aside from its relationship to

these ateliers, the Sens manuscript is of interest because it represents the kind of link which must have existed between southern Burgundy and those more northern regions that, as we have seen, may have directly influenced work at the abbey. It also demonstrates the importance of this style among the others available in the region, and the possibility of meaningfully distinguishing among Dionysian styles now generically referred to as "byzantinizing."[64]

The second manuscript is a two-volume folio bible made at Chartres in the mid-twelfth century and having Saint-Denis class marks of the mid-thirteenth century.[65] Its large illuminated initials include figures which recall the kings in the abbey's Tree of Jesse window but are painted in a more mannered style occurring widely in the Paris region just after mid-century (fig. 21).[66] The ornamental motifs in the initials are of particular interest, however, for they are very similar to the borders of several windows at Saint-Denis.[67] Such large, expensive, multivolume bibles tended to be more stationary than other kinds of manuscripts, and so the fact that this one belonged to Saint-Denis at least by the mid-thirteenth century raises the possibility that it was produced at Chartres expressly for the abbey. A relationship between the two institutions is suggested in any case by certain Chartrain motifs occasionally appearing in Saint-Denis manuscripts.[68] Whatever the intended destination of this bible, it presents the familiar problem of artistic relationships between Saint-Denis and Chartres. Further research on manuscripts from both sources is required to sort these problems out, but it may not be too early to suggest that in manuscript painting as apparently in other media, their artistic relationship changes and takes on a new interest after the death of Suger.[69]

The three works discussed above—the drawing in the Greek manuscript, the Origen manuscript, and the antiphonal—yield only a bare sketch of manuscripts illuminated at Saint-Denis in the early twelfth century. Dating approximately from the 1120s, 1140s, and 1150s, they share certain physical characteristics and a common decorative vocabulary, but they provide no evidence that a single style of painting developed consistently over a thirty-year period. Nor is there evidence of a major scriptorium there at this time, although work at some level must have gone on continually. Suger's primary interest in books may have been in the historically significant ones the abbey already possessed, but, for manuscripts as for other works, he was apparently ready to draw upon outside sources. The manuscripts we have studied suggest the abbey both relied on its own resources and had more cosmopolitan interests: on the one hand, we saw several references to eleventh-century works in the abbey's collections and parallels at mid-century to its new stained-glass windows; on the other, influences from important artistic centers in nearby regions and a spirited experimentation that anticipates important developments of the future. In its own way each work was linked to the abbey and to the characteristic concerns of that time and place.

Even though the antiphonal may be considered a modest work, this does not necessarily indicate a decline in manuscript painting at the abbey; unillustrated works of the second half of the century from Saint-Denis are often of fine quality and, after all, these three manuscripts should be considered only as a starting point for future studies. One hopes that such studies will lead to the identification of other illuminated manuscripts and a more precise definition of the hallmarks of Saint-Denis's production. It remains to be seen whether or not the apparently occasional works we have studied will eventually form part of a real tradition or school, and what differences there ultimately are in intention and vision between works produced at Saint-Denis and those commissioned and obtained for it.

NOTES

* I am especially grateful to François Avril of the Bibliothèque Nationale and to Alphons Stickler of the Vatican Library for permitting me to examine the numerous manuscripts necessary for the preparation of this study. Donatella Nebbiai, who also compiled listings of the manuscripts once belonging to Saint-Denis, generously permitted me to read her important dissertation and to incorporate several points into this revised text. I am also grateful to Monsieur Avril, Adelaide Bennett, Elizabeth A. R. Brown, Walter Cahn, Danielle Chopin-Gaborit, Patricia Stirnemann, R. M. Thomson, and Anne Walters for advice and assistance on specific points, and to James Marrow for his helpful critical reading of the text.

1. Several important manuscripts, especially those housed in the treasury, are cited by such early authors as Jacques Doublet, *Histoire de l'abbaye de S. Denys en France* (Paris, 1625), pp. 15, 222, 264, 346ff., 1347ff.; and Michel Félibien, *Histoire de l'abbaye royale de Saint-Denys en France* (Paris, 1706), pp. 96, 317, 411–17, 540–43. The first discussion of the library or scriptorium itself is in Félicie d'Ayzac, *Histoire de l'abbaye de Saint-Denis en France* (Paris, 1861), vol. 2, pp. 138–56. For later studies of the Saint-Denis library and of the manuscripts the abbey owned, see Léopold Delisle, *Le Cabinet des manuscrits de la Bibliothèque Nationale* (Paris, 1868), vol. 1, pp. 6, 200–207 and vol. 3, p. 356; Germain Lebel, *Catalogue des actes de l'Abbaye de Saint-Denis relatifs à la province ecclésiastique de Sens de 1152 à 1346* (Paris, 1935), pp. xxvi–xxxi; Émile Lesne, *His-*

toire de la propriété ecclésiastique en France (Lille, 1938), vol. 4, pp. 591–94; and Charles Samaran, "Études Sandionysiennes, I: Notes sur la bibliothèque de l'abbaye de Saint-Denis au XVᵉ siècle," *Bibliothèque de l'École des Chartes* 104 (1943): 5–26. The most recent and complete study and listing is now Donatella Nebbiai, "Histoire de la bibliothèque de Saint-Denis-en-France," thèse du 3ᵉ cycle (University of Paris, 1980), to be published in the near future. The important early manuscripts belonging to the abbey are discussed in Charles Samaran, "En Marge du *Romanus* de Vergile [Vat. 3867]," *Revue des études latines* 7 (1929): 334–47; Carl Nordenfalk, *Vergilius Augusteus* (Graz, 1976); Elias A. Lowe, *Codices Latini Antiquores* (Oxford, 1953), pt. 6, pp. xxvi–xxvii; Leo Mohlberg, ed., *Missale Francorum*, Rerum Ecclesiasticarum Documenta, series maior, fontes 2 (Rome, 1957); and Jean Vezin, "Hincmar de Reims et Saint-Denis," *Revue d'histoire des textes* 9 (1979): 289–98.

2. The Greek original of the works of pseudo-Dionysius is contained in Paris, Bibliothèque Nationale, ms. gr. 437. Translations are preserved in several copies; the only one I have been able to examine, Paris, Bibliothèque Nationale, ms. lat. 15645, is of the late twelfth century and appears to be of Saint-Denis origin. See Henri Omont, "Manuscrit des oeuvres de S. Denys l'Aréopagite envoyé à Louis le Débonnaire en 827," *Revue des études grecques* 17 (1904): 230–36; *Byzance et la France médiévale*, exhib. cat. (Bibliothèque Nationale, Paris, 1958), p. 3, no. 6; and Percy E. Schramm and Florentine Mütherich, *Denkmale der deutschen Könige und Kaiser* (Munich, 1962), no. 19, pp. 120ff.

3. The tradition that Charlemagne offered the abbey a psalter, which was written in gold letters and belonged to his wife, Hildegard, is first recorded in the late thirteenth century in the *Grandes Chroniques;* see Léopold Delisle, review of Montague R. James, *The Western Manuscripts in the Library of Trinity College, Cambridge* in *Journal des Savants* (1900), pp. 730ff., who cites the relevant passages and connects the psalter with one of similar description which Herbert of Bosham saw at Saint-Denis and recorded in his own psalter, now Cambridge, Trinity College, MS. B. 54. For manuscripts donated by Charles the Bald and Odo, see Delisle, *Le Cabinet*, vol. 1, p. 6; Schramm and Mütherich, *Denkmale*, p. 65; and Blaise de Montesquiou-Fezensac and Danielle Gaborit-Chopin, *Le Trésor de Saint-Denis* (Paris, 1973–77), vol. 1, pp. 6–8, and vol. 3, pp. 129ff. For manuscripts donated by Fulrad, see Ayzac, *Histoire*, vol. 2, p. 509.

4. See note 1 here, esp. Nebbiai, "Histoire," esp. pp. 35–39.

5. Suger, *Adm.* (L), pp. 160–61, 181, and *Vita Lud.* (W), pp. 216–18, in which Suger speaks of reading the abbey's documents as a youth in connection with the Argenteuil charter. For William of Saint-Denis's comments on Suger's reading habits, see his *Vita Sug.* (L), pp. 382–89. Also see notes 3 and 11 here.

6. Louis Carolus-Barré, "Pillage et dispersion de la bibliothèque de l'abbaye de Saint-Denis," *Bibliothèque des l'École des Chartes* 138 (1980): 97–101; and Nebbiai, "Histoire" pp 130ff.

7. Suger, *Adm.* (P), pp. 41ff., and 53–81, esp. 62–64.

8. Montesquiou-Fezensac and Gaborit-Chopin, *Le Trésor,* vol. 1, pp. 6–9, vol. 2, pp. 200–213, and vol. 3, pp. 67–73, 83–87. The seven preserved manuscripts all have bindings that are restored or entirely remade. Several of the preserved covers exhibit the characteristics of Saint-Denis or Parisian craftsmanship (for example, Paris, Bibliothèque Nationale, mss. lat. 9436; n.a. lat. 305; and perhaps Paris, Musée du Louvre MR. 416), but they are bound with manuscripts made elsewhere and none dates to the first half of the twelfth century. Only two of the seven manuscripts appear to have been produced at Saint-Denis: Paris, Bibliothèque Nationale, mss. n.a. lat. 307 and 1420, which date to the early twelfth and early thirteenth centuries, respectively. The former contains Gospel and Epistle readings for use at Saint-Denis and probably predates Suger by a few years. It is unlikely that the tenth century(?) ivories that were part of its binding in the sixteenth century were associated with it in the twelfth. In Félibien's engraving, the metalwork borders surrounding the ivories resemble those of other late thirteenth- and fourteenth-century covers he had engraved; for example, compare pls. 56b, 57b with 53a, 53b.

9. See Georges Tessier, "Originaux et pseudo-originaux carolingiens du chartrier de Saint-Denis," *Bibliothèque de l'École des Chartes* 106 (1945–46): 35–69, esp. 47–55; and Jean Vezin, "Le Point d'interrogation, un élément de datation et de localisation des manuscrits. L'Exemple de Saint-Denis au IXᵉ siècle," *Scriptorium* 34 (1980): 181–96; see also May Vieillard-Troïekouroff, "Art carolingien et art roman parisien," *Cahiers archéologiques* 16 (1965): 75–105. On the question of a Carolingian school of painting at the abbey, see the recent summary in Herbert Kessler, *The Illustrated Bibles from Tours* (Princeton, 1979), p. 7 n. 34. On the thirteenth century, see Robert Branner, *Manuscript Painting in Paris during the Reign of Saint Louis* (Berkeley-London, 1977), pp. 9, 87, who believes that many manuscripts made for Saint-Denis at this time were painted by professional artists in Paris; however, the excerpts from the fiscal accounts published in Ayzac, *Histoire*, vol. 2, pp. 147–52, suggest that manuscripts continued to be produced at the abbey. See also the list of liturgical manuscripts in the essay by Niels Rasmussen in this volume, pp. 41–42.

10. See especially Paris, Archives nationales, K. 23 nos. 5, 15; K. 24; J. 168, no. 31, and Rome, Vatican Library, cod. Reg. lat. 571. Françoise Gasparri, *L'Écriture des actes de Louis VI, Louis VII et Philippe Auguste* (Paris-Geneva, 1973), p. 21, notes the unusually book hand character of the script found in the acts relevant to Saint-Denis.

11. The study of texts related to Denis and to pseudo-Dionysius cannot be considered apart from the larger subject of Greek studies at the abbey. See Élie Berger, ed., "Annales de St.-Denis, généralement connues sous le titre de Chronicon sancti Dionysii ad cyclos paschales," *Bibliothèque de l'École des Chartes* 40 (1879): 278; Delisle review of James, *Western Manuscripts,* pp. 725–32; Omont, "Manuscrit," pp. 230–36; Gabriel Théry, "Documents concernant Jean Sarrazin, réviseur de la traduction Érigénienne de Corpus Dionysiacum," *Archives d'histoire doctrinale et littéraire du moyen-âge* 18 (1950): 45–87; Roberto Weiss, "Lo Studio del greco all'abbazia di San Dionigi durante il Medioevo," *Rivista di Storia della Chiesa in Italia* 6 (1952): 426–38; and Michel Huglo, "Les Chants de la 'Missa greca' de Saint-Denis," in Jack Westrup, ed., *Essays presented to Egon Wellesz* (Oxford, 1966), pp. 74–83. For the chronicles, see Gabrielle Spiegel, *The Chronicle Tradition of Saint-Denis: A Sur-*

vey (Brookline, Mass., and Leiden, 1978), esp. pp. 39–55. The charters and *Ordinatio* (Paris, Archives nationales, K. 23 no. 55) are the only writings by Suger preserved in exemplars dating from his lifetime. *De Consecratione* (Rome, Vatican Library, cod. Reg. lat. 571) may have been started about the time of his death but is finished in a later hand (after fol. 129v). The earliest copies of his letters (Paris, Bibliothèque Nationale, ms. lat. 14192 fols. 1r–22r) and of the *Vita Ludovici grossi* (Paris, Bibliothèque Mazarine, ms. 2013 and Bibliothèque Nàtionale, ms. lat. 17546) would appear to date from the second half of the twelfth century on the basis of script and secondary decoration. There is no evidence that the latter manuscript was ever at Saint-Denis; for the other manuscripts, see notes 23 and 40 here. The Paris copy of *De Rebus in Administratione* (Bibliothèque Nationale, ms. lat. 13835), which was dated by Panofsky, *Suger,* p. 143, to the twelfth century, seems to me to be from the first quarter of the thirteenth. Of special interest is a problematic coronation rite (Paris, Bibliothèque Nationale, ms. lat. 14192 fols. 73r–83r), in the same collection of *membra disjecta* cited above for Suger's letters. The *ordo* was never part of a larger work, such as a pontifical, but seems to have been intended as a small, fine, easily readable document, much like the mid-thirteenth-century coronation rite in Paris, Bibliothèque Nationale, ms. lat. 1246. Its script, lining, and modest secondary decoration are not inconsistent with Saint-Denis work of about 1130–50 but are only distinctive enough for an attribution to the Paris region. The possibility of the manuscript's connection with the coronation of Eleanor of Aquitaine, in which Suger played an important role, has been discussed by Elizabeth A. R. Brown in a paper, " 'Franks, Burgundians, and Aquitanians' and the Royal Coronation Ceremony in France: The *Ordo* of Paris, Bibliothèque Nationale, ms. lat. 14192," delivered at the International Conference on Medieval Coronations, Toronto, 31 January to 2 February, 1985.

12. For the thirteenth century, see note 9 here; for the twelfth, see Suger, *Adm.* (P), pp. 43, 57.

13. See, for example, Paris, Bibliothèque Nationale, ms. lat. 17371, which contains a colophon indicating that the largest part of the text—St. Jerome on Jeremiah—was copied on the order of Fardulfus, abbot of Saint-Denis from 793 to 806; see Delisle, *Le Cabinet,* vol. 1, p. 202, vol. 3, p. 240; and Lowe, *Codices,* vol. 5, p. 42, no. 668.

14. The notable exception has been attributions of ninth-century manuscripts on the basis of paleographical evidence; see Vezin, "Le Point," pp. 181–96.

15. It was not unusual at the time for abbeys to keep manuscripts in several different locations; see Jean Dufour, *La Bibliothèque et le scriptorium de Moissac,* École des Hautes Études, Centre de Recherche d'Histoire et de Philologie, vol. 5 (Geneva and Paris, 1972), pp. 13ff.; Danielle Gaborit-Chopin, *La Décoration des manuscrits à Saint-Martial de Limoges et en Limousin du X^e au XII^e siècle,* École des Chartes, Mémoires et Documents, vol. 18 (Geneva and Paris, 1969), p. 27; A. J. Piper, "The Libraries of the Monks of Durham," in Malcom B. Parkes and Andrew G. Watson, eds., *Medieval Studies, Manuscripts and Libraries: Essays Presented to N. R. Ker,* (London, 1978), pp. 220–23; and André Vernet, *La Bibliothèque de l'abbaye de Clairvaux du XII^e au*

XVIII^e siècle (Paris, 1979), vol. 1, pp. 15ff. For the locations of libraries at Saint-Denis, see Nebbiai, "Histoire," pp. 74ff.

16. Delisle, *Le Cabinet,* vol. 1, pp. 200–207. The class marks frequently occur independently of an inscription or *ex libris.*

17. In addition to Nebbiai, "Histoire," see, among others, H. O. Coxe, *Bodleian Library, Quarto Catalogues, II. Laudian Manuscripts* (Oxford, 1973), pp. xvi–xvii (this is a reprint of the 1858–85 edition with additions and corrections by Richard W. Hunt); Donatien Bruyne, "Membra disjecta," *Revue bénédictine* 36 (1924): 121–31; Paul Lehmann, "Skandinavische Reisefrühte," *Nordskrift Tidskrift för Bokoch Bibliotekväsen* 21 (1934): 165–69; Otto Homburger, "Die Herkunft einer Berner Horaz-Handschrift. Einer Beitrag zur Bibliotheksgeschichte von Saint-Denis," *Der Schweizer Sammler* 16 (1942): 7–9; Elisabeth Pellegrin, "Possesseurs français et italiens de manuscrits latin du fonds de la Reine à la Bibliothèque Vaticane," *Revue d'histoire des textes* 3 (1973): 272–75; and François Dolbeau, "Anciens possesseurs des manuscrits hagiographiques latins conservés à la Bibliothèque Nationale à Paris," *Revue d'histoire des textes* 9 (1979): 204, 213, 218, 232.

18. For donations and treasury inventories, see notes 3 and 8 here. Other listings of manuscripts or titles are found in Lebel, *Catalogue,* pp. xxvi–xxxi; André Vernet, "Un Programme de lectures spirituelles à l'abbaye de Saint-Denis à la fin du XIV^e siècle," *Bulletin de la Société nationale des Antiquaires de France* (1970): 208–14; and Nebbiai, "Histoire," pp. 12–16 and annex 13. Treasury, liturgical, and non-Latin manuscripts ordinarily do not have library class marks, although in some cases markings were added at a later date as the manuscripts passed among the internal collections of the abbey. For example, Paris, Bibliothèque Nationale, ms. lat. 256, an eighth-century evangeliary in uncial script was at Saint-Denis at least by the ninth century (Vezin, "Le Point," p. 188) but has only fifteenth-century class marks; the absence of thirteenth-century library markings may reflect only its being stored separately with other service books. The same may be true for Paris, Bibliothèque Mazarine, ms. 526, an important Saint-Denis ceremonial dated 1234–47, which lacks class marks for the thirteenth and fifteenth centuries but has inscriptions and stamps of the seventeenth and eighteenth centuries; see Charles Samaran and Robert Marichal, *Catalogue des manuscrits en écriture latine* (Paris, 1959), vol. 1, p. 245.

19. See, for example, Victor Leroquais, *Les Sacramentaires et les Missels manuscrits des bibliothèques publiques en France* (Paris, 1924), vol. 1, pp. 19, 64ff., 142–45, vol. 2, pp. 73, 140ff., 292ff.; D. Ph. Schmitz, "Les Lectures de table à l'abbaye de Saint-Denis vers la fin du Moyen-Âge," *Revue bénédictine* 17 (1930): 163–67; and D. Ph. Schmitz, "Les Lectures du soir à l'abbaye de Saint-Denis au XII^e siècle," *Revue bénédictine* 44 (1932): 147–49. For early exemplars of texts, see note 11 here. Other Dionysian texts known in twelfth-century copies which belonged to the abbey are: Paris, Bibliothèque Nationale, ms. lat. 18061 and Rome, Vatican Library, cod. Reg. lat. 67 (Dionysius Areopagita, *Liber de coelesti hierarchia*), neither of which was copied there; Paris, Bibliothèque Nationale, ms. lat. 15645 (Hilduin, *Vitae S. Denys*) deriving from Paris, Bibliothèque Nationale, ms. gr. 437 (see notes 2 and 40 here); and Paris, Bibliothèque Nationale, ms. lat. 2445A (*Passio et Miracula*

S. Dionysii), rejected by Nebbiai on the basis of doubtful class marks but having characteristically late twelfth-century Dionysian pen work.

20. The chronological distribution is roughly: ninth century—21 percent; tenth century—10 percent; eleventh century—6 percent; twelfth century—13 percent; thirteenth century—23 percent; and fourteenth century—13 percent, with the remaining 14 percent almost equally divided between the earlier (fifth- to eighth-century) and later (fifteenth- to sixteenth-century) periods. These figures use a base of 275 manuscripts and dates either drawn from published catalogues or, for about half of the manuscripts, resulting from personal examination.

21. For an excellent survey of the problem and insights on many specific collectors and manuscripts, see Nebbiai, "Histoire," pp. 148–75. Saint-Denis manuscripts figured importantly in at least a dozen collections but two were especially significant. The first, that formed by Jacques-Auguste de Thou, incorporated medieval manuscripts once belonging to several other collectors of Saint-Denis manuscripts, including Pierre Pithou, Claude Depuy, and Nicolas LeFèvre; de Thou's collection was acquired in 1680 by Colbert and is now part of the Bibliothèque Nationale in Paris. The second is the extraordinary collection of some fifteen hundred manuscripts that belonged to Paul Petau and his son Alexandre. Most of these were acquired in 1650 by Isaac Vossius for Queen Christina of Sweden. The queen's collection and part of Vossius's own, both of which included manuscripts from Saint-Denis and elsewhere, now constitute the Reginensis collections of the Vatican Library, although some are to be found among the Vatican Ottoboni manuscripts and others are in Leyden, Stockholm, and elsewhere; similarly, Petau's manuscripts have been identified in libraries in Paris, Geneva, London, and Oxford. Manuscripts from the collections of de Thou and Pithou are being studied by Marie-Pierre Lafitte of the Bibliothèque Nationale, to whom I am grateful for information on several works; however, all these important late-sixteenth and early-seventeenth-century collections require systematic study. For the Bibliothèque Nationale, Paris, the basic work for the moment remains Delisle, *Le Cabinet,* but for other collections and collectors see, among others, Karel A. de Meyier, *Paul en Alexandre Petau en de Geschiedenis van hun Handschriften* (Leiden, 1947); Christian Callmer, *Königin Christina, ihre Bibliothekare und ihre Handschriften,* Acta Bibliothecae regiae Stockholmensis, 30 (Stockholm, 1977); Jeanne Bignani-Odier, "Le Fonds de la reine à la Bibliothèque Vaticane," *Collectanea Vaticana in Honorem Anselmi M. Card. Albareda,* Studi e Testi, 219 (Vatican City, 1962), vol. 1, pp. 159–89; Jeanne Bignani-Odier, *Premières recherches sur le fonds Ottoboni,* Studi e Testi, 245 (Vatican City, 1966); Pellegrin, "Possesseurs," pp. 271ff.; Elisabeth Pellegrin "Liste des manuscrits provenant de Paul et Alexandre Petau conservés à la Bibliothèque Royale de Stockholm," *Bulletin d'information de l'Institut de Recherche et d'Histoire des Textes* 3 (1954): 19–31; and Hippolyte Aubert, "Notices sur les manuscrits conservés à la Bibliothèque de Genève," *Bibliothèque de l'École des Chartes* 70 (1909): 247–302, 471–522, and *Bibliothèque de l'École des Chartes* 72 (1911): 279–313, 556–99.

22. To judge from the shelf numbers, the manuscripts of known or suspected Saint-Denis provenance today number fewer than 10

percent of the total inventoried in the main library alone in the fifteenth century; see Nebbiai, "Histoire," pp. 104ff. Aside from such prominent exceptions as the Second Bible of Charles the Bald (Paris, Bibliothèque Nationale, ms. lat. 2), the loss of manuscripts of scripture is striking. An overall picture of the collections is thus impossible to construct at present; in particular areas, however, such as saints' lives and some classical texts, the impression given by the preserved works and by those known only by title generally corresponds to the range of holdings described for Bury St. Edmunds by Rodney M. Thomson, "The Library of Bury St. Edmunds in the Eleventh and Twelfth Centuries," *Speculum* 47 (1972): 617–45, esp. 627ff., 632ff. See also the twelfth-century inventory of the library of Cluny published in Delisle, *Le Cabinet,* vol. 2, pp. 458–81.

23. The eight manuscripts, most of which are discussed in the text and notes of this study, are: Paris, Bibliothèque Nationale, ms. gr. 375 fol. 1r (*Miscellanea: Officium,* and so forth; see note 24 here); ms. lat. 17371 fols. 199r–201r (*Miscellanea: Hieronymus in Jeremiam,* and so forth; see notes 13 and 40 here); ms. lat. 2581 (Gilbertus Porretanus, *Glossa super Epp. Pauli*); ms. lat. 1626 (Origenes, *Homiliae;* see notes 38, 40, and 42 here); ms. lat. 17296 (*Antiphonarium;* see note 39 here); Paris, Bibliothèque Mazarine, ms. 2013 (*Miscellanea: Ex genere Priami,* and so forth; see notes 11 and 40 here); Rome, Vatican Library, cod. Reg. lat. 571 fols. 72r–129v (*Miscellanea: Gesta Dagoberti, De consecratione;* see note 10 here, and Pellegrin, "Possesseurs," p. 275); and cod. Reg. lat. 2079 (Vitruvius, *De Musica;* see Elisabeth Pellegrin et al., *Les Manuscrits classiques latins de la Bibliothèque Vaticane* [Paris, 1978], vol. 2, pp. 504ff.). Three additional twelfth-century manuscripts that may have been produced slightly before or after the abbacy of Suger are discussed elsewhere in these notes: Paris, Bibliothèque Nationale, ms. n.a. lat. 307 (*Evangelarium et Epistolarium;* see note 8 here); ms. lat. 14192 (note 11 here); and ms. lat. 16820 (note 40 here). From the period of Suger may be noted three other manuscripts that belonged to Saint-Denis, although their attribution to the abbey is at present doubtful: Paris, Bibliothèque Nationale, ms. lat. 2504 fols. 77r–123r (Gislibertus de Stanfordia, *Expositio in Canticum Canticorum*); ms. lat. 4937 fols. 1r–27r (*Antenor et alii*); and ms. lat. 17813 (*Commentarium in Porphyrium*).

24. See Delisle, *Le Cabinet,* vol. 1, p. 204; Henri Omont, *Facsimiles des manuscrits grecs datés de la Bibliothèque Nationale du IXᵉ au XIVᵉ siècle* (Paris, 1881), p. 27, pl. XIV; Kirsopp and Silvia Lake, eds., *Dated Greek Manuscripts to the Year 1200* (Boston, 1935), IV/2, p. 12, no. 149; and Huglo, "Les Chants," p. 80. Folio 1 is original to the codex and is the only one with twelfth-century decoration.

25. Paris, Bibliothèque Nationale, ms. lat. 9387; see Weiss, "Lo Studio," pp. 427–29; and Montesquiou-Fezensac and Gaborit-Chopin, *Le Trésor,* vol. 2, pp. 256ff., vol. 3, pp. 86ff.

26. The damage the folio has suffered evidently made it necessary to consolidate the parchment in a paraffinlike substance. To be well seen and photographed, the folio must be backlit, which is the case in our figure 1, where the Greek text of the verso shows through the parchment and makes a palimpsest of the page.

27. Contemporary scenes based on this portion of Luke generally illustrate Christ's promise or commission to the apostles, not

their recognition of him; see A. Fabre, "L'Iconographie de la Pentecôte," *Gazette des Beaux-Arts,* 5th ser., 23 (1923): 33–42; and Meyer Schapiro, *The Parma Ildefonus. A Romanesque Illuminated Manuscript from Cluny and Related Works* (New York, 1964), pp. 43ff.

28. Beat Brenk, *Tradition und Neuerung in der christlichen Kunst des ersten Jahrhunderts. Studien zur Geschichte des Weltgerichtsbildes* (Graz-Vienna-Cologne, 1966), esp. pp. 238–42; Beat Brenk in Engelbert Kirschbaum, ed., *Lexikon der christlichen Ikonographie* (Rome, 1972), p. 4, col. 519; Willibald Sauerländer, "Uber die Komposition des Weltgerichts-Tympanoms in Autun," *Zeitschrift für Kunstgeschichte* 29 (1966): 261–64, esp. 276ff.; Yves Christe, *Les Grands portails romans: Études sur l'iconographie des théophanes romanes* (Geneva, 1969), pp. 103–33; and Gertrude Schiller, *Ikonographie der christlichen Kunst* (Gutersloh, 1968–71), vol. 2, pp. 200–202.

29. The gestures of Christ in the tympana at Beaulieu, Conques, and St. Georges de Camboulas are particularly similar to those in the drawing; see Christe, *Portails,* pp. 268ff.

30. Schiller, *Ikonographie,* vol. 2, pp. 201ff.

31. Christe, *Portails,* pp. 135–53; Frederick van der Meer, *Maiestas Domini, théophanies de l'Apocalypse dans l'art chrétien* (Rome-Paris, 1938); Schiller, *Ikonographie,* vol. 3, pp. 233–49; also Louis Grodecki, "Le Problème des sources iconographiques du tympanum de Moissac et l'occident au XIᵉᵐᵉ siècle," *Actes du Colloque internationale de Moissac, 1963* (Toulouse, 1964), pp. 59–68.

32. Most similar to our drawing are the representations on the bronze doors at Verona and in a Regensburg manuscript of the *De laudibus sanctae crucis;* see Albert Boeckler, *Die Bronzetur von San Zeno* (Marburg, 1931), p. 14, pl. III, fig. 31; and Albert Boeckler, *Die Regensburg-Prüfeninger Buchmalerei des XII. und XIII. Jahrhunderts* (Munich, 1924), p. 40, pl. XXXV, fig. 39.

33. The two motifs occur throughout the twelfth century but in the drawing Christ sits on the upper rim of a full circle, his feet at its approximate center, and there is no mandorla. The motifs go back to early Christian art but most relevant to our drawing is their appearance together in Carolingian art; see Kessler, *Illustrated Bibles,* p. 38 and figs. 52, 54; and Schiller, *Ikonographie,* vol. 3, pp. 242–45.

34. The inscription above Christ's head reads, *Ita sed [e]tur dominu{s} quando judicabit seculum.*

35. Christe, *Portails,* pp. 129, 150–52; Adolf Katzenellenbogen, *The Sculptural Programs of Chartres Cathedral* (Baltimore, 1959), p. 25; and Willibald Sauerländer, *Gotische Skulptur in Frankreich 1140–1270* (Munich, 1970), pp. 26ff. For the iconography of the central portal at Saint-Denis, see Paula Gerson, "The West Facade of St.-Denis: An Iconographic Study" (Ph.D. diss., Columbia University, 1970), pp. 98–139, and her essay in this volume, pp. 188–90. Gerson points out that the central portal iconography uses Matthew's *Last Judgment* with very few elements drawn from Apocalyptic iconography.

36. Paris, Bibliothèque Nationale, ms. lat. 9436; see Montesquiou-Fezensac and Gaborit-Chopin, *Le Trésor,* vol. 3, pp. 70–72 with bibliography. The treatment of the drapery folds ultimately derives from Anglo-Saxon painting; see, for example, Elżbieta Temple, *Anglo-Saxon Manuscripts 900–1066, A*

Survey of Manuscripts Illuminated in the British Isles, vol. 2 (London, 1976), figs. 86, 302.

37. Paris, Bibliothèque Nationale, ms. lat. 2500; see Monique-Cécile Garrand, "Le Scriptorium de Guibert de Nogent," *Scriptorium* 31 (1977): 3–29, pl. 1B.

38. Delisle, *Le Cabinet,* vol. 1, p. 201. Previously in the collections of Lefèvre, de Thou, and Colbert.

39. René-Jean Hesbert, *Corpus Antiphonalium Officii,* Rerum Ecclesiasticarum Documenta, Series Maior, Fontes VIII (Rome, 1965), esp. vol. 2, pp. xi–xv. G. M. Beyssac, "Le Graduel-antiphonaire de Mont-Renard," *Revue de musicologie* 39 (1957): 131–50.

40. Two other manuscripts related to the Origen and the antiphonal suggest the larger tradition of which they are part. The first is the Miscellany, Paris, Bibliothèque Mazarine, ms. 2013, a compilation of historical texts that Spiegel, *Chronicle Tradition,* pp. 40ff., associates with the beginning of the tradition of historical writing at Saint-Denis. The manuscript was begun about 1120, continued to about 1131, and was completed about 1160 with the addition of Suger's *Vita Ludovici grossi;* it has thirteenth- and fifteenth-century class marks and inscriptions. This manuscript and the Origen are of the same general size and format and are similar in the quality and preparation of parchment, script, and even in some lining dimensions. The two works are by no means sister manuscripts—there are variations in measurements and quality within each one—but the similarities they do share are noteworthy and, furthermore, extend to slightly earlier and later works associated with the abbey, such as the twelfth-century addition to the Fardulfus codex (Paris, Bibliothèque Nationale, ms. lat. 17371 fols. 194r–201r) and the late twelfth-century Miscellany (Paris, Bibliothèque Nationale, ms. lat. 15645). The second manuscript is Paris, Bibliothèque Nationale, ms. lat. 16820, a lectionary made for Saint-Corneille at Compiègne and containing readings for numerous major Saint-Denis saints. Its text initials have floral and animal forms similar to those in the Origen but rendered with the exuberance of its last penned initials; compare for example, fol. 67v in the lectionary with fols. 80r and 180v in the Origen. The lectionary also provides several parallels to the antiphonal; compare, for example, the latter's fol. 229r to fol. 122r in the lectionary. The lectionary may well have been made at Saint-Denis for Compiègne about 1150, when Suger chose Odo of Deuil, soon to be his successor, to reestablish order at Saint-Corneille. However, no Saint-Denis manuscript of a size and type similar to the lectionary has been identified so that production characteristics cannot be used to attribute it to the abbey. The lectionary's initials have certain similarities to Amiens, Bibliothèque municipale, mss. 142–43, which Merindol has shown to have been made for, but not at, Corbie about 1150. However, the initials in the Corbie manuscript do not have the fineness of line one finds in the Compiègne lectionary; see Christian de Merindol, *La Production des livres peints à l'abbaye de Corbie au XIIᵉ siècle* (Lille, 1976), vol. 1, pp. 20ff., 290ff.; and compare his figs. 71–73, 82, and 148 to fols. 94r, 117v, and 90r, respectively, in the lectionary.

41. Hans Swarzenski, "Fragments from a Romanesque Bible," *Gazette des Beaux-Arts,* 6th ser., 62 (1963): 70–82.

42. Walter Cahn, *Romanesque Bible Illumination* (Ithaca, 1982), p. 269, no. 59 for the bible fragments, and p. 281, no. 110 for the Sens Bible and the related manuscripts, including the Origen. More recently, François Avril, "Les Arts de la couleur," *Les Royaumes d'Occident*, L'univers des formes, ed. André Malraux et al. (Paris, 1983), p. 192, attributes the bible fragments to Champagne or the Ile-de-France and also connects with it the Origen manuscript which he considers as *"probablement d'origine dionysienne."*

43. In the Toledo miniature the background is blue and the initial and floral forms are reserved but tinted in green and decorated with gold bands edged in red. The Origen initials, in contrast, generally have backgrounds of blue, red, tan, and green, with the initial forms colored throughout in thin tan and green washes.

44. François Bibolet, "Les Manuscrits de Clairvaux au XII^e siècle," *Congrès archéologique de France* 113 (1955): 117; and Cahn, *Bible Illumination*, p. 281. For Mosan works, see, for example, the four gabled reliquaries in Brussels and related works discussed in *Rhein und Maas, Kunst und Kultur 800–1400* (Brussels-Cologne, 1972), vol. 1, pp. 242–51. The problem of dating the metalwork and the related manuscripts, which have been put into the 1130s by Chapman and Klemm, is judiciously reviewed by Dietrich Kötzsche, "Zum Stand der Forschung der Goldschmiedekunst des 12. Jahrhunderts im Rhein-Maas-Gebiet," *Rhein und Maas, Kunst und Kultur 800–1400* (Brussels-Cologne, 1973), vol. 2, pp. 191–236, esp. 149–204, with bibliography.

45. Oxford, Bodleian Library, MS. Auct. E. inf. 1; see Otto Pächt and Jonathan J. G. Alexander, *Illuminated Manuscripts in the Bodleian Library, Oxford* (Oxford, 1973), vol. 3, p. 15, no. 128; and Claus Michael Kauffmann, *Romanesque Manuscripts 1066–1190, A Survey of Manuscripts Illuminated in the British Isles*, vol. 3 (London, 1975), pp. 107ff., no. 82.

46. Walter Oakeshott, *The Two Winchester Bibles* (Oxford, 1981), pp. 101ff., believes that the Oxford Bible was begun at St. Albans and that the Master of the Entangled Figures went from there to Winchester. However, Rodney M. Thomson, *Manuscripts from St. Albans Abbey 1066–1235* (Woodbridge, 1982), vol. 1, pp. 33–36, argues that the Oxford Bible was begun at Winchester about 1140–50 and that the Master of the Entangled Figures and his pupils worked widely in southwest England.

47. Oxford, Bodleian Library, MS. Auct. D. 2. 6; see Pächt and Alexander, *Illuminated Manuscripts*, vol. 3, p. 14, no. 117; Kauffmann, *Romanesque Manuscripts*, p. 101, no. 71; Oakeshott, *Winchester Bibles*, pp. 130ff; Thomson, *Manuscripts*, pp. 28–31, 36–38, 101ff., and figs. 100–114. Pächt, Alexander, and Thomson have connected the style of the calendar figures with the early work of the Master of the Lambeth Bible, but Kauffmann correctly doubts this attribution. The floral forms are in any case indebted to the Alexis Master of the St. Albans Psalter and resemble those in Princeton, University Library, Garret Ms. 73 fol. 1a, and in the Lansdowne Psalter, London, British Library, MS. Lansdowne 383; in the latter, Thomson finds the early work of the Master of the Entangled Figures. Whatever the precise connections, all agree that the Oxford

calendar was decorated in the 1140s. For striking parallels in sculpture, see Deborah Cahn, "Recent Discoveries of Romanesque Sculpture at St. Albans," in Frederick Hugh Thompson, ed., *Studies in Medieval Sculpture*, London Society of Antiquaries, Occasional Papers, new ser. 3 (London, 1983), p. 186.

48. See, for example, the important bible from Fécamp in Rouen, Bibliothèque municipale, ms. 7 (A.5) discussed in François Avril, *Manuscrits normands XI–XII^ème siècles*, exhib. cat. (bibliothèque municipale, Rouen, 1975), pp. 74ff., no. 79; and Cahn, *Bible Illumination*, pp. 280ff., no. 105. An important parallel in Champagne is the Commentary on Deuteronomy (Paris, Bibliothèque Nationale, ms. lat. 186), which Avril kindly indicated to me. The problem of the relationship between English and French styles is discussed in Larry M. Ayres, "English Painting and the Continent during the Reign of Henry II and Eleanor," in William W. Kibler, ed., *Eleanor of Aquitaine: Patron and Politician* (Austin, 1976), pp. 115–46; Ayres finds the matter of the priority of England or France unclear during this period.

49. Hans Swarzenski, "Der Stil der Bibel Carilefs von Durham. Ein Beitrag zu den Beziehungen zwischen England und dem Kontinent," *Form und Inhalt, Kunstgeschichtliche Studien. Festschrift für Otto Schmitt* (Stuttgart, 1951), pp. 89–95; Charles R. Dodwell, *The Canterbury School of Illumination 1066–1200* (Cambridge, 1954), pp. 115–18; Kauffmann, *Romanesque Manuscripts*, pp. 19ff.; see also Pächt and Alexander, *Illuminated Manuscripts*, vol. 1, p. 35, no. 445. For the Carilef manuscripts, see most recently Anne Lawrence, "The Influence of Canterbury on the Collection and Production of Manuscripts at Durham in the Anglo-Norman Period," in Alan Borg and Andrew Martindale, eds., *The Vanishing Past. Studies in Medieval Art, Liturgy and Metrology presented to Christopher Hohler* (Oxford, 1981), pp. 95–107.

50. See note 12 here and the essay by Madeline Caviness in this volume.

51. Paris, Bibliothèque Nationale, ms. lat. 6755, no. 2; Swarzenski, "Fragments," p. 75; and Cahn, *Bible Illumination*, p. 269.

52. The conception depends on English models, particularly the style associated with the Master of the Apocrypha Drawings; compare the David figure to, for example, the seated king in the initial to Ezra in the Winchester Bible (Oakeshott, *Winchester Bibles*, figs. 54, 60). For other continental parallels, see Ayres, "English Painting," pp. 116–20; and Ayres, "The Role of Angevin Style in English Romanesque Painting," *Zeitschrift für Kunstgeschichte* 37 (1974): 193–223.

53. For Charlieu, Vézelay, Autun, and related works, see most recently Bernhard Rupprecht, *Romanische Skulptur in Franreich*, 2d ed. (Munich, 1984), pp. 54–57, 105–14, with bibliography. A study integrating visual analysis with new archaeological and iconographical findings is badly needed. Still fresh and pertinent are the insights and characterizations in Wilhelm Vöge, *Die Anfänge des monumentalen Stiles im Mittelalter* (Strassburg, 1894), esp. pp. 3–20, 61–63, 92–100; and Henri Focillon, *L'Art des sculpteurs romans* (Paris, 1931), esp. pp. 274–81, although many ideas about dating and the relations between specific monuments have changed. A somewhat different approach has been recently taken by C. Edson Armi, *Ma-*

sons and Sculptors of the Romanesque Period: The New Aesthetic of Cluny III (London and College Park, Pa., 1983), esp. vol. 1, pp. 96–98, 105–13, and 117–90.

54. The style and sources still remain problematic; for two different perspectives on the relative role of Burgundy, see Willibald Sauerländer, "Sculpture on Early Gothic Churches: The State of Research and Open Questions," *Gesta* 9 (1970): 32–48, esp. 34; and Charles T. Little, "Monumental Sculpture at Saint-Denis under the Patronage of Abbot Suger: The West Facade and Cloister," in *Royal Abbey,* pp. 29–31, esp. 31.

55. Hesbert, *Corpus,* vol. 4, p. 23, no. 6093. The irregular placement of the miniature toward the lower right of folio 136v results from the artist having used the lining of the musical staffs on the recto to delimit the edges of the miniature. The other folios in the manuscript have similar measurements and lining, so that the miniature on folio 136v directly faces the music and text on the facing recto. The folio with the miniature is in any case integral to the codex.

56. Paris, Bibliothèque Mazarine, ms. 384; see René-Jean Hesbert, *Le Graduel de Saint-Denis,* Monumenta Musicae Sacrae, vol. 5 (Paris, 1981), with earlier bibliography.

57. The results of Anne Walters's work appear in her dissertation "Music and Liturgy at the Abbey of Saint-Denis, 567–1567: A Survey of the Primary Sources" (Ph.D. diss., Yale, 1984).

58. Louis Grodecki, *Les Vitraux de Saint-Denis, étude sur le vitrail au XIIᵉ siècle* (Corpus Vitrearum Medii Aevi) France, "Études" (Paris, 1976), vol. 1, pp. 71–80, esp. figs. 41, 43. Grodecki, *Le Vitrail roman* (Fribourg, 1977), pp. 98–100, attributes the Tree of Jesse window to the "principal" atelier, which was responsible for all but the St. Benedict and Signum Tau windows, each of which he attributes to a separate atelier. In contrast, see Jane Hayward, "Stained Glass in the Time of Abbot Suger," in *Royal Abbey* pp. 65–67, who recognizes three masters in Grodecki's main atelier, in addition to his other two. See the essay by Madeline Caviness in this volume, pp. 257–72.

59. See Grodecki, *Les Vitraux,* fig. 137 and Sumner McK. Crosby and Pamela Z. Blum, "Le Portail central de la façade occidentale de Saint-Denis," *Bulletin monumental* 131 (1973): 258, fig. 18; p. 259, fig. 19.

60. See Grodecki, *Les Vitraux,* figs. 151, 161. The panel today at Fougères (fig. 155), although superficially the most similar, is somewhat atypical in its drawing and is in any case too poorly preserved for detailed comparison.

61. See the appropriately cautious observations in Caviness, "Suger's Glass at Saint-Denis: The State of Research," in this volume, pp. 264–66.

62. The figures in the scene of the Martyrdom of Saint Lawrence, for example, may be compared to those in the Sens miniature in their conception and gestures, the fold patterns and their prolific, oblique movement, the facial types, and even the system of highlights. For Berzé-la-Ville, see Otto Demus, *Romanische Malerei* (Munich, 1968), pp. 136ff., with bibliography; Jeanine Wettstein, *La Fresque romane,* Bibliothèque de la Société Française d'Archéologie (Paris-Geneva, 1971), vol. 2, pp. 75–96; see also Neil Stratford, "A Romanesque Marble Altar-Frontal," in Borg and Martindale, *The Vanishing Past,* pp. 223–

39, esp. p. 229 n. 47, where a dating in the 1120s is proposed.

63. Caviness, "Suger's Glass," pp. 265ff. The Tree of Jesse and St. Vincent windows depend, I believe, on different byzantinizing styles; see below, notes 64 and 66 here.

64. The earliest discussion of byzantinizing influence in Burgundy and northern Europe is in Wilhelm Köhler, "Byzantine Art and the West," *Dumbarton Oaks Papers* 1 (1941): 63–87. Edward B. Garrison, *Studies in the History of Medieval Italian Painting* (Florence, 1953–58), vol. 3, pp. 198–210, esp. 204, made an important distinction between two byzantinizing styles, describing one as clinging and curvilinear, with nested V-folds, and the other as multilinear. Otto Demus, *Byzantine Art and the West* (New York, 1970), pp. 115–200, similarly distinguished between two byzantinizing currents in the frescoes at Berzé-la-Ville. These distinctions may be usefully extended in the orbit of works discussed here. For example, the Berzé-la-Ville apse and the Cluniac lectionary (Paris, Bibliothèque Nationale, ms. n.a. lat. 2246) use cloison patterns defined by clinging, curvilinear folds in order to suggest the smooth surfaces and rounded parts of the body. These patterns are ultimately a Comnenian stylization of drapery forms of the Macedonian period and they appear widely in northern Europe and especially in England (cf. Schapiro, *Parma,* pp. 41–53, esp. 49ff.; and Kauffmann, *Romanesque Manuscripts,* p. 25); in Burgundy, its most advanced statement may be in such Cîteaux paintings as the Virgin and Child in Dijon, Bibliothèque municipale, ms. 129 fol. 4v, and its clearest manifestation at Saint-Denis is in the Tree of Jesse window. The style of the lower niches, in contrast, depends upon more recent Comnenian models in which dynamic lines sweep in currents across the body and define its forms. It is this conception that appears in the Sens miniature (see note 62 here) and in the thinner and more elongated figures in the panel from the Saint Benedict window now at the Musée de Cluny (Grodecki, *Les Vitraux,* fig. 145). The latter may show a particularly Italianate variation of the style: the ridges of folds are thinner, sharper, and more elastic, they move in broad, multilinear swathes, and they sweep back and away from the leading edge of the figure with a real calligraphic energy. Similarly, one may compare the Martyrdom of Saint Vincent window at Saint-Denis to the Martyrdom of Saint Blasius at Berzé-la-Ville and to the Entombment of Saint John the Evangelist in the Lateran Palace, reproduced in Garrison, *Studies,* vol. 2, fig. 195. Otto Demus in Franz Unterkircher et al., *Das Antiphonar von St. Peter,* Codices Select 21 (Graz, 1974), pp. 267–70, sees Cluny as the principal center of this current in northern Europe, but Joachim M. Plotzek, "Zu den neu aufgefunden Fresken von St. Gereon on Köln," in *Rhein und Maas,* vol. 2, pp. 297–305, demonstrates this same approach in monumental painting in the Rhineland. For the possible relation of the lower Berzé-la-Ville frescoes to Burgundian sculpture, see Willibald Sauerländer, "Gislibertus von Autun. Ein Beitrag zur Entstehung seines Kunstlerischen Stils," *Studien zur Geschichte der europäischen Plastik. Festschrift für Theodor Muller* (Munich, 1965), pp. 17–29. For the Italian background, see Ernst Kitzinger, "The Arts as an Aspect of Renaissance: Rome and Italy," in Robert L. Benson and Giles Constable, eds., *Renaissance and Renewal in the Twelfth Century* (Cambridge, Mass., 1982), pp. 637–70, with bibliography.

65. Paris, Bibliothèque Nationale, mss. lat. 55 and 116. See Avril, "Les Arts," p. 191; see also Cahn, *Bible Illumination*, pp. 276ff., no. 88.

66. See, for example, Paris, Bibliothèque Nationale, ms. lat. 12270, a Miscellany made at Corbie and discussed in Merindol, *La Production*.

67. See Grodecki, *Les Vitraux*, pp. 126–30, and compare his border type A (Jesse window) and F (now Moses and Ezekial windows) to Paris, Bibliothèque Nationale, mss. lat. 55, fol. 197r and lat. 116, fols. 35r, 163r, and 179r. The author points out that type A is rare except at Saint-Denis and Chartres and that the design of F is found also in the ornamental sculpture of the Saint-Denis facade.

68. Compare for example the secondary decorative motifs of the initials in the Chartres Pontifical, Paris, Bibliothèque Nationale, ms. lat. 945, fols. 4r, 44v with those in the Saint-Denis Antiphonal, ms. lat. 17296, fols. 93r, 301r, and the Vitruvius, Rome, Vatican Library, cod. Reg. lat. 2079, fols. 1r, 7v.

69. The issue effectively shifts to one of new currents emerging in the Paris region. In sculpture the problem centers on the Saint-Denis cloister; see Little, "Monumental Sculpture," p. 31; and the essay by Léon Pressouyre in this volume.

V.
SCULPTURE AND MOSAICS

Suger as Iconographer: The Central Portal of the West Facade of Saint-Denis

Paula Lieber Gerson

SUGER'S ICONOGRAPHIC programs were themselves works of art. Although the abbot may never himself have painted on glass or held a sculptor's chisel, he created iconographic masterpieces of great power and substance. Much of this is evident from Louis Grodecki's study of the anagogical windows of Saint-Denis.[1] Another of Suger's compositions, the central portal of the west facade, deserves similar study. Its internal structure, balance, and dynamic cast light on Suger's style and method as well as on his intentions and the quality of his mind. Thus, it is not my intention to discuss all aspects of the portal's iconography in this short essay, but rather to explore those elements that lend special insight into Suger's style as a creator of iconographic programs.

The west facade has suffered over the years from the vicissitudes of war, climate, inept repair, disfiguring restoration, and industrial pollution, but because fewer problems are presented by the central portal than by the left and right portals, where much less of the original work remains, the underlying meaning of its program can be made clear.[2] Thanks to the pioneering studies of Pamela Blum and Sumner Crosby on the restorations of the west facade, we now know how much of the sculpture is restored and how much is original. In addition we know where the restorers followed the original iconography in repairing the facade.[3] This knowledge is essential because Suger's iconographic programs can be very difficult to understand. Due to their complexity and, at times, obscurity, it is often the small detail that explains the whole.[4]

The central portal's iconography is deceptively simple (figs. 1 and 2). At the level of the church entrance the bronze doors commissioned for this doorway (later destroyed during the French Revolution) contained scenes of Christ's Passion, Resurrection, and Ascension.[5] On the enclosing doorposts, which still exist, are the Wise and Foolish Virgins, referred to in the parable that precedes the Gospel account of the Last Judgment. Above the doors, the scenes on the lintel, tympanum, and first archivolt illustrate the Last Judgment according to the Gospel of Matthew. The three remaining archivolts contain the Trinity, surrounded by the Twenty-four Elders, together representing the ultimate state of grace at the end of time. Thus, the central portal of Saint-Denis depicts Christ's life beginning with the Passion and ending with the establishment of the new heaven. This combination of scenes constitutes an unusual iconographic program for a portal. Portrayals of Passion cycles and of the Last Judgment (based on the Apocalypse or Matthew's Gospel) are found in works predating 1137, but the combination of the two in extant monuments seems to be unique, especially in the absence of reference to the early life of Christ. To explain Suger's choice of episodes we must turn to the abbey's patron saint, Denis, and the liturgy of the abbey dedicated to him.

By the twelfth century Denis had become a composite of three separate people intentionally conflated in the ninth century by Abbot Hilduin.[6] The first person of this tripartite saint was Dionysius the Areopagite, a first-century Athenian philosopher mentioned in Acts 17:22–34 as having been converted by Saint Paul. The second was Denis, a third-century martyr sent with two companions, Rusticus and Eleutherius, to convert the people of Gaul. The third person was a fourth- to sixth-century Neoplatonic theologian, now called pseudo-Dionysius the Areopagite, who went to great lengths to indicate that he actually lived in apostolic times. Under the pseudonym Dionysius the Areopagite, he wrote four metaphysical treatises, *The Divine Names,*

Notes for this essay begin on page 194.

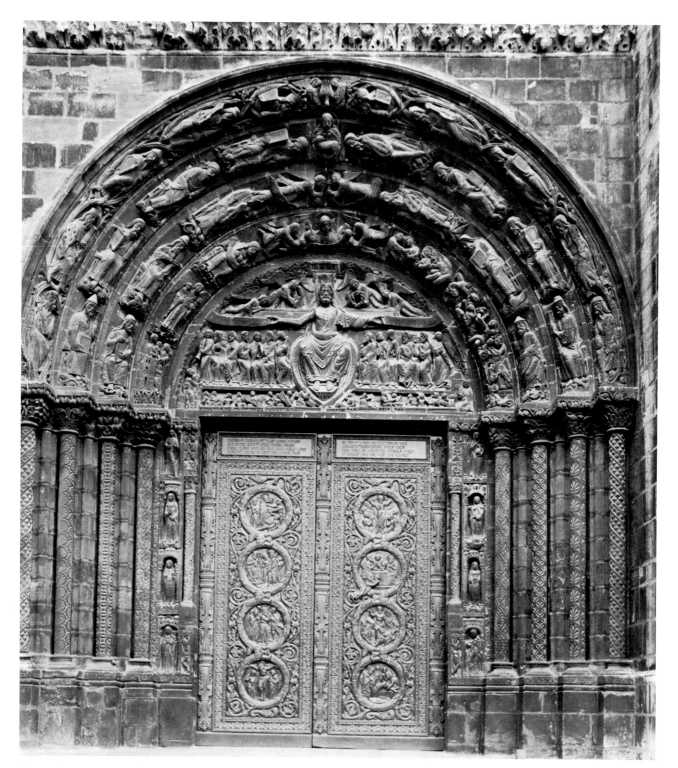

Fig. 1. Saint-Denis, west facade, central portal

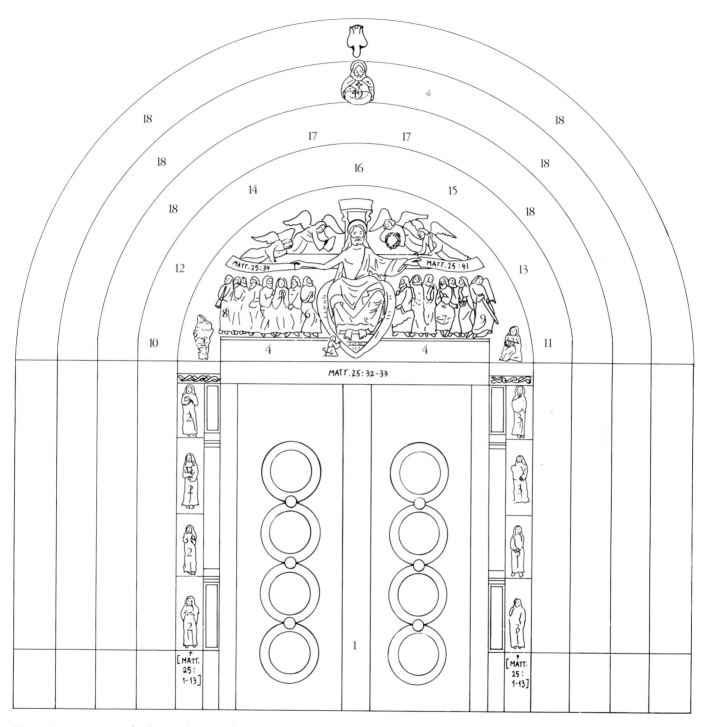

Fig. 2. Saint-Denis, west façade, central portal, schematic drawing

1. *Trumeau statue of Saint Denis; 2. Wise Virgins; 3. Foolish Virgins; 4. Dead Arise; 5. Portrait of Kneeling Suger; 6. The Virgin; 7. The Apostles; 8. Angel with Trumpet; 9. Angel with Flaming Sword; 10. Gate of Heaven; 11. Gate of Hell; 12. The Elect; 13. The Damned; 14. Souls in the Bosom of Abraham; 15. Damned Soul Turned Back; 16. Christ Blessing Souls Held by Angels; 17. Incensing Angel; 18. Elders; 19. The Trinity*

Mystical Theology, The Celestial Hierarchy, and *The Ecclesiastical Hierarchy,* and ten letters.[7] Despite Abelard's efforts to separate these three people, for Suger and his contemporaries Saint Denis remained the tripartite saint created by Hilduin, and the iconography of the west facade of Saint-Denis can only be understood in terms of the legends, life, and writings of this composite saint.

Dionysius the Areopagite was converted by Paul when the Apostle was preaching in Athens. Paul came upon an altar of the Unknown God and asked about its curious dedication. The Athenians explained that they had set up the altar after the unnatural eclipse that had occurred at the moment of Christ's death. Paul told the Athenians that their Unknown God, who caused the eclipse, was the Christ he preached; he informed them that the Lord who created the world appointed a day of judgment, and that He who had been appointed judge was the one whose death caused the eclipse and who had been raised from the dead. With this, Dionysius the Areopagite was converted.[8] Thus, in the biblical passage read every year as the Epistle for the Feast of Saint Denis, Christ's Passion, Resurrection, and the Last Judgment were united.[9] This combination of episodes is the subject of the central portal. From within this broad contextual outline comes a rich and complex program based on the tripartite Saint Denis, Christ, and Suger's perception of their relationship.

The clear organization of the subject matter of the central portal has been much discussed and ultimately seen as a prime factor in the creation of the Gothic facade.[10] The scenes on the central portal (fig. 2) move upward in chronological order. At the lowest level, that of the bronze doors, are scenes of Christ's life on earth. Above, the Last Judgment appears in the tympanum. Finally, the archivolts depict the heavens and the end of time, with the Trinity surrounded by the Twenty-four Elders; here, according to the treatises of pseudo-Dionysius the Areopagite, the saved will see and understand the greatest mystery, the Trinity. However, within this primary upward movement there are countermovements, just as in a painting or sculpture subsidiary actions create a more complex dynamic. These will become apparent as smaller units within the larger program are discussed.

The Bronze Doors

The ideas of pseudo-Dionysius the Areopagite permeate many of Suger's compositions, both literary and visual; but they are nowhere as obviously present as on the bronze doors.[11] Suger's inscription for the doors, an eight-line poem, has been interpreted by Panofsky as a general example of Neoplatonic thought derived from the theories of pseudo-Dionysius the Areopagite, and by Grover Zinn as an example of Suger's belief in a christocentric universe.[12] In fact, the poem is a paraphrase of the first chapter of the pseudo-Dionysius's *Ecclesiastical Hierarchy.* The third, fourth, and fifth lines of Suger's inscription read:

> Bright is the noble work; but, being nobly bright, the work
> Should brighten the minds, so that they may travel, through the true lights,
> To the True Light where Christ is the [T]rue [D]oor.

The same idea is found in reverse in the second paragraph of the first section of the first chapter of the *Ecclesiastic Hierarchy.*[13]

> Theology has taught us worshippers that Jesus Himself is the transcendentally divine and supra-essential mind, the source and essence of all hierarchy, holiness, and divine operation, the divinely sovereign power who illumines the blessed beings superior to us in a manner at once more spiritual and clear, assimilating them to his own light as far as possible. As for us, because of our love of the beautiful which attracts us to Him, and by which we are raised up to Him, He folds together our multiple differences and perfects us into a unified divine life, habit and activity. . . .

There are many levels of relationship between the text of pseudo-Dionysius, the poem composed by Suger for the bronze doors, and the scenes on the doors themselves.[14] The phrase, from the fifth line of the poem, "where Christ is the True Door" signals the complexity with which the abbot constructed his iconographic program. As we look at the bronze doors and read Suger's poem, with its reference to Christ as the True Door, we notice the confluence of the bronze doors, Christ the True Door, and the actual church doors.[15] The salient line in Suger's poem can be traced to John 10:9:

> I am the door: by me if any man enter in,
> he shall be saved, and shall go in and out,
> and find pasture.

Elsewhere in this chapter (John 10:7–18) we find the image of Christ as the Good Shepherd, the door of the sheep, who lays down His life for the sheep. These verses thus serve to link the doors iconographically to the lintel, which contained Suger's inscription:

> Receive, O stern Judge, the prayers of Thy Suger;
> Grant that I be mercifully numbered among Thy own sheep.[16]

The lintel inscription, alluding to the passage in John, is also a direct reference to the chapter in Matthew in which the Last Judgment is described:

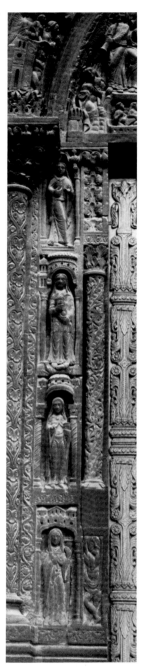 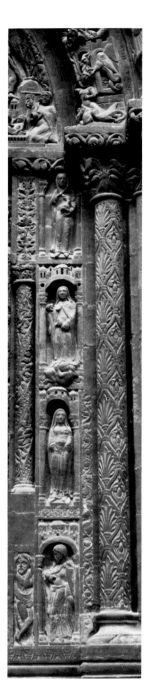

Fig. 3a–b. Saint-Denis, west facade, central portal. Above left: Left doorpost, Wise Virgins; above right: Right doorpost, Foolish Virgins

And before him shall be gathered all nations: and
 he shall separate them one from another, as a
 shepherd divideth his sheep from his goats:
And he shall set the sheep on his right hand, but the
 goats on the left.

<div align="right">Matthew 25:32–33</div>

In literal interpretation of these verses, a kneeling Suger has been depicted to the right of Christ at the bottom of the tympanum, above the resurrection of the Souls (fig. 5).

Here the movement has gone from doors to lintel to tympanum. In turning to consider the doorposts—which are thematically linked to the doors and tympanum—the movement becomes more complex. The doorposts enclosing the bronze doors contain the Wise and Foolish Virgins (figs. 3a and b), symbols the source of which is a parable concerning the Last Judgment (Matthew 25:1–13). Here the fate of the Wise and Foolish Virgins depends on their presence at the door to the wedding feast at the right moment. The Five Foolish Virgins did not bring along enough oil for their lamps when they went to await the arrival of the bridegroom at the door to the wedding feast. As a result they ran out of oil and had to leave to purchase more. While they were gone the bridegroom arrived and went into the marriage feast with the Five Wise Virgins, who had enough oil in their lamps with which to greet him. When the Foolish Virgins returned the door was shut to them. The door to the wedding feast thus symbolizes the door to heaven and salvation; it is open to the Wise Virgins (the blessed) and closed to the Foolish Virgins (the damned). Jesus tells the parable of the Wise and Foolish Virgins to explain that mankind must always be prepared for the coming of the bridegroom, Christ, who will then judge. On the central portal there are four Wise Virgins on the left doorpost and four Foolish Virgins on the right doorpost. The fifth Wise and fifth Foolish Virgins are placed directly above the doorposts at the lowest level of the tympanum at either end of the row of resurrected dead (figs. 3a, 3b, and 2). The Wise Virgin stands in front of an open door, whereas the Foolish Virgin stands in front of a closed door.

The Wise and Foolish Virgins are thematically linked to the church doors, for it is by passing through these doors that one can prepare (in this world) for the day of judgment. And, because the Virgins appear as a preamble to Matthew's description of the Last Judgment, they are also linked to the tympanum, above. The movement therefore is both lateral and upward. Thus, we go from the bronze doors to the church doors, to Christ the True Door, the door of the sheep, to Suger petitioning to be one of the sheep permitted through the door, as the Wise Virgins were permitted through the door to salvation. This complex sequence unites a multiplicity of images drawn from the works of pseudo-Dionysius the Areopagite, John, and Matthew, as well as com-

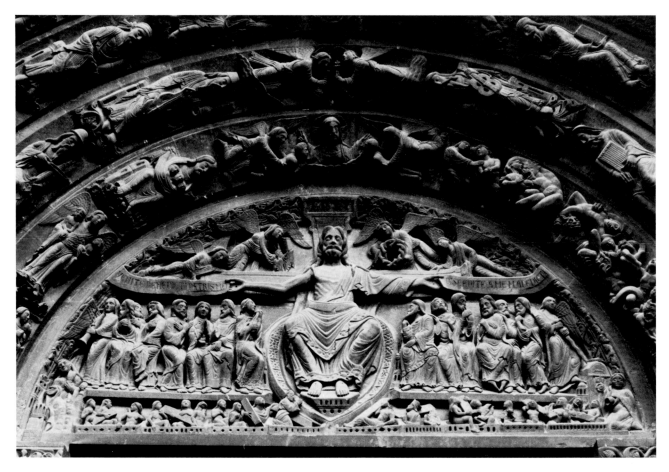

Fig. 4. Saint-Denis, west façade, central portal tympanum

mentaries on their Gospels. The principle of composition is not unlike what Robert Hanning noted as an example of "collective unity" in Suger's writing style, but here the tendency toward accretion is subjected to an overall, well-organized scheme with interlocking parts.[17]

The Last Judgment, Matthew, and Augustine

Suger's Last Judgment is found on the doorposts, tympanum, and first archivolt of the central portal (figs. 2 and 4). The iconography of the ensemble depends on Matthew's Gospel rather than John's Apocalyptic Vision.[18] Although precedents exist for many of the individual elements of Suger's Last Judgment, there is no single prototype that includes all the elements or ideas presented at Saint-Denis.[19]

The Last Judgment as described by Matthew was not a popular subject in twelfth-century monumental sculpture. There are only three other Last Judgments in the first half of the twelfth century that follow Matthew's Gospel: those at Autun, Conques, and Beaulieu. Although superficial resemblances exist be-

tween Beaulieu and Saint-Denis, ultimately each of the four Last Judgment doorways is unique in its use of Matthew, its composition, and its underlying meaning.[20]

Suger's use of Matthew's Gospel is, in part, distinguished by the orderly sequence of "quotes" from the text. At the level of the doors, the Wise and Foolish Virgins come, as we have seen, from Matthew 25:1–13 and the lintel inscription from Matthew 25:32–33. The inscriptions on the scrolls held in Christ's hands then follow directly from Matthew 25:34–41 (fig. 4).

The Wise and Foolish Virgins have already been discussed as elements thematically linking the doors, doorposts, and tympanum. Whereas the Wise and Foolish Virgins do figure in medieval art, and in connection with the Last Judgment, prior to their appearance at Saint-Denis, Suger was the first to incorporate them in a monumental sculptural program.[21] In this way, Suger depicted on his doorposts an allegory of what he represented in actuality in the tympanum.

The lintel creates an area of transition between the allegorical preamble and the Last Judgment itself. It contained the now lost inscription referring to the separation of the sheep from the goats

found in Matthew's Gospel and, extant, though restored, a kneeling figure of Suger (fig. 5), the dead rising from their coffins, and (on the extreme right and left) the last Wise and Foolish Virgins.

The text on the lintel leads to the scrolls held by Christ. Although these inscriptions are the work of the nineteenth-century restorers, there is evidence that they were originally Suger's.[22] The inscriptions are drawn from the verses of Matthew immediately following Matthew 25:32–33 in which the sheep and goats are separated. The inscription on the scroll in Christ's right hand (*VENITE BENEDICTI PATRIS MEI*) is based on Matthew 25:34:

> Then shall the King say unto them on his right hand,
> Come ye blessed of my Father, inherit the
> kingdom prepared for you from the foundation of
> the world.

The inscription on the scroll in Christ's left hand (*DISCEDITE A ME MALEDICTI*) comes from verse 41:

> Then shall he say also unto them on the left hand,
> Depart from me, ye cursed, into everlasting fire,
> prepared for the devil and his angels.

This is, of course, just what has been represented in the right and left lowest registers of the innermost archivolt, with heaven on Christ's right and hell on His left. The scrolls visually lead the viewer's eye to the region of the archivolts, where we see carried out the words that appear on the scrolls: *Come to me blessed* and *Depart from me cursed* (figs. 2 and 4).

Within this armature of quotations from Matthew 25 are iconographic elements drawn from various chapters of Matthew's Gospel. On the tympanum the Twelve Apostles are seated below the scrolls held in Christ's hands. Apostles are common features of Last Judgment scenes, and yet it is important to remember that the source of this iconography is Matthew 19:28, in which Jesus says to the Apostles:

> Verily I say unto you, that ye which have followed me,
> in the regeneration when the Son of man shall sit
> in the throne of his glory, ye also shall sit upon
> twelve thrones, judging the twelve tribes of Israel.

The angels at either end of the row of Apostles (figs. 6 and 7) are also found in Matthew's Gospel.[23] After relating the parable of the Tares of the Field (Matthew 13:24–30), Christ explains to His disciples that at the end of the world the harvest is gathered by angels who deliver the Wheat (the good) to the heavenly kingdom and discard the Tares (the bad), to be burned in everlasting fire (Matthew 13:37–43). Even trumpeting angels, like the figure at the left end of the row of Apostles, can be found in Matthew's Gospel.[24] In Matthew 24:31 Christ says:

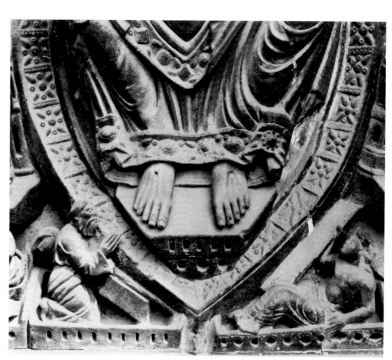

Fig. 5. Saint-Denis, west facade, central portal, detail of Abbot Suger on tympanum

And he will send out his angels with a loud trumpet
call, and they will gather his elect from
the four winds, from one end of heaven
to the other.

Iconographic details culled from Matthew's Gospel continue
in the archivolts immediately above the heaven and hell scenes
(figs. 8 and 9).[25] The Three Souls in the Bosom of Abraham, on
the paradise side of the inner archivolt, and the small figure
being turned back on the hell side are drawn from Matthew
8:11–12, where Jesus says that many shall come to heaven from
the East and from the West to feast with Abraham, Isaac, and
Jacob, but many will be cast out "with weeping and gnashing of
teeth." The angel on the hell side of the archivolt is obviously
casting out one such rejected soul.[26]

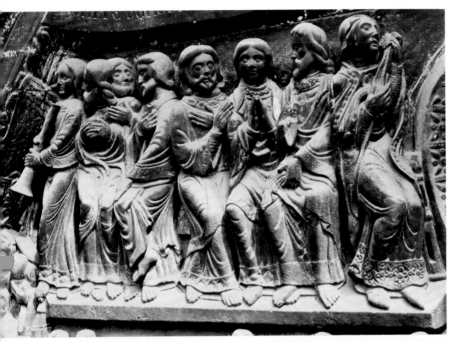

*Fig. 6. Saint-Denis, west facade, central portal, detail
of the Virgin and Evangelists to the right of
Christ*

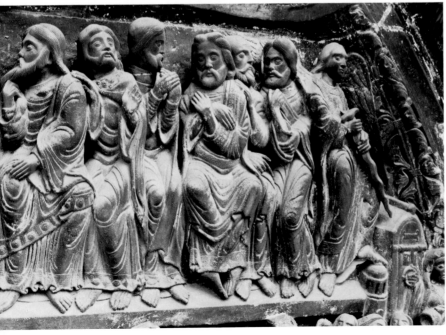

*Fig. 7. Saint-Denis, west facade, central portal, detail
of Evangelists to the left of Christ*

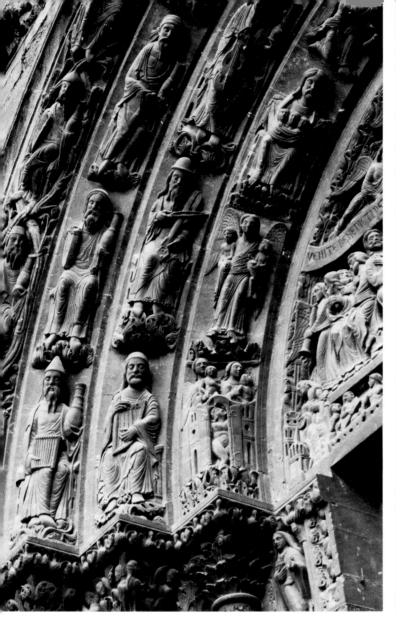

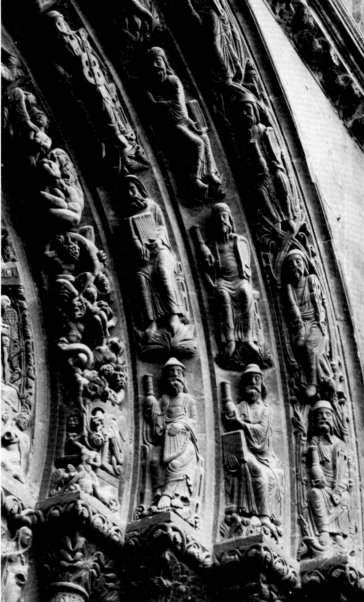

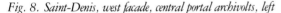

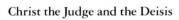

Fig. 8. *Saint-Denis, west façade, central portal archivolts, left* Fig. 9. *Saint-Denis, west façade, central portal archivolts, right*

Christ the Judge and the Deisis

Matthew's Gospel does not, however, account for all the icono-graphic details of Suger's Last Judgment. It does not explain, for instance, the unique position of Christ the Judge, or the inclu-sion of the Virgin and John the Evangelist as intercessors at the Last Judgment (figs. 4, 6, and 7).

 The judging Christ of Saint-Denis is strikingly unusual (fig. 4).[27] He appears as He did at His Crucifixion, with His arms spread out upon the Cross, which is clearly delineated.[28] The lower part of Christ's body is surrounded by what seems to be half a mandorla. The source of this image seems likely to have been Augustine's treatise *De Trinitate,* book I, chapter 13, a work used by many commentators and certainly available to Suger.[29]

 In his treatise Augustine discusses which member of the

Trinity will be present at the Last Judgment. This, he says, will be Christ. He then attempts to reconcile contradictory Gospel statements about the Last Judgment. According to Matthew 25:31–32, the Son of Man will judge, but in John 12:47 Christ says He will not judge. Augustine explains this by calling on the two natures of Christ in one person (the Son of Man and the Son of God). It is in His form as the Son of God that He is equal to God the Father. Christ judges the wicked in His form as the Son of Man, as He appeared on the Cross, because the wicked cannot see Him in the form in which He is equal to God. The good, however, will see Him in His form as the Son of God, in His glory. Thus, it is possible for Christ to say at one time that He will judge and at another that He will not judge.

 The image at Saint-Denis appears to be a literal interpretation of this passage from Augustine, with the upper part of Christ on the Cross and the lower part surrounded by the mandorla, the

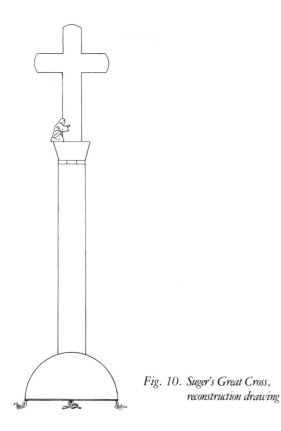

*Fig. 10. Suger's Great Cross,
reconstruction drawing*

traditional manner of depicting Christ in His glory. But why did Suger create such an image? To answer this question it is necessary to return to Saint Denis, the patron saint of Suger's abbey. The image of Christ on the Cross was extremely important for Suger's Saint Denis, for it was at the moment of Christ's death on the Cross and the unnatural eclipse that the legendary Saint Denis first began to think about the metaphysics of light.

Thus, it was Suger's Saint Denis who told of his own introduction to Christianity in his letter to Polycarp, Bishop of Smyrna. He and his friend Apollophanes were in Egypt when Christ was being crucified. Suddenly the elements became confused, and an eclipse occurred. This eclipse could not be explained by natural phenomena because the moon, which had come up from the east to obscure the sun (from the sixth to the ninth hour), reversed itself and returned to the east instead of passing to the west of the sun. Dionysius writes, "This new night at which we wonder signifies the coming of the True Light of the world."[30] According to the Acts of the Apostles the final conversion of Saint Denis did not come about until Paul, who was then preaching in Athens, was able to explain the cause of the eclipse to Denis. Later, under the tutelage of Saint Paul, Denis organized his metaphysical thoughts on light and the absence of light and wrote his treatises.

The image of Christ on the Cross seems to have had a special

meaning for Suger.[31] The abbot uses it twice in his chevet windows, once in the roundel of the Quadriga of Aminadab (see Grodecki fig. 8), and once rising from the back of the Brazen Serpent (see Grodecki fig. 13). Suger also commissioned the Great Cross, which stood twenty feet tall in front of the new chevet (fig. 10) and consisted of a base, capital, and crucifix. At the foot of the crucified Christ was a donor portrait of Suger, and on the capital below this a figure holding a scroll with the words *VERE FILIUS DEI ERAT ISTE,* the words spoken by the people witnessing Christ's death at the moment the eclipse occurred (Matthew 27:54).

Suger's unusual image of Christ the Judge partly upon the Cross provides us a clue to the appearance of the Virgin and John the Evangelist as intercessors at the Last Judgment (figs. 6 and 7). The tradition of supplicators at the Last Judgment is first found in Byzantine examples of the Deisis, where the intercessors are the Virgin and John the Baptist.[32] At Saint-Denis, however, the figure (to the left of Christ) echoing the supplicating position of the Virgin seems to be John the Evangelist. Although there is no definite proof that this figure is John the Evangelist (the head is a nineteenth-century restoration, and it is not known if the figure was originally bearded or clean-shaven),[33] the row of Apostles includes twelve figures plus the Virgin. It thus seems fair to assume that the figure turning toward Christ would be the Apostle John the Evangelist and not John the Baptist.

As Mary and John turn toward Christ they are presented as figures grieving, with hands held in positions similar to those assumed in Crucifixion images where Mary and John are shown to the right and left of Christ on the Cross.[34] Suger, it would appear, has made a transfer of images here. Reinforcing Christ the Judge partially on the Cross, he has taken the Virgin and the Evangelist from Crucifixion scenes and introduced them as intercessors at the Last Judgment. John the Evangelist's replacing John the Baptist at Saint-Denis would constitute the first appearance of the Western version of the Deisis.[35] When the iconographical form is used in the thirteenth century (at Chartres, Amiens, and Reims, for instance), it loses the subtle Sugerian message in which the relationship between Christ on the Cross and Saint Denis is amplified.

The Trinity in the Archivolts

Suger's Trinity is placed in the apex of the third and fourth archivolts of the central portal (fig. 11). At the highest point of the doorway, it marks the end of the anagogical ascent begun at the bronze doors. This is the first recorded appearance of the Trinity in a monumental sculptural program,[36] and its appearance in conjunction with the Last Judgment is even more unusual.[37]

The Trinity had a special meaning for Suger, and he often re-

ferred to his facade in trinitarian terms.[38] According to legend, Saint Denis and his two companions died professing their belief not in Christ but in the Trinity. The Trinity was of central importance in the writings of pseudo-Dionysius, who placed this mystery at the summit of all hierarchy.[39] Certainly the master idea of his four treatises concerns the deserving man's final unity at the end of time with the One that is Three.

The placement of the Trinity in the archivolts is related textually through Augustine to the position of the tympanum's Christ as well (fig. 2). Recall Augustine's treatise on the Trinity, from which Suger drew his image of Christ the Judge at the Last Judgment. The passage in Augustine from which the image was drawn (book 1, chapter 13) appears in Augustine's discussion of how Christ would appear at the Last Judgment as He speaks the words from Matthew's Gospel, which would have been seen on the scrolls held by Suger's Christ: "Depart from me, ye cursed" and "Come, ye blessed of my Father, inherit the kingdom prepared for you. . . . " When Augustine discusses the meaning of inheriting, or entering, the kingdom, he states that it means more than simply entering heaven. Referring to the Pauline analogy (I Corinthians 13:12), Augustine says that here on earth the faithful see the image of the Trinity "through a glass darkly," but after the Last Judgment, when the saved enter the kingdom, they will see the Trinity perfectly, "face to face," and the understanding of this mystery is the supreme hope and desire of man.[40]

Thus, the Trinity surrounded by the Twenty-four Elders in the archivolts does not merely represent heaven but final salvation, made possible by Christ who died on the Cross. The presence of the Trinity indicates the ultimate state of grace to which the saved will be welcomed at the end of time, the pseudo-Dionysian union with the One that is Three, and the immaterial end of the progression of upward movement that began in Suger's material doors.

Although this confluence of Augustinian and pseudo-Dionysian ideas can explain the presence of the Trinity in the archivolts, it does not explain Suger's unusual treatment of it. God the Father is presented as a syndesmos figure, with only head, arms, hands, and feet visible (fig. 12).[41] The rest of His body is covered by the disk He holds, which contains the Lamb, representing Christ, and the Cross.[42] The Dove of the Holy Ghost hovers above both Father and Son. The textual sources for this trinitarian image are complex and related to christological and cosmological concepts current in the first half of the twelfth century.[43] Suger interweaves these ideas and then creates an image by combining elements from two quite separate iconographic traditions in order to express his vision of the Trinity.

The disk-holding figure, with only head and extremities visible, has a long tradition in the vocabulary of images.[44] It seems to appear first as a depiction of the creator and the created, God and His cosmos.[45] Later, by extension, disks held in this way, no

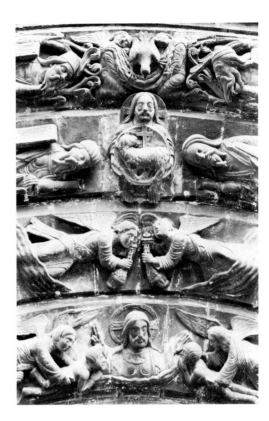

Fig. 11. Saint-Denis, west facade, central portal archivolts with the Trinity

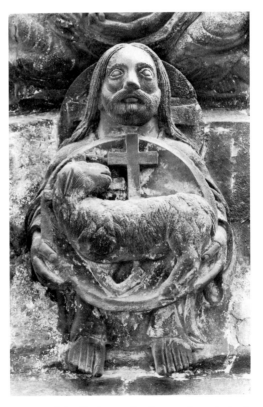

Fig. 12. Saint-Denis, west facade, central portal, detail of the Trinity

matter by whom, come to represent the cosmos.[46] In the twelfth century this schema was adapted to fit many cosmological phenomena[47] and found use as a visual expression of a literary image derived ultimately from Iraneus and Origen—the cosmic cross.[48] It is in the context of cosmos-creator and cosmic cross that the meaning of Suger's image of the Trinity becomes clear. God the Father holds the disk, which represents the cosmos. On the disk the Lamb and the Cross stand for the sacrificed Christ, who died on the Cross to make his relationship to the cosmos visible to us.

To create this image Suger grafted the Lamb and Cross in a *clipeus* onto a popular schema used in depictions of the universe.[49] In combining them Suger has reinforced the Cross behind Christ the Judge both visually and thematically.

Conclusion

Suger composed the central portal's iconography with considerable logic and clarity (fig. 2). The text that serves as the underlying source is Acts 17:22–34, in which pseudo-Dionysius the Areopagite (Saint Denis to Suger) is converted when Paul speaks of the Last Judgment and Christ's death and Resurrection. These scenes have been laid out in a comprehensible fashion on the portal following a hierarchical structure, from the lowest level of the bronze doors (on which the theory of the anagogical method is presented in an eight-line poem) to the highest level, the heavens and the Trinity in the archivolts. In organizing such an overall structure, which is then clearly divided into its many parts in an orderly manner, Suger's style in the composition of iconography seems more akin to his new Gothic chevet than to his rather old-fashioned writing style.[50]

Suger's use of images seems more sophisticated than his use of words—certainly his plays on words are more simplistic than his manipulation of symbols. This is clear in the transition from one idea to the next through images and in the sequencing of idea-images. His visual memory must have been prodigious and highly developed, for he seems to have had at his disposal an enormous bank of images from which he chose symbols from different periods and traditions with an abandoned eclecticism.

When standard representations did not say what Suger wanted, he frequently took images from quite different sources and combined them to express something new. The new meanings were not always easy to understand, and often Suger's originality and creativity led to representations of such idiosyncrasy that they were never repeated after their appearance at Saint-Denis.[51]

In creating images, Suger seems to have been predisposed toward literal interpretations of the written word, as if visually translating the literary source. He uses texts, as well, to create tight-knit constructions with interlocking parts.[52]

Stylistically, we find both the accretion of many meanings in one symbol (doors) and the thematic repetition of symbols with subtle variations (the Cross).[53] Because this occurs in the context of a strongly structured, unified program, the overall effect is one of great richness and depth.

Lastly, in Suger's program certain themes are of such essential importance to the abbot that they are interwoven rather like musical motifs at all levels of his compositions. Saint Denis, the relationship between Christ and Denis, the writings of Saint Paul, and the theories of pseudo-Dionysius the Areopagite constitute the primary matter here.[54]

Postscript

Using this methodology—analyzing an iconographic program as a work of art—has considerably enriched our understanding of the Saint-Denis central portal. Greater insight has been gained into the workings of Suger's mind, especially his organization and structuring of ideas and images. Characteristics of Suger's "style" can now be isolated and, rather like Morellian traits, their presence or absence in other Sugerian programs can be used to determine the validity of given interpretations.

Does this approach, in which an iconographic program is treated almost like a work of conceptual art, have greater application? Can other programs, either medieval or of other periods, be examined in this way? Can this methodology be extended to increase our understanding of the ways in which artists and thinkers relate ideas and images? If so, Suger has left us an unexpected and provocative legacy.

NOTES

1. Louis Grodecki, "Les Vitraux allégoriques de Saint-Denis," *Art de France* 1 (1961): 19–46; and Louis Grodecki, *Les Vitraux de Saint-Denis, étude sur le vitrail au XIIᵉ siècle (Corpus Vitrearum Medii Aevi),* France, "Etudes" (Paris, 1976), vol. 1, pp. 93–103. See also Konrad Hoffmann, *"Sugers Anagogisches Fenster in Saint-Denis," Wallraf-Richartz Jahrbuch* 30 (1968): 57–88. Hoffmann's analysis of the window shows how Suger used Carolingian motifs in his iconographic programs. He also discusses the repetition of certain forms (as, for instance, the wheel) as leitmotivs.

2. See the essay by Pamela Z. Blum in this volume, pp. 199–228. The restorations and repairs to the facade of Saint-Denis have been treated at length in many publications. See the excellent discussion in Pamela Z. Blum and Sumner McK. Crosby, "Le Portail central de la façade occidentale de Saint-Denis," *Bulletin monumental* 131 (1973): 209–16; and Paula Lieber Gerson,

"The West Facade of Saint-Denis" (Ph.D. diss., Columbia University, 1970), pp. 8–17.

3. Blum and Crosby, "Le Portail," pp. 217–64.

4. See Grodecki, *Les Vitraux*, p. 99. In the roundel of the Quadriga of Aminadab the cross sat inside the Ark of the Alliance along with the Tablets of the Law and the Rod of Aaron. These details have been omitted from the nineteenth-century restoration and are known only from the drawings of Cahier and Martin. If these details were completely lost the true meaning of the roundel would have been lost as well.

5. Suger, *Adm.* (P), pp. 46–47, tells us that the doors contained the Passion, Resurrection, and Ascension. Later descriptions adding to our knowledge of the bronze doors are found in Jacques Doublet, *Histoire de l'abbaye de S. Denys en France* (Paris, 1625), p. 240; Gabriel Millet, *Le Trésor sacré ou inventaire des sainctes reliques et autres précieux joyaux qui se voyent en l'église et au trésor de l'abbaye de Sainct-Denis en France* (Paris, 1638), pp. 26–27; and Michel Félibien, *Histoire de l'Abbaye Royale de Saint-Denys en France* (Paris, 1706), pp. 173, 534. For the disappearance of the doors during the Revolution, see Gerson, "West Facade," pp. 24–25.

6. On the conflation, see Sumner McK. Crosby, *The Abbey of Saint-Denis, I, 475–1122* (New Haven, 1942), pp. 24–40; and more recently, Charlotte Lacaze, *The "Vie de St. Denis" Manuscript (Paris, Bibliothèque Nationale, Ms. fr. 2090–2092)* Garland Series, Outstanding Dissertations in the Fine Arts (New York, 1979), pp. 4–14.

7. The complete works of pseudo-Dionysius the Areopagite are found in Pseudo-Dionysius the Areopagite, *Oeuvres complètes du Pseudo Denys l'Aréopagite,* ed. and trans. Maurice de Gandillac (Paris, 1943). For English editions see Dionysius the Pseudo-Areopagite, *On the Divine Names and the Mystical Theology,* ed. and trans. Clarence Edwin Rolt (1920; reprint, London and New York, 1940); and Dionysius the Pseudo-Areopagite, *The Ecclesiastical Hierarchy,* ed. and trans., Thomas L. Campbell (Washington, D.C., 1981). For the actual identity of pseudo-Dionysius the Areopagite, see Campbell's discussion in Dionysius the Pseudo-Areopagite, *Ecclesiastical Hierarchy,* pp. 3–11.

8. From the ninth century on, this episode from Acts appears with many embellishments in the legends that arose concerning Saint Denis. According to one version, when Paul sees the Altar of the Unknown God he asks Dionysius, the "most learned" of the Athenian philosophers, who this God is. Dionysius answers, "He is the true God who is not to be discovered among the other Gods, but is unknown and unknowable to us, and he shall be in the future time and shall reign forever." Also, "He is God and Man." Paul then says, "This is He that I preach which descended from heaven, and took our human nature, and suffered death and rose again on the third day." At this moment a blind man passes and Dionysius says he will believe if Paul can cure the man by reciting "In the name of Jesus Christ, born of a Virgin, crucified, dead, risen again, and ascended into heaven, receive thy sight." Paul has Dionysius say these words, the beggar sees again, and Dionysius is baptized. This variation of the legend appears in the thirteenth-century work of Jacobus de Voragine, but is based on the account of Hincmar in his *Miracula Sancti Dionysii.* See Jacobus de Voragine, *The Golden Legend,* trans. Granger Ryan and Helmut Lothar Ripperger (New York, 1941), pp. 618–19. For the text of Hincmar, see Jean Mabillon, *Saeculum III,* vol. 13 of *Acta sanctorum ordinis benedicti* (Paris, 1668–1701), pt. 2, pp. 342–65.

9. See, for example, the twelfth-century Epistolary for Saint-Denis, Paris, Bibliothèque Nationale, ms. n.a. lat. 307, fol. 4r.

10. See Émile Mâle, *L'Art religieux du XIIᵉ siècle en France* (Paris, 1966), p. 178ff.; and Sumner McK. Crosby, *L'Abbaye royale de Saint-Denis* (Paris, 1953), pp. 36–37.

11. See Suger, *Adm.* (P), pp. 46–48 for the inscription on the doors.

> Portarum quisquis attollere quaeris honorem,
> Aurum nec sumptus, operis mirare laborem,
> Nobile claret opus, sed opus quod nobile claret
> Clarificet mentes, ut eant per lumina vera
> Ad verum lumen, ubi Christus janua vera.
> Quale sit intus in his determinat aurea porta:
> Mens hebes ad verum per materialia surgit,
> Et demersa prius hac visa luce resurgit.

For Suger's use of concepts of pseudo-Dionysius in literary compositions see Gabrielle Spiegel's essay in this volume, pp. 151–58.

12. Panofsky, *Suger,* pp. 22–24; and the essay by Grover Zinn, Jr., in this volume, pp. 33–40.

13. Dionysius the Pseudo-Areopagite, *Ecclesiastical Hierarchy,* p. 17.

14. For a full discussion of the relationship of the text of pseudo-Dionysius, Suger's poem, and the scenes portrayed on the bronze doors, see Gerson, "West Facade," pp. 103–10, and her forthcoming article, "Suger's Bronze Doors."

15. Christ is, of course, the true door of the church, the door to salvation. Although this theme is richly elaborated in patristic literature, Suger appears to be the first creator of iconographic programs in the West to emphasize this concept strongly, with Christ's Passion alone on the doors (it is His willingness to give up His life for mankind that makes our salvation possible, John:14–18).

For the development of the theme of Christ as the Door on Gothic facades, see Joseph Sauer, *Symbolik des Kirchengebäudes und seiner Ausstattung in der Auffassung des Mittelalters* (Freiburg im Breisgau, 1924), p. 119.

16. Suger, *Adm.* (P), pp. 48–49.

17. See the essay by Robert Hanning in this volume, p. 145–50, where the effect is described as one of many things piled up around a single focus.

18. See Mâle, *L'Art religieux,* pp. 406–19; and Sumner McK. Crosby, *L'Abbaye royale de Saint-Denis* (Paris, 1953), p. 37. Although this distinction is made, it must be noted that neither type of Last Judgment remains uncontaminated in the twelfth century. Elements from gospel description creep into basically Apocalyptic Judgments and vice versa. The Apocalyptic Elders appear in the gospel Last Judgment at Autun, and gospel elements are found in the basically Apocalyptic Last Judgment at Saint-Trôphime, Arles.

19. The standard works on the Last Judgment are Georg Voss, *Das Jüngste Gericht in der Kunst des frühen Mittelalters* (Leipzig,

1884); Abbé Auguste Bouillet, *Le Jugement dernier dans l'art aux douze premiers siècles* (Paris, 1894); and W. H. von der Mülbe, *Die Darstellung des Jüngsten Gerichts in den romanischen und gotischen Kirchenportalen Frankreichs* (Leipzig, 1911). Recent studies are Beat Brenk, *Tradition und Neuerung in der Christlichen Kunst des ersten Jahrtausends, Studien zur Geschichte des Weltgerichtsbildes* (Vienna, 1966); and Yves Christe, *La Vision de Matthieu* (Paris, 1973). Of interest is the forthcoming volume from the Medieval Institute, Kalamazoo, Early Drama, Art, and Music Monograph Series to be entitled *Homo, Memento Finis: The Iconography of Just Judgment in Medieval Art and Drama*, especially the essay by Pamela Sheingorn, "For God Is Such a Doomsman: Origins and Development of the Theme of Last Judgment," which I have read in typescript.

20. The tympanum at Autun is dated 1130–35 by Denis Grivot and George Zarnecki, *Gislebertus, sculpteur d'Autun* (Paris, 1965), pp. 163–64. Francis Salet, "Gislebertus, sculpteur d'Autun," *Bulletin monumental* 124 (1966): 109–12, dates the tympanum ca. 1140–46. For the iconography of the Autun portal, see Willibald Sauerländer, "Über die Komposition des Weltgerichts Tympanos in Autun," *Zeitschrift für Kunstgeschichte* 29 (1966): 261–94.

 The sculpture at Conques has been dated as early as 1110 and as late as 1150. For a review of all opinions, see Don Denny, "The Date of the Conques Last Judgment," *Art Bulletin* 66 (1984): 7 n. 1.

 The Last Judgment at Beaulieu has been considered an early and disorganized prototype for the Saint-Denis central portal tympanum (Mâle, *L'Art religieux*, pp. 178, 409). Important recent studies have disagreed with this thesis, interpreting the Beaulieu tympanum as iconographically independent from Saint-Denis. See Yves Christe, "Le Portail de Beaulieu, étude iconographique et stylistique," *Bulletin archéologique du Comité des Travaux Historiques et Scientifiques*, 2d ser., 6 (1970): 57–76; and Jean French, "The Innovative Imagery of the Beaulieu Portal Program: Sources and Significance," *Studies in Medieval Culture* 8 and 9 (1976): 19–30, and her unpublished dissertation of the same title, Cornell, 1972. French argues that the Beaulieu tympanum is based on Peter the Venerable's *Tractatus contra Petrobrusianos*, and would be contemporary with or postdate Saint-Denis (1972, pp. 80–82).

21. Mâle, *L'Art religieux*, pp. 181–82. The Wise and Foolish Virgins appeared in connection with the Carolingian fresco at the church of Gorze. Although the fresco is lost, we have a record of the consecration inscription (transcribed by Alcuin) which mentions the Virgins. See Julius ritter von Schlosser, *Schriftquellen zur Geschichte der Karolingischen Kunst* (Vienna, 1892) n.f. 4, p. 312, no. 900.

22. For the engraving of these inscriptions in 1840, see Blum and Crosby, "Le Portail," p. 219. Scrolls similar to those at Saint-Denis, held either by Christ or by angels, are found in a number of Last Judgments. When the scrolls appear with inscriptions, the text is always Matthew 25:34 and 41. Examples of Christ holding the scrolls can be found on a Carolingian ivory at the Victoria and Albert Museum, London (catalogue number 253–1867); the Stavelot Bible, London, British Library, MS. Add. 28106–7, vol. 1, fol. 6r; a late twelfth-century psalter and book of hours for English use, now in Paris, Bibliothèque Nationale,

ms. lat. 10433, fol. 9r; a twelfth-century copy of Augustine's *De Civitate Dei* in Boulogne, Bibliothèque de la Ville, ms. 53, fol. 73r; a late twelfth-century gospel book in Trier, Cathedral treasury, Ms. 142, fol. 146v; and a thirteenth-century psalter in Baltimore, Walters Gallery, ms. 500, fol. 23r. Angels holding scrolls with Matthew's words are found on the Conques tympanum, in the Bamberg Apocalypse, Bamberg, Staatsbibliotek Ms. Bibl. 140, fol. 53r, and on a series of Italian frescoes from the eleventh to the thirteenth centuries: nave wall, west, S. Angelo in Formis; entrance wall, S. Giovanni a Porta Latina, Rome; the apse of S. Maria Maggiore, Pianella; and the nave wall, west, S. Maria ad Cryptas, Fossa.

23. For an interesting interpretation of the angel with the sword at the extreme right of the row of apostles, see Blum and Crosby, "Le Portail," pp. 226–27.

24. Trumpeting angels are best known from Revelations 8 and 9, where seven appear upon the opening of the seventh seal.

25. For the restorations to the heaven and hell scenes, see Blum and Crosby, "Le Portail," pp. 236–41. Although the hell scenes have been very heavily restored, the present configuration does reflect the original disposition of the sculpture. The left side of the innermost archivolt has been less heavily restored. See Blum and Crosby, "Le Portail," pls. IX–XVI.

26. Three Souls in the Bosom of Abraham is the traditional iconographic representation of "feasting with Abraham, Isaac, and Jacob" and has a long history of representation in Last Judgments. The presence of the three patriarchs, as at Saint-Trôphime, Arles, is more unusual. See Brenk, *Tradition*, pp. 82ff. The unique element at Saint-Denis is Suger's organization of the figures in the archivolt so that the "cast out" soul is just opposite Abraham's Bosom.

27. For restorations to this figure, see Blum and Crosby, "Le Portail," pp. 217–20.

28. There are no other known examples of this iconography. The Cross does appear in Last Judgments, either next to, or behind, Christ. It is interpreted as a representation of Matthew 24:30, the sign of the Son of Man appearing in heaven on the day of judgment. Examples of the Cross placed next to Christ are found in the Beaulieu and Laon Last Judgments and the fresco of the west wall of Saint-George, Richenau-Oberzell, and in many manuscripts. The Cross placed directly above, or behind, Christ is not found as frequently, but examples include the sculpture at Conques, Corbeil (now destroyed), and Saint-Jouin-de-Marnes. An interesting variation can be found in a number of paintings in which the Cross is superimposed on the body of Christ. Examples include the painting on the west wall of Burgfelden; an early twelfth-century gospel book, Cambridge, Pembroke College Library, MS. 120, fol. 6v; a manuscript leaf illustrating Christ's life, New York, Morgan Library, M. 44, fol. 15r; and a psalter in Munich, Staatsbibliotek, Cod. Lat. CLM 23093, fol. 133v.

29. Augustine, *De Trinitate*, bk. 1.13, *PL*, vol. 42, cols. 840–44. The following discussion summarizes Augustine's complex arguments. Mâle, *L'Art religieux*, p. 400, has suggested that Suger's image was derived from the *Elucidarium* of Honorius Augustodunensis, but there is no evidence that Suger read this work. It seems more probable that Suger took the image from

its source in Augustine (on which Honorius himself depends). Augustine's treatise would certainly have been available to Suger, and the abbot had a considerable interest in the Trinity (see pp. 192–94). For the discussion in Honorius, see Yves Lefèvre, ed., *Honorius Augustodunensis, L'Elucidarium et les lucidaires* (Paris, 1954), p. 181.

30. Albert M. Friend, "Carolingian Art in the Abbey of St.-Denis," *Art Studies* 1 (1923): 67. The letter to Polycarp is the seventh of ten letters written by pseudo-Dionysius. See Gandillac, *Oeuvres complètes*, pp. 331–35.

31. The abbey had relics of the Passion given in the eleventh century, but quite quickly the legend arose that they had been donated by Charles the Bald in 862. See Crosby, *Abbey*, p. 45; and Baron François de Guilhermy, *Notes archéologiques, Saint-Denis*, Paris, Bibliothèque Nationale, ms. n.a. fr. 6122, fol. 284v.

32. The traditional representation of the Deisis comes from Byzantium and is specific to the Virgin and John the Baptist. In examples of the Last Judgment they appear as intercessors, seen respectively on Christ's right and left. A number of examples existed in the West, notably in the Ottonian Pericope of Henry II (Munich, Staatsbibliotek, Cod. Lat. 4452 (CLM 57) and on the west wall of Torcello.

33. See Blum and Crosby, "Le Portail," p. 223.

34. In ibid., p. 225, Blum and Crosby have authenticated the hands of the Virgin as original twelfth-century stone. Whereas the right forearm of the Apostle on Christ's left is restored, the new stone follows the original placement of the twelfth-century arm (p. 226). In the West, standing figures of John the Evangelist with his right arm raised to his face in a gesture of mourning can be found in Crucifixion scenes as early as the ninth century. See Gertrud Schiller, *The Passion of Christ*, vol. 2 of *Iconography of Christian Art* (New York, 1972), figs. 346, 347, 348, 368, 384, 392, 410, 416, for examples from the Carolingian to the Gothic period. The gesture of Mary, holding her veil to her face, can also be found from the Carolingian period on but seems to be less frequent. See Schiller, *Iconography*, vol. 2, figs. 362, 365, 383, 384, 386, 387, and 428.

35. Crosby, *L'Abbaye royale*, p. 37, was the first to suggest that the Western form of the Deisis appeared for the first time at Saint-Denis. Previously, Mâle, *L'Art religieux*, pp. 416–17, suggested that the Western form of the Deisis occurred first at Autun, identifying one of the seated apostles in the upper register of the tympanum (opposite the Virgin) as John the Evangelist. However, the figure Mâle thought was John does not turn toward Christ in supplication, but he turns in the opposite direction as if to speak with the figure to his left. In current scholarship these two figures are generally thought to be two apostles fitted into the available space. See Grivot and Zarnecki, *Gislebertus*, p. 28, who discuss the problem and suggest an alternate identification; and Sauerländer, "Komposition," pp. 292–93, who disagrees.

It is possible that the tympanum of Saint-Maur, Huy, contains the earliest example of the Western Deisis. Here, Mary and John the Evangelist do appear as supplicators, but the tympanum is dated broadly in the first half of the twelfth century, and it is uncertain whether the sculpture pre- or postdates the tympanum of Saint-Denis. See Lisbeth Tollenaere, *La Sculpture*

sur pierre de l'ancien diocèse de Liège à l'époque romane (Namur, 1957), pp. 107–10.

36. After the representation at Saint-Denis we find four examples, all in Spain, in the second half of the twelfth century. In these images of the Trinity, God the Father holds the Christ Child on His lap, while the Dove hovers above. See Adelheid Heimann, "L'Iconographie de la Trinité I: une formule byzantine et son développement en occident," *L'Art chrétien* 1 (1934): 37–58. See also German de Pamplona, *Iconografía de la Santisima Trinidad en el Arte Medieval Español* (Madrid, 1970) pp. 65–88.

37. Only one other example of the Trinity placed in context of the Last Judgment can be found. This is in the Weisbaden copy of Hildegarde of Bingen's *Liber Scivias*, written between 1141–51 and illustrated between 1160–80 (see Louis Baillet, "Les Miniatures du *Scivias* de Sainte Hildegarde conservé à la bibliothèque de Weisbaden," *Monuments et mémoires, Fondation Piot* 19 (1911): 142–43. The Trinity appears only in the Weisbaden copy of the *Scivias* and is found on the folio following the depiction of the Last Judgment. See Gerson, "West Facade," p. 132 n. 1. It is intriguing that the Trinity in the Weisbaden *Scivias* is closer to Suger's image than any other Trinity found.

The Trinity surrounded by Elders in the Saint-Sever Beatus (Paris, Bibliothèque Nationale, ms. lat. 8878, fols. 121v–122r) illustrates Revelations 7:9–17, the account of the 144,000 who have "washed their robes and made them white in the blood of the Lamb," and does not depict a judgment scene. See Gerson, "West Facade," pp. 131–32.

38. Note in particular Suger's description of the dedication ceremony, Suger, *Adm.* (P), pp. 44–47. See also Sumner McK. Crosby, "The Inside of St.-Denis' West Facade," in Margarete Kühn and Louis Grodecki, eds., *Gedenkschrift Ernst Gall* (Berlin and Munich, 1965), pp. 61–62, on the *ecclesia triplex*.

39. See especially the opening lines of Dionysius the Pseudo-Areopagite, *Mystical Theology*, pp. 191–92, "Trinity which exceedeth all Being, Deity and Goodness!"; and the first chapter of Dionysius the Pseudo-Areopagite, *Ecclesiastical Hierarchy*, pp. 17–22, esp. 20: "The source of this hierarchy is the Trinity, the fountain of life, the essence of goodness, the one cause of things that are."

40. Augustine, *De Trinitate*, bk. 1.13, *PL*, vol. 42, col. 844. The Pauline analogy (I Corinthians 13:12) is brought up in many contexts in this treatise. See especially bk. 1.10 where Augustine discusses the meaning of the phrase "deliver the kingdom," (*PL*, vol. 42, col. 835) and again in bk. 14.19, (*PL*, vol. 42, col. 1056).

41. See Blum and Crosby, "Le Portail," pp. 234–36, for the restorations to the Trinity. The head and feet of God the Father and the Cross supported by the Lamb are nineteenth-century insets. While the head and Cross follow the original disposition of the twelfth-century sculpture, the area around the feet of God the Father (fig. 12) has been so heavily recarved that it is not possible to determine what was there originally. The Dove is also a nineteenth-century inset but replaces the twelfth-century carving.

42. It is extremely rare to find the Lamb replacing the body of Christ in Trinities where God the Father is depicted anthropomorphically, especially before the thirteenth century. There

seem to be only five examples extant prior to Suger's Trinity. The earliest appeared in the Creation cycle in S. Paolo fuori le mura, Rome. Four others are in manuscripts: the ninth-century Utrecht Psalter, Utrecht, University Library, Cod. 32, fol. 89v; an eleventh-century English psalter, London, British Library, MS. Cotton Tiberius C.VI, fol. 126v; the eleventh-century Bury Psalter, Rome, Biblioteca Apostolica Vaticana, cod. Reg. lat. 12, fols. 168v–169r; and the eleventh-century Saint-Sever Apocalypse, Paris, Bibliothèque Nationale, ms. lat. 8879, fols. 121v–122r.

43. See Marie-Thérèse d'Alverny, "Le Cosmos symbolique du XIIᵉ siècle," *Archives d'Histoire Doctrinale et Littéraire du Moyen Âge* 28 (1953): 31–81; and Gerhart B. Ladner, "St. Gregory of Nyssa and St. Augustine on Cross Symbolism," in Kurt Weitzman, ed., *Late Classical and Medieval Studies in Honor of Albert Mathias Friend, Jr.* (Princeton, 1955), pp. 88–95. See also Paula L. Gerson's forthcoming article, "The Trinity at Saint-Denis."

44. Anna C. Esmeijer, "La Macchina dell'universo," in *Album Discipulorum Van Gelder* (Utrecht, 1963), pp. 5–15; and Anna C. Esmeijer, *Divina Quaternitas, A Preliminary Study in the Method and Application of Visual Exegesis* (Amsterdam, 1978), pp. 97–108.

45. Adelheid Heimann, "Trinitas Creator Mundi," *Journal of the Warburg Institute* 2 (1938–39): 42ff.; and more recently, Adelheid Heimann, "Three Illustrations from the Bury St. Edmunds Psalter and their Prototypes," *Journal of the Warburg Institute* 29 (1966): 46ff.

46. See note 44 here.

47. This cosmic schema was quite useful in the depiction of macrocosm and microcosm, and it is used by Hugh of Saint-Victor in *De arca Noe mystica*. See Grover A. Zinn, Jr., "*De gradibus ascensionum:* The Stages of Contemplative Ascent in Two Treatises on Noah's Ark by Hugh of St. Victor," *Studies in Medieval Culture* 5 (1975): 61–79; and Grover A. Zinn, Jr., "Mandala Symbolism and Use in the Mysticism of Hugh of St. Victor," *History of Religions* 12 (1972–73): 317–41.

48. Ladner, "St. Gregory," p. 90.

49. The Agnus Dei in a *clipeus* (with and without a cross) has itself a long history in symbolic representations from the Early Christian period through the middle ages; see Schiller, *Iconography,* vol. 2, pp. 117–21. Suger could have taken the image from a number of iconographic sources. To mention only a few, see Gerson, "West Facade," pp. 128–29, for discussion of the Lamb and Elders in the archivolts of monuments in southwest France in the twelfth century; another possibility is the symbolic Crucifixion (Schiller, *Iconography,* vol. 2, figs. 404, 407); the Lamb in a *clipeus* was also very common as an attribute of John the Baptist.

50. See the essay by Robert Hanning in this volume, pp. 145–50.

51. The anagogical window in the chevet and the Trinity in the central portal archivolts are both good examples.

52. Recall especially the visual quotations from Matthew's description of the Last Judgment, where the images follow the order of the gospel verses.

53. This is very like the repetition of certain forms noticed by Hoffmann, "Sugers Anagogisches Fenster," pp. 57–88.

54. For a different analysis in which *regnum* and *sacerdotium* play a more major role, see Millard Fillmore Hearn, Jr., *Romanesque Sculpture. The Revival of Monumental Sculpture in the Eleventh and Twelfth Centuries* (Ithaca, 1981), pp. 192–97; and more recently Konrad Hoffmann, "Zur Enstehung des Königsportals in Saint-Denis," *Zeitschrift fur Kunstgeschichte* 48, no. 1 (1985): 29–38.

The Lateral Portals of the West Facade of the Abbey Church of Saint-Denis

ARCHAEOLOGICAL AND ICONOGRAPHICAL CONSIDERATIONS*

Pamela Z. Blum

For the last century and a half two related issues have inhibited efforts to reconstruct the original iconographical program of the sculptural ensemble on the lateral portals of the west facade of the abbey church of Saint-Denis: uncertainties about what has survived from the twelfth century and about what should be attributed to one or another of the campaigns of restoration.[1] Answers to various stylistic and iconographic questions posed by art historians awaited precise knowledge of all changes that distorted or modified the original sculptures. This essay rests on an archaeological examination of the left and right portals as systematic as the one completed for the central portal in 1973.[2] On that basis this study provides new information of importance to both stylistic and iconographical questions. The findings attest to the authenticity of various portions of the carving on the lateral portals that the literature has tended to dismiss as nineteenth-century invention; conversely, other portions of the sculptures have proved more heavily restored than anyone anticipated. By authenticating the attributes held by the two major figures flanking the Deity in the apex of the outer archivolt framing the left doorway, the archaeological analysis has removed a major obstacle to reconstructing the original program.[3] As one study suggested, the key to the complex iconographical statement presented in that portal ensemble would lie in the identification of those figures.[4] By establishing their identities the archaeological evidence also permits a new hypothesis concerning the subject matter of the lost twelfth-century mosaic that originally filled the tympanum. As reconstructed here, the sculptural program of the left doorway, with its mosaic, drew on standard biblical typologies but presented them in the context of theological concepts found in the writings of pseudo-Dionysius the Areopagite. The analysis will demonstrate how the constituent parts of the sculpture on the left portal (the statue-columns, the jambs, tympanum, and archivolt) were interwoven into a unified whole of an importance greater than the sum of its parts.

Damages and Restorations

Dedicated on June 9, 1140, the western portals and their sculptural ensemble were part of the first building campaign undertaken by Abbot Suger to enlarge and glorify the church that had nurtured him (figs. 1 and 4).[5] Throughout the centuries, the erosive effects of time and weather and repeated assaults by man took their toll on the sculptures of those portals. Although we lack detailed accounts of the damage inflicted on the portals during the Hundred Years War and the wars of the Huguenots, we know that in 1435 and in 1567 the abbey was a center of conflict and the target of bombardments and pillaging.[6] As the burial place of kings and queens of France, the abbey again became a scene of violence in 1793, during the French Revolution.[7] Even without contemporary documentation, no one doubts that the systematic smashing of heads throughout the portal ensemble dates to that period.

Two major campaigns of restoration, one in 1770–71, the other in 1839–40, equaled, perhaps surpassed, the damaging effects of weather and violence. Chronicling events during his tenure as organist at the abbey, Albert Gautier left a brief summary of what constituted the most significant aspects of the 1771 campaign.[8] Presumably, to the eighteenth-century eye, the statue-columns were damaged beyond repair, and at that time the twenty figures in the embrasures of the three doorways were dismounted.[9] This robbed the ensemble of its most striking innovation—the one that inspired and became the hallmark of the

Notes for this essay begin on page 218.

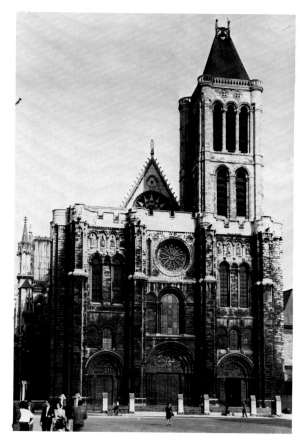

Fig. 1. *Saint-Denis, abbey church, west facade*

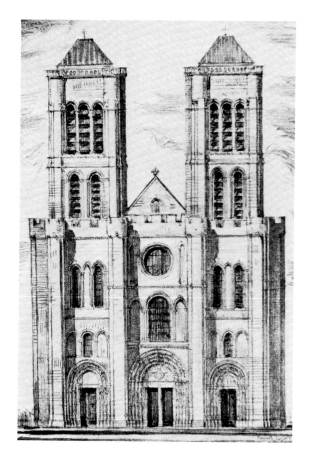

Fig. 2. *Saint-Denis, abbey church, reconstruction drawing by Kenneth J. Conant of original appearance in the twelfth century*

Early Gothic triple-portal facades known as *portails royaux*. Gautier also recorded the removal of the trumeau-statue supporting the lintel of the central portal in order to provide enough height and breadth for the passage of the processional dais and royal catafalque.

A third campaign of restoration, initiated by Napoleon in 1806, had little effect on the sculpture itself. But, by raising the pavement of the parterre in front of the west facade,[10] the architect in charge permanently stunted the proportions of the west elevation.

In 1837 a bolt of lightning struck the thirteenth-century spire of the north tower. In rebuilding the tower, François Debret, the architect of the abbey, used stone with a specific gravity much greater than that of the original limestone. The additional weight opened huge fissures across the fabric of the facade that continued into the tympana of all three portals. Because the crushing weight threatened the entire structure, Debret's tower had to be dismantled.[11] The damage provided an excuse for a complete restoration of the west facade and of its sculpture. Debret delegated the restoration of the sculpture to Joseph-Sylvestre Brun, who worked from 1839 to 1840.[12]

A drawing by Kenneth J. Conant that reconstructs the orig-

inal appearance of the portals and west elevation (fig. 2) provides a comparison with the facade as it appears today (fig. 1). The reconstruction includes the twelfth-century towers and shows the statue-columns still in place, the parterre at its original level, and the upper levels of the facade stripped of all nineteenth-century embellishments. As the archaeological study of the central portal published in 1973 demonstrated, the overzealous nineteenth-century restorations were lacking in subtlety.[13] Scrutiny of the sculpture under tenpower magnification has allowed the identification of all unrestored twelfth-century carving in the three portals and made possible the distinction between the restoration of 1770–71 and that by Brun in 1839.

Gautier's account of work done in the eighteenth-century campaign has been misleading. Although he documented the chapter's wish for a larger central entrance, he failed to say that in achieving this the masonry of the jambs had also been dismantled and reassembled and their sculptures extensively restored.[14] The more detailed notes kept by the baron de Guilhermy on work in progress during 1839–40 further nourished the misconception that, until the advent of Debret, the carving on the jambs of the western portals had survived almost unscathed.[15] Fossier's drawings of the left and right doorways, published in 1791 by Le

Gentil de la Galaisière, seemed to corroborate that notion.[16] Those drawings picture the Signs of the Zodiac on the left portal and the Labors of the Months on the right (figs. 3a and 3b) as nearly intact, with only a few details missing from the figures of the right portal. In fact, the visual documents postdate the restorations of 1771, when the jambs of all three portals were dismantled and their sculptures restored. Predictably, the small and delicate jamb carvings proved as vulnerable to the assaults of time and weather as the statue-columns in the adjacent embrasures and the monumental sculptures of the tympana and archivolts.

The two campaigns of restoration account for the otherwise irrational network of insets found at jamb-level in all three entrances. For example, the diagram defining the insets repairing the Labor of the Month for December on the left jamb of the right portal (fig. 5b) shows how several small carved insets have been superimposed upon a larger inset.[17] The earlier campaign also explains the presence of the dark mastic applied in a viscous state to the surfaces of the sculptures on the lower half of the jambs of all three portals. Above the level of the jambs the mastic occurs only in the lintel zone of the central portal—another area affected by the 1771 restorations.[18] The mastic in question dried and hardened into a brittle shell-like layer that camouflaged repairs. It also protected a number of delicate and perishable restorations modeled in plaster of Paris—a type of repair occurring primarily, but not exclusively, on the jambs of the left portal.[19] There, in the lowest figures of those jambs, the restorers even experimented with a compound of fine-grained sand mixed in a bituminous matrix. The limited use of the medium suggests that the restorer found it unsatisfactory and discontinued its application almost immediately.[20]

The mastic coating complicated the archaeological analysis,

3a

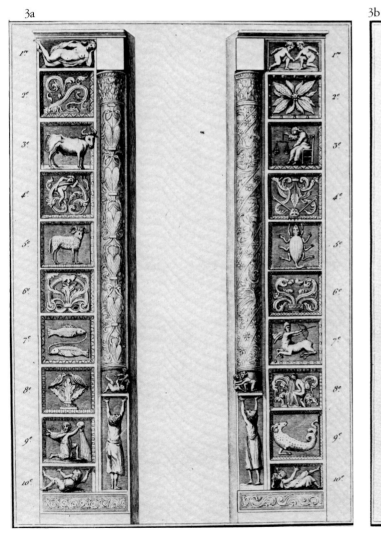

3b

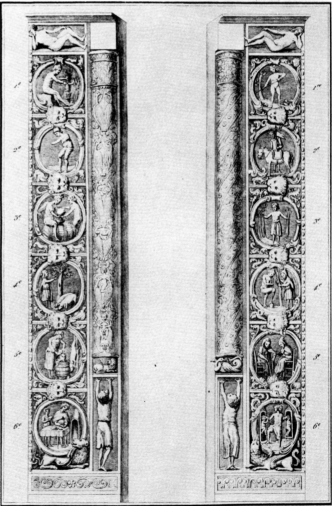

Fig. 3. Saint-Denis, west façade, lateral portal jambs, undated drawing by Fossier, ca. 1788, of the sculpture a. Left portal; b. Right portal

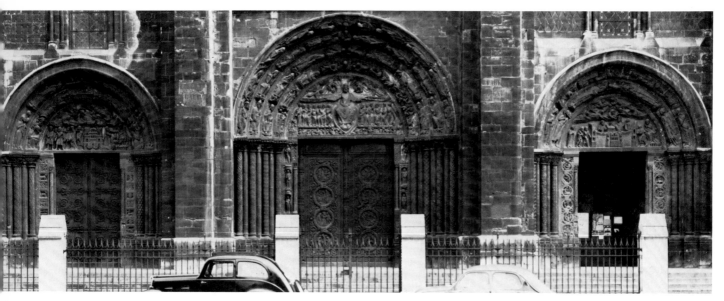

Fig. 4. Saint-Denis, west facade, triple portals

which depended on identifying differences in surface texture and color. But, where visible, surface phenomena found in the central portal recurred in the lateral doorways, with differences a matter of degree only.[21] The nineteenth-century restorer used the same yellowish stone throughout—one slightly coarser in grain than the creamy, fine-grained limestone of the twelfth century. The patina of age was the determinant in distinguishing between the unspoiled twelfth-century carving and areas that had been sanded or lightly recut. Formed by minerals carried to the surface as the newly quarried and cut stone dried, that protective skin in the course of time became crackled, and the minerals created a lively, at times crystalline appearance. The variegated color and texture of the patina contrast with the dull, even-textured surfaces of the nineteenth-century insets, which, because of the accumulation of grime, have taken on a yellowish-gray hue.

A few details from the tympanum of the central portal help to demonstrate those phenomena. Figure 6b provides a diagram of the restorations to the figure of the Virgin seated at the right of Christ in the row of Apostles flanking his mandorla. By referring to the adjacent, undiagramed photograph (fig. 6a), one can compare the texture of the Virgin's hands, her goffered sleeves, and the veil she holds—all good twelfth-century carving—with the nineteenth-century insets replacing her head and neck. The undisturbed, crusty patina of age on the ornamented border along the hem of her gown, as well as the fine detail in the pearled welting on her scaling slippers, also survived unretouched.

Recutting removed the patina of age. When severe, the process could distort and deplete the twelfth-century forms; when superficial, it did little more than remove the encrusted deposits

and reveal the color of the original stone. In every instance, however, the loss of the patina produced a somewhat grainy surface appearance. In the lintel zone of the central portal the textural differences are easily discernible in the figure of the Foolish Virgin at the far right. A detail of the figure juxtaposed with the diagram of the restorations (fig. 7) shows the lightly recut surface of her abdomen. (The vertical cut that runs through the figure was caused by the temporary removal of a portion of that sculpture to facilitate the replacement of the lintel stone).[22] The creamy, fine-grained, twelfth-century stone on the right side of the cut borders the yellower, nineteenth-century inset restoring the major portion of the left sleeve and its ornamental edging. The black and white photographs reveal the slightly grainy surface texture resulting from recutting. Again the unrecut surfaces, visible on the Virgin's left hand and on the empty lamp she holds, contrast with the recut areas below. A comparison of surface manifestations in this figure with the carving on the lowest section of the left jamb, right portal (fig. 5), illustrates how the dark mastic that coats the jamb sculptures hides the characteristics of the stone.

The Right Portal

On the right portal the restorations to the scenes of the Labors of the Months in the lower half of both jambs created a three-dimensional jigsaw puzzle beneath the mastic coating (figs. 5b and 8b). The diagram shows the network of insets repairing the roundels that contain the scenes of January and February, the adjacent Atlante, and the couchant lion below (fig. 8). Fossier's

drawing (fig. 3b) would not have led one to expect such a patch-work of repairs. Yet the archaeological conclusions presented in the diagram received unexpected confirmation. Although the recent cleaning of the west facade was not to have included the portal sculptures, in the early 1970s the first three roundels on the right jamb were cleaned. The procedure proved rigorous enough to remove the mastic coating. Stripped of that protective shell, each little inset became visible as diagramed (figs. 8c and 8d).

The differences between the eighteenth- and nineteenth-century restorations also stand out because of their contrasting styles and the deep yellowish-buff tones of the nineteenth-century insets.[23] For example, the large inset replacing the lion at the base of the scenes betrays the rococo aesthetic that informed the artistic vision of the eighteenth-century restorer. The curving lines that advance and recede, the restless movement in space of the foliate branchings, and the delicate articulation of the rinceau contrast

Key to diagrams:

 1. Nineteenth-century insets

 2. Recut areas

 3. Mortar fill

5a

5b

Fig. 5. *Saint-Denis, west facade, right portal, lower zone of left jamb*
 a. Labors of the Months, December and adjacent Atlante
 b. Diagram of restorations to same

6a

6b

Fig. 6. Saint-Denis, west facade, detail of central portal tympanum
a. Virgin Mary
b. Diagram of restorations to same

Fig. 7. Saint-Denis, west facade, central portal, lintel zone
a. Fifth Foolish Virgin
b. Diagram of restoration to same

Fig. 8. Saint-Denis, west facade, right portal, lower zone of right jamb
a. Labors of the Months, January and February and adjacent Atlante
b. Diagram of restorations to same
c. January after cleaning
d. February after cleaning

7a

7b

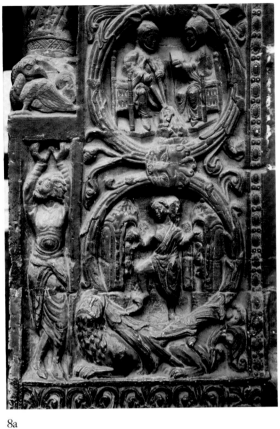

8a

8b

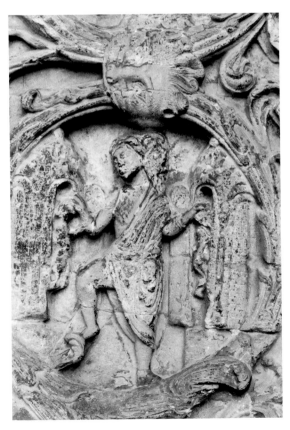

8c

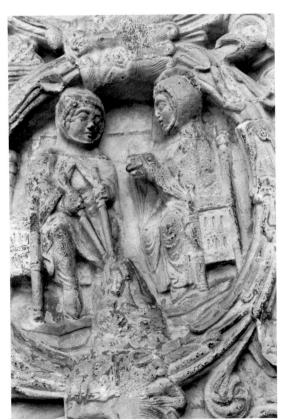

8d

with the rounder, flatter, firmer forms of the twelfth-century vine and foliage directly above. Yet in the scene of February we find what the archaeologist seeks: a superb example of the twelfth-century carving. From the shoulders down, the figure on the right has survived unretouched—perfection, even to the diapered pattern on the cloak.

As in the roundels representing January and February, all of the sculptures on the jambs of both lateral portals have undergone numerous repairs. The majority date from the restorations of 1771, when insets replaced lost or damaged details. But, more important, many excellent examples of the twelfth-century carving survive.[24] Equally important, analysis indicated that the iconography of each scene remains unmodified by the restorations.

The findings in the tympanum of the south portal also contradicted expectations, for with few exceptions art historians of our century have viewed that sculpture as a nineteenth-century work.[25] Following the criteria established for the central portal, analysis revealed that the scene consisted of twelfth-century stone now almost entirely and very severely recut. As the diagram indicates (fig. 9b), many heads as well as some faces, hands, and attributes are nineteenth-century insets. With the original iconography and composition preserved, but with the twelfth-century aesthetic completely violated, the scene depicts the celebration of the Eucharist on the eve of the martyrdom of Saint Denis and his two companions. According to legend, Christ himself with a company of angels descended to administer the sacraments.[26] The tympanum shows the executioners lurking outside the prison; Larcia, who denounced Saint Denis to the Roman prefect, stands on the left.[27] Although instrumental in bringing about the death of the saint, she became a convert during his trial. Fescinius (or Sisinnius), the Roman consul who sentenced the three, sits on the right.

Final authentication of the tympanum as a twelfth-century carving came from laboratory tests.[28] Stone samples from every section of the fracture-ridden lunette proved compatible with the twelfth-century limestone taken from the central portal.[29] Brutal recutting has robbed the composition of its twelfth-century flavor. Cutting back the level of the background to a depth varying from 7cm. to 14cm. increased the salience of the figures. The deepened shadows and higher contrast between positive and negative space have transformed the twelfth-century aesthetic almost beyond recognition. As an example of the change in the plane, note where the carved pallium ceases on the left shoulder of Saint Denis (fig. 10a). From that point back, the figure has been hewn from stone that originally lay as much as 9cm. behind the surface plane. The same holds true to a greater or lesser degree for all the figures in the tympanum, for the cloud formations, and for the walls of the prison at the left and right ends. The hand of Brun is unmistakable in the style of the restored

heads and attributes.[30] Yet the savage recutting of every figure in the tympanum has no parallel in his restorations to the central portal. In both lateral portals that aspect of the restorations must be attributable to another hand—presumably one of those at work in 1771. The eighteenth-century restorer's recutting appears as a purposeful modification of the twelfth-century style, whereas Brun's deepest and most distorting recutting reflected his efforts to eliminate surface damage without the aid of any carved insets.

Throughout the entire right tympanum the patina of age has survived in two places only—on the cuff of Saint Denis's inner right sleeve (fig. 10b) and on the upper stages of the left tower (fig. 10c). Progressively severe, the recutting has caused the gradual recession of the lower half of that wall, until at the base of the tower the surface has been cut back 14cm. A plumb line dropped from the upper stories indicated that at its base the tower originally projected almost to the front edge of the tympanum stone.

The same ubiquitous recutting characterizes the restoration of the twelfth-century figures of the inner archivolt (fig. 9). Again the heads, hands, and attributes have been repaired or replaced. The archivolt alludes to the martyrdom of Saint Denis and his two companions. Standing in the lower tier, the executioners carry the instruments of the martyrdom; hovering at the apex of the archivolt, an angel proffers the crown that is the martyr's reward. Except for the bare feet of the companion saints and the cloud formations that support the three, one finds an accurate although stylistically anomalous restoration by Brun. As an integral part of the twelfth-century voussoir stones, each figure can be authenticated.[31] As with the figures in the tympanum, recutting has rendered them useless for purposes of stylistic comparison.

The ponderous figures of angels in the outer archivolt represent one of Brun's gratuitous additions, as do the sculptures of the inner archivolt of the left portal (figs. 9 and 15). An 1813 drawing by the architects Cellérier and Legrand pictures those archivolts as blanks (fig. 11). Yet a drawing by Charles Percier of details from the left portal (fig. 12) usually dated in the 1790s, but perhaps done as early as 1771, allows us to speculate about the possibility of lost decorative elements on the archivolts of both lateral portals. In the center of the drawing, the artist preserved evidence of a decorative band of abstract ornament on one of the archivolts, presumably one framing the north portal.[32] The decoration could have embellished either the inner or outer archivolt, or possibly both, as at the cathedral of Notre-Dame, Rouen (fig. 13). The unusual abstract pierced ornament pictured by Percier probably had its only following in the bands of late twelfth-century decoration on the archivolts of both lateral portals of the west facade at Rouen. Surviving on portals dating from the 1180s, those ornamental friezes now frame thirteenth-cen-

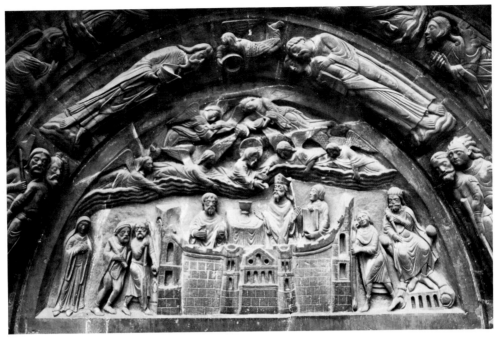

9a

Fig. 9. Saint-Denis, west façade, right portal
a. Tympanum and archivolts; b. Diagram of restorations to same

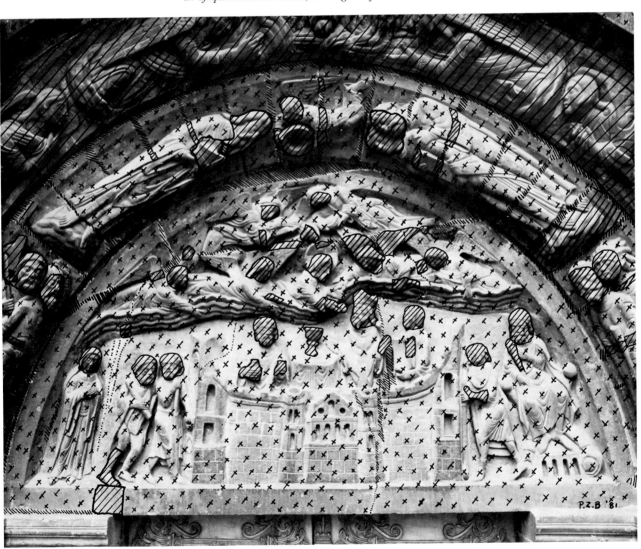

9b

10a

10b

10c

Fig. 10. Saint-Denis, west façade, right portal, details of tympanum
a. Saint Denis celebrating Mass in prison; b. Right arm of Saint Denis;
c. Left tower of prison

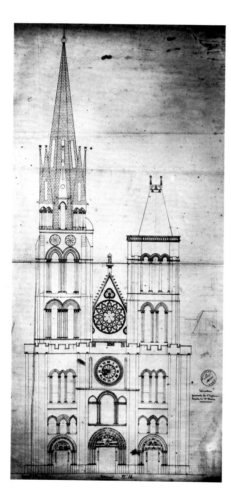

Fig. 11. Saint-Denis, west façade, drawing by
Cellérier and Legrand, ca. 1815

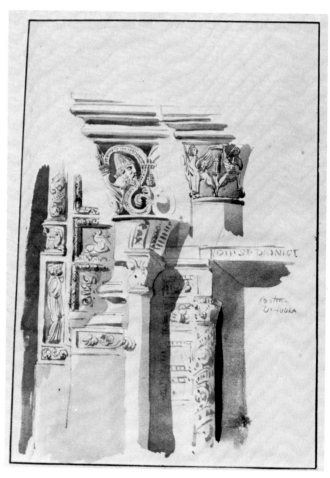

Fig. 12. Saint-Denis, west façade, left portal, undated drawing of selected
details by Percier, before 1771(?)

tury tympana. The twelfth-century building campaigns at Rouen began with the tower of Saint-Romain, work sponsored by the archbishop of Rouen, Hugh of Amiens. A friend of Suger who had been present at the dedication of the western block at Saint-Denis, Hugh initiated the new construction at Rouen less than a year after he had participated in the dedication of Suger's choir in 1144.[33] Whatever Hugh's plans, work on the west facade did not begin until after his death (1164). Despite that time lag, Percier's drawing suggests that we should credit the type of pierced work on the archivolts—ornament without other surviving parallels—to influences from the programs at Saint-Denis.

The Program of the Left Portal

Panofsky once wrote that " . . . archaeological research is blind and empty without aesthetic re-creation; and aesthetic re-creation is irrational and often misguided, without archaeological research."[34] The same holds true for iconographical re-creation when undertaken without archaeological research. Examination of the outer archivolt of the north portal provided information suggesting a possible solution to the iconographical puzzle of the entire north portal. The loss of the famed mosaic ordered by Suger for the tympanum of the north portal ("contrary," as he said, "to modern custom")[35] and uncertainty about the identities of the original figures in the outer archivolt have hampered all attempts to reconstruct the portal's program.[36] Unfortunately no description of the twelfth-century mosaic has been discovered, but the earliest reference to that tympanum suggests that the mosaic no longer existed in the second half of the eighteenth century. Gautier's description of work done in 1771 reads, *"Le bas relief en pierre à la porte de côte du grand portail sous la flèche fut aussi refait dans le mesme tems"*[37] ("The bas-relief in stone on the side door of the great portal beneath the spire was also remade [or reworked] at the same time.") That statement must refer to the left (or north) portal, situated beneath the only tower at Saint-Denis ever topped with a spire. Gautier's use of the word *refaire* in connection with the bas-relief of stone, together with the lack of any mention of a mosaic, implies that the mosaic had already been replaced by a carved tympanum, which by 1771 stood in need of repairs or replacement. The *"refait"* tympanum of 1771 (fig. 14) was, in turn, replaced in 1839 by Brun's sculpture, the carving still *in situ* today (fig. 15).[38] At the same time, Brun gratuitously added the figures on the inner archivolt. The question arises as to whether those two carved tympana—both representations of the martyrdom of Saint Denis—perpetuated the subject matter of the lost twelfth-century mosaic.[39] The themes in the twice-restored twelfth-century outer archivolt and the twelfth-century Signs of the Zodiac on the jambs suggest not.

In the outer archivolt the Deity appears in an aureole of light, supported by two angels. He is handing the Tablets of the Law to Moses, on his right; to Aaron, on his left, he presents the flowering rod. Archaeological examination fully authenticated both attributes, and therefore the identities of the figures are no longer in dispute. The insets restoring the attributes are backed by and joined to remnants of the original ones, which, in turn, are of a piece with the twelfth-century voussoir stones (fig. 16). The validation of these figures as Moses and Aaron now allows their sym-

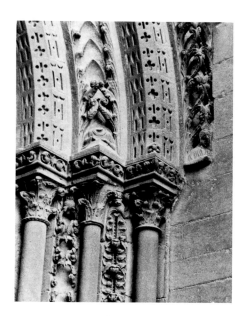

Fig. 13. Rouen, Cathedral of Notre-Dame, west facade, left portal archivolts, detail

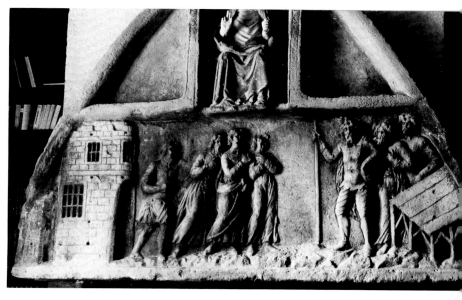

Fig. 14. Saint-Denis, west facade, left portal, dismounted tympanum carved in 1771, photographed in an apartment in Paris, 18 Quai d'Orléans, Ile-Saint-Louis

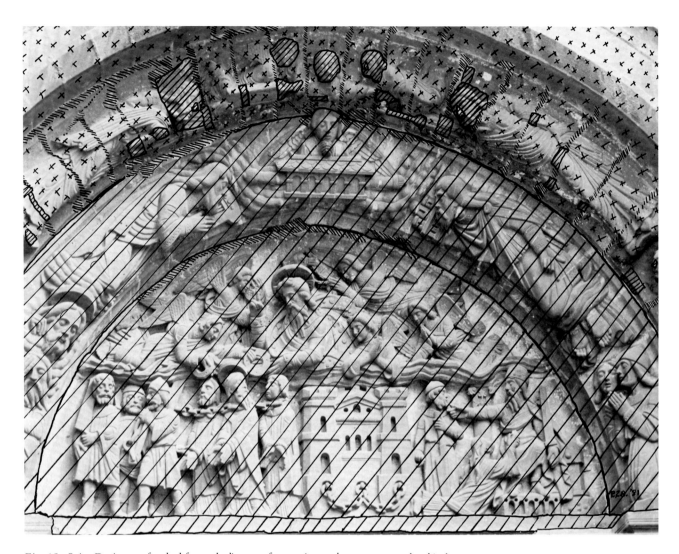

Fig. 15. Saint-Denis, west facade, left portal, diagram of restorations to the tympanum and archivolts

bolic and typological significance to be factored into any hypothesis concerning the original program for this door.[40]

Below that central group in the outer archivolt are two groups of three figures each, one on the left, the other on the right in the lower tier of the same archivolt (fig. 21). Other known sculptures on this portal include the Signs of the Zodiac on the jambs (fig. 22) and the six statue-columns that formerly stood in the embrasures.[41] The drawings of these lost statues, published in 1729 by Bernard de Montfaucon (fig. 17a), indicate that four of the six were royal figures wearing crowns. Of the two remaining statues, one, non-royal, was barefoot and wore a low, tiered headdress; the status of the other, a headless figure, also barefoot, remains unclear.[42] This ratio of royal to non-royal figures contrasts with the central portal, where only half of the figures had crowns (fig. 17b), and with the south portal, where none of the statue-columns had any attributes of royalty (fig. 17c). One can

presume that the ecclesiastical theme in the south portal informed the iconography of its non-royal column figures; by extension, one should then ask whether the predominance of royal figures on the north portal reflects the theme of the lost tympanum. As Paula Gerson has pointed out, "Most scholars have simply looked for one 'meaning' which would apply to all three portals, thus reading the range of statue-columns horizontally."[43] Her illuminating iconographical analysis of the right portal, based on *De ecclesiastica Hierarchia* by pseudo-Dionysius the Areopagite, proposed that within each portal one would find some correlation between the statue-columns and the theme represented above them in the archivolts and tympanum.

The literature has emphasized how the sculptures on both the right and central portals make tightly knit and fully integrated statements.[44] There the figures in the archivolts allude to the subjects in the tympana, and the sculptures on the jambs enlarge

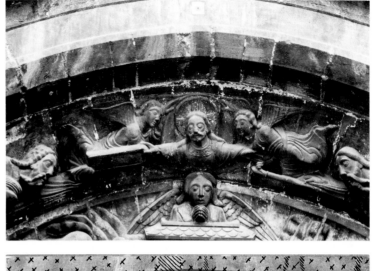

16a

16b

Fig. 16. Saint-Denis, west facade, left portal, archivolts
a. Central section of archivolts; b. Diagram of restorations to same

upon these themes. On the right portal (fig. 4), where a terrestrial event takes place in the tympanum, the Labors of the Months refer to the annual cycle of seasons governing man's life on earth. In the central portal the linkage is both formal and iconographical; two of the Wise and Foolish Virgins belonging to the series on the jambs have invaded the lintel zone of the tympanum. One is about to enter Paradise, and the other looks toward the Gates of Hell. By that placement their allegorical significance as the blessed and the damned of the Last Judgment becomes explicit (Matthew 25:1–12; figs. 4 and 7).[45]

Extrapolating from the programs of the center and right portals, one would expect to find the Signs of the Zodiac on the left portal juxtaposed to a celestial or cosmic scene rather than to the terrestrial scene depicted in the 1771 and 1839 tympana (figs. 14 and 15). By the same reasoning the figures in the outer archivolt of the left portal should enlarge upon the theme in the tym-

panum. Yet Moses and Aaron, two Old Testament figures, have no iconographical associations with the martyrdom of Saint Denis, which is represented in both modern tympana. In the exegetical literature of the early Church fathers, Moses is understood as a type for Christ, for he led his people in the way of the Lord.[46] The tablets containing the Old Law make a typological reference to the New Law, which first fulfilled and then supplanted the Old. As an allegorical figure for both the Temple and the priesthood, Aaron, the first priest, provides a type for the Church; his flowering rod makes a typological reference to the Virgin, who in the language of symbols bore the *flos,* or flower, that is Christ.[47] Also, in the medieval tradition of a play on words, the rod, *virga,* and the Virgin, *virgo,* were linked conceptually. The flowering rod had further associations with the Tree of Jesse, a reference to the royal ancestry of Christ.

On the assumption that, like the other two doorways, the left

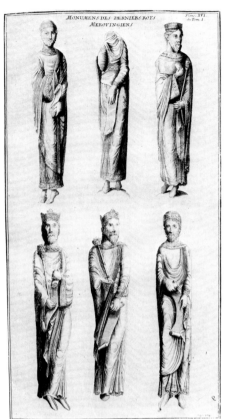

17a

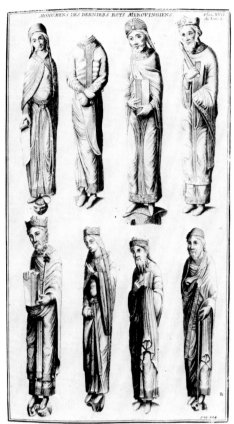

17b

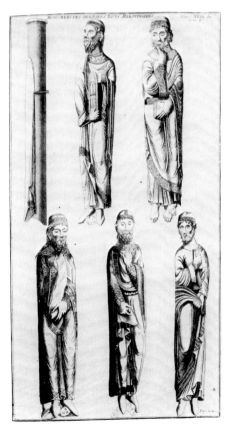

17c

Fig. 17. Saint-Denis, west façade, engravings of lost statue-columns after drawings by Antoine Benoist, published by Bernard de Montfaucon in 1729
a. Left portal; b. Central portal; c. Right portal

portal originally contained an integrated iconographical statement, the typologies of the Old Testament archivolt figures would seem to require a representation in the tympanum of Christ, the Virgin, and the Church; the zodiac symbols on the jambs propose a celestial setting, and the statue-columns emphasize kingship. The only event answering all prerequisites would be the scene of the Coronation of the Virgin, probably in its earliest version, properly called the Triumph of the Virgin.[48] In the Triumph, the Virgin, already crowned, sits on Christ's right and shares his throne. Assumed into heaven after her death and resurrection and placed in the seat of honor, the Virgin in that context becomes Maria/*Ecclesia*—the *sponsa,* or bride of Christ—a metaphor for the Church. Christ, the Son of God and Giver of the New Law, one in whom kingship and priesthood are combined, has called *Ecclesia,* his bride, to his side to share his throne for a reign under the New Law that will endure through eternity.

Surviving monuments in the Ile-de-France that date from the first three decades of the twelfth century provide no parallels or prototypes for a Triumph or Coronation of the Virgin. We find examples in England from the third decade of the twelfth century. By the 1120s the cult of the Virgin had become particularly strong there.[49] Doubtless as a reflection of the renewed liturgical and theological emphasis on the Virgin, the theme of her Coronation appeared on a capital at Reading Abbey (ca. 1130) and in a lost cycle of wall paintings in the chapterhouse at Worcester (ca. 1125–29).[50] Both examples occurred almost immediately after the institution of the Feast of the Immaculate Conception in the liturgical calendars of those two foundations.[51] The capital from Reading Abbey (fig. 18), now in storage in the municipal library of Reading, precociously introduced the fully developed version of the Coronation, in which Christ places the crown on the Virgin's head—a version not found on the Continent until the thirteenth century.

Dating from about 1160, some thirty years after the Reading and Worcester representations, the tympanum of the west portal at Senlis contains the first Coronation of the Virgin that has survived in northern French monumental art (fig. 19).[52] There the coronation is not performed by Christ but instead takes place in the two scenes in the lintel zone: first, in the Dormition of the Virgin, pictured on the left, where angels are crowning her soul; then in the Assumption of the Virgin, on the right, where an angel brings the crown for the bodily coronation. Above, in the tympanum proper, she sits in triumph, crowned and sharing Christ's throne.

The well-known Roman mosaic in the apse of S. Maria in Trastevere (fig. 20) is generally recognized as the earliest extant Triumph of the Virgin in monumental art on the Continent (1130–43).[53] Among the possible prototypes for that Roman mosaic and for the post-1150 Coronation scenes on northern French Gothic portals, Adolf Katzenellenbogen cited an Ottonian sacramentary.[54] Yet, as his study demonstrated, the immediate inspiration for the imagery in the Triumph and Coronation scenes lay in the liturgy for the Feast of the Assumption, and the ultimate source lay in biblical metaphors: "Come from Libanus, my spouse . . . come: thou shalt be crowned . . ." (Canticles 4:8); and, "The queen stood on thy right hand in gilded clothing" (Psalms 44:10/45:9). In the ninth century Paschasius Radbertus had used the former quotation in the context of the Assumption of the Virgin.[55] The lessons for the Feast of the Assumption and its octave depended heavily on his letter. Crowned and resplendent in clothing of gold, the Virgin in the Roman mosaic illustrated the metaphors of both texts. Such imagery gave visual expression to the rapidly growing veneration of the Virgin, and we find ample evidence of Suger's interest in the cult of the Virgin in the programs he commissioned for Saint-Denis.[56] One need only look to the central portal for an example. There, seated in

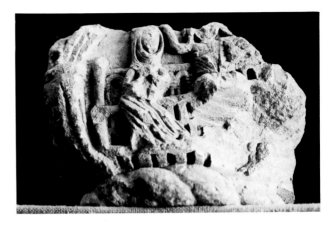

Fig. 18. *Capital from Reading Abbey (Reading, Municipal Library), Coronation of the Virgin, ca. 1130*

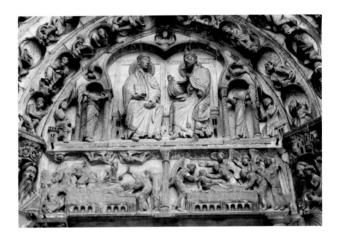

Fig. 19. *Senlis, Cathedral of Notre-Dame, western portal, tympanum and lintel depicting the Dormition, Coronation, and Triumph of the Virgin, ca. 1160*

the place of honor on Christ's right, Mary appears in her role of intercessor at the Last Judgment (figs. 4 and 6).[57]

Seeking circumstances that might have made Suger aware of iconographical developments in England, we find no evidence that Suger ever crossed the Channel. Yet earlier cross-Channel connections with the Benedictine abbey of Bury St. Edmunds are a matter of record.[58] Also, the web of contacts within the Benedictine order to which Saint-Denis belonged had often proved effective in disseminating theological and artistic concepts. The monastic communities of Worcester and Reading were part of that network. In addition, around the date generally accepted for the Reading capital, the abbot of Reading Abbey (1123–1129) was Suger's close friend, Hugh of Amiens, who became archbishop of Rouen in 1130.[59] Hugh, who had previously instituted the Feast of the Immaculate Conception in the Reading calendar, attended the council convened in London that confirmed the feast.[60] The friendship between Suger and Hugh suggests the cir-

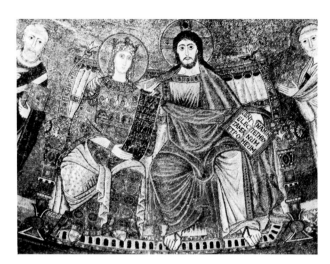

Fig. 20. Rome, S. Maria in Trastevere, apse mosaic depicting the Triumph of the Virgin, ca. 1140

cumstances in which Suger might have become fully conversant with events and attitudes in England that had fostered the early development of the cult of the Virgin and inspired the visual image of the Coronation scene.[61] Thus, the likelihood increases that the imagery had become part of Suger's iconographical vocabulary by the late 1130s.

We know from Suger's biographer that Suger gave a window to the cathedral of Notre-Dame in Paris, probably ca. 1150, although neither the date nor the subject matter was recorded.[62] In describing fragments of the window still extant shortly before the French Revolution, the eighteenth-century glass painter Pierre Le Vieil called it *"une espèce de Triomphe de la Vierge"* and indicated that the remnants included several medallions.[63] On the basis of that description Émile Mâle concluded that the window had contained a Coronation of the Virgin and posited the program as the prototype for the tympanum at Senlis and for the ensuing series of Gothic portals dedicated to the theme.[64] Speculation about the program of Suger's window touches upon the question of the medallions and whether or not they contained scenes of the Dormition and Assumption of the Virgin. If one accepts the thesis of a Triumph of the Virgin as the subject matter of Suger's lost mosaic, a decade later in the window ordered for Notre-Dame he could have echoed and probably elaborated upon the imagery.

Perhaps the most persuasive argument in favor of such a hypothesis rests on a tradition placing pseudo-Dionysius the Areopagite with the Apostles at the deathbed of the Virgin and as a witness to her Assumption.[65] From the time of Abbot Hilduin (ca. 814–841) the monks of Saint-Denis spread the claim that their patron, Saint Denis, martyred in the third century, was the same Dionysius the Areopagite converted by Saint Paul on the Areopagus in Athens in the first century A.D. (Acts

17:34).[66] To this conflated personality a third was added, that of pseudo-Dionysius the Areopagite, an Eastern mystic and theologian who had flourished around A.D. 500. In his writings pseudo-Dionysius had claimed discipleship to Saint Paul, and the all but apostolic authority then accorded to his works by medieval theologians also extended to his remarks about his presence at the death of the Virgin.[67]

An eclectic iconographer fully versed in the works of pseudo-Dionysius, Suger was capable of drawing on multiple sources and traditions to create a new iconographical synthesis for the program of the window, and perhaps for the mosaic of the left portal as well.[68] Yet, however appropriate the themes of the Dormition and Assumption might be in the context of the abbey dedicated to Saint Denis, speculation about their inclusion in the program of the portal seems unproductive; they are not needed to complete the iconographical statement proposed by the extant sculptures on the portal. Either a Triumph or Coronation scene suffices and finds support not only in the imagery of the archivolts, jambs, and embrasures but also in the circumstance of Suger's friendship with Hugh of Amiens. Although a Coronation scene similar to the one on the Reading capital remains a possibility, a Triumph of the Virgin characteristic of the earliest representations on the Continent would provide the image necessary to clarify the meaning of the rest of the portal ensemble, to complete the ideas embodied in the groups of figures in the outer archivolt, and to explain the predominance of royal statue-columns in the embrasures below.

As Katzenellenbogen pointed out, the Triumph of the Virgin in S. Maria in Trastevere reflected the imagery of the liturgy for the Feast of the Assumption,[69] and the liturgy depended to a great extent on the ninth-century letter of pseudo-Jerome (a fabrication in the name of Saint Jerome attributed to Paschasius Radbertus).[70] In his exegesis of the biblical passages from Canticles and Psalms, Radbertus placed emphasis on the idea of kingship. The Virgin, who surpassed angels and archangels in dignity, explained Radbertus, was worthy of sharing Christ's throne and rule.[71] The program for the left portal also emphasized kingship by the preponderance of royal figures among the statue-columns of that doorway. Although the literature has represented the royal figures as evocations of the theme of *regnum/ sacerdotium*,[72] that theme fails to elucidate the complicated theological concepts originally expressed in the program of the left portal.

To comprehend the full significance of the ensemble we must turn to the writings of pseudo-Dionysius the Areopagite. Here as elsewhere at Saint-Denis we find the ideas of pseudo-Dionysius, which, as Panofsky wrote, Suger "professed as a theologian, proclaimed as a poet, and practiced as a patron of the arts."[73] By perceiving how the sculptural ensemble on the right portal at Saint-Denis expressed concepts found in *De ecclesiastica*

Hierarchia by pseudo-Dionysius, Paula Gerson heightened our understanding of that portal's program.[74] Rich in metaphors, the program of the left portal was based on the same treatise. The imagery occurs within the framework of a Neoplatonic schema of the universe and emphasizes the Dionysian distinction between the earthly and celestial hierarchies.[75]

In general terms, the pseudo-Dionysian system postulated a totally ordered universe, a Christianized, Neoplatonic, cosmic order, with hierarchical substrata forming an endless chain of being.[76] All had been brought into existence by the primal source, the Trinity, the superessential Godhead, whom pseudo-Dionysius equated with Light. Just as all beings had emanated from the primal source, so all strove to return to, to know, and to become one again with that Light. In the process, the universe itself was divided into three hierarchies leading back to the primal source. At the lowest level and farthest from the Godhead was the hierarchy of the Old Law. In the middle was the ecclesiastical hierarchy of the Church, and at the highest level and closest to the Godhead was the celestial hierarchy. Each of these three hierarchies was again subdivided into three: the mysteries, those who understood the mysteries and initiated others, and those who were initiated. The treatises also postulated that the universal cosmic scheme was based on two types of law: *nomos,* or the written law bestowed by God on the human stratum through Moses; and the divine, unwritten law, or *thesmos.* Divine law was fully knowable only through the ecclesiastical hierarchy, which pseudo-Dionysius equated with the Church. Through its priesthood and its sacraments those who understood the mysteries initiated and taught those presented for initiation in a process called illumination. According to pseudo-Dionysius, temporal leadership functioned under *nomos; thesmos* extended to the mundane and gave omnipresent unity and definition to the earthly *politeia,* or hierarchy of the law.[77]

Returning now to the statue-columns of the left portal, we understand that the royal figures represent the leaders of the earthly, or mundane, hierarchy. With *thesmos,* or the divine order of the cosmos, signified by the Signs of the Zodiac on the jambs, Maria/*Ecclesia,* crowned and enthroned with Christ, would complete the metaphor. Together they represent cosmic kingship.

De ecclesiastica Hierarchia also explains the significance of the six figures grouped by threes in the lower range of the portal's outer archivolt (fig. 21). Although the meaning of these enigmatic figures has eluded critics, their function in the program becomes clear in the context of pseudo-Dionysian imagery. According to pseudo-Dionysius the substrata of the hierarchies indicate the order by which God communicates to man and the degree to which man can make the mystical ascent toward the "unknowable." Noting that Moses was the first to make the ascent into the "shadow that is beyond intelligence," the Dionysian text established him as an analogue to the ascension into the

"unknowable."[78] The sacraments of the ecclesiastical hierarchy were derived from the divinely transmitted laws and symbols received by Moses and handed down in the Scriptures. Yet, within the hierarchy of the Church the ascent became attainable to a greater extent than was possible for Moses. Because under Mosaic law purging, or purification, was a precondition for approaching the mysteries (Exodus 30:17–21), pseudo-Dionysius posited that the process of illumination ultimately leading us to the Godhead begins with Baptism, the sacrament of purification.[79]

In the two groups of three figures located below Moses and Aaron in the archivolt we see the process of illumination begun. A bishop officiates in the sacrament of Baptism, the rite of initiation into the hierarchy of the Church. His role parallels that of Moses and Aaron, for the bishop ranks as first leader of the ecclesiastical hierarchy, one empowered to transmit the sacraments.[80] *De ecclesiastica Hierarchia* outlines ceremonial procedures for this initiation, and the group on the left side of the archivolt is involved in early stages of the ritual (fig. 21a). Opposite on the right we find the final moment (fig. 21c).[81]

These figures, although totally recut and therefore worthless for stylistic comparisons, nevertheless have survived with their iconographical content intact. In the first group the figure in secular dress on the far left has been brought to the bishop by a person already initiated, also dressed in secular garb. Presumably the sponsor is the figure standing to the right, slightly behind the candidate. Situated behind and above those two figures, the bishop is vested in chasuble and amice. With his right hand he is making the gesture that provided the key to the meaning of the trio. He has placed his hand on the head of the candidate— one of the ceremonial acts in the primitive Christian ritual of initiation.[82] Although the fingers of the bishop's right hand and the face of the candidate are a single modern inset, archaeological examination has authenticated the bishop's gesture. As the diagram shows (fig. 21b), the original hand proper still rests on the surviving twelfth-century portion of the candidate's head. The bishop's other hand, pointing to the apex of the archivolt, may evoke the ritual's significance as the beginning of the candidate's ascent toward union with the Godhead.

The gestures made by the candidate and sponsor, although cryptic, without doubt also have meaning. Like the bishop, the candidate is pointing with his left hand, but obliquely downward, so that it leads the viewer's eye to the door below. Possibly that directional signal refers to the candidate's entry into the Church. His right hand, palm flattened, rests on his chest in a gesture often associated with despair.[83] Presumably a reference to his former life in sin, his gesture reminds us of the next step in the ritual, the candidate's renunciation of Satan. That required a triple immersion in water, which conveyed the usual threefold meaning of dying, renunciation, and rebirth.[84] Also, according to the text, while the candidate pronounced the renunciation, the

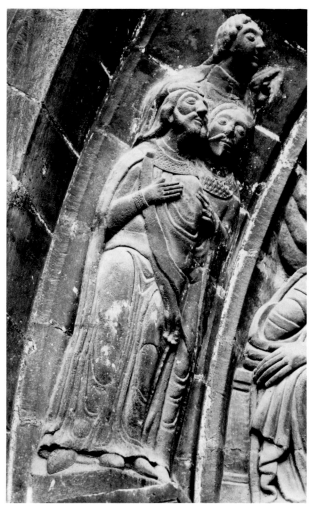

21a

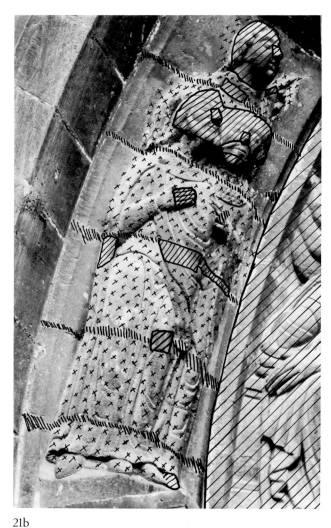

21b

Fig. 21. Saint-Denis, west facade, left portal, figures in the lower tier of the outer archivolt
a. Group at lower left: bishop, sponsor, and candidate in the first steps of the ritual of initiation, or Baptism, according to the rite as described by pseudo-Dionysius the Areopagite
b. Diagram of restorations to same
c. Group at lower right: the same three figures enacting the final moments in the ritual
d. Diagram of restorations to same

bishop was to be looking heavenward with his hands raised. In the bishop's gesture and glance perhaps we should see a conflation of the first two steps in the initiation.

The significance of the sponsor's hand on the candidate's left shoulder presents a problem, possibly compounded by nineteenth-century restoration. Damage necessitated exceptionally deep recutting of the candidate's shoulder and recarving of the sponsor's hand and fingers. Mastic also repairs his knuckles (fig. 21b). Recutting may have modified the original iconography, since nothing in the ritual explains why the sponsor is touching the candidate's shoulder with two fingers extended. Had he extended three fingers, the gesture might have alluded to the triple immersion. Perhaps two fingers specify the second immersion involving the renunciation of sin and Satan. Unfortunately, with the accuracy of the restoration in question, such an interpretation remains purely speculative.

The group of figures on the opposite side of the portal also

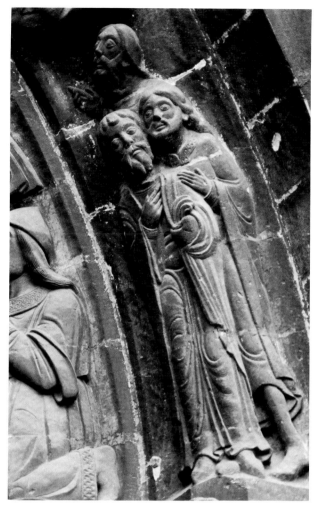

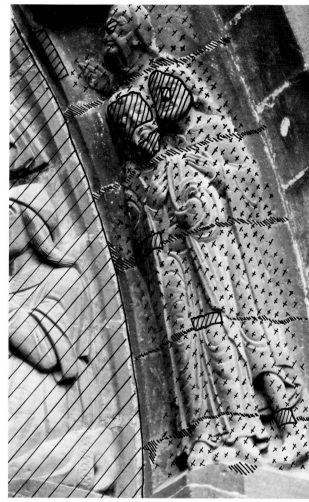

21c

21d

proved enigmatic, but here the meaning seems to depend on dress rather than gesture (fig. 21c). The figure in the foreground—his place paralleling that of the candidate in the left group—wears a himation, or toga. That striking change from mantle to himation held the key to the iconography of the second group. Again *De ecclesiastica Hierarchia* provided the explanation. If one accepts the group on the left as a representation of early stages in the ceremony of purification, or initiation into the Church, the group on the right would then depict the final step in that ritual. Upon completion of the rite of triple immersion, the candidate, according to the Dionysian text, should then be reclothed in symbolic "godlike" white garments.[85] Despite severe and pervasive recutting, the himation still follows the form of garments traditionally found in representations of God the Father, of Christ, of angels, and of the Apostles and thus provides an exact counterpart to the "godlike" garment of the text. Beneath the himation, the candidate again wears a floor-length

tunic banded at the neck and wrists in a manner closely resembling the ornament on the tunic worn by the candidate in the initial scene.

The compositional parallels between the two groups seem as telling as the dress. Once again the bishop occupies an elevated place, surely a reflection of his primacy in the ecclesiastical hierarchy; again he points upward toward the Godhead in the summit of the archivolt. Next to but slightly behind the candidate, the sponsor occupies his same position. As in the earlier scene, he has one hand on the candidate's shoulder, but here the gesture seems to illustrate the relationship of sponsor to candidate rather than a particular step in the ritual of initiation.

The Pseudo-Dionysian Interpretation of the Left Portal

Suger's complex program for the left portal combined standard typologies and Dionysian concepts to make an unequivocal state-

ment about the role of the Church in relationship to the congregation of the Temple and Mosaic law, and as a way to the True Light. The bust of the Deity, the primal source of the universal schema, appears in the apex of the outer archivolt in an aureole of light, with the angels of the celestial hierarchy on either side (fig. 16). He is giving the written law, or *nomos,* to Moses, the first leader under the Old Law, who also represents the first one to have made the mystical ascent toward the "unknowable." The flowering rod received by Aaron confirms his divinely derived authority as the first priest of the Temple (Numbers 17). The imagery follows the pseudo-Dionysian text by suggesting that, like the Old Law, divine law remained in shadow, imperfectly understood by the old priesthood but finally illuminated through the Church and the hierarchy of the new priesthood. The candidate for initiation into the Church standing directly below Moses represents those able to penetrate farther than Moses toward the "unknowable" in the ascent toward oneness with the Godhead. The bishop, who has performed the rite of initiation, stands in the same preferential position vis-à-vis Aaron, on the right side of the archivolt, as he does to Moses on the left. Just as Christ fulfilled the Old Law and was the giver of the New, so those initiated in the ecclesiastical hierarchy that is the Church will share more fully in the divine wisdom and light of the Godhead. In this context—and as a figure for the Church, which in the Dionysian scheme will lead men to the full light—Maria/ *Ecclesia* enthroned with Christ seems to complete the Dionysian statement proposed by the figures in the outer archivolt. A metaphor for the ecclesiastical hierarchy, the Church, she is the indispensable intermediary between the hierarchy under Mosaic law and the heavenly hierarchy. With the royal statue-columns representing the leaders of the earthly hierarchy, the program of the

left portal can also be read in terms of the earthly and cosmic *politeia.* and of *eros,* the movement or pervasive force, according to pseudo-Dionysius, that moves all things toward the "first cause," or primal source—each according to a transcendental ratio.[86] The Signs of the Zodiac allude to that cosmic order, and the portal program as a whole provides the visual correlative for the pseudo-Dionysian schema of the Christian universe.

Just as each part of the sculptural ensemble on the left portal as interpreted here contributes to a unified statement embodying Dionysian concepts, so future consideration of the three portals will doubtless uncover new layers of meaning that integrate the program of the left portal with the whole. For example, if one accepts the Triumph of the Virgin, with the Church as the bride of Christ, as the original subject in the left tympanum, the lost mosaic would have provided a corollary to the Church as the body of Christ, the metaphor implicit in the eucharistic scene in the tympanum on the right portal. Presented in the context of Dionysian metaphors, both allude to the role of the Church and its sacraments in attaining mystical union with the Godhead.[87]

Those metaphors on the left portal remained obscure until information recovered by archaeological examination of the outer archivolt provided a key to the program of the portal. As it does for every aspect of Suger's building campaign—the architecture, the glazing programs, the crypt capitals, as well as the portal sculptures—the archaeological approach has increased our understanding of the monument and its patron. In some instances the information may fit into previous interpretations, but for the most part, in the study of the royal abbey of Saint-Denis, the new data have forced a reconsideration of conventional points of view.

NOTES

* This paper is based on a study in preparation that will treat all the figural sculpture of the twelfth-century building campaigns sponsored by Abbot Suger at Saint-Denis. The initial field research for this essay dates from the period when I worked as a research assistant in the history of art at Yale University under the sponsorship of Sumner McK. Crosby. In the preparation of this paper I continued to enjoy unlimited access to his files and photographs. I remain in his debt both for the privilege and experience of those years as his assistant and for his unusual generosity in allowing me the use of his files.

I also acknowledge with gratitude the courtesies extended to me at Saint-Denis and in Paris. These include indispensable permissions to erect my scaffolding in front of the portals. The list of those who facilitated my archaeological and archival research is long, but I would be remiss without giving special thanks to M. Michel Fleury and Mme Sylvie Legaret of the Commission de Vieux Paris, A. J. Brankovic of the Bâtiments de France de la Seine-Saint-Denis, Mme Françoise Bercé of the Archives des Monuments Historiques, and Mme Laurence at Saint-Denis; also to the Columbia University Council for Research in the Humanities for a grant which provided the scaffolding essential to the archaeological examination.

1. The most important iconographical study of the western portals remains the unpublished work by Paula Gerson, "The West Facade of St.-Denis: An Iconographic Study" (Ph.D. diss., Columbia University, 1970). Two other unpublished critical studies have been consulted: the thesis of Cécile Goldscheider for L'École du Louvre and the resumé, "Les Origines du portail à statue-colonnes," *Bulletin des Musées de France* 11 (August-September 1946): 22–25; and Johann Eckart von Borries, "Die Westportale der Abteikirche von Saint-Denis. Versuch einer Rekonstruktion" (Ph.D. diss., Universität Hamburg,

1957). The major published work remains, Émile Mâle, *L'Art religieux du XII^e siècle en France. Étude sur l'origine de l'iconographie du Moyen Age* (Paris, 1922), pp. 176–82, 221–22) (Eng. trans. *Religious Art in France. The Twelfth Century. A Study of the Origins of Medieval Iconography,* ed. Harry Bober [Princeton, 1978], pp. 177–83, 221–23).

2. Sumner McK. Crosby and Pamela Z. Blum, "Le Portail central de la façade occidentale de Saint-Denis," *Bulletin monumental* 131, no. 3 (1973): 209–66.

3. Gerson, "West Facade," pp. 80–83.

4. Ibid., p. 83, and ch. 5, which provides a summary of the various hypotheses concerning the program of the left portal, except for the recent assessment by Willibald Sauerländer, *Gothic Sculpture in France 1140–1270,* trans. Janet Sondheimer (New York, 1972), pp. 379–81; and the analysis by Millard Fillmore Hearn, Jr., *Romanesque Sculpture. The Revival of Monumental Sculpture in the Eleventh and Twelfth Centuries* (Ithaca, 1981), pp. 192–97. Although in developing his thesis, the latter took as his point of departure Adolf Katzenellenbogen's interpretation of the statue-columns in terms of *regnum/sacerdotium* (Adolf Katzenellenbogen, *The Sculptural Programs of Chartres Cathedral. Christ. Mary. Ecclesia* [New York, 1964], pp. 27–34), this article disagrees with the symbolism Hearn attached to representations of Saint Denis and with the monadic aspect of his conclusion.

5. Suger, *Adm.* (P), pp. 40–48 and Suger, *Cons.* (P), pp. 89–91.

6. On the siege and pillaging of 1435, see Michel Félibien, *Histoire de l'abbaye royale de Saint-Denys en France* (Paris, 1706), pp. 347–48; for that of 1567, see Félibien, *Histoire,* p. 398, and Jacques Doublet, *Histoire de l'abbaye de S. Denys en France* (Paris, 1625), pp. 1313–14, 1347–49; and for a reference to the pillaging and occupation of the abbey again in 1591, see Sumner McK. Crosby, *The Abbey of St.-Denis, 1, 475–1122* (New Haven, 1942), p. 6.

7. For a general description of events at Saint-Denis during the French Revolution, see Louis Réau, *Les Monuments détruits de l'art français, histoire du vandalisme,* vol. 1, *Du Haut Moyen Age au XIX^e siècle* (Paris, 1959), pp. 224–27, 306–7.

8. Alfred Gautier, *Journal qui fait suite à Félibien,* Paris, Bibliothèque Nationale, ms. fr. 11681, fol. 20r.

9. A marginal note made by François Debret cites a document contemporary with the 1770–71 campaign that attributed the removal of the statue-columns to that period.

 According to Debret the monks of Saint-Denis had ordered the dismounting and destruction of the figures. Debret concluded from the document that the ruined state of the statue-columns had prompted their removal. The order to destroy them indicated that the statues represented figures of saints and holy persons. François Debret, "Réponse aux observations critiques du Rapport de la Commission des Monuments Historiques, adressée à Monsieur le Ministre des Travaux Publics au Sujet des travaux de Restauration exécutés à l'Église Royale de St. Denis," Saint-Denis, Seine, *Dossier de l'Administration 1841–1876,* Paris, Archives de la Commission des Monuments Historiques, fol. 19r., marginal note.

10. François Cellérier, "État de situation des travaux exécutés à l'Église Impériale de St. Denis, dans le courant de l'année

1812, conformément aux dispositions concertées avec M. Le Chevalier Fontaine," 1813, Paris, Archives nationales, F¹³ 1295, fol. 177v. For a brief summary of restorations and modifications to the west facade effected between 1806 and 1838, see Sumner McK. Crosby, *L'Abbaye royale de Saint-Denis* (Paris, 1953), pp. 71–72.

11. Paul Vitry and Gaston Brière, *L'Église abbatiale de Saint-Denis et ses tombeaux. Notice historique et archéologique,* 2d ed. (Paris, 1925), pp. 39–42. By 1846 the tower had been dismantled, but the measure proved insufficient. According to Viollet-le-Duc, the structure could be saved only by demolishing the tower down to the "plate forme" of the facade. Eugène Emmanuel Viollet-le-Duc, "Rapport," 27 November 1846, *Dossier de l'Administration, 1841–1876,* Paris, Archives de la Commission des Monuments Historiques.

12. Although the restorations done in 1839 to the figure-sculpture on the portals is attributable solely to the hand of M. Brun, fairly detailed accounts for 1838 and 1839 indicate that he had considerable assistance from the workshop of le Sieur Blois, but mainly for restorations to and replacement of ornamental details. These included the execution of twenty large columns decorated with abstract vegetal and geometric designs, carved to replace the statue-columns; 686cm. of new decorative friezes to frame the Signs of the Zodiac on the jambs of the left portal; the recutting and restoration of 703cm. of the great frieze that surrounds the central portal; as well as the nineteenth-century additions of both figural and ornamental sculptures to the upper stages of the west facade. Saint-Denis, Seine, Registre des attachements de l'Église royale de Saint-Denis, "Statuaire, sculpture," Paris, Archives de la Commission des Monuments Historiques, Carton 27, Folder 1835–1842, le Sieur Blois, "Église Royale de St. Denis. État des dépenses. . . . "

 In the years 1821–39, the atelier of le Sieur Blois had done much of the work commissioned by Debret. This involved the restorations to the statue-columns and archivolt figures on the Porte des Valois; to the sculptures on the portal of the south terminal of the transept; also to many effigies and statuary then destined for the crypt; as well as new altar retables and such controversial pastiches of medieval and nineteenth-century sculptures as the monument to Saint Denis ("Statuaire, sculpture," Carton 27, Folders 1813–1834 and 1839).

13. Crosby and Blum, "Le Portail."

14. On the various problems presented by the masonry of the jambs, see ibid., pp. 241–44.

15. Baron François de Guilhermy, "Notes," Paris, Bibliothèque Nationale, ms., n.a. fr. 6121 and 6122.

16. Guillaume le Gentil de la Galaisière, "Observations sur plusieurs anciens monumens gothiques . . . sur lesquels sont gravés les Signes du Zodiaque & quelques hyérogliphes Égyptiens, relatifs à la religion d'Isis," *Histoire de l'Académie Royale des Sciences, année 1788, avec les mémoires de mathématique et de physique pour la même année, 1788* (Paris, 1791), vol. 90, pls. XVII, XVIII.

17. In the interest of precision, diagrams of the restorations have been superimposed directly on photographs. To facilitate comparisons undiagramed photographs of the same details are included here. The unmarked areas in the diagrams indicate

original twelfth-century carving, unmodified by repairs or re-cutting. Areas outlined and hatched with widely spaced diagonal lines define carved insets of stone that replace damaged or missing portions of the original sculpture. Broken, cross-hatched lines indicate recut or sanded surfaces; and closely spaced hatchings on a downward diagonal from left to right without any circumscribing outlines represent repairs made with mortar or cement or, occasionally, surfaces remodeled with plaster of Paris and then given a protective coating of mastic. (See note 19 here.) The coat of mastic that still covers the carved surfaces in the lower half of every jamb has not been diagramed. To do so would have obscured the lines defining the other repairs. Finally, the dotted lines represent incisions or cuts made by the restorers either to facilitate the removal of the colonnettes at the angles of the jambs or to define an area about to be recut. Because the recutting did not always penetrate to the depth of those incisions, some vestiges of the guidelines still remain. The dotted lines also map fractures that have not been sealed with mortar.

18. Crosby and Blum, "Le Portail," p. 210 n. 2, p. 251 n. 4. The mastic used in the nineteenth-century restoration was applied in a malleable rather than a viscous state. See also pp. 213–14.

19. For example, plaster of Paris was used to remodel the zodiac sign of Pisces. The pattern of fish scales was then incised in the plaster and a protective coating of mastic applied over all (fig. 4a). Where the forms under a heavy application of mastic are lacking in definition, one suspects, but cannot verify, that the restorer resorted to modeling in plaster to re-create small details. In the scene of October on the left jamb of the right portal, for example, he may well have used plaster of Paris (fig. 4). The soft forms of the branches and foliage bear no resemblance to carved elements. But with the coating of mastic still intact, the integrity of the surface makes verification of this supposition impossible.

20. On the left jamb of the left portal, in the surface plane directly above the upturned face of the Atlante, one of a series of core borings produced surprising information. The boring penetrated not into stone, but into a substance resembling sand suspended in a binding matrix of a bituminous character. The closest comparison for that binder would be with tar-based compounds used in resurfacing roads. Apparently the compound was quickly judged unsuitable, for the substance occurs only in the lowest frames on the jambs of the left portal. I attribute the material to the restoration of 1771 since there is no trace of it in the work attributable solely to M. Brun.

Although not confirmed by additional core borings, the general appearance of the Atlante and reclining figure on the right jamb suggests the use of the same bituminous-based substance. Where used, it apparently contributed to the degraded state of the surface carving. The compound seems to have hardened and set, as does a macadam surface. Then, like macadam under a torrid summer sun, the material softened, shifted, and sagged in response to the pull of gravity. In the course of time, the surfaces wrinkled and puckered, thus blurring the forms and obscuring carved details. Today the two reclining figures at the base of the ensemble as well as the ornamental rinceau forming their frames have deteriorated to the point where their surfaces have become illegible contour maps. It is no longer pos-

sible to follow with certainty any of the lines of joining that define insets, or to determine what, if anything, survives of the original carving. To a lesser degree, the same surface phenomena obtain in the figures of the two standing Atlantes of the left portal.

21. For a descriptive analysis of the carved surfaces of the central portal, see Crosby and Blum, "Le Portail," esp. pp. 212–17.

22. Ibid., pp. 247–48.

23. The nineteenth-century repairs include the insets restoring the legs and arms of Janus; the left foot and right fingers of the Atlante; and repairs to the fire tongs, both heads, and some of the adjacent background in the scene of February.

24. The best examples of well-preserved twelfth-century carving occur in the upper half of the roundels of March and August, the scenes of May and September, the lower part of the figure of July, and the drapery over the hip and thigh of the Atlante on the left jamb.

25. Aware of the observations recorded by Guilhermy during the restorations at Saint-Denis, Mâle accepted the tympanum as original but acknowledged the heavy restorations and modern heads. See Mâle, *L'Art religieux du XII^e siècle* p. 222; Eng. trans., pp. 221–22. (See also Baron François de Guilhermy, *Monographie de l'église royale de Saint-Denis* [Paris, 1848], pp. 12–13; and Baron François de Guilhermy, Paris, Bibliothèque Nationale, ms. n.a. fr. 6121, fol. 56r.) Since Mâle, the twentieth-century critics have overlooked this evidence.

Cautious because of the thoroughly restored appearance of the tympanum, Gerson had reservations about the validity of all but the central section of the tympanum, which depicts Saint Denis and his companions in prison. As authenticating evidence of a prison scene, she cited Cellérier's drawing of ca. 1813 (fig. 11) but noted that most of the details do not coincide with what exists today. With understandable skepticism, she awaited the results of the archaeological examination promised by Sumner Crosby in his preliminary report on research at Saint-Denis of July 1968. See Gerson, "West Facade," pp. 27–28, 94–95; and Sumner McK. Crosby, "The Sculpture of the Western Portals of Saint-Denis and the Saint-Denis Style." Paper presented at a symposium sponsored by the International Center of Medieval Art, the Department of Art, Brown University and the Rhode Island School of Design, 14–15 May 1969. This paper was published as "The West Portals of Saint-Denis and the Saint-Denis Style," *Gesta* 9, no. 2 (1970): 1–11.

In his article Crosby authenticated only the figure of Larcia standing on the far left of the tympanum (see note 27 here). The fractures traversing the tympanum, which the weight of Debret's tower had caused, Crosby mistook for joints defining insets attributable to later restorations. His conclusions predated the detailed examination of the tympanum and the stone analysis that authenticated every section of the lunette as stone with the same characteristics as that used in the twelfth century for the sculpture on the central portal. See notes 28 and 29 here.

26. This embellishment of the legend dates to the time of Hilduin (814–841). See his *Passio sanctissimi Dionysii, PL,* vol. 106, col. 45; also Crosby, *Abbey,* p. 194; Charles J. Liebman, *Étude sur la vie en prose de saint Denis* (Geneva and New York, 1942), pp.

174–75; and Charlotte Lacaze, *The 'Vie de St. Denis' Manuscript (Paris, Bibliothèque Nationale, Ms. fr. 2090–2092)* Outstanding Dissertations in the Fine Arts (New York and London, 1979), p. 9.

27. This identification seems preferable to that of Catulla proposed by Gerson, "West Facade," p. 94. As the one who denounced Saint Denis, Larcia earned a place in the tympanum with the others responsible for his martyrdom. Catulla, who provided for the burials of the saint and his companions, seems less likely in the company of the persecutors. On their roles, see Lacaze, "Manuscript," pp. 17, 19.

28. C. Jaton and A. Blanc, Report, 1973: Dossier, Monument no. 9, Commune Saint-Denis, Fiches prélèvements nos. 93–25 to 93–29. Files of Sumner McK. Crosby, Woodbridge, Ct.

29. Samples of twelfth-century stone from the central portal were taken from the second archivolt, right, and from the tympanum. The analysis of samples from the tympanum and inner archivolt, left, of the right portal indicated that the stone of both portals was identical and came from the same bed. Described as calcareous and beige gray of a fine grain with microfossils and shells of lamellibranches, the stone had a homogeneous structure with minute vacuoles and crystals of quartz.

30. See Crosby and Blum, "Le Portail," pp. 223–24, 254–55, and compare the restored heads (pls. V, VI, and IX) with those in the tympanum and inner archivolt of the right portal (fig. 9a).

31. In the figure of Saint Denis on the upper left, no vestige of the twelfth-century head has survived, nor is there any remnant of the original miter, the attribute he now holds in his hands. Nevertheless, the adequate space allowed for a head in the voussoir stone backing the nineteenth-century replacement is the evidence validating that aspect of the restored figure. Also, the heads of the figures of the companion saints on the right side, although recut, survive intact with only the faces dating from the nineteenth century. This suggests that the archivolt depicts the moment before the martyrdom, with the angel who hovers above holding the symbolic crown that is to be their reward.

The question then arises about the validity of the cloud formations beneath the feet of the three martyrs—an iconographical element suggesting that all three were ascending bodily after their deaths. Such an occurrence lacks both textual and pictorial precedents. The bare feet and clouds supporting the two saints in the right archivolt are replacements of a piece with the modern voussoir stone; the bare feet and cloud formation beneath Saint Denis have been completely recut. According to the legend, Saint Denis was present with the Apostles at the death of the Virgin. (See p. 214.) Therefore to represent him with bare feet might be iconographically arguable. Perhaps extrapolating from this, the restorer mistakenly depicted the companion saints with bare feet—a detail without any parallels. In summary, even though authenticating vestiges of the original carving are lacking, one could accept Saint Denis's unshod feet, his head as restored, and the bishop's miter that identifies him, but one would question the cloud formation beneath his feet as well as the bare feet of the two companions and clouds that seem to carry them heavenward. Unfortunately the

Cellérier-Legrand drawing (fig. 11) is schematic and impressionistic, thus totally unreliable for such details.

32. Information provided by Debret supports the hypothesis that before the restoration of 1771 the inner archivolt of the left portal and outer archivolt of the right portal were not blank. In response to the report that criticized the restorations effected under his direction, Debret replied as follows to the commission's allegation that originally both had been simple torus moldings without sculpture:

> *Ces deux bandeaux d'archivoltes non ornés de figures et irrégulièrement placés au-dessus des deux portes latérales étaient de l'époque de cette restauration [1770–71]; non en forme de tores, et non réservés à dessein comme on suppose, ce qui est sans exemple à ma connaissance, mais construits par assises beaucoup plus régulières que celles qui les accompagnaient; de plus, d'une qualité de pierre différente de nature, et avec ciselures levées sur les joints, ce qui atteste une reconstruction beaucoup plus moderne que l'édifice.*

Debret, "Réponse," fol. 18v.

The ornamental fretwork documented by Percier's undated eighteenth-century drawing gives substance to Debret's statement attributing the blank voussoir stones to the restoration of 1771, rather than to any earlier but undocumented campaign of repairs. See Gerson, "West Facade," p. 29.

On the dating of Percier's drawings, see George Huard, "Percier et l'abbaye de Saint-Denis," *Les Monuments historiques de la France* 1 (1936): 134–35. Using the pivotal date of 1797 assigned to the drawings by Eugène Emmanuel Viollet-le-Duc (*Dictionnaire raisonné de l'architecture française du XIᵉ au XVIᵉ siècle* [Paris, 1867], vol. 2, pp. 40, 262; [1868], vol. 6, p. 404; and [1870], vol. 9, p. 32), Huard concluded that, with some dated a bit before and some a bit after, the oeuvre belonged in the 1790s. Yet the drawing of the details of the left portal must be earlier. The corner colonnettes of the jambs of the west portals visible in the Percier drawings did not remain *in situ* much beyond 1793, if at all. See the Fossier drawings published in 1791, fig. 3; and Crosby and Blum, "Le Portail," p. 249 n. 1. All verifiable information offered by Debret in his rebuttal has proved accurate, and since there is nothing to contradict his statement concerning the removal of the carved archivolts in 1771, a reconsideration of the dating of Percier's details of the left portal seems indicated.

In his restoration, Brun filled the outer archivolt with angels, a gratuitous invention that the commission severely condemned for aesthetic as well as iconographic reasons; see Debret, "Rapport sur la restauration de l'Église royale de Saint-Denis," June 1841, in Saint-Denis, Seine, *Dossier de l'Administration, 1841–1876*, Paris, Archives de la Commission des Monuments Historiques, fol. 3r.

33. For occasions attended by and participated in by Hugh, see Suger, *Adm.* (P), pp. 44–45, 68–69; and Suger, *Cons.* (P), pp. 96–97, 112–13, 118–21. See also pp. 213–14 of this essay.

On the west portals of Rouen, see Sauerländer, *Gothic Sculpture*, p. 470; and William W. Clark, "The Central Portal of Saint-Pierre at Lisieux: A Lost Monument of Twelfth-Century Gothic Sculpture," *Gesta* 11, no. 1 (1972): 52–54.

34. Erwin Panofsky, "The History of Art as a Humanistic Discipline" in *Meaning in the Visual Arts* (Garden City, N.Y., 1955), p. 19.

35. Suger, *Adm.* (P), pp. 46–47; and Panofsky, *Suger*, p. 162.

36. For a definition of the problem and a summary of opinions, see Gerson, "West Facade," pp. 76–84.

37. Alfred Gautier, "Journal qui fait suite à Félibien," Paris, Bibliothèque Nationale, ms. fr. 11681, fol. 20.

38. For the same interpretation of the Gautier statement, see Léon Pressouyre, "Une Tête de reine du portail central de Saint-Denis," *Gesta* 15 (1976): 151–60.

On the rediscovery of the 1771 tympanum on the Ile-Saint-Louis, see Sumner McK. Crosby, "A Relief from Saint-Denis in a Paris Apartment," *Gesta* 8, no. 2 (1969): 45–46; and Crosby, "West Portals," p. 8. Crosby supposed that the eighteenth-century restorer was replacing the mosaic and presumed that the carver would have perpetuated the original iconography.

39. As Gerson pointed out, no evidence exists to suggest that the subject matter of the 1771 and 1839 tympana perpetuated that of the lost mosaic. Gerson, "West Facade," p. 27. For a summary of the hypotheses concerning the scene depicted in the mosaic, see pp. 76–84.

40. Ever since Guilhermy wrote that the figures should have been restored as Peter and Paul and not as Moses and Aaron, the literature has dismissed the possibility that the restoration perpetuated the original iconography. Guilhermy wrote, *"On avait cru reconnaître Aaron et Moïse dans deux statues des apôtres saint Pierre et saint Paul, qui ont été restaurées; en conséquence on a figuré . . . le Christ donnant d'une main des tables à Moïse, et de l'autre, une verge au grand prêtre Aaron."* (Baron François de Guilhermy, "Saint-Denis: Restauration de l'église royale," *Annales archéologiques* 1 [Paris, 1844]: 405). A year earlier Guilhermy had mistakenly called the outer as well as the inner archivolt of the left portal modern: Guilhermy, *Monographie*, p. 13. See also Gerson's summary of recent opinions. In the final analysis she concluded that with the numerous unknowns, any chance of deciphering the portal program must await the results of an archaeological examination and the identification of the figures. The theme of the center archivolt would, she concluded, be essential to the formulation of a tenable hypothesis concerning the subject matter of the lost mosaic: Gerson, "West Facade," pp. 80–82.

41. Bernard de Montfaucon, *Les Monumens de la monarchie françoise* (Paris, 1729), vol. 1, pls. XVI–XVIII. See also the drawings in his *Desseins et gravures pour les monumens de la monarchie françoise*, in Paris, Bibliothèque Nationale, ms. fr. 15634, t. 1, fols. 33–77.

42. Katzenellenbogen, *Sculptural Programs*, p. 115 n. 4, compared the headless figure on the left portal with the queen on the extreme right at Chartres and concluded that the Saint-Denis figure was also royal. The bare feet were not taken into account.

43. Gerson, "West Facade," p. 149.

44. See inter alia, ibid., pp. 150–53, 157, 160; Crosby, *L'Abbaye royale*, p. 37; and Hearn, *Romanesque Sculpture*, pp. 191–97.

45. In her analysis Gerson ("West Facade," pp. 100–111, 137–39) also integrated the program of Suger's bronze doors with that of the sculpture. On formal unity, see also Crosby and Blum, "Le Portail," pp. 234–59, 265–66, where some of the interpretations of details of the sculpture differ from Gerson's. For

example, the Christ of the inner archivolt is in the act of judging (Matthew 25:35–46), not merely blessing the souls (Gerson, "West Facade," p. 135). Also, by identifying the vine that enframes the figures in the outer archivolt as the Tree of Jesse, the Crosby/Blum interpretation attributed a double significance to those twenty-four seated kings and read them as a conflation of the Elders of the Apocalypse with the Patriarchs and royal ancestors of Christ of the Old Testament. Given that additional layer of meaning and the representation of the angel with the flaming sword guarding the gate to Paradise (Genesis 3:24; tympanum right), the sculpture of the central portal can be read as an iconographical program encompassing the Christian history of the universe from Genesis to the Last Judgment.

46. Gertrud Schiller, *Iconography of Christian Art*, trans. Janet Seligman (London, 1969), vol. 1, pp. 54, 71. See also note 78 here.

47. Ibid., pp. 41, 141, which specifies that the flowering rod in Aaron's hand is a reference to his priesthood and thereby to the Church. Cf. Psalm 110 (109): *"Virgam virtutis tuae emittet Dominus ex Sion . . . Tu es sacerdos in aeternum . . . "* ("The Lord will send forth the sceptre of thy power out of Sion . . . Thou art priest forever.")

48. For brief, well-documented accounts of the theological concepts, biblical and apocryphal elements, and the textual sources that informed the themes of the Triumph and the Coronation of the Virgin, see Katzenellenbogen, *Sculptural Programs*, pp. 56–60; Jaroslav Pelikan, *The Christian Tradition. A History of the Development of Doctrine*, vol. 3, *The Growth of Medieval Theology 600–1300* (Chicago and London, 1978), pp. 69–74, 158–74; Gertrud Schiller, "Die Inthronisation und Krönung Marias in der Monumentalkunst," *Ikonographie der Christlichen Kunst*, vol. 4, no. 2 (Gütersloh, 1980): 114–18; and for a much expanded treatment, Philippe Verdier, *Le Couronnement de la Vierge. Les Origines et les premiers développements d'un thème iconographique*, (Paris and Montreal, 1980). This essay went to press before the author could examine the study published late in 1984 by Marie-Louise Thérel, *Le Triomphe de la Vierge-Église. À l'origine du décor du portail occidental de Notre-Dame de Senlis; sources historiques, littéraires et iconographiques* (Paris, 1984).

49. On the Anglo-Saxon celebration of the Feast of the Immaculate Conception (abolished by the Normans), its reinstitution, and the flowering of the cult of the Virgin in the 1120s, fostered by Osbert of Clare, St. Anselm of Canterbury, and his nephew, Anselm of Bury St. Edmunds, see inter alia, Edmund Bishop, "Origins of the Feast of the Conception of the B.V.M. [Blessed Virgin Mary]," *The Downside Review* 5 (1886): 107–19; Xavier-Marie Le Bachelet, "Immaculée conception," *Dictionnaire de théologie catholique*, vol. 7, no. 1 (Paris, 1922), cols. 989–1010; and A. W. Burridge, "L'Immaculée conception dans la théologie de l'Angleterre médiévale," *Revue d'histoire ecclésiastique* 32 (1936): 570–97. (See also notes 50 and 51 here.) The reintroduction into English monastic observance of the eastern Feast of the Immaculate Conception (there usually called the Conception of Anna) appears to have been the touchstone for the insular developments of the cult. (On the eastern liturgy see Albert Schultz, *Der Liturgische Grad des Festes der Empfängnis Mariens in*

byzantinischen Ritus vom 8.–13. Jahrhundert [Rome, 1941].)
Aroused by the theological debate, England seems to have become a generative environment for literary and other artistic manifestations of the veneration of the Virgin. For one example, see the case made for England as the locus of the earliest compilation of the *Miracles of the Virgin*, Richard W. Southern, "The English Origins of the 'Miracles of the Virgin,' " *Mediaeval and Renaissance Studies* 4 (1958): 176–216; for a lucid analysis of the influence of the active cult on aspects of English architectural design, see Stephen Gardner, "The Role of Central Planning in English Romanesque Chapter House Design" (Ph.D. diss., Princeton University, 1976), pp. 203–21. See also Kristine Edmondson Haney, "The Immaculate Imagery in the Winchester Psalter," *Gesta* 20 (1981): 111–18; and for a more general treatment of the influence of the concept on art, see Mirella Levi-d'Ancona, *The Iconography of the Immaculate Conception in the Middle Ages and the Early Renaissance* (New York, 1957), prefaced by a concise summary of textual sources and doctrinal developments of the theme.

50. For the Reading Abbey capital, see George Zarnecki, "The Coronation of the Virgin on a Capital from Reading Abbey," *Journal of the Warburg and Courtauld Institutes* 13 (1950): 1–12.

 For the lost painting in the Worcester chapterhouse, see Gardner, "Central Planning," pp. 207–20, esp. 214ff. Gardner argued convincingly for the early date, whereas the traditional dating for the cycle placed the paintings ca. 1170–80. The cycle consisted of ten groups of images, each with three Old Testament types and a New Testament antitype—a number of which evoked the Virgin as *Ecclesia*. The arrangement and subject matter of the paintings have been tentatively reconstructed from the *tituli* (*in circuitu domus*) copied on the last page of a manuscript, *Ieronimus super Psalterium et in fine quidam versus super biblia*, Worcester, Cathedral Library, MS. F. 81. As Gardner pointed out, because the emphasis of the chapterhouse program was on the Virgin, the *titulus* for the painting in question leaves little doubt that the couplet referred to Maria/*Ecclesia*, not simply *Ecclesia*:

 > *De Christo et Ecclesia*
 > *Dote subarrate fidei meritisque sacrata*
 > *Sponsa coronatur sponsoque deo sociatur.*

 > Of Christ and *Ecclesia*.
 > Betrothed with a dowry of faith and merit,
 > The holy *Sponsa* is crowned, and is joined by God with the *Sponsus*. (Gardner, "Central Planning," p. 214.)

 See also Montague Rhodes James, "On Two Series of Paintings formerly at Worcester Priory," *Proceedings of the Cambridge Antiquarian Society* 10, no. 2 (1900): 99–110; James Maurice Wilson, "On Some Twelfth Century Paintings on the Vaulted Roof of the Chapter House of Worcester Cathedral," *Reports and Papers of the Associated Architectural Societies* 33 (1913): 132–48; and M. D. Trenchard-Cox, "The Twelfth-Century Design Sources of the Worcester Cathedral Misericords," *Archaeologia* 97 (1959): 165–78, esp. pp. 166–70, showing that many of the rare typologies found in the Worcester chapterhouse paintings also appeared in monumental art of three other English Benedictine foundations: Bury St. Edmunds, Canterbury, and Peterborough. Trenchard-Cox did not try to establish a firm

chronology but suggested that Peterborough (ca. 1177) may have influenced Worcester. She apparently attached the late-twelfth-century date of the manuscript containing the *tituli* to the mural paintings as well. See also Neil Stratford, "Notes on the Norman Chapter House at Worcester," *Medieval Art and Architecture at Worcester Cathedral* (British Archaeological Association Conference Transactions for the year 1975 [1978]), p. 65 n. 14. Following the early literature, Stratford dated the cycle ca. 1170–80.

51. Bishop, "Origins," pp. 116–17, gives the dating and documentation for these and other English foundations that instituted the feast before 1150. See also Le Bachelet, "L'Immaculée conception," col. 1005. For the Worcester adoption, see also Gardner, "Central Planning," pp. 216–17, 253 n. 195; for Reading, see Zarnecki, "Coronation," pp. 11–12. About 1127 the feast was introduced there by Abbot Hugh of Amiens (1123–29), an intimate friend of Abbot Suger. See pp. 209 and 213–14 and notes 59, 60, and 61 here.

52. The recent redating of the west portal nearer 1160 than 1170 reflects the immediate influence of Notre-Dame de Paris now dated ca. 1150–60. See for the dating of Notre-Dame, Alain Erlande-Brandenburg, "La Sculpture à Paris dans la seconde moitié du XIIᵉ siècle," *Senlis. Un Moment de la sculpture gothique* in *La Sauvegarde de Senlis*, nos. 45–46 (Spring, Summer 1977): 6; and for Senlis, the review of that catalogue by Fabienne Joubert, "Bibliographie," *Bulletin monumental* 136 (1978): 99. The first of recent authors to marshal arguments for an 1150–65 date (or perhaps earlier) for Notre-Dame de Paris was Jacques Thirion, "Les Plus Anciennes Sculptures de Notre-Dame de Paris," *Académie des Inscriptions et Belles-Lettres. Comptes rendus des séances de l'année 1970* (1971), pp. 85–112.

 On the west portal of Senlis, see also Sauerländer, *Gothic Sculpture*, pp. 406–8, with bibliography up to 1972, in which the most important reference given is perhaps, Willibald Sauerländer, "Die Marien-Krönungsportale von Senlis und Mantes," *Wallraf-Richartz Jahrbuch* 20 (1958): 115–62. René Jullian, "Évolution des thèmes iconographiques: Le Couronnement de la Vierge," in *Le Siècle de Saint Louis* (Paris, 1970), pp. 153–60, despite lapses in bibliographical references, provides a useful survey of the chronological development of the theme of the Coronation of the Virgin in French monumental art.

53. See inter alia, Katzenellenbogen, *Sculptural Programs*, p. 57; Verdier, *Le Couronnement*, pp. 40–47; and Ernst Kitzinger, "A Virgin's Face. Antiquarianism in Twelfth-Century Art," *Art Bulletin* 62 (1980): 6–19. In discussing the currents of thought and influences that could account for the appearance in Rome of the theme of the Triumph of the Virgin, Katzenellenbogen and Kitzinger focused on local liturgical practices, processions, and ceremonies; Verdier interjected imperial and papal politics as well as Mosan exegetical texts into the possible impulses leading to the emergence of the imagery. See also note 61 here.

 Dated between 1140 and 1143—immediately after Innocent II returned to Rome in 1139 from his exile in France and before his death in 1143—the mosaic fills the apse of the church that Innocent undertook to renovate. The mosaic preceded by seven to ten years the generally accepted date of ca. 1150 assigned to the window commissioned by Suger for Notre-Dame in Paris. Mâle had assumed that Suger had invented the

theme of the Coronation of the Virgin, and that the window containing that imagery had provided the inspiration for Innocent's mosaic; see Mâle, *L'Art religieux du XIIᵉ siècle*, pp. 183–85; Eng. trans., pp. 184–86 and note 64 and p. 214 here. For the historiography of the literature refuting Mâle's hypothesis, see Zarnecki, "Coronation," pp. 8–12; and more recently, Verdier, "Suger a-t-il été en France le créateur du thème iconographique du couronnement de la Vierge?" *Gesta* 15 (1976): 227–36.

54. Katzenellenbogen, *Sculptural Programs*, pp. 57, 126 n. 11: the Sacramentary of Petershausen (Heidelberg, University Library, Cod. Sal. IXb, fols. 40v, 41r). Yet since Christ and the Virgin, crowned and enthroned, appear on facing pages, this is not a *synthronos* image. See for the illustration, Adolph Goldschmidt, *German Illumination*, vol. 2, *Ottonian Period*, Eng. trans. (Florence and Paris, 1928), pls. 1–2, dated ca. 980–90.

55. *"Veni de Libana, veni, coronaberis,"* quoted by Radbertus. For his letter, see Hieronymus (*scripta supposititia*), *Epistola IX ad Paulam et Eustochium. De Assumptionis beatae Mariae Virginis*, in *PL*, vol. 30 (1846), col. 131; vol. 30 (1851), cols. 135–36, now attributed to Radbertus. On the attribution and on the importance of the letter to the development of the litany for the Feast of the Assumption, see Martin Jugie, *La Mort et l'Assomption de la sainte Vierge. Étude historico-doctrinale*, Studi e Testi, 114 (Vatican City, 1944), pp. 276–91; and Katzenellenbogen, *Sculptural Programs*, pp. 57–59.

56. A chapel in the upper story of the western block was dedicated to the Virgin and St. Michael (Suger, *Cons.* (P), pp. 98–99), as was the axial chapel in the chevet and also the main altar of the crypt (pp. 118–19). The veneration was reflected in the liturgy as well, for ca. 1130 Suger had instituted a special votive mass to be said Saturdays in honor of the Virgin (Verdier, *Le Couronnement*, p. 30). The Tree of Jesse window also belongs on the list of manifestations of Suger's devotion to the Virgin. (See Louis Grodecki, *Les Vitraux de Saint-Denis* (Paris, 1976), vol. 1, pp. 73–80.) Then, too, in an inscription on the new side panels ordered by Suger for the main altar he invoked the Virgin: "Make worthy the unworthy through thy indulgence, O Virgin Mary. May the fountain of mercy cleanse the sins both of the King and the Abbot" (Suger, *Adm.* [P], pp. 60–61).

Verdier has suggested that Suger may have been aware of the particular veneration that Peter Abelard (d. 1142) rendered to the Virgin (Verdier, "Suger a-t-il été en France le créateur du thème," p. 233; and Verdier, *Le Couronnement*, pp. 40–105). Abelard's sermon on the Assumption of the Virgin speaks of her bodily resurrection and glorification, seated on the right of Christ (Abelard, *Sermo 26 in Assumptione Beatae Mariae* in *PL*, vol. 178, cols. 541–43). The mariology of Saint Bernard of Clairvaux also provided a major impetus to the cult, although Saint Bernard never became a proponent of the doctrine of the Immaculate Conception or of the bodily resurrection. See Pelikan, *Christian Tradition*, vol. 3, p. 6; and for a brief discussion of the thought and attitudes of other theologians of the period in question and references to earlier patristic sources, see Pelikan, *Christian Tradition*, vol. 3, pp. 160–74; and Jugie, *La Mort*, pp. 263–88.

57. Prior to the west portals of Saint-Denis, representations of the Virgin in portal programs depicting the Last Judgment occurred in the tympanum of the west portal at Conques, ca. 1115–20 and at Autun, ca. 1135. (For Conques, see Georges Gaillard et al., *Rouergue roman*, La Nuit des temps, Zodiaque vol. 17 [1963], p. 46 and illus. p. 35; on the dating, see Willibald Sauerländer, "Das 7. Colloquium der Société Française d'Archéologie: Saint-Foy in Conques," *Kunstchronik* 26 [August 1973]: 230; for Autun, Denis Grivot and George Zarnecki, *Gislebertus, Sculptor of Autun* [New York and Paris, 1961], p. 26, pl. M.) A wall painting in the apse of the chapterhouse at Montecassino showed the Virgin seated by Christ at the Last Judgment. We know this from a text dated ca. 1138 which describes the dream of a monk wherein the painting became animated: *". . . iudicarius Domino una cum matre considente sedes in apsida ipsius capituli . . ."* (Petrus Diaconus, *Continuatio Libri III, Chronica Monasterii Casinensis*, ed. Wilhelm Wattenbach, *Monumenta Germaniae Historica*, ed. Georg Heinrich Pertz, *Scriptorum* 7 [Hanover, 1846], p. 843). Because the date of the text provides only a *terminus a quo* for the painting, one wonders whether an earlier date of execution permitted Suger to see the image when he visited the abbey in 1123. For this trip, see Suger, *Vita Lud.* (L), p. 114; and Suger, *Vita Lud.* (W), p. 217.

58. For example, Baldwin, a monk of Saint-Denis, became abbot of Bury St. Edmunds, 1065–97/98: David Knowles, Christopher N. L. Brooke, and Vera C. M. London, eds., *The Heads of Religious Houses. England and Wales 940–1216* (Cambridge, Eng., 1972), p. 32. Other important evidence reflecting English contacts or influence includes: the tower built for the abbey as a gift of William the Conqueror (Crosby, *L'Abbaye royale*, pp. 20–22; and Panofsky, *Suger*, p. 161); Suger's friendship with Henry I (Panofsky, *Suger*, p. 4); the altar dedicated to Saint Edmund, the Anglo-Saxon king (Suger, *Cons.* (P), pp. 118–19); and in Suger's program for the crypt capitals, the cycle based on the legend of the martyrdom of Saint Edmund (Pamela Z. Blum, "The Saint Benedict Cycle in the Crypt at Saint-Denis," *Gesta* 20, no. 1 [1981]: 82). The cycle suggests that the saint was particularly important at Saint-Denis. Yet after Baldwin's time the extent of contact between Saint-Denis and Bury St. Edmunds remains unclear. Possessing the relics of the saint, Bury was the center of the cult. Anselm, whose efforts provided the major impulse for the development of the cult of the Virgin in England in the 1120s, was abbot of Bury. See also note 60 here.

59. In Suger's account of important events associated with his building campaigns, Hugh of Amiens was invariably mentioned among those present. (See note 33 here.) Suger described him as a "venerable" and "excellent man," and Panofsky characterized Hugh as an old and very intimate friend of Suger's. See Suger, *Adm.* (P), pp. 44–45; Suger, *Cons.* (P), pp. 96–97; and Panofsky's comments on pp. 233–34. Hugh earned renown for his piety and for his abilities as an administrator. His close relationship with Henry I of England and with Pope Innocent II testify to his skills as a diplomat. See also P. Hébert, "Un Archevêque de Rouen au XIIᵉ siècle: Hugues III d'Amiens, 1130–1164," *Revue des questions historiques* 64, nouv. sér. 20 (1898): 325–71; E. Vancandard, "Hugues d'Amiens," *Dictionnaire de théologie catholique*, 7, no. 1 (Paris,

1922), cols. 205–15; and Jamieson B. Hurry, *In Honour of Hugh de Boves and Hugh Cook, First and Last Abbots of Reading* (Reading, 1911).

60. On the lack of contemporary accounts of the proceedings of the London council of 1129, see Bishop, "Origins," p. 112; on the dates of the institution of the feast at Reading (in or before 1127), and in other English foundations, see pp. 113–14, 116.

A letter from Osbert of Clare (prior of Westminster), to Anselm of Bury St. Edmunds dated 1127/1128 included Hugh among the proponents already keeping the feast whom Anselm should enlist to excite others to accept the doctrine (Bishop, "Origins," p. 113). Burridge has concluded, however, that Hugh, although an advocate of the feast, was not a partisan of the doctrine. That conclusion was based on the lack of any texts by Hugh affirming the sanctification or purification of the Virgin from the moment of her conception in the womb of Saint Anne rather than at the moment of the Annunciation. (Burridge, "L'Immaculée conception," 575–77.) Burridge thus dismissed the prime contemporary evidence preserved in Osbert's letter:

And since our lord and father Gilbert . . . bishop of London . . . is sufficiently instructed in these matters, and Hugh, abbat [*sic*] of Reading, who at the prayer of King Henry solemnly keeps this festival, is well versed in both sacred and profane learning, I exhort you to discuss this matter with them and to enlist their co-operation . . .

Et quia dominus et pater noster Gillebertus . . . Lundoniensis episcopus . . . de his est sufficienter instructus, et vir vite venerabilis domnus Hugo Abbas Radingensis, qui hanc festivitatem prece etiam regis Henrici solemniter celebrat, in divinis et humanis est liberaliter edoctus, hortor ut cum eis de hac eadem re sermonem instituatis, et ut eos coadjutores et cooperatores habeatis . . . (Bishop, "Origins," pp. 110–14.)

61. Circumstances also brought Hugh and Pope Innocent II (1130–43) together at Rouen in 1131. Hugh, who became papal legate in 1133, accompanied Innocent to the Council of Montpellier in 1134, attended the council at Pisa in 1135, and throughout the papal schism of the 1130s espoused and forwarded Innocent's claim over that of Anaclete II. See inter alia, Hébert, "Un Archevêque." In addition to the close and continuing association of Hugh and Innocent, the pope's years in northern France during the schism exposed him to currents of thought and theological debates on both sides of the Channel. Given those circumstances, the Triumph of the Virgin in the mosaic ordered by Innocent for Santa Maria in Trastevere appears less of an isolated occurrence of local Roman inspiration than most of the literature has assumed.

62. William, *Vita Sug.* (L), p. 387.

63. "*Quelques parties conservées dans un vitreau de la galerie de choeur représentaient, très grossièrement à la vérité, une espèce de Triomphe de la Vierge* [*et*] *ont été démolies depuis peu*" (Pierre LeVieil, *L'Art de la peinture sur verre et de la vitrerie* [Paris, 1774], p. 23; and Marcel Aubert et al., *Les Vitraux de Notre-Dame et de la Sainte-Chapelle de Paris* [Paris, 1959], p. 15).

64. Mâle, *L'Art religieux du XIIᵉ siècle*, pp. 183–84, Eng. trans., pp. 184–85. Recent scholarship has questioned Mâle's interpretation of LeVieil's description without offering a convincing alternative (Aubert et al., *Les Vitraux*, p. 15). The window

continues to be cited as the earliest known example of the Triumph of the Virgin in northern French monumental art. But with the accumulated evidence of pre-1150 insular examples, scholarship no longer accepts Mâle's suggestion that Suger invented the imagery, or that the window provided the inspiration for the mosaic in Santa Maria in Trastevere. (See also notes 50 and 61 here.)

65. The text on which the legend rests is found in ch. 3:2 of *De divinis Nominibus* which contains one of the most direct references made by pseudo-Dionysius to having lived in the first century A.D. Somewhat cryptically he remarked how he and many of his holy brethren, including James the brother of God and Peter the greatest of the theologians, had been gathered to view the God-receiving and life-giving body. See Dionysius the Pseudo-Areopagite, *The Divine Names and The Mystical Theology*, ed. and trans. Clarence Edwin Rolt, Translations of Christian Literature, reprint (new ed. 1940; London, 1971), p. 83; Pseudo-Dionysius the Areopagite, *Oeuvres complètes du Pseudo-Denys, l'aréopagite*, ed. and trans. Maurice de Gandillac (Paris, 1943), p. 92; and also notes 67 and 75 here.

66. Hilduinus, *Passio*, *PL*, vol. 106, cols. 25–50, initiated the conflation of identities. See Crosby, *Abbey*, pp. 24–40; and more recently, Gabrielle Spiegel, "The Cult of Saint Denis and Capetian Kingship," *Journal of Medieval History* 1 (1975): 43–69, esp. 46–51; also Gabrielle Spiegel, *The Chronicle Tradition of Saint-Denis* (Brookline, Mass. and Leyden, 1978), pp. 23–24.

67. On the motives of the author in assuming the identity of Dionysius the Areopagite, see Dionysius the Pseudo-Areopagite, *The Ecclesiastical Hierarchy*, ed. and trans. Thomas L. Campbell (Abstract of diss., Catholic University of America, Washington, D.C., 1955), pp. xiii, xix (Campbell published his complete dissertation in 1981, under the same title); and Ronald F. Hathaway, *Hierarchy and the Definition of Order in the "Letters" of Pseudo-Dionysius* (The Hague, 1969), pp. xvii–xviii; also "Letter 7, to Polycarp, a Bishop," in Hathaway, p. 139, in which pseudo-Dionysius claimed to have witnessed the eclipse of the sun at the time of Christ's crucifixion.

68. For the bibliography concerning Suger's iconographical programs, see Blum, "Saint Benedict Cycle," p. 83 n. 3.

69. Katzenellenbogen, *Sculptural Programs*, pp. 57–59.

70. Ibid., and pp. 126–27; and Hieronymus (*scripta supposititia*, now attributed to Radbertus), *Epistola IX*, *PL*, vol. 30, (1846), cols. 122–42; vol. 30 (1851), cols. 126–47. For a discussion of earlier patristic authorities writing on doctrinal questions involving Mary, see Pelikan, *Christian Tradition*, vol. 3, pp. 68–74, and Pelikan, *Development of Christian Doctrine* (New Haven, 1969), pp. 95–119.

71. "*Hodie gloriosa namque semper Virgo Maria coelos ascendit: rogo, gaudete: quia (ut ita fatear) ineffabiliter sublimata cum Christo regnat in aeternum. Regina mundi hodie de terris et de praesenti saeculo nequam eruptur: . . . quia secura de sua immarcescibili gloria ad coeli jam pervenit palatium*" (Hieronymus [Radbertus], *Epistola IX*, *PL*, vol. 30 [1846], col. 126; vol. 30 [1851], col. 130) " . . . *Haec est, inquam, dies, in qua usque ad throni celsitudinem intemerata mater et virgo processit, atque in regni solio sublimata, post Christum gloriosa resedit*" (*PL*, vol. 30 [1846], col. 128; vol. 30

[1851], col. 132) "... *Ascendit Christus* ... *et preparavit huic sanctissimae et gloriosissimae Virgini locum immortalitatis, ut cum eo regnare posset in perpetuum*" (PL, vol. 30 [1846], col. 129; vol. 30 [1851], col. 133) "... *Salvator ... cum gaudio eam secum in throno collocavit*" (PL, vol. 30 [1846], col. 130; vol. 30 [1851], col. 134).

The concept of Mary's resurrection and bodily assumption is also mentioned in the text but left unresolved: "*De transitu ejusdem Virginis, dubia pro certis recipiatis: quod multi Latinorum pietatis amore, studio legendi charius amplectuntur: praesertim cum ex his nihil aliud experiri possit pro certo, nisi quod hodierna die gloriosa migravit a corpore*" (PL, vol. 30 [1846], col. 123; vol. 30 [1851], col. 127). See also Jugie, *La Mort*, p. 280; Pelikan, *Christian Tradition*, vol. 3, p. 72; and Walter Burghardt, "Mary in Eastern Patristic Thought," *Mariology*, ed. Juniper B. Carol (Milwaukee, 1957), vol. 2, pp. 139–53.

72. Katzenellenbogen, *Sculptural Programs*, pp. 27–34. See also Gerson, "West Facade," pp. 140–61, who traced the development of the idea in the literature. Hearn, *Romanesque Sculpture*, pp. 192–97, stressed the theme of *regnum/sacerdotium* as the unifying idea that transcended all others in importance; and most recently, Konrad Hoffmann, "Zur Enstehung des Königsportals in Saint-Denis," *Zeitschrift für Kunstgeschichte* 48, no. 1 (1985): 29–38.

Rather than a generic, abstract meaning applying to the statue-columns across the facade, Gerson sought vertical integration and significance for them within each portal. In my analysis, her approach proved as important for the left portal as for the right, where Gerson could identify one of the figures. Although the lack of distinguishing attributes for the figures on the left portal made it impossible to apply Gerson's method to individual statues, the dominant theme of kingship expressed by the columns dovetails with the pseudo-Dionysian interpretation proposed here.

Unlike the program designed by Suger for the bronze doors of the central portal, that for the left doors—*spolia* reused by Suger—did not appear to play an iconographical role in the portal program. Early descriptions of these lost valves tell us that they showed Airardus, a Carolingian monk at Saint-Denis whose life had been saved by the intervention of Saint Denis, presenting doors to the abbey. Alluding to a postmortem miracle of the saint that occurred when scaffolding was being dismantled at the end of the Carolingian building campaign, these *valvae antiquae* would have had associational as well as intrinsic value to account for their reuse. See Panofsky, *Suger*, pp. 159–62, for the bibliography and a discussion of the doors; and also Gerson, "West Facade," pp. 76–77, 159–60.

73. Panofsky, *Suger*, p. 20.

74. Gerson, "West Facade," pp. 150–53.

75. The surviving oeuvre of pseudo-Dionysius consists of four major treatises: *De divinis Nominibus; De mystica Theologia; De coelestia Hierarchia; De ecclesiastica Hierarchia;* and some letters.

The reconstruction of the program of the left portal in terms of pseudo-Dionysian concepts has depended on the following translations and interpretations: Rolt, ed., *Dionysius;* Gandillac, ed., *Oeuvres complètes;* René Roques, *L'Univers dionysien. Structure hiérarchique du monde selon le Pseudo-Denys* (Aubier, 1954); Campbell, ed., *Dionysius* (1955); Jan Vanneste, *Le Mys-*

tère de Dieu. Essai sur la structure rationnelle de la doctrine mystique du Pseudo-Denys l'aréopagite (Brussels, 1959); Dom Denys Rutledge, *Cosmic Theology. The Ecclesiastical Hierarchy of Pseudo-Denys: An Introduction* (London, 1964); and Hathaway, *Hierarchy.*

76. For a lucid summary of the pseudo-Dionysian system, see Pelikan, *Christian Tradition*, vol. 1, pp. 344–49. See also Rutledge, *Cosmic Theology*, p. 49.

77. *De ecclesiastica Hierarchia*, 5, 1, 2, *De coelestia Hierarchia*, 4, 3, in Gandillac, ed., *Oeuvres complètes*, pp. 294, 201. See also Hathaway, *Hierarchy*, pp. 37–46.

78. On Moses as an analogue for the ascent, see *De mystica Theologia*, 1, 3, in Rolt, ed., *Dionysius*, pp. 193–94; and Gandillac, ed., *Oeuvres complètes*, pp. 179–80.

In Deuteronomy 18:15, Moses declared, "The Lord thy God will raise up to thee a prophet of thy nation and of thy brethren like unto me ... " In a direct quote, the apostle Peter restated Moses's prophecy (Acts 3:22), but we find an antithetical concept in John 1:17: "For the law was given by Moses; grace and truth came by Jesus Christ." The resolution came from Gregory of Nyssa who made Moses the type for the Christian mystic, Gregory of Nyssa, *De Vita Moysis*, trans. Abraham J. Malherbe and Everett Ferguson, *The Life of Moses*, Cistercian Studies ser., no. 31 (New York, 1978). As Jaroslav Pelikan pointed out in a note to the author (July 1982), Gregory's formulation led directly to the pseudo-Dionysian typology.

79. *De mystica Theologia*, 1, 3, in Gandillac, ed., *Oeuvres complètes*, pp. 178–79; and Rolt, ed., *Dionysius*, pp. 193–94; also *De ecclesiastica Hierarchia*, in Campbell, ed., *Dionysius* (1955), pp. 6–13; and Gandillac, ed., *Oeuvres complètes*, pp. 251–62.

80. On the parallel relationships of the leaders of the hierarchies and on the administration of the sacraments, see *De ecclesiastica Hierarchia*, 5, 1, 5; and 5, 3, 5, in Gandillac, ed., *Oeuvres complètes*, pp. 297–98, 302.

81. On the eastern rituals of initiation or baptism according to the pseudo-Dionysian text, see *De ecclesiastica Hierarchia*, 2, in Gandillac, ed., *Oeuvres complètes*, pp. 252–62; and Campbell, ed., *Dionysius* (1955), pp. 7–13.

82. *De ecclesiastica Hierarchia*, 2, 2, 5, in Gandillac, ed., *Oeuvres complètes*, p. 254; Campbell, ed., *Dionysius* (1955), p. 8. On the imposition of the hand during baptism in the primitive Christian ceremony, see Geoffrey W. H. Lampe, *The Seal of the Spirit. A Study in the Doctrine of Baptism and Confirmation in the New Testament and the Fathers* (London, New York, and Toronto, 1951), pp. 107, 136, 223–31, and 307. Although a historical precedent is found in Acts 8:17, this practice was certainly not universal. Little by little an anointing with oil on the forehead was substituted for the imposition of the hand—the act by which the initiate's soul was sanctified by the Holy Spirit. In a progression difficult to track, the laying on of hands became a ritual in the sacrament of confirmation. But for the early Church fathers the sacrament of confirmation made operable the Spirit which had entered the soul at baptism, and the second sacrament represented spiritual progress. See Jean Daniélou, "Le Symbolisme des rites baptismaux," *Dieu Vivant* 1 (1945): 40–41.

For the quite different ritual followed in the west, see inter alia, Hugh of Saint-Victor, *De Sacramentis Christianae Fidei*, 2,

6, 10–11, in *PL,* vol. 176, cols. 456–57; and Eng. trans., *Hugh of Saint Victor. On the sacraments of the Christian Faith,* trans. Roy J. Deferrari (Cambridge, Mass., 1951), pp. 298–99.

In the western church, the laying on of the hand was reserved for the rite of confirmation. Baptism in the west involved a series of rituals, each with a particular significance: the signing of the cross in water on the forehead, breast, eyes, nostrils, ears, and mouth; the placing of salt in the mouth; the touching of the ears and nostrils with saliva; the anointing of the breasts and shoulders with holy oil; followed by an acknowledgment of faith by the baptized; the threefold immersion; the anointing of the head with holy chrism; and finally, the giving of the white garment, covering of the head with a holy veil, and the placing of a lighted candle in the hand of the baptized.

83. Moshe Barasch, *Gestures of Despair in Medieval and Early Renaissance Art* (New York, 1976), p. 17 and fig. 2.

See also a letter from Hugh of Amiens to Pope Innocent II concerning the death of Henry I of England (1135). After attending the dying monarch, Hugh reported that in the final three days Henry had made his confession three times, and Hugh had thrice absolved the king. The archbishop seemed to attach special significance to the fact that Henry had had sufficient strength to strike his breast energetically as an act of contrition. (Hébert, "Un Archevêque," p. 350.) The striking of the breast was connected with the *Non sum dignus* in the liturgy (cf. Matthew 8:8), for which this was the prescribed gesture.

84. *De ecclesiastica Hierarchia,* 2, 2, 6–8; and 2, 3, 6–8, in Gandillac, ed., *Oeuvres complètes,* pp. 254–56, 260–62; and Campbell, ed., *Dionysius* (1955), pp. 8–9, 12–13. See also, Roques, *L'Univers,* pp. 246–56.

85. *De ecclesiastica Hierarchia,* 2, 3, 8, in Gandillac, ed., *Oeuvres complètes,* p. 261; and Campbell, ed., *Dionysius* (1955), p. 13. See also, Cyril of Jerusalem, *Catechetical Lectures,* 19, 10 (Library of Nicene and Post-Nicene Fathers), 2d ser., ed. Edwin H. Gifford (London, 1894), p. 146; and Daniélou, "Le Symbolisme," pp. 23, 30, 32, and 39. The Fathers of the Church understood the tunic of white as a metaphorical replacement of animal skins, the latter a reference to Adam's garment in exile after the Fall. Such symbolism was congruent with their metaphor of baptism as Paradise regained. By shedding the "animal skins" the baptized are stripped of original sin and reclothed in the garments of incorruptibility, with their implications of salvation.

86. See Hathaway, *Hierarchy,* pp. 48–56.

87. Roques, *L'Univers,* pp. 294–302.

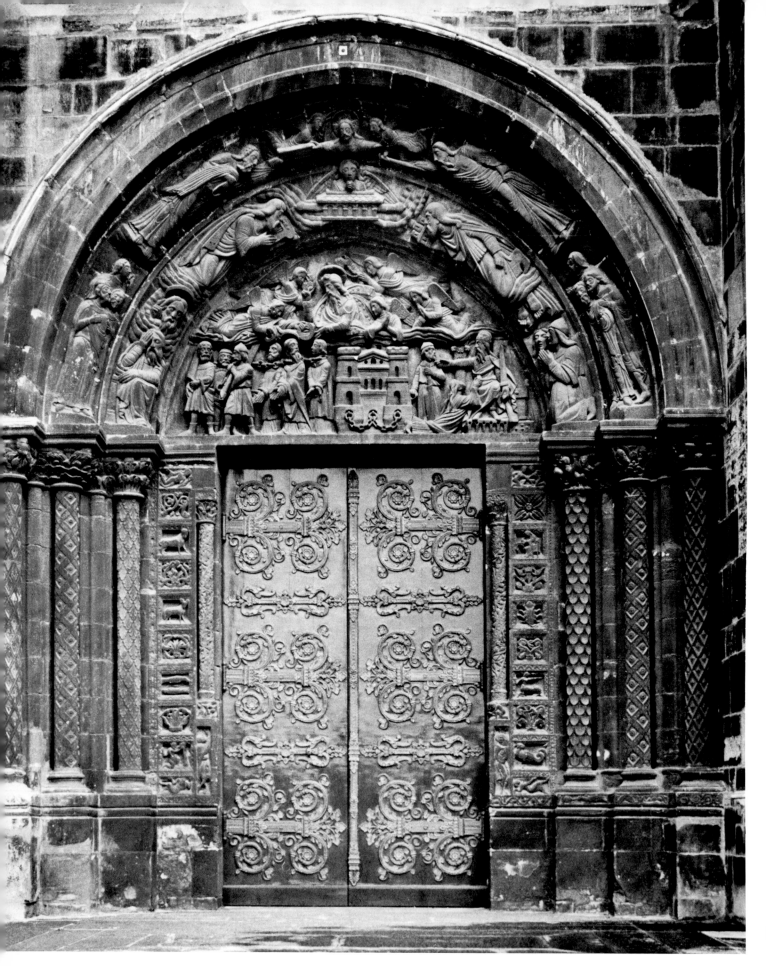

Fig. 22. Saint-Denis, west façade, left portal

Did Suger Build the Cloister at Saint-Denis?*

Léon Pressouyre

Like the rotunda of Saint-Bénigne in Dijon, like the nave of Cluny III, the cloister of Saint-Denis is a key monument frequently invoked by historians of medieval art. The cloister indeed belongs to that ill-fated family of important buildings that have disappeared, whose study is governed by a unique set of rules. The game is to work from far too laconic descriptions and very limited material evidence in order to reconstruct accurately the original disposition of the architectural elements and, furthermore, to give a cogent definition of the aesthetic characteristics without omitting any reference to a particularly rich historical background.

Generally attributed to the abbacy of Suger and generously considered as one of the first cloisters with statue-columns, the "Romanesque" cloister of Saint-Denis, by virtue of this archaeological fiction, has become well known without being properly understood. Study of its successive reworkings has been evaded; the circumstances surrounding its final destruction have drawn scarcely any attention until recently. It was only in 1978 that an as yet unpublished monograph, devoted to the abbey of Saint-Denis in the eighteenth century,[1] established a reliable chronology of the work done at the behest of the Maurists; previously Gautier,[2] Félicie d'Ayzac, Brière and Vitry[3] had given only inexact or incomplete information concerning this work. The respective roles of Robert de Cotte and Jacques-Ange Gabriel in the construction of the modern monastic buildings have now been well defined. When Robert de Cotte died in 1735, the east and south wings of the new buildings had been completed; Gabriel in turn died in 1742, at which time only half of the west wing had been built, and not without defects.

The demolition of the remaining portions of the medieval cloister began in January 1752 under the direction of the architect Bayeux.[4] The foundation stone of the new cloister was laid in April of that year.[5] Eighteen months later, in 1753, masons were at work on the balustrades of the recently completed galleries; in 1754 the east and south walls received their finishing touches.[6] Thus, contrary to a tenacious myth,[7] the old cloister had disappeared completely by 1752–53. Only the Châtelet and a few monastic buildings located to the west remained standing;[8] the construction of the Cour d'Honneur by Franque in 1778 entailed the razing of the last vestiges of the medieval abbey, apart from the church itself.

The graphic documentation portraying the cloister before its demolition in the eighteenth century is extremely summary. The series of bird's-eye views is disappointing; only the *Abbatiae Regalis ichnographia* from the *Monasticon gallicanum* gives us a rough idea of the elevation of the monument itself, or rather of its north gallery.[9] Much more precise are the ground plans drawn up for the building program undertaken by the Maurists: the three projects by Robert de Cotte, now in the collection of the Bibliothèque Nationale, are superimposed on very careful, light tracings of the conventual buildings;[10] the same is true of the plans in the Archives nationales.[11] But no exact drawing, no dimensioned sketch ever indicated in a detailed manner the elevation of the galleries of the medieval cloister, and verbal descriptions prior to 1753 do not fill this documentary void adequately.

Perhaps the most interesting description, certainly the most frequently cited, is that of Dom Jacques Doublet.[12] All the same, this rather general description appears to derive its most suggestive elements from the observation of different parts of the cloister, and it is impossible to sort out in that rather conventional evocation what might belong to the "Romanesque" gallery, to alterations executed in a "Gothic" style, or even to later rework-

Notes for this essay begin on page 242.

ings.[13] Very little of any value can be drawn from the few passages devoted to the cloister in the *procès-verbaux* of 1672 concerning the partitioning of the abbey: *"très grand et spacieux,"* it is *"proportionné à la grandeur de l'église."* The experts linger somewhat over the *"bancs de bois de menuiserie capables de contenir cent religieux assis"* but omit any description of the galleries themselves.[14]

The authors of the past seem less interested in the architectural details of the cloister, whose beauty they praise in traditional, stock phrases, than in some of the remarkable monuments it embraced: the fountain, or lavabo, of the monks, located in the southeast corner[15] and the relief of Dagobert, Clovis II, and Sigebert[16] are those most frequently mentioned, probably because they were considered to be extremely ancient.[17] It was the same fallacious reason that led Montfaucon to remark that *"dans la plus vieille partie du cloître de l'Abbaye de S. Denis, qui fut fondée long tems avant Dagobert"* are *"deux statues de nos Rois avec le nimbe, sculptées sur deux des colonnes qui soutiennent le cloître."*[18] These two statue-columns, as well as a third without a nimbus, figure among the *"Monumens des rois Mérovingiens"* on plate 10 of volume 1 of the *Monumens de la monarchie françoise.*[19]

If the rare literary and archival accounts of the cloister fail— as do the bird's-eye views, architects' renderings, drawings, and engravings—to give us a coherent picture, a third kind of source material exists that compensates for the inadequacies of our documentation while adding to its complexity. A series of sculptures has survived, attributable to the cloister of Saint-Denis either because they were discovered on the site or because of some traditional association. Formigé made a brief study of the elements belonging to the thirteenth-century parts of the cloister,[20] but the summary list of fragments datable to the twelfth century has circulated only in an incomplete or allusive form, buried in a small number of publications that are difficult to obtain. In view of this, it seemed advisable in the following pages to begin with

a critical catalogue of the "Romanesque" objects, whether previously published or not, describing them according to where they are presently housed. Thereafter, a comparative analysis, combined with a few morphological and stylistic observations, will permit us to make some reflections directly related to the theme of this symposium.

(*Note: Lit d'attente* and *lit de pose,* for which no equivalent English terms exist, refer to the upper and lower horizontal beds of the stone.)

Saint-Denis. Maison de la Légion d'Honneur

1. Fragment of the impost block for a double capital (fig. 1). Under consideration for classification as a *"monument historique."*

Found in 1946 during restoration work undertaken after the bombings of World War II. According to the information annexed to the classification file, this piece of reused stone was discovered in the foundations of that part of the north wall of the Maison de la Légion d'Honneur that faces the Cour de la Madeleine.

Dimensions: maximum height (fragmentary): 11cm.; maximum length (fragmentary): 28cm.; maximum width (fragmentary): 45cm. Only one of the short sides of this impost block, decorated with two dragons placed back to back, is moderately well preserved; the opposite face is missing as well as the adjacent extremities. What remains of the long sides is decorated with monsters placed back to back. The upper part has been recut parallel to the *lit d'attente* of the block. An examination of the *lit de pose* gives the dimensions of the double capital that was surmounted by the impost block: 30cm. × 40cm. (approximately).

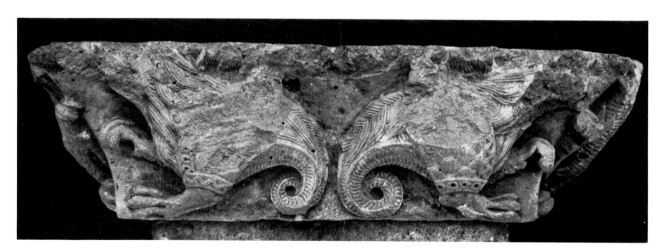

Fig. 1. Impost block for a double capital {no. 1}. (Saint-Denis, Maison de la Légion d'Honneur)

Bibliography: Léon Pressouyre, *Un Apôtre de Châlons-sur-Marne* (Berne, 1970), p. 20 n. 26. Referring to this publication, Charles T. Little mentions "another harpy capital in the Maison de la Légion d'Honneur in Saint-Denis" in *Royal Abbey*, p. 47. This inaccurate description relies, in fact, on the one by Jules Formigé, *L'Abbaye royale de Saint-Denis. Recherches nouvelles* (Paris, 1960), p. 19, according to which *"un chapiteau magnifique qui montre des griffons est conservé à la maison de la Légion d'Honneur."* I have never seen the capital with griffons reported by Formigé; and the archives of the Commission des Monuments Historiques do not mention its existence. It is quite likely that Formigé was describing, inaccurately, this impost, which was reproduced for the first time by Michel Le Moël, *L'Abbaye royale de Saint-Denis, Maison d'éducation de la Légion d'Honneur* (Paris, 1980), p. 56, fig. 71.

missing, as are the upper tori of the paired bases. The height of the plinth (7.2cm.) and the characteristic profile of the lower torus should be noted.

Bibliography: unpublished.

3. Base for a single colonnette (figs. 3 and 15).
 Martin-Demézil Inventory, no. 347.

The same remarks apply here as those for the preceding base (see Guilhermy, *Inventaire,* no. 111; Archives Photographiques, cliché Ferron 59 P. 938).

Dimensions: maximum height (fragmentary): 15.6cm.; side: 30cm. The height of the plinth (7.3cm.) and the characteristic profile of the lower torus should be noted.

Bibliography: unpublished.

Fig. 2. Base for paired colonnettes {no. 2}, (Saint-Denis, lapidary collection of the basilica)

Fig. 3. Base for a single colonnette {no. 3}, (Saint-Denis, lapidary collection of the basilica)

Saint-Denis. Lapidary collection of the Basilica in the Orangerie

2. Base for paired colonnettes (figs. 2 and 15).
 Martin-Demézil Inventory, no. 401.

This object may correspond with one of the *"bases simples, doubles, quadruples provenant d'un cloître, 12ème siècle,"* globally described in 1842–46 by François de Guilhermy in his *Inventaire des objets encore en magasin* (Paris, Bibliothèque Nationale, ms., n.a. fr. 6121 = collection Guilhermy, vol. 28, no. 111, fol. 239v). When the *dépôt lapidaire* of the Orangerie of Saint-Denis was reorganized in 1959, the base was improperly included among the *"fragments du jubé roman"* (see Archives Photographiques, cliché Ferron, 59 P. 938).

Dimensions: maximum height (fragmentary): 17.9cm.; length (integral): 41.2cm.; width (integral): 30cm. The *lit d'attente* is

Saint-Denis. Musée municipal d'art et d'histoire

4. Double capital for paired colonnettes (figs. 4 and 16).

Neither the date nor the circumstances surrounding the arrival of this capital (not inventoried until 1981) in the municipal collection of Saint-Denis is precisely known. In the old municipal museum, the label gave the following information: *"Chapiteau orné de figures humaines romanes et de feuilles d'acanthe. XIIème siècle. Atelier de Suger. Don Cailleux."* But in the twentieth century three generations of the Cailleux family have enriched the museum of Saint-Denis: Alexandre Cailleux, his son, Gaston, and his grandson, Jacques, appear successively in the inventory registers among the most assiduous donors.

The capital in question was perhaps picked up by Gaston Cailleux, an architect, who assembled in his home, 23 rue des Ursulines, an important collection of sculpture that included the

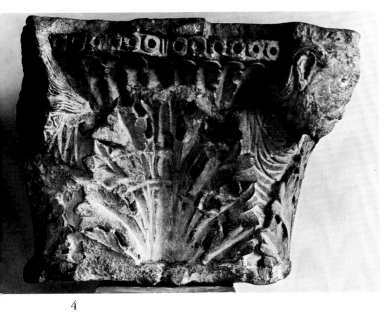

4

6

7

8

5

Fig. 4. *Double capital for paired colonnettes {no. 4}, (Saint-Denis, Musée Municipal d'Art et d'Histoire)*

Fig. 5. *Base {no. 5} and double capital {no. 6} for paired colonnettes, (Paris, Musée du Louvre)*

Fig. 6. *Capital for a single colonnette {no. 7}, (Paris, Musée du Louvre)*

Fig. 7. *Impost block for a double capital {no. 8}, (Paris, Musée du Louvre)*

Fig. 8. *Impost block for a double capital {no. 9}, (Paris, Musée du Louvre)*

fragment of a colonnette exhibited in 1981 at the Metropolitan Museum of Art in New York as no. 2c (Musée de Saint-Denis, Inventory no. 51 01 01 = formerly 3696). In view of the absence of any explicit mention in the old inventory registers, this source must remain purely conjectural.

Dimensions: height (integral): 26.5cm.; maximum length (fragmentary): 35cm.; width (integral): 30cm. An examination of the *lit d'attente* of this double capital with notched abacus enables us to reconstruct its original dimensions: 30cm. × 41cm. (approximately). *Lit de pose* prepared for the fitting of two colonnettes measuring 13.5cm. in diameter.

Bibliography: Royal Abbey, pp. 47–49, no. 5A (entry by Charles T. Little).

Paris. Musée du Louvre

5. Base for paired colonnettes (figs. 5 and 15).
 Inventory R.F. 496.

Taken by Courajod from the chantiers of Saint-Denis in 1881 and traditionally attributed to the cloister, as is the following double capital (no. 6) with which it was exhibited in the museum, in a restitution with false colonnettes, this base may be one of those described by Guilhermy in 1842–46 (see nos. 2 and 3 here).

Dimensions: height (integral): 21.2cm.; length (integral): 41.4cm.; width (integral) 30.2cm. The height of the plinth (7.2cm.) should be noted.

Bibliography: André Michel, *Musée National du Louvre. Catalogue sommaire des sculptures du Moyen Âge, de la Renaissance et des temps modernes* (Paris, 1897), no. 28; Paul Vitry and Marcel Aubert, *Musée national du Louvre. Catalogue des sculptures du Moyen Âge, de la Renaissance et des temps modernes* (Paris, 1922), vol. 1, no. 43; Marcel Aubert and Michèle Beaulieu, *Musée national du Louvre. Description raisonnée des sculptures du Moyen Âge, de la Renaissance et des temps modernes* (Paris, 1950), vol. 1, p. 60, no. 64; Bernhard Kerber, *Burgund und die Entwicklung der französichen Kathedralskulptur im zwölften Jahrhundert* (Recklinghausen, 1966), p. 44; and Wilhelm Schlink, *Zwischen Cluny und Clairvaux, Die Kathedrale von Langres und die burgundische Architektur des 12. Jahrhunderts* (Berlin, 1970), p. 129 n. 398.

6. Double capital for paired colonnettes (fig. 5).
 Inventory R.F. 497.

Taken by Courajod from the chantiers of Saint-Denis in 1881, as was the preceding number, with which it has been associated ever since. Capital with three registers of acanthus leaves whose central veins are emphasized by a pearled band. The abacus is notched; the *lit d'attente* bears traces of guidelines for the preliminary boasting (incised with a stylet).

Dimensions: height (integral): 26.5cm.; length (integral): 41cm.; width (integral): 30cm. *Lit de pose* prepared for the fitting of two colonnettes measuring 13cm.–14cm. in diameter.

Bibliography: published with the preceding number in the *Catalogue* of 1897; the capital is entered as no. 44 in the *Catalogue* of 1922; Aubert and Beaulieu, *Description raisonnée,* no. 65; Kerber, *Burgund,* p. 44; and Schlink, *Zwischen,* pp. 62, 129, and fig. 50.

7. Capital for a single colonnette (fig. 6).
 Inventory R.F. 525.

Taken by Courajod from the chantiers of Saint-Denis in 1881 and traditionally considered as a vestige of the abbey. This capital, which is decorated with one register of acanthus leaves and four harpies sculpted at the angles, was not attributed to the cloister until 1970.

Dimensions: maximum height (fragmentary): 19.5cm.; the upper part of the block seems to have been purposely recut, perhaps following an accidental break; the *lit de pose* is not fully preserved. Length of the best preserved side: 28.5cm.

Bibliography: Vitry and Aubert, *Catalogue des sculptures,* no. 46; Aubert and Beaulieu, *Description raisonnée,* p. 62, no. 62; Pressouyre, *Un Apôtre,* pp. 20–23; *Senlis. Un Moment de la sculpture gothique* (Senlis, 1977), no. 28 (entry by Diane Brouillette); and *Royal Abbey,* pp. 47–49, no. 5B (entry by Charles T. Little).

8. Impost block for a double capital (fig. 7).
 Inventory R.F. 492.

Taken by Courajod from the chantiers of Saint-Denis in 1881. Decorated with acanthus leaves treated naturalistically, which form a symmetrical motif on each face.

Dimensions: height (integral): 18.5cm. *Lit d'attente:* length (integral): 52.2cm.; maximum width (fragmentary): 35.5cm.; width (reconstructed): 40.4cm. *Lit de pose:* length (integral): 41cm.; maximum width (fragmentary): 27cm.; width (reconstructed): 31cm.

Bibliography: Michel, *Catalogue des sculptures,* no. 11; Vitry and Aubert, *Catalogue des sculptures,* no. 19; and Aubert and Beaulieu, *Description raisonnée,* no. 59.

9. Impost block for a double capital (fig. 8).
 Inventory R.F. 493.

Taken by Courajod from the chantiers of Saint-Denis in 1881, as was the preceding capital with which it has been associated ever since. Acanthus leaf decoration; ornamental motifs of zigzags and pierced pearls accent the medial vein of the principal leaves and are found at the angles and on the axis of each side.

Dimensions: height (integral): 18.5cm. *Lit d'attente:* length (integral): 53cm.; maximum width (fragmentary): 37cm.; width (reconstructed): 43cm. *Lit de pose:* 41.3cm. × 31cm.

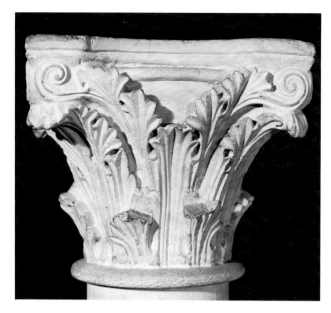

Fig. 9. *Capital for a single colonnette {no. 11}, (Paris, Musée de Cluny)*

Fig. 10. *Double capital for paired colonnettes {no. 12}, (Paris, Musée de Cluny)*

Fig. 11. *Double capital for paired colonnettes {no. 13}, (Paris, Musée de Cluny)*

Bibliography: Michel, *Catalogue des sculptures,* no. 12; Vitry and Aubert, *Catalogue des sculptures,* no. 20; and Aubert and Beaulieu, *Description raisonnée,* no. 60.

10. Fragment of an impost block.
 Inventory R.F. 510.

Taken by Courajod from the chantiers of Saint-Denis in 1881. Traditionally considered to have come from the abbey, it was not attributed to the cloister until 1981.

Dimensions: maximum height (fragmentary): 16.2cm.; maximum length (fragmentary): 27cm. Only the central portion on one side remains, decorated with a head flanked by rinceaux.

Bibliography: Michel, *Catalogue des sculptures,* no. 32; Vitry and Aubert, *Catalogue des sculptures,* no. 29; Aubert and Beaulieu, *Description raisonnée,* no. 58; *Senlis. Un Moment,* no. 27 (entry by Diane Brouillette); and *Royal Abbey,* pp. 58–59, no. 9A (entry by Charles T. Little).

Paris. Musée de Cluny

11. Capital for a single colonnette (fig. 9).
 Inventory 12119.

Taken from the chantiers of Saint-Denis, this capital found its way into the museum in 1890. It was originally considered as belonging to a group of capitals from *"l'église primitive, datée de 623 à 625"* (see Guilhermy, *Inventaire,* vol. 7, no. 12119, 6), a dating still accepted in 1922. The capital was not removed from this early medieval series until 1956, when Francis Salet reorganized the Cluny galleries and exhibited it with other works from the twelfth century.

Dimensions: maximum height (fragmentary measurements exclude modern astragal): 23.5cm.; side of the *lit d'attente:* 29.5cm.; diameter of the *lit de pose:* 17cm.

Bibliography: Edmond Haraucourt and François de Montrémy, *Musée des Thermes et de l'Hôtel de Cluny. Catalogue général* (Paris, 1922), vol. 1, no. 611; May Vieillard-Troïekouroff, "Les Chapiteaux de marbre du Haut Moyen Âge à Saint-Denis," *Gesta* 15 (1975): 105–12, and esp. p. 110, no. XII.

12. Double capital for paired colonnettes (fig. 10).
 Inventory no. 18925 A.

This capital was undoubtedly in the museum as early as 1891. At that time it was listed in the *Inventaire,* vol. 8, no. 12556, without any indication of provenance. In the revised inventory of 1912, it was entered in volume 14, no. 18925 A, and the provenance *"cloître de Saint-Denis"* was noted for the first time. Shortly before (in 1905), this double capital, as well as the following double capital (no. 13) and five other sculptures from the Musée de Cluny, appeared in Egon Hessling's album entitled *Le Vieux*

Fig. 12. Double capital for paired colonnettes {no. 14}, (Ex collection Maignan)

Fig. 13. Capital for a single colonnette {no. 15}, (Rouen, Musée des Antiquités de la Seine-Maritime)

Paris under the general heading *"Cathédrale de Saint-Denis."*

A provenance from the works of Saint-Denis is probable. It is possible that this capital and no. 13 are those that figure in the inventory drawn up by Guilhermy in 1842–46 as nos. 236–37 (see Paris, Bibliothèque Nationale, ms. n.a. fr. 6122, fol. 36v: *"Deux chapiteaux doubles, romans; feuillages, griffons"*). However, it is not known how this capital came into the collection of the Musée de Cluny. It is doubtful that it belonged, together with 18925 B, to the Maignan collection, as was asserted in a handwritten note in volume 14 of the *Inventaire,* a point I made in 1970. It was, however, in accordance with a *"renseignement donné par M. Albert Maignan, peintre"* that these capitals were attributed to the cloister of Saint-Denis in 1912 (see nos. 13 and 14 here).

Dimensions: height (integral): 27cm.; length (integral): 41cm.; width (integral): 29cm. *Lit de pose* prepared for the fitting of two colonnettes measuring approximately 13.5cm. in diameter.

Bibliography: Egon Hessling, *Le Vieux Paris. Recueil de vues de ses monuments,* first volume: *Moyen Âge,* first delivery: Berlin-New York, s.d. (= 1905), pl. 11; Haraucourt and Montrémy, *Catalogue général,* no. 94; Willibald Sauerländer, "Skulpturen des 12. Jahrhunderts in Châlons-sur-Marne," *Zeitschrift für Kunstgeschichte* 25 (1962): 100 and fig. 6; Kerber, *Burgund,* p. 44; Pressouyre, *Un Apôtre,* p. 20; and *Royal Abbey,* p. 47 (entry by Charles T. Little).

13. Double capital for paired colonnettes (fig. 11).
 Inventory 18925 B.

This capital did not appear in the registers of the Musée de Cluny until 1912; it was then recorded immediately after the preceding double capital (no. 12) as no. 18925 B (*Inventaire,* vol. 14). Prior to this, in 1905, it had been reproduced in Egon Hessling's album. As with capital 18925 A, a hypothetical identification with one of the double capitals listed by Guilhermy at Saint-Denis (nos. 236 and 237) may be suggested.

Dimensions: height (integral): 27cm.; length (integral): 41 cm.; width (integral): 29cm. *Lit de pose* prepared for the fitting of two colonnettes measuring approximately 13.5cm. in diameter.

Bibliography: Hessling, *Le Vieux Paris,* pl. 11; Pierre Verlet and Francis Salet, *Le Musée de Cluny* (Paris, 1965), pp. 69–70, fig. 48; Pressouyre, *Un Apôtre,* p. 20; and *Royal Abbey,* p. 47 (entry by Charles T. Little).

Paris. Ex-collection Albert Maignan

14. Double capital for paired colonnettes (fig. 12).

An article by Gaston Migeon in 1906 devoted to the Albert Maignan collection brought to light this *"chapiteau provenant de l'ancien cloître de l'abbaye de Saint-Denis."* The 1906 photograph re-

produced here shows a strong resemblance between the composition of this capital and that of capitals 12 and 13. Two winged sirens, one feminine and the other masculine with the head of a tonsured monk, face each other on the long side. The composition of the opposite face seems to have been identical in that the sirens (?) on the far side have symmetrically coiled tails that are just visible on the short side, under the motif of the rinceaux.

Today most of the Maignan collection has passed into the Musée de Picardie in Amiens, as a result of donations made from 1910 to 1947. Mademoiselle Alemany, curator of the museum, investigated the matter at my request. She has confirmed that this capital (valued at 1,000 francs when, following the death of Albert Maignan, an inventory of his collection was drawn up on December 19, 1908) was not listed among the objects bequeathed or donated to the museum. Its present location remains unknown.

Dimensions: unknown.

Bibliography: Gaston Migeon, "La Collection de M. Albert Maignan, II," *Les Arts* 59 (November 1906): 3–16, esp. p. 4 and fig. 17.

Rouen. Musée des Antiquités de la Seine-Maritime

15. Capital for a single colonnette (figs. 13, 18, 20).
 Inventory 736.

This capital was given to the museum on November 25, 1838, by André-Ariodant Pottier, then librarian of the city of Rouen. Achille Deville entered this object in the first inventory register of the Musée des Antiquités (vol. 1, p. 222) with the following mention: *"Chapiteau de pierre, sculpté (abbaye de Saint-Denis); des personnages à corps d'oiseau, ailes déployées, occupent les 4 angles du chapiteau. Palmes entre (du 12ème siècle)."* This information has been repeated in successive museum catalogues. In 1970, I proposed that this capital be assigned to the cloister of Saint-Denis.

Dimensions: maximum height (fragmentary): 23.2cm.; side of the *lit d'attente:* 29.2cm.; diameter of the *lit de pose:* 17cm. The *lit d'attente* bears traces of five circular bedding holes, set at the corners and in the center of a 19cm. square space that is regularly inscribed with relation to the abacus.

Bibliography: Abbé Cochet, *Catalogue du Musée d'antiquités de Rouen* (Rouen, 1860), p. 56, no. 88 (2d ed. [Rouen, 1875], p. 82, no. 88); Pressouyre, *Un Apôtre,* p. 20 n. 26; and *Royal Abbey,* p. 47, fig. 18 (entry by Charles T. Little).

New York. The Metropolitan Museum of Art

16. Statue column (figs. 14 and 17).
 Inventory 20.157.

This statue-column came into the collection of the museum in 1920 from that of Alphonse Kahn, who gave no precise information about its provenance (Breck, "King of Judah"). In 1955 Vera Ostoia identified the Metropolitan statue-column with one of the kings in the Saint-Denis cloister as represented in a drawing made for Montfaucon and engraved on plate 10 of volume 1 of the *Monumens de la monarchie françoise.* Since that date Pierre Quarré has shed additional light on the itinerary of this royal statue. Bought in Paris in 1774 by a Burgundian "antiquary," the marquis de Migieu, it was soon moved by this collector to his château at Savigny-lès-Beaune and entered in the 1785 inventory of his collection (Quarré, "L'Abbé Lebeuf").

A comparison between the following entries of Migieu: *"Une figure en pierre d'un roy de la 1ère race venue du cloître St. Denis"* (1774) and *"le roi Dagobert, avec le nimbe et la grande robe en pierre, de trois pieds huit pouces"* (1785) strongly suggests the identification of this statue-column, bought by the marquis, with the first of the kings reproduced on plate 10 of the *Monumens.* Moreover, the late Pierre Quarré recorded the memoirs of an eyewitness, the vicomte de Vaulchier, who recalled that the statue now on exhibit in the Metropolitan stood, at the time of World War I, in a corner of the great staircase of the castle of Savigny.

The difference between the measurements of this object in 1885 (*trois pieds huit pouces* = 119.10cm. or 119.90cm., according to the value given to the *"pied de roi"*) and the present ones (115cm.) does not present an obstacle to the identification of the Savigny sculpture with the Metropolitan king. The latter has obviously been recarved in its lower portions where tool marks on the *lit de pose* indicate a recent restoration (before 1920). Around the same time the statue-column appears to have been partially reworked: the folds of the garment have been mechanically recut, several surfaces sanded down, and certain reliefs reduced in depth, particularly on the upper torso. The surface dryness produced by this restoration has been criticized time and again (see, most recently, Little in *Royal Abbey*). But this does not mean that the authenticity of this object should be questioned as I, at one time, rashly proposed (Pressouyre, "Une Tête du Louvre"; and repeated by Sauerländer, *Gotische Skulptur*), an opinion I have since abandoned.

Dimensions: height (integral): 115cm.; width (integral): 20cm.; diameter of the column: 13.5cm.

Bibliography: Dom Bernard de Montfaucon, *Les Monumens de la monarchie françoise* (Paris, 1729), vol. 1, pp. 57–58, pl. X; Dom Urbain Plancher, *Histoire générale et particulière de Bourgogne, avec des notes, des dissertations et des preuves justificatives* (Dijon, 1739), vol. 1, pp. 521–22; Wilhelm Vöge, *Die Anfänge des monumentalen Stiles in Mittelalter, Eine Untersuchung über die erste Blütezeit französischer Plastik* (Strasbourg, 1894), pp. 197–200; Joseph Breck, "A King of Judah and Other Mediaeval Sculptures," *Bulletin of the Metropolitan Museum of Art* 16 (March 1921): 48–52;

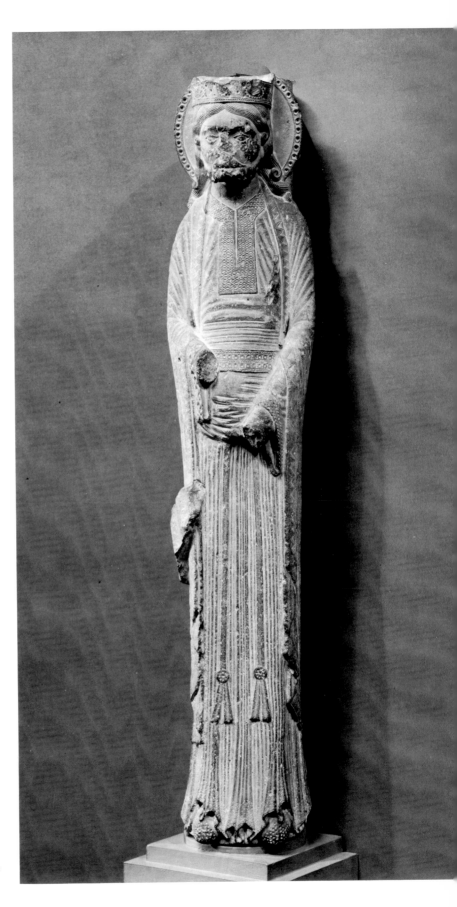

Fig. 14. Statue-column of a king {no. 16}, (New York, The Metropolitan Museum of Art)

Raimond Van Marle, "Twelfth Century French Sculpture in America," *Art in America* 10 (1921): 3–16; William H. Forsyth, *The Metropolitan Museum of Art: A Brief Guide to the Medieval Collection* (New York, 1947), p. 8.; Vera K. Ostoia, "A Statue from Saint-Denis," *Bulletin of the Metropolitan Museum of Art* 13 (1955): 298–304; Pierre Quarré, "La Sculpture des anciens portails de Saint-Bénigne de Dijon," *La Gazette des Beaux-Arts*, 6 ser., 50 (October 1957): 170–94, esp. 193–94; Louis Grodecki, "La 'Première sculpture gothique.' Wilhelm Vöge et l'état actuel des problèmes," *Bulletin monumental* 107 (1959): 265–89, esp. 273, 276; Formigé, *L'Abbaye royale*, p. 19; André Lapeyre, *Des Façades occidentales de Saint-Denis et de Chartres aux portails de Laon* (Mâcon, 1960), p. 224; *The Metropolitan Museum of Art. Guide to the Collection. Medieval Art* (New York, 1962), pp. 27–29; Pierre Quarré, "L'Abbé Lebeuf et l'interprétation du portail de Saint-Bénigne de Dijon," *L'Abbé Lebeuf et le Jansénisme. XXIᵉᵐᵉ congrès de l'association bourguignonne des sociétés savantes* (Auxerre, 1962), pp. 281–87, esp. 282–83; Kerber, *Burgund*, pp. 44–46; Léon Pressouyre, "Une Tête du Louvre prétendue dionysienne," *Bulletin de la Société nationale des antiquaires de France*, 1967, pp. 242–50, esp. 249; William D. Wixom, *Treasures from Medieval France* (Cleveland, 1967), pp. 74–75; *L'Europe gothique. XIIᵉᵐᵉ–XIVᵉᵐᵉ siècles.* Douzième exposition du conseil de l'Europe. (Paris, 1968), p. 5, no. 1 (entry by Françoise Baron); H. Gerhard Franz, *Spätromanik und Frühgotik* (Baden-Baden, 1969), pp. 36–37, 103; Willibald Sauerländer, *Gotische Skulptur in Frankreich, 1140–1270* (Munich, 1970), pp. 65–66; Schlink, *Zwischen Cluny und Clairvaux*, pp. 125, 130, and fig. 107; Sumner McK. Crosby, "The West Portals of Saint-Denis and the Saint-Denis Style," *Gesta* 9, no. 2 (1970): 1–11, esp. 10–11, and p. 11 n. 13; Sumner McK. Crosby, *The Apostle Bas-Relief at Saint-Denis* (New Haven-London, 1972), p. 67; H. Gerhard Franz, *Le Roman tardif et le premier gothique* (Paris, 1973), pp. 36–37, 104; Léon Pressouyre, "Une Tête de reine du portail central de Saint-Denis," *Gesta* 15 (1976): 151–60, esp. 158–59 n. 19; Panofsky, *Suger*, p. 167; and *Royal Abbey*, pp. 44–46 (entry by Charles T. Little).

Baltimore. The Walters Art Gallery

17. Fragment of an impost block.
 Inventory 27.498.

Given to the museum in 1927 by Joseph Brummer, an antiques dealer who claimed that it came from the abbey of Saint-Denis (Ross, "Monumental Sculptures"), the fragment was not assigned to the cloister until 1981.
Dimensions: maximum height (fragmentary): 10cm.; length (fragmentary): 12.6cm.; depth (fragmentary): 8cm. (The measurements given by Ross in 1940 and listed in the catalogue of

the New York exhibition are inaccurate.)
Bibliography: Marvin C. Ross, "Monumental Sculptures from St.-Denis. An Identification of Fragments from the Portal," *Journal of the Walters Art Gallery* 3 (1940): 90–107, esp. 100 and 104, fig. 20; *Senlis. Un Moment*, no. 27 (entry by Diane Brouillette); and *Royal Abbey*, pp. 55–59, no. 9B (entry by Charles T. Little).

The provisional list of seventeen objects described above merely constitutes a working tool and is susceptible to emendations and additions. Had anyone ever remarked that most of the attributions rely only on the authority of one or several contemporary critics, he would have had no trouble ridiculing their fragility.[21] But we cannot legitimately extend the same suspicions to the sculptures that were described as coming from the cloister at a time when there was no concern about defining the style of this monument.

The dismantled cloister of Saint-Denis at first attracted collectors of all stripes. The eclectic Migieu, who in 1774 described for Séguier *"une figure en pierre d'un roy de la 1ᵉʳᵉ race venue du cloître St. Denis"* between *"une cuillère de bois singulière avec animaux dessus"* and *"Marie d'Autriche et Christine de Lorraine, deux beaux médaillons dorés en or moulu par Dupré,"*[22] bought, with the help of well-known intermediaries,[23] the most incongruous hodgepodge of objects in view of using them as illustrations for an ambitious encyclopedia of the arts to which he intended to devote his life; only a minute portion of this work was published.[24] André-Ariodant Pottier, the donor of the capital to the Musée de Rouen (no. 15), later became curator of this museum, whereupon he saw to the museum's acquisition of his own ceramic collection.[25] In any case Pottier's almost exclusive taste for faïence was not yet clearly manifested in 1838, when, as head librarian of the Bibliothèque municipale in Rouen, he was finishing the "texte historique et descriptif" for the *Monuments français inédits pour servir à l'histoire des arts* by Nicolas Xavier Willemin. Is it not possible that he obtained from Willemin, whose interest in Saint-Denis is well known, or from one of his occasional collaborators, such as Eustache-Hyacinthe Langlois, that piece of medieval sculpture whose origin he could so precisely describe?[26]

Another kind of collector makes his appearance in the course of the nineteenth century, a collector for whom the sculptures of Saint-Denis do not represent documents to be appended to an encyclopedia—projected, in progress, or partially published—but, rather, works of art, precious both in themselves and for the light they shed on Suger's abbey. The *"musée lapidaire"* envisioned by Guilhermy never took shape at Saint-Denis, but the subsequently dispersed objects in the collections inventoried by this great scholar cogently illustrate this new interest. The appropriations made by Courajod in 1881 complied with a well-

known policy; those that enriched the Musée de Cluny were inspired by similar principles of quality, and, if private collectors such as Maignan turned to the same source, the motives governing their choices were scarcely any different from those of the curators of the great public collections. Nobody had yet reached the point of assigning an object to the cloister of Saint-Denis using stylistic criteria, but—like Guilhermy in his time—everyone was interested in collecting living oral traditions.

Taken separately, the bits of evidence used to buttress the attribution of the *membra disjecta* to the same lost ensemble have nothing very conclusive to offer. Taken together, however, the common characteristics of the objects said, at diverse dates and from diverse sources, to have come from the cloister or from the old abbey of Saint-Denis are very striking, and we are compelled to acknowledge the existence of a coherent series of capitals, impost blocks, and other architectural elements that can only have come from one and the same ensemble.

After remarking on identical quality of the stone,[27] morphological observations are the first to draw our attention. Let us begin with the dimensions. If we take, as a base of reference for single capitals, the capital in the Musée de Rouen (no. 15), we note that the measurements of the *lit d'attente* (29.2cm. × 29.2cm.) are comparable to those of the single capital (no. 11) in the Musée de Cluny (29.5cm. × 29.5cm.); that the preserved height of these two capitals is almost the same (Rouen: 23.2 cm.; Cluny: 23.5cm.), either because they never had an astragal or because this molding had been broken on each under the same circumstances; finally, that the diameter of the *lit de pose* (17cm.) is identical. The badly damaged single capital of the Musée du Louvre (no. 7) has been boasted in the same manner, and it is likely that its dimensions were quite similar.

Next, the double capitals. The similarities are even more striking in a series of four measurable capitals: the height varies between 26.5cm. (nos. 4 and 6) and 27cm. (nos. 12 and 13); the width of the abacus varies between 29cm. (nos. 12 and 13) and 30cm. (nos. 4 and 6); the length is identical (41 cm.). In these four cases the inside diameter of the *lit de pose* appears to be approximately 14cm., but the present installation of capitals, numbers 6, 12 and 13, does not facilitate verification.

As would be expected, the dimensions of the *lit de pose* of the impost blocks are similar to those of the *lit d'attente* of the double capitals they surmounted: 41cm. × 31cm. for impost block no. 8; 41.3cm. × 31cm. for impost block no. 9. Analogous dimensions (41cm. × 30cm.) may be proposed for the impost found in 1946 (no. 1). Furthermore, even though the fragments in the Louvre (no. 10) and the Walters Art Gallery (no. 17) are too incomplete to authorize a control of their measurements, their height (16.2cm. for no. 10 and 10.0cm. for no. 17) is compatible with the height of the undamaged objects (18.5cm. for nos. 8 and 9).

Fig. 15. Base profiles of nos. 2, 3, and 5

The bases of paired colonnettes should be studied with reference to the base in the Louvre (no. 5), which is the most complete. The dimensions of the *lit de pose* coincide (no. 2: 41.2cm. × 30cm.; no. 5: 41.4cm. × 30.2cm.), and correspond, as would be expected, to the dimensions of the *lit d'attente* of the double capitals as well as to the dimensions of the *lit de pose* of their imposts. The height of the plinth is approximately 7.2cm. The only remaining base for a single colonnette that has, as yet, been identified, has the same dimensions and the same lower torus with the characteristic profile (fig. 15). Moreover, its *lit de pose* (a 30cm. square) also reproduces the dimensions of the *lit d'attente* of the single capitals.

To the logic of the measurements correspond the notable structural consistency (for example, the capitals with notched abacus adhere to a generalized type of boasting) and, above all, the coherence of style (figs. 16 and 17). The sculptures attributed to the cloister of Saint-Denis have in common an extreme delicacy of modeling, a slightly precious elegance of design, and a decided taste for ornamental motifs, reflected in the systematic repetition of decorative bands along the veins of acanthus leaves (nos. 6, 9, and 15) and on the bodies of the monsters (nos. 1, 7, 12, 14, and 15), as well as under the abacus of capitals, on the necklines of garments, or on the circumferences of nimbi (nos. 4 and 16). In spite of the diversity of the subject matter, there is a fundamental uniformity of inspiration in the sculptural vocabulary. Apart from the king in the Metropolitan Museum (no. 16), which is the only manifestation of a more didactic iconographic program, all the existing sculptures bring to mind something of one of those Benedictine cloisters so harshly attacked by Saint Bernard in the *Apologia ad Guillelmum Sancti Theodorici abbatem;*

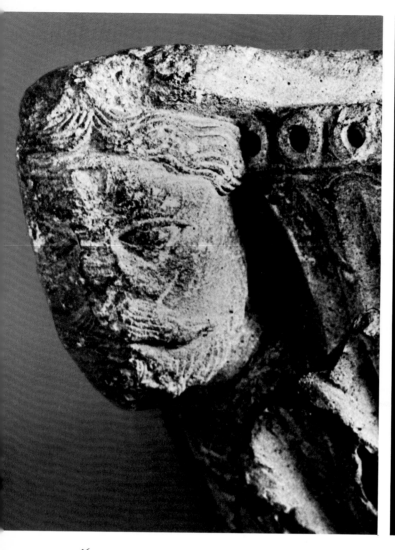

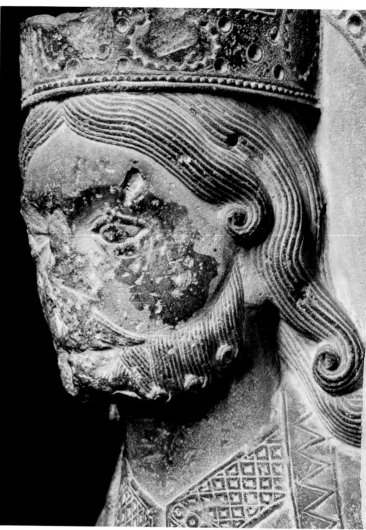

16

17

Fig. 16. Double capital for paired colonnettes {no. 4}, detail of head
Fig. 17. Statue-column of a king {no. 16}, detail of head
Fig. 18. Capital for a single colonnette {no. 15}, detail of head
Fig. 19. Saint-Germain-des-Prés, capital, detail of head
Fig. 20. Capital for a single colonnette {no. 15}, detail of head
Fig. 21. Saint-Germain-des-Prés, capital, detail of head

18

19

20

21

nothing in this commonplace repertory, composed of disturbing winged sirens (nos. 7, 14, and 15), assorted winged dragons (nos. 1, 12, 13, and 14), and lush foliage (nos. 6, 8, 9, and 11) can claim either to have any moral value or to belong to a narrative cycle.

If we consider the extant objects as representative of the lost ensemble, the question of the date of the monument deserves discussion within the framework of this symposium. Does the cloister date from before 1151? If this is indeed the case, Suger would have been the source of inspiration for a resolutely "Cluniac" program, which followed traditional aesthetic principles and displayed almost none of the "anagogical" preoccupations so noticeable in the facade and choir of the abbey church.[28]

Scholars, without ever having properly posed this question, have swept it aside as resolved. In fact, most twentieth-century authors have accepted without argument the premise that the "Romanesque" cloister dates from Suger's abbacy and have, consequently, proposed dates of between 1130 and 1150 for its construction.[29] A certain ambiguity, which has been carefully nurtured since Félicie d'Ayzac, might well be at the root of this uncritical acceptance. According to Ayzac, who invokes Suger as witness, Pope Innocent II held a magnificent banquet worthy of a king in the galleries of the cloister on Easter Sunday 1131; on the eleventh of June, 1144, the king of France, Louis VII, and his retinue followed in procession the *"fiertes"* of the martyrs in the same galleries.[30] Unfortunately these texts, thus paraphrased, have little authority: In 1131 the banquet tables were simply set up *"in claustro";*[31] during the dedication the procession took place *"per claustrum."*[32] None of these expressions implies the existence of galleries, *a fortiori* of newly erected galleries. On the other hand the fact that Suger is silent about the construction of a cloister is worthy of closer consideration. Are we to believe that this great builder, who described so accurately the work executed on the facade and in the choir of the abbey church, would have forgotten to mention the work performed on the monastic buildings?[33] This omission is extremely difficult to explain, and, in the light of what is known about Suger's personality, it is highly unlikely that he would have concealed his active participation in the rebuilding of the cloister.

In the absence of explicit texts,[34] the problem of dating this twelfth-century cloister can only be resolved with the help of stylistic comparisons, and the best terms of reference are located outside Suger's abbey church.[35] Unfortunately the chronology of the group of sculptures related to the lost monument is not firmly established. If we turn to Saint-Germain-des-Prés, where the sculptors of the cloister of Saint-Denis must have worked in the choir, analogies between motifs are numerous, technical similarities are close, and stylistic affinities disquieting (figs. 18 and 19; 20 and 21), but our only point of reference for dating is the dedication, on April 21, 1163, which is generally understood as a *terminus ante quem.*[36] If we evoke certain capitals in the choir of Notre-Dame, Paris, we must envisage a period after Maurice de Sully's accession to the see of Paris in 1160.[37] With datable, comparative material outside Paris, we are also obliged to acknowledge that the kind of capitals with acanthus leaves or monsters adopted by the artists of the Saint-Denis cloister enjoyed a great popularity in the 1160s: at Notre-Dame, Châlons-sur-Marne, the capitals of the nave and the south portal were certainly executed after 1157. The presence of a small group of similar works in the cloister of Châlons attests to the remarkable persistence of an ornamental taste that had become slightly outmoded around 1170.[38]

If the great shadow of Suger at Saint-Denis had not clouded critical judgment, it is likely that the vestiges of the cloister would have been dated between 1150 and 1170; art historians could then have concentrated their efforts on narrowing the chronological brackets. Given the present state of research, it is easier to state the problem than to have one's opinion win acceptance. At most, however, we must conclude that, if we accept the unverified hypothesis that the cloister of Saint-Denis, with its innovative architecture and style,[39] constitutes the beginning of a series, the work could not have been begun before the very end of Suger's abbacy, at the time when the tireless builder, having already given his final corrections for the manuscript of the *De administratione,*[40] turned his attention to other matters.

NOTES

*This essay was translated by Patricia Danz Stirnemann and Danielle Johnson.

1. Jannie Mayer-Long, "L'Abbaye de Saint-Denis au XVIII^ème siècle" (Mémoire de maîtrise in art history, University of Paris—IV, 1978). The manuscript, on deposit in the Bibliothèque des Monuments historiques (4° doc. 179), has been partially published: Jannie Mayer-Long, "Les Projets de Robert de Cotte pour les bâtiments conventuels de l'abbaye de Saint-Denis," *Bulletin de la Société de l'histoire de l'art français,* 1981 [1983], pp. 59–69.

2. Gautier gives, for the beginning of the rebuilding of the abbey, the inaccurate date of 1718 (Paris, Bibliothèque Nationale, ms. fr. 11681, *Recueil d'anecdotes et autres objets curieux relatifs à l'histoire de l'abbaye royale de Saint-Denis en France pour faire suite à l'histoire de Dom Félibien*).

3. See Félicie d'Ayzac, *Histoire de l'abbaye de Saint-Denis en France,*

2 vols. (Paris, 1860–61), vol. 2, pp. 390ff.; and Gaston Brière and Paul Vitry, *L'Abbaye de Saint-Denis* (Paris, 1948), p. 22.

4. Paris, Archives nationales, H5 4273; and Paris, Bibliothèque Nationale, ms. fr. 8599.

5. The contract for the new buildings was signed with the entrepreneur Chopine on March 17, 1752. The foundation stone was laid on April 8, 1752 (Paris, Archives nationales, H5 4273).

6. Ibid.

7. It has been said repeatedly that the cloister was dismantled in 1771. See, even recently, Pierre Quarré, "L'Abbé Lebeuf et l'interprétation du portail de Saint-Bénigne de Dijon," *L'Abbé Lebeuf et le Jansénisme. XXIᵉᵐᵉ Congrès de l'association bourguignonne des sociétés savantes* (Auxerre, 1962), pp. 281–87, esp. 283; and *Royal Abbey*, p. 31 (entry by Charles T. Little).

8. The Châtelet was torn down in August 1769, as recounted by Gautier, Paris, Bibliothèque Nationale, ms. fr. 11681, p. 15.

9. The *Pourtraict de la ville de Sainct-Denys en France* by Sébastien Munster and François de Belleforest (1575) offers only a very sketchy representation of the cloister.

10. See Paris, Bibliothèque Nationale, Estampes, Va 438, no. 66 (first project), no. 67 (second project), and no. 69 (third project). These documents have been used frequently to reconstruct the plan of the medieval abbey. See, for example, Jules Formigé, *L'Abbaye royale de Saint-Denis. Recherches nouvelles* (Paris, 1960), p. 11, fig. 10. The plan on pp. 28–29 includes a great deal of personal interpretation and requires correction in many details.

11. Paris, Archives nationales, N II Seine 214, nos. 1 and 2.

12. Dom Jacques Doublet, *Histoire de l'abbaye de S. Denys en France* (Paris, 1625), p. 325: "Lesdits Cloistres sont les plus beaux qui se voyent, pauez entierement de pierre de liais, enrichis de pilliers & colomnes, dont il y en a partie de pierre de liais, partie d'ardoise, partie de marbre, partie de pierres foudües, diuersifiées de tant de diuersitez de couleurs, qu'il semble que cela ait esté fait par plaisir, et partie de grez. Et ce qui est digne d'estre admiré, c'est que de toutes ces colomnes et de tous ces pilliers qui sont en grand nombre, tous les chapiteaux sont de diuerses façons, diuersement taillez et diuersement éleuez en bosse." In his *Catalogue des objets encore en magasin à la fin de 1842* (Paris, Bibliothèque Nationale, n.a. fr. 6121), the Baron de Guilhermy describes no. 120 (fol. 239v) as "enviṙon 32 colonnettes de divers marbres, provenant du cloître. Environ 40 colonnes (ou fragments) plus ou moins mutilées. La plupart en marbre noir." These columns—lost today—correspond to Doublet's description; the question of their date remains open.

13. Because of its proximity to the guest house which, in fact, dates from Suger's abbacy, the west gallery of the cloister has often been considered as "Romanesque." This western gallery received wood paneling in 1488, as recalled by Dom Michel Félibien, *Histoire de l'abbaye royale de Saint-Denis en France* (Paris, 1706), p. 367. The history of the cloister's successive restorations deserves a thorough study. The archival sources concerning the work executed in the thirteenth and fourteenth centuries form a rich, though incomplete series (see Germaine Lebel, *Histoire administrative, économique et financière de l'abbaye de Saint-Denis, étudiée spécialement dans la province ecclésiastique de Sens, de 1151 à 1346* [Paris, 1935], pp. 234–35). The excerpts published by Ayzac, *Histoire*, vol. 1, pp. 547–51, without

any critical apparatus, have misled many art historians, as work executed in the cloister has sometimes been confused with work executed in the abbey church.

14. Saint-Denis, Archives communales, GG 19, fols. 38, 139, 140r, 143r.

15. Arnold Van Buchell (University of Utrecht, Ms. 798 = Hist. 132–33) is the author of one of the oldest descriptions accompanied by a drawing. See L. A. van Langeraad and Alexandre Vidier, "Description de Paris par Van Buchell d'Utrecht (1585–1586)," *Mémoires de la Société de l'histoire de Paris et de l'Ile-de-France* 26 (1899): 59–195; the fountain was again mentioned by Doublet, *Histoire*, p. 325 and by Félibien, *Histoire*, p. 588. For the bibliography prior to 1970, see Willibald Sauerländer, *Gotische Skulptur in Frankreich, 1140–1270* (Munich, 1970), p. 103.

16. Doublet, *Histoire*, p. 325; Félibien, *Histoire*, p. 551; and Dom Bernard de Montfaucon, *Les Monumens de la monarchie françoise* (Paris, 1729), vol. 1, p. 163.

17. Doublet thought that the *"bassin pourroit avoir esté fait par curiosité des Romains résidans en France."*

18. Montfaucon, *Les Monumens*, vol. 1, p. 57. The corresponding Latin text is less explicit: *"In vetustiore parte claustri Monasterii Sancti Dionysii, quod diu ante Dagobertum fundatum fuit, ut probarunt nostri Mabillonius et Felibenius, duae statuae Regum sunt cum nimbo ad columnas duas claustri sculptae."*

19. Preparatory drawings and counter-tracings by Benoist, Paris, Bibliothèque Nationale, ms. 15634, fols. 38, 42, 45, 46, 47. See André Rostand, "La Documentation iconographique des monuments de la monarchie française de Dom Bernard de Montfaucon," *Bulletin de la Société de l'histoire de l'art français*, 1932, pp. 104–49.

20. Formigé, *L'Abbaye royale*, pp. 18–22.

21. We have eliminated from our list several twelfth-century sculptures attributed to the cloister of Saint-Denis by various art historians. The fragment R.F. 2564 from the Louvre thought by Marcel Aubert to be the head of the figure with a ribbed cap reproduced on plate 10 of volume 1 of the *Monumens* by Montfaucon, comes from Châlons-sur-Marne. Neither the torso of the king from the *dépôt lapidaire* at Saint-Denis (Formigé, ibid., p. 19, fig. 17) nor the head of the king of the Liebighaus in Frankfort (Bernhard Kerber, *Burgund und die Entwicklung der französichen Kathedralskulptur im zwölften Jahrhundert* [Recklinghausen, 1966], p. 44) can be taken as serious candidates for the third king reproduced by Montfaucon. See Léon Pressouyre, "Une Tête du Louvre prétendue dionysienne," *Bulletin de la Société nationale des antiquaires de France*, 1967, pp. 242–50; and Sauerländer, *Gotische Skulptur*, pp. 65–66.

22. Nîmes, Bibliothèque municipale, ms. 98, fols. 20r–21r, letter from Migieu to Séguier, Paris, May 20, 1774.

23. One of them was Father Grimod whose death was announced to Séguier by Migieu in a letter dated January 4, 1775: *"Fort estimé à Paris de M. de Caylus, de M. Pellerin et de tous les habiles gens . . . , c'étoit mon oracle quand j'avois quelque chose à acheter et que je me défiois des friponneries italiennes qui sont quelquefois faites avec beaucoup d'adresse"* (Nîmes, Bibliothèque municipale, ms. 9, fol. 23r).

24. Migieu explained his plans in a long letter to Séguier, dated May 1, 1773 (ibid., fols. 10r–13r). Only a *Recueil des sceaux du Moyen Âge dits sceaux gothiques* was finally published in Paris in 1779.

25. On André-Ariodant Pottier, the essential work is A. Decorde, *Notice nécrologique sur M. André Pottier, conservateur de la Bibliothèque publique de la ville de Rouen, et du musée départemental d'antiquités, membre résidant de l'Académie* (Rouen, 1867). See also Édouard Frère, *Manuel du bibliographe normand* (Rouen, 1860), vol. 2, p. 407. In 1863 Pottier sold 1,200 ceramic pieces to the museum for 24,500 francs. See *Chronique des arts et de la curiosité*, no. 33, (10 August 1863): 286; and "Collection céramique du musée des antiquités de Rouen. Faïences," *Le Nouvelliste de Rouen*, October 5, 6, and 7, 1864.

26. According to the first hypothesis, Pottier would have had the capital in his possession before January 27, 1833, the date of the death of Willemin; according to the second, he acquired it at the sale following the death of Eustache-Hyacinthe Langlois on December 29, 1837 (sale of January 29, 1838 = Lugt 14.919). The second hypothesis was suggested to me by Madame Françoise Arquié, the foremost authority on the scholars and collectors in the circle of Willemin. Cf. F. Arquié-Bruley, "Les *Monuments français inédits* (1806–1859) de Nicolas Xavier Willemin et la découverte des antiquités nationales," *Revue d'art canadienne/Canadian Art Review* 10, no. 2 (1983): 139–56.

27. The appearance of the stone is extremely homogeneous. The testing of samples of all objects believed to come from the cloister of Saint-Denis is now in progress. Thus far, only a sample from the Metropolitan king (no. 16) has been analyzed, in 1970, at the Centre de Recherche sur les Monuments Historiques (Paris). A microscopic examination of thin sections has confirmed that the material is a limestone of the Parisian basin quite similar to the stone used for the statues of the west facade of the abbey church (see Léon Pressouyre, "Une Tête de reine du portail central de Saint-Denis," *Gesta* 15 (1976): p. 158–59 n. 19).

28. Concerning Suger's reserve with regard to Cluniac aesthetics, see the penetrating pages by Panofsky, *Suger*, pp. 10–37.

29. The cloister has been dated "around 1130–35" by François Baron, author of the entry treating the king in the Metropolitan Museum in the catalogue of the exhibition *L'Europe gothique, XIIᵉ–XIVᵉ siècles* (Paris, 1968), p. 5, no. 1; "around 1140," according to Gaston Migeon, "La Collection de M. Albert Maignan," *Les arts* 99 (1906): 4; and "around 1150 or in the five years before," according to Vera K. Ostoia, "A Statue from Saint-Denis," *Bulletin of the Metropolitan Museum of Art* 13 (1955): 304. To these three examples could be added many others, since most of the authors who have discussed the cloister of Saint-Denis have dated it in reference to Suger's abbacy. Wilhelm Schlink, *Zwischen Cluny und Clairvaux, Die Kathedrale von Langres und die burgundische Architektur des 12. Jahrhunderts* (Berlin, 1970), p. 130, seems to have been among the few who have proposed a dating between 1150 and 1170.

30. Ayzac, *Histoire*, vol. 1, p. 571.

31. Suger, *Vita Lud.* (M), p. 121.

32. Suger, *Cons.* (P), p. 116.

33. Notwithstanding Sumner McK. Crosby's opinion, *L'Abbaye royale de Saint-Denis* (Paris, 1953), p. 32, the restoration or re-building of all the monastic buildings cannot be construed from the *Testamentum* of 1137. (See Félibien, *Histoire, Recueil de pièces justificatives*, p. C.)

34. At the end of this symposium, Elizabeth Brown drew my attention to a passage from the *De nobilitate domni Sugerii abbatis et operibus eius* written by *Radulfus phisicus* (R. C. B. Huygens, ed., "Inediti. Mitteilungen aus Handschriften. II. Radulfus phisicus," *Studi medievali*, 3d ser., December 3, 1962, pp. 763–64. In this passage Suger is praised for the works that he dedicated to Saint-Denis:

> Struxit ei capsas auro gemmis decoratas
> ordine, ditavit claustrum templumque novavit,
> ars ornavit, auro gemmis radiavit,
> pallia mira dedit distractaque plura redemit,
> tres tabulas fecit auro gemmisque replevit,
> quarta nitens perlis gemmis preciosa lapillis
> vernat in onichinis smaragdis arte berillis,
> aurea crux miris fulgens distincta saphiris
> ostendit vivis quam sit pater iste virilis.

However, the second line of this quotation (l. 33) does not seem to apply explicitly to work executed in the cloister. Since the opposition *claustrum/templum* is typical of the poetic language of the twelfth century, I propose the following translation: "he enriched the monastery and renovated the church."

35. One cannot compare the sculptures of the cloister to the sculpture of the facade. On the other hand, there are obvious stylistic affinities with the decor of the eastern parts of the church consecrated in 1144, but they concern only a small group of capitals: for example, two capitals with monsters bear a close resemblance to our no. 13 (= inv. 18925 B from the Musée de Cluny). Other buildings at Saint-Denis may have been worked on by the same sculptors who worked in the cloister. At the *dépôt lapidaire* of the Orangerie, a few unpublished voussoirs from an archivolt (Martin-Demézil inventory, nos. 38, 209, and 405) are comparable to impost block no. 9, but their exact provenance remains unknown.

36. See William W. Clark, "Spatial Innovations in the Chevet of Saint-Germain-des-Prés," *Journal of the Society of Architectural Historians* 38 (1979): 348–65. Some art historians still doubt that the choir was completed by that date (mistakenly, in my opinion): see, lastly, Neil Stratford's review of The Cloisters' exhibition, "The Royal Abbey of Saint-Denis in the Time of Suger" and the "Suger and Saint-Denis Symposium," *Burlington Magazine* 123 (1981): 509 ("usual dating before the consecration in 1163 . . . not assured").

37. Even if one refuses to believe the fictitious episode of the laying of the first stone by Pope Alexander III in 1163.

38. See Léon Pressouyre, *Un Apôtre de Châlons-sur-Marne* (Berne, 1970), p. 20.

39. Was the formula of a cloister with statue-columns, which was to enjoy a certain popularity in Northern France, initiated at Saint-Denis? It would not be fruitful to treat this question here because it is too closely associated with the discussions concerning the date of the monument. Nor can it be dissociated from an overall study of the multiple architectural functions of the statue-column in the twelfth century.

40. The last contemporary recorded fact is the death of Evrard de Breteuil, while on crusade, during the winter of 1148–49 (Panofsky, *Suger*, p. 142).

The Mosaic Pavement of the Saint Firmin Chapel at Saint-Denis: Alberic and Suger*

Xavier Barral i Altet

CENTURIES AGO a mosaic pavement decorated the floor of the present Saint Firmin chapel, the first chapel on the north side of the ambulatory at Saint-Denis (fig. 1).[1] This pavement was composed of a U-shaped border containing the Labors of the Months and the two steps which it surrounded, leading up to the chapel's altar. The lower step held five medallions with a monk, Alberic, depicted in the central medallion. The decoration of the upper step, the step directly in front of the altar, consisted of two large octagons with fantastic animals. In modern times only three panels of the pavement remain (fig. 2), and it is indeed fortunate that early descriptions and sketches exist. Thus its original appearance can be known in spite of the drastic restorations it has undergone.[2]

Dom Doublet described the mosaic in 1625,[3] and it was described again eleven years later by Gabriel Millet.[4] The pavement was then still visible and well preserved. In 1706 Michel Félibien recorded the overall deterioration of the chevet pavement, but the Saint Firmin mosaic was still partially in place.[5] It suffered some damage during the French Revolution: watercolors by the architect Percier[6] show that half of the twelve medallions depicting the months of the year that surround the central part of the mosaic had disappeared by 1794 (figs. 3 and 4). This same year the extant fragments were brought by Alexandre Lenoir to the Musée des Monuments Français and were listed in its catalogue.[7] In 1816, the mosaic panels came back to Saint-Denis, were stored in the crypt for a time, and in 1839 found their way to the dépôt lapidaire of the church. Later these fragments were repeatedly moved from one place to another.[8] The central medallion of the lower step, which depicts the monk Alberic, was restored for the first time under the direction of François Debret, and in 1842 it was placed in front of the altar of the Virgin. In 1878 the frag-

ments were removed again, and stored in the dépôt lapidaire. In 1886, during the liquidation of the Saint-Denis dépôt, they were sent to the Musée de Cluny.[9] The panel depicting the winegrower (October) was then restored by Guilbert Martin; in 1888 the two octagonal medallions of the upper step were in turn restored. Finally, in 1957, all the available fragments were put back in the Saint Firmin chapel according to the arrangement shown in Percier's drawing (fig. 2).[10]

This brief review allows us to measure the scope of the restorations and transformations this pavement has undergone, and indicates the caution which must accompany the study of its exact disposition and its style.

Description of the Mosaic

In the Middle Ages the whole chevet and all the radiating chapels of Saint-Denis were paved with glazed tiles or incised and engraved plaques. Only the pavement of the Saint Firmin chapel was in opus tessellatum.[11] The combination of several paving techniques in a single floor was a fairly common practice in the Middle Ages.[12] Christopher Norton has recently written a comprehensive study devoted to the medieval floor tiles throughout all of Saint-Denis.[13] My study is concerned only with the opus tessellatum pavement.

Because only three mosaic panels from the Saint Firmin chapel today remain in place, we must look at Percier's watercolors in order to understand the whole pavement (figs. 1, 3, and 4). The original pavement of this rectangular chapel covered the entire floor and was composed of a double-banded U-shaped border and two rectangular steps within. The outer frame of the U-shaped border, combining geometrical and floral designs, sur-

Notes for this essay begin on page 253.

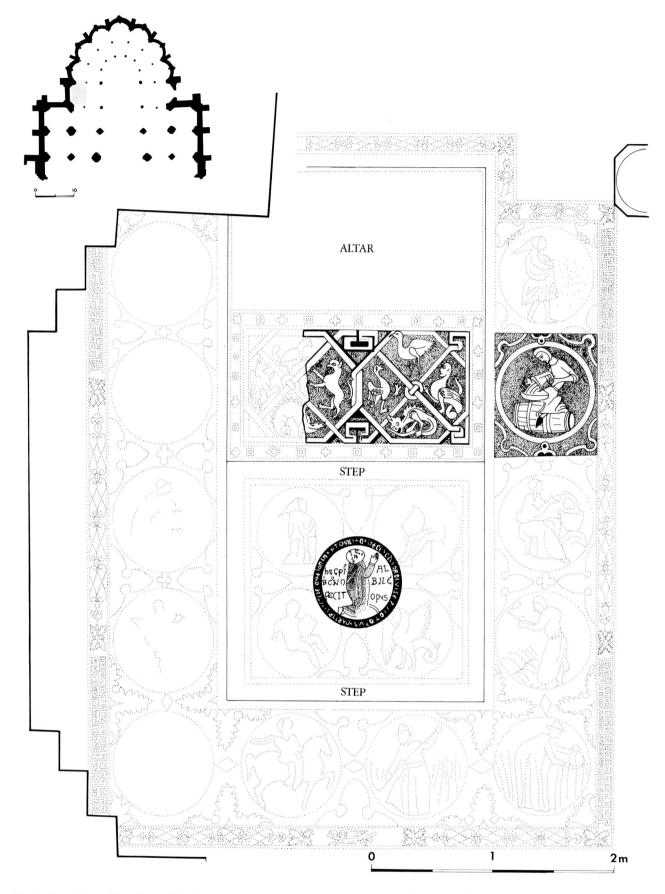

Fig. 1. Saint-Denis, Saint Firmin Chapel mosaic, restoration drawing based on the preserved fragments and the Percier watercolors

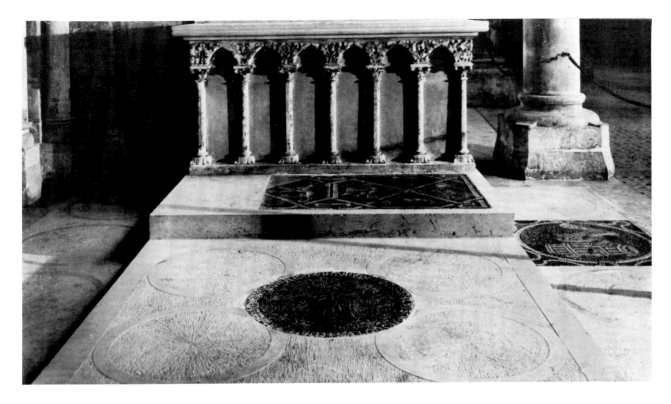

Fig. 2. Saint-Denis, Saint Firmin Chapel mosaic, present condition

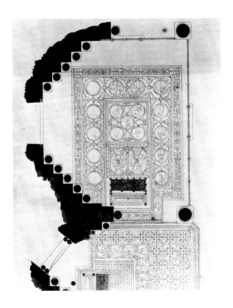

Fig. 3. Saint-Denis, Saint Firmin Chapel mosaic, watercolor by Percier (Compiègne, Musée Vivenel), showing condition ca. 1794

Fig. 4. Saint-Denis, Saint Firmin Chapel mosaic, watercolor by Percier (Compiègne, Musée Vivenel), showing condition ca. 1794

rounded a wider band decorated with medallions depicting the twelve Labors of the Months. Only one of the original twelve, as has been noted, was preserved; six come to us through Percier's drawings. The other five medallions had already been lost by the end of the eighteenth century. Those available for study, then, depict the following months (beginning at the bottom left of fig. 1): May (a horseman going hunting), June (a peasant scything hay), July (a harvest scene with sickles), August (the flailing of wheat), September (a figure in front of a caldron), October (a winegrower pouring wine into a barrel), November (a man wearing a loose coat sowing grain).

The October medallion (figs. 5 and 6)—the only one preserved from the border—allows us to reconstruct the dominant colors of the mosaic. The composition consists mostly of gilded tesserae, but red, chestnut brown, and bluish marble is also used. At the top of the background field, behind the figure, we can distinguish the letters OCTO in gilded tesserae, although they do not stand out in a photograph taken before the 1886 restoration. The winegrower, turned toward the left, is wearing a white bonnet and a yellow tunic. He is sitting astride a barrel and pours wine from a wooden, iron-banded pail into the barrel through a large circular funnel. Fragments of red-veined marble are used for the wood, and black marble enhanced with white for the hoops of both pail and barrel. White marble outlined with red is used for the face, hands, and arms, which have rolled-up sleeves (figs. 5 and 6).

The first of the two rectangular steps contained five medallions (figs. 1 and 7). In Percier's sketch of the upper left medallion is the figure of a hooded monk, probably kneeling. In the lower left medallion we can see a seated figure, possibly naked, with an open book. Percier's sketch of the upper right medallion is limited to only a few strokes depicting the legs of a seated man (fig. 4). Finally, in the bottom right medallion, there is a winged sphinx, its head covered with a cowl. These four figures have been referred to as the "Four Elements" since the eighteenth century.[14]

The preserved central medallion containing the monk has been heavily restored (fig. 7). Its diameter is 76cm. and its tesserae are made of terracotta; porphyry; white, yellow, red, and black marble; gilded enamel; and glass. The kneeling monk, identified by inscription as Alberic, is represented on a gold background in an attitude of prayer. He is surrounded by a circular inscription made of white marble tesserae on a green- and turquoise-enamel background: *Qui te devotus oro/cui servio totus/ martyr sancte Dei/quaeso memento mei.*[15] A second inscription, placed in three horizontal lines on either side of the monk, reads: *Hoc pius Albericus nobile fecit opus.*[16]

On the second step, directly in front of the altar, there were two adjacent octagons (figs. 1, 8, and 9) originally surrounded by a border (no longer extant). Here, one octagon and a little more than a quarter of the second one have been preserved. The right-hand octagon (wholly preserved) is divided into four fields

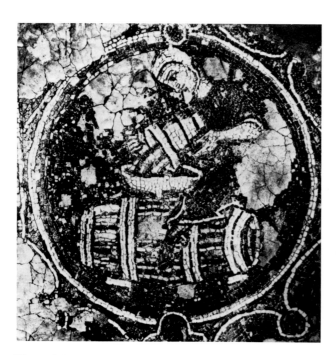

Fig. 5. Saint-Denis, Saint Firmin Chapel mosaic, October, from the Labors of the Months, before restoration

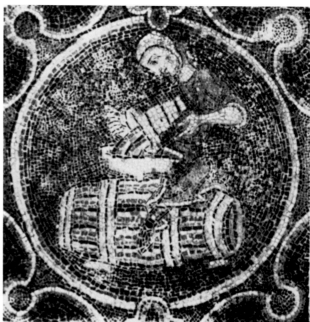

Fig. 6. Saint-Denis, Saint Firmin Chapel mosaic, October, from the Labors of the Months, present condition

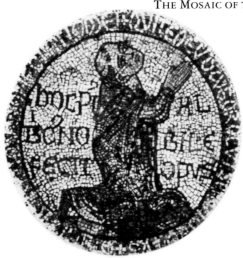

Fig. 7. Saint-Denis, Saint Firmin Chapel mosaic,
the monk Alberic, present condition

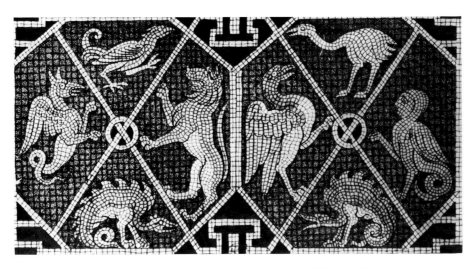

Fig. 8. Saint-Denis, Saint Firmin Chapel mosaic, drawing (Paris, Bibliothèque Nationale, Cabinet des
Estampes), upper panel of the mosaic

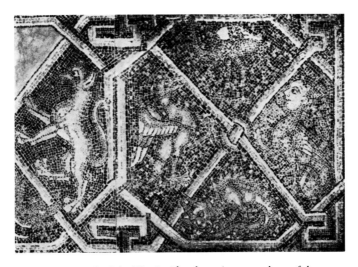

Fig. 9. Saint-Denis, Saint Firmin Chapel mosaic, preserved part of the upper
panel, present condition

by an X-shaped cross with a central ring. The four fields contain a heron with a green and pink body; a horned salamander with a spiny, bristling backbone, green on a yellow background; a sphinx with a white head, blue body, and white and green wings; and an eagle with a blue body. Of the left-hand octagon the part preserved is a standing monster with a lion's body. In the three other fields Percier depicted a horned salamander similar to that of the right medallion (a monster resembling a saurian); a basilisk; and a horned, winged horse with a triton's tail (figs. 4 and 8).

Thus, by using Percier's watercolors and old descriptions, we can propose a reconstruction of the mosaic of the chapel of Saint Firmin at Saint-Denis (figs. 1, 3, and 4). The upper step directly in front of the altar held two large adjacent octagons with fantastic animals. On the lower step four medallions surrounded a fifth and central medallion. The four medallions contain intriguing figures and have been called representations of the Four Elements, while the central medallion depicts the kneeling monk Alberic. At the lowest level twelve medallions containing the Labors of the Months form a U-shaped border enclosing the entire floor of the chapel.

One of the most interesting aspects of the chapel's mosaic is the material used in its execution. Although the technique applied was indeed characteristic of mosaic pavements, the materials are in part borrowed from those used for wall mosaics: glass and gilded enamel tesserae are seldom found in pavement mosaics.[17]

Fig. 10. *Saint-Denis, west facade, right portal, left jamb, Labors of the Months, detail of winegrower filling a barrel*

Iconographic Considerations and the Labors of the Months

The iconographic program of the Saint Firmin chapel mosaic is certainly governed by the overall compositional scheme of the pavement. The border, with representations of the Labors of the Months, surrounds two central compositions and is arranged as three sides of a rectangle, with the fourth side being the altar. A similar composition can be found in the old mosaic of the church of Saint-Bertin at Saint-Omer, where the Signs of the Zodiac, arranged in a square, surround the central images.[18]

While the Labors of the Months in this U-shaped border seem at first glance to follow established iconographic traditions, the series has provoked controversy since the last century.[19] Of particular concern has been the identification of the winegrower with the month of October, despite the fact that the medallion is inscribed OCTO. The debate over the medallion of the winegrower arose because of its placement in the series as the next-to-last medallion. This means that the last month represented in the series would be November.

In my view the identification of the winegrower with the month of October seems clear enough, and I see no reason to question Percier's watercolor, according to which the medallion

has been replaced in its original position. If we begin reading Percier's watercolor (figs. 3 and 4) at the lower left opposite the altar, the first medallion with an image is the sixth in the series, a hunting scene. This activity usually corresponds to the month of May. Between the hunting scene (May) and the winegrower (October) there are four medallions that would seem to depict the months of June, July, August, and September. Thus, the winegrower representing October is in the correct position in relation to the rest of the series. The winegrower cannot, in any case, be associated with the month of November, as has sometimes been suggested, for to the best of our knowledge November has never been personified by a winegrower.[20] In French calendars the worker in his vineyard always corresponds to September or October, and especially to October in the north of France.[21] It is important to note here that the closest parallel to the iconographic details in the winegrower medallion of the Saint Firmin chapel can be found in the same scene on the doorposts of the right portal of the west facade of Saint-Denis (fig. 10 and Blum fig. 22).[22]

The fact that the cycle of the months ends with November on the right-hand side of the altar can be explained in two ways: either the cycle was not complete[23] (Percier's drawing seems, how-

ever, to exclude this possibility, as it shows twelve medallions) or, more likely, the cycle began with December on the left-hand side of the altar. While studying this problem Émile Mâle noticed that certain annual cycles often began with a month other than January, and he went on to note that the beginning of the year varied from one region to the next, sometimes due to a desire to mark the new year with a particular religious feast; for December, this might be the Nativity.[24] In Amiens, for instance, the year begins with a representation of the month of December, while at Chartres we observe the unusual association of January with the sign of Capricorn. Joanne Y. T. Winjum mentions other examples in her study of the Canterbury pavement.[25] This was undoubtedly the case at Saint-Denis where, it seems, the cycle began with December to the left of the altar.

Turning to the iconography of the mosaic as a whole, we find that it can be read as a representation of the world. The months surround depictions of the Four Elements and fantastic, mythical animals. A similar scheme can be found in the Romanesque mosaic in the cathedral of Aosta (fig. 11), and study of it contributes much to our understanding of the pavement at Saint-Denis.[26]

In the Aosta choir mosaic the twelve months surround the personification of the Year. This circular composition is set into a rectangle with representations of the Rivers of Paradise in the four corners. One step above is a large rectangular panel in the center of which there is a circle within a circle inscribed within a square. In the outer circle are four animals that seem to represent various species. Four fantastic animals are placed in the corners around the square which encloses the circles, and a chimera and elephant appear in the outermost panels above representations of the Tigris and the Euphrates. Inside the geographical framework defined by the rivers, the fantastic beasts surround the different animal species of Creation to form an image of the world.[27]

Returning now to Saint-Denis, we find the cycle of the months surrounding, probably, the Four Elements and the different animal species as well as fantastic and monstrous creatures.[28] What we are confronting here is an iconography that has been widely accepted since the creation of programs like that of the rose window of Lausanne.[29]

The Portrait of Alberic

In the center of the composition, the central medallion on the step farther from the altar portrays a kneeling monk with hands joined in prayer, head raised, and gaze turned toward the altar. The figure is accompanied by two inscriptions: *Hoc pius Albericus nobile fecit opus;* and, around the medallion: *Qui te devotus oro/cui servio totus/martyr sancte Dei/quaeso memento mei.*

The identification of this figure has always been open to debate. It is generally claimed that the figure is the donor of the mosaic,[30] that is to say the person who commissioned it. There

are numerous arguments in favor of this interpretation. Manuscripts and certain Italian bronze doors, for instance, depict the donor in this manner, kneeling at the feet of Christ or of a saint.[31] At Saint-Denis itself, Suger appears both kneeling at the feet of Christ in the central tympanum of the west facade[32] and prostrated before the feet of the Virgin in the Infancy of Christ window.[33] In medieval mosaic pavements, the donor is sometimes mentioned by name: at Lescar,[34] at Otranto,[35] or at S. Maria del Patirion, near Rossano,[36] for example. Each time, however, the

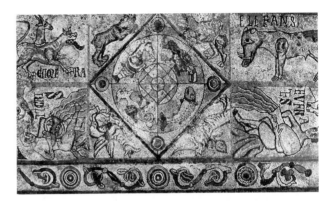

Fig. 11. Aosta, choir mosaic depicting the year, Labors of the Months, Rivers of Paradise. On the upper step: animals, the Tigris and Euphrates

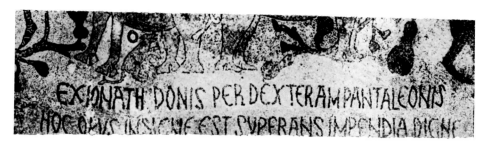

Fig. 12. Otranto, mosaic inscription at the entrance to the church

phrase used in the inscription is *fieri iussit.*[37] At Saint-Denis, the formula is clear: Pious Alberic *hoc nobile fecit opus.* On one of the Reggio Emilia mosaics the following inscription can be seen: *Petrus fecit. . . .*[38] In Otranto (as in Ganagobie), the names of both the artist and the donor appear (fig. 12): *Ex Ionath[e] donis per dexteram Pantaleonis hoc opus insigne est superans impendia digne* and then *Humilis servus Ch[rist]i Ionathas Hydruntin[us] archiep[iscopu]s iussit hoc op[us] fieri p[er] manus Pantaleonis p[res]b[yte]ri.*[39] The inscription at Otranto shows, on the one hand, the importance of the artist and, on the other hand, a formula similar to the Saint-Denis inscription for describing the work: *hoc opus insigne* at Otranto; *hoc nobile opus* at Saint-Denis.

The inscription that surrounds the Alberic medallion at Saint-Denis is a prayer to the Lord asking Him to remember His obedient servant. The submission of the artist and his work to God is frequently expressed in this way. The phrase *memento mei* at Saint-Denis can be found in other works, notably in the Beatus manuscripts,[40] as for instance in the Burgo de Osma copy where the following words are used to refer to both the scribe and the illuminator: *Memento mei Petrus clericus scripsit* and *Martini peccatoris mementote.*[41]

Two other works cast light on the Alberic medallion at Saint-Denis. At Otranto, a cleric is depicted on the pavement near the altar in one of the medallions of the Bestiary,[42] but unfortunately there are no inscriptions, and thus we do not know his identity. In Münster, in Westphalia, the master painter Gerlachus depicted himself on one of the fragments of the Moses window, which is preserved in the Landesmuseum. Brush in hand, he is accompanied by the following inscription: *Rex regum clare Gerlacho propiciare.*[43] The artist beseeches the prestigious King of Kings to favor him in a prayer which bears a strong resemblance to the one found in the Saint-Denis mosaic.

In the Middle Ages artists frequently signed their works, often employing the formula *me fecit.* Those used at Tournus,[44] Chauvigny,[45] and Autun[46] are very similar to the *fecit opus* of Saint-Denis. There is little difference between Alberic who dared to have himself depicted in an attitude of prayer in front of the altar, the most privileged place on the pavement, and Gislebertus who, at Autun, dared to engrave *Gislebertus hoc fecit* on the most

prominent part of the tympanum, underneath the feet of Christ in Majesty. Following the example of certain Roman marble carvers,[47] Gislebertus might well have directed the entire construction of the church, which could explain why his signature appears in such a prominent place. But who was the Alberic who "signed" the mosaic and had himself depicted at Saint-Denis? Was he the master mosaicist or the *maître d'oeuvre?* Whatever the answer, his impulse to be strongly identified with his work would be repeated down through the ages by others. The labyrinths set into pavements at Reims and at Amiens, for example, include portraits of the architects accompanied by inscriptions.[48]

Style and Chronology

A close stylistic analysis of the mosaic at Saint-Denis is hindered by its numerous restorations. The pavement sections available for study, however, allow us to glimpse the stylistic harmony so characteristic of the Middle Ages in general and here, in particular, between the floor and the monastery's other works of art.

The general disposition of the mosaic floor's large medallions reminds us, on the one hand, of the stained-glass windows and, on the other hand, of the interlocking sequence of medallions on the jambs of the west facade's right portal. We have already mentioned the iconographic relationship between the winegrower and the facade medallions, which enables us to place the mosaic into a larger chronological framework.[49]

Stylistic parallels between the floor and Suger's stained-glass windows suggest themselves readily. One is tempted to compare Alberic's head with those of monks witnessing the death of Saint Benedict from the Musée de Cluny,[50] and to propose a close date for these two works which may well have been executed in a same artistic milieu. Similar wide eyes, firmness of line, position of the heads, and elegantly attenuated hands are found in both works. This comparison becomes all the more convincing when one considers Louis Grodecki's comments on the resemblances between the ornamental details in the window borders and those of the west facade. Grodecki dated the Saint Benedict window in the 1140s, and thus contemporary with the facade. Furthermore,

Grodecki did not hesitate to describe the window as Romanesque, recalling its stylistic features, its ties with northern French and English manuscript illuminations, and also its relationship with Mosan art.[51] In other essays in this volume Louis Grodecki and Harvey Stahl draw our attention to the important role the "Romanesque Dionysian" tradition played around 1140 in the creation of the artistic genre characteristic of Saint-Denis.

There is unfortunately no further stylistic factor that helps us to assign a more precise date to the mosaic at Saint-Denis—and, in fact, in spite of its similarities to Dionysian works of around 1140, a later date could be posited and the above comparisons would still remain valid. Given what we know about the construction of Saint-Denis we could well fix the pavement's execution after 1140. Should we choose to date it after 1145–48, we might more easily understand why Suger did not mention the mosaic in any of his writings.[52] What is more, our knowledge of medieval *opus tessellatum*[53] mosaics and their replacement by tiles in the north of France during the second half of the twelfth century bars us from assigning too late a date to the mosaic pavement at Saint-Denis.[54]

Did Suger Commission the Execution of the Mosaic Pavement at Saint-Denis?

This question has aroused deep interest. Faced as we are with a work that is exceptional for the way as well as for the materials in which it was executed, it is very tempting to link it with a privileged moment in the life of the abbey, when Suger began his vast program to rebuild and redecorate the abbey church. In the Middle Ages, and particularly during the Romanesque period, major religious, architectural, or decorative projects often included a mosaic pavement.[55]

Suger must certainly have entertained the idea of having a mosaic pavement at Saint-Denis. He had undoubtedly been dazzled by the beauty of the Italian floors he saw while visiting Rome, Montecassino, and Apulia. He had, in fact, ordered the execution of an even more unusual work for northern France: the tympanum mosaic for the left portal of the west facade—"... *sub musivo, quod et novum contra usum hic fieri et in arcu portae imprimi elaboravimus.*"[56] In the Western world at this time, such decoration was still executed only in Italy.

As has already been stated here, and noted elsewhere by Henri Stern,[57] the Saint-Denis pavement makes use of materials characteristic of wall mosaics. The *retardataire* Romanesque element of the Saint-Denis floor contrasts with the boldness of the building's architectural conception but is in complete harmony with the stylistic content of the Saint Benedict windows and with the iconography and style of the west facade—with the exception of the statue columns and certain archivolt sculpture.[58]

In the end, however, and in spite of the multiple similarities between the pavement and elements of Suger's other artistic programs, there is no mention of this mosaic in his writings. For this reason Erwin Panofsky and, more recently, others have viewed the mosaic as dating from the end of the twelfth century, "not before 1190,"[59] as Eugène Emmanuel Viollet-Le-Duc had earlier done. This dating should be discarded. It seems likely, however, that if the mosaic had existed in Suger's time he would have discussed it and explained the exact role of Alberic. On the other hand, Sumner Crosby has pointed out that there might have been other inscriptions concerning Suger incorporated into parts of the mosaic that have not been preserved. This hypothesis must in turn be rejected, though, for two reasons: Percier's watercolors and the privileged location of the Alberic medallion.

As with the cloister at Saint-Denis, the mosaic pavement of the Saint Firmin chapel does not belong to Suger's abbacy but to a slightly later date, sometime during the 1150s. The mosaic floor which Suger does not mention, can nevertheless be considered as a part of the artistic legacy, originally inspired by and created for the abbot of Saint-Denis.[60]

NOTES

*This essay was translated by Françoise Vachon.

1. The principal bibliography has been gathered by Jean-Pierre Darmon and Henri Lavagne, *Recueil général des mosaïques de la Gaule* (Paris, 1977), vol. 2, fasc. 3, pp. 177–83.

2. Baron François de Guilhermy, *Notes archéologiques et historiques sur Saint-Denis* (1840 and after), Paris, Bibliothèque Nationale, ms. n.a. lat. 6121, fols. 16r, 161r, 168r; see also Paris, Bibliothèque Nationale, Cabinet des Estampes, 6b–62a (drawing of a panel), and Compiègne, Musée Vivenel, watercolors by Percier.

3. Jacques Doublet, *Histoire de l'abbaye de Saint-Denys en France* (Paris, 1625), vol. 1, p. 317.

4. Gabriel Millet, *Le Trésor sacré ou inventaire des sainctes reliques de Saint-Denis* (Paris, 1636), pp. 45–48.

5. Michel Félibien, *Histoire de l'abbaye royale de Saint-Denys* (Paris, 1706), p. 532.

6. Georges Huard, "Percier et l'Abbaye de Saint-Denis," *Les monuments historiques de France* 1 (1936): 133–44, 174–82, esp. 175; Jules Formigé, *L'Abbaye royale de Saint-Denis. Recherches nouvelles* (Paris, 1960), pp. 124–30; and Louis Grodecki, *Les Vitraux de Saint-Denis, étude sur le vitrail du XII^ème siècle* (Corpus

Vitrearum Medii Aevi) France, "Études" (Paris, 1976), vol. 1, pp. 40–41.

7. Alexandre Lenoir, *Musée des monuments français* (Paris, 1800), vol. 1, no. 429, pp. 210, 211; vol. 2, nos. 429bis, 522, 522bis, 523, pp. 19–25.

8. Darmon and Lavagne, *Recueil*, pp. 177–78.

9. Inventory number 11924.

10. Formigé, *Abbaye royale*, pp. 124ff.

11. Eugène Emmanuel Viollet-le-Duc, "Pavements du Moyen-Âge. Carrelage de l'église abbatiale de Saint-Denis," *Annales archéologiques* 9 (1849): 73–77; Alfred Ramé, *Étude sur les carrelages historiés du XIIème au XVIIème siècle en France et en Angleterre* (Paris, 1858), p. 42; Émile Amé, *Les Carrelages émaillés du Moyen Âge et de la Renaissance . . .* (Paris, 1859); and Lucien Bégule, *Les Incrustations décoratives des cathédrales de Lyon et de Vienne . . .* (Paris-Lyon, 1905), pp. 24ff., 66ff.

12. Henri Stern, "Mosaïques de pavement préromanes et romanes en France," *Cahiers de civilisation médiévale* 5 (1962): 13ff.

13. Christopher Norton, "Les Carreaux de pavage du Moyen Âge de l'abbaye de Saint-Denis," *Bulletin monumental* 139 (1981): 69–100.

14. *Procès-verbaux de l'Académie royale d'architecture, 1671–1793*, year 1678 (Paris, 1911), vol. 1, p. 190.

15. This inscription uses uncial as well as lower-case letters as follows: QVI Te DeVOtVS ORO CVI Se(R)VIO tOTVS MARTYR SCE DeI QVeSO MemeNTO meI.

16. According to Alfred Ramé's transcription, some doubts might linger as far as the exact spelling of the name Albericus is concerned. See Alfred Ramé, "La Mosaïque du moine Albéric à Saint-Denis," *Revue des Sociétés savantes des départements*, 6th ser., 8 (1878): 147–56; and Baron François de Guilhermy and Robert de Lasteyrie, *Inscriptions de la France du Vème au XVIIIème siècles* (Collection des documents inédits sur l'histoire de France) (Paris, 1883), vol. 5, pp. 338–41. The first reading of Guilhermy, before the 1842 restoration, has been discarded.

17. Hiltrud Kier, *Der mittelalterliche Schmuckfussboden unter besonderer Berücksichtitung des Rheinlandes* (Düsseldorf, 1970).

18. Henri Stern, *Recueil général des mosaïques de Gaule* (Paris, 1957), vol. 1, fasc. 1, pp. 96–99; Kier, *Schmuckfussboden*, figs. 354–56.

19. This controversy has been summarized by Darmon and Lavagne, *Recueil*, p. 182.

20. J. Sénégal, "Les Occupations des mois dans l'iconographie du Moyen Âge. Le XIIᵉ et XIIIᵉ siècles," *Bulletin de la Société nationale des Antiquaires de Normandie* 35 (1921–23): 68–78; Olga Koseleff, *Die Monatsdarstellungen der französischen Plastik des 12. Jahrhunderts* (Bäsel, 1934); and James Carson Webster, *The Labours of the Months in Antique and Medieval Art* (Princeton, 1938).

21. Webster, *Labours*, pp. 150ff. Note that this differs from cycles in Italian mosaic pavements where a winegrower pouring wine into a barrel never represents October. See Gerardo Rasetti, *Il Calendario nell'arte italiana e il calendario abruzzese* (Pescara, 1941).

22. Willibald Sauerländer, *La Sculpture gothique en France, 1140–1270* (Paris, 1970), pp. 61ff.

23. This is the case, for example, on the pavement mosaic of the church of S. Maria delle Stuoie in Pavia. See Adriano Peroni, *Pavia. Musei civici del castello visconteo* (Bologna, 1975), p. 102.

24. Émile Mâle, *L'Art religieux du XIIIᵉ siècle en France* (1898; reprint, Paris, 1958), vol. 1, pp. 144ff.

25. Joanne Y. T. Winjum, "The Canterbury Roundels" (Ph.D. diss., University of Michigan, 1974), pp. 48ff.

26. Illustrations are in Edoardo Brunod, *La Cattedrale di Aosta* (Aosta, 1975); and Kier, *Schmuckfussboden*, figs. 375–77.

27. On the circular images of the world, see Manfred Lurker, "Der Kreis als imago mundi, Abwandlungen des Kreismotivs in der christlichen Kunst," *Das Münster* 25 (1972): 297–306; on the square images, see Victor H. Elbern, "Species Crucis–Forma quadrata Mundi. Die Kreuzigungsdarstellung am fränkischen Kasten von Werden," *Westfalen Hefte für Geschichte Kunst und Volkskunde* 64 (1966): 174–85; and Anna C. Esmeijer, *Divina Quaternitas: A Preliminary Study in the Method and Application of Visual Exegesis* (Amsterdam, 1978).

28. Some of the important bibliography includes: Mia I. Gerhardt, "Zoologie médiévale, préoccupations et procédés," *Methoden in Wissenschaft und Kunst des Mittelalters*, Miscellanea mediaevalia (Berlin, 1970), vol. 7, pp. 231–48; and Francis D. Klingender, *Animals in Art and Thought to the End of the Middle Ages* (Cambridge, Mass., 1971).

29. Ellen J. Beer, *Die Rose der Kathedrale von Lausanne und der kosmologische Bilderkreis des Mittelalters* (Bern, 1952). Ellen J. Beer, "Nouvelles réflexions sur l'image du monde dans la cathédrale de Lausanne," *Revue de l'art* 10 (1970): 57–62. Ellen J. Beer, in the collective volume *La Cathédrale de Lausanne*, Bibliothèque de la Société d'histoire de l'art en Suisse, vol. 3 (Bern, 1975), pp. 221ff.

30. The various points of view have been summarized by Darmon and Lavagne, *Recueil*, pp. 182–83.

31. Margaret E. Frazer, "Church Doors and the Gates of Paradise: Byzantine Bronze Doors in Italy," *Dumbarton Oaks Papers* 27 (1973): 147ff. On the meaning of these images, see Nicolas Oikonomides, "Leo VI and the Narthex Mosaic of Saint-Sophia," *Dumbarton Oaks Papers* 30 (1976): 151–72.

32. Sumner McK. Crosby and Pamela Z. Blum, "Le Portail central de la façade occidentale de Saint-Denis," *Bulletin monumental* 131 (1973): 220–21.

33. Grodecki, *Les Vitraux*, vol. 1, pp. 178–79.

34. Catherine Balmelle and Xavier Barral i Altet, *Recueil général des mosaïques de la Gaule* (Paris, 1980), vol. 4, fasc. 1, pp. 181ff.

35. Walter Haug, *Das Mosaik von Otranto, Darstellung, Deutung und Bilddokumentation* (Wiesbaden, 1977).

36. Paolo Orsi, *Le Chiese basiliane della Calabria* (Florence, 1929), pp. 113–51; and Kier, *Schmuckfussboden*, fig. 411.

37. At Otranto: *Jonathas Rydruntin[us] Archiep[iscopus] iussit hoc opus fieri . . .*; at S. Maria del Patirion in Calabria: *Blasius venerabilis Abbas hoc totum iussit fieri.* See also the old though rather interesting remarks by F. de Mély, "Les Primitifs français et leurs signatures," *L'ami des monuments et des arts* (Paris, 1908).

38. Mario Degani, *I Mosaici romanici di Reggio Emilia* (Reggio Emilia, 1961), pl. 18.

39. Haug, *Mosaik*, pp. 11–17.

40. Information concerning these colophons can be found in Agustin Millares Carlo, *Manuscritos visigóticos. Notas bibliográficas* Monumenta Hispaniae Sacra, (Madrid-Barcelona, 1963), vol. 1.

41. Anscario M. Mundo and Manuel Sanchez Mariana, *El Comentario de Beato al Apocalipsis. Catálogo de los códices* (Madrid, 1976), pp. 22 and 23, no. 3. In the Bible of León in 960, one can see at the end of the text, under the omega, the two scribes Florentius and Sanctius thanking God for having successfully reached the end of their work. See John Williams, *Manuscrits espagnols du Haut Moyen Âge* (New York-Paris, 1977), p. 61. The essential bibliography can be found in Teófilo Ayuso Mazaruela, *La Vetus latina hispana* (Madrid, 1953), vol. 1, pp. 354–55; and his "La Biblia visigótica de San Isidoro de León," *Estudios bíblicos* 20 (1961): 181ff.

42. Haug, *Mosaik,* figs. 12–13 (second row, last medallion).

43. Louis Grodecki, *Le Vitrail roman* (Fribourg, 1977), pp. 97ff.

44. Jean Vallery-Radot and Victor Lassalle, *Saint-Philibert de Tournus* (Paris, 1955), pl. 105.

45. Robert Favreau and Jean Michaud, *Corpus des inscriptions de la France médiévale, 1, Poitou-Charentes; 2, Département de la Vienne* (Paris-Poitiers, 1975), p. 25, pl. XI, fig. 26.

46. Denis Grivot and George Zarnecki, *Gislebertus Sculptor of Autun* (London, 1961).

47. Carlo Promis, *Notizie epigrafiche degli artefici marmorarii romani dal Xº al XVº secolo* (Turin, 1836); Antonietta Maria Bessone Aureli, *I marmorari romani* (Rome, 1935); and Dorothy F. Glass, *Studies on Cosmatesque Pavements* (Oxford, 1980).

48. Xavier Barral i Altet, "Les Mosaïques de pavement médiévales de la ville de Reims," *Congrès archéologique de France. Champagne (1977)* 135 (1980): 97–99.

49. On the dating of the west facade of Saint-Denis, see Sauerländer, *Sculpture,* pp. 61ff.; Crosby and Blum, "Le Portail"; and Léon Pressouyre, "Une Tête de reine du portail central de Saint-Denis," *Gesta* (Essays in Honour of S. McK. Crosby) 15 (1976): 151–60. From now on, *Royal Abbey* is to be used.

50. Grodecki, *Les Vitraux,* vol. 1, pp. 108ff.

51. Grodecki, *Le Vitrail,* pp. 290, 97ff.

52. Panofsky, *Suger,* pp. 162–63.

53. Xavier Barral i Altet, "Mosaïque de pavement," in *Le Monde roman,* L'Univers des formes (Paris, 1982–83), vol. 1, pp. 109–21; vol. 2, pp. 145–54.

54. Norton, "Les Carreaux," pp. 83ff.

55. Barral i Altet, "Les Mosaïques de Reims," pp. 79–108.

56. Suger, *Adm.* (P), p. 46.

57. Stern, "Les mosaïques," p. 28.

58. See Neil Stratford's remarks in his review of the exhibit, "The Royal Abbey of Saint-Denis in the time of Abbot Suger (1122–1151)," *The Burlington Magazine* 123, no. 941 (August 1981): 506–9.

59. Darmon and Lavagne, *Recueil,* p. 183; and Panofsky, *Suger,* p. 163.

60. I would like to pay tribute to the works of Sumner McK. Crosby. I cannot but admire his clear-sightedness when he wrote in 1953 about the mosaic at Saint-Denis, "I would be inclined to admit that this ornamentation was part of Suger's program, even if some parts were executed only after his death." Sumner McK. Crosby, *L'Abbaye royale de Saint-Denis* (Paris, 1953), p. 48.

VI.
STAINED GLASS AND METALWORK

Suger's Glass at Saint-Denis: The State of Research[*]

Madeline Harrison Caviness

Research on the twelfth-century stained glass of Saint-Denis falls into three broad categories: first, the essential study of the windows themselves, including the examination of panels *in situ* for authenticity, the recognition of panels scattered in collections, the reconstruction of the original program and of the contents of individual windows based on authentic remaining fragments and on documentary sources, and the characterization of different styles in the original glass; second, investigation of the sources, both iconographic and stylistic; third, an assessment of the influence of the Saint-Denis windows. Logically these would have been investigated sequentially, but art history had not demonstrated such impeccable methods until the late Louis Grodecki conceived of a two-volume format for the *Corpus Vitrearum Medii Aevi* for Saint-Denis, under the rubric *Études*. Only in 1976 with the appearance of the first volume, divided into sections dealing with the history of the glass and its inventory, did the corpus of surviving glass emerge.[1] In the first part, Grodecki traced the vicissitudes of the glass through pre-Revolutionary alterations, then through post-Revolutionary dispersals and restorations. In its recent history this precious glass was tragically like the *peau de chagrin* of Balzac; it diminished each time attention was directed to its value. Ironically, by the time Westlake (1881), Mâle (1905 and 1914), and Lethaby (1915) made elaborate claims for the far-reaching influence of the Saint-Denis windows, the small amount of authentic glass remaining on the site had been transformed by restoration and de-restoration, and the whereabouts of an equal amount of original glass that had been dispersed in various collections was unknown.[2] Grodecki has shown that only 31 of about 140 panels removed in 1799 had been put back in the chevet; his inventory, including glass in col-

lections, records 42 figured panels, 17 border fragments, and 10 ornamental medallions.

Despite terrible losses among the windows of Suger's choir, it might be true to say that we now know more about them than at any time since his or his immediate followers' lifetimes. Rigorous study of Suger's writings, notably by Panofsky, has established the date of the glass of the chevet chapels beyond reasonable doubt: the windows referred to by Suger were surely in position for the 1144 consecration.[3] Glass may also have been placed in the clerestory of the chevet and in the crypt.[4] Although Suger mentioned only three of his windows, his descriptions help to fill out some of the losses as well as to elucidate his meanings.[5] Parts of at least seven of the windows have been recovered, and a coherent program has begun to emerge. In 1961 Louis Grodecki examined some of the textual sources for the most abstruse subjects—sources that had not been recognized since the time of the creation of the windows—and emphasized their esoteric nature.[6] That demonstration contradicted Mâle's theory of the seminal nature of Suger's iconographies; Mâle, for instance, had seen the curious subject of the Quadriga of Aminadab from the Allegories of Saint Paul window as the prototype of later representations of the Trinity, with the Almighty holding Christ on the Cross. In fact, the essential subject of this panel is nowhere imitated.[7] Some, at least, of Suger's iconographies may have been imperfectly comprehended outside his immediate circle.

Although of major interest today, neither Suger nor his successors would have concerned themselves with a detailed analysis of the styles of the various painters. Any analysis has to take as a point of departure Suger's own statement that the glass was made by the "exquisite hands of many masters from different regions."[8]

Notes for this essay begin on page 269.

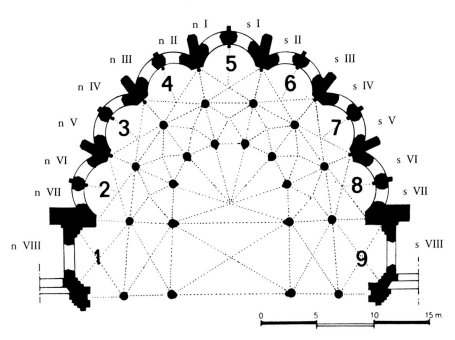

n I s I
n II s II
n III 5 s III
n IV 4 6 s IV
n V 3 7 s V
n VI s VI
n VII 2 8 s VII
n VIII 1 9 s VIII

0 5 10 15 m

1. Chapel of Saint Innocent
2. Chapel of Saint Osmanna
3. Chapel of Saint Eustace
4. Chapel of Saint Peregrinus
5. Chapel of the Virgin
6. Chapel of Saint Cucuphas
7. Chapel of Saint Eugene
8. Chapel of Saint Hilary
9. Chapel of Saint John the Baptist and Saint John
 the Evangelist

Fig. 1. Saint-Denis, plan of ambulatory chapels with window numbers (after Grodecki)

Both Louis Grodecki and Harvey Stahl treat aspects of this subject in this volume, but, paradoxically, the style of the Saint-Denis windows did not become a focus for research until recently—until, in fact, scholars in other fields turned to social and "contextual" concerns. This paradox has long been inherent in medieval studies. When Heinrich Wölfflin was systematizing the observation of form in Renaissance and Baroque works and when Bernard Berenson was expanding the Morellian tradition of connoisseurship in his studies of Italian painting, Mâle formed his conclusions about the "school of Saint-Denis" from a study of ornament and iconography, both subjects favored by nineteenth-century scholarship.[9] Until recently a parallel situation existed in this country; iconographic studies, under the impetus of the Princeton school, dominated the research and teaching of Early Christian and Byzantine art history, whereas other fields, including criticism, concentrated on formal or stylistic concerns.[10]

On the other hand, in light of the disappearance of so much of the original glass from the site by 1900, Mâle's conservative working method has often proved valid. His comparisons of border types were apt even though he was dealing with nineteenth-century copies in the windows of Saint-Denis; but he was not prudent, for he could not have known at the time whether these designs were authentic. There seems an element of luck, too, in his selection of relatively well-preserved panels for discussion and illustration, but this no doubt is because the engravings he used were made during or before the extensive restorations.[11] His hypotheses were often daring; in his analysis of the Tree of Jesse window he placed much weight on the inclusion of prophets

flanking the kings, as at Chartres. Yet Grodecki's recent study has shown how little remains of these figures *in situ;* the well-preserved ones in Wilton, England, could not have been known to Mâle.[12] Even apparent confirmation by Hans Wentzel, to whom we owe the recognition of a prophet from Saint-Denis in the Burrell Collection, Glasgow, has not worn well;[13] Grodecki has reassigned the figure to the Infancy window on the authority of eighteenth- and nineteenth-century drawings.[14]

In fact, the appearance in 1976 of the first volume of Louis Grodecki's great study for the *Corpus Vitrearum* has completely changed the vantage point from which we now view the Saint-Denis glass. It was followed in 1977 by a chapter in his *Vitrail Roman,* which placed the styles in the glass in relation to manuscript painting and metalwork in the north and east of France.[15] He added a study, published posthumously, of the Mosan elements in the *Signum Tau* panel.[16] His paper in this collection presents some new material, and it is much to be regretted that the yet more rigorous and detailed analysis that he planned for the second volume of the *Corpus* was not completed at the time of his death. The first volume deals with the greatest single problem that confronts the student of stained glass, that of distinguishing authentic parts of the design, authentic pieces of glass, and authentic paint from restorations. A rich legacy of documents is used to maximum effect, beginning with Suger's own writings.[17] Discrepancies between Suger's account, which is incomplete, later drawings and descriptions, and surviving glass are meticulously noted. To the well-known drawings made for Montfaucon in 1721 and those (1794–95) by Charles Percier, Louis

Grodecki has added those of Juste Lisch and of the restorer Nicolas Coffetier, the latter newly discovered in a Paris collection. He made good use of little-known descriptions made before the Revolution by Jacques Doublet (ca. 1590) and Michel Félibien (1706)[18] and was very frank about the travesties of Alexandre Lenoir, who had the glass so carelessly transported to the Musée des Monuments Français in Paris in 1799. With equal directness, Grodecki cited the glass painter Tailleur who, beginning in 1802, sold much of it before the rest was returned to Saint-Denis in 1816.[19] The majority, and the best preserved, of surviving panels are either in the Dépôt of the Château de Champs-sur-Marne or scattered in collections. Grodecki had been systematically rediscovering them during the past thirty years, in the museums of Lyon and Turin, in the churches of Twycross and Wilton, and in the Victoria and Albert Museum in London; Jane Hayward has added panels in the Pitcairn Collection in Pennsylvania, and others are in Dennis King's possession in England.[20] The history of the glass after the Revolution is so tortuous, and so poorly documented, that strong arguments had to be marshaled to "prove" that a panel such as the Martyrdom of Saint Vincent, undocumented prior to the twentieth century, was in fact from Saint-Denis, because glass from other sites such as Saint-Germain-des-Prés was sent to Saint-Denis in the shipments from the Musée des Monuments Français in 1816; in the case of the Martyrdom panel, Panofsky based his argument for a Saint-Denis provenance on the established cult of Saint Vincent at Saint-Denis and on the resemblance in the rendering of the nude figure of Saint Vincent to those in the inhabited scrolls of the jambs of the west portal.[21] Its original position in the church remains problematic.

At this point it may be useful to summarize Grodecki's findings as far as the twelfth-century program is concerned.[22] The plan shows the seven radiating chapels that open off the ambulatory, each lit by diptychs of windows, and two chapels to the west, of square plan, with a single window only (fig. 1). The grouping of windows is highly eccentric; the diptych arrangement does not allow for an axial east window. Grodecki believed that all the chapel windows were glazed between 1140 and 1144. Suger said the program began with the Tree of Jesse at the head of the church (*in capite ecclesiae*), surely one of the windows in the axial chapel that was dedicated to the Virgin and in which the Jesse window is now to be seen (sI in fig. 1). Its companion (now nI) was evidently the Early Life of Christ (also referred to as the Infancy window), though it is not mentioned by Suger; it begins with the heavily restored panel of the Annunciation to the Virgin, now *in situ,* and shows an authentic if partly restored representation of the abbot himself as suppliant. I will return later to the problems concerning the reconstruction of the rest of this window and its dating.

Another of the chevet chapels was glazed with a pair of "anagogical" windows, which were described in some detail by Suger and located in the east end in pre-Revolutionary references.[23] These windows presented allegories of the New Testament as seen by Saint Paul, and the history of Moses; they include, for instance, the Crucifixion prefigured in the Quadriga of Aminadab and in the Brazen Serpent. In 1851–52 seven out of an original ten panels were restored by Gérente and placed in the Chapel of Saint Pérégrin, to the north of the Lady Chapel, probably their original position (fig. 1, nII, nIII). One of these panels, Christ between Synagogue and Ecclesia, was not mentioned by Suger, who only gave four subjects for the first window; there is, however, every indication that each light had five medallions and that this subject belongs here.

Although the original location of these windows is fairly certain, the location of others is still not resolved. According to a sketch by Percier a third chapel, probably the complementary one to the south (fig. 1, sII, sIII), contained the story of the Passion in pairs of medallions. Grodecki has argued, from the survival of the *Signum Tau* medallion, which is of smaller size than the medallions containing the Pauline allegories, that Old Testament types accompanied Passion scenes; this program might have filled two windows, each with six pairs of panels. He suggested that the armature had straight bars, although an ornamental boss separated the circular figural scenes in the Percier drawing; the design would be more coherent if the bars, like those of the anagogical windows, were curved. Analogous compositions, with curved bars, can be cited at Canterbury toward the end of the century.[24]

In a fourth chapel, Grodecki envisaged a pair of historical windows containing the story of the First Crusade and Charlemagne's journey to the Holy Land, perhaps combined with the expedition to Spain as told in the *Chanson de Roland.* Two panels survive in the Pitcairn Collection, and a copy of one of them is in Turin; they correspond to drawings published by de Lasteyrie in 1845. Although other scenes recorded for Montfaucon in 1721 have disappeared, the drawings indicate an arrangement of paired circular panels. More recently Elizabeth Brown and Michael Cothren have convincingly argued that a single window contained all fourteen known panels; the Crusading theme was introduced by general scenes of royal Crusade and the awarding of martyrs' crowns, followed by Charlemagne's pilgrimage and campaigns, and finally the events of the First Crusade.[25]

Seven figured fragments and some border panels from a Life of Saint Benedict were identified by Grodecki in collections, and their Saint-Denis provenance established. As he indicated, one of the upper chapels could have accommodated the Saint Benedict cycle in five registers of demi-medallions, giving a total of ten scenes; yet, two windows in the chapel of the crypt that was dedicated to Saint Benedict in 1144 provide a more likely place of origin; each window would have contained three pairs of scenes

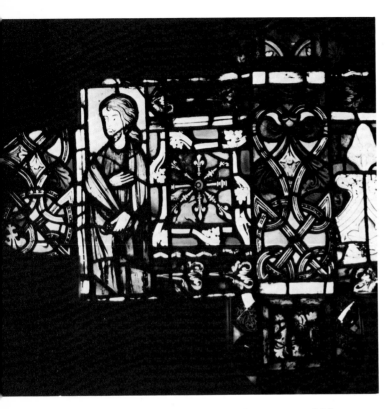

Fig. 2. Fragments of stained glass (London, Victoria and Albert Museum, Department of Ceramics, no. C.2-1983), including two pieces of border from the Infancy window of Saint-Denis

to make a total of twelve. Another panel, with Saint Benedict in the cave, has recently come to light in an English collection.[26] A more rigorous study of textual and pictorial sources for this window may confirm Grodecki's reconstruction, especially comparison with the program of the crypt capitals recently studied by Pamela Blum.[27] As already indicated, the unique surviving panel of a Life of Saint Vincent raises similar questions. Since there was no chapel dedicated to him in the upper church, his Life may well have been in the crypt. More detailed study of the liturgical processions may also shed light on these problems, as suggested by Niels Rasmussen in this volume.

Finally, fragments of one or more ornamental "griffin windows" survive in Saint-Denis. The authentic pieces are now used in the last radiating chapel on the south side of the choir, originally the Chapel of Saint Hilary (fig. 1, sVI, sVII). Grodecki has estimated that ten medallions with griffins survive, but the modern glasses are very difficult to detect. The surround, by Oudinot (1852–54), seems to be based on earlier restorations. Drawings by Percier may not indicate the original composition.

Thus, Grodecki's first volume of the *Corpus* presented objectively and clearly the archaeological and documentary evidence for each cycle; where restoration charts could not be established with any degree of certainty, as in the griffin windows, Grodecki

was content to enumerate in his text alone the medallions that may be at least in part old, and he did not commit himself to graphic schemas. When he did provide a schema, he also reproduced evidence for restoration in the form of photographs of the exterior surface of the glass (even though these have to be used with great caution) and eighteenth- and nineteenth-century drawings and engravings.[28] What is very evidently lacking, however, is complete examination of the glass itself, because much of it had to be dealt with *in situ*; examination on the bench, especially out of the leads, might have given very different results, especially in dating the replacements and in detecting overpainting. It is unfortunate that the anagogical panels were not taken out until after publication of the *Corpus*.[29] As a result inevitable doubts will continue to surround judgments of style and iconography. In general, the charts clearly transmit the message "*méfiez-vous*"; they will ensure that other researchers proceed with extreme caution, perhaps even overcaution. Grodecki warned against modern glasses that already appear more heavily corroded than medieval ones, without stressing that some twelfth-century glasses—notably the light blues of Saint-Denis and Chartres west—have not corroded. The problem is compounded when we consider that some of the Saint-Denis glass has not been exposed to the elements and to industrial pollutants since the eighteenth century. Such difficulties become factors in evaluating the authenticity of other panels in collections.

In 1978, when I discovered two border fragments from Saint-Denis in the drawing room of a house in New England (they are now in the Victoria and Albert Museum, London), I was startled by the brilliance and garishness of their colors, but close examination of the interior and exterior surfaces of the glasses satisfied me that the undulating surface and slight corrosion are indications of authenticity (fig. 2); the blues are intact except for a typical shaling off where there was a large air bubble; the greens, purples, and whites are slightly crusted or show pinpoint pits. Bought in Europe about 1900, the panel is a medley of pieces leaded together in a typical nineteenth-century arrangement; it probably came from a French restorer, since the figure on the left is a prophet from a mid-thirteenth-century Tree of Jesse from Soissons Cathedral.[30] In fact, the border design exactly matches that of other less-well-preserved fragments in the Dépôt de Champs-sur-Marne, the Metropolitan Museum, and the collection of Dennis King in Norwich.[31] As Grodecki has shown, this border design corresponds to that in Percier's drawing of the Infancy window before the Revolution.[32] A copy made under the direction of Viollet-le-Duc, now in the Infancy window, was surely based on fragments of the original.[33] Some mutilation of the lower panels seems to be indicated by the Percier drawing, which might explain both the halving of the motifs lengthwise in the Metropolitan panels and also the awkward turning of a corner in one of the Victoria and Albert Museum fragments, in-

dicated by a diagonal lead that juxtaposes two centers of palmettes; according to Grodecki's reconstruction of the composition of the Infancy window, there was no border in the bottom. Some border lengths in the sides, however, were apparently only 42cm. high, or exactly the dimension of the larger fragment in the Victoria and Albert Museum.[34]

A much more difficult problem is raised by two other panels: one with the Flight into Egypt, which entered the Pitcairn Collection in 1930 through Lucien Demotte; and a fragment with three women attendants from a Presentation in the Temple that was with Acézat in 1932 and has now disappeared. In a paper presented at Kalamazoo in 1978, Michael Cothren argued that both are authentic pieces from the Infancy window.[35] Grodecki's own reconstructions of this window evolved over a period of nearly twenty years, beginning with his publication in Panofsky's festschrift volume in 1961. Recognition of the prophet Jeremiah in the Burrell Collection and a fragmentary scene identified by Grodecki as the Flight into Egypt in Wilton Church added to his knowledge of the window. A Virgin and Child, also in Wilton, confirmed the presence of an Adoration, which he postulated in 1961.[36] It must be said that neither of his compositions looks "right"; the variety of combinations of squares, circles, and semicircles is arbitrary in the extreme. One has, however, to accept as authentic the curious arrangement of a small rectangular panel with the Three Kings forming a pendant to and juxtaposed with a larger semicircle with Herod and his Wisemen; a single scene is divided between two panels, with alternating red and blue grounds.

Chartres west may be invoked for an iconographic parallel both for this sequence and for the presence of two scenes depicting the Holy Family journeying, one illustrating the Flight into Egypt, with the idols falling as a pendant, the other showing the return journey, with the greeting of the inhabitants of Soutine as a pendant.[37] At Chartres the Virgin of the Flight holds a palm in her left hand, whereas she picks a bunch of dates in the Pitcairn panel; according to the Nativity story of pseudo-Matthew, as noticed by Cothren, a tree laden with fruit has bent to provide food for the journey. The correspondence with Chartres cannot be regarded as evidence for the authenticity of the Pitcairn panel. Early in the century, on reading Mâle, a forger might well have decided to copy the Chartrain cycle in order to provide missing panels from Saint-Denis; yet the correction of the iconography would be surprising. But there is other authenticating evidence. The glasses, undulating, variably and only slightly corroded or crusted, compare well with authentic panels, and as yet no evidence of recutting has emerged—on the contrary, some of the more corroded examples have a lip at the edge where the leads afforded protection. Chemical analyses carried out by Robert Brill at the Corning Glass Center match these glasses with accepted Saint-Denis specimens, and the evidence cannot be dismissed by the assertion that fragments of Saint-Denis glass "left over" after one of the restorations were recut and painted anew to form this scene.[38]

Still, both Jane Hayward and I have serious reservations about the painting style, especially the blue drapery of the Virgin and much of Joseph, and we question whether or not there was an extensive replacement of lost trace lines.[39] These details, and the facial types, are in fact closer to the panels from the Charlemagne window than to authentic details from the Infancy window. As an alternative to assigning these anomalies to modern restoration, one might consider whether they are due to a restoration of the 1150s by the Charlemagne painter; we know that Suger created a permanent position for a glazier to repair his precious windows.[40] Another hypothesis is that the Infancy window may have been completed after Suger's lifetime; I will return to this question later.

On the basis of photographs, the other piece, with the women of the Presentation, is difficult to judge, although a view of the outer surface is helpful.[41] The composition could have been modeled on Chartres, but it must be said, as with the Flight, that such a conception was prophetic before 1932, because the Presentation scene had not yet been discovered in Twycross; it would be purely fortuitous that the dimensions coincide with that panel, for the analogous sequence of the Magi and Herod with the Wisemen had not yet been recognized either. I am inclined, therefore, to the view that this panel is also of the twelfth century, perhaps with some retouching of the paint. On the other hand, if both of these panels are to be rejected as forgeries, they are precious replicas of missing originals, made in at least one case with twelfth-century glass from Saint-Denis.[42] The reconstruction proposed by Cothren is extremely convincing in the regular alternation of red and blue grounds and the mirror symmetry of the arrangement of panels, with a quatrefoil in the center of the window; the centrifugal arrangement emphasizes the Virgin and Child in the Adoration scene. In the taller window at Chartres, where no such emphasis is provided in the composition, a second Virgin and Child, enthroned, dominate the upper part of the window.

This discussion demonstrates that the task of establishing the corpus of extant Saint-Denis glass is probably not complete. Although Grodecki has added twelve scenes in collections to the twenty or so preserved in Saint-Denis, his publication is more likely to aid in the recognition of additional panels than to remain definitive. Indeed, yet another panel, with the Dream of the Magi, has now been identified in Raby Castle and will be taken into account in Cothren's reconstruction.[43] Such is the fate of Corpus volumes; for instance, the publication of the Corpus of the Sainte-Chapelle allowed scholars to recognize several panels in collections that now form a sizable addendum.[44] Meanwhile we have the core of a reliable body of material for Saint-Denis

awaiting full investigation as to its sources and its influence.

I am more concerned here with problems of method than with making new suggestions as to specific sources. Too often art historians seem to confuse the different kinds of sources that were utilized by patron and artist. These might be fourfold; formulated in the manner of Richard of Saint-Victor, two are spiritual or iconographic and two are material or stylistic.

First, there would be textual sources. In the case of Suger's program they center on Saint Paul and his supposed disciple pseudo-Dionysius the Areopagite and draw, too, upon the general currency of theology in northern France in the first half of the twelfth century. From these, Suger distilled his leonine hexameters for the anagogical windows as well as his list of subjects for the other windows. Some of the textual sources were brilliantly exposed by Grodecki in 1961.[45] Since that publication some new observations on Suger's theological sources are relevant to the glass. One is Meredith Lillich's cogently argued thesis that the predominance of blue in the windows of the ambulatory chapels

was a conscious evocation of "divine darkness" and the "inaccessible light in which God is said to dwell" that were referred to by pseudo-Dionysius the Areopagite.[46] The other is the analysis, presented by Grover Zinn in this volume, of Victorine parallels for some of Suger's concepts and their phrasing; I will have occasion to refer to this analysis later. Most recently, Brown and Cothren have examined the textual sources and political content of the Crusading subjects and argued that they were composed either during preparations for the disastrous Second Crusade, about 1146–48, or, more probably, during the abbacy of Odo of Deuil, around 1158.[47]

Second, there would be a pictorial iconographic guide, to use Ernst Kitzinger's phrase, such as a Nativity cycle illustrating pseudo-Matthew for the Infancy window or a Life of Saint Benedict for that cycle.[48] Given the present state of our knowledge, it is mere speculation whether these were most likely to have been provided by the patron, from a manuscript in the library or perhaps from a reliquary, or whether guides for some of the standard

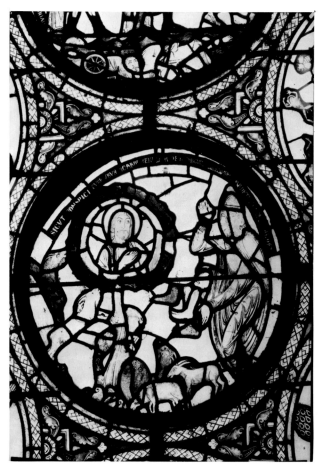

Fig. 3. Saint-Denis, ambulatory chapel 4, Life of Moses window (n. III), detail of Moses and the Burning Bush

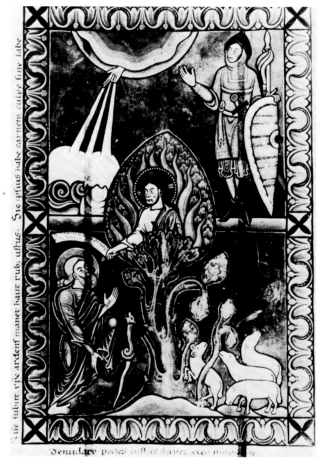

Fig. 4. Averbode Gospels (Liège, Bibliothèque de l'Université, ms. lat. 363 B, fol. 16v), Mosan manuscript ca. 1145–65, lower scene depicting Moses and the Burning Bush

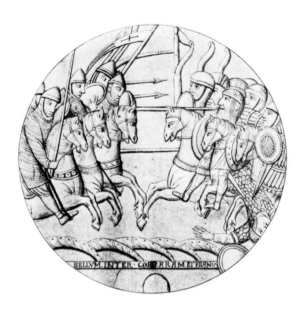

Fig. 5. Saint-Denis, ambulatory chapel windows, lost scene from the First Crusade series drawn for Montfaucon (Paris, Bibliothèque Nationale, ms. fr. 15634/1, fol. 162r)

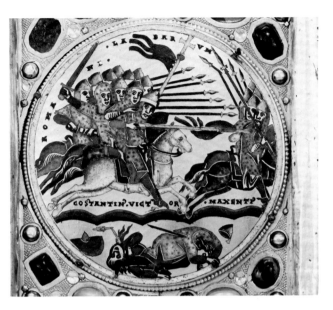

Fig. 6. Stavelot Triptych (New York, Pierpont Morgan Library), ca. 1150, enamel plaque depicting Constantine's Victory over Maxentius

cycles were part of the baggage of an itinerant artist during this time. In either case we should be very careful not to draw conclusions about stylistic sources from iconographic ones.[49] For instance, comparison between the Chartres and Saint-Denis Infancy cycles establishes similarities in the compositions—the number and arrangement of figures. Similarly, I believe, the affinities with Mosan manuscripts, including the Floreffe Bible group, invoked to argue a Mosan source for the main glass painter at Saint-Denis, are restricted to iconography.[50] If we compare the Moses before the Burning Bush of the Averbode Gospel Book with the scene at Saint-Denis, there is a similarity of composition (again reversed) that may indicate a common iconographic guide, but the style is not related (figs. 3 and 4); the miniaturist, who Gretel Chapman believed added this subject to the repertory of the Floreffe Bible after 1139, was concerned with depth and plasticity, evidenced in the heavy, curving folds of the mantle over the leg, whereas the glass painter spread out the compositional elements more evenly and decoratively and was content with sharply defined peaked folds that read as a series of ciphers.[51] (I will suggest sources for these stylistic traits later.) In the case of the *Signum Tau* painter, however, Grodecki demonstrated that stylistic and iconographic features lead consistently toward the Mosan region; even so, he was reluctant to speculate on the origin of the painter.[52]

A more complex situation occurs where an iconographic guide may be adapted for another purpose by the selection of a like scene—as, for example, a biblical battle scene adapted to illustrate a recent chronicle. A case in point is the enticing comparison between a battle scene from the First Crusade window, as we

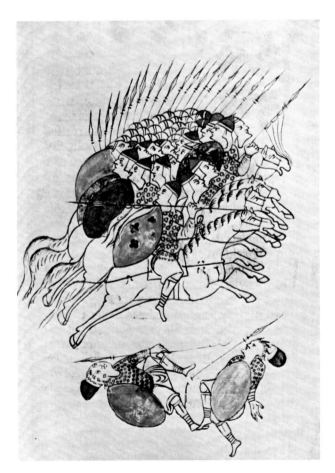

Fig. 7. Manuscript from Saint-Gall (Leyden, University Library, Ms. Periz. F. 17, fol. 46r), tenth century, illustration from Maccabees

know it in the drawing made for Montfaucon, and the enamel plaque of the Morgan-Stavelot triptych showing Constantine's victory over Maxentius, a comparison first made by Mâle (figs. 5 and 6).[53] Does the Mosan work, which is contemporary with or later than the Saint-Denis panel, lead us to a common pictorial source? The first question to ask is what they have in common. Evidently they share the clustering of soldiers into the collective noun *army,* the parallel placement of spears across the caesura between two armies, and the regular curving and hard-edged forms of the ground line forming an exergue. Such features are readily explained, however, by an adaptation to media that have much in common; both enamelist and glass painter tend to fill the field with objects—such as the spears—because of the nature of their media, and both have to define areas such as the ground with a continuous metallic line separating masses of solid color. Since the subjects represented here are not in fact the same, I suggest that both derive from a common type-scene showing a battle, most probably one that evolved in Old Testament illustration. A tenth-century drawing from Saint-Gall illustrating the Maccabees provides many of the elements that could have been independently adapted to the media of stained glass or champlevé enamel and to the subjects of Constantine or the First Crusade (fig. 7). Such adaptations were not the result of mere laziness or lack of inventiveness on the part of the artist but were intended as visual similes; a later chronicle likened Simon of Montfort, in his crusade against the Albigensians, to a Maccabee.[54]

This example demonstrates one of the difficulties of pinpointing pictorial iconographic sources; we have to allow for creative adaptation between different cycles, and even for invention. Because the texts on which the Crusade and Charlemagne subjects were based date only from the twelfth century, it is possible that the glass painters were working directly from them in order to evolve their own pictorial guide, at times adapting type-scenes, at times inventing.

Konrad Hoffmann in 1968 presented some suggestions as to the kinds of pictorial material that were adapted to Suger's unique anagogical program. For instance, he brilliantly exposed the extent to which images in the Carolingian Vivian Bible were creatively adapted in these windows, and he was at pains to argue the presence of the manuscript at Saint-Denis in the twelfth century.[55] He also noted that Christ between Synagogue and Ecclesia bears a strong resemblance to a type of Byzantine scene depicting the coronation of monarchs, as in the tenth- or eleventh-century ivory in the Musée de Cluny that he illustrated or in a miniature of Alexander crowning his two successors in the Dover Bible (Cambridge, Corpus Christi, MS. 4, fol. 139v). Such a type-scene was apparently fused with a pictograph of the ordered universe, held by God, of a kind found in an early twelfth-century school book.[56] The example illustrated by Hoffmann is from an English manuscript, but it is exciting to note

the description of such a schema in the *De arca Noe mystica* of ca. 1120 by Hugh of Saint-Victor, cited by Grover Zinn.[57] This is certainly the kind of model that would be more familiar to theologians than to itinerant artists, so one may tentatively conclude that the pictorial as well as the verbal compositions of the "anagogical" scenes were intimately linked with Suger and his monastic community.

According to the approach that I suggested earlier, which separates stylistic from iconographic sources, two levels of operation also apply to the formation of a style. The first is the artist's repetition of *moduli,* such as certain poses, drapery schemas, and facial types—that is, of a repertory of forms he may have collected in a model book, a repertory that also includes ornamental motifs.[58] The second is his manner of combining these elements into coherent compositions within certain modes of expression. Compare the treatment of groups of spectators by the master of the Life of Saint Benedict—who preferred to separate his figures—with that of the master of the Moses window, who grouped some tightly while separating them rigidly from others (fig. 3 and Grodecki fig. 2); though grouping his figures closely, the painter of the *Signum Tau* panel allowed them volume and space, and he eliminated the ground line (Grodecki fig. 3). Since the *moduli* and the way of composing with them allow us to separate one artist or team of painters from another, they should lead us to their sources. Yet the use of a different mode by the same painter may confuse the historian of style; hence differing opinions as to whether the same or different artists provided the diagrammatic compositions of the 'Pauline' anagogical window and the narrative scenes of the Infancy window.

For Saint-Denis, Grodecki indicated three ateliers: one responsible for most of the surviving work—the Jesse window, the Infancy cycle, the anagogical scenes; a second for the Saint Benedict cycle; and a third for the typological Passion cycle.[59] Jane Hayward, in the catalogue for the 1981 exhibition, has preferred to recognize five ateliers.

The problem of identifying stylistic sources is compounded by the scarcity of glass surviving from the decades preceding the work at Saint-Denis, so the search has to be conducted in other media. Here Grodecki rightly deplored the state of our knowledge of metalwork and manuscript illumination from the second quarter of the twelfth century. While alluding in 1977 to Mosan affinities in two of the hands, or ateliers—the main shop and the *Signum Tau* master—he admitted that the metalwork and manuscripts he referred to are frequently dated later than the firmly dated glass of the ambulatory. Even the pre-1139 date put forth by Gretel Chapman for the Bible of Floreffe did not greatly help his argument, because its stylistic affinity is not strong with either of the Saint-Denis groups;[60] we have already seen that the related Averbode Gospels provides an iconographic rather than a stylistic parallel for the scene of Moses and the Burning Bush. In

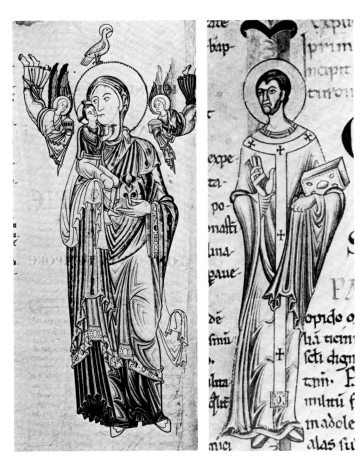

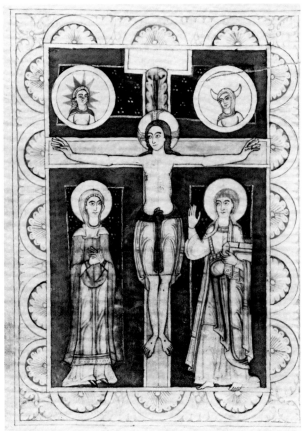

Fig. 8. Left: *Commentary of Saint Jerome from Cîteaux (Dijon, Bibliothèque municipale, ms. 129, fol. 4v), ca. 1130, Virgin and Child*

Fig. 9. Right: *Cîteaux Lectionary (Dijon, Bibliothèque municipale, ms. 641, fol. 113r), ca. 1120–30, initial*

Fig. 10. *Sacramentary of Wibald of Stavelot (Brussels, Bibliothèque Royale, ms. 2034–35, fol. 25v), Mosan, ca. 1130–59, Crucifixion*

fact, the derivation of the distinctive folds in this Moses scene at Saint-Denis is quite old; the *moduli* used by this glass painter may have resembled those in the famous drawing of the Virgin and Child in a Cîteaux manuscript of a decade earlier (figs. 3 and 8). The nested V-folds are only slightly softened in some passages at Saint-Denis, and the series of peaks are more insistent.

As Jane Hayward remarked, other echoes of this style are found in the prophets from the Tree of Jesse. For the emperor presiding over the martyrdom of Saint Vincent, and for some of the kings of the Tree of Jesse, the Cluniac painting in the apse of Berzé-la-Ville may be invoked. If the early date (ca. 1100) claimed for this encaustic painting is correct, it represents a coherent and vigorous phase of a style that had been simplified and stripped of its meaning through repetition of formulaic renderings by 1140.[61] *Moduli* of this kind may have been so widespread by then that an exclusively Burgundian source is not claimed. One can point to a mid-twelfth-century manuscript from Saint-Amand that demonstrates their spread through the northern regions.[62] Similarly, the more elongated and banal figures of the Saint Benedict master may also, in my opinion, be derived from Burgundian work; again, comparison is made with a Cîteaux lec-

tionary (ca. 1120–50, figs. 9 and 10), but manuscripts from Saint-Bertin and Normandy have also been cited for comparison.[63] There is also a parallel for these stiff figures in the sacramentary of Wibald, Abbot·of Stavelot (1130–59), although the folds in the manuscript are more rigidly compartmentalized and the gestures are less energetic (fig. 10).[64]

This work may be contemporary with the Saint-Denis glass, but *moduli* of earlier Mosan derivation seem to have played a part in the glass painters' selection of motifs. A Bible made at Lobbes in 1084 provides a generic source for the back-view figures of the Martyrdom of Saint Vincent (fig. 11); many such figures also appear in the related Stavelot Bible (fig. 12).[65] Furthermore, the Stavelot Bible, dated 1093–97, already contains a composition heralding that of the Infancy window at Saint-Denis, with a comparable density of narrative scenes in the small lateral fields as well as in the major convex ones.[66] The composition seems to dictate the use of curved armatures, of which the earliest surviving example is at Saint-Denis.[67]

Only after a more systematic investigation of the use of older conventions at Saint-Denis will the originality of the artists fully emerge. Yet, when finally assigned a place in the development of

northern European painting, probably neither the main master
nor the Saint Benedict master will appear as forward-looking as
Master Hugo, who in 1130–40 was practicing the fully devel-
oped damp-fold style at Bury St. Edmunds; his sinuous lines and
emphatic volumes set a trend for several decades.[68] The Saint-
Denis glass painters seem to reiterate traditional motifs that had
filtered down from two of the great creative centers of the early
twelfth century, Burgundy and the Meuse.

The third of Grodecki's styles is represented by the *Signum
Tau* panel, from a typological Passion window (Grodecki fig. 3).
In 1977 he indicated an affinity with earlier and later Mosan
works and admitted the difficulty of identifying precise stylistic
sources. On the one hand, the font of Renier of Huy—dating
from the first decade of the century—was invoked as an example
of the classicizing tradition; on the other hand, works sometimes
dated 1175 or so were found to show an affinity with this "pre-
cocious" hand.[69] There seems, in fact, to be little connection
with the very stiff figures of the Bible from the Premonstraten-
sian House of Sainte-Marie-du-Parc, dated 1148, or even with
the Bible of Floreffe, which may be a decade earlier.[70] One ex-
ample closer in date, however, is the earliest of the great Mosan
shrines, that of Saint Hadelinus of about 1130–50 from Celles-
lez-Dinant Abbey (now in Visé), which demonstrates the use of
massive, stocky figures, their stiffly molded garments weighted
down with jeweled hems and belts (fig. 13).[71] In his last contri-
bution to this discussion, Grodecki noted close stylistic and
compositional similarities between the *Signum Tau* panel and the
Berlin Psalter fragment, or model book, accepting the date—
before 1140—proposed for it by Elisabeth Klemm.[72]

One frustration encountered by following up four kinds of
sources as I have proposed to do is that all trails do not necessarily
lead in the same direction, and it is difficult to form conclusions
from conflicting evidence. Although a satisfactorily cohesive
view of the iconography, style, and date of the *Signum Tau* panel
has at last been reached, the textual and historical associations
evoked by Brown and Cothren for the Crusading window create
difficulties for the style and chronology of the related panels in
the Infancy window, as indicated above. It is difficult to imagine
the consecration of 1144 taking place with only one of the win-
dows in the axial chapel having been glazed; and the hypothesis
that Suger's image was placed at the foot of the Infancy window
after his death is in conflict with views of his patronage argued
by Lillich, and by Maines in this volume.[73] The fact that Suger
did not refer to this window should not weigh heavily in argu-
ments as to its date; he was consistent in showing no interest in
purely narrative cycles, probably because they belonged to a
lower mode than his allegorical and anagogical subjects.[74] His
omissions include the Benedict and Vincent cycles as well as the
Infancy and Crusading windows. The most convincing hypoth-
esis proposed by Brown and Cothren allows a stylistic continuity

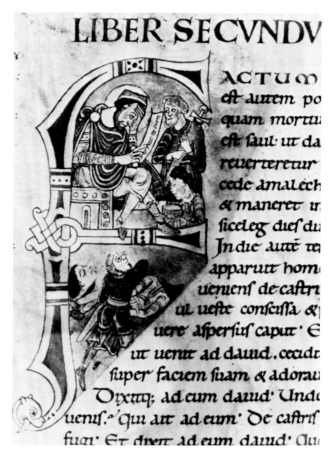

Fig. 11. *Saint-Denis, panel of window possibly from the crypt (Paris,
Dépôt of Champs-sur-Marne), Martyrdom of Saint Vincent*

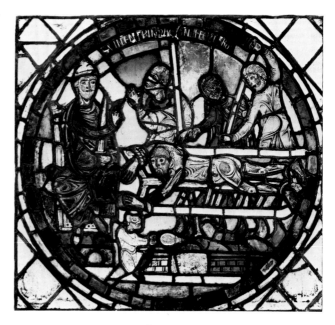

Fig. 12. *Lobbes Bible (Tournai, Bibliothèque du Séminaire, ms. 1, fol.
131v), Mosan, 1084, initial to Samuel II*

over as long as fifteen years between the glazing of the axial chapel and the addition of the Crusading window. To their arguments I would add that the unusual collaboration of two such different artists on the same (Infancy) window might be a sign of its hasty production in time for the consecration.

The third area of concern I delineated is the influence of the Saint-Denis glass. Mâle's view has also had to be modified here, as it became clear that the anagogical windows were too esoteric to be imitated in later typological cycles.[75] Even the allegorical Passion cycle was extremely conservative, following an older diptych or answering cycle arrangement rather than the forward-looking triple composition of the Stavelot Bible initial.[76] On the other hand, our greater knowledge of the Infancy window has reconfirmed the view that the central west window of Chartres is based on the same iconographic guide. The positioning of the Chartres windows in relation to those of Saint-Denis is noteworthy, too. The Tree of Jesse, also very evidently modeled on the Dionysian formula, is to the north of the Incarnation at Chartres, the Passion to the south. This could have been the original order, now reversed, in Saint-Denis's axial chapel.[77] The Chartres Passion window, like the allegorical ones of Saint-Denis, is composed of paired medallions, although a simple narrative rendering is preferred. Dionysian influence at Chartres is, however, restricted to iconography; examination of both ensembles has now made it possible to conclude that the styles of the painters at Chartres and the *moduli* they used are not those of the Saint-Denis ateliers. A comparison of two heads, one of the prophet in the Burrell Collection, the other of Balaam in the Jesse window at Chartres, suffices to demonstrate the more emphatic, monumental painting of the Chartrain work of a decade later.[78]

As noted long ago, the Jesse window was reproduced not only at Chartres but also in England, at York Minster about 1170 and at Canterbury Cathedral about 1200.[79] It is unlikely that the design was repeated as a mere convenience. James Rosser Johnson has attempted to see in the design at Chartres a conscious and meaningful use of the fleur-de-lis motif, a visual reference to the ruling house of France.[80] Though skeptical of this all-too-hidden symbolism, I am much interested in Eleanor Greenhill's suggestion that both Eleanor of Aquitaine and Louis VII were involved in meeting the very high cost of glazing at Saint-Denis.[81] It may be no coincidence that the York window was probably glazed about 1170, when Eleanor's second husband, Henry II of England, so ill-fatedly had their son crowned by the archbishop of York, Roger of Pont l'Évêque, thus enraging Thomas Becket.[82] Was that window a royal gift to commemorate the event? Attesting to their interest in glazing programs, Eleanor and Henry appear as donors at the foot of the great Crucifixion window in the cathedral at Poitiers.[83] In Canterbury the Jesse window, celebrating the kings of Judea, is a concession to monarchical ideals in a

Fig. 13. Shrine of Saint Hadelinus from Celles-lez-Dinant (Visé, Saint-Martin), detail

program dominated by the old and new priesthood; I have shown elsewhere that the surviving king from it may have been modeled on the new seal of Richard I, made in 1198.[84] On his return from Crusade and imprisonment in 1194 he had been greeted on the Continent by his widowed mother, Eleanor, and together they visited Canterbury on their way to London.[85] This window could represent their gift, an *ex voto* for his safe return. The Canterbury window is not only analogous in composition to the one at Saint-Denis, but it is also positioned in the axial chapel. It is worth noting that the Sainte-Chapelle, constructed and decorated by Eleanor's great-grandson as royal chapel to house the royal emblem of Christ, also has a Tree of Jesse on the north side of a central christological window.[86]

Evidence of stylistic influence from Saint-Denis has so far been elusive. We have not found it at Chartres. Glass provided by Suger for Notre Dame of Paris has disappeared without trace, though Le Vieil suggested the characteristic blue glass of Saint-Denis was also used there.[87] Only the style of the *Signum Tau* panel, classified as Mosan by Grodecki, has reverberations in extant glass. Grodecki long ago noted a resemblance in the later panels at one time in Troyes Cathedral, glass now dated in the twelfth century, probably before 1188.[88] Troyes is closer than Saint-Denis to the Meuse basin, but it may be relevant that Eleanor of Aquitaine's daughter Marie of Champagne held court in Troyes.[89]

It has previously been overlooked that in Sens Cathedral there also appear to be fragments of twelfth-century glass that are closely related in style to this group. At some time two heavily restored panels from a Life of Saint John and one from the Life of

Fig. 14. *Cathedral of Sens, axial chapel window, Saint Peter Walking on the Water*

Fig. 15. *Cathedral of Sens, axial chapel window, Saint John Tortured by Domitian*

Saint Peter were installed in the axial chapel, together with thirteenth-century scenes from the Life of Saint Peter and some debris from the Saint Eustace window in the ambulatory (figs. 14 and 15). Further research may indicate their history, but possibly the early-looking fragments belong to the building campaign of the 1150s. As Kenneth Severens has indicated, that campaign shows strong influence from Saint-Denis in the construction of the apse.[90] The glass may have been damaged by fire in 1184 and repaired in the thirteenth century, as seems to have been the case with the Troyes glass of this period.[91]

Finally, there is the question of the nature of lost glass from Saint-Denis and its impact elsewhere. Whatever qualifiers are made as to the influence of individual panels and windows from the lower parts of the east end (the chevet and crypt chapels), the program as a whole has components that appear to have become the norm later: that is, hagiographical and legendary windows treating the lives of saints or the history of relics, scriptural windows, and ornamental windows.[92] Given the small-scale nature of all the remnants, comparison with metalwork, manuscripts, and even textiles is inevitable.[93] Yet the clerestory of the choir surely had glass of a very different conception. Large-scale figures had already been used in such openings, in Augsburg Cathedral

about 1120–30; and, according to Louis Grodecki, a series of French kings and apostles and patriarchs may have been placed in the nave of Saint-Remi in Reims as early as 1150.[94] Given the growing rivalry between the abbey that housed both the Oriflamme and the burial places of the French kings and the house that protected the chrism for the kings' unction and also claimed some royal tombs, one might speculate that such a program had underlined the alliance of priesthood and kingship at Saint-Denis, too.[95] Grodecki has dismissed the statement of Lenoir that the triforium of the later Gothic structure contained the figures of French kings, including Pepin the Short.[96] Yet such a program for the upper windows of Suger's chevet can easily be imagined. Either the original figures could have been carefully preserved and reset in the mid-thirteenth-century reconstruction, as at York in the fourteenth century, or the original program could have been imitated, as probably occurred at Strasbourg.[97] The prototype has not yet been established for the "classic" composition of clerestory windows with two superimposed seated figures, but the concept might have spread from Saint-Denis to Reims and Strasbourg, Canterbury, Saint-Yved of Braine, and Chartres.[98] Such suggestions, like all those having to do with the influence of lost works, will remain speculative.

NOTES

* I am very grateful to Pamela Blum for her careful reading of this paper and many suggestions for improvements in style and clarity.

1. Louis Grodecki, *Les Vitraux de Saint-Denis, étude sur le vitrail au XII^e siècle* (Corpus Vitrearum Medii Aevi) France "Études" (Paris, 1976), vol. 1; hereafter cited as *CVMA*.

2. Nat H. J. Westlake, *A History of Design in Painted Glass* (London, 1881), vol. 1, pp. 27–33, 41–46, dates Chartres west ca. 1145 and Saint-Denis ca. 1150 (p. 21). Émile Mâle, "La Peinture sur verre [du XII^e siècle] en France," in André Michel, *Histoire de l'Art depuis les premiers temps chrétiens jusqu'à nos jours*, vol. 1, pt. 2 (Paris, 1905), pp. 786–92, cites Chartres, York, Vendôme, Le Mans, Angers, and Poitiers: *"Tous les vitraux de l'Ouest de la France semblent donc, au XII^e siècle, l'oeuvre des maîtres verriers qui travaillèrent à Saint-Denis ou tout au moins de leurs élèves."* In the equivalent section on thirteenth-century glass in Michel, *Histoire de l'Art*, vol. 2, pt. 1 (Paris, 1906), pp. 374, 376, he cites iconographic influence at Chartres; Émile Mâle, "La Part de Suger dans la création de l'iconographie du Moyen-Âge," *Revue de l'art ancien et moderne* 35 (1914): 91–102, 161–68, 253–62, 339–49, reprinted in Émile Mâle, *L'Art religieux du XII^e siècle en France. Étude sur les origines de l'iconographie du moyen âge* (Paris, 1922), pp. 151–60 with fewer illustrations; and William R. Lethaby, "Archbishop Roger's Cathedral at York and Its Stained Glass," *Archaeological Journal* 72 (1915): 40–43.

3. Panofsky, *Suger*, p. 206. See also Grodecki, *CVMA*, pp. 25–27.

4. Grodecki, *CVMA*, pp. 27–28, 30, for a discussion of Suger's statement that all the windows from the chevet to the entrance were glazed, and for the probability that the crypt and clerestory windows were also filled with glass.

5. Suger, *Adm.* (P), pp. 72–77; and Suger, *Cons.* (P), p. 101.

6. Louis Grodecki, "Les Vitraux allégoriques de Saint-Denis," *Art de France* 1 (1961): 19–46.

7. Mâle, *L'Art religieux*, pp. 182–83.

8. *"De diversis nationibus manu exquisita depingi fecimus"* (Suger, *Adm.* [P], pp. 182–83).

9. Heinrich Wölfflin, *Principles of Art History*, originally published in German in 1915, tr. into English in 1932; for his approach and that of Morelli (1816–91) and Berenson, see W. Eugene Kleinbauer, *Modern Perspectives in Western Art History* (New York, 1971), pp. 45–49, with bibliography. Mâle's work was based on engravings rather than photographs and follows in the tradition of Arthur Martin and Charles Cahier, *Monographie de la cathédrale de Bourges* (Paris, 1841–44).

10. Compare the works of Charles Rufus Morey and Kurt Weitzmann with the recent synthetic view of stylistic developments by Ernst Kitzinger, *Byzantine Art in the Making: Main Lines of Stylistic Development in Mediterranean Art 3rd–7th Century* (Cambridge, Mass., 1977).

11. Mâle, *L'Art religieux*, figs. 122, 124, 130, 133, 139; these are after engravings by Du Sommerard or Cahier and Martin, made ca. 1840.

12. Ibid., pp. 169–72; and Grodecki, *CVMA*, pp. 73–78, figs. 51–63.

13. Hans Wentzel, "Unbekannte mittelalterliche Glasmalereien der Burrell Collection zu Glasgow," *Pantheon* 19 (1961): 247–49.

14. Grodecki, *CVMA*, pp. 66, 85, pl. VIII, figs. 66, 90–92.

15. Louis Grodecki, Catherine Brisac, and Claudine Lautier, *Le Vitrail Roman* (Fribourg, 1977), pp. 91–103.

16. Louis Grodecki, "Un *Signum Tau* mosan à Saint-Denis," in Rita Lejeune and Joseph Deckers, eds., *Clio et son regard, Mélanges d'histoire de l'art et d'archéologie offerts à Jacques Stiennon* (Liège, 1982), pp. 337–56.

17. Grodecki, *CVMA*, pp. 138–42, 144–49 for the sources used.

18. For the Coffetier drawings, now in the collection of Mr. Arnold Fawcus, see Grodecki, *CVMA*, pp. 53 and 83 n. 24; for those of Lisch, in the Bibliothèque de la Direction du Patrimoine, Ministère de la Culture et de la Communication in Paris, ibid., p. 55 n. 52.

19. Ibid., pp. 42–46.

20. Louis Grodecki, "Fragments de vitraux provenant de Saint-Denis," *Bulletin monumental* 110 (1952): 51–62; Louis Grodecki, "Une Scène de la vie de saint Benoît provenant de Saint-Denis au Musée de Cluny," *Revue des Arts* 8 (1958): 161–71; Grodecki, *CVMA*, pp. 65–70; and Jane Hayward, "Stained Glass at Saint-Denis," in *Royal Abbey*, pp. 84–98, with prior bibliography.

21. Panofsky, *Suger*, pp. 205–6, and compare his figs. 19 and 6.

22. The following is based on Grodecki, *CVMA*, pp. 71ff.

23. The term *anagogical* is Panofsky's, condensed from a passage in Suger's text concerning the use of gems, *Suger*, p. 203.

24. Grodecki, *CVMA*, pp. 104–5, fig. 139; cf. Madeline H. Caviness, *The Windows of Christ Church Cathedral Canterbury* (Corpus Vitrearum Medii Aevi), Great Britain (London, 1981), vol. 2, pp. 181, 250; hereafter cited as Caviness, *CVMA*.

25. Elizabeth A. R. Brown and Michael W. Cothren, "The Twelfth-Century Crusading Window of the Abbey Church of Saint-Denis: 'Praeteritorum enim Recordatio Futurorum Exhibitio,' " forthcoming in the *Journal of the Warburg and Courtauld Institutes*. I am grateful to the authors for a copy of this manuscript and for discussions of the work in progress.

26. Collection of the Lord Barnard, Raby Castle (Durham); I am indebted to Peter Gibson and Peter Newton for this information and to Michael Cothren for a photograph. The same subject is in the Benedict cycle in York Minster; see Madeline H. Caviness, "Stained Glass," in Arts Council of Great Britain, *English Romanesque Art 1066–1200*, exhib. cat. (Hayward Gallery, London, 1984), pp. 136, 138 n. 33.

27. Pamela Z. Blum, "The Saint Benedict Cycle on the Capitals in the Crypt at Saint-Denis," *Gesta* 20 (1981): 73–87.

28. The schemas, where presented, attempt to distinguish only four categories of glass: original twelfth-century (white); early restorations (before the eighteenth century) and stopgaps (dark gray); modern restorations (midtone gray); and that of doubtful authenticity or repainted in the nineteenth century (light gray). The tones are difficult to distinguish, especially in isolation. The dark is very seldom used.

29. Grodecki, *Vitrail Roman*, p. 100.

30. Madeline H. Caviness and Virginia Chieffo Raguin, "Another

Dispersed Window from Soissons: A Tree of Jesse in the Sainte-Chapelle style," *Gesta* 20 (1981): 191–98; and Madeline H. Caviness, "Some Aspects of Nineteenth Century Stained Glass Restoration: Membra Disjecta et Collectanea," in Peter Moore, ed., *Crown in Glory: A Celebration of Craftsmanship—Studies in Stained Glass* (Norwich, 1982), p. 69, pls. 51–53. The panel was given to the Victoria and Albert Museum in 1983 and is now in the Department of Ceramics, no. C. 2–1983.

31. Grodecki, *CVMA*, pp. 126–28, figs. 193–95. Several more palmettes from this border, of unknown provenance, are in the Yorkshire Museum (see Caviness, "Stained Glass," p. 138 n. 26), and Michael Cothren has identified more in Raby Castle.

32. Grodecki, *CVMA*, fig. 66.

33. Ibid., pp. 88–89, fig. 23.

34. Ibid., p. 90 and fig. on p. 91.

35. Michael Cothren, "A Re-evaluation of the Iconography and Design of the Infancy Window from the Abbey of Saint-Denis." Paper delivered at Thirteenth Conference on Medieval Studies, Western Michigan University, Kalamazoo, Michigan, 4–8 May 1978; abstract published in *Gesta* 17 (1978): 74–75. I am grateful to the author for the loan of a copy of his paper and accompanying slides; the full version, "The Twelfth-Century Infancy of Christ Window from the Abbey of Saint-Denis: A Reconsideration of Its Design and Iconography," will be published in *The Art Bulletin* 68 (1986). The panel with the women attendants was also known to Lucien Demotte; a detail was used in illustration of an article that was published posthumously: "Lucien Demotte 1906–1934," *Stained Glass* 29 (Autumn 1934): 76.

36. Louis Grodecki, "Les Vitraux de Saint-Denis. L'Enfance du Christ," *De Artibus Opuscula XL,* Essays in Honor of Erwin Panofsky (1961), pl. 63, fig. 13.

37. Yves Delaporte and Étienne Houvet, *Les Vitraux de la cathédrale de Chartres* (Chartres, 1926), pp. 151–52, where Bethlehem is mentioned instead of Soutine, and pls. IV–VI.

38. A synopsis of the technical findings is given by Robert H. Brill and Lynus Barnes in *Royal Abbey,* p. 81. Neil Stratford's observation that the blues may be reused antique glass strengthens the argument for a Saint-Denis provenance, since Suger refers to the expense of obtaining "sapphire glass" (Suger, *Adm.* [P], pp. 52–53); see "Current and forthcoming exhibitions," *Burlington Magazine* 123 (1981): 506.

39. Hayward, "Stained Glass," pp. 78–81.

40. Suger, *Adm.* (P), pp. 76–77.

41. Michael Cothren found a photograph in the Pitcairn Collection files, reproduced in *Gesta,* fig. 5b (see note 35 here); he has also since discovered a photograph of the outer surface of the panel which he believes confirms its authenticity.

42. Replicas do seem to have been made, but the one of the Triple Coronation now in Turin contains very little old glass; see Grodecki, *CVMA*, pp. 119–121, fig. 180.

43. Collection of the Lord Barnard, Raby Castle (Durham).

44. Madeline H. Caviness, "Three Medallions of Stained Glass from the Sainte-Chapelle of Paris," *Philadelphia Museum of Art Bulletin* 62 (1967): 245–59; Louis Grodecki and Madeline H. Caviness, "Les Vitraux de la Sainte-Chapelle," *Revue de l'Art* 1 (1968): 8–16; and Madeline H. Caviness, "French Thirteenth-Century Stained Glass at Canterbury: A Fragment from the Sainte-Chapelle," *Canterbury Cathedral Chronicle* 66 (1971): 35–41.

45. Grodecki, "Vitraux allégoriques."

46. Meredith Parsons Lillich, "Monastic Stained Glass: Patronage and Style," in Timothy G. Verdon, ed., *Monasticism and the Arts* (Syracuse, 1984), pp. 222–25. Similar conclusions were reached by John Gage, "Gothic Glass: Two Aspects of a Dionysian Aesthetic," *Art History* 5 (1982): 39–46.

47. Brown and Cothren, "Crusading Window."

48. Ernst Kitzinger, *The Mosaics of Monreale* (Palermo, 1960), pp. 43, 48–49.

49. Earlier writers, such as Mâle, overlooked style in favor of iconographic parallels or similarities in ornament in formulating "schools" of glass painting.

50. Grodecki, *Vitrail Roman,* p. 98, fig. 78.

51. Gretel Chapman, "The Bible of Floreffe: Redating of a Romanesque Manuscript," *Gesta* 10 (1971): 49–62. The Averbode Gospels, Liège, Bibliothèque de l'Université, ms. lat. 363B, are dated by her after the Floreffe Bible and before 1164, perhaps even before 1147.

52. Grodecki, *"Signum Tau,"* p. 350.

53. Mâle, *L'Art religieux,* p. 157; and Grodecki, *Vitrail Roman,* p. 95, figs. 74, 75.

54. Chronicle of the Anonymous Laudunensis (Paris, Bibliothèque Nationale, ms. lat. 5011) under the year 1216, quoted by Norbert Backmund, *Die Mittelalterlichen Geschichtschreiber des Prämonstratenserordens* (Averbode, 1972), p. 272, *"qui et Machabeus meruit appellari."*

55. Konrad Hoffmann, "Sugers 'Anagogisches Fenster' in Saint-Denis," *Wallraf-Richartz-Jahrbuch* 30 (1968): 63–64.

56. Ibid., pp. 69–71, figs. 54, 55. The diagram of world order is in Cambridge, Gonville and Caius College, *Tractatus de Quaternario,* MS. 428, fol. 10r; see Montague R. James, *A Descriptive Catalogue of the Manuscripts in the Library of Gonville and Caius College* (Cambridge, 1908), vol. 2, p. 501. The impact of this kind of pictograph is discussed in my paper, "Images of Divine Order and the Third Mode of Seeing," *Gesta* 22 (1983): 108–10. For the Dover Bible, a Canterbury book of ca. 1140–60, see Charles R. Dodwell, *The Canterbury School of Illumination 1066–1200* (Cambridge, 1954), pl. 57a; and Claus Michael Kauffmann, *Romanesque Manuscripts 1066–1190, A Survey of Manuscripts Illuminated in the British Isles* (London, 1975), vol. 3, pp. 97–98, fig. 191. This example, not cited by Hoffmann, demonstrates the assimilation of the Byzantine type of coronation image in the west.

57. Grover Zinn, p. 42 in this volume.

58. Kitzinger, *Monreale,* pp. 69ff. Also, Florens Deuchler, "The Artists of the Ingeborg Psalter," *Gesta* 9 (1970): 58.

59. Grodecki, *Vitrail Roman,* pp. 96–100.

60. For the early dating of the Floreffe Bible, London, British Library, MSS. Add. 17737–38, see Chapman, "Bible of Floreffe," pp. 51–52. The conventional date is ca. 1155–70, adhered to by Herbert Köllner, "Zur datierung der Bibel von Floreffe. Bibelhandschriften als Geschichtsbücher?" *Rhein und*

Maas, Kunst und Kultur, 800–1400 (Cologne, 1973), vol. 2, pp. 361–76.

61. Charles R. Dodwell, *Painting in Europe 800–1200* (Harmonds-worth, 1971), p. 174; and Otto Demus, *Romanesque Mural Painting* (New York, 1976), pp. 416–17, with bibliography.

62. Life of Saint Amand, Valenciennes, Bibliothèque municipale, ms. 501, fol. 60r, illus. Dodwell, *Painting,* fig. 209.

63. Harvey Stahl also discusses this comparison; cf. Grodecki, *Vitrail Roman,* p. 97, who suggests comparison with manuscripts from Normandy (Manche) and Saint-Bertin of Saint-Omer; and Hayward, "Stained Glass," p. 67, who cites books from Mont-Saint-Michel.

64. Brussels, Bibliothèque Royale, ms. 2034–35, fol. 25v. The hardness of the forms is even more marked in the Majesty on fol. 29r, which is less rubbed. For this manuscript see *Rhein und Maas,* vol. 1, p. 291.

65. Tournai, Bibliothèque du Séminaire, ms. 1; *Rhein und Maas,* vol. 1, pp. 230–31; Wayne Dynes, "The Dorsal Figure in the Stavelot Bible," *Gesta* 10 (1971): 41–48; and Wayne Dynes, *The Illuminations of the Stavelot Bible, British Museum, MSS. Add. 28106–28107* (Ann Arbor, 1970).

66. Dynes, *Stavelot Bible,* fig. 4; Genesis initial.

67. Grodecki, *Vitrail Roman,* p. 102.

68. Kauffmann, *Romanesque Manuscripts,* pp. 88–90, with bibli-ography, and figs. 148–53.

69. Grodecki, *Vitrail Roman,* p. 98.

70. For the former, London, British Library, MS. Add. 14790, see Grodecki, *Vitrail Roman,* fig. 78; and Chapman, "Bible of Flo-reffe," pp. 56–57.

71. *Rhein und Maas,* vol. 1, p. 242.

72. Berlin, Staatliche Museum, Kupferstichkabinett, HS. 78 A 6, and a leaf in Liège, Bibliothèque de l'Université, ms. 2613; see *Rhein und Maas,* vol. 1, pp. 296–97, where it is dated about 1150–70. Cf. Elisabeth Klemm, *Ein romanischer Miniaturen-zyklus aus dem Maasgebiet* (Vienna, 1973), pp. 86–88, 92; and Grodecki, "Signum Tau," pp. 348–52.

73. Lillich, "Monastic Stained Glass," p. 213; and Maines, pp. 77–94 in this volume.

74. The distinction was articulated, but not for the first time, by Richard of Saint-Victor later in the century; Caviness, "Images of Divine Order," p. 115.

75. An early challenge to Mâle was that of William R. Lethaby, "The Part of Suger in the Creation of Mediaeval Iconography," *Burlington Magazine* 25 (1914–15): 206–7. See also Karl Künstle, *Ikonographie der Christlichen Kunst* (Freiburg im Breis-gau, 1928), vol. 1, pp. 82–90; and Madeline H. Caviness, *The Early Stained Glass of Canterbury Cathedral ca. 1175–1220* (Princeton, 1977), pp. 116–17.

76. "Answering pairs" is Wayne Dynes's phrase for the parallel ar-rangement of Old and New Testament cycles, *Stavelot Bible,* pp. 142–43. Additional examples are given in Caviness, *CVMA,* p. 80 n. 6. The Genesis initial of the Stavelot Bible, referred to in note 65 here, is analyzed by Dynes in pp. 94–151, figs. 4–12. A similar triple arrangement, and selection of types from the New Testament and church history as well as from the Old Testament, is common in the Canterbury windows and related

cycles; the Klosterneuberg Ambo utilized a highly ordered grouping of threes.

77. Baron François de Guilhermy's notes indicate that in the 1840s the Jesse Tree was divided between the two windows, though he judged the original figures to be on the right; Grodecki, *CVMA,* p. 50.

78. Reproduced in Grodecki, *Vitrail Roman,* figs. 82, 85. Hay-ward, "Stained Glass," p. 65, has found the master of the In-fancy window at Saint-Denis, to whom she also attributes the Saint Vincent, Charlemagne, and First Crusade subjects, closer than any other to the Chartres painters.

79. See note 2 here; and Madeline H. Caviness, "The Canterbury Jesse Window," in Jeffrey Hoffeld, ed., *The Year 1200: A Sym-posium* (New York, 1975), pp. 374–76.

80. James R. Johnson, "The Tree of Jesse Window of Chartres: 'Laudes Regiae,'" *Speculum* 36 (1961): 1–22. Also see the es-say by Brigitte Bedos Rezak in this volume, p. 100.

81. Eleanor S. Greenhill, "Eleanor, Abbot Suger, and Saint-Denis," in William W. Kibler, ed., *Eleanor of Aquitaine: Patron and Politician,* University of Texas Symposia in the Arts and Humanities (Austin, 1976), vol. 3, pp. 90, 96. Although Eleanor's direct influence on the sculptural programs, or even in the choice of quarries for the stone, remains hypothetical, it is clear that the king was more generous to churches during the time he was married to Eleanor.

82. It has been noted that the coronation of the prince in the life-time of his father followed French custom; Anne Heslin, "The Coronation of the Young King in 1170," in Geoffrey J. Cum-ing, ed., *Studies in Church History* (London, 1965), vol. 2, p. 165. The chronicles, however, state that the queen remained in Normandy. The coronation took place in Westminster, and she does not seem to have been involved, nor was Margaret, daugh-ter of Louis VII of France, who was betrothed to the young King Henry, crowned in 1170, to the annoyance of her father. See also *The Life and Death of Thomas Becket Chancellor of England and Archbishop of Canterbury based on the account of William fitz-Stephen his clerk with additions from other contemporary sources,* George Greenaway, ed. and trans. (London, 1961), pp. 132–34; and Raymonde Foreville, *L'Église et la royauté en Angleterre sous Henri II Plantagenet* (Paris, 1943), pp. 302–7. I am grateful to Elizabeth A. R. Brown for the last reference and for a dis-cussion of the matter of a royal donation in York; she inclines to believe, if it was so, that Henry acted without Eleanor. I believe the design of the Saint-Denis window was most probably intro-duced into England through her, on this or another occasion.

83. Grodecki, *Vitrail Roman,* p. 71, fig. 56, with bibliography.

84. The political implications of this choice are reviewed in Made-line H. Caviness, "Conflicts between *Regnum* and *Sacerdotium* as reflected in a Canterbury Psalter of ca. 1215," *Art Bulletin* 61 (1979): 49.

85. For the presence of Eleanor and Richard in Canterbury in 1194, see Gervasius Cantuariensis, *Opera Historica: The Historical Works of Gervase of Canterbury* in William Stubbs, ed., *The Chronicles of the Reigns of Stephen, Henry II, and Richard I,* vol. 1, Rolls Series 73 (London, 1879), pp. 523–24.

86. Marcel Aubert et al., *Les Vitraux de Notre-Dame et de la Sainte-Chapelle de Paris* (Paris, 1959), pp. 81, 181–83, pls. 42–44. A

Jesse Tree was also among the apse clerestory windows of Soissons Cathedral, probably a gift of Philippe Auguste; fragments remain in the axial window; see Louis Grodecki in Marcel Aubert et al., *Le Vitrail français* (Paris, 1958), p. 123. Other examples made under royal patronage are in the Ingeborg Psalter and the Psalter of Blanche of Castille; see Caviness, "Jesse Window," p. 376, fig. 5; and Florens Deuchler, *Der Ingeborgpsalter* (Berlin, 1967), fig. 18.

87. Cited by Grodecki, *CVMA*, p. 38 n. 81.

88. Louis Grodecki, "Problèmes de la peinture en Champagne pendant la seconde moitié du douzième siècle," *Romanesque and Gothic Art* in Millard Meiss, ed., *Studies in Western Art 1: Acts of the Twentieth International Congress of the History of Art* (Princeton, 1963), pp. 135–41. He dated the Troyes fragments ca. 1205 and questioned whether the Saint-Denis panel could be as early as 1144. For the earlier date of Troyes, see Louis Grodecki, "Nouvelles découvertes sur les vitraux de la Cathédrale de Troyes," and Madeline H. Caviness, " 'De convenientia et cohaerentia antiqui et novi operis': Medieval Conservation, Restoration, Pastiche and Forgery," both in Peter Bloch et al., eds., *Intuition und Kunstwissenschaft: Festschrift für Hanns Swarzenski* (Berlin, 1973), pp. 191–203 and 206–9, respectively. See also Charles T. Little, "Membra Disjecta: More Early Stained Glass from Troyes Cathedral," *Gesta* 20 (1981): 119–27, who reports some newly discovered fragments, in a style very close to Troyes, in Vézelay, and speculates on a Burgundian source.

89. For her patronage of music and poetry, see Rebecca A. Baltzer, "Music in the Life and Times of Eleanor of Aquitaine," in William W. Kibler, ed., *Eleanor of Aquitaine*, pp. 61–80. Marie was born about the time of the consecration of Suger's choir and was raised at the court in Paris, so she would have been quite familiar with the windows of Saint-Denis, whether or not her taste was formed by her mother.

90. Kenneth W. Severens, "The Early Campaign at Sens, 1140–1145," *Journal of the Society of Architectural Historians* 29 (1970): 105–6.

91. The fire is mentioned in two chronicles from the Abbey of Saint-Pierre-le-Vif, but Clarius may have exaggerated when he stated ca. 1190 that it destroyed the town and all its churches; Clarius in Louis-Maximilien Duru, ed., *Bibliothèque historique de l'Yonne* (Auxerre, 1863), vol. 2, p. 548. Cf. Gustave Julliot, ed., *Chronique de l'abbaye de Saint-Pierre-le-Vif redigée vers la fin du XIIIᵉ siècle par Geoffrey de Courlon* (Sens, 1876), pp. 496–97.

92. The programs of Canterbury and Bourges may be cited for the coherent arrangement of hagiographical and biblical or typological windows; the ornamental panels now in the tribune of Saint-Remi in Reims, of the late twelfth century, continue the tradition of the griffin windows.

93. Mâle, *L'Art religieux*, p. 345, cited textiles as the source of the griffin motif; Grodecki, *Vitrail roman*, p. 100, refers to metalwork from Lorraine in this connection.

94. For Augsburg, see Gottfried Frenzel, "Glasmalerei," in *Suevia Sacra: Frühe Kunst in Schwaben*, exhib. cat. (Städt Kunstsammlungen, Augsburg, 1973), pp. 217–28. The early dating of the nave figures in Saint-Remi was suggested by Louis Grodecki, "Les Plus anciens vitraux de Saint-Remi de Reims," in Rüdiger Becksman, ed., *Beiträge zur Kunst des Mittelalters: Festschrift für Hans Wentzel* (Berlin, 1975), pp. 76–77.

95. Gabrielle M. Spiegel, "The Cult of Saint Denis and Capetian Kingship," *Journal of Mediaeval History* 1 (1975): 60.

96. Grodecki, *CVMA*, p. 30 n. 26.

97. T. W. French, "Observations on some Medieval Glass in York Minster," *Antiquaries Journal* 61 (1971): 86–88. Fridjof Zschokke, *Die Romanischen Glasgemälde des Strassburger Münster* (Basel, 1942), pp. 63–188, was the first to argue that some of the figures of emperors and so forth of the late twelfth century were reused in the thirteenth-century rebuilding of the nave; Christiane Wild-Bloch, who is preparing the *Corpus Vitrearum Medii Aevi* volume for Strasbourg, believes the ancestors of Christ were also part of the Romanesque cycle, imitated in the Gothic building.

98. The clerestory glazing of Saint-Remi and Saint-Yved is the subject of a book by Madeline H. Caviness in preparation.

The Style of the Stained-Glass Windows of Saint-Denis*

Louis Grodecki

IN THIS ESSAY, I am going to review in part what I wrote in my last book on Romanesque stained glass, although I am well aware, as Professor Caviness has just said, that much remains to discover and to modify in this somewhat simplistic vision of the Dionysian style.[1] The problem is indeed complex. Let us not forget that Suger himself said very clearly in a beautiful passage in *De administratione* that he had had the stained-glass windows created by numerous craftsmen of "different nationalities." We should therefore expect to find little homogeneity in their stylistic executions and artistic conceptions, as is indeed the case. There are at Saint-Denis hagiographical and narrative cycles as well as symbolic, anagogical, and allegorical ensembles that are true puzzles for all. This applies particularly to the window depicting the moralized Life of Moses and the windows based on allegories of the letters of Saint Paul. There is no doubt that, even shortly after Suger's death, these programs could no longer be understood by the monks of Saint-Denis or by the erudites of the time. These diverse "spiritual" ideas converged in all probability with formal concepts derived from equally diverse sources. The Saint-Denis windows reveal, indeed, a multiplicity of experiences, a variety of styles, and a number of hands it has not yet been possible to catalogue.

Let us compare, for example, a panel from the Tree of Jesse (fig. 1), located in the axial chapel of the ambulatory of Saint-Denis, with a panel of the Life of Saint Benedict from the Musée de Cluny (fig. 2), which portrays two monks witnessing the death of the saint. It is obvious that there is no stylistic relationship between the carefully planned and executed art of the first panel and the schematic style of the second: the fully modeled and drawn head of the king in the Tree of Jesse panel bears no similarity to the second panel, where forms are excessively elon-

gated and dry in their movement as well as in their overall treatment. In the Benedict panel the style of painting and compositional principles differ completely from those of the Tree of Jesse window. We are, in fact, confronted with two different artistic realities; and yet the works in question belong to the same period and were executed at the same time at Saint-Denis, probably between 1140 and 1144.

Similarly, if we compare the panel of the scene of the Brazen Serpent from the moralized Life of Moses and the *Signum Tau* panel (fig. 3), we face once more two completely different worlds. This is evident in the way the draperies are rendered as well as in the composition and the general definition of the figures. Among the panels remaining at Saint-Denis, the Brazen Serpent is one of the most beautiful; it is executed with a precision very close to goldsmiths' work in its composition, its symmetrical grouping of figures, and the "miniaturist" treatment of the upper parts of the Cross above the serpent (fig. 13). In contrast, the *Signum Tau* panel reveals a more expansive and plastic style in its formal expression, with more coherence and, in a way, less narrative in the organization of the figures.

The *Signum Tau* panel has been rightly compared to Mosan works. I am firmly convinced—and many specialists have already accepted this idea—that the painter who executed it came from the Meuse valley. This certitude does not, however, come to us from the choice of subject matter alone, Ezekiel's vision of the Salvation of the Just: in this vision a celestial writer passes through the town, marking the just with the sign of salvation; subsequently, all those not bearing the sign are killed. This symbolism, so frequent in the typology of the Passion, is not, of course, exclusively Mosan, but it was particularly prevalent in the Meuse region because of the writings of Rupert of Deutz.

Notes for this essay begin on page 281.

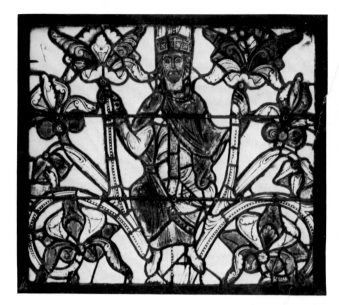

Fig. 1. Saint-Denis, axial ambulatory chapel, Tree of Jesse window, detail of a king

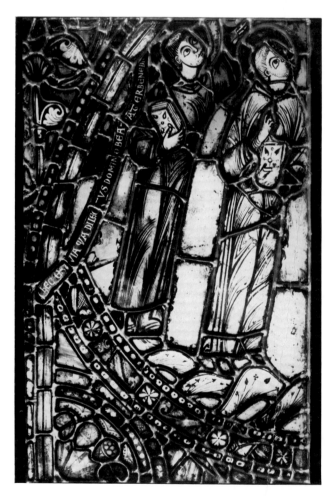

Fig. 2. Saint-Denis stained-glass panel (Paris, Musée de Cluny), scene from the life of Saint Benedict

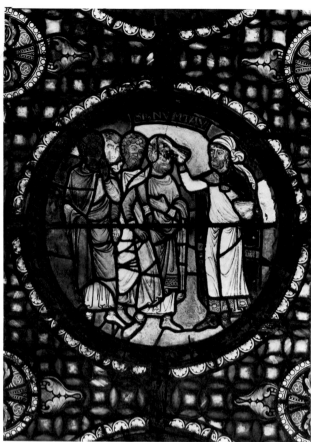

Fig. 3. Saint-Denis, ambulatory chapels, window of the Visions of Ezechiel, panel depicting the Signum Tau

Links with Mosan works are further borne out by the style: other similarly dense and crowded compositions that have been traced to the Meuse region, especially from the time of the Liège font (fig. 4), show the same cohesiveness in the grouping of figures and the same compositional balance. This characteristic is unlike the slightly artificial symmetries evident, for example, in the Brazen Serpent panel.

The validity of a comparison between these stained-glass panels and Mosan works is now accepted, but the comparison does not obtain in the case of the Stavelot Triptych at the Pierpont Morgan Library or in that of the great twelfth-century Mosan enamels; the comparison I have in mind is essentially one with manuscripts. I am referring here to the psalter of the Berlin Kupferstichkabinett (78 A 6), which comes in all probability from Liège (figs. 5 and 6), rather than to the Floreffe Bible and related manuscripts. Hanns Swarzenski recently dated this fragment as belonging to the years 1150–55. Elisabeth Klemm, another Mosan-miniature specialist, has, however, proved (in my opin-

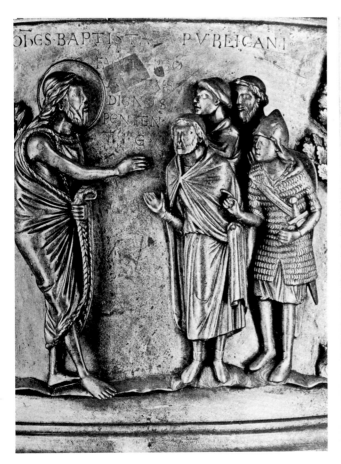

*Fig. 4. Renier of Huy, Liège Baptismal Font, 1107–18, scene of Saint
 John preaching*

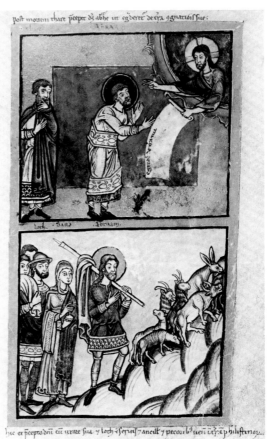

*Fig. 5. Psalter (Berlin, Kupferstichkabinett, HS. 78 A 6, fol.
 1r), scenes from the story of Abraham*

ion with good arguments) that the work in question was executed
between 1135 and 1140 or, perhaps, 1145. She published this in-
formation a few years ago in her dissertation, which she defended
in Vienna. According to her dating, the Psalter would be con-
temporary with the Saint-Denis *Signum Tau* panel. In both
works, however, certain features, general and specific, are strik-
ingly similar. Let us look, for example, in the stained-glass win-
dow (fig. 3) and in the miniature (fig. 6), at the wide
metalworklike bands that decorate the bottoms, the middles,
and the collars of the garments: they are exceptionally wide and
rich, and characteristic of the renderings of the Meuse region. Let
us also note in the manuscript a detail that might appear to be of
secondary importance but is quite typical (as is often the case
with small details). I am talking about the figures' shoes, which
could be called Mosan shoes (see fig. 5). They are a kind of short
boot just covering the ankles and flaring out above them in geo-
metrical shapes. At this period in history, such a shoe was found
in no other area of the West—and yet it found its way to the

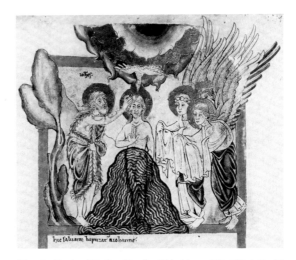

*Fig. 6. Psalter (Berlin, Kupferstichkabinett, HS. 78 A 6, fol.
 10r), Baptism of Christ*

Saint-Denis panel (fig. 3).

In order to better formulate this Mosan hypothesis, let us compare the scene of Abraham and his tribe in the Berlin manuscript (fig. 5) with the wonderful composition of the Liège baptismal font (fig. 4), which is dated prior to 1120. The same character of nobility (one could almost call it classicizing) is evident in the "effect" and in the composition as well as in the suppleness of the draperies, without the schematization noticed earlier in the Saint Benedict panel (fig. 2). We find here the spirit and the fullness characteristic of Mosan art. I think that the Liège baptismal font and the miniatures of the Berlin Psalter, along with the Saint-Denis panel, constitute a separate stylistic group to which, perhaps, other works could be added; but this group should be kept apart from such better-known works as the Floreffe and Averbode Bibles, which belong to a different development in the Mosan area.

The second atelier I believe it necessary to isolate is the one that executed the Saint Benedict window, an outstanding work that has so far remained almost unknown, as it was not until 1956 that this Cluny panel was proven to have originated at Saint-Denis. But parts of the window had been summarily sketched (with, however, enough details for identification) by Charles Percier during the Revolution. In the middle of the nineteenth century Juste Lisch, another architect and draftsman, made a tracing of the panel and wrote "Saint-Denis" in the margin. Lisch worked in Gérente's atelier, which was responsible for the restoration of Saint-Denis's stained glass. We can, therefore, be assured that the panel now at the Musée de Cluny, and all those grouped around it, came from Suger's abbey church. Their obviously awkward style is in total contrast with the Mosan style. The panel of the two monks witnessing the death of Saint Benedict, from the Musée de Cluny (fig. 2), can be compared with two panels from the same Life of Saint Benedict window, which are today in a bay of the church in Fougères, Brittany (they were given as a private donation in the nineteenth century). One of the latter two depicts the young saint taking holy orders, and the other shows the miracle of Easter (a priest taking food to Benedict in the mountains). The identifications are clearly indicated by the inscriptions accompanying the scenes. It is important to note that all the ornamental details of these panels can be found in Percier's drawing.

Finally, another figure traced by Lisch, but now lost, confirms that both the Cluny and the Fougères panels are part of one stylistic ensemble, characterized by the disparity in proportion among the figures and the poor adaptation of the axis of the composition to the form of the medallions. We can, therefore, conclude that, in spite of the extreme preciosity and beauty of the glass, the skillful craftsmanship, and the careful rendering of detail, we are faced with the work of a minor artist, one quite unrelated to the Mosan style, so firmly established at Saint-Denis.

We must, therefore, look elsewhere for stylistic sources of the Saint Benedict window.

The north of France, including the area of Saint-Bertin, has proved to be a disappointment in the further search for sources. Burgundy may prove more probable, since it is a question of an essentially Romanesque style. It is utterly impossible to associate the panel's figures with the "origins of Gothic art." They are in no way innovative figures, neither in their gestures, their facial expressions, nor the manner in which they occupy space. It is, therefore, to Romanesque art we must turn, and perhaps Romanesque Parisian art. While studying manuscripts at the Bibliothèque Nationale, Harvey Stahl recently found an illuminated antiphonary executed at Saint-Denis, probably between 1125 and 1145. This manuscript, which only includes one miniature (Stahl fig. 7), is neither beautiful nor significant—but seems to have been made for Suger. In fact, the folds of the garments, with their "Romanesque" awkwardness, the attitudes of the figures, and the simplified drawing of the facial features, bear some stylistic similarity to the Saint Benedict window. Perhaps, then, there is more to discover, in Paris or Burgundy, that will establish the sources for this Romanesque-Dionysian style.

Let us now turn our attention to two scenes that together represent Herod and the Three Magi. They too have been recently found, one at Saint-Denis itself (in the large window over the western portal of the church) and the other on the Parisian art market, from which it was repurchased by the service of the Monuments historiques. These panels, which were originally placed side by side, are part of the Infancy of Christ window and are stylistically related to what I call the "principal atelier" at Saint-Denis. The panel depicting the Three Magi is most clumsily rendered: the artist seems to have been hampered by the short proportions of the rectangular panel. However, on the second panel, which depicts Herod and his counselors (fig. 7), Herod's welcoming gesture is full of ease and there is a decided suggestion of physical volume. Behind him his two counselors form a rather tightly composed group, but the whole does not fit comfortably into the semicircular shape of the compartment. The marvelous ease of the grouping of the scenes inside the medallion (already discovered by some glass painters working at Saint-Denis), and which is so characteristic of Gothic art, is lacking. I believe, therefore, that even within the third and "principal atelier" there are differences in execution due to the presence of a number of hands—doubtless five or six—which can be distinguished only by very close observation.

One might ask what relationship can exist between the awkwardly composed and executed Three Magi panels and two other panels at Saint-Denis, the Brazen Serpent medallion from the Life of Moses window and the Quadriga of Aminadab (fig. 8) from the allegorical Saint Paul window. The latter is a commentary on a passage from the Epistle to the Hebrews concerning

Fig. 7. Saint-Denis, stained-glass panel (Paris, Dépôt of Champs-sur-Marne), Herod receiving the Three Magi, from the Infancy window

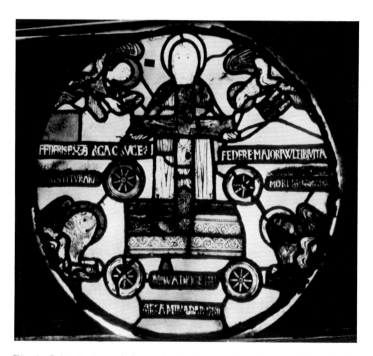

Fig. 8. Saint-Denis, ambulatory chapel, Anagogical window, panel depicting the Quadriga of Aminadab

Christ's entering the Temple, behind the curtains of the Tabernacle: the crucified Christ rests in the Ark of the Covenant; God the Father supports the Cross before a veil that is the veil of the Temple; the whole Church, represented by the four Evangelists, surrounds this symbolic vision, at once Jewish and Christian, since the Ark of the Covenant symbolizes the Altar of Christ. This very complex scene is expressed by an unusually felicitous composition: the figures are harmoniously proportioned and fit perfectly into the frame. Compared to the mediocre compositions of the Infancy of Christ window, it is a work of genius.

Here again, as for the preceding panels, we are faced with the same workshop, where master glass painters probably worked side by side. It is indicative of the complexity of the Dionysian atelier as well as the speed with which Suger wanted to have this

9a 9b

10a

*Fig. 9. Saint-Denis, west facade, detail of colonnette from the door jambs of the lateral portals
(Paris, Musée de Cluny) compared to detail of stained-glass borders (Bryn Athyn,
Glencairn Museum)*
a. Colonnette; b. Stained-glass border

*Fig. 10. Saint-Denis, west facade, detail of colonnette from the door jambs of the lateral
portals (Paris, Musée de Cluny) compared to detail of stained-glass borders (Bryn
Athyn, Glencairn Museum)*
a. Colonnette; b. Stained-glass border

10b

Fig. 11. Saint-Denis, ambulatory chapel windows, lost scene from the First Crusade series drawn for Montfaucon (Paris, Bibliothèque Nationale, ms. fr. 15634/1, fol. 162r)

work completed. The nine bays of the ambulatory, and perhaps the upper windows of the chevet and probably those of the crypt—that is to say, an ensemble of fifty windows—must have been executed in four or five years. It must, therefore, have been necessary to have many artists in the workshop at the same time. Some were mediocre, others very gifted, and within the same window (such as the window of the Life of Moses) poorly conceived, composed, and executed panels (the Mount Sinai, for instance) are often found next to panels of high quality. This disparity cannot be attributed to restoration, since even some original sections are of inferior quality while others are quite beautiful.

The style of the stained-glass windows at Saint-Denis warrants a further remark: their ornamentation—which I shall not describe in detail—bears a great similarity to the sculpture found on the west portals of the abbey church. The colonnettes now in the Musée de Cluny and the Musée du Louvre (figs. 9a and 10a) must have served as models for the windows' borders (figs. 9b and 10b), for the colonnettes' oblique strips of rinceaux and floral motifs provide precise prototypes. It is, then, probable that Dionysian glass painters drew their inspiration from sculptors of ornament who came from elsewhere and had been at work

Fig. 12. Psalter (Berlin, Kupferstichkabinett, HS. 78 A 6, fol. 1v), scene of Abraham's battle against enemy kings

Fig. 13. Saint-Denis, ambulatory chapel, Life of Moses window, detail from the Brazen Serpent panel

at the chantier for several years, which had doubtless provided the models. Thus, a Dionysian style of ornament would be born of the collaboration between painters and sculptors, and the new type of glass border thereby created—the influence of which was felt as late as the thirteenth century—undoubtedly represents the most significant contribution of the Saint-Denis workshops to the later development of stained glass.

It must also be noted that relationships exist between the disposition of the scenes depicted in certain Saint-Denis windows and the compositions, in the form of superimposed medallions, found in the facade sculpture of the abbey church. These windows are the first known examples of such compositions in the field of stained glass; if earlier examples exist, we lack documented evidence. On the contrary, the superimposed carved medallions of the Labors of the Months (see Blum fig. 3), located on the south portal of the west facade, follow a widespread Romanesque sculptural formula. We should also keep in mind the resemblance, first noted by Panofsky, between the "flayed" Atlantes (Blum fig. 5a), flanking the plinths of the portals, and the stained-glass panel (the only known panel from the Saint Vincent cycle) depicting poor Saint Vincent on his rack above the flames (see Caviness fig. 11). The similarities are most striking

in the rendering of the movement of the legs and in the form of the head of the martyr. But are the Atlantes authentic? Or have they undergone extensive restoration? In short, can they be considered as valid vehicles of comparison? In spite of such questions, I find the resemblances too compelling to be discarded.

I shall not dwell on the problematic relationship between the Stavelot Triptych medallion (see Caviness fig. 6), which depicts the Battle against Maxentius, and the battles of the First Crusade drawn for Montfaucon and based on windows at Saint-Denis (fig. 11) that have since been lost. All conform to a representational formula suitable to all battles and other armed engagements between knights. One detail, however, indicates the true complexity of the relationship: the grassy hillocks in the shape of crescents or horns at the bottom of the Montfaucon panel drawings (see Caviness fig. 5) also appear in enamels and to a lesser degree in the Stavelot Triptych, where bands of terrain become a simple undulating line. The same motif recurs in such Mosan manuscripts as the Berlin Psalter (fig. 12) and is a convention similar to the "bridge" that cuts across the lower part of several medallions in the same series. This comparison of "horns" also confirms more general resemblances between the two compositions. I use the word "horns" as Montfaucon employed it in de-

scribing these lost panels, although this usage may seem somewhat naïve today: "Under the horses' hooves there are horns; I do not know what they mean; I do not know why the artist represented them in such a manner nor why they are so numerous."[2] It should be stressed, without entering into too many details, that this formula of representation appears frequently in paintings, miniatures, and metalwork but rarely in stained glass.

The First Crusade windows are almost secular in character, depicting historical events that had taken place only fifty years before. Suger probably commissioned them in 1146 or 1147 to plead the cause of the Second Crusade, to create as it were a "poster" in its favor. They were located in the first radial chapel windows of the ambulatory, and thus not on the main axis of the church. I believe that the Crusade window as well as its neighbor, the Pilgrimage of Charlemagne window, were executed because of the pope's visit to Saint-Denis in 1147 and the departure of King Louis VII the same year. I cannot discuss in detail here the historical and iconographic problems of these windows, but these issues are important and must be studied separately and seriously, not merely as part of a corpus.

To conclude I should like to examine a beautiful detail from the panel of the Life of Moses cycle depicting the Brazen Serpent (fig. 13). It is closely related to miniatures and to the finest goldsmiths' work, an aspect little emphasized until now. The image shows Christ on the Cross above the serpent, a very singular idea of which there are few examples in twelfth-century iconography. If we examine the rinceaux on the green background of the Cross, to which the arms of Christ are pinned, or, better, the gold serpent, a masterpiece of goldsmith work, we clearly perceive the relationship between these windows and objects wrought of precious metals—gold and enamels—arts that Suger had always encouraged and that he preferred, perhaps, to all the others. The abbot of Saint-Denis greatly admired, to be sure, stained-glass windows, numbering them among some of the most precious works he commissioned, but his description of metalwork reveals a much deeper involvement. The Brazen Serpent panel, which belongs to the "principal atelier" at Saint-Denis, exemplifies the sophistication of Suger's taste as well as the beauty of the creations of this workshop, with its inexhaustible supply of problems, be they historical, stylistic, iconographic, or aesthetic.

This colloquium has allowed us to explore many of the Dionysian problems and come closer to their solutions. But it represents only one more step toward a complete knowledge of Saint-Denis, its works of art, and its "patron."

NOTES

*The text for this essay was transcribed by Carol Lazio and Bella Meyer from a tape made during the Suger and Saint-Denis symposium in April 1981. The French transcription was sent to Professor Grodecki, who made some corrections to the text before his death. This translation, completed after his death by Françoise Vachon, was established with the help of Madame Grodecki.

1. Most of the relevant bibliographical material for this paper can be found in the essay here by Madeline Caviness. I would like to add that the actual and historical study of the stained-glass windows at Saint-Denis and additional bibliographic information are to be found in the following works: Louis Grodecki, *Les Vitraux de Saint-Denis, étude sur le vitrail au XII^e siècle* (Corpus Vitrearum Medii Aevi) France "Études" (Paris, 1976) vol. 1. The stylistic problems must be studied in vol. 2 of the same work, soon to be published; a final outline pertaining to this question can be found in Louis Grodecki, *Le Vitrail roman* (Fribourg, 1977), pp. 96–103. For Carolingian sources at Saint-Denis, see Konrad Hoffmann, "Sugers 'Anagogisches Fenster' in Saint-Denis," *Wallraf-Richartz Jahrbuch*, 1910, pp. 57–88. For the Berlin Psalter, see Elisabeth Klemm, *Ein romanischer Miniaturenzyklus aus dem Maasgebiet* (Vienna, 1973); and Hanns Swarzenski, *Mosaner Psalter-Fragment* (Graz, 1974).

2. Bernard de Montfaucon, *Les Monumens de la Monarchie françoise*, 5 vols. (Paris, 1729–39), vol. 1, p. 395.

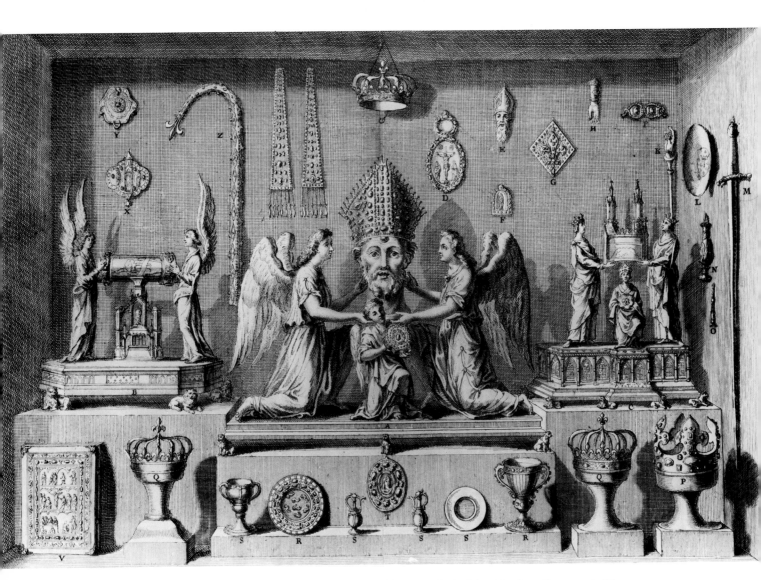

Saint-Denis Treasury, etching from Michel Félibien, Histoire de l'abbaye royale de Saint-Denis en France, *pl. III*

Suger's Liturgical Vessels*

Danielle Gaborit-Chopin

IT IS A well-known fact that Suger took a keen interest in gold-smith's work, precious stones, pearls, in short in any valuable object destined to enhance liturgical pomp. This interest is clearly revealed in Suger's writings,[1] as if the abbot of Saint-Denis was attempting to justify himself in light of the criticisms of Saint Bernard, who denounced Saint-Denis as "a workshop of Vulcan."[2] The reasons for Suger's interest, which was directed toward objects already belonging to the treasury as well as those he acquired himself, are numerous.

First, the ideas that nothing was too beautiful to be consecrated to God and that no vessel was too precious to receive the blood of Christ, although widely held in the twelfth century, were defended with great conviction by Suger, possibly because they were in opposition to Cistercian doctrine.[3] On a second level, and as Panofsky has so aptly pointed out, Suger was also motivated by a sort of aesthetic emotion or experience which he—almost alone in his generation—tried to describe. The rapture felt by the abbot when he gazed on a vessel or precious stones sparkling in the light resembles above all—whatever the influence of the theories of the pseudo-Areopagite—the pleasure felt by an art lover before a masterpiece.[4] But above all else Suger passionately wanted his church to be the richest and the most beautiful not only of the kingdom, but of the Western world, with treasures rivaling those of the Hagia Sophia, in Constantinople, of whose glories he had often heard.[5] A further motivation, and a more subtle one, was his desire to surpass the reputation of the emperor Charles the Bald in the memories of Saint-Denis' monks. Through his writings, we see that Suger took great care to pay homage to this Carolingian prince, who had been a lay abbot and patron of Saint-Denis and whom he seems to have con-

sidered a model.[6] He described with care some of the emperor's gifts to the abbey, like the gold altar, the portable altar, the cross of gold, and the *crista,* which we mistakenly call today the *écran de Charlemagne.*[7] It is probable that the Cup of the Ptolemies (fig. 1) and the serpentine paten, both beautiful liturgical vases made of semiprecious stones set in metalwork mountings and given to Saint-Denis by Charles the Bald, had influenced Suger's taste. The serpentine paten (Paris, Musée du Louvre) is inlaid with gold fish and encircled by a cloisonné metalwork border similar to the mounting of the magnificent agate cameo cantharus called the Cup of the Ptolemies (Paris, Bibliotheque Nationale, Cabinet des Médailles).[8] The setting of the Cup of the Ptolemies disappeared in the nineteenth century, but it is well known through the engravings of Michel Félibien (see pages 282 and 294) and Tristan de Saint-Amant as well as by an eighteenth-century description.[9] Its base, in the shape of a truncated cone, and its knob, partially covered with cloisonné goldsmith work, are indeed Carolingian, but Suger may have been responsible for adding the metalwork circle that widens the base of the vase; the metallic bands that join the base to the knob and the *versiculi* engraved on the base remind us that this object was a gift of "Charles the Third," the name by which Charles the Bald was traditionally referred to at Saint-Denis and by Suger himself.[10]

It is in his *Liber de rebus in administratione sua gestis* that Suger best explains how he strove to enrich the treasury of his abbey. This documentation, quite exceptional in the twelfth century, sheds some light on certain aspects of the man and the objects he treasured but, paradoxically, brings up certain problems in the study of the objects themselves: of particular concern in the study of Suger's vase is the identification of the goldsmiths work-

Notes for this essay begin on page 292.

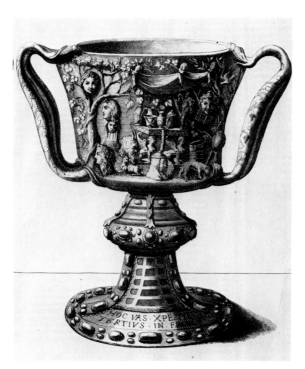

Fig. 1. *Cup of the Ptolemies (Félibien,* Histoire, *plate VI)*

Fig. 2. *Incense boat (Félibien,* Histoire, *plate IV)*

ing at Saint-Denis. The abbot mentions four groups working for him on various projects, and distinguishes each of them by nationality:

1. The goldsmiths *de diversis partibus,* who worked on the Great Cross of gold. (We must stress, however, that Suger's notes do not necessarily rule out French artists.)[11]

2. The *Lotharingi,* who executed the enameled copper foot of the Great Cross, and are distinct from (1). Traditionally, the *Lotharingi* have been considered Mosan goldsmiths.[12]

3. The *Barbari,* who worked on the *ulteriorem tabulam,* that is to say the back panel Suger added to the gold altar frontal of Charles the Bald. According to Suger himself, their work was more lavish than that of native craftsmen.[13] Although other interpretations are possible, they are generally thought to be the *Lotharingi* mentioned above.[14]

4. Finally, there are the *nostrates,* to whom Suger also referred in the passage concerning the back panel added to the altar frontal of Charles the Bald. They were probably responsible for the execution of the short sides Suger had added to the same altar, and it is quite likely that they were French goldsmiths.[15]

It would be interesting to know, or at least to attempt to discover, which of these ateliers of goldsmiths worked on the mountings for Suger's liturgical vessels, assuming of course, that Suger commissioned their execution. In *De administratione* Suger does indeed mention several precious liturgical vases that he knew of and admired but had not commissioned, among them the Incense Boat (also called the Vase of Saint Éloi, fig. 2) and the vase of Theobald of Blois-Champagne.

Suger describes with admiration the aventurine Incense Boat, set in a metalwork cloisonné mounting. He tells us that it had been pawned by Louis VI and that he redeemed it for Saint-Denis with the king's permission.[16] In 1804, in the course of the Bibliothèque Nationale's Cabinet des Médailles robbery,[17] the mounting disappeared, as did the mounting for the Cup of the Ptolemies. We have a record of the cup, however, in the inventories of the treasury of Saint-Denis as well as in Félibien's engraving (fig. 2). (The incorrect reconstruction provided by Charles de Linas in the nineteenth century is not helpful.[18])

The vase offered to Saint-Denis by Theobald of Blois-Champagne (to whom it was given by Roger II of Sicily) was a *lagena.* This term is difficult to translate precisely but seems to refer to a rather large vase, probably shaped like a jug.[19] This vase has traditionally been identified with the rock crystal Fatimid ewer belonging to the treasury of Saint-Denis and now in the Musée du Louvre (fig. 3). Its identification remains tenuous, however, because Suger never specified the material of which the *lagena* was made.[20] In any case, it seems certain that the abbot of

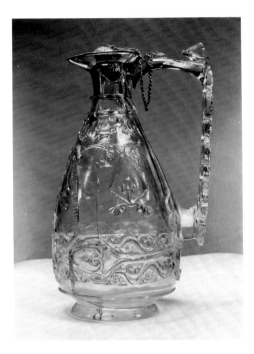

Fig. 3. *Rock crystal ewer of Saint-Denis (Paris, Musée du Louvre)*

Fig. 4. *Cruets of Saint-Denis, or of Suger (Félibien,* Histoire, *plate III)*

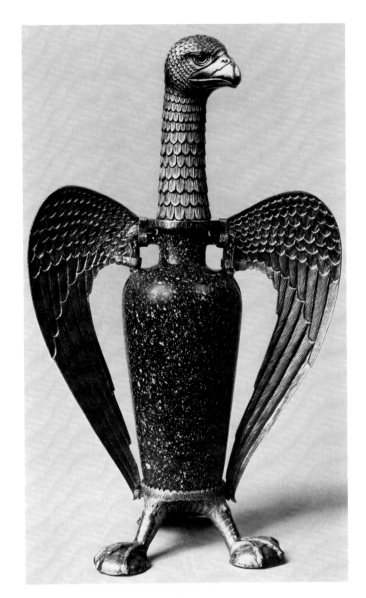

Fig. 5. *Suger's Eagle Vase (Paris, Musée du Louvre)*

Saint-Denis had no part in the execution of its gold cover, which may be a work of Italian craftsmanship.

On the other hand, Suger might well have been responsible for the execution of the mountings of the other vases he mentions. Unfortunately the scant evidence at our disposal precludes any certain knowledge of this. I am referring here to a pair of crystal cruets (fig. 4) shaped like tiny ewers, which Suger had intended for use in his private chapel's daily service. They have been lost since the end of the eighteenth century and are known only through Félibien's engraving.[21] The second vessel mentioned by Suger is a gold chalice, which has also disappeared. This bejeweled vase, weighing one hundred forty gold ounces, was to have replaced a more ancient chalice. The abbot uses the term *restitui*

elaboravimus, which indeed suggests the possibility that he retained the services of numerous goldsmiths.[22]

Thus, we can rely only on four preserved vases to attempt a better understanding of Suger's patronage of the goldsmith's art: the Eagle Vase (fig. 5), the chalice (fig. 9), the ewer (fig. 12), and the Eleanor Vase (fig. 14). Although their dates and origins differ, they share common characteristics: the four vessels are made of semiprecious stones and are mounted in metalwork; and three of them carry inscriptions attesting to Suger's use of them in holy services.

The Eagle Vase (fig. 5), now in the Musée du Louvre, is the only one that raises no serious problems in spite of its exceptional mounting.[23] Suger explains discovering this porphyry vessel

(*urna*) in the abbey after it had lain idly in a chest for many years. When he decided to have it mounted, he had it converted from a flagon into a vase in the shape of an eagle: *de amphora in aquilae formam transferando.*[24] He then added the following verses, which can still be seen on the bird's silver-gilt neck:

> *Includi gemmis lapis iste meretur et auro.*
> *Marmor erat, sed in his marmore carior est.*

> This stone deserves to be enclosed in gems and gold.
> It was marble, but in these [settings] it is more
> precious than marble.

This inscription, in uncials, of niello on a gold enamel ground, is in slight relief (fig. 6). A second inscription, *Sugerius,* engraved underneath the eagle but dated later than the previous one, bears witness to the lasting veneration in which Suger was held in the abbey itself throughout the centuries. The delicately chiseled wings, head, tail, and talons of the eagle (fig. 7) reveal the hand of an exceptional goldsmith who was almost certainly established in the Ile-de-France. At the beginning of the seventeenth century, Nicolas Claude Fabri de Peiresc, an erudite from Aix with a passion for antique vases, had a watercolor done depicting a stone vase shaped like a bird (fig. 8).[25] Its mounting is almost identical to that of Suger's eagle: similarities in the renderings of the vases' fastenings to their metallic supports, the tails, and the details of the talons gripping fish allow us to at-

tribute the two mountings to the same origin. Peiresc's vase was, at that time, in a collection that, though not identified, was very probably Parisian.[26] The existence of two such similar mountings, one of which was surely executed in the twelfth century under Suger's patronage, would indicate that both came from an atelier located in Paris or nearby.

As for the three other vases, a number of complex problems confront us. The chalice, purchased by Suger (*comparavimus*)[27] and now in the National Gallery in Washington (fig. 9), is a fluted cup made of sardonyx and probably Byzantine. Did Suger purchase a complete chalice, that is to say the cup plus mounting, or did he acquire only the sardonyx cup?

The mounting has been restored many times since the twelfth century, but another of Peiresc's watercolors gives a clear indication of the state of the chalice in the seventeenth century (fig. 10).[28] The base is raised on a molded band. Originally, five medallions on the base depicted Christ and the Four Evangelists, but today only the bust of Christ remains. The terminal curls on the upper part of the handles are probably remade. The knob beneath the cup is also slightly changed (the base of the hard-stone vase can be seen on the Peiresc watercolor). Gems have been inserted to fill the empty settings. Finally, the upper band of the chalice, adorned with cabochons and double filigree volutes, is poorly fastened on a silver lip, which may be the remains of the original, perhaps Byzantine, mounting.

Fig. 6. Suger's Eagle Vase (Paris, Musée du Louvre), detail of inscription on the neck

Fig. 7. Suger's Eagle Vase (Paris, Musée du Louvre), detail of feet and tail

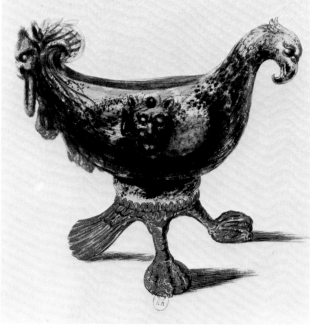

Fig. 8. Vase in the shape of a bird, from a watercolor in the Peiresc Collection (Paris, Bibliothèque Nationale, Cabinet des Estampes, Aa 53, fol. 98r)

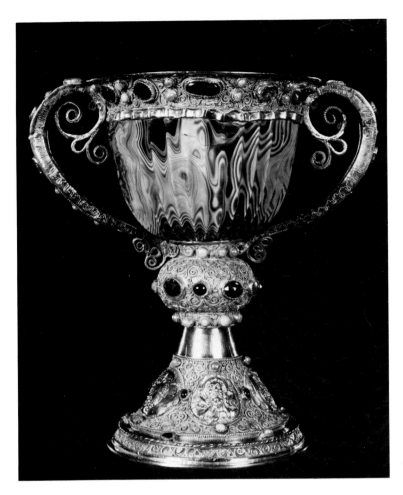

Fig. 9. Suger's Chalice (Washington, D.C., National Gallery of Art, Widener Collection)

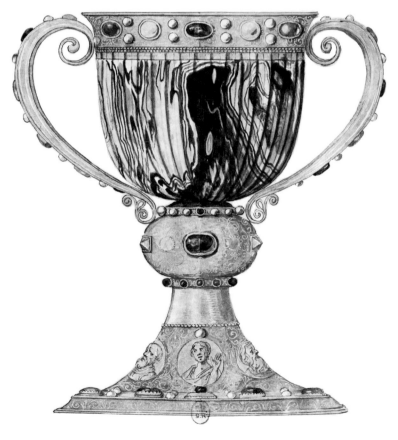

Fig. 10. Suger's Chalice, watercolor from the Peiresc Collection (Paris, Bibliothèque Nationale, Cabinet des Estampes, Aa53, fol. 92r)

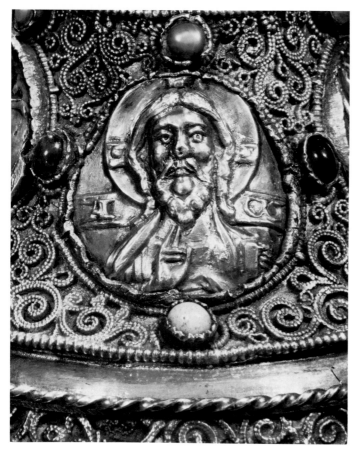

11

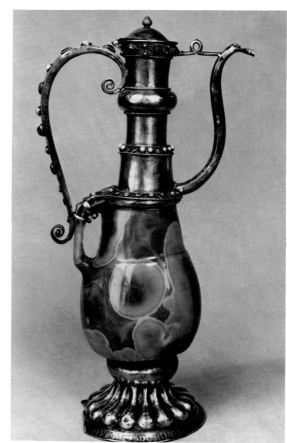

12

13

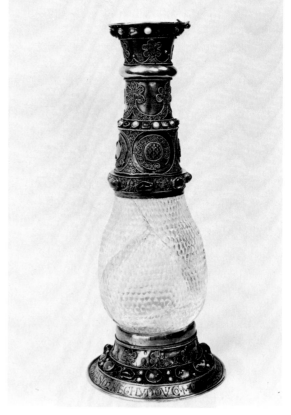

Fig. 11. Suger's Chalice (Washington, D.C., National Gallery of Art, Widener Collection), detail of the base and the medallion of Christ

Fig. 12. Sardonyx Ewer (Paris, Musée du Louvre)

Fig. 13. Sardonyx Ewer (Paris, Musée du Louvre), detail of the base with inscription, showing the soldering of the restored part

Fig. 14. Eleanor Vase (Paris, Musée du Louvre)

14

Although the mounting is clearly Byzantine in inspiration,[29] it is Western in its execution. Particularly Western technical details include the alternation of cabochons with paired pearls; the setting of precious stones in notched bezels surrounded by beaded filigree; densely set beaded double filigree wires soldered completely to the metallic ground instead of being bound by wires at intervals; and the presence of some granulation surrounded by a beaded wire (fig. 11).

Suger tells us that he owned another sardonyx vase but in a different shape from that of his chalice.[30] This is the sardonyx ewer now at the Musée du Louvre (fig. 12).[31] Suger mentions only the vase, not its mounting, and seems to associate the ewer and chalice, using the word *adjunximus*. Just as he did for the Eagle Vase, Suger had some verses added to the base of the ewer to commemorate his donation. This inscription (fig. 13)—in capital letters gilded on a niello ground—differs greatly, however, from the one engraved on the neck of the eagle in one simple respect: the ewer's present base was, for the most part, restored in the fifteenth century, as proved by clearly discernible soldering traces on its upper section. The present inscription probably copies the original one, but it is in a script that does not belong to the twelfth century.[32]

By contrast, the mounting of the upper part of the ewer is well preserved and can be compared to that of the chalice: the handles, with the exception of the terminal flourished curls, are similar, displaying the same alternation of cabochon and filigree (figs. 9 and 12). But the greatest resemblance between the two objects lies in their technical characteristics: notched bezels surrounded by a single beaded filigree wire; densely set double filigree "volutes"; and granulation encircled by beading (figs. 11, 16, and 17). Thus, it seems evident that the two sardonyx vases, although different in shape and origin, had their mountings produced in the same atelier. Therefore when Suger used the word *comparavimus* (we have acquired) in writing about the chalice, he was referring only to what was hardest to obtain, the sardonyx cup itself.

The last of Suger's vessels is the Eleanor Vase, now also at the Musée du Louvre (fig. 14).[33] Suger tells us the story of this strange rock crystal Fatimid object, with a design not unlike hammered metal, which Queen Eleanor of Aquitaine gave to Louis VII shortly after their marriage, and which the king subsequently presented to the abbot of Saint-Denis. And Suger adds:

We have recorded the sequence of these gifts on the vase itself, after it had been adorned with gems and gold, in some little verses:

As a bride, Eleanor gave this vase to King Louis,
Mitadolus to her grandfather, the king to me, and
Suger to the saints.[34]

Suger's text indicates clearly this time that both the mounting and the inscription were added on his orders. The inscription (fig. 15), in niello on a gold background, is in the same type of uncial letters as the inscription on the neck of the Eagle Vase. At first glance the mounting of the Moslem crystal might seem quite different from the mountings of both the ewer and the chalice because of the superb filigree flowers covering the neck and the base. However, a careful examination of the Eleanor Vase alters this first impression. A few spots show signs of old restorations: the band of filigree rinceaux set with amethysts and located above the rim of the crystal vessel was certainly added in the thirteenth century;[35] and the enamel medallions adorned with fleur-de-lis are characteristic of the fourteenth century.

Apart from those details, the affinities in design between the neck of the Eleanor Vase and the neck of the ewer (figs. 12 and 14) are unmistakable, particularly if we consider the segments that ascend with decreasing diameters and the same alternation of brilliantly shining segments, rounded segments, and segments with filigree work. The particular shape of the neck can, of course, be observed on the vases held by the Apocalyptic elders found in the archivolts surrounding the Last Judgment tympanum at Saint-Denis (see Gerson figs. 8 and 9). This proves, all the more, that this type of vase, with variations, was fashionable at the time.[36]

It should further be emphasized that the form of the bezels is exactly the same on the Eleanor Vase, the chalice, and the ewer; that the double filigree work (even when shaped as flowers) is absolutely the same as that found on the chalice and ewer; and that we find on the Eleanor Vase granulation surrounded by a beaded filigree wire (compare figs. 11 and 15 to 18). We therefore conclude that the mountings of these three vases were executed in the same atelier, at Suger's behest. But one question remains: Who were the goldsmiths?

Resemblances between the techniques used in Suger's vases and in earlier or contemporary metalwork objects have not yet been fully explored. We could certainly draw some parallels between the forms of Suger's vases and certain mounted vases in the S. Marco treasury or objects produced in the North in the tenth or eleventh century, but this would only concern their general appearance.[37] If we compare, for instance, Suger's vases to the small fluted oval bowl of Saint-Denis (fig. 19, Paris, Bibliothèque Nationale, Cabinet des Médailles), which Suger must have seen,[38] we are confronted not only by resemblances but also by dissimilarities: the small fluted oval bowl is composed of an agate body set into a silver gilt mounting with gems and filigree work as are Suger's chalice and ewer, and the general disposition of the cabochons set in the middle of filigree work and the small filigree rosettes brings to mind the decoration of the Eleanor Vase. But the differences in technique are considerable and certainly indicate another date and origin; the setting of the precious stones is not

15

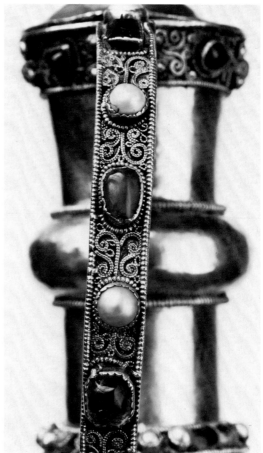

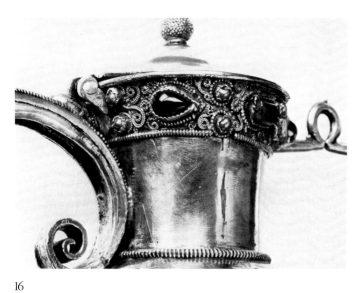

16

17

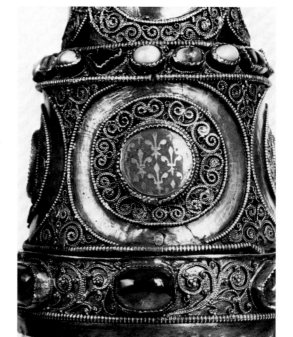

Fig. 15. Eleanor Vase (Paris, Musée du Louvre), detail of the base
Fig. 16. Sardonyx Ewer (Paris, Musée du Louvre), detail of the neck
Fig. 17. Sardonyx Ewer (Paris, Musée du Louvre), detail of the handle
Fig. 18. Eleanor Vase (Paris, Musée du Louvre), detail of the neck

18

the same, and the bezels are not encircled by filigree. Moreover, the type of filigree is completely different, with simple metal wires in loose volutes, which are fixed at intervals to the metal ground by small rings (fig. 20).

This last point is, perhaps, decisive because no other northern European metalwork of the tenth, eleventh, or twelfth century displays the tightly rolled, beaded filigree completely soldered to the metal ground found on Suger's vases. This type of filigree, observable on the chalice, the ewer, and the Eleanor Vase, is indeed one of the chief characteristics of the Dionysian atelier. It is completely different both in the manner in which it is attached and in its design from earlier or contemporary works executed in Mosan or Rhenish workshops: the *Lotharingi* and the *Barbari* did not work on these vases.

These purely technical observations, and particularly the differences in the appearance of the filigree work, lead us to the conclusion that this easily recognizable atelier (from which we have no extant work other than those objects made for the abbot of Saint-Denis) was composed of goldsmiths called *nostrates* by Suger (see page 284). This hypothesis is strengthened by other arguments: why, for example, did Suger, who was always eager to boast of his commissionings of foreign artists, not reveal the origins of the craftsmen responsible for the mounting of the vases? The obvious answer is that they were local goldsmiths. Certainly the existence of these Ile-de-France goldsmiths,[39] and the quality of their work, are sufficiently proved by the undeniable beauty of the mounting of the Eagle Vase (fig. 5), and the clearly related vase in the shape of a bird, known from the Peiresc watercolor (fig. 8). If indeed Suger had at his disposal an atelier capable of such exceptional work, why not entrust it with the mounting of these hard-stone vases as they were gradually acquired by or presented to him?

The interpretation of Suger's text presents some difficulties and the translation proposed here concerning the Eleanor Vase could perhaps be questioned. It is possible that the king presented the Fatimid rock crystal, already mounted as a vase, to Suger and that the abbot only added his inscription to the object. If this were the case, it still does not rule out identifying the atelier with Suger's *nostrates*. If we take into consideration the technical affinities existing between the Eleanor Vase, the chalice, and the ewer, we must then accept the fact that the royal atelier of goldsmiths and Suger's workshop were one and the same, and our argument for a local atelier is further strengthened.

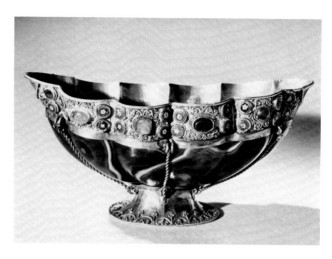

Fig. 19. Fluted boat of Saint-Denis (Paris, Bibliothèque Nationale, Cabinet des Médailles)

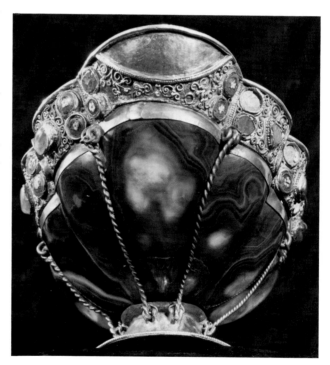

Fig. 20. Fluted boat of Saint-Denis (Paris, Bibliothèque Nationale, Cabinet des Médailles), detail of filigree work

NOTES

*This essay was translated by Françoise Vachon.

1. This interest is particularly clear in the *Liber de rebus in administratione sua gestis*. See Suger, *Adm.* (L), pp. 151–209; Suger, *Adm.* (P), pp. 40–81. All further references to Suger's text come from the edition of Lecoy de la Marche.

2. See particularly Panofsky's analysis in *Suger*, pp. 6, 10–16.

3. See Suger, *Adm.* (L), pp. 198–200. Besides, this idea is resumed in the *versiculi* engraved on the base of the Louvre sardonyx ewer. See note 30 here; also Panofsky, *Suger*, pp. 13–16.

4. Suger, *Adm.* (L), pp. 198–200; and Panofsky, *Suger*, pp. 20–22.

5. See Suger, *Adm.* (L), pp. 198–99.

6. Ibid., esp. pp. 196–98, 202–3; and Suger, *Ch.* (L), pp. 353–56 (it was compulsory to celebrate the anniversary of Charles the Bald).

7. See Blaise de Montesquiou-Fezensac and Danielle Gaborit-Chopin, *Le Trésor de Saint-Denis* (Paris, 1973–77), vols. 1 and 2, nos. 188, 156–57, 15, and 4. For the *écran de Charlemagne* and its attribution to the goldsmiths of Charles the Bald, see Jean Hubert, "L'Escrain dit de Charlemagne au trésor de Saint-Denis," *Les Cahiers archéologiques* 4 (1949): 71–77. See also Peter Lasko, "The Escrain de Charlemagne," *Festschrift für H. Wetzel* (Berlin, 1975), pp. 127–34; and Danielle Gaborit-Chopin, "L'Orfèvrerie cloisonnée à l'époque carolingienne," *Les Cahiers archéologiques* 29 (1981–82): 6–26.

8. See Montesquiou-Fezensac and Gaborit-Chopin, *Le Trésor*, vols. 1 and 2, no. 69, vol. 3, pp. 54–57 and pls. 36–40; and Gaborit-Chopin, "L'Orfèvrerie," pp. 6–26.

9. Montesquiou-Fezensac and Gaborit-Chopin, *Le Trésor*, vol. 2, pp. 172–73 (Description of 1726), vol. 3, pp. 54–56, pls. 36 and 38; Michel Félibien, *Histoire de l'abbaye royale de Saint-Denys en France* (Paris, 1706), pls. IV, F, and VI; and Jean Tristan de Saint-Amant, *Commentaires historiques contenant l'histoire générale des empereurs* (Paris, 1644), vol. 2, p. 602.

10. Ernest Babelon believed that the *versiculi* ("*Hoc vas Xte* [*Christe*] *tibi mente dicavit/Tertius in Francos regmine Karlus*") had been added by Suger. See Ernest Babelon, *Catalogue des camées de la Bibliothèque Nationale* (Paris, 1897), p. 205; and Montesquiou-Fezensac and Gaborit-Chopin, *Le Trésor*, vol. 3, pp. 55–56. Suger conformed to the Dionysian custom and referred to Charles the Bald by the name of "Carolus tertius" on at least three occasions. See Suger, *Adm.* (L), pp. 196, 202; Suger, *Ch.* (L), p. 353; and Gaborit-Chopin, "L'Orfèvrerie," n. 49.

11. "*Artifices peritiores de diversis partibus convocavimus.*" ("We convoked the most experienced artists from diverse parts.") (Suger, *Adm.* [L], pp. 194–95.)

12. "*Per plures aurifabros* Lotharingos, *quandoque quinque, quandoque septem, vix duobus annis*" ("through several goldsmiths from Lorraine—at times five, at others seven—barely within two years.") (Ibid., p. 196.) The identification of the *Lotharingi* with Mosan goldsmiths should be qualified. It is likely but not at all certain. In any case, one cannot extrapolate from Suger's text that the "head of the atelier was Godefroy of Huy," as has

been done recently. See Philippe Verdier, "Saint-Denis et la tradition carolingienne des tituli," *Mélanges René Louis*, 1982, p. 351 and n. 22.

13. "*Ulteriorem vero tabulam, miro opere sumptuque profuso, quoniam barbari et profusiores nostratibus erant artifices . . . extulimus.*" ("But the rear panel, of marvelous workmanship and lavish sumptuousness, for the barbarian artists were even more lavish than ours, we ennobled with chased relief work.") (Ibid., 196–98.)

14. According to Du Cange, *Glossarium*, the *barbari* are those who do not speak a romance language and come from countries located beyond the Rhine. Verdier, "Saint-Denis," p. 351, does not identify them with the *Lotharingi*, whom he considers to have been a Mosan, French-speaking atelier.

15. *Nostrates*, those "who come from our own country, compatriots." Even if we accept the idea that the *Lotharingi* are French-speaking Mosan craftsmen, the term *nostrates* would not apply to them but would refer only to French goldsmiths, probably from the royal domain.

16. "*. . . ad formam navis exculptum,*" see Suger, *Adm.* (L), p. 207; Babelon, *Catalogue*, no. 374; and Montesquiou-Fezensac and Gaborit-Chopin, *Le Trésor*, vols. 1 and 2, no. 74, vol. 3, pp. 60–61, pl. 45.

17. The vase as well as part of the treasury of Saint-Denis were brought to the Cabinet des Médailles in 1791. In 1804 it was stolen at the same time as Suger's chalice and the Cup of the Ptolemies. The Cup of the Ptolemies and the Incense Boat were found and returned to the Cabinet des Médailles, but their precious mountings were missing. The history of Suger's Chalice, which belongs today to the National Gallery in Washington, can be found in *Royal Abbey*, pp. 108–11.

18. See Montesquiou-Fezensac and Gaborit-Chopin, *Le Trésor*, vols. 1 and 2, no. 74, vol. 3, pp. 60–61; and Charles de Linas, *Orfèvrerie mérovingienne. Les oeuvres de Saint Éloi et la verroterie cloisonnée* (Paris, 1864), pp. 60–64.

19. See Suger, *Adm.* (L), p. 208.

20. Paris, Musée du Louvre, M. R. 333. See Montesquiou-Fezensac, and Gaborit-Chopin, *Le Trésor*, vols. 1 and 2, no. 33, vol. 3, pp. 44–45, pls. 26–27.

21. Ibid., vols. 1 and 2, no. 63, vol. 3, p. 52, pl. 34B; Suger, *Adm.* (L), p. 208. As suggested by Panofsky (*Suger*, p. 206), it seems that these crystal cruets can be identified with the ones called "of Saint-Denis." They are reproduced on plate III, S, of Félibien's book (see page 282). According to this engraving, there is a striking resemblance between their mounting and that of Suger's sardonyx ewer which they were supposed to accompany. This could indicate that the two crystal objects might have been executed by the same atelier. Panofsky interprets Suger's words *capella nostra* to mean the cruets were to be used in his private chapel.

22. "*Magnum videlicet calicem aureum . . . pro alio, qui tempore antecessoris nostri vadimonio perierat, restitui elaboravimus.*" This is translated by Panofsky, "Specifically we caused to be made a big golden chalice . . . as a substitute for another one which had been lost as a pawn in the time of our predecessor" (Suger, *Adm.* [P], pp. 76–77).

23. Paris, Musée du Louvre, M. R. 422. Ht., 431cm.; L. max.,

270cm. See Montesquiou-Fezensac and Gaborit-Chopin, *Le Trésor*, vols. 1 and 2, no. 28, vol. 3, pp. 42–43, pls. 23–24. According to Daniel Alcouffe, the body of the vase could come from Roman Imperial times rather than from Egypt as suggested by Richard Delbrueck, *Antike Porphyrwerke* (Berlin-Leipzig, 1932), pp. 203–4.

24. Suger, *Adm.* (L), p. 208; and Panofsky's translation, *Suger*, p. 79.

25. Joseph Guibert, *Les Dessins du Cabinet Peiresc au Cabinet des Estampes de la Bibliothèque Nationale* (Paris, 1910).

26. This strange vase appears in the collection of watercolors that contains the vases of Saint-Denis as well as other Parisian collections which Peiresc had commissioned for his research on antique measures. Guibert was not able to identify the origin of the vase; however, he noticed that the watercolor was done by the same hand that executed the watercolors of the vases of Saint-Denis, that of the painter Daniel Rabel (1578–1637). But no object of this type is listed in the inventories of the treasury. However, the vase could have been kept in the *Cabinet du roi* or owned by one of the great Parisian collectors with whom Peiresc had frequent contacts. On the other hand, the obvious difference of quality between the eagle vase and the "griffin nail" of Saint-Denis mitigates against a relationship between the two objects, as is suggested by Anne Lombard-Jourdan, "Les Mesures-étalon de Saint-Denis," *Bulletin monumental* 137 (1979): 141–54.

27. "*Comparavimus etiam praefati altaris officiis calicem preciosum, de uno et continuo sardonice . . .*" (Suger, *Adm.* [L], p. 207; and Panofsky, *Suger*, p. 79). See also Montesquiou-Fezensac and Gaborit-Chopin, *Le Trésor*, vols. 1 and 2, no. 71, vol. 3, pp. 57–59, pls. 41–43; and *Royal Abbey*, no. 25. Ht., 19cm.; Diam. at base, 10.8cm.; sardonyx cup: Alexandria (?) or Byzantium. According to Mr. Douglas Lewis, curator at the National Gallery in Washington, a recent analysis proved that the mounting of the chalice was not made of gilt silver as had been previously believed. I would like to thank Mr. Lewis for this information.

28. See Guibert, *Dessins*, pl. 3.

29. See the article by William D. Wixom in this book, pp. 295–303.

30. *Vas quoque aliud, huic ipsi materia, non forma persimile, ad instar amphorae adjunximus, cujus versiculi sunt isti:*
 Dum libare Deo gemmis debemus et auro,
 Hoc ego Sugerius offero vas Domino (Suger, *Adm.* [L], p. 208).
 The translation by Panofsky is "Further we added another vase shaped like a ewer, very similar to the former in material but not in form, whose little verses are these:

 Since we must offer libations to God with gems and gold,
 I, Suger, offer this vase to the Lord (Suger, *Adm.* [P], p. 79).

31. Paris, Musée du Louvre, M. R. 127. Ht., 357cm.; gilt-silver cabochons, pearls; sardonyx vase: Byzantium, fifth or eleventh century, *Royal Abbey*, no. 26; and Montesquiou-Fezensac and Gaborit-Chopin, *Le Trésor*, vols. 1 and 2, no. 27, vol. 3, pl. 22; and *Le Trésor de S. Marc de Venise*, exhib. cat. (Paris, 1984), no. 5 (Daniel Alcouffe) and no. 34 (Danielle Gaborit-Chopin), fig. 34d.

32. The soldering line attaching the fluted base (fifteenth or early sixteenth century) to the older part of the mounting is clearly visible; it was restored before 1534. It is quite likely that the inscription was copied from an older one, but it is not absolutely certain. The *versiculi* in Paris, Bibliothèque Nationale, ms. lat. 13835, the twelfth-century text of *De administratione*, have been added in a later, perhaps sixteenth-century hand. See Suger, *Adm.* (L), p. 208 n. 1. Panofsky also includes this inscription in his edition. See Suger, *Adm.* (P), p. 78, ll. 18–21.

33. Paris, Musée du Louvre, M. R. 340. Montesquiou-Fezensac and Gaborit-Chopin, *Le Trésor*, vols. 1 and 2, no. 75, vol. 3, pp. 63–64, pls. 47–48, Ht., 337cm.; max. diam., 159cm.; gilt silver, niello, filigree, cabochons, pearls, champlevé enamels; rock crystal: Moslem art, tenth century.

34. *Cujus donationis seriem in eodem vase, gemmis auroque ornato, versiculis quibusdam intitulavimus:*

 Hoc vas sponsa dedit Aanor regi Ludovico
 Mitadolus avo, mihi rex, sanctisque Sugerus (Suger, *Adm.* [L], p. 207; and Suger, *Adm.* [P], p. 79).

 The identity of Mitadolus remains a subject of discussion. Émile Molinier, *Histoire générale des Arts appliqués à l'industrie, IV: l'orfèvrerie religieuse et civile* (Paris, 1901), p. 168, thought Mitadolus was synonymous with "heathen" or "infidel"; others think that it was the name of an Arab emir. According to Verdier, "Saint-Denis," pp. 353–54, it could very well be an alteration of the name Mathilde (Matéode), wife of William the Troubadour who died in 1126. However, it would be very strange indeed for Suger to have distorted and given a masculine ending to the name of the wife of William of Aquitaine only twenty years after William's death.

35. The gilding of this added filigree band has a different tonality from that of the rest of the neck. The dentelation of the bezels in which the amethysts are set also differs from that of the rest of the neck.

36. See Verdier, "Saint-Denis," p. 354. It seems to me that the vases in question are not carved representations of the Eleanor Vase itself, but rather "bottle-shaped" vases which belong to the same type.

37. For these comparisons see Wixom, "Traditional Forms," pp. 295–298 in this volume.

38. See Montesquiou-Fezensac and Gaborit-Chopin, *Le Trésor*, vols. 1 and 2, no. 73, vol. 3, pls. 44–45. Ht., 126cm.; L., 211cm. Bowl: Byzantium, tenth century. Mounting: Rhineland (?), first half of the eleventh century. Gilt-filigreed silver, precious stones, cloisonné enamels on gold.

39. As Grodecki so aptly pointed out to me, it is better not to speak of a strictly Parisian atelier at this particular time.

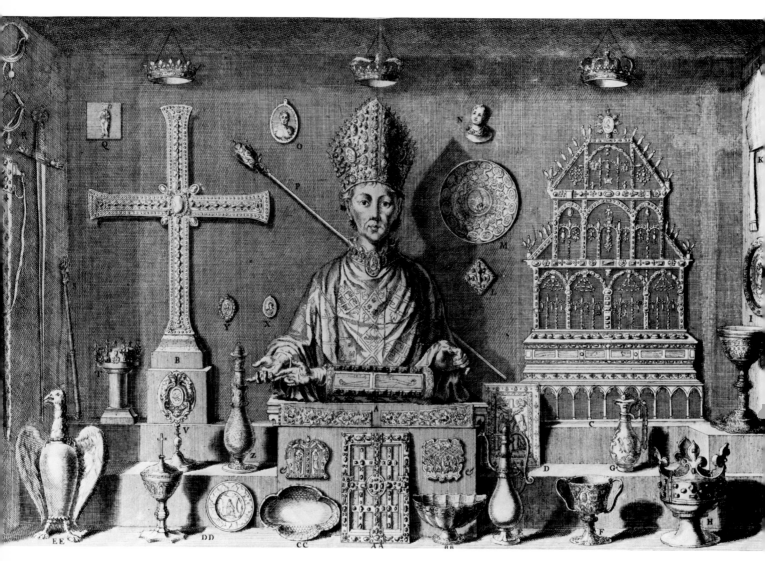

Saint-Denis Treasury, etching from Michel Félibien, Histoire de l'abbaye royale de Saint-Denis en France, *pl. IV*

Traditional Forms in Suger's Contributions to the Treasury of Saint-Denis

William D. Wixom

Ⲓ N HIS overriding compulsion to enrich the altars of his abbey, Suger must have been keenly aware of the splendors of liturgical furnishings elsewhere, and he seems to have been eager to summon gifted artists from many regions. Suger's grand intentions for his abbey must have been in partial response to what he observed on his travels in France, Italy, and Germany, en route, for example, to Montpellier (1118), Bordeaux, Poitiers (1137), Mainz (1125), Rouen, possibly Liège (1131), Rome, and Apulia.[1] He was intensely interested in the comments of travelers who had seen church treasuries beyond the reach of his own journeys.

As a result, Suger was very conscious of the magnificence of Byzantium, which he attempted to surpass. He wrote:

> I used to converse with travelers from Jerusalem and, to my great delight, to learn from those to whom the treasures of Constantinople and the ornaments of Hagia Sophia had been accessible whether the things here could claim some value in comparison with those there.[2]

While it is clear from the context of this excerpt that Suger hoped to outdo the treasures of Constantinople, we may also suspect that he wished to emulate these treasures of the East.

Certainly Suger's own chalice[3] demonstrates a healthy respect for Byzantine tradition (fig. 1). The chalice's overall shape and proportions are generally similar to those of several Byzantine chalices made in the previous two centuries in Constantinople and brought back to Venice after the sack of the imperial city in 1204.[4] Although there was an even earlier Western tradition with a common Eastern root with respect to the general proportions, as represented by the late-eighth-century Tasillo Chalice and the tenth-century chalice of Bishop Gauzelin,[5] and, al-

though the examples now in S. Marco, Venice, were not yet in Western possession when Suger's chalice was completed, several similarities to Suger's chalice are compelling. The conical foot of Suger's chalice, originally graced with busts of holy personages;[6] the knob; the bowl of agate (or sardonyx); the wide rim of gold; and the handles that clamp the rim and knob tightly to the bowl are the elements that most recall Byzantine tradition.[7] Let us take, for comparison's sake, three of the S. Marco chalices, each with an agate bowl with silver-gilt mounts, pearls, and cloisonné enamels: a chalice from the tenth or eleventh century (fig. 2);[8] the chalice of Emperor Romanus I (or II?) from the tenth century (fig. 3);[9] and a chalice, probably from the eleventh century, with additional cabochon decoration (fig. 4).[10] Suger's goldsmith left us a special clue to this postulated Byzantine patrimony. The one original, surviving medallion in gold, that of Christ as Pantocrator (fig. 5), while clearly Western in its modeling and in the paleographic character of the letter A (alpha) is nevertheless Byzantine in inspiration, as underscored by comparison with Byzantine coins (fig. 6)[11] or with the repoussé medallions on Byzantine metalwork objects of the tenth century and the first half of the eleventh century (fig. 7).[12]

Similarly, in Suger's ewer (fig. 8), which actually incorporates a Byzantine sardonyx pitcher,[13] elements in the mounting attest to an awareness of Byzantine forms. The construction of the segmented neck, with a compressed knob bordered with beaded wire, recalls the stems of the Constantinopolitan chalices previously illustrated, particularly the Romanus Chalice (figs. 3 and 4).

The overall configuration of the Eagle Vase (fig. 9),[14] brilliantly adapting an ancient porphyry urn to a new purpose, was probably equally inspired by a Byzantine imperial represen-

Notes for this essay begin on page 303.

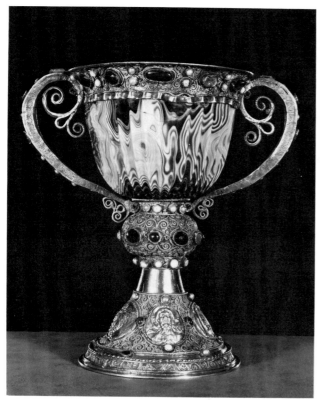

1

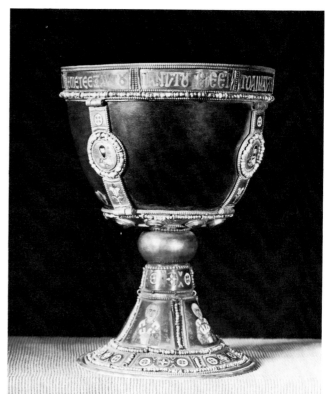

2

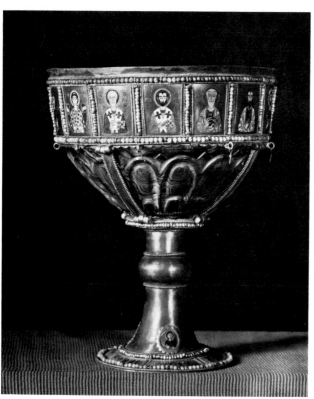

3

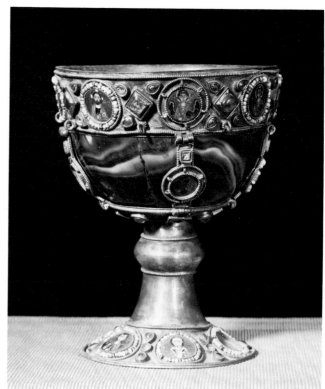

4

Fig. 1. *Suger's Chalice (Washington, D.C., National Gallery of Art, Widener Collection)*

Fig. 2. *Sardonyx chalice from Constantinople (Venice, Basilica of S. Marco, Treasury), tenth–eleventh century*

Fig. 3. *Chalice of Emperor Romanus (Venice, Basilica of S. Marco, Treasury), tenth century for mounts*

Fig. 4. *Onyx-agate chalice from Constantinople (Venice, Basilica of S. Marco, Treasury), eleventh century*

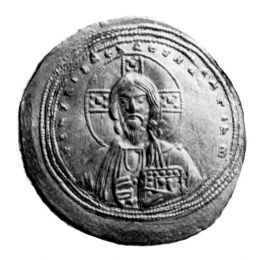

Fig. 6. *Histamena of Michael IV (Washington, D.C., Dumbarton Oaks Collection, Wittemore Loan), 1034–41*

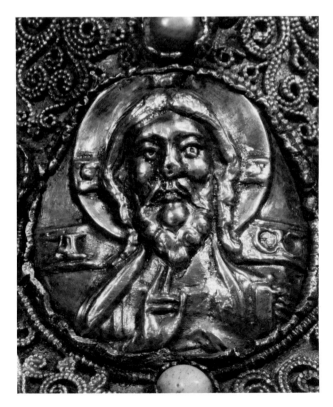

Fig. 5. *Suger's Chalice (Washington, D.C., National Gallery of Art, Widener Collection), detail of Christ Pantocrator, relief medallion in gold*

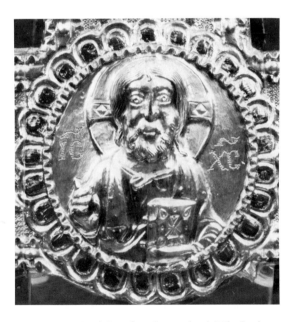

Fig. 7. *Processional Cross from Constantinople (Cleveland, Cleveland Museum of Art), late tenth century–first half eleventh century, detail of central medallion, face of Christ Pantocrator*

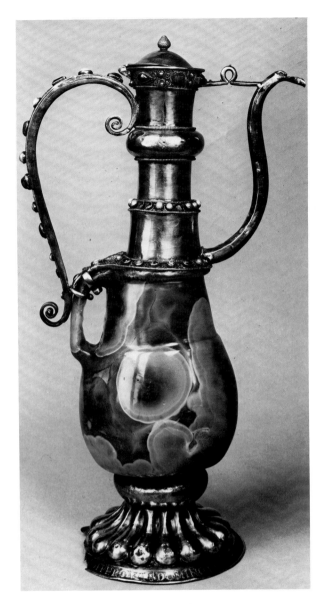

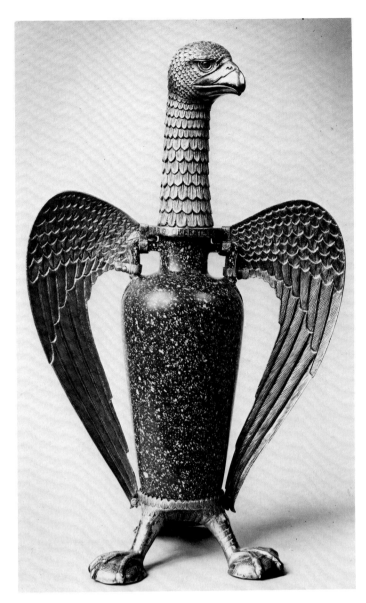

Fig. 8. Sardonyx Ewer (Paris, Musée du Louvre)

Fig. 9. Suger's Eagle Vase (Paris, Musée du Louvre)

tation, such as one of the hieratic eagles on imperial textiles of the tenth and eleventh centuries. This was suggested long ago by Joan Evans, who cited in particular the shroud of Saint Germain in the church of Saint-Eusèbe at Auxerre (fig. 10). [15]

Suger's inspiration was, as already noted, not solely of the East. In their continuation of Carolingian and Rhenish-Ottonian decorative schemes of ornament, Suger's goldsmiths were still steeped in Western traditions. Suger's own words document his admiration for earlier Western work. He proudly chronicled the acquisition of the Vase (incense boat) of Saint Éloi (see Gaborit-Chopin fig. 2), a green aventurine incense boat with Merovingian settings, probably dating from the sixth or seventh century. [16] The settings, destroyed early in the nineteenth century,

are recorded in Félibien's engraving of 1706. Martin Conway, in his important 1915 article on the treasury, offered a conjectural reconstruction recently corrected by a careful reading of the 1634 inventory. [17] From both coloristic and technical points of view, the lost mounts may have been similar to the contemporary lapidary work on the casket of Teudericus in the treasury of Saint-Maurice d'Agaune. [18] The concept of adapting a hard-stone vessel to a larger form with metalwork mounts was clearly at hand in this piece which had been pawned by Louis VI and subsequently redeemed by Suger for Saint-Denis. Yet the actual details of this mounting—a quatrelobed upper rim in silver-gilt cloisonné with inset blue glass, emeralds, garnets, and pearls—had no more stylistic impact on Suger's goldsmiths than did the now-

*Fig. 10. Shroud of Saint Germain from Constantinople (Auxerre, Saint-Eusèbe), late tenth
or early eleventh century*

lost Cross of Saint Éloi, visible in the upper portion of the late-
fifteenth-century painting by the Master of Saint-Giles (fig. 11).

Carolingian goldsmith work was still richly evident and much
revered in Suger's time, as was made clear by Suger's own account
concerning the altar frontal of Charles the Bald (also shown in
fig. 11 but adapted as an altarpiece):

We hastened to adorn the Main Altar of the blessed Denis,
where there was only one beautiful and precious frontal panel
from Charles the Bald, the third Emperor; for at this [altar]
we had been offered to the monastic life. We had it all en-
cased, putting up golden panels on either side and adding a

fourth, even more precious one; so that the whole altar would
appear golden all the way around.[19]

Suger referred admiringly to the so-called *escrin de Charlemagne*
as "that incomparable ornament commonly called 'the Crest.'"

[When it is] placed upon the golden altar, then I say, sighing
deeply in my heart: *Every precious stone was thy covering, the sar-
dius, the topaz, and the jasper, the chrysolite, and the onyx, and the
beryl, the sapphire, and the carbuncle, and the emerald.* To those
who know the properties of precious stones it becomes evi-
dent, to their utter astonishment, that none is absent from the

number of these (with the only exception of the carbuncle), but that they abound most copiously.[20]

Danielle Gaborit-Chopin has ascribed most of the mounting of this "splendidly useless decoration," as Panofsky called it, to the second half of the ninth century; it was probably a gift to the abbey from Charles the Bald.[21] The embellishment of Suger's new tabernacle, the tomb and altar of Saint Denis and his companions Saints Rusticus and Eleutherius, included elements and gems reemployed from the Carolingian shrine.[22] The important place of Carolingian tradition in Suger's mind is symbolized for us today by the large rock crystal with the Crucifixion, produced in one of the court ateliers of Charles the Bald.[23] Reused by Suger's artists for the new shrine, this great work must have had enormous appeal to the zealous abbot. Its size, luminosity, and completeness are impressive; its engraved imagery is refined yet expressive in its depiction of a key sacred subject. Both symbol-

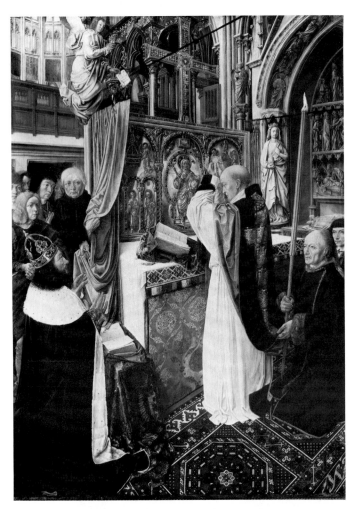

Fig. 11. Master of Saint Giles, The Mass of Saint Giles *(London, National Gallery), late fifteenth century*

ically and visually this immense gem must have taken a primary position in the tabernacle, dominating the whole series of carved cameos and intaglios — most of them pagan — and precious jewels that Suger eagerly acquired from a variety of sources.

Turning again to Suger's chalice (fig. 1) and ewer (fig. 8), we should recognize that even though the overall format is Byzantine-inspired, the decorative details are Western in inspiration. Yet a direct correlation with Carolingian works still at Saint-Denis in the twelfth century is difficult to establish. The painting by the Master of Saint Giles (fig. 11), which is useful in many respects, does not help in the search for technical models for Suger's craftsmen. We might better turn for clues to the extant and well-known book covers from the court workshops of Charles the Bald, such as the Codex Aureus from Saint-Émmeran now in the Bayerische Staatsbibliothek, Munich, or the upper cover of the Lindau Gospels, in the Pierpont Morgan Library, New York (fig. 12). In the latter we see the outer borders encrusted with gems and pearls set in high, arcaded bezels placed in an orderly pattern. The pearls in these side bands are arranged in the four quadrants of small crosses, each formed by five separate stones. When the eye moves along these borders, the pearls appear to be arranged in pairs, a characteristic of Suger's vessels, as seen in the upper rim of the chalice or in the lost rim of the foot as recorded in the drawing made for Peiresc (fig. 1 and Gaborit-Chopin fig. 10). The inner narrow border that frames the cross in the center of the Morgan cover is of special interest because of its row of alternating pearls and gems edged with a beaded wire. This might be compared with the handles of Suger's chalice and ewer (figs. 8 and 13), where in each case single-wire volutes of filigree separate the pearls and gems. Still, the goldsmith work of the Charles the Bald shops, as represented in the lost frontal and the two book covers, is far more complicated in organization and richer in detail than the surviving objects made for Suger.

The system of a series of gems flanked by paired pearls, which is so attractive in Suger's chalice and the foot of the Eleanor Vase (see Gaborit-Chopin fig. 14) seems even more closely related to examples of Rhenish-Ottonian work than to the Carolingian monuments we have examined. The cross (fig. 14), dating around 973–982 and given to the Essen Minster by Mathilda, abbess of Essen, and by her brother Otto, duke of Bavaria and Swabia, continues the Carolingian tradition of gems and pearls on high, arcaded bezels, a detail we have seen abandoned by Suger's goldsmiths.[24] But the Mathilda Cross shows a row of single gems flanked by paired pearls. Except for the bezels and the details of the filigree, Suger's craftsmen have created a fairly close approximation of this design. The chief difference in the filigree, as pointed out by Blaise de Montesquiou-Fezensac and Danielle Gaborit-Chopin, is that Suger's artists favored a double-wire filigree,[25] whereas the Rhenish works seem to be entirely restricted to a single-wire filigree, best seen at the extremities of the Ma-

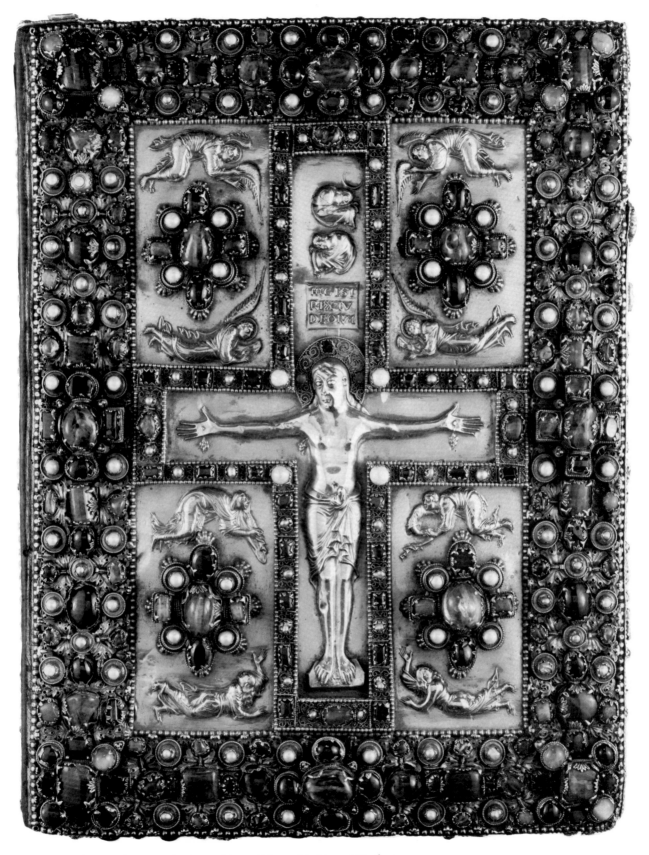

Fig. 12. Lindau Gospels (New York, Pierpont Morgan Library, M. 1), ca. 870, front cover

Fig. 13. Suger's Chalice (Washington, D.C., National Gallery of Art, Widener Collection), detail of the edge of one handle

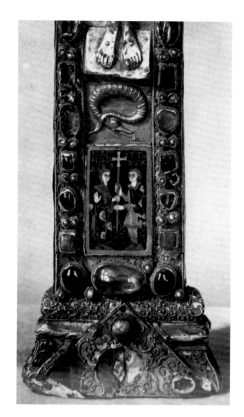

Fig. 14. Altar Cross of Abbess Mathilda and Duke Otto (Essen, Minster Treasury), 973–982, front of the Cross

thilda Cross. Although the Cross of Abbess Theophanu, which dates from about 1050, also at Essen, was probably partially reworked in the twelfth century, we can see here again the series of gems along the arms, interspersed by the pearls in pairs.[26] In summary, the technique and decorative motifs of Suger's three vessels—the chalice, the ewer, and the Eleanor Vase—stand clearly outside any effort to emulate Byzantine forms but seem instead dependent as much on Rhenish-Ottonian works in the same media as on Carolingian examples.

As a postscript to this hypothesis of partial Rhenish dependence, one may observe that the simplified leaf patterns engraved on the sides of the handles of the chalice recall similar patterns in the borders of Cologne manuscripts dating from 1050 to 1150.[27]

My last point regarding the traditions underlying Suger's contributions to the treasury is by no means the least. Suger and his craftsmen were heirs to a long medieval tradition in their reemployment of ancient cameos, intaglios, and hard-stone containers. This interest, analyzed by William Heckscher in 1937, was in keeping with continuing medieval ideas of permanence and beauty in relation to the flawless appearance of these works preserved from earlier times.[28] Such objects were considered and valued within a perceived and established divine order of the universe. Integrity or perfection, consonance of parts, symmetry,

clarity, and luminosity were primary in categorizing the beautiful. In their Christian adaptations the amuletic or pagan magical functions of objects were given a new and superseding purpose. The ancient gem or vessel was carefully preserved intact during this adaptive process.

These medieval principles were already evident in the now-lost Merovingian mounting of the incense boat of Saint Éloi (see Gaborit-Chopin fig. 2), which Suger acquired as a complete ensemble. They are also clearly found in the figural sardonyx chalice, the "Cup of the Ptolemies" (see Gaborit-Chopin fig. 1), with its now-lost Carolingian gold foot beset with gems, an object already in the treasury yet probably restored by Suger's artists.[29] These principles are equally clear in the insertions in a whole series of Rhenish-Ottonian works, perhaps the most spectacular being the pulpit of Henry II at Aachen, with its great vessels of semiprecious stones arranged in a cross flanked by pagan ivories.[30] On a similar scale we are reminded of one of Heckscher's illustrations: the antique intaglio of a nude youth next to an enamel showing a lamenting Sun on the second Cross of Abbess Mathilda.[31] The Roman lapis lazuli head of Livia used as a head of Christ in the Herimann Cross, a Cologne work of the mid-eleventh century, is an especially familiar example.[32] Suger's artists continued this adaptive process with special brilliance in the

instance of the ancient Roman porphyry vase transformed into the Eagle Vase (fig. 9) and of the Alexandrian second-century-B.C. agate cup transformed into the chalice (fig. 1), both for use on the altar in Suger's new chevet. We have learned from Jean Bony the importance of Suger's columns in the chevet.[33] If Suger had carried out his idea of transporting the great columns from Diocletian's palace in Rome,[34] he would have succeeded in outdoing the scale of all these antique insertions. Perhaps in his own mind he would have fulfilled his *renovatio* more completely if he had done so.

NOTES

1. Sumner McK. Crosby, "Abbot Suger, the Abbey of Saint-Denis, and the New Gothic Style," *Royal Abbey*, p. 17.

2. Suger, *Adm.* (P), p. 65.

3. Blaise de Montesquiou-Fezensac and Danielle Gaborit-Chopin, *Le Trésor de Saint-Denis*, 3 vols. (Paris, 1973–77), vol. 3, pp. 57–59 and figs. 41–43; and William D. Wixom, "For the service of the Table of God," *Royal Abbey*, pp. 108–11, no. 25.

4. William D. Wixom, *Treasures from Medieval France*, exhib. cat. (Cleveland Museum of Art, Cleveland, 1967), p. 70; François Avril, Xavier Barral i Altet, and Danielle Gaborit-Chopin, *Les Royaumes d'Occident* (Paris, 1983), pp. 333, 335, 430 (no. 442); *The Treasury of San Marco, Venice*, exhib. cat. (Metropolitan Museum of Art edition, Milan, 1985), pp. 136–140, 156–67, nos. 11, 15, 17.

5. Victor Elbern, "Der eucharistische Kelch im frühen Mittelalter," *Zeitschrift des deutschen Vereins für Kunstwissenschaft* 17 (1963): Tassilo Chalice, 8, 13–15, 70–71, no. 17, figs. 4, 5; Gauzelin Chalice, 34–35, 37, 72, no. 22, fig. 36.

6. For analysis of the postmedieval changes in the chalice, see Montesquiou-Fezensac and Gaborit-Chopin, *Le Trésor*, vol. 3, p. 58; and Wixom, in *Royal Abbey*, pp. 108–10, no. 25.

7. William Martin Conway, "The Abbey of Saint-Denis and Its Ancient Treasures," *Archaeologia or Miscellaneous Tracts Relating to Antiquity*, 2d ser., 66, no. 16 (1915): 143, mentions as Byzantine-inspired only the handles set with pearls and jewels "as in the case of several Byzantine chalices of about the same date preserved in the treasury of St. Mark at Venice."

8. Hans Hahnloser, ed., *Il Tesoro di San Marco*, II: *Il Tesoro e il museo* (Florence, 1971), pp. 58–59, no. 40, figs. XL and XLI (Inventory no. 69); *The Treasury of San Marco*, pp. 159–65, no. 16.

9. Hahnloser, *Il Tesoro*, pp. 59–60, no. 41, figs. XLII and XLVI (Inventory no. 65); *The Treasury of San Marco*, pp. 136–40, no. 11.

10. Hahnloser, *Il Tesoro*, pp. 63–64, no. 49, fig. XLVIII (Inventory no. 68); *The Treasury of San Marco*, pp. 165–67, no. 17.

11. Alfred Bellinger and Philip Grierson, *Leo III to Nicephorus III (717–1081)*, vol. 3 of *Catalogue of the Byzantine Coins in the Dumbarton Oaks Collection and in the Wittemore Collection* (Washington, D.C., 1973), pt. 2, p. 724, no. 1c3, pl. LVII.

12. William D. Wixom, "State of Research on Some Recent Acquisitions." Unpublished paper given at the First Annual Byzantine Studies Conference, Cleveland, Ohio, 25 October 1975. For a comparison with Byzantine enamels, see Marc Rosenberg, "Ein wiedergefundener Kelch," *Festschrift zum Sechsigsten Geburtstag von Paul Clemen* (Bonn, 1926), fig. 9.

13. Montesquiou-Fezensac and Gaborit-Chopin, *Le Trésor*, vol. 3, pp. 41–42, pl. 22; and Wixom, *Royal Abbey*, pp. 112–13, no. 26.

14. Montesquiou-Fezensac and Gaborit-Chopin, *Le Trésor*, vol. 3, pp. 42–43, figs. 23–24; and Wixom, *Royal Abbey*, p. 103, fig. 33.

15. Joan Evans, "Die Adlervase des Sugerius," *Pantheon*, 10 (1932): 221–22, figs. 1 and 2.

16. Suger, *Adm.* (P), pp. 76–79; Montesquiou-Fezensac and Gaborit-Chopin, *Le Trésor*, vol. 3, pp. 60–61, fig. 45B; and Wixom, *Royal Abbey*, p. 106, no. 23, fig. 34 (detail of Félibien's engraving).

17. Conway, "Abbey," pp. 126–27, pl. IX, fig. 1; and Montesquiou-Fezensac and Gaborit-Chopin, *Le Trésor*, vol. 1, pp. 165–66, no. 74, and vol. 3, pp. 60–61, pl. 45B.

18. Pierre Bouffard, *Saint-Maurice d'Agaune, Trésor de l'abbaye*, (Geneva, 1974), pp. 55, 59–65.

19. Suger, *Adm.* (P), p. 61.

20. Ibid., p. 63.

21. Danielle Gaborit-Chopin, "L'Orfèvrerie cloisonnée à l'époque carolingienne, *Cahiers archéologiques* 29 (1980–81): 16–22, figs. 14, 19, 22, 23.

22. Montesquiou-Fezensac and Gaborit-Chopin, "Le Tombeau des corps-saints à l'abbaye de Saint-Denis," *Cahiers archéologiques* 23 (1974): 81–94.

23. Wixom, *Royal Abbey*, p. 107, no. 24.

24. Hanns Swarzenski, *Monuments of Romanesque Art* (London, 1954), p. 42, pl. 28, fig. 69; and Hermann Schnitzler, *Rheinische Schatzkammer* (Düsseldorf, 1957), no. 43, pls. 143, 144.

25. Montesquiou-Fezensac and Gaborit-Chopin, *Le Trésor*, vol. 3, p. 42.

26. Schnitzler, *Schatzkammer*, no. 46, pl. 155.

27. Wixom, *Royal Abbey*, p. 110; see Anton Legner, ed., *Monumenta Annonis: Köln und Siegburg, Weltbild und Kunst im höhen Mittelalter*, exhib. cat. (Cologne, 1975), p. 155: c-15, p. 158: c-17, p. 159: c-15, p. 160: c-19, p. 233: g-2.

28. William S. Heckscher, "Relics of Pagan Antiquity in Medieval Settings," *Journal of the Warburg Institute* 1 (1937): 210–12.

29. Gaborit-Chopin, "L'Orfèvrerie," pp. 14–15, figs. 12, 13.

30. Percy Ernst Schramm and Florentine Mütherich, *Denkmale der deutschen Könige und Kaiser: ein Beitrag zur Herrschergeschichte von Karl dem Grossen bis Friedrich II, 768–1250* (Munich, 1962), pp. 165–66, pl. 137.

31. Heckscher, "Relics," pl. 30b.

32. Ursula Bracker-Wester, "Der Christuskopf vom Herimann-kreuz—ein Bildnis der Kaiserin Livia," *Rhein und Maas, Kunst und Kultur 800–1400* (Cologne, 1973), vol. 2, pp. 117–80, figs. 2, 3, and color plate 7.

33. See pp. 136–37.

34. Suger, *Cons.* (P), pp. 90–91.

Photo Credits

Some illustration sources are given in the captions accompanying the figures; below are given all other sources, which are listed in alphabetical order, followed by the number of the page on which the illustration appears. If there is more than one illustration on a page, the figure number is also given.

Aosta Valley, Superintendant of Monuments 251; Art Resource/Alinari 296 (figs. 2–4); J. Austin 132 (fig. 3), 134 (fig. 6), 137 (fig. 12); X. Barral i Altet 248 (fig. 6), 249 (figs. 7, 9); J. Blécon 239; P. Z. Blum 133 (fig. 4), 203, 204, 205 (figs. 8b–d), 207, 208 (figs. 10, 12), 210, 211, 213 (fig. 19), 216, 217, 250, 278 (figs. 9a, 10a); J. Bony 132 (fig. 1), 139 (fig. 14), 140 (fig. 16); Margaret Burke 134 (fig. 7); M. H. Caviness 260; W. H. Clark, after Crosby 113, 125; W. W. Clark 106, 109, 110 (fig. 3), 129 (figs. 18, 19), 130 (fig. 20a), 209 (fig. 13); Compiègne, Musée Vivenel 133 (fig. 4), 208 (fig. 12); S. Crosby 124; S. Crosby Archives 200 (fig. 1), 209 (fig. 14); F. H. Crossley, Courtauld Institute 132 (fig. 2); after Darmon and Lavagne, *Recueil* 248 (fig. 5); after Demenais, *Bulletin monumental* vol. 80, 1921, 135; Franceschi 234 (figs. 10, 11); Le Gentil de la Galaisière, after Fossier 201; N. Geiger 185, 192; S. Geiger and W. H. Clark 78; P. Gerson 184, 187, 188, 189, 190, 191, 193, 228; L. Grodecki 277, 281; J. Herschman 110 (fig. 4), 117, 126, 127, 128, 129 (fig. 17), 130 (figs. 20b–d), 137 (fig. 10); IGN, Crosby 112; after *Les Arts*, 1906, 235 (fig. 12); C. Little 76; London, NMR, Crown Copyright, Royal Commission on Historical Monuments 133 (fig. 5); Foto Marburg 139 (fig. 13), 202, 205 (fig. 8a), 302 (fig. 14); New York, The Metropolitan Museum of Art 237, 240 (fig. 17), 278 (figs. 9b, 10b); after W. Oakeshott 214; Paris, Archives Photographiques, SPADEM 208 (fig. 11), 247 (fig. 2), 262 (fig. 3), 268, 278 (fig. 8), 299; Paris, Giraudon 266 (fig. 11); Paris, Réunion des Musées Nationaux 234 (fig. 9), 285 (fig. 5), 298 (fig. 8); L. Pressouyre 230, 231, 240 (fig. 16), 241 (figs. 18, 19, 21); after Quicherat, *Revue Archéologique* 11 (1854) 81; M.-P. Raynaud, H Delhumeau 246; Rome, Gabinetto Fot. Nationale 252; Rouen, Musée des Antiquités 235 (fig. 13), 241 (fig. 20); D. Sanders, after Crosby 114; S. Sechrist (Bournazel chart pp. 64–65), 96 (fig. 1b–c), 97 (figs. 4b–c); P. Verzone; after Rusconi 137 (fig. 11); F. Walch 274.